ATLAS
OF
WESTERN
ART HISTORY

ATLAS
OF
WESTERN
ART HISTORY

Artists, Sites and Movements from
Ancient Greece to the Modern Age

JOHN STEER ANTONY WHITE

Facts On File®

AN INFOBASE HOLDINGS COMPANY

Atlas of Western Art History:
Artists, Sites and Movements from Ancient Greece to the Modern Age

Facts On File, Inc.
460 Park Avenue South
New York, NY 10016

Library of Congress Cataloging-in-Publication Data

Steer, John
 Atlas of western art history: artists, sites, and movements
 from ancient Greece to the modern age / John Steer, Antony White.
 p. cm..
 Covers the Americas, Europe, and the classical ancient world.
 Includes index.
 ISBN 0-8160-2457-X
 1. Art—History—Maps. I. White, Antony 1941– . II. Title.
G1046.E6437 1992 <G&M>
700'.22'3—dc20 92–11226

Consultants
Dr. François Baratte, Conservateur
Département des Antiquités Grecques, Etrusques et Romaines
Musée du Louvre, Paris

Professor Eric Fernie
Dean of Fine Arts
Edinburgh University

Dr. Irma Jaffe
Professor Emeritus of Art History
Fordham University

Professor John Steer
Professor Emeritus of Art History
London University

Dr. Christopher White
Director
Ashmolean Museum, Oxford

Facts On File books are available at special discounts when purchased in bulk quantities for businesses, associations, institutions or sales promotions. Please call our Special Sales Department in New York at 212/683-2244 or 800/322-8755.

Designed by David Cook
Cartography by Chapman Bounford & Associates, London
 Lovell Johns Limited, Oxford
Jacket design by Trevor Bounford
Composition by Chapman Bounford & Associates, London
Index compiled by Francesca Stanley
Manufactured by Mandarin Offset
Printed in China

10 9 8 7 6 5 4 3 2 1

This book is printed on acid-free paper.

to

BRUCE ROBERTSON

Contents

Contents

Contents

Contents

Acknowledgments

This book has taken five years to make. Doubtless there are errors; and there are certainly many points with which some specialists may take issue; but we have tried to piece together an enormous number of facts and points of view and to express them in a relatively new manner.

So many people have helped us that we can only mention a few here. We would never have got so far as we have done without the extraordinary dedication and encouragement of a very small team of people who have helped us on a daily basis at various times in recent years, in particular, Shona Getty, Jane White, Julia Waley, Cathy Cardozo and Sarah Hoexter, with assistance from Sam Hoexter.

In the very early days of the project we were given help and support in different ways by Hal Robinson, Heather Dean, Jo Carpenter, Damian Timmer and, in particular, by Charles Merullo. Much early research in both the fields of history and art history were provided by Mira Hudson, Tom Henry, Dr. Richard Leslie and Dr. Martin Postle. We are also indebted to Dr. Eric Stenton for assistance with the cartographic details of some of the classical maps.

Tony Kingsford's contribution to the editing of the text, and its marriage to the maps themselves was crucial. Deirdre Mullane, our editor in New York has supported us at every stage. Many others have helped with the editing including John Latimer Smith, Sam Merrel, Maureen Cartwright and David Lambert. Jane Robertson has also cheerfully helped us by converting our text files for the whole project.

Pat Robertson gave us time and knowledge to set up our picture research department. When established, this work was made much easier and pleasanter by the patience and cooperation of Lily Richards at the Bridgeman Archive.

Our cartographers in Oxford and London have been endlessly resourceful and patient. In particular we would like to thank Andrea Pullen, Denise Goodey and Justin Ives. The knowledge of historical cartography of Andras Bereznay has avoided a multitude of inaccuracies, and any that have remained are our responsibility rather than his.

Karen Byrne has schemed many of the maps and implemented many of the ideas of David Cook, who has both designed the book and advised us at every stage.

Without Sheila Bounford, of Chapman Bounford and Associates, who pulled the whole project together, the book would never have been published.

Facts On File wishes to thank Paul M. Smith of Smith McDonnell Stone & Co. Without his encouragement, publishing this book would not have been possible.

Consultants and contributors

Contributors

The following have written the text and provided the information for maps and texts:

Brian Allen:	pages 250-255
Dr. Geoffrey Ashton:	pages 246–249
Dr. Sylvia Auld:	pages 86–87
Christopher Baker:	pages 222–227
François Baratte:	pages 20–2l, 44–49, 50–57
Andras Bereznay:	pages 60–61, 62–63, 196–197
Thomas S. Brown:	pages 70–73
Ian Chilvers:	pages 92–93, 100–101, 188–193, 242–243, 276–277, 290–291, 294–299
Neil Manson Cameron:	pages 98–99
Dr. Paul Crossley:	pages 116–117
David Dearinger:	pages 310–311
Sophie Descamps:	pages 18–19, 26–29, 32–37
Dr. Jane Geddes:	pages 106–107
Dr. Richard Goy:	pages 210–211
Dr. Lindy Grant:	pages 110–111
Professor Michael Greenhalgh:	pages 142–147, 166–169
Gerhard Gruitrooy:	pages 272–281
John Higgitt:	pages 82–85
Paul Holberton:	pages 156–157
Dr. Elizabeth James:	pages 68–69
Susan Jenkins:	pages 214–217
Lori Laqua:	pages 300–301
Luc Leconte:	pages 22–23
Pascal Liévaux-Senez:	pages 176–177
Nic Madormo	pages 312–313
Professor S.D. Markman:	pages 258–265
Dr. Michael Michael:	pages 104–105
Lesley Milner:	pages 94–95
Moralis y Maria:	pages 178–181
Dr. Paula Nuttall:	pages 128–129, 174–175
Dr. Jaroslavl Petru:	pages 238–241, 244–245
Kimberley Pinder:	pages 112–113
Timothy Porter:	pages 170–171
Dr. Martin Postle:	pages 220–221
Durward Potter:	pages 306–309
Venceslava Raidl:	pages 242–243
Caroline Richardson:	pages 88–89
Dr. Lyn Rodley:	pages 74–79
Dr. Peter Rumley:	pages 282–283, 286–287, 290–293
James Sibal:	pages 304–305
Michael Siewert:	pages 302–303
Professor Roger Stalley:	pages 102–103
Francesca Stanley:	pages 134–135, 138–139
Professor John Steer:	pages 136–137, 150–155, 164–165, 182–187, 284–285
Dr. Slavka Sverakova:	pages 238–239, 244–245
Roger Tarr:	pages 122–127
Dr. Thomas Tolley:	pages 80–81, 120–121
Marcia Wallace:	pages 256–257
Christopher Welander:	pages 118–119
Antony White:	pages 60–65, 92–93, 100–101, 132–133, 140–141, 158–163, 172–173, 188–193, 196–199, 268–271, 312–313
Dr. Christopher White:	pages 200–209, 212–213, 228–237
Roger White:	pages 256–257
Humphrey Wine:	pages 218–219
Dr. Francis Woodman:	pages 114–115

Introduction

Maps are a very special phenomenon. The knowledge and enjoyment they bring depends on an unusual combination of the abstract and the concrete. Within the limits of scale, maps truly represent, at least as far as their outlines and proportions are concerned, the real world they chart. When it finally became possible to photograph our planet from the stratosphere, it surprised no one that reality looked like the maps depicting it.

Yet all the information that a map conveys is, of necessity, coded. The signs it employs range through an infinite series of modulations from the natural to the conventional. Thus the black dots standing for towns, which spatter almost all the maps in this atlas partake of both conditions. Towns do not, even from the stratosphere, look like black dots, but the functioning of the dots is determined by something concrete and real. They record the actual position of the towns on the earth's surface and in this vital respect they are truly representational of what is.

In color a similar complexity of factors applies. It is easy to take for granted the fact that in almost all physical maps the sea is represented by blue and the land as brown until you try to reverse them. Brown is not described as "earth color" for nothing and blue as a translucent or penetrable color stands for the aqueous and the empyrean. On a political map the colors of the land standing for different countries or groupings of countries are, or seem to be, wholly conventional.

But even map colors acquire their own resonances. As E. H. Gombrich wittily remarked of Harry Beck's classic map of the London Underground: the different lines somehow take on the timbre of the colours that represent them – the Piccadilly Line, for example, bright blue; the Northern Line, black – so that travelling below ground in London becomes an emotionally rainbow-like experience.

This not altogether facetious example indicates why, in the preparation of this book, we have laid so much emphasis on the presentation and appearance of the maps and devoted so much time to trying to code in visually coherent ways the information which, in conjunction with the accompanying lists, they carry. We cannot say how successful we have been, but we are proud of our team of cartographers, of the standards they have achieved, and of the book's visual appearance. It is by the maps first and foremost that it stands or falls.

But why an *atlas* of art history? Whereas it is obvious that some subjects such as the medieval pilgrimage routes lend themselves especially to cartographic treatment – one may think of the lines linking northern France to Spain as pilgrims and craftsmen moving like busy ants to Santiago de Compostela and back again – almost all aspects of the history of art have a mappable dimension.

The texts relate to the maps and we hope that by using them the purpose and function of the maps will become clear to the reader. But equally they are designed to provide a general introduction to someone approaching each subject for the first time, so that he or she may start a new journey of exploration, literally in some cases by discovering where the works of art in question are to be seen.

The city maps, such as those of Rome, Florence, Paris, Prague and Vienna, among others will, we hope, also act as stimulating companions to the standard guidebooks, putting the major works of art and monuments in both their chronological and stylistic contexts. In addition the history maps are intended to provide a basic political background.

At a more detailed level, we think that certain maps, like that of the sites visited by the painters of the Danube School, or that showing the summer journeyings of the Fauves and Cubists, bring together information which will be of particular use to specialists. This is true also in the areas of medieval and antique art where the material is perhaps most obviously mappable. We are particularly pleased with the contrast between the medieval maps which show the actual routes which objects and materials are known to have traveled, and the three 19th century maps dealing with Impressionism and Post-Impressionism. These, beginning with Paris, show how related styles spread first throughout France and then rapidly through the rest of Europe. We also hope that the maps on the travels of artists in the Renaissance and the 17th century will provide information which could not be readily conveyed except by cartographic means.

In principle, the virtue of the cartographic approach is to tie the subject quite literally to the ground: to where works of art were produced, to the territorial relationships between the various schools and styles to the availability and dissemination of the materials from which they were made and in general how they came about. This is, of course, only one way of approaching them, but it may be useful at a time when much of the study of the visual arts has become tautologically linguistic and theoretical. The geographical circumstances surrounding a work of art play a role in its creation. We hope that this presentation will provide information, pleasure and in some cases even illumination.

John Steer and Antony White

Physical Map of Europe

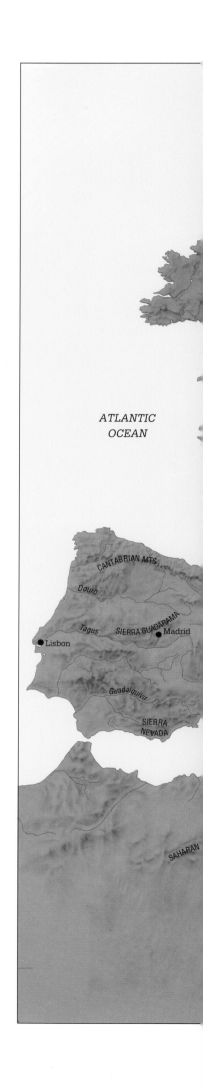

ATLANTIC
OCEAN

CANTABRIAN MTS.

Douro

Tagus

SIERRA GUADARAMA

●Lisbon

● Madrid

Guadalquivir

SIERRA
NEVADA

SAHARAN

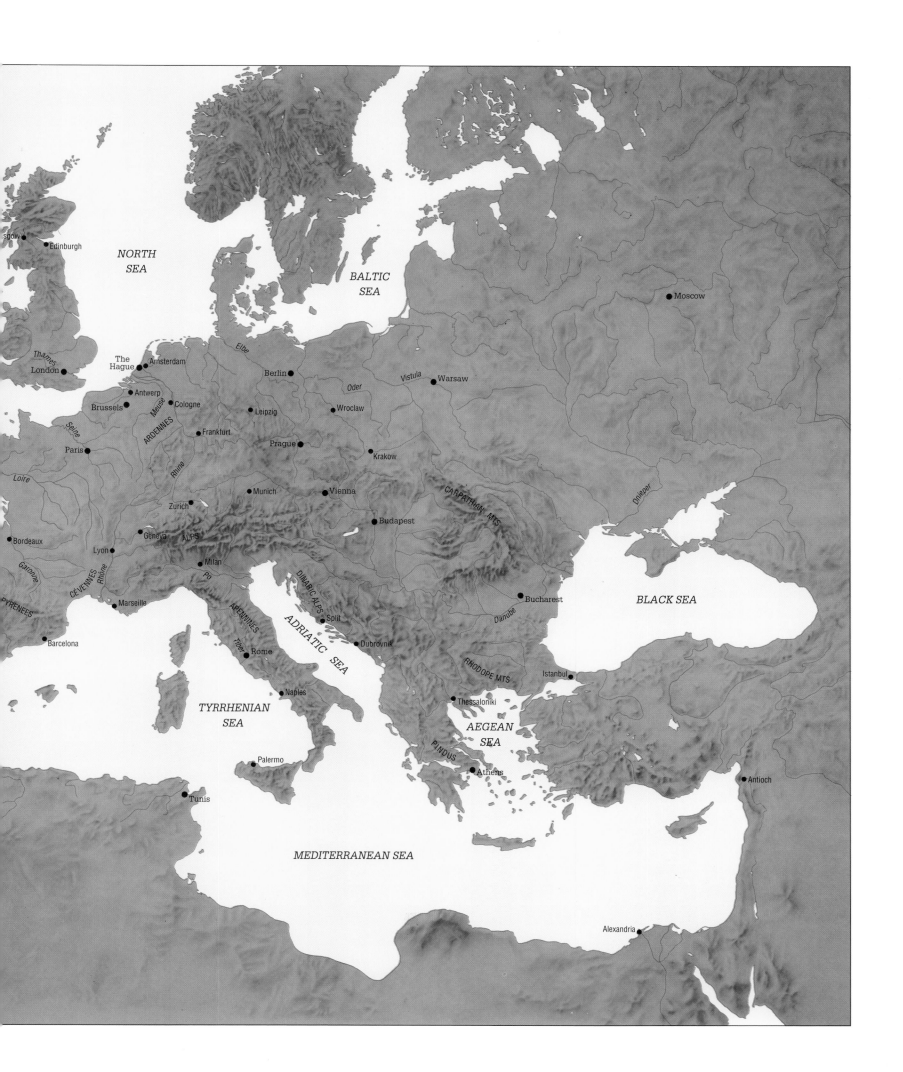

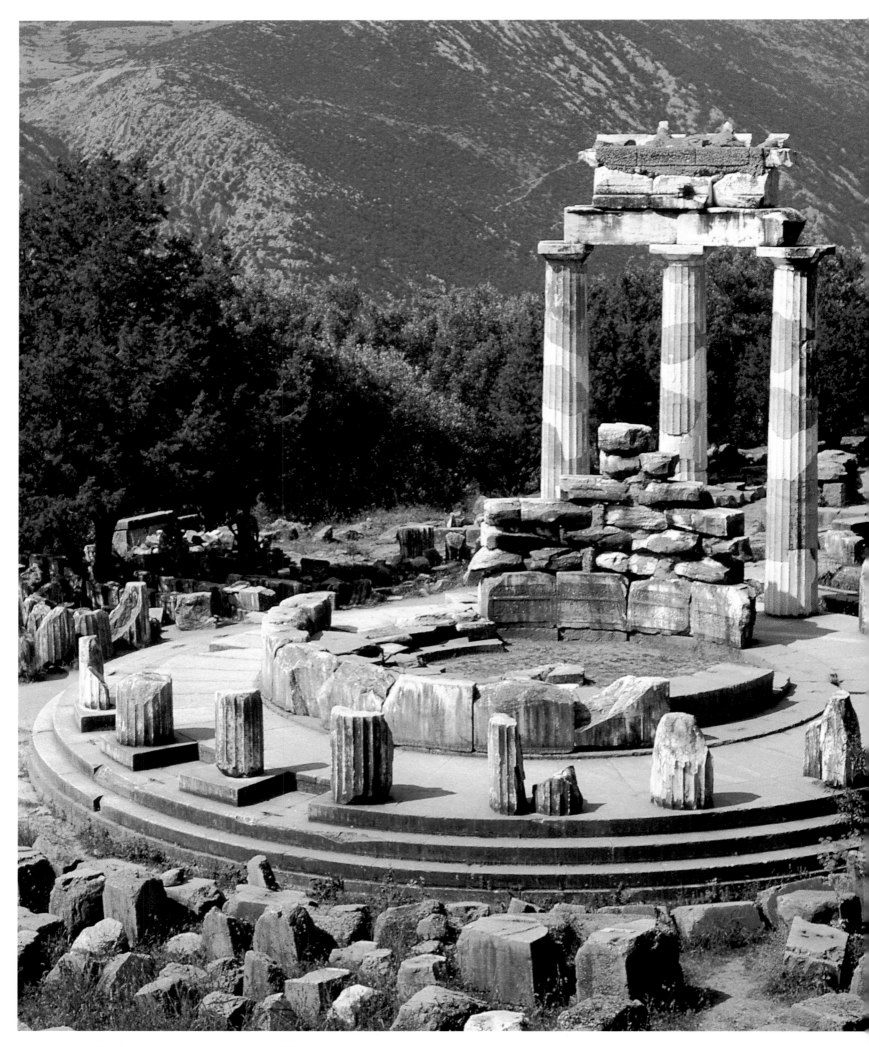

Above: Tholos Temple Sanctuary of Athena Pronaia, c.*600 B.C., Delphi, Greece.*

THE ANCIENT WORLD

700 B.C. – 313 A.D.

The Ancient Greeks, in addition to creating the basis of modern theater, literature, science, philosophy and political theory, created an art that reached an extraordinary perception of realism, balance and harmony. Greek architects combined mathematical harmony with an elaborately conceived and gradated series of decorative orders, imposed upon a post and lintel method of construction. Greek civilisation reached its height in the city states and colonies of the 5th century B.C. – in particular in Athens.

The Roman Empire likewise was based initially on a single city, that of Rome, and on an originally republican consititution. It became from the first century B.C. a seat of empire and its artists borrowed extensively from the Greeks but evolved a style both in architecture and sculpture which was to reach from the Scottish borders to the Euphrates. Roman architecture incorporated the arch and the dome and built on a scale, and with a technical virtuosity, that subsumed the art of Greece and also became a direct inspiration for much of the later art and building of the West.

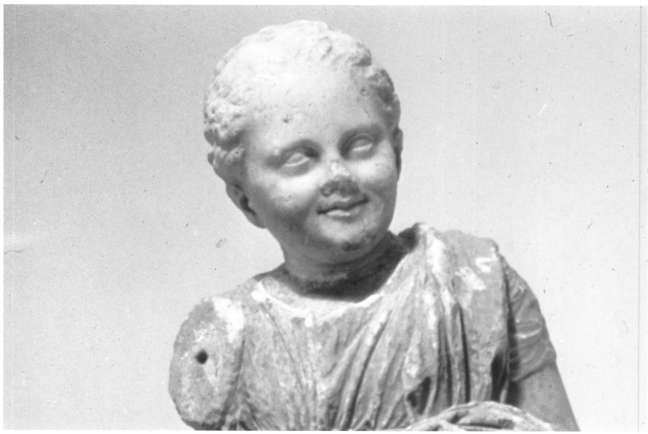

Above: Statue of Little Girl, *marble, 3rd century B.C. (Delphi, Greece).*

The Greek World and its Colonies

The greatest achievements of Greek art and culture took place in Athens in the 6th century B.C.. The most spectacular military successes came with Alexander the Great (336–323 B.C.), but it was the gradual process of colonization that spread the Greek way of life throughout the Mediterranean world.

From 8th century B.C. the Greeks retraced the ancient sea routes which connected Crete, Cyprus and Rhodes to the ports of the Levant. Their need for raw materials soon led them to search for themselves for sources of supplies which did not depend on Egypt and the Orient. This would partly explain their expansion north of the Aegean and into the western Mediterranean basin in the tracks of their Mycenaean predecessors.

The search for food and trade outlets was far from being the only incentive for Greeks to emigrate. Cities founded at this time were above all settlements of people. The expansion of Greece through colonization thus appeared as the remedy for the social malaise produced by demographic pressure and the unequal distribution of arable land, upheld in the main by rich aristocratic families. In *Works and Days* the poet Hesiod described the hard work of the small landowner who tried to survive in 7th-century Boeotia.

The Greek colonies were all founded close to a shore and, it would seem, were organized along rational lines which demonstrated the theoretical ideas on town planning expounded by Hippodamos of Miletos at the beginning of the 5th century. The Sicilian cities of Megara Hyblaea, Naxos and Kamarina show traces of the preliminary carving up, into regular plots, of the site chosen for each town and its territories. The recurrence every 210 meters of lines at right angles to the shore has been brought to light in the countryside around Metapontion, which was founded around 630.

The colonizing drive, which had begun around the middle of the 8th century B.C., petered out around 550. Foundations of the classical age, like Thurioi, were rare. In two centuries the boundaries of the Greek world had spread from Spain to the shores of southern Russia. Certain cities had played a decisive role in this expansion – Miletos, for example, had founded nearly 80 city colonies on the periphery of the Black Sea.

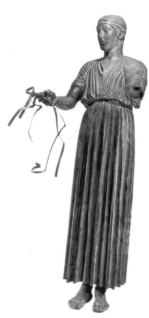

Above: The Charioteer, *bronze, c.470 B.C. (Delphi Museum, Greece).*

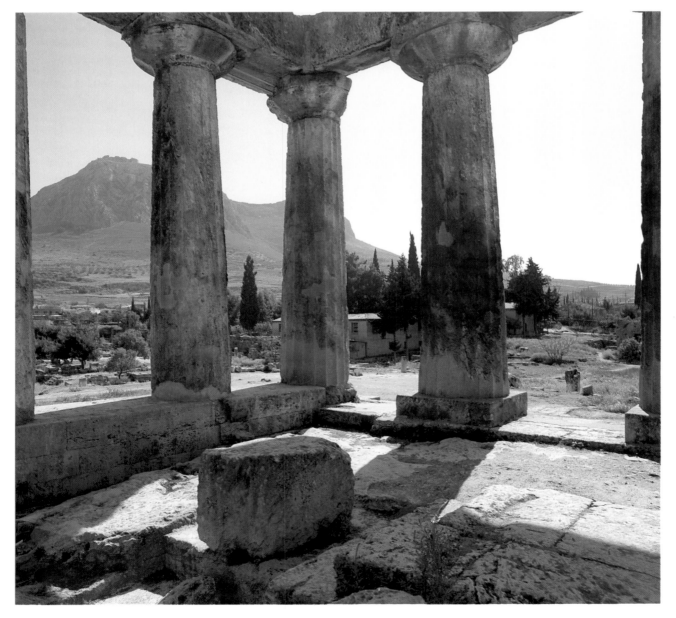

Left: The Temple of Apollo, *6th century B.C., with the fortress of Acrocorinth in the distance (Corinth, Greece).*

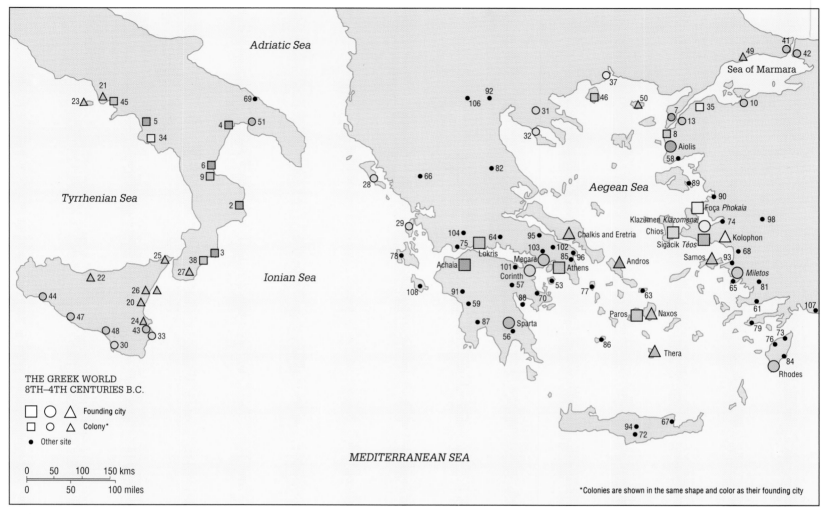

Adriatic Sea

Tyrrhenian Sea

Ionian Sea

Aegean Sea

Sea of Marmara

21
23 45
5
34
4 51
6
9
2
29
25
38 3
27
22
44
47
48
24
43 33
20
26
30

28
66
82
31
32
106
92
37
46
50
7 13
8
Aiolis
58
89
90
Foça *Phokaia*
Klazümen *Klazomenai*
Chios
Sigacik *Téos*
74
98
68
Kolophon
Samos 93
Miletos
65 81
61
107
79 73
76
84
Rhodes

104
75
Lokris
64
Achaia
Megara
Corinth
101
Chalkis and Eretria
95
103 102
85 96
Athens
57
53
70
77
63
Andros
Paros
Naxos
108
91
59
88
87
56
Sparta
86
Thera

94
67
72

49
41
42

35
10

MEDITERRANEAN SEA

THE GREEK WORLD
8TH–4TH CENTURIES B.C.

□ ○ △ Founding city
▫ ○ △ Colony*
● Other site

0 50 100 150 kms
0 50 100 miles

*Colonies are shown in the same shape and color as their founding city

1	Alalia	37	Abdera
2	Crotone *Kroton*	38	Lokroi Epizephyrioi
3	Caulonia *Kaulon*	39	Chersonesos
4	Metaponto *Metapontion*	40	Ereğli *Herakleia*
5	Paestum *Poseidonia*	41	Istanbul *Byzantion*
6	Sybaris	42	Kadiköy *Chalkedon*
7	Sestos	43	Megara Hyblaea
8	Sigeion	44	Selinunte *Selinus*
9	Thurioi	45	Naples *Neapolis*
10	Belkis *Kyzikos*	46	Thasos
11	Histria *Istros*	47	Agrigento *Akragas*
12	Kerch *Pantikapaion*	48	Gela
13	Nağara Point *Abydos*	49	Marmaraereğlisi *Perinthos*
14	*Odessos*	50	Samothrace
15	Olbia	51	Taranto *Taras*
16	Samsun *Amisos*	52	Cyrene
17	Sinop *Sinope*	53	Aigina
18	Tomis	54	Aksu *Perge*
19	Trabzon *Trapezous*	55	Al Mina
20	Catania *Katane*	56	Amyklai
21	Cumae	57	Argos
22	Himera	58	Assos
23	Ischia *Pithekoussai*	59	Bassai
24	Lentini *Leontinoi*	60	Belkis *Aspendos*
25	Messina *Zankle*	61	Bodrum *Halikarnassos*
26	Punta di Schisò *Naxos*	62	Carthage
27	Reggio di Calabria *Rhegion*	63	Delos
28	Corfu *Kerkyra*	64	Delphi
29	Leukas	65	Didim *Didyma*
30	Kamarina	66	Dodona
31	Pojani *Apollonia*	67	Dreros
32	Poteidaia	68	Efes *Ephesos*
33	Syracuse	69	Egnatia *Gnathia*
34	Elea	70	Epidauros
35	Lapseki *Lampsakos*	71	Gordion
36	Marseille *Massalia*	72	Gortyn

73	Ialysos		
74	Izmir *Smyrna*		
75	Kalydon		
76	Kameiros		
77	Keos		
78	Kephallenia		
79	Knidos		
80	Kom Giéif *Naukratis*		
81	Labraunda		
82	Larissa		
83	Larnaka *Kition*		
84	Lindos		
85	Marathon		
86	Melos		
87	Messene		
88	Mycenae		
89	Mytilene		
90	Namurt Limani *Kyme*		
91	Olympia		
92	Pella		
93	Priene		
94	Prinias		
95	Ptoion		
96	Rhamnous		
97	Salamis		
98	Sardis		
99	Selimiye *Side*		
100	Sidon		
101	Sikyon		
102	Tanagra		
103	Thebes		
104	Thermos		
105	Tyre		
106	Vergina		
107	Xanthos		
108	Zakynthos		

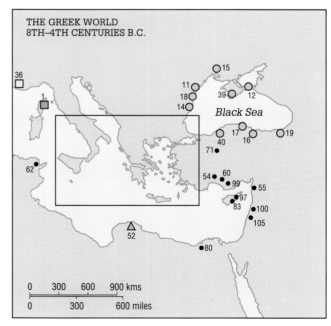

THE GREEK WORLD
8TH–4TH CENTURIES B.C.

Black Sea

36
1
14
18
11
15
39 12
17
40
16
19
71
62
54 60
99 55
97
83 100
80
105
52

0 300 600 900 kms
0 300 600 miles

The Roman World

The city of Rome was founded c.750 B.C., a small urban community on the banks of the Tiber, under the political and cultural influence of the Etruscans. The rise of Rome was to coincide with the decline of Etruscan dominance in Italy. By 280 B.C., the Roman Republic controlled the Italian peninsula from Pisa across to Ariminum (Rimini) and down to the straights of Messina. By 146 B.C., the end of the last Punic war, the Roman Republic had acquired five overseas provinces: Corsica, Sardinia, the two provinces of Spain and the Carthaginian kingdom in Africa – in effect the western Mediterranean. To the east Macedonia was annexed and the kingdom of Pergamum which became the Province of Asia, followed by the annexation of Cyrene, Crete, Bithynia, Pontus, Cilicia, Syria and Cyprus. The tribes along the Rhône were defeated and the whole of Gaul divided into three provinces.

By 44 BC the Roman Republic controlled the whole of the Mediterranean but was being constitutionally weakened by its provinces which provided military power for generals such as Pompey, Julius Caesar and Mark Antony. Their ambitions threatened the constitution and destroyed the Republic with a series of civil wars. These were concluded in 31 B.C. when Octavius Caesar defeated Mark Antony and Cleopatra's joint forces and became sole ruler of the Empire under the title Augustus. The Roman world enjoyed two centuries of peace; the boundaries of the Empire were defended by permanent military garrisons linked by a formidable network of roads. Naval vessels protected the sea trade routes which criss-crossed the Mediterranean carrying the vast amount of resources needed by Rome to feed a population of about 1,000,000 inhabitants and supply the garrisons in the provinces.

Augustus annexed Egypt, Galatia and Judaea in the east and Rhaetia, Noricum, Pannonia and Moesia to the north. The conquest of Britain was completed by Domitian in 84 A.D.. Under Trajan (98–117 A.D.) the Empire was extended to include Dacia, Armenia, Assyria and Mesopotamia: its fullest extent.

By the end of the 2nd century A.D. the empire was disintegrating. Diocletian's administrative reforms postponed the split between East and West, which finally took place under Constantine who established a new capital in Byzantium (renamed Constantinople 330 A.D.). The western half of the Empire was overrun by the barbarians: in 410 Rome was sacked by the Visigoths. Only the Church, the inheritor of Roman administration, kept alive the concept of an international power in the early years of the barbarian kingdoms.

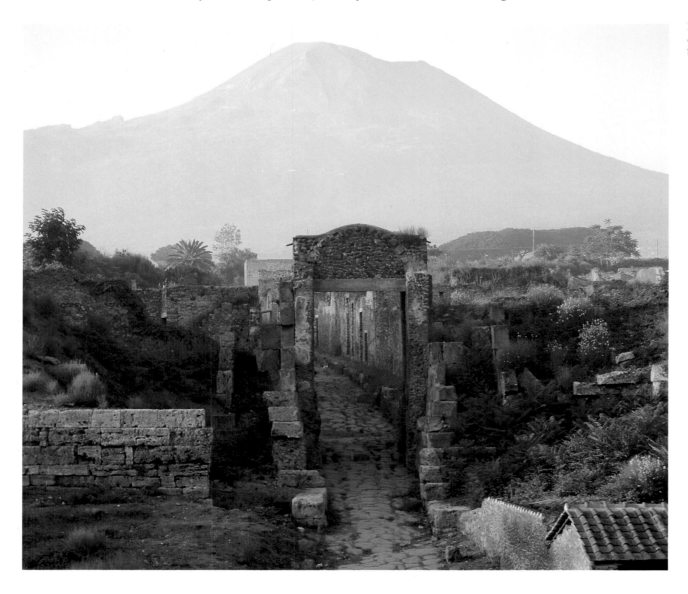

Left: Tombs beyond the walls of Pompeii with Vesuvius in the background.

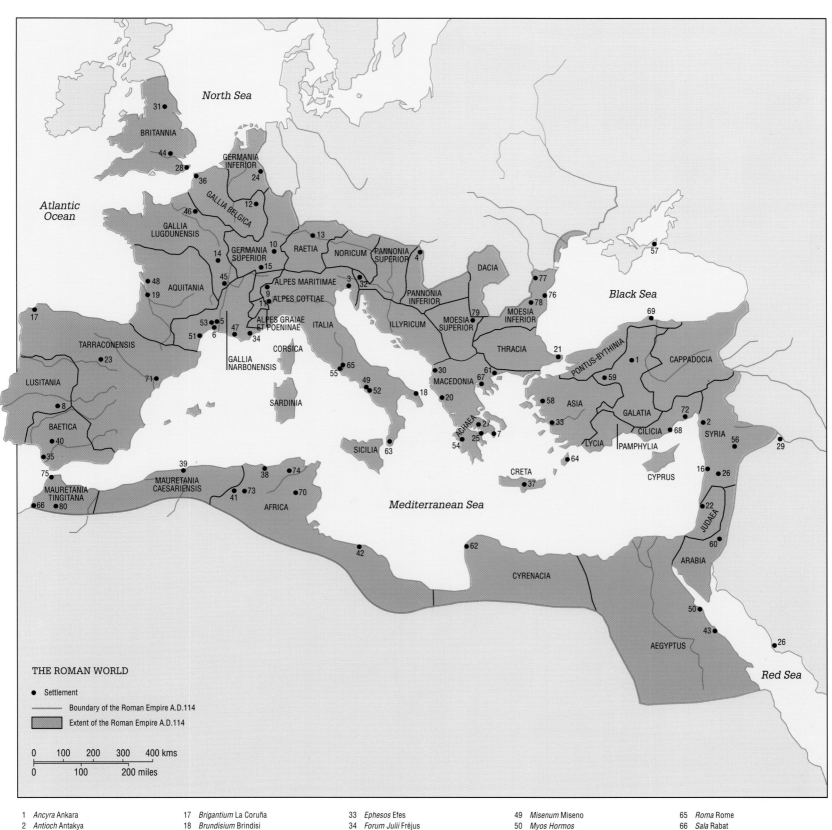

North Sea

Atlantic
Ocean

31 ●

BRITANNIA

44 ●
28 ●
36 ●

GERMANIA
INFERIOR
24 ●

GALLIA BELGICA
12 ●

46 ●

GALLIA
LUGDUNENSIS

13 ●

14 ●

GERMANIA
SUPERIOR
10 ●
15 ●

RAETIA

NORICUM

PANNONIA
SUPERIOR
4 ●

DACIA

57 ●

Black Sea

48 ●
19 ●

45 ●

AQUITANIA

ALPES MARITIMAE
9 ●
ALPES COTTIAE

3 ●
32 ●

PANNONIA
INFERIOR

77 ●
76 ●
78 ●

69 ●

17 ●

TARRACONENSIS

53 ●
51 ●

5 ●
6 ●

ALPES GRAIAE
ET POENINAE

47 ●
34 ●

ITALIA

CORSICA

ILLYRICUM

MOESIA
SUPERIOR

79 ●

MOESIA
INFERIOR

21 ●

PONTUS-BYTHINIA

1 ●

59 ●

CAPPADOCIA

72 ●

23 ●

GALLIA
NARBONENSIS

THRACIA

2 ●

LUSITANIA

71 ●

65 ●
55 ●

49 ●
52 ●

18 ●

30 ●
MACEDONIA
20 ●

67 ●
61 ●

58 ●

ASIA

GALATIA

CILICIA

68 ●

SYRIA

56 ●

8 ●

BAETICA

SARDINIA

33 ●

LYCIA

PAMPHYLIA

29 ●

40 ●
35 ●
75 ●

39 ●
38 ●

74 ●

ACHAEA
27 ●
25 ●
54 ●

7 ●

64 ●

16 ●
26 ●

MAURETANIA
TINGITANA
66 ●
80 ●

MAURETANIA
CAESARIENSIS

41 ●
73 ●

70 ●

AFRICA

SICILIA
63 ●

Mediterranean Sea

CRETA
37 ●

CYPRUS

22 ●
60 ●

JUDAEA

62 ●
42 ●

CYRENAICA

ARABIA

50 ●

AEGYPTUS

43 ●

26 ●

Red Sea

THE ROMAN WORLD

● Settlement

—— Boundary of the Roman Empire A.D.114

▨ Extent of the Roman Empire A.D.114

0 100 200 300 400 kms

0 100 200 miles

1 *Ancyra* Ankara	17 *Brigantium* La Coruña	33 *Ephesos* Efes	49 *Misenum* Miseno	65 *Roma* Rome
2 *Antioch* Antakya	18 *Brundisium* Brindisi	34 *Forum Julii* Fréjus	50 *Myos Hormos*	66 *Sala* Rabat
3 *Aquileia*	19 *Burdigala* Bordeaux	35 *Gades* Cadiz	51 *Narbo* Narbonne	67 *Salonika* Thessaloniki
4 *Aquincum* Budapest	20 *Buthrotum* Butrino	36 *Gesoriacum Bononia* Boulogne	52 *Neapolis* Naples	68 *Seleucia* Silifke
5 *Arausio* Orange	21 *Byzantium* Istanbul	37 *Gortyna*	53 *Nemausus* Nîmes	69 *Sinope* Sinop
6 *Arelate* Arles	22 *Caesarea H.* Qesari	38 *Hippo Regius* Annaba	54 Olympia	70 *Sufetula* Sbeitla
7 *Athenae* Athens	23 *Clunia* Peñalba de Castro	39 *Iol* Cherchel	55 Ostia	71 *Tarraco* Tarragona
8 *Augusta Emerita* Mérida	24 *Colonia Agrippinensis* Cologne	40 *Italica* Santi Ponce	56 *Palmyra* Tadmor	72 Tarsus
9 *Augusta Praetoria* Aosta	25 *Corinthus* Corinth	41 *Lambaesis* Lambèse	57 *Pantikapaion* Kerch	73 *Thamugadi* Timgad
10 *Augusta Rauricorum* Augst	26 Damascus	42 *Lepcis Magna* Labdah	58 *Pergamon* Bergama	74 *Thugga* Dougga
11 *Augusta Taurinorum* Turin	27 Delphi	43 *Leuke Kome*	59 *Pessinus* Balhisa	75 *Tingis* Tangiers
12 *Augusta Treverorum* Trier	28 *Dubris* Dover	44 *Londinium* London	60 *Petra* Selah	76 *Tomis* Constanta
13 *Augusta Vindelicum* Augsburg	29 *Dura Europas* Salahiye	45 *Lugdunum* Lyon	61 *Philippi* Crenides	77 *Troesmis*
14 *Augustodunum* Autun	30 *Dyrrachion* Durrës	46 *Lutetia Parisiorum* Paris	62 *Ptolemais* Tolmeta	78 *Tropaeum Trajani* Adamclisi
15 *Aventicum* Avenches	31 *Eboracum* York	47 *Massilia* Marseille	63 *Rhegion* Reggio di Calabria	79 *Viminacium* Kostolae
16 *Berytus* Beirut	32 *Emona* Ljubljana	48 *Mediolanum Santonum* Saintes	64 *Rhodes* Ródhos	80 *Volubilis* Ksar Pharadun

The Early Celtic Age

Celtic-speaking peoples north of the Alps formed a culture that between about 500 B.C. and A.D. 100 extended across much of Europe until almost overwhelmed by largely Roman conquest. In places, though, its decorative Celtic style of art endured into the Middle Ages.

Archeologists tend to link the dawn of the Celtic Age with the early iron-using Hallstatt culture named after a site near Salzburg in Austria. From the 8th to the 5th centuries B.C., Hallstatt-type metalwork, pottery, burials and buildings appeared between what are now France and Czechoslovakia, Germany and North Italy. Then a striking new influence emerged about 500 B.C.. Named after La Tène in Switzerland, where much of its metalwork has been discovered, the La Tène civilization featured a growth of towns, trade and warfare, with metalwork and carved stone patterned with interlaced curves and stylized creatures and plants.

This distinctive Celtic culture quickly appeared in different regions, chiefly west and north of the Hallstatt zone: as in the French Champagne region, the Ardennes in Belgium and Hunsrück-Eifel (e.g. at Klein Aspergle) in Germany, but also as far east as Bohemia, and in the former Hallstatt regions of west Switzerland and the Tirol (e.g. at Durrnberg). The Tirol linked Celts with Alpine peoples and the Mediterranean Veneti and Illyrii. From west Switzerland the Rhône linked Celts and Massilia to the south. Meanwhile Alpine passes extended contacts between north Italy and the rivers Rhine and Danube.

The Celts formed tribal societies ruled by petty chiefs. When they died some of the more powerful received sumptuous chariot burials, for instance at Weiskirchen, Schwarzenbach, Bass-Yutz, Somme-Bionne and Berru.

In the 5th and 4th centuries B.C., population movements and the diffusion of ideas spread Celtic culture through Burgundy, Switzerland (as evidenced at Ertsfeld and Münsingen-Raïn) and south and east Germany (as at Oberwittighausen and Parsberg).

Soon, a much greater Celtic expansion was under way. The Danube provided an axis of penetration eastward through central Europe, and it was near the Danube that a Celtic embassy met Alexander the Great in 335 B.C.. Meanwhile, in 385 B.C., Celts thrusting south into Italy had seized the city of Rome all but the Capitol, and various Celtic tribes settled down on the Adriatic coast, in the Po valley and in the Apennines, as at Filottrano and Monte Bibele. On this last site archeologists have discovered a sanctuary seemingly similar to several in north and west France, such as those at Gournay-sur-Aronde and St.-Jean-de-Trolimon. All of these sanctuaries lie outside the La Tène culture's zone of origin, yet show a strong unity of religious expression. To the north, in Great Britain, important chariot burials figure at Wetwang Slack in Yorkshire.

The beginning of the 3rd century B.C. marked the climax of the Celtic world, which sprawled from Ireland to the southern Ukraine. Celts thrusting east and southeast through the Balkans had settled at centers including Dobova, Mesek and Ciumesti. In the 3rd century Celts also controlled or occupied the land between Moravia and Byzantium. Major Celtic settlements from central through eastern and southeastern Europe included Kosd and Szob in Hungary, Dochsov and Jesinuv-Ujezd in Czechoslovakia, and Karaburma in east Yugoslavia. Contacts with Illyria and Greece strengthened Celtic influence in the southeast, and Celts thrusting farther afield even settled in Galatia (central Turkey).

Meanwhile, Roman power was expanding through Italy and largely at Celtic expense. By the beginning of the 2nd century B.C. Rome held all northern Italy, although the rest of the Celtic world seemed to have stabilized, built on economies featuring farming and handicrafts. Centers like Levroux, Manching and Mesecke-Zehrovice reveal artefacts of iron, bronze, pottery, glass, bone and wood.

Soon, though, Roman trade became conquest. The Celts' increasing vulnerability may reflect great changes begun in the 2nd century B.C.. Political and economic power had become based on individual hillforts like those of Bibracte, Basel and Velemszentvid, and military chiefs appear to have lost much of their wider influence. All this could explain why the Roman conquest of Gaul (58–51 B.C.) took only a few years, compared with the century needed to conquer north Italy, and why the Draci (Dacians) wiped out the Celtic Boii south of the Danube about 50 B.C..

Celts lost their last lands in the heart of Europe when the Germanic Marcomanni seized Moravia and Bohemia in 9 B.C.; and in A.D. 43 the Emperor Claudius completed the Roman conquest of Britain.

Most of the Celtic world now lay under Roman dominion. However, Scotland and Ireland remained free custodians of a Celtic heritage whose foliated scrolls and triskelions would embellish Christian manuscripts and monuments in the Dark Age ahead.

Above: Incised and stamped decorative pot, *4th century B.C., St.Pol-de-Léon, Finistère, France.*

The decoration on this wheel-turned pot, found in a barrow grave, shows a double palmette motif and undulating leaves with a toothed stamp infilling.

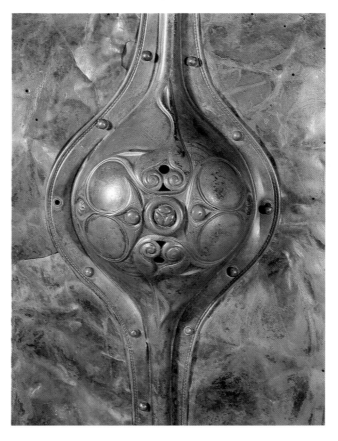

Left: The Witham Shield *(detail), 3rd century B.C. (British Museum, London).*

Discovered in the River Witham, Lincolnshire, in 1826, this central, coral inlaid, high-domed boss was added later to provide a handgrip at the rear of the original wood or leather shield. It is said that the Celts attributed magical qualities to coral.

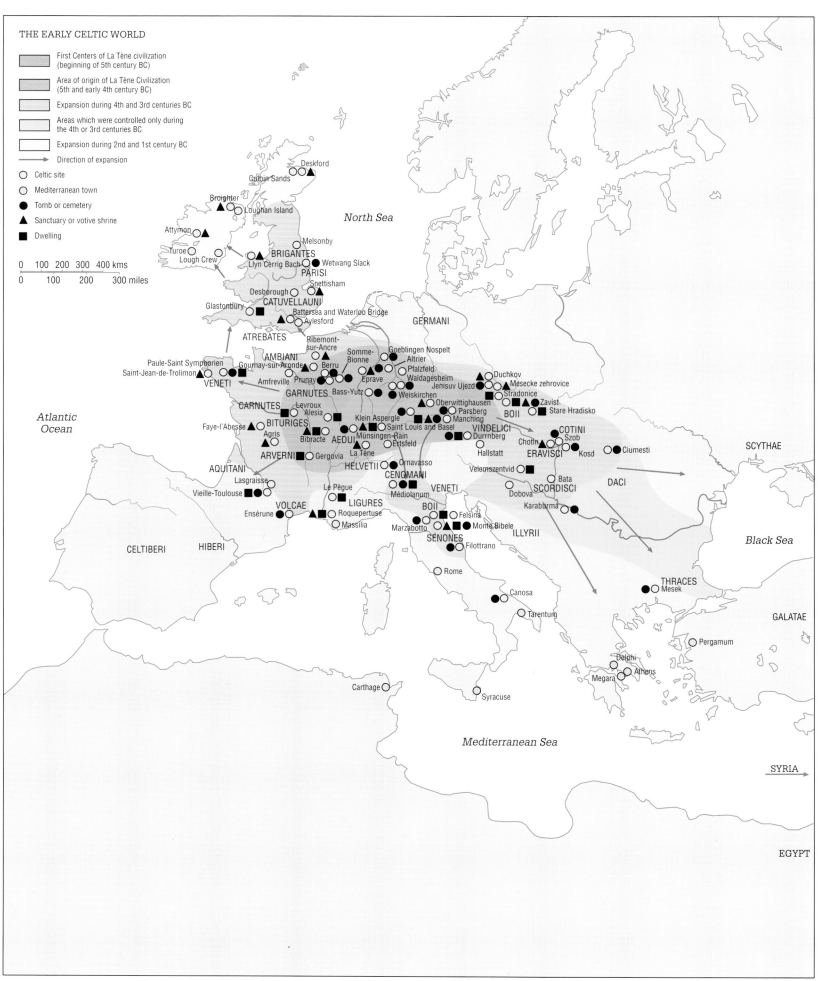

THE EARLY CELTIC WORLD

First Centers of La Tène civilization
(beginning of 5th century BC)

Area of origin of La Tène Civilization
(5th and early 4th century BC)

Expansion during 4th and 3rd centuries BC

Areas which were controlled only during
the 4th or 3rd centuries BC

Expansion during 2nd and 1st century BC

→ Direction of expansion

○ Celtic site

○ Mediterranean town

● Tomb or cemetery

▲ Sanctuary or votive shrine

■ Dwelling

0 100 200 300 400 kms
0 100 200 300 miles

North Sea

Deskford
Culbin Sands
Broighter
Loughan Island
Attymon
Turoe
Lough Crew
Melsonby
BRIGANTES
Llyn Cerrig Bach Wetwang Slack
PARISI
Snettisham
Desborough
CATUVELLAUNI
Glastonbury
Battersea and Waterloo Bridge
Aylesford
ATREBATES
GERMANI
Ribemont-sur-Ancre
AMBIANI Somme-Bionne Goeblingen Nospelt
Paule-Saint Symphorien Gournay-sur-Aronde Berru Altrier
Saint-Jean-de-Trolimon Amfreville Prunay Eprave Pfalzfeld Duchkov
VENETI Waldagesheim Mšecke zehrovice
CARNUTES Bass-Yutz Jenisuv Ujezd Stradonice
GARNUTES Weiskirchen Oberwittighausen Zavist
Levroux Parsberg BOII Stare Hradisko
Alesia Klein Aspergle Manching
BITURIGES Saint Louis and Basel COTINI
Faye-l'Abesse VINDELICI Szob
Agris Münsingen-Rain Durrnberg ERAVISCI Kosd
Bibracte AEDUI Extsfeld Chotin Ciumesti
ARVERNI Gergovia La Tène Hallstatt Bata DACI
AQUITANI HELVETII Ornavasso Velemszentvid Dobova SCORDISCI
Lasgraisse CENOMANI Karaburma
Vieille-Toulouse Le Pègue Médiolanum VENETI ILLYRII
VOLCAE LIGURES BOII Felsina
Ensérune Roquepertuse Marzabotto Monte Bibele
Massilia SENONES Filottrano
CELTIBERI HIBERI Rome
Canosa
Tarentum
Carthage
Syracuse
THRACES Mesek
SCYTHAE
Atlantic Ocean
Black Sea
GALATAE
Pergamum
Delphi Athens
Megara
Mediterranean Sea
SYRIA
EGYPT

© Antony White Publishing Ltd.

23

Greek and Etruscan Art and Architecture

The art and architecture of the ancient Greeks reached a level of perfection in terms of harmony, proportion, grace and representational ability that has provided the foundation for the whole strand of Western art based on the primacy of mankind. The classical canons of figure composition and of balance and decoration in architecture evolved in Greece from the archaic style of the 8th century B.C. to the Hellenistic world after the conquests of Alexander the Great.

Greek sculptors and painters, almost alone in the ancient world, were known as individuals: such as the sculptors Phidias and Praxitiles, whose work has come down to us, and the painter Apelles whose work we only know from literature.

The Etruscans, the precursors of the Romans in the Italian peninsular produced an art and architecture that acted as a link between the arts of Greece and Rome, although it origins, as indeed those of the Etruscan people themselves, remain obscure.

Right: Centaur and Lapith, *marble sculpture from the Parthenon, Athens, 6th century B.C. (British Museum, London).*

Below: Geometric Urn, *detail of figures with chariots and horses, 900–720 B.C. (National Archeological Museum, Athens).*

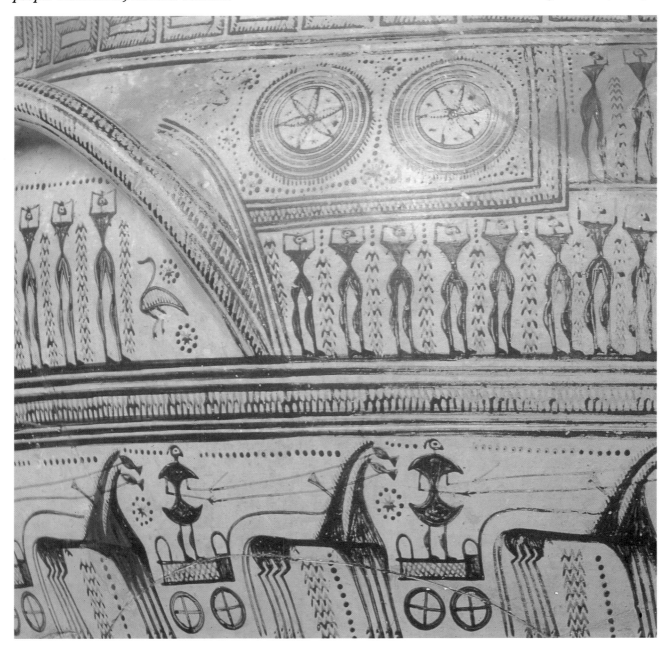

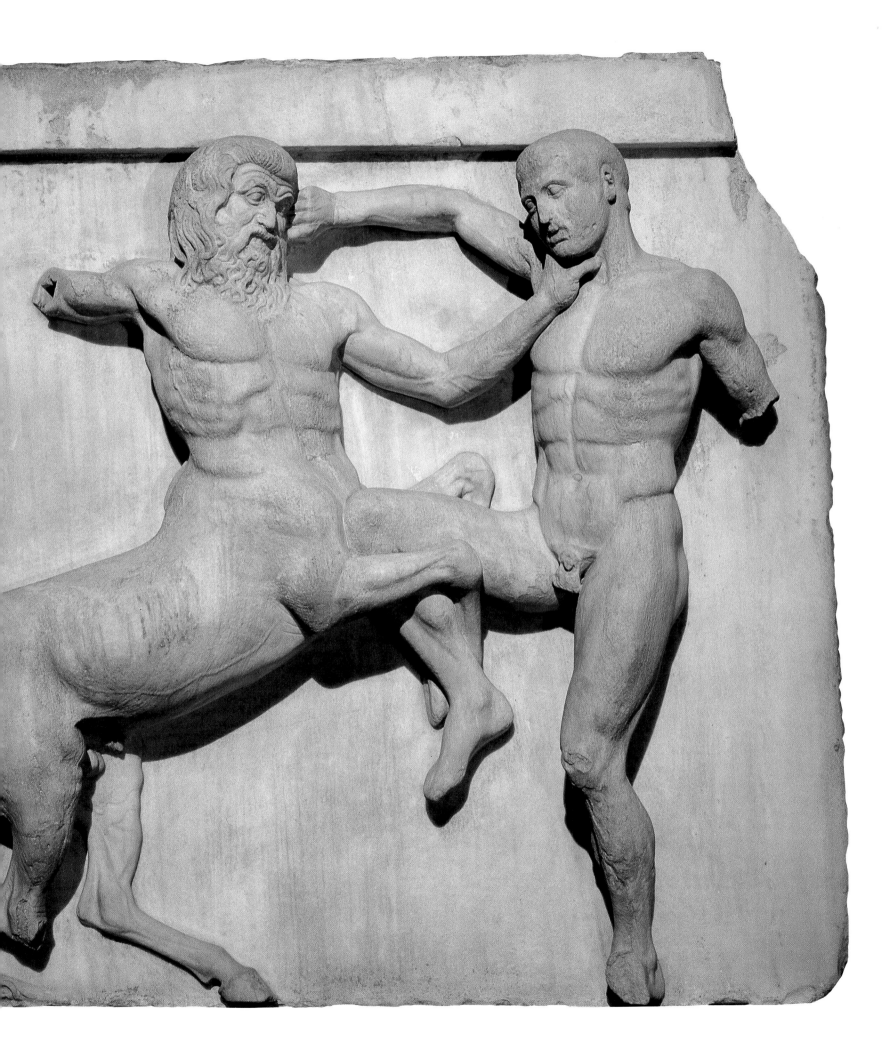

Doric and Ionic Temples and Sanctuaries

The Greek world was at once both unitary and disparate. The Greeks, conscious of sharing a common civilization, defined themselves as "Greeks" in contrast to the "barbarians" who did not speak their language. The sanctuaries of Zeus at Olympia and Nemea, and those of Apollo at Delphi and Poseidon at the Isthmus, were panhellenic sanctuaries, sanctuaries of "all the Greeks".

Nevertheless, even in the very places where, on account of the cyclical performance of the Games, this collective sentiment of recognition was regularly reaffirmed, monuments and ex-votos were intended to honor gods as much as to glorify the civic community that dedicated them. Here every free male was first and foremost the citizen of one particular city, and that city was in itself an autonomous political, economic and religious entity. Rivalry between the cities did indeed reveal itself in bloody battles, but equally, and in a constant manner, it was reflected in the increasing ostentation which governed the commissions given to artists. The originality of the architecture and the riches contained in the *treasuries* (the small buildings which were dedicated to the gods at Delphi and at Olympia) showed quite clearly the conscious individuality of each city and its determination to eclipse its rivals.

Rivalry also explains the decisive evolution of Greek architecture during the 6th century B.C.. It was during this period that architects learned how to cut stone and marble, which progressively replaced brick and wood. They also developed increasingly better solutions for creating internal space so as to provide a good view of the statue to be venerated. Finally they defined the esthetic and technical terminology for the Orders which from now on determined the elevation of all Greek buildings.

The architectural language was not totally identical from region to region. Regional dialects seem to justify various affinities between cities and to explain their preference for a similar type of architecture. The establishment of these dialects can be traced to the middle of the 5th century. They were probably the result of the movements of peoples who left the Aegean world and brought about the decline of the Mycenaean civilization towards the end of the 13th century B.C.. The Dorians in that period destroyed whole regions, but spared Attica before putting down roots in the Peloponnese. The previous inhabitants, fleeing before the invader, laid the foundations of the cities of what would become the Ionian civilization on the shores of Asia Minor. In this way could the relationship between Attic and Ionian dialects be explained.

The eastern Greek cities adopted the Ionic Order and their architects, influenced by the buildings of nearby Egypt, erected temples of majestic proportions. The Artemision of Ephesus was to become one of the seven wonders of the ancient world. The well-shaped columns of its buildings were distinguished by the plastic treatment of their capitals decorated with large volutes. Further north, the Aeolic Order developed as a variant of the Ionic, but this remained fairly localized and died out altogether in the 5th century B.C..

The temples of the Peloponnese and the cities of western Greece were essentially Doric. More squat and sober in form, they displayed an ornate décor which enlivened the pediments and copings. In the second half of the 5th century the Corinthian capital with its acanthus-leaf decoration made its appearance and was then used here and there in Doric buildings.

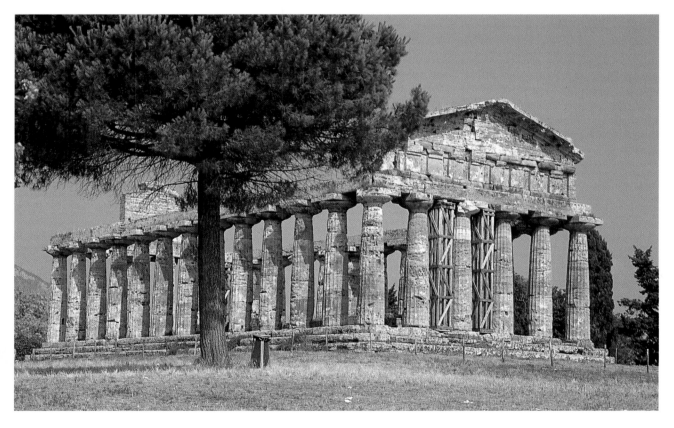

Left: The Temple of Ceres, c.510, Poseidonia (Paestum), Italy.

*Poseidonia, on the southwest coast of Italy, boasted two Doric temples, the Temples of Hera and Ceres. The capitals are heavy, with a strong element of optical correction (*entasis*).*

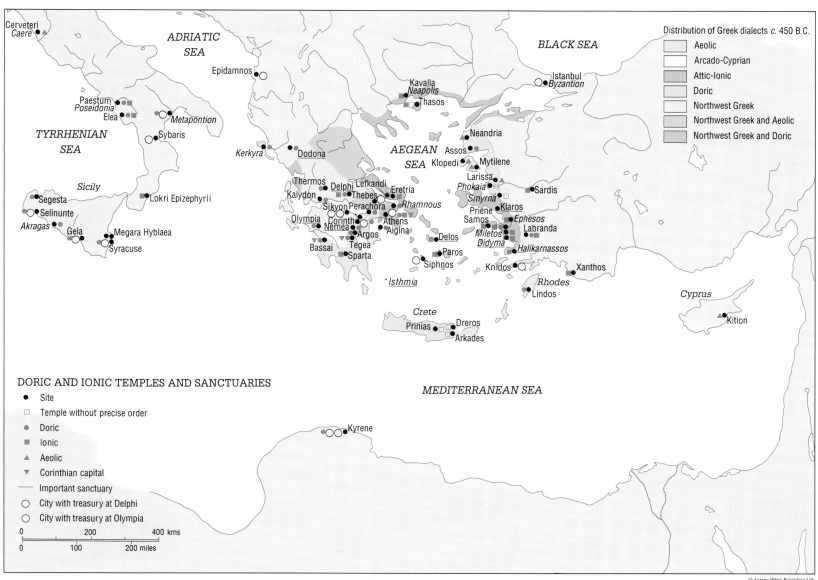

ADRIATIC
SEA

BLACK SEA

Distribution of Greek dialects *c.* 450 B.C.

Aeolic
Arcado-Cyprian
Attic-Ionic
Doric
Northwest Greek
Northwest Greek and Aeolic
Northwest Greek and Doric

Cerveteri
Caere

Epidamnos

Kavalla
Neapolis
Thasos

Istanbul
Byzantion

Paestum
Poseidonia
Elea

Metapontion

Neandria

*TYRRHENIAN
SEA*

Sybaris

Kerkyra

Dodona

*AEGEAN
SEA*

Assos
Klopedi

Mytilene

Thermos
Kalydon

Delphi Lefkandi
Thebes

Larissa
Phokaia

Sardis

Sicily

Lokri Epizephyrii

Sikyon Perachora
Rhamnous

Eretria

Smyrna
Priene

Klaros

Segesta
Selinunte

Olympia
Nemea

Corinth
Athens

Samos

Ephesos
Labranda

Akragas
Gela

Argos
Tegea

Aigina

Delos

Miletos
Didyma

Halikarnassos

Megara Hyblaea
Syracuse

Bassai
Sparta

Siphnos

Paros

Knidos

Xanthos

Isthmia

Rhodes
Lindos

Cyprus

Crete
Prinias

Dreros
Arkades

Kition

MEDITERRANEAN SEA

DORIC AND IONIC TEMPLES AND SANCTUARIES

- • Site
- □ Temple without precise order
- • Doric
- ▪ Ionic
- ▲ Aeolic
- ▼ Corinthian capital
- — Important sanctuary
- ○ City with treasury at Delphi
- ○ City with treasury at Olympia

Kyrene

```
0          200          400 kms
0     100        200 miles
```

© Antony White Publishing Ltd.

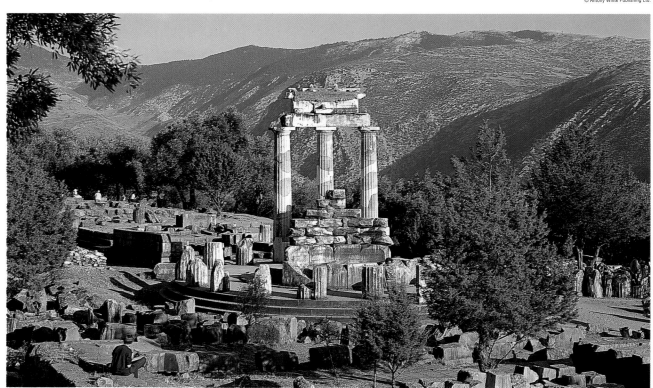

Right: The Tholos in the Sanctuary of Athena Pronaia, *Delphi, Greece.*

A tholos is a circular building or commemorative monument – never a temple, which in Greek architecture had to be rectangular. The tholos at Delphi had an internal colonnade with Corinthian capitals, as did the Philippeion at Olympus.

Athens and the Acropolis

Greece is a mountainous country with a shortage of good soil, and this is one reason why the ancient Greek states developed independently of one another, each centered on a city (*polis*) surrounded by a pocket of arable land. Athens was one of more than a hundred such states, and like many of the others it grew around an area of high ground that could be easily defended – an *acropolis* (upper city). The Acropolis at Athens was inhabited from about 5000 B.C.; there was a dramatic rise in population in the 8th century B.C. (perhaps caused by improved agricultural techniques), and by 500 B.C. Athens was a major city, with a population of probably about 100,000. The city was sacked by the Persians in 480 B.C., but in the following year the combined Greek states drove the invaders out and Athens emerged from the war as the leading power in Greece.

Its fighting prowess was based on its superb navy, and its economic strength likewise depended much on the sea, for it was a great trading city. The ports at Piraeus (with its three harbors Kantharos, Munychia and Zea) and Phalerum were so important to Athens's safety and prosperity that in 461–456 B.C. defensive walls about 4 miles (6 km) long – the Long Walls – were built linking them to the city; thus the whole area between Athens and her ports was a fortress. Originally the walls enclosed a wedge shape bounded by Athens, Piraeus and Phalerum, but in about 445 B.C. another wall was built parallel to the Piraeus (north) wall, enclosing a narrow corridor of land between Piraeus and Athens, and the wall to the less important Phalerum fell into disuse. Little remains of any of them today.

The Athenians were full of pride and self-confidence after the victory over the Persians, and under the great statesman Pericles (*c*.495–429 B.C.), who was in effect ruler of the city from about 460 B.C., it had its most glorious cultural flowering. The philosopher Socrates, the historian Herodotus, and the playwrights Aeschylus, Euripides and Sophocles were among the great figures who adorned the era. In the visual arts the age was no less remarkable, for Pericles launched a major building program on the Acropolis – the religious center of the state as well as its fortress – which had lain desolate as a memorial to Persian barbarism until the war formally ended in 449 B.C.. In his beautification of the city, Pericles' right-hand man was his friend Phidias (*d.c*.432 B.C.), the greatest of all Greek sculptors and the most famous artist of the ancient world.

A temple to Athena, the patron goddess of the city, had been in course of construction when the Persians burnt the Acropolis in 480 B.C., and creating a new building in her honor was the first consideration. Athena was a virgin goddess and the temple was called the Parthenon, from the Greek word for "maiden" – *parthenos*; it was begun in 447 B.C. and dedicated in 438 B.C.. As well as being the most beautiful of all Greek buildings, it had exceptionally lavish sculptural decoration, which was completed in 432 B.C.. Much of this survives, mainly in the British Museum in London; the quality is uneven, as a large team of sculptors was involved, but the finest parts are among the greatest survivals of ancient art. The marble for the building and the

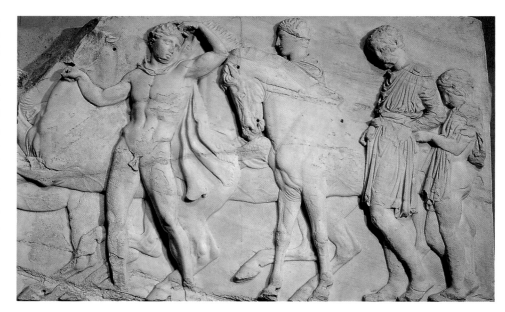

sculpture (22,000 tons of it) came from Mount Pentelicus, 10 miles (16 km) from Athens. Phidias made a huge "chryselephantine" (gold and ivory) statue of Athena – about 33 ft (10 m) tall – for the temple, but this has not survived. He also made an equally big bronze statue of Athena Promachos ("champion") for the Acropolis, but of this only part of the base remains. His work was said to be supremely majestic.

Other buildings on the Acropolis included the Erechtheum (*c*.421–406 B.C.), in which Erechtheus, a mythical king of Athens, was worshiped, as well as Athena; the Propylaea (438–432 B.C.), the great gateway; the little temple of Athena Nike ("of victory"), built in the 420s B.C.; the Chalkotheke, in which precious offerings were kept; and the house of the Arrephoroi (young girls chosen from noble families, who spent several months living in the Acropolis as temple attendants).

The building scheme for the Acropolis was never completed (partly because Athens capitulated to Sparta in 404 B.C. after a disastrous war), but the comments of the Greek biographer Plutarch, who was writing some 500 years afterwards, still hold good today: "Every work of the time of Pericles had from the moment of its creation the beauty of an old master, but yet they retain their freshness and newness to this day, as if they had perpetual breath of life."

Although the Acropolis was the spiritual heart of Athens, the everyday center was the *agora* (marketplace). The characteristic building type here was the *stoa*, a roofed colonnade intended as a sheltered place for walking or talking. One of these, the Stoa Poikile ("painted colonnade"), had frescoes by leading artists, but not a trace of these remains. Near the agora is the Temple of Hephaestus, which is contemporary with the Parthenon and the best preserved of all Greek temples. Other major sites include the Pnyx (the hill where the assembly of citizens met), the open-air Theater of Dionysus, the Odeon of Pericles (an *odeon* was a roofed theater for musical performances) and the Olympeion, an immense temple to Olympian Zeus, not completed until A.D. 132.

Above: *Phidias (d.c.432 B.C.):* Youths ready to mount, *from the North Frieze of the Parthenon, c.445–440 B.C. (British Museum, London).*

The lost chryselephantine cult statue of Athena Parthenos – with drapery made of gold, and flesh of ivory, and the goddess fully armed with helmet, spear and shield – was the work of Phidias. He also supervised the remainder of the Parthenon sculpture, a 350-foot-deep frieze, 92 bas-relief metopes and also free-standing groups, of which many were removed by Lord Elgin in 1801–3. Phidias represents the high point of expressive realist classical Greek sculpture.

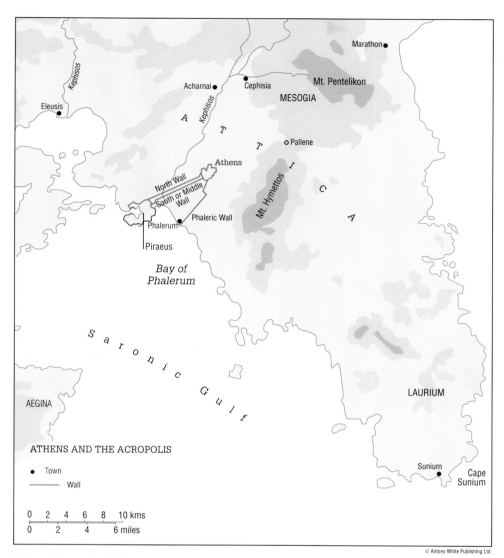

ATHENS AND THE ACROPOLIS

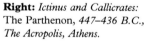

● Town

— Wall

| 0 | 2 | 4 | 6 | 8 | 10 kms |
| 0 | 2 | 4 | 6 miles |

© Antony White Publishing Ltd.

ATHENS

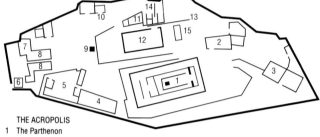

0 200 400 meters
0 200 400 yards

© Antony White Publishing Ltd.

THE ACROPOLIS

1 The Parthenon
2 Temple of Zeus Polieus
3 Heroon of Pandion
4 Chalkotheke
5 Sanctuary of Artemis Brauronia
6 Temple of Athena Nike
7 Picture Gallery
8 Propylaea

9 Statue of Athena Promachos
10 House of the Arrhephoroi
11 Temple of Pandrosos
12 Old Temple of Athena
13 Portico of the Caryatids
14 Erechtheum
15 Great Altar of Athena

Right: *Ictinus and Callicrates: The Parthenon, 447–436 B.C., The Acropolis, Athens.*

*The Acropolis at Athens was originally a fortified late Bronze Age citadel. Within the sanctuary area a temple was under construction when the Acropolis was burnt by the Persians in 480 B.C.. The new building, the Parthenon, is the supreme example of Doric temple architecture, with the columns slightly distorted (*entasis*) to give the optical illusion of perfect form. The building houses the votive statue of Athena Parthenos.*

Greek Vases

Pottery makes up easily the most abundant category of surviving Greek art. Statues are now known mainly through Roman copies, panel paintings have all disappeared, and only a few precious fragments of murals exist. Many potters and painters signed their works (occasionally potter and painter were one and the same) and some of them were outstanding artists with distinctive styles. Other artistic personalities are recognized, even though their names are not known, so scholars have given them pseudonyms such as the Berlin Painter (with about 300 attributed works) or the Achilles Painter. More than a thousand other vase painters are known by their real or such invented names.

In spite of the huge number of objects that have been collected and catalogued, little is known in detail about how the pottery industry worked, although many scholars are now trying to make up for this by turning away from what has been seen as an overemphasis on attribution and instead studying vases in their sociological context. Ancient writers scarcely mention the subject, for although particularly beautiful or elaborate vases must always have been prized, pottery was commonplace and cheap and simply not deemed worthy of the attention given to other arts. Almost all pottery was designed for use rather than ornament, with vessels for wine being by far the most commonplace. Many different names are given to the various types and shapes. The amphora, for example, was used for storing oil or wine and the crater for mixing wine with water (it was always drunk thus mixed); other common types were scent bottles and ointment pots.

It was not until the 18th century that Greek vases began to be seriously studied and collected. The first major collection was made by Sir William Hamilton (1730–1803), British envoy at Naples, who sold it to the British Museum in 1772, then went on to accumulate another, equally fine group of vases. Greece itself was scarcely known at this time and the vases studied by antiquarians came mainly from Italy, where there had been many Greek colonies. At first it was widely believed that they had been made by the Etruscans, the ancient people who had the most important civilization in Italy before the rise of Rome (this is why Josiah Wedgwood gave the name Etruria to the village he built for his Staffordshire pottery workers). Gradually, however, scholarly investigation revealed the true origin of the vases, and slowly – after much learned controversy – problems of dating and distribution were resolved. There are still many areas of obscurity or scholarly contention, but the main lines of development are clear.

The first major phase of Greek vase painting – covering the 9th and 8th centuries B.C. – is called Geometric because of the prevailing style of ornamentation. Vases were decorated with horizontal bands filled with various types of repeated geometric motifs and patterns. Highly stylized human and animal figures were later added. Although there were local variations, the style was virtually universal in the Greek world. At the end of the 8th century B.C. a less severe style developed, with richer color and more varied, larger-scaled motifs, often based on plant forms or half-real, half-imaginary creatures. Some of the motifs derived from contact with the east (particularly Syria) and the style has consequently been dubbed Orientalizing.

From about 650 to 550 B.C. the most important center of vase production was Corinth, a major maritime power strategically situated between the Aegean and Ionian seas and the focal point of north-south and east-west trade routes. It was at Corinth, early in the 7th century B.C., that there developed the black-figure, one of the two main divisions of the great age of Greek vase painting. Figures were painted in solid black silhouette against the red background of the pottery, with details such as facial features added by incising through the black pigment or sometimes by overpainting in red or white. The figures now became not merely conventional ornaments but vivid characterizations, and black-figure painters created genuine pictures (often scenes from mythology) rather than decorative arrangements.

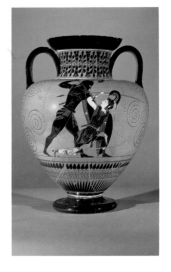

Above: *Exekias:* Athenian black-figure neck amphora, *c.540 B.C., (British Museum, London).*

Exekias was one of the greatest painters of the age. Here he depicts Achilles killing the Amazon Queen, Penthesilea, who, at the point of death, sees that through his visor slits, Achilles' eyes are full of love for her.

Below left: Attic red-figure calyx crater, *early 4th century B.C. (National Archeological Museum, Athens).*

Below: Attic amphora depicting the struggle between Theseus and the Minotaur, *6th century B.C. (Louvre, Paris).*

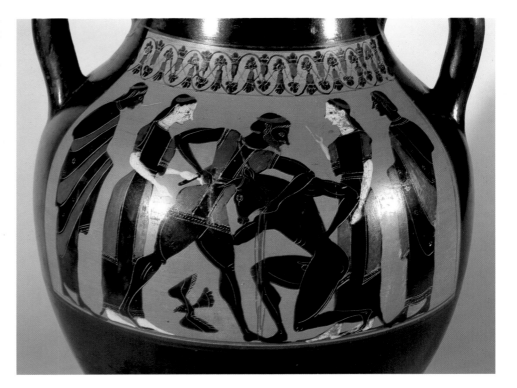

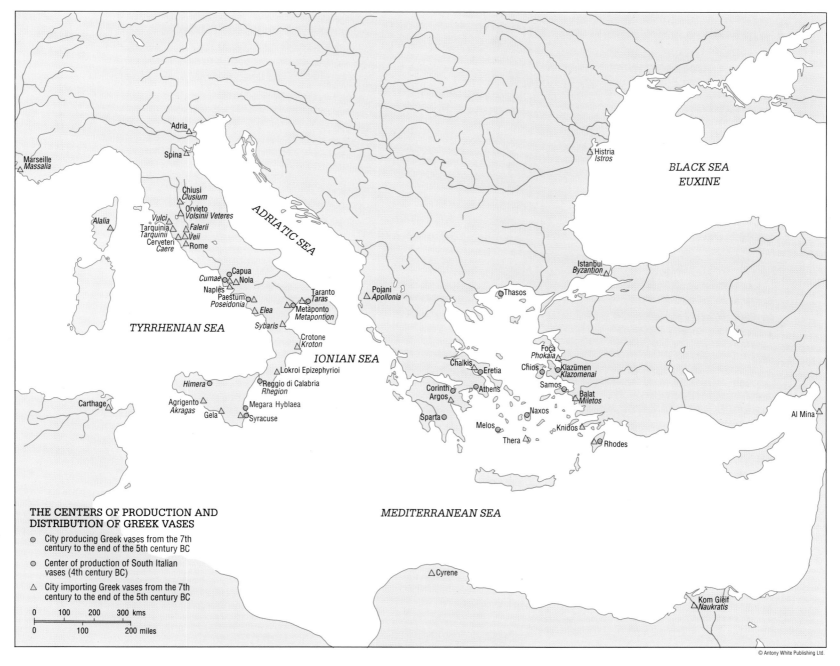

THE CENTERS OF PRODUCTION AND
DISTRIBUTION OF GREEK VASES

- ⊚ City producing Greek vases from the 7th
 century to the end of the 5th century BC
- ⊙ Center of production of South Italian
 vases (4th century BC)
- △ City importing Greek vases from the 7th
 century to the end of the 5th century BC

| 0 | 100 | 200 | 300 kms |

| 0 | 100 | 200 miles |

© Antony White Publishing Ltd.

From about the middle of the 6th century B.C. Athens took over from Corinth as the greatest center of Greek pottery. Athenian clay was of particularly good quality and the city's artists were unsurpassed. It was in Athens that the red-figure technique (the second great division of Greek vase painting) was invented in about 530 B.C.. In this the background of the vase was painted black, the figures being left in the unpainted red of the pottery. Details could therefore be added with a brush (rather than incised through the pigment as in black-figure), allowing the artist much greater flexibility and subtlety of treatment. For a while the two techniques coexisted (there is a vase in the Louvre in Paris painted in black-figure style on one side and in red-figure on the other), but by about 500 B.C. the new style had made the old one redundant.

Athens was a great commercial power as well as a great artistic center, and Athenian vases (or Attic vases as they are generally called – from Attica, the country around Athens) completely dominated the market throughout the Greek world in the 5th century B.C.. There were potteries active in many other cities, but almost all the best pieces of the period are Attic and they were widely exported. A great variety of themes was treated by Attic painters, including many from everyday life, making these vases one of the richest sources of information on the social history of the time.

By the end of the 5th century B.C. Attic pottery had lost its dominance (Athens suffered a disastrous defeat by Sparta in the Peloponnesian War, 431–404 B.C.) and the most creative centers of pottery were henceforward not in Greece itself but in the Greek colonies of southern Italy.

Greek Sculpture from the 7th to the Early 5th Century B.C.

The relief on the Lion Gate at Mycenae, dating from the 14th century B.C., may appear to be the first example of sculpture in the Greek world, but if so, there is oddly no sequel to it. The Mycenaeans appear to have had no interest in creating an artistic identity despite their awareness of the possibility through the influence of neighboring civilizations in Egypt and the Orient. It is only in the "orientalizing" period in the 7th century B.C., when exchanges with the Orient were resumed, that one can trace the beginning of Greek sculpture.

The origins of statuary are part of a wider process which leads artists consciously to create a new plastic language. Indeed, the Daedalic (Geometric) style, the original response to these oriental influences, was not merely applied to free-standing figures and the sculptured decorations of some buildings; it is equally present in the minor arts. Heads with layered "wigs", which adorn certain jewels from the Kameiros treasure of Rhodes, or the neck of a protocorinthian aryballos, recall those of the statues of Gortyn or Prinias.

The daedalic figures are known for their hieratic form, their frontality and the precisely articulated divisions between different parts of the body, which remains very flat. This esthetic sense is clearly expressed by the presence in the Aegean world, particularly at Corinth, of small terracotta plaques imported from the Orient, showing the goddess Astarte in very light relief.

The role of Crete in the forming of this style is emphasized by the number of fragments unearthed there, and even more by the discovery at Dreros of three cult statuettes which are not yet in the Daedalic style. These demonstrate the interest in the human figure already shown by Cretan artists as early as the end of the 8th century B.C. These statuettes, in which Apollo, Artemis and Leto can be identified, are made of sheets of bronze beaten out with hammers and fastened onto a wooden core. This technique was soon supplanted by hollow cast iron but its continuance is attested by a winged female bust in bronze of the 6th century discovered at Olympia and by the remains of sumptuous votive offerings made at Delphi. The chryselephantine statues discovered along the Sacred Way herald, in their use of ivory and gold combined, the statues of Athena Parthenos and the Olympian Zeus sculpted by Phidias (c.490–432) in the second half of the 5th century B.C.

Daedalic sculptures were essentially worked in soft materials such as limestone and wood. The apparent clumsiness of the statue of Artemis dedicated by Nicandra in the sanctuary of Apollo at Delos can be explained by the audacity of the sculptor. This statue (640–630; National Archeological Museum, Athens) is the first attempt to realize the human figure in marble; the artist from Naxos has here opened a way which his successors would quickly follow.

At the beginning of the Archaic period, about 600 B.C., Greek sculpture tended to be on a gigantic scale. Then, during the 6th century, it rediscovered life-size proportions. The sculptors responded first of all to the wishes of their patrons; the rich aristocratic families, landowners and those in charge of religious ritual, and the tyrants who ruled a number of the cities, required

them to create works which would manifest their power. Marble votive offerings – figures of animals like the lions at Delos; family groups like those consecrated in the Heraion at Samos; seated figures of Didyma; Kouroi and Korai – and sculpted decorations on the buildings transformed the appearance of the sanctuaries.

The artist is not free in his choices; themes and types are imposed upon him. However, figures such as the Kouros – the naked young male figure – and the Kore – the fully-clothed young female figure – allow him to explore, beyond the bounds of the religious convention, his knowledge and mastery of human anatomy. Thus these statues, created as ex-votos for sanctuaries or as sepulchral headstones, none the less reveal the sensitivity of the artist and show a variety of approaches. There were major centers of production, and each sculptor, although itinerant, would have had strong links with the stylistic tradition of his city or region of origin.

The choice of the year 480 B.C. to mark the end of the archaic period can be justified by a comparative study of the two pediments of the temple of Aphaia at Aigina. However, it applied only to monumental sculpture; as far as small bronzes are concerned, the concept of schools is still present up to the middle of the century.

Left: Bronze statuette of young man with daedalic *(geometric)* hair style, *7th century B.C. (Delphi, Greece).*

The influence of oriental art, strong because of commercial and cultural contacts in the 7th century B.C., are strongly felt on the Daedalic style of Greek sculpture. The figures are frontal, hieratic and stiff – typically with formal "layered" hair styles – but with a clear articulation of form and structure.

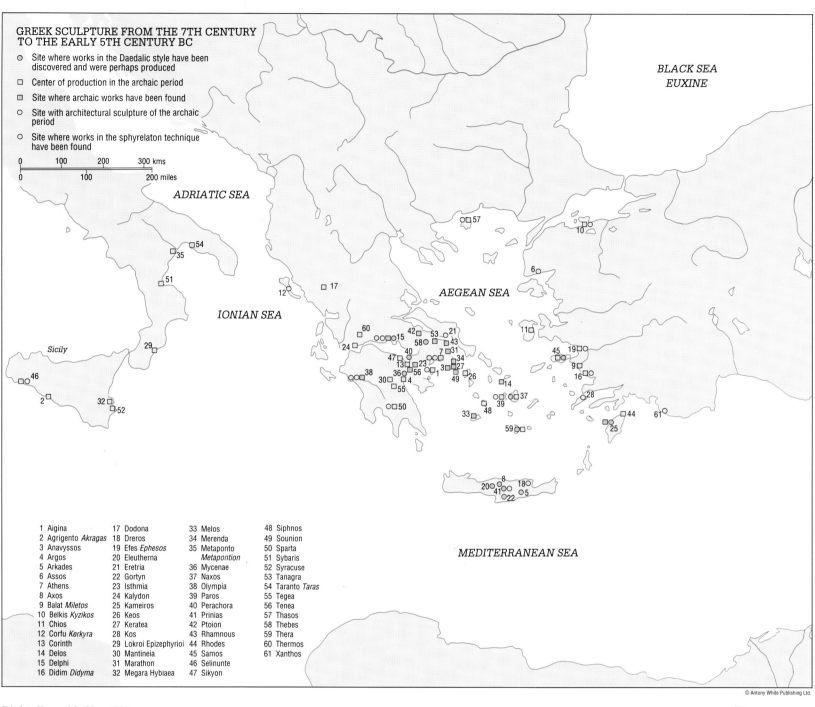

GREEK SCULPTURE FROM THE 7TH CENTURY
TO THE EARLY 5TH CENTURY BC

- ◎ Site where works in the Daedalic style have been discovered and were perhaps produced
- ◻ Center of production in the archaic period
- ◼ Site where archaic works have been found
- ○ Site with architectural sculpture of the archaic period
- ○ Site where works in the sphyrelaton technique have been found

BLACK SEA
EUXINE

ADRIATIC SEA

IONIAN SEA

AEGEAN SEA

Sicily

MEDITERRANEAN SEA

1 Aigina	17 Dodona	33 Melos	48 Siphnos
2 Agrigento *Akragas*	18 Dreros	34 Merenda	49 Sounion
3 Anavyssos	19 Efes *Ephesos*	35 Metaponto	50 Sparta
4 Argos	20 Eleutherna	*Metapontion*	51 Sybaris
5 Arkades	21 Eretria	36 Mycenae	52 Syracuse
6 Assos	22 Gortyn	37 Naxos	53 Tanagra
7 Athens	23 Isthmia	38 Olympia	54 Taranto *Taras*
8 Axos	24 Kalydon	39 Paros	55 Tegea
9 Balat *Miletos*	25 Kameiros	40 Perachora	56 Tenea
10 Belkis *Kyzikos*	26 Keos	41 Prinias	57 Thasos
11 Chios	27 Keratea	42 Ptoion	58 Thebes
12 Corfu *Kerkyra*	28 Kos	43 Rhamnous	59 Thera
13 Corinth	29 Lokroi Epizephyrioi	44 Rhodes	60 Thermos
14 Delos	30 Mantineia	45 Samos	61 Xanthos
15 Delphi	31 Marathon	46 Selinunte	
16 Didim *Didyma*	32 Megara Hyblaea	47 Sikyon	

© Antony White Publishing Ltd.

Right: Kore, *Marble, c.540 B.C. (Acropolis Museum, Athens).*

A standing figure of a female.

Center: Anavyssos Kouros, *Marble, 6th century B.C., (National Museum, Athens).*

Far right: Melos Apollo, *Marble, c.550 B.C. (National Museum, Athens).*

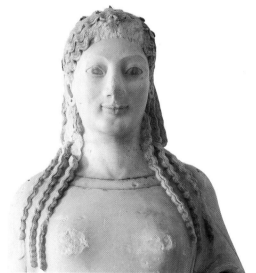

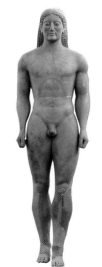

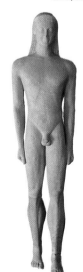

Macedonia at the Time of Philip and Alexander

The accession of King Philip II of Macedonia in 359 B.C. marked the beginning of a policy of expansion which in a few years led to the abatement of civic and moral values of the Greek cities. At the death of his son Alexander, in 323 B.C., the boundaries of the Hellenic world had been extended to the banks of the Indus.

Philip had been able to reunite the Macedonians and gain their confidence by dispelling any threat of invasion from neighboring peoples. The Illyrians and the Pannonians were being held in check by the frontiers of his now well-consolidated kingdom. He could therefore turn his attention to the Greeks and chase them out of. the colonies of Pydna and Methone which they had founded in the rich coastal plain of Pieria – the ancient homeland, since about 700 B.C., of the royal house of the Argeadae. He also regained control of Chalkidiki and the mines of Mt. Pangaion, which brought in a revenue of 1000 silver talents a year, sufficient to finance a militant policy equal to his ambitions. Amphipolis became Philip's mint. He reorganized Thessaly and took up the role of defender of Delphic interests. A hostile campaign was initiated in Athens by Demosthenes, but what hope can a city, whose policy depends on the general consent of all its citizens voted in a general assembly, have against a monarch who alone swiftly makes his own decisions and is a clever and cunning tactician? At Chaeronea in 338 Greece yielded to Philip, brilliantly supported by Alexander.

In 336 Philip was murdered at Aigai while one part of the Macedonian army had advanced into Asia under Parmenion. Is it possible that Philip had schemed to dominate the Persian empire and thus pave the way for his son's brilliant conquest? Before the end of 333 Alexander had made himself master of Asia Minor. He inflicted a serious defeat on King Darius at Issos, then conquered Phoenicia and marched on Egypt, where he founded Alexandria. Plutarch tells us that Alexander "founded over 70 towns amongst the Barbarians". The young king conquered Babylon and then Persia; the weakness of the Persian empire lay in its vastness and its scattered capitals.

In 330 Darius was assassinated and Alexander moved towards the satrapies of Asia. Drangiana, Sogdiana and Bactriana (Bactria) fell in turn, despite grave conflicts between the king and his soldiers. The army reached the banks of the Indus in 326, and by the end of 325 northwest India was conquered. However, since his troops refused to follow him any further, Alexander had to give up his plans of conquest in the East. The young king died in Babylon and, contrary to tradition, he was not buried at Aegae in Macedonia. The ancient royal citadel, although supplanted by Pella after the end of the 5th century as administrative capital, had kept the privilege of receiving the remains of its defunct rulers, but Alexander was buried in Alexandria.

The site of Vergina/Palatitsa has been identified with certainty as Aigai. The traces of a palace of the 3rd century B.C. and those of the theater where Philip was assassinated and the ramparts of the city have been unearthed. The Acropolis shows that this prosperous site was inhabited from the beginning of the Iron Age. In 1977 three princely tombs dating from the 4th century B.C. were discovered under a huge tumulus about 100 meters in diameter. The most lavish tomb, from the treasures it held, was that of King Philip, spared by vandals. Vases in silver or bronze, ivory portraits, ceremonial arms or adornments enable one to reconstruct the sumptuous art of the Macedonian court in the second half of the 4th century. Philip, the "barbarian of Pella" as Demosthenes called him, was as Greek as the citizens of the cities which refused to share with the Macedonians what were nevertheless their common origins. The king had gathered at his court the greatest artists of the era, as did his son after him. Lysippus, Apelles, Pyrgoteles were Alexander's official portrait painters.

Philip's tomb is built on the model of the Macedonian masonry tombs which have been found at several other sites. Five tombs have also been found in the vicinity of the old city of Thessaloniki. The roof vaulting, the use of stucco and of painted plaster point towards the direction architects would take in the Hellenistic age. The houses in Pella, with their rich mosaic pebble décor, are an indication of the luxury of the domestic architecture favored by the class of high functionaries who had risen in the kings' entourage.

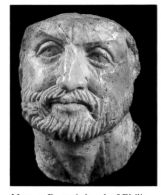

Above: Portrait head of Philip II of Macedon, *ivory, 350–325 B.C. (Royal tombs, Vergina).*

Philip II, 359–336 B.C., gained control over all Greece and thus laid the basis for the conquest and expansion achieved by his son Alexander the Great.

Below: The Battle of Issos, *mosaic, Roman replica from Pompeii of the original by Philoxenos of 4th century B.C.*

Issos was Alexander's first great victory in the conquest of Asia.

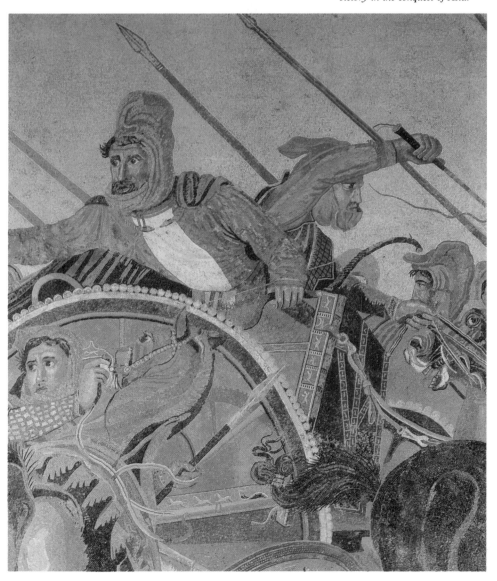

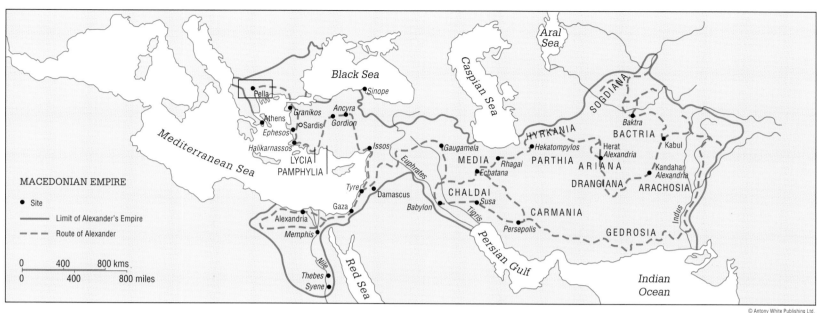

MACEDONIAN EMPIRE

- ● Site
- ——— Limit of Alexander's Empire
- - - - Route of Alexander

| 0 | 400 | 800 kms |
| 0 | 400 | 800 miles |

Aral Sea

Black Sea

Caspian Sea

SOGDIANA

Pella

Granikos
Ancyra
Athens
Sardis
Gordion
Ephesos
Halikarnassos
LYCIA
PAMPHYLIA
Issos

Baktra
BACTRIA
HYRKANIA
Herat
Alexandria
Kabul
Gaugamela
MEDIA
Rhagai
PARTHIA
ARIANA
Kandahar
Alexandria
Ecbatana
DRANGIANA
ARACHOSIA

Mediterranean Sea

Euphrates

Tyre
Damascus
Gaza
Babylon
CHALDAI
Susa
CARMANIA

Alexandria
Memphis

Tigris

Persepolis
GEDROSIA

Indus

Nile
Red Sea
Thebes
Syene

Persian Gulf

Indian Ocean

© Antony White Publishing Ltd.

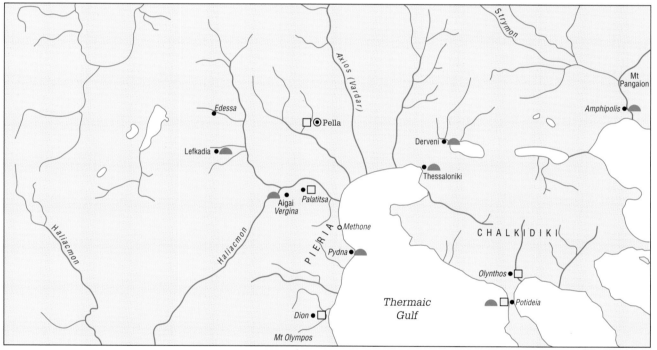

MACEDONIAN HEARTLAND

- ◉ Capital
- ● Other town
- ☐ Remains of domestic architecture
- ◖ Macedonian tombs

| 0 | 20 | 30 kms |
| 0 | 10 | 20 miles |

Strymon

Mt Pangaion

Edessa

Axios (Vardar)

☐ ◉ Pella

Amphipolis

Derveni

Lefkadia

Thessaloniki

Aigai
Vergina
☐ Palatitsa

Methone

CHALKIDIKI

Haliacmon

Haliacmon

PIERIA

Pydna

Olynthos ☐

Potideia

Dion ☐

Thermaic Gulf

Mt Olympos

© Antony White Publishing Ltd.

Below: *View from Balcony of the* Palace of the Macedonian Kings, *mid-3rd century B.C., Vergina.*

Vergina, built on the site of a Stone Age city, was the capital of ancient Macedonia and the power center from which the conquest of Asia was launched.

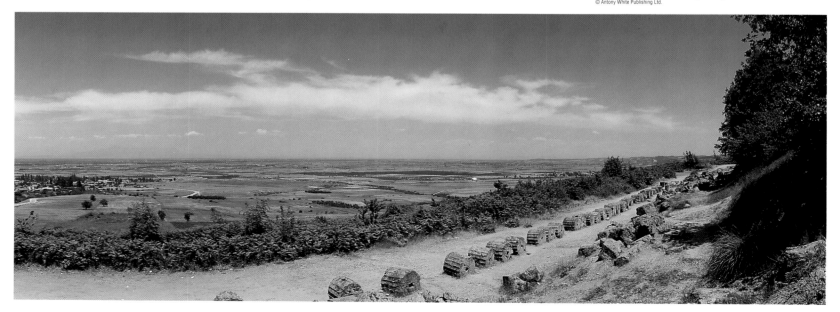

Hellenistic Architecture

Hellenistic architecture was a princely and royal architecture, ostentatious and monumental, reflecting the political ambitions of the rulers who lorded it over a world whose boundaries had been rolled back by the conquests of Alexander. It was no longer a city-state architecture created only in honor of the gods and for the civic functions of the community; now it had become the emblem of the power of Alexander's successors.

The Antigonid, Lagid, Attalid and Seleucid dynasties encouraged their architects to plan grandiose programs of rebuilding to embellish the capitals and other cities under their sway. Thus the great centers of architectural development were henceforth in Macedonia, Asia Minor, Egypt and Syria. The cities of Magna Graecia, Sicily and even continental Greece had no share in this program of renovation apart from benefiting from princely gifts.

The architects, mainly from eastern Greece, experimented along lines suggested by the fusion of Hellenic techniques and oriental principles, such as can be seen in Caria from the second half of the 4th century B.C. Halicarnassos, Alinda, the sanctuaries of Zeus at Labraunda and those of Artemis at Amyzon reveal the aim of the Carian rulers, influenced by the works of the Achaemenid royal house, to create vast complexes, in which, nevertheless, there are buildings in the Greek tradition. Terraces, linked by staircases and supported by thick sustaining walls with structural embossing, unify the spaces; the horizontal lines are emphasized by long porticoes. Buildings are no longer isolated, or conceived as independent of each other, but fit into the framework of an architectural composition.

At the end of the 4th century B.C. a terrace defined the temple of Athena Polias built in Priene by Pythius. In Pergamon, in the reigns of Attalos I (241–197 B.C.) and Eumenes II (197–c.159), the architects devised a complete architectural landscape. They took advantage of the sloping ground to create vast esplanades surrounded by colonnades and defined by porticoes which are rooted on the outer slope by mighty buttresses. The principles of Pergamene town planning were exported to many sites: they are evident in the sanctuary of Asklepios at Kos or, on the scale of an entire city, at Kameiros on Rhodes.

There is also a more linear type of town planning derived from the orthogonal plan used in the 8th century B.C. for the foundation of the earliest colonies in Sicily and Magna Graecia, and repeated in the 5th century B.C.by the philosopher and geometer Hippodamos for his city of Miletos, then under reconstruction, and for the port of Athens, Piraeus. The checkerboard plan is cut into zones which correspond to the various functions of the city. In the Hellenistic period this rational town planning used porticoes to define the axes of the city and provide boundaries for the public places and the sanctuaries. At Miletos and Kos, a plan was developed based on the street and the interplay of its colonnades, and of which sacred buildings, gymnasia, monumental gateways and nymphaea formed part.

The gate of the agora to the south of Miletos appears to mark the ultimate point of evolution which, ignoring

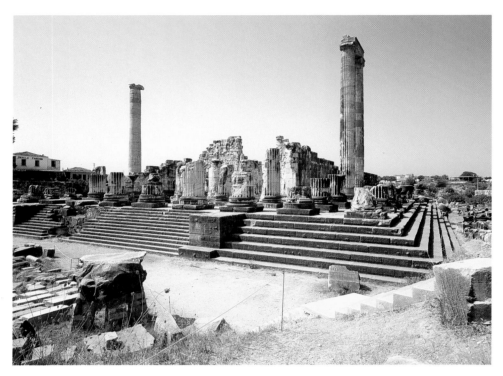

architectural and functional values in favor of theatrical ones, employed an architecture of the façade. The precise vocabulary of the great architectural orders gave way to a pictorial language which played on light and shadow cast by the projections and recesses of the motifs.

By the end of the 4th century the search for decorative values had changed the strict use of the orders. The Doric Order, although widely used for the colonnades of porticoes, was considered too restricting and was rarely chosen for temples. The 2nd-century architect Hermogenes, to whom is attributed the perfecting of the pseudo-dipteral design, strongly affirmed in his treatises the superiority of the Ionic Order. There are also numerous buildings which reflect the plastic qualities of the Corinthian Order – and, indeed, architects did not hesitate to create composite orders. The new temple of Apollo at Didyma provided the first examples of historiated capitals and an enlarged repertoire of decorative motifs which enliven the walls, columns and door-jambs. The two corridors which gave access to the monumental adytum of this temple are vaulted, calling to mind a technique of arching which was used by the architects in the brickwork of the Macedonian tombs.

The rise of a rich merchant bourgeoisie and a civil servant class around the kings explains the flourishing of a luxurious domestic architecture. The sumptuous houses of Pella and of Delos reveal, just like the remains of certain palaces, the transformation of moral values. Now anyone could adorn his house without fear of being accused by his fellow citizens of excess or impiety.

Above: Temple of Apollo at Didyma, *main façade, temple complex from 3rd century B.C.– 2nd century A.D., Didyma, Turkey.*

Didyma, south of the ancient city of Miletos, was conquered by Alexander in 344 B.C.. Its temple complex, surrounding the ancient site of an oracle, sacred tree and spring, was intended to be the largest in the world.

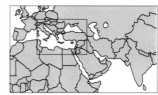

HELLENISTIC ARCHITECTURE

◉ Royal city of the Hellenistic empires *c.* 240 BC
● City: plan based on Pergamon
● City: plan based on Miletos
● Other site

Surviving buildings:
○ Domestic
▢ Palace
⬠ Theater
△ Monumental altar

Architectural features:
◇ False ornamental façade
▽ Vault or arch

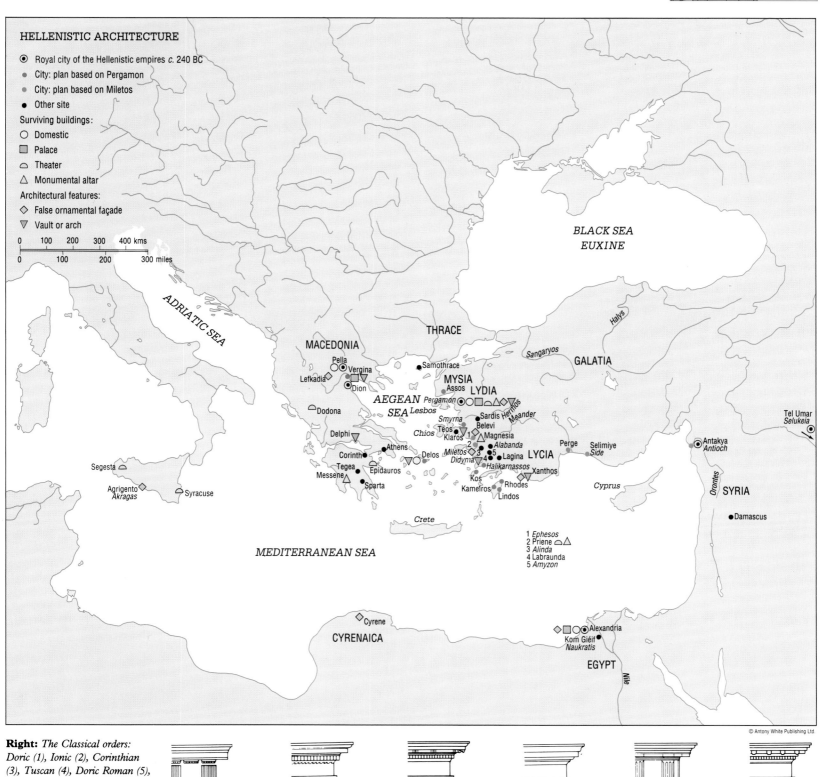

ADRIATIC SEA

BLACK SEA
EUXINE

THRACE

MACEDONIA

Halys

GALATIA

Pella
Vergina
Lefkadia
Dion

● Samothrace

Sangaryos

AEGEAN
SEA

MYSIA
LYDIA
Assos
Pergamon

Dodona

Lesbos

Sardis *Hermos*
Meander

Tel Umar
Selukeia

Delphi

Chios

Smyrna
Teos
Klaros

Belevi
Magnesia
Alabanda

Antakya
Antioch

Athens

Corinth
Tegea
Messene
Epidauros
Sparta

Delos

Miletos
Didyma
Halikarnassos

Lagina
LYCIA

Perge

Selimiye
Side

Orontes

SYRIA

Segesta

Kos
Kameiros
Lindos

Rhodes

Cyprus

Agrigento
Akragas

Syracuse

Crete

1 *Ephesos*
2 *Priene* ⬠△
3 *Alinda*
4 Labraunda
5 *Amyzon*

● Damascus

MEDITERRANEAN SEA

◇ Cyrene

CYRENAICA

◇ ▢ ○ ◉ Alexandria
Kom Giéif
Naukratis

EGYPT

Nile

© Antony White Publishing Ltd.

Right: *The Classical orders:*
Doric (1), Ionic (2), Corinthian
(3), Tuscan (4), Doric Roman (5),
Composite (6).

All classical architecture – Greek
Roman and Renaissance – was
defined by a variety of decorative
types of column and base, shaft,
capital and entablature (the
horizontal area above the column
and capital). In terms of
complexity, and roughly of
chronology, these evolved from the
Doric to the Composite, with later
Hellenistic and Roman architects
mixing the orders together on the
same building for decorative and
emotional effect.

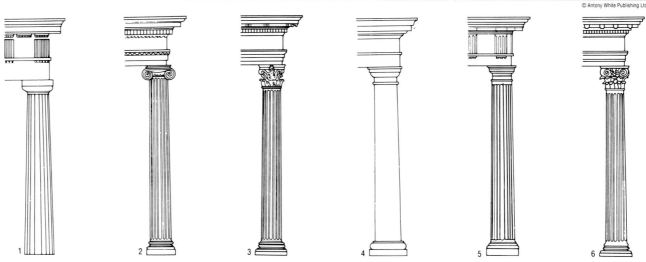

1 2 3 4 5 6

Etruscan Art 650–450 B.C.

Etruscan art, although rooted in a distinct local tradition, came swiftly to depend upon Greek art for its inspiration and progression, within an area between the Arno, the Tiber and the Tyrrhenian Sea. The predilection each city had for a particular artistic form (such as painting in Tarquinia, bronze statuary in Vulci) and the degree of external influence both contributed to increase the variety of local characteristics.

In the second half of the 8th century, by which time the first Greek colonies had been established in the Gulf of Naples, the amount of goods imported from Greece and the East had vastly increased. The craftsmen from these regions introduced new images and more sophisticated techniques. In pottery, refined clay was thrown on a wheel, fired at a high temperature and then painted with borrowed "new geometric" designs. The main centers included Veii, Vulci, Bisenzio and Tarquinia.

Vulci, Bisenzio and Vetulonia, towards the end of 8th century, also became renowned for their work in bronze. These three centers frequently decorated their works with human and animal figures produced in a more three-dimensional manner and with greater detail. The painted pottery inspired by the Greek tradition represented such figures in silhouette only. Tarquinia, however, developed into an important center of embossed laminated bronze work.

The geometric style was developed during the first half of the 7th century. Veii, Tarquinia, Vulci and above all Cerveteri produced huge amounts of pottery that was verging on the geometric. A great number of exotic artefacts, in gold, ivory and bronze, have been found in the royal tombs of Etruria and Latium. Gradually the Syro-Phoenician motifs began to enrich the decorative vocabulary of the local craftsmen. This period, c.720–480 B.C., is known as the Orientalizing period. Great advances in gold and silver filigree and granulation techniques were made.

During this period Cerveteri appears to have assumed a dominant role in the production of artefacts, and it developed, along with Veii and Vulci, into one of the principal centers of orientalizing pottery. The creative range and ability of its workshops was reflected in their introduction of the fine black bucchero pottery.

There was at this time a flourishing use of eastern monumental motifs in chamber tombs. Those built in the north were covered with a false cupola or with a false vault (as found in Artimino and Castellina in Chianti). In the south, the chambers were carved directly out of the rock (such as those found at Cerveteri, Veii, Tarquinia, Vulci). The tombs were always marked above ground by a large tumulus. The statues in the *Tomb of La Pietrera*, Vetulonia, and in the *Tomb of Statues* and the *Tomb of the Five Chairs*, Cerveteri, provide the first known examples of stone and terracotta statuary. Cerveteri together with Veii has also given us the oldest examples of fresco art.

The end of the 8th century and the beginning of the 7th heralded a period of great artistic creativity and saw the development of civic architecture, in Murlo and Acquarossa, and of religious architecture in Veii. During the Archaic period, between 580–c.480 B.C., Cerveteri's supremacy in several artistic fields, such as stone statuary, passed to other centers. At the end of the 6th century, Vulci became one of the principal centers of stone carving.

Etruscan painting progressed and evolved similarly, and a large quantity of the most beautiful examples (dating from 580 B.C.) are to be found at Tarquinia.

However, Veii with its Temple of Apollo at Portonaccio, Cerveteri with its *Sarcophagi of the Spouses* and the architectural decor of the Temple of Pyrgia remain uncontested masterpieces of monumental terracotta statuary. Vulci was one of the principal centers of black-figure pottery.

At the turn of the 6th century B.C., Etruria reached its creative peak, but it was on the verge of a crisis. The naval defeat inflicted upon the Etruscans at Cumae (c.474 B.C.) by the fleet of Hiero of Syracuse was a key moment, and altered, for some time, the artistic geography of Etruria.

Below: Lupa Capitolina, c.5th century B.C., bronze (Palazzo dei Conservatori, Rome).

One of the few bronzes to have survived the Gallic Sack and the Capitol fire (83 B.C.). The twins Romulus and Remus were added during the Renaissance. The quality of the casting is very high in this early period, and the style is archaic and probably related to terracottas from Veii.

Below left: Sarcophagus with reclining couple, c.575 B.C., terracotta (Villa Giulia, Rome).

One of the only two surviving masterpieces of ceramic sculpture extant from Cerveteri, it shows a wife and husband comfortably united, as was the custom. This terracotta is the earliest preserved from Etruria and demonstrated considerable technical knowledge and skill.

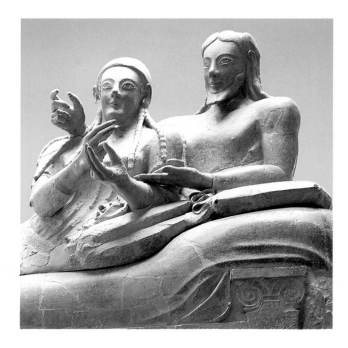

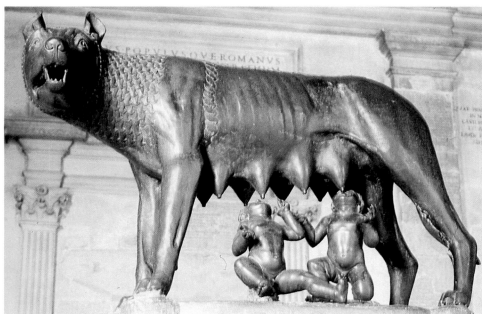

ETRUSCAN ART 650-450 BC

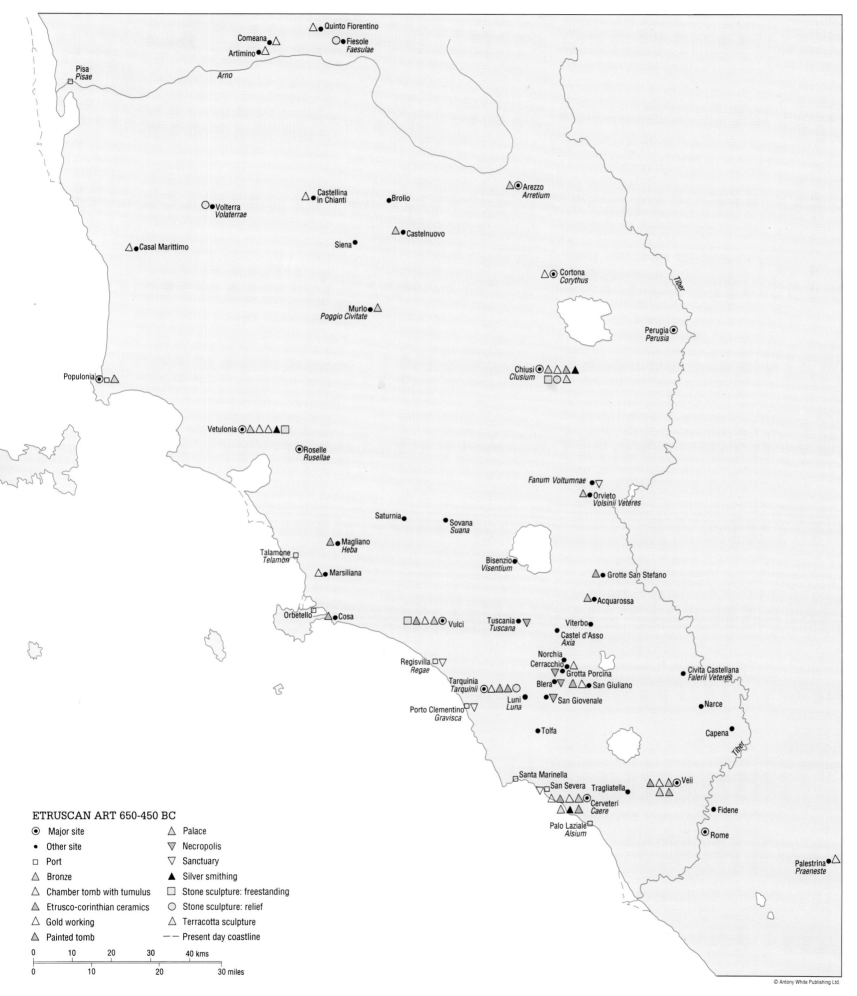

Quinto Fiorentino
Comeana
Fiesole
Faesulae
Artimino

Pisa
Pisae

Arno

Arezzo
Arretium

Castellina
in Chianti
Brolio
Volterra
Volaterrae

Castelnuovo

Casal Marittimo
Siena

Cortona
Corythus

Murlo
Poggio Civitate

Perugia
Perusia

Chiusi
Clusium

Populonia

Vetulonia

Roselle
Rusellae

Fanum Voltumnae

Orvieto
Volsinii Veteres

Saturnia
Sovana
Suana

Magliano
Heba

Talamone
Telamon

Bisenzio
Visentium

Marsiliana

Grotte San Stefano

Acquarossa

Orbetello
Cosa

Vulci

Tuscania
Tuscana

Viterbo
Castel d'Asso
Axia

Civita Castellana
Falerii Veteres

Norchia
Cerracchio
Grotta Porcina

Regisvilla
Regae

Blera
San Giuliano

Narce

Tarquinia
Tarquinii

Luni
Luna
San Giovenale

Porto Clementino
Gravisca

Tolfa

Capena

Santa Marinella

San Severa
Tragliatella
Veii

San Severa
Cerveteri
Caere

Fidene

Palo Laziale
Alsium

Rome

Palestrina
Praeneste

Legend

⊙ Major site
• Other site
□ Port
△ Bronze
△ Chamber tomb with tumulus
△ Etrusco-corinthian ceramics
△ Gold working
△ Painted tomb
△ Palace
▽ Necropolis
▽ Sanctuary
▲ Silver smithing
□ Stone sculpture: freestanding
○ Stone sculpture: relief
△ Terracotta sculpture
— — Present day coastline

0 10 20 30 40 kms
0 10 20 30 miles

© Antony White Publishing Ltd.

Etruscan Art 450–150 B.C.

The crisis brought about by the naval defeat at Cumae (474 B.C.) affected above all the southern and coastal cities of Etruria, such as Cerveteri, Tarquinia and Vulci. The ties they had established with Greece were weakened, precisely at the moment when Athens reached the peak of its classical period under Pericles (c.495–492 B.C.), and this disruption was reflected in the standard of their artistic output.

It was also during this period that the Adriatic trade route was developed, which meant that Greek goods reached the inland cities from the Adriatic ports by way of the plain of the Po River and the Tiber Valley. Consequently, due to both these factors, the center of Etruscan economic and political power shifted towards the cities of Chiusi, Arezzo, Orvieto, Veii and Civita Castellano.

The workshops of Chiusi supplied the demands of the local aristocracy for large stone funerary statues. The forges of Arezzo and Orvieto produced outstanding bronze votive monuments for local sanctuaries, such as the *Chimera* of Arezzo and the *Todi Mars*. The work produced by these bronze workshops was undoubtedly stimulated by the proximity of the federal sanctuary of Fanum Voltumnae, situated a short distance from Orvieto. During the 5th and 4th centuries, the temples at Fanum Voltumnae also underwent large-scale programmes of renovation and include the terracotta architectural *décor* of Vigna Grande and Via San Leonardo.

These monuments, as well as the votive statues in the sanctuary of Apollo at Portonaccio near Veii, echo in some respects the artistic formulas and styles elaborated by the Greek sculptors of the 5th century B.C., Phidias and Polyclitus. Such influences may also be found in the terracottas of Civita Castellano, for example the Zeus-Tinia in the sanctuary of Lo Scasato.

The cities of Chiusi, Orvieto and Civita Castellano, however, remained the most vibrant centers of Etruria. They had been sufficiently thriving in the 5th century B.C. to attract accomplished vase painters, such as the Dispater Painter. In the wake of the downfall of Veii in 396 B.C. there followed the first stage of a long process of colonization and assimilation. The southern and coastal cities of Vulci, Tarquinia and Cerveteri, despite the increasing pressure from Rome, started to flourish once again. As at Civita Castellano, Orvieto and Chiusi, figured pottery reappeared and there was a healthy production of bronzes, as well as vases, candlesticks and mirrors, which have been attributed to Vulci. The resurgence of construction was accompanied by a renewal of wall paintings, for example the *Tomb of the Ogre* at Tarquinia, and of funerary stone sculpture, such as the *Tomb of the Sarcophagi* at Cerveteri and the sarcophagus of the *Tomb of the Teitnies* at Vulci or the "priest's" sarcophagus in the *Tomb of the Partunus* at Tarquinia. Similarly there was a revival in the production of terracotta statuary, for instance the winged horses of Tarquinia.

In the second half of the 4th century B.C. a new quality may be discerned in the works produced. The pediment statues of the sanctuaries of San Severa and Cerveteri are no longer confined to the conventions of

the early, classical-Greek style, becoming instead more animated. Ties with southern Italy were also re-established at this time, and from the south there came a profusion of Hellenistic methods and styles together with the new innovations of Apulian pottery, for instance the *Clasp Tomb* at Tarquinia and the *Francis Tomb* at Vulci. This diffusion and assimilation of artistic styles and influences contributed to the development of a common artistic language throughout Campania, Latium and Etruria.

The autonomy of Etruscan art, as well as Etruria itself, had been steadily eroded for years by the Romans, since the capture of Veii in 396 B.C.. Finally, in the first half of the 3rd century B.C., the Roman armies overran Etruria. Artistic production came to an end in Orvieto with its destruction in 265 B.C.. Its people were dispersed around the shores of Lake Bolsena and throughout the regions of Vulci and Cerveteri.

From this point onwards the artistic output tended to become standardized. The iconographic repertoire became meager and motifs borrowed from mythology and the epics gave place to a subject-matter based on travels in the afterworld, peopled with symbolic animals and funerary demons. Monumental architectural *décor* now celebrated Roman victories, and the art of Etruria became increasingly just an adjunct of Roman art. Etruscan artefacts became restricted to the production of urns and stone sarcophagi, such as those found at Volterra, Chiusi, Tarquinia and Vulci, of terracotta objects like those of Chiusi, Perugia and Cerveteri, and of group portraits and, more rarely, individual portraits in which the aristocracy proudly proclaimed its Etruscan origins.

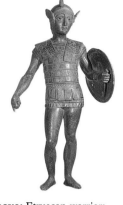

Above: Etruscan warrior: *450–400 B.C., bronze, Falterona (British Museum, London).*

The detail of the armor shows clearly the Greek influence.

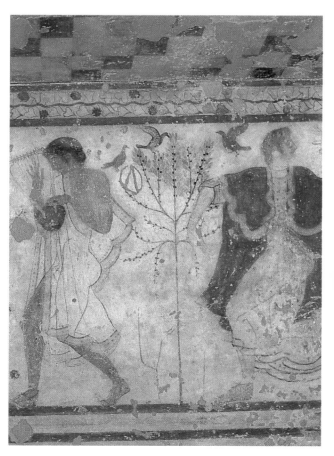

Left: *Wall painting,* Dancers; *c.450 B.C., Tomb of the Banquet, Tarquinia.*

It is likely that the murals were executed by a workshop group, with taste, subtlety, finely drawn outlines and delicate coloring. The dancers are in the open with trees dividing them and with birds in the air.

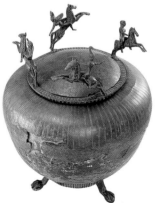

Above: *Etruscan vase showing typical prancing horses, 3rd century B.C., Campania (British Museum, London).*

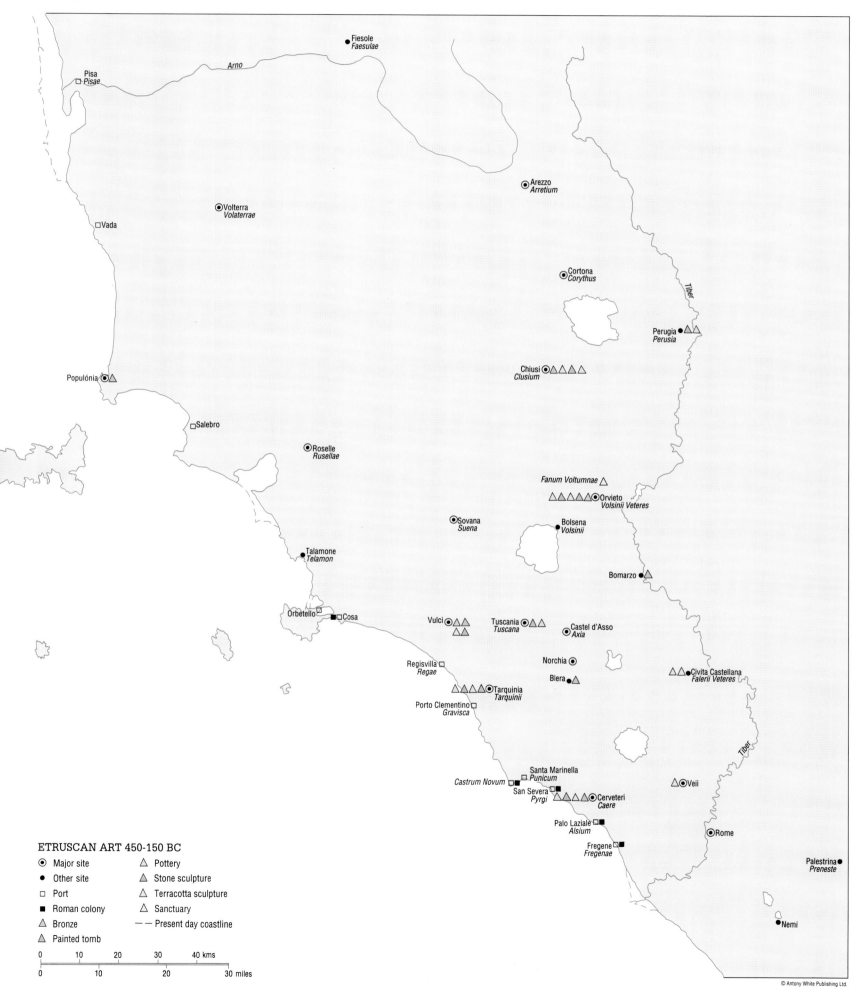

Fiesole
Faesulae

Arno

Pisa
Pisae

⊙ Arezzo
Arretium

⊙ Volterra
Volaterrae

□ Vada

⊙ Cortona
Corythus

Tiber

Perugia ● △△
Perusia

Chiusi ⊙△△△△
Clusium

Populónia ⊙△

□ Salebro

⊙ Roselle
Rusellae

Fanum Voltumnae △

△△△△△⊙ Orvieto
Volsinii Veteres

⊙ Sovana
Suena

Bolsena ●
Volsinii

Talamone ●
Telamon

Bomarzo ● △

Orbetello □
■ Cosa

Vulci ⊙△△
△△

Tuscania ⊙△△
Tuscana

Castel d'Asso
Axia ⊙

Norchia ⊙

△△ Civita Castellana
Falerii Veteres

Regisvilla □
Regae

Blera ● △

△△△△⊙ Tarquinia
Tarquinii

Porto Clementino □
Gravisca

Santa Marinella
□ *Punicum*

△⊙ Veii

Castrum Novum □ ■

San Severa □ ■ △△△△⊙ Cerveteri
Pyrgi *Caere*

⊙ Rome

Palo Laziale ■
Alsium

Fregene ■
Fregenae

Palestrina ●
Preneste

● Nemi

ETRUSCAN ART 450–150 BC

⊙ Major site △ Pottery
● Other site △ Stone sculpture
□ Port △ Terracotta sculpture
■ Roman colony △ Sanctuary
△ Bronze — — Present day coastline
△ Painted tomb

0 10 20 30 40 kms

0 10 20 30 miles

© Antony White Publishing Ltd.

Roman Art and Architecture

Roman art and architecture built upon the legacy of the Greeks and Etruscans, indeed many of the great masterpieces of classical Greek sculpture are only known to us through Roman copies. Roman sculpture was realistic, narrative and imbued with an element of propaganda value – and what it lacked in the inner harmony of 5th century B.C. Greek classical sculpture it made up for in vitality and scale.

Roman painting, particularly as murals both for palaces and luxury villas but also for humbler homes as found at Pompeii and Herculaneum, was primarily illusionistic and decorative.

Roman architecture on the other hand was predominantly an art of monumental public works such as baths, amphitheaters and aqueducts, military buildings and engineering works. The Romans rediscovered brick and concrete and used them to develop vaults and domes, creating a style of architecture that was to become the basis of both the Romanesque in the early medieval period and classical architecture in the Renaissance.

Right: *detail from* The Column of Trajan, *early 2nd century A.D., Rome.*

Below: *detail from the Venus Pompeiana, wall painting, 2nd century B.C., Pompeii, Italy.*

Republican Rome

According to ancient tradition the city of Rome was founded by Romulus in 753 B.C. on the banks of the Tiber. The site was a particularly favorable one, located in a landscape of volcanic hills created by the erosion of the river and at a natural junction of communications.

It is difficult to re-create a complete picture of Rome's urban development in the early years. Recent studies show evidence of human remains there from the Bronze Age. Clearer traces are found at the beginning of the Iron Age (9th to 8th centuries B.C.) – huts on the Palatine hill and a cemetery on the site of the future forum.

The process of urbanization continued in the 6th century and Rome, under Etruscan domination, grew rich and powerful. The town was provided with surrounding fortifications and the marshy area of the forum (the Cloaca Maxima) was drained. A hippodrome, the Circus Maximus, was built at the foot of the Palatine hill, and several temples were erected, that of Jupiter Capitolinus on the Capitoline hill and others in the Forum Boarium (cattle market).

After the overthrow of the monarchy in 509, more temples continued to be built: the temples of Saturn and of Castor and Pollux in the Forum; that of Ceres at the foot of the Aventine hill. However, the second half of the 5th century, which was a period of political crisis, was marked by a slowing down of new building. It only resumed after the sack of Rome by the Gauls in 390 B.C. when public buildings, often Greek in style, multiplied. Town planning was fairly haphazard, but a network of roads was developed, including the Via Appia, and also a water-supply system (the first aqueduct dates from 312).

By the end of the 3rd century Rome had become a great power; as a result the last two centuries of the Republic (the 2nd and the 1st centuries B.C.) show a notable growth of the city. The population had increased and working-class quarters had been built, contrasting greatly with the luxurious villas on the Palatine and Esquiline hills and the many private gardens. The center of the city, particularly the area of the Campus Martius, was organized on an increasingly monumental scale, inspired by the ideas brought back by victorious generals on their return from Greece and Asia Minor (in 132 the first temple built entirely of marble was erected by the Greek architect Hermodoros of Salamis). The number of functional buildings increased and included arsenals along the Tiber and warehouses to store food.

Julius Caesar had made grandiose plans for urban renewal which involved the complete remodeling of Rome. His assassination in 44 B.C. prevented them being carried out, but the early works in the Forum (the construction of a new Senate, the Basilica Julia and the creation of the Julian forum) mark the beginning of a major transformation which Augustus later carried out in a careful and pragmatic fashion. He divided the city into fourteen regions, embellished several sanctuaries and created his own forum around the temple of Mars Ultor. He also laid out the Campus Martius in a symbolic design incorporating his own mausoleum, the Altar of Peace (the Ara Pacis) and a monumental sundial [see Imperial Rome].

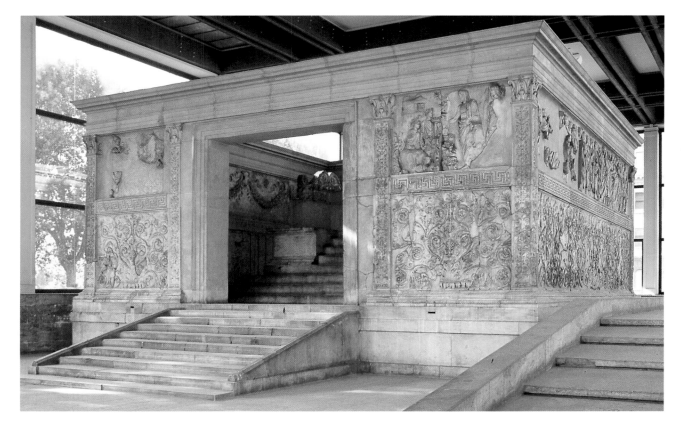

Left: Ara Pacis Augustae, *13–9 B.C., Rome (see map on Imperial Rome).*

The Altar of Peace built by the Emperor Augustus symbolized the triumph of Imperial over Republican Rome, and celebrated the international peace following Augustus' victories in Spain and Gaul.

Right: The Temple of Vesta.

A simple circular temple in which the Vestal Virgins maintained their sacred fire. The building is very ancient indeed, although rebuilt in the 3rd century, constantly added to, and restored recently.

Far right: Servian Wall, *post 390 B.C., restored in the 3rd and 4th centuries A.D., Rome.*

The original city walls of Rome, built after the Gallic invasions of 390 B.C., restored during the last days of the Empire, and now incorporated into the new railway station (completed 1950).

Veduta del Tempio di Vesta
In Roma presso Pietro Neg.di Stampe e Carta a S.Carlo al Corso N.481.

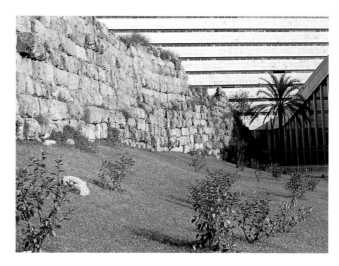

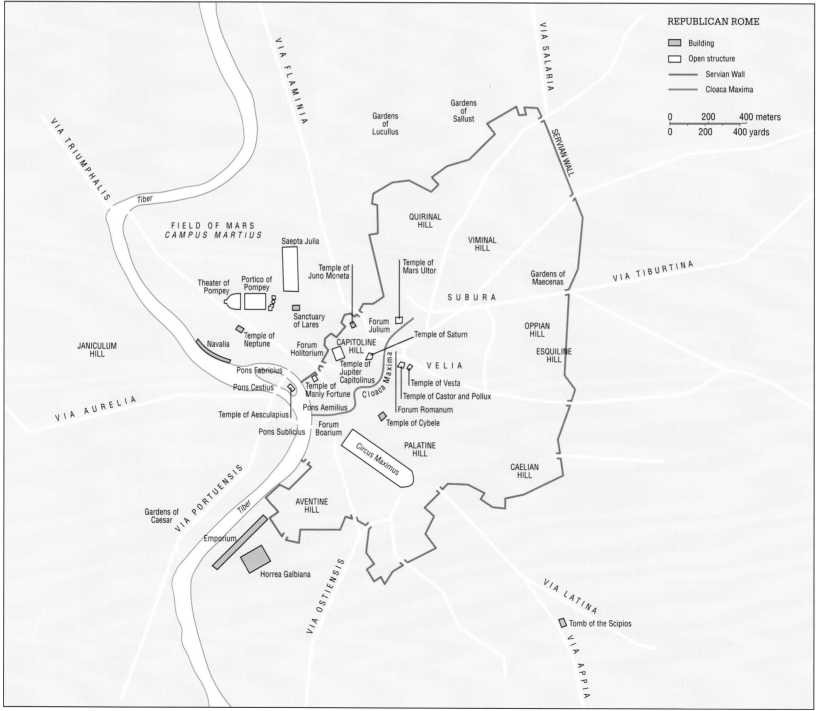

REPUBLICAN ROME

- ▭ Building
- ▢ Open structure
- — Servian Wall
- — Cloaca Maxima

0 200 400 meters
0 200 400 yards

VIA FLAMINIA

VIA SALARIA

VIA TRIUMPHALIS

Tiber

Gardens of Lucullus

Gardens of Sallust

SERVIAN WALL

FIELD OF MARS
CAMPUS MARTIUS

QUIRINAL HILL

VIMINAL HILL

Saepta Julia

Temple of Juno Moneta

Temple of Mars Ultor

Gardens of Maecenas

VIA TIBURTINA

Theater of Pompey

Portico of Pompey

SUBURA

Sanctuary of Lares

Forum Julium

OPPIAN HILL

Temple of Neptune

Forum Holitorium

CAPITOLINE HILL

Temple of Saturn

ESQUILINE HILL

JANICULUM HILL

Navalia

Temple of Jupiter Capitolinus

VELIA

Pons Fabricius

Cloaca Maxima

Temple of Vesta

Pons Cestius

Temple of Manly Fortune

Temple of Castor and Pollux

VIA AURELIA

Temple of Aesculapius

Pons Aemilius

Forum Romanum

Pons Sublicius

Forum Boarium

Temple of Cybele

Circus Maximus

PALATINE HILL

CAELIAN HILL

Gardens of Caesar

VIA PORTUENSIS

Tiber

AVENTINE HILL

Emporium

Horrea Galbiana

VIA OSTIENSIS

VIA LATINA

Tomb of the Scipios

VIA APPIA

© Antony White Publishing Ltd.

45

Imperial Rome

Augustus' successors at first followed his program of town planning, adding only a few monuments, such as the Ara Pietatis of Claudius. But in A.D.64 the huge fire which devastated Rome gave Nero the opportunity to remodel the city. He had a new residence, the *Domus Aurea* (the Golden House of Nero), built, with a vast complex of gardens and pavilions. It was originally set in a landscaped park, complete with an artificial lake where the Colosseum now stands, and was based on the country houses of the Roman Campagna. The *Domus Aurea* set the scene for the lavishness of later Imperial Rome. Nero also undertook the construction of new residential districts.

At the end of the 1st century, the Flavian emperors undertook an intensive building program, made necessary by the damage caused by the fires of 69 and 80 on the Capitol and the Campus Martius. The temple of Jupiter Capitolinus was rebuilt, and a large amphitheater, the Colosseum, commenced by Vespian in A.D. 70 and inagurated by Titus in 80, was erected, together with a palace on the Palatine hill. Vespasian laid out an imposing open space around the Temple of Peace. At the end of the Forum, Domitian dedicated an arch erected chiefly to commemorate the capture of Jerusalem to his deified brother Titus.

In the 2nd century, the most brilliant period in the history of the city, town planning was intensified. The development of an architecture based on brick made possible the construction of more numerous and less costly buildings, and sometimes allowed bold solutions – such as multi-storied blocks, or functional buildings like the markets erected by Trajan on the edge of the Quirinal hill and the great public baths. Trajan employed a talented architect, Apollodorus of Damascus, between 107 and 113 to realize, at the cost of extensive terracing works, the last and most grandiose of the imperial forums. His immediate successors, particularly Hadrian, built several spectacular monuments such as the Pantheon, the Temple of Venus and Rome, and the mausoleum built beyond the Tiber. The Pantheon, in particular, was, and remains one of the great achievements of classical Roman architecture. Together the Pantheon and the Mausoleum of Hadrian (now the Castel S. Angelo) still dominate their respective areas of modern Rome.

The Severan dynasty which came to power in 193 attempted to repair the destruction which followed the fire that occurred in 191 under Commodus. The imperial palace was enlarged and provided with a monumental eastern façade. A triumphal arch was erected in 203 at the western end of the Roman Forum to commemorate the victories of Septimus Severus over the Parthians. These and the grandiose baths built by Caracalla testified to the vigor of the public building program in this period. The grave crisis which gripped the Empire until the end of the 3rd century almost completely halted these works. The walls with which Aurelian encircled Rome in 270 are the grandest public monument of this period.

Having restored the imperial power in 286, Diocletian gave a new impetus to large-scale building.

The monument erected in the Roman Forum in honor of the Tetrarchs marked the restoration of central Rome after the fire of 283. Meanwhile the northeast of the city was remodeled by the construction of Rome's largest baths. In the first years of the 4th century Maxentius, before he was defeated by Constantine, put his stamp on Rome by building a hippodrome and a mausoleum on the Via Appia and a huge basilica in the Forum which was completed by Constantine.

Constantine marked his victory with the last triumphal arch of ancient Rome, built by the side of the Colosseum. But the times were no longer favorable for civic building; from now until the sack of Rome by Alaric in 410, Christian basilicas shaped the cityscape.

Below: *Interior of* The Pantheon, *118–128, Rome.*

The most magnificent temple of Imperial Rome – consisting of a vast portico attached to a rotunda, with the dome with the largest known span until Brunelleschi's in Florence in the 15th century. An extraordinary feat of engineering, layers of travertine marble and tufa at ground level are replaced with tufa and brick and then tufa and pumice surrounding the open "eye" in the roof.

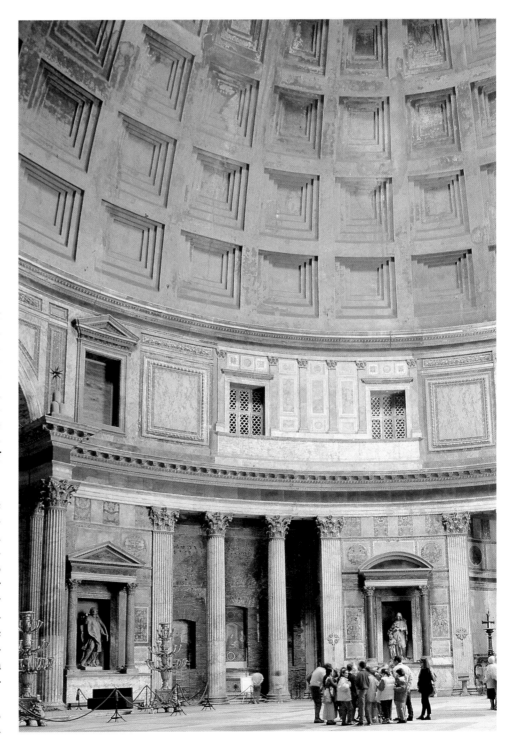

Right: *Ruins of the* Forum Romanum *with the* Basilica of Maxentius, *307–12 and later, Rome (on the right is the church of S. Francesca Romana).*

The Basilica, of which three huge arched bays on the north side are all that remain, was begun by Maxentius and completed by Constantine. It thus represented the end of the monumental architectural building of the Roman emperors in Rome, before the rival growth of the power of Constantinople.

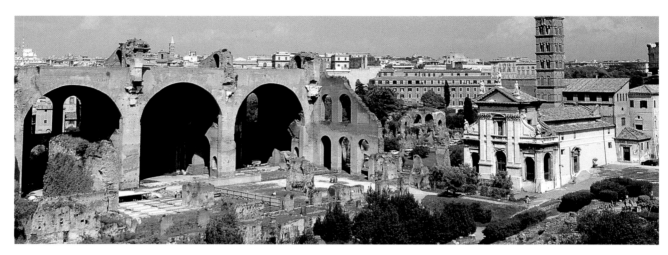

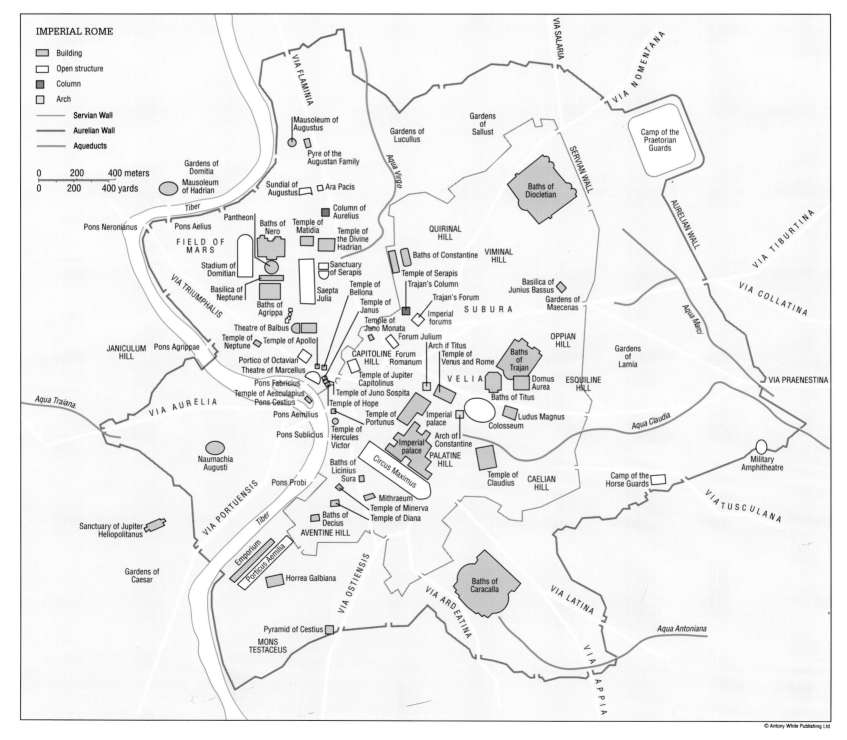

IMPERIAL ROME

- ▨ Building
- ▢ Open structure
- ▨ Column
- ▨ Arch

— Servian Wall
— Aurelian Wall
— Aqueducts

0 200 400 meters
0 200 400 yards

VIA SALARIA
VIA NOMENTANA
VIA FLAMINIA

Mausoleum of Augustus
Pyre of the Augustan Family
Gardens of Domitia
Mausoleum of Hadrian
Sundial of Augustus
Ara Pacis
Aqua Virgo
Gardens of Lucullus
Gardens of Sallust
Camp of the Praetorian Guards
Baths of Diocletian

Tiber
Pons Neronianus
Pons Aelius
Pantheon
Baths of Nero
Temple of Matidia
Column of Aurelius
Temple of the Divine Hadrian
QUIRINAL HILL
VIMINAL HILL
Baths of Constantine
AURELIAN WALL
VIA TIBURTINA

FIELD OF MARS
Temple of Serapis
Trajan's Column
Basilica of Junius Bassus
VIA COLLATINA
Stadium of Domitian
Sanctuary of Serapis
Saepta Julia
Temple of Bellona
Trajan's Forum
Imperial forums
SUBURA
Gardens of Maecenas
Aqua Marci

VIA TRIUMPHALIS
Basilica of Neptune
Baths of Agrippa
Temple of Janus
Temple of Juno Monata
Forum Julium
OPPIAN HILL
Gardens of Lamia

Theatre of Balbus
Temple of Neptune
Temple of Apollo
CAPITOLINE HILL
Forum Romanum
Arch if Titus
Temple of Venus and Rome
Baths of Trajan
VIA PRAENESTINA

JANICULUM HILL
Pons Agrippae
Portico of Octavian
Theatre of Marcellus
Temple of Jupiter Capitolinus
VELIA
Domus Aurea
Baths of Titus
ESQUILINE HILL

Aqua Traiana
VIA AURELIA
Pons Fabricius
Temple of Aesculapius
Pons Cestius
Pons Aemilius
Temple of Juno Sospita
Temple of Hope
Temple of Portunus
Imperial palace
Colosseum
Ludus Magnus
Arch of Constantine
Aqua Claudia

Pons Sublicius
Temple of Hercules Victor
Imperial palace
PALATINE HILL
Temple of Claudius
CAELIAN HILL
Military Amphitheatre

Naumachia Augusti
Baths of Licinius Sura
Circus Maximus
Camp of the Horse Guards
VIA TUSCULANA

Pons Probi
Mithraeum
Temple of Minerva
Temple of Diana

Sanctuary of Jupiter Heliopolitanus
VIA PORTUENSIS
Tiber
Baths of Decius
AVENTINE HILL

Gardens of Caesar
Emporium
Porticus Aemilia
Horrea Galbiana
VIA OSTIENSIS
Baths of Caracalla
VIA ARDEATINA
VIA LATINA

Pyramid of Cestius
MONS TESTACEUS
Aqua Antoniana
VIA APPIA

© Antony White Publishing Ltd.

Roman Art and Architecture in Italy

Rome's pre-eminence as a political and urban center should not let us forget the considerable importance of the rest of Italy in the Roman world. Up to the time of Augustus, Italy remained no more than a land under colonization, on the same footing as other, more distant, provinces. However, as the Roman Empire expanded, provincial Italy gained in significance, and not least as a springboard from which Roman culture influenced Europe north of the Alps.

The clearest picture of Italian provincial culture comes from around Naples in the south. Our main source of information has been the archeological study of the Campanian towns of Pompeii, Herculaneum and Stabiae (now Castellammare di Stabia), all three overwhelmed (and the first two superbly preserved) by the eruption of Vesuvius in A.D. 79. Yet the contribution of Pompeii and Herculaneum to our knowledge of Roman art is out of proportion to their importance at the time when they throve. Other, artistically more significant, centers remain less well known simply because these continued developing, so that their Roman monuments decayed bit by bit or were plundered for, and replaced by, later constructions.

Nonetheless, enough remains to reveal that Italian art and architecture showed considerable regional diversity. Much of this local variety was due to the mountains partitioning Italy and limiting inter-regional contacts. Take, for example, the remarkable originality of the sculptures around Chieti, in the Abruzzi region. The deepest cultural gulf, though, lay between lands to the north of the Tuscan-Emilian Apennines and those in the far south of the peninsula. The north came under Rome's political and cultural sway much sooner and more completely than the far south, thanks to a dense network of Roman colonies. Rimini, Piacenza, Cremona and Bologna, among others, played an essential role in the creation of provincial Roman art, with its distinctive funerary sculpture and other art forms. Aquileia, Brescia and Velleia became especially important centers for the production of bronze statuettes, decorations for horses' harnesses providing some of the most original and striking examples.

Outstanding features of the provincial art of northern Italy were its stress upon ornament and a treatment of space that rejected or modified the classical rules of illusionism. This artistic taste found its extreme expression on certain monuments, for instance the arch built at Susa. At the same time, there were numerous borrowings from Hellenism. The Adriatic coast, especially Rimini, kept in close contact with Greece, and some of the monumental sarcophagi characteristic of northern Italian workshops owe an obvious debt to sarcophagi created by sculptors working in Athens.

Aquileia and other northeastern towns at the gateways to great Alpine routes played key roles both in elaborating Roman provincial art and in spreading it north to the Roman province of Rhaetia (parts of present-day Austria, Germany and Switzerland) and up the Rhine valley.

Much of the art rediscovered in Italy attests to immense private wealth. Huge villas figured in several regions, notably Campania. These grand houses were the country residences of the emperor and leading Roman families, as in Tiberius' villa on Capri and the Villa Sperlonga where a grotto featured a scholarly *mise en scene* of grouped statues illustrating episodes from the *Odyssey*. Cicero's correspondence gives us a clear picture of that orator-statesman's own villa: its layout, refined architecture and sumptuous furnishings and works of art purchased largely in Greece. Murals, mosaics and sculptures all figured in everyday life. So, too, did valuable pieces of furniture such as beds decorated with bronze appliqué work; and amazing silver tableware services have been found in Campania at Boscoreale and at Menander's house in Pompeii.

In Italy, as in the rest of the Empire, the rich exploited art to make public displays of their wealth and importance. Besides contributing to their city's upkeep, middle-class citizens commissioned statues and portraits. The very rich went further, endowing major political and religious centers with substantial structures such as the capitol at Brescia and the arches at Aosta, Verona, Rimini and Capua. The arches of Augustus at Susa and Trajan at Benevento bore decorations in relief, though that was exceptional. Among the most impressive of all urban structures were vast public buildings, theaters and amphitheaters, as at Verona, Pozzuoli and Capua. More modest versions figured at Minturno and elsewhere. Sculptures richly adorned many theaters. The theater at Cerveteri even boasted a gallery of portraits of the Julian and Claudian emperors. Plainly, public welfare was only one aspect of town planning: the public buildings of Roman Italy also served as political tools.

Above: The temple of Augustus, *probably 1st century A.D., Pula, Croatia.*

One of the finest examples of Roman religious architecture in the Italian provinces, the temple combines the use of Corinthian columns, a richly sculpted frieze with floral motifs, and strong vertical lines. It represents a type of Roman religious building found throughout the Empire, as at Assisi, Nîmes, Vienna and Baalbek

Below: *Decorative wall-painting from the House of Marcus Lucretius Fronto, probably early 1st century A.D., Pompeii.*

The Roman city of Pompeii was buried and preserved in volcanic ash from a massive eruption of Vesuvius in A.D. 79, leaving for posterity an accurate picture of an early Imperial Roman city and its art.

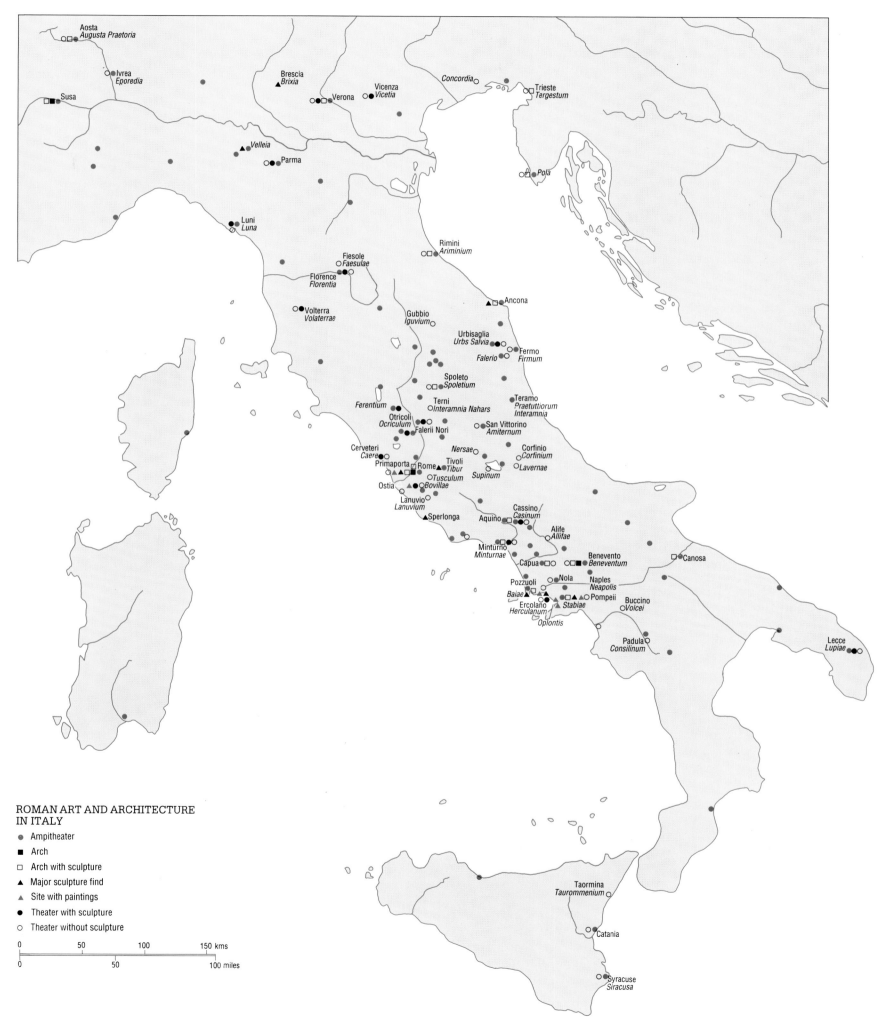

Aosta
Augusta Praetoria

Ivrea
Eporedia

Susa

Brescia
Brixia

Vicenza
Vicetia

Verona

Concordia

Trieste
Tergestum

Velleia

Parma

Pola

Luni
Luna

Fiesole
Faesulae

Florence
Florentia

Rimini
Ariminium

Volterra
Volaterrae

Gubbio
Iguvium

Ancona

Urbisaglia
Urbs Salvia

Fermo
Firmum

Falerio

Spoleto
Spoletium

Teramo
*Praetuttiorum
Interamnia*

Ferentium

Terni
Interamnia Nahars

Otricoli
Ocriculum

Falerii Nori

San Vittorino
Amiternum

Corfinio
Corfinium

Cerveteri
Caere

Nersae

Lavernae

Primaporta

Rome

Tivoli
Tibur

Tusculum

Supinum

Ostia

Bovillae

Lanuvio
Lanuvium

Sperlonga

Cassino
Casinum

Aquino

Alife
Allifae

Minturno
Minturnae

Capua

Benevento
Beneventum

Canosa

Nola

Pozzuoli

Naples
Neapolis

Buccino
Volcei

Baiae

Pompeii

Ercolano
Herculanum

Stabiae

Oplontis

Lecce
Lupiae

Padula
Consilinum

Taormina
Taurommenium

Catania

Syracuse
Siracusa

ROMAN ART AND ARCHITECTURE
IN ITALY

- ● Ampitheater
- ■ Arch
- □ Arch with sculpture
- ▲ Major sculpture find
- ▲ Site with paintings
- ● Theater with sculpture
- ○ Theater without sculpture

| 0 | 50 | 100 | 150 kms |

| 0 | 50 | 100 miles |

Sources of Materials in the Roman World

The artistic output in the Roman world was abundant and varied, making use of the most diverse materials. Some of these had to be imported from far away, outside the frontiers of the empire. These imports form the basis of long-distance trade, which was often very expensive. Amber was imported from the shores of the Baltic across the Alps into northern Italy, especially Aquileia. Ivory, much sought after, came from India across the Red Sea and through Africa to Alexandria. Silk, used in the manufacture of luxury fabrics, came by sea from China and by caravan along the silk route, bringing prosperity to stage cities like Palmyra. It was not until the middle of the 6th century A.D. that silkworms were introduced into the Byzantine Empire and their cultivation taken up in the west.

The study of sources of materials necessary for works of art is becoming more and more of interest to historians and archeologists, but it is by no means a simple matter. In quarries and mines the faces worked by the Romans must be distinguished from those of more recent times. In the case of silver, for example, we are familiar with the wealth of silver and lead mines in Spain and how they were worked in imperial times because of traces of use and very detailed inscriptions. We are also familiar with the mines in the Kosmaj region of Yugoslavia, south of Belgrade; but our information on mines in Gaul, for example, is much scantier.

The presence of mines or quarries often provided the impetus for a local production of artefacts. This would account for the establishment of a sculptor's workshop near the marble cuttings at Dokimeion and Aphrodisias in Asia Minor. Aphrodisias became the center of an export trade in pre-carved capitals. In Britain, the development of a unique manufacture, pewter (an alloy of lead and tin), which challenged the importance of silverware production, is mostly due to the abundance of mines producing these two metals. However, artists often bypassed direct sources of metal production by utilizing second-hand materials. Goldsmiths and bronze workers melted down artefacts that were old-fashioned or no longer of use and re-used the metal. Even sculptors at times followed a similar process, refashioning old busts and adapting them for new commissions.

Stone quarries were very numerous in the Roman world, and were of importance both for architecture and for sculpture. Most were of merely local importance but some were highly productive and supplied a regional commerce stretching at times right across the empire. The stone was transported by sea or river since boats were the most convenient form of transport for such heavy wares. Several wrecks loaded with marble have been discovered in the Mediterranean. Their cargoes were unhewn blocks, or partially worked stone such as columns or sarcophagi worked in rough at the mines and destined to be completed on site. There were huge depots at Ostia, and above all in Rome, on the left bank of the Tiber at the foot of the Aventine Hill in the quarter that still retains the characteristic name of Marmorata. It was possible here to unload and stock very large shiploads. In imperial Rome a whole department, the *ratio marmorum*, supervised this industry.

Most of the major quarries were imperial property. Egypt supplied granite and porphyry. Colored marbles were much sought after for decorating walls and pavements, and also for statuary, and at times commanded exorbitant prices. Yellow marble came from Chemtou in Tunisia; green from Larissa in Thessaly; black from the Pyrenees in particular. But the most important trade was in white marble. Not all its sources were suitable for the same job: certain marbles, sought after by architects, were not appropriate for sculpture. The quarries of Luni (Carrara) in Italy were worked only towards the end of the Republic and the marble cut here was used only in the western provinces of the empire. The best-known marbles came from Greece and Asia Minor, such as those for sculpting from the Pentelikon, the Cyclades (Paros), Thasos and indeed from Teos (Sigacik) whose reputation continued up to the Byzantine period

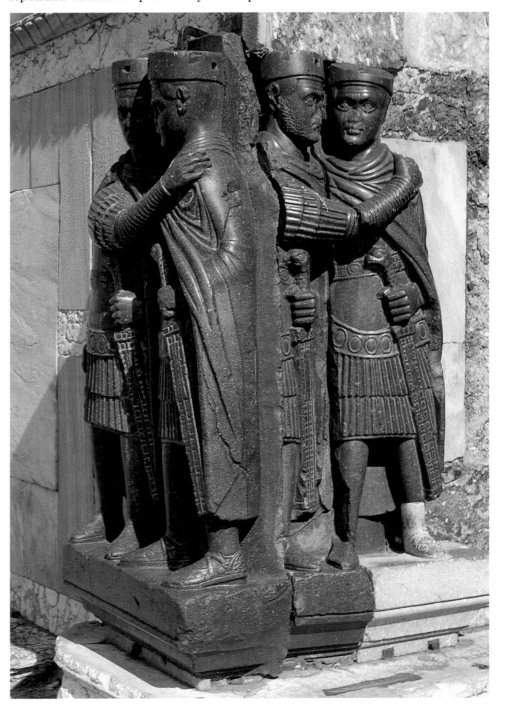

Below: The Tetrarchs, *porphyry sculpture, probably 4th century (S.Marco, Venice).*

A sculpture of two pairs of warriors embracing each other, probably representing the tetrarchs, or four emperors (Diocletian, Maximian, Valerius and Constantius) who shared the administrative burden of Empire at the turn of the third and fourth centuries. The stone probably came from Egypt, sculpted in either Egypt or Syria. It is now outside S. Marco in Venice.

SOURCES OF MATERIAL IN THE ROMAN WORLD

- ● City
- △ Stone used for sculpture only ⎤ exported
- △ Stone used for sculpture and architecture ⎬ throughout the empire
- △ Stone for local and regional use only ⎦
- **Sn** Source of tin
- **Ag** Source of silver
- **Pb** Source of lead
- ▬ Boundary of Roman Empire in 117 AD
- → Movement of materials
- Mining area

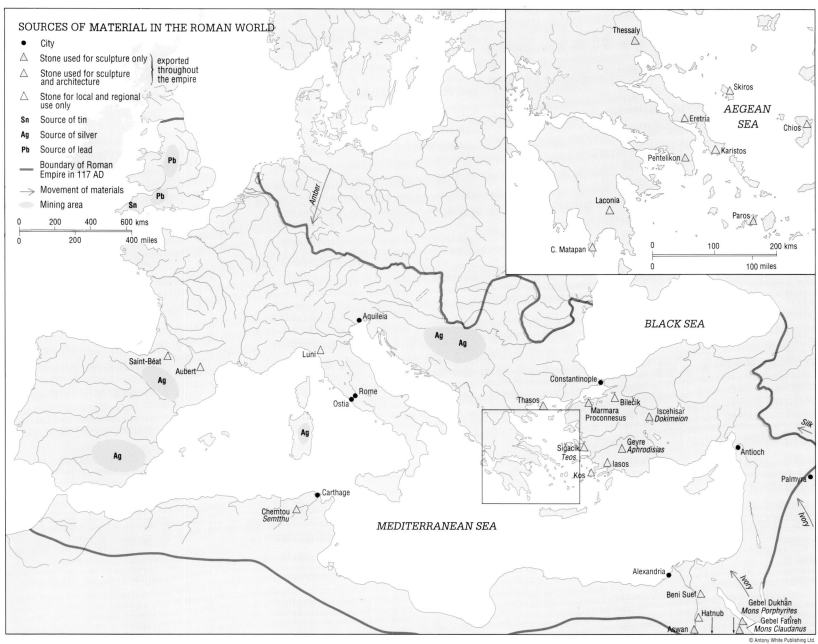

Thessaly
Skiros
AEGEAN SEA
Eretria
Chios
Pentelikon
Karistos
Laconia
Paros
C. Matapan

Pb
Pb
Sn
Amber

BLACK SEA

Aquileia
Luni
Ag Ag
Rome
Ostia
Constantinople
Thasos
Bilecik
Marmara Proconnesus
Iscehisar *Dokimeion*
Saint-Béat
Aubert
Ag
Geyre *Aphrodisias*
Ag
Sigacik *Teos*
Antioch
Ag
Iasos
Kos
Palmyra
Ag
Carthage
Silk
Chemtou *Semtthu*
MEDITERRANEAN SEA
Ivory
Alexandria
Ivory
Beni Suef
Ivory
Gebel Dukhân *Mons Porphyrites*
Hatnub
Gebel Fatîreh *Mons Claudanus*
Aswan

© Antony White Publishing Ltd.

Right: Quarries at Aswan, *Egypt.*

Aswan, on the right bank of the Nile, was one of the sources of the supply of granite and porphyry in the Roman world.

Silver Plate in the Roman World

Silverware was a very important artefact in the Roman world and from the 1st century B.C. a valuable collector's item. Its wide diffusion and economic importance can be explained on two levels: the high quality of craftsmanship in the decoration made these artefacts real works of art; and the fact that they were luxury goods, attesting to the wealth of their owners, accorded them a specific economic value. Silver objects were given to friends, placed in tombs, or presented as votive offerings to the gods. The temple of Mercury at Berthouville or that of Minerva at Notre-Dame d'Alençon had silver treasures.

Spectacular finds of silverware dating from the end of the Republic and the beginning of the Empire have been made in towns destroyed by the eruption of Vesuvius in A.D. 79 – at Boscoreale and at the House of Menander at Pompeii. But other individual pieces have come to light from all parts of the Roman world; an important discovery, as yet unexplained, was made beyond the borders of the Empire, at Hildesheim. The 1st century was also a famous period for goldsmiths' art, especially cups, which were chased with great technical skill and virtuosity.

Since silver represented a capital investment, it was often buried by the owner in times of peril, in the hope of recovering it later. Much of it was never retrieved, and it is thanks to these subsequent finds that we can map the distribution of silver throughout the Empire and make deductions about the evolution of taste. It happens that finds are not numerous in the eastern part (Greece, Turkey, Syria), although literary texts show that silverware was as prized there as elsewhere. In France, on the contrary, numerous hoards were found; many were hidden towards A.D. 260 just as the big Germanic invasions took place – in the north, along the road which led from the Rhine to the North Sea, and in the valleys of the Saône and the Rhône. Important workshops certainly existed in Gaul at this time, although the decorations were less ornate than those of the 1st century.

In the 4th century, hoards are more scattered: in the great cities of the Empire, Rome, Carthage, Trier, Thessaloniki, Antioch; near the frontiers where the army and an important part of the administration were; near the Rhine (Kaiseraugst; Trier) and the Danube. There were also numerous finds in Britain (Mildenhall, Thetford, Canterbury), including the oldest known church treasure (Water Newton). We know too of several finds looted in antiquity by robbers who hoarded silver pieces solely because of the value of the precious metal, cutting them into bits: beautiful samples have been found in Denmark, Germany (Gross-Bodungen) and also in Scotland (Traprain Law).

From some discoveries, we know that the most important of the Roman aristocratic families owned silverware (Esquiline Treasury, Rome). Emperors would give silver objects as gifts to men they wanted to honor; several finds near the Danube (Niš, Červen Br'ag, Esztergom) point to this.

Despite the quality of the decoration and the sumptuousness of dishes, we know little about goldsmiths' work. They mostly operated in the large towns of the Empire, but rarely signed their products: only two are known during Late Antiquity, Euticius from Naissus (Niš in Serbia), and Pausylypos from Thessaloniki. From this time, however, the government tried to keep a check on silverware: some hallmarks have been found, but a system of stamps was not in regular use before the end of the 6th century at Constantinople.

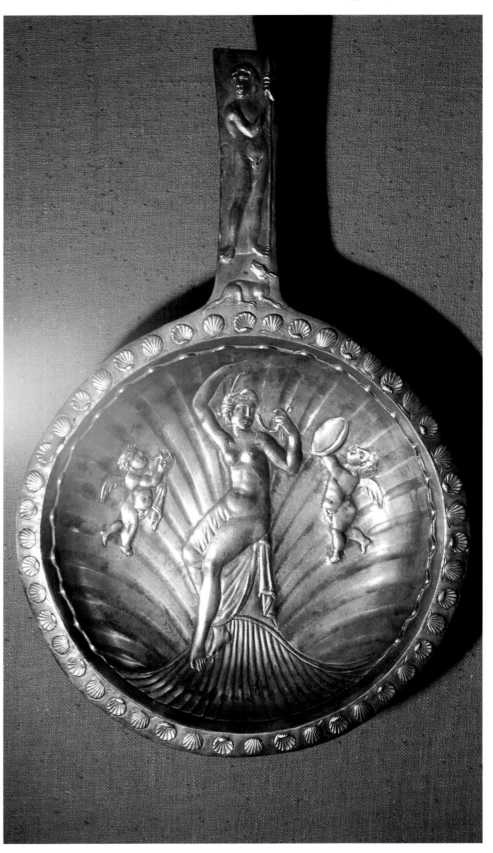

Below: A patera (shallow silver saucepan), c. *A.D. 500, (Esquiline Treasure, Petit Palais, Paris).*

A large scallop-shell design of Venus, attended by two putti, *holding a lotus flower and a mirror. Adonis on the handle has a dog at his feet.*

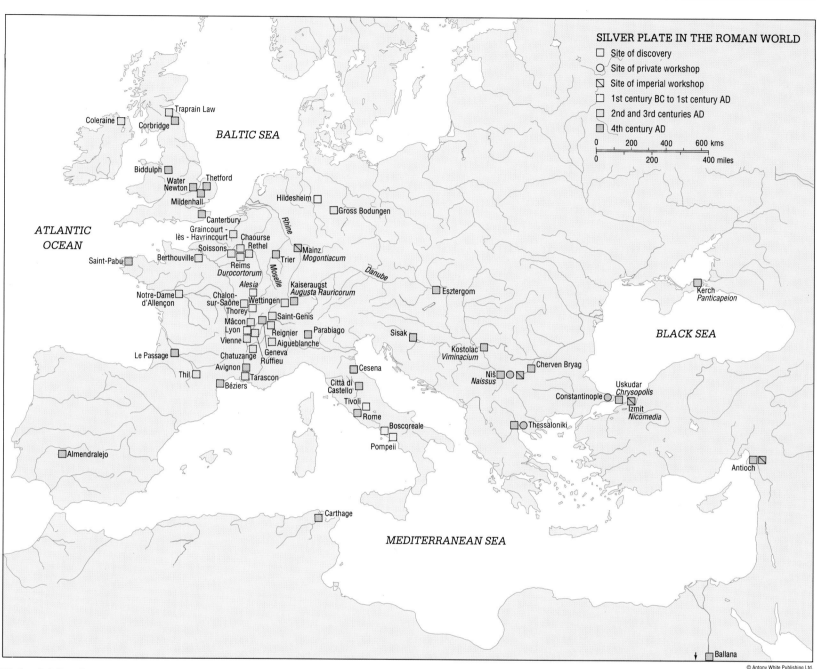

SILVER PLATE IN THE ROMAN WORLD

- □ Site of discovery
- ○ Site of private workshop
- ▨ Site of imperial workshop
- □ 1st century BC to 1st century AD
- □ 2nd and 3rd centuries AD
- ■ 4th century AD

| 0 | 200 | 400 | 600 kms |
| 0 | 200 | 400 miles |

BALTIC SEA

ATLANTIC OCEAN

Coleraine
Traprain Law
Corbridge
Biddulph
Water Newton
Thetford
Mildenhall
Canterbury
Hildesheim
Graincourt-lès-Havrincourt
Chaourse
Rethel
Mainz
Mogontiacum
Soissons
Trier
Berthouville
Saint-Pabu
Reims
Durocortorum
Moselle
Rhine
Gross Bodungen
Alesia
Kaiseraugst
Augusta Rauricorum
Notre-Dame d'Allençon
Chalon-sur-Saône
Wettingen
Danube
Esztergom
Kerch
Panticapeion
Thorey
Saint-Genis
Mâcon
Reignier
Parabiago
Lyon
Aigueblanche
Vienne
Sisak
BLACK SEA
Le Passage
Chatuzange
Geneva
Rúffieu
Kostolac
Viminacium
Cherven Bryag
Avignon
Cesena
Niš
Naissus
Uskudar
Chrysopolis
Thil
Tarascon
Città di Castello
Constantinople
Izmit
Nicomedia
Béziers
Tivoli
Rome
Thessaloniki
Boscoreale
Pompeii
Almendralejo
Antioch
Carthage

MEDITERRANEAN SEA

Ballana

© Antony White Publishing Ltd.

Right: Achilles dish, c. *A.D. 350, Kaiseraugst Treasure, (Roman Museum, Augst, Switzerland).*

Central roundel of an eight-sided dish shows the discovery of Achilles among the daughters of King Lykomedes.

Far right: The Emperors Theodosius I, Valentinian II and Arcadius, *silver dish, probably from Constantinople, A.D. 388 (Madrid, Academia de la Historia).*

A great dish made to celebrate the Decennalia (10th anniversary of the Emperors' accession). It is not definitely the work of a Constantinoplitan workshop, and could be western. Silver craftsman-ship was still international in the late 4th century.

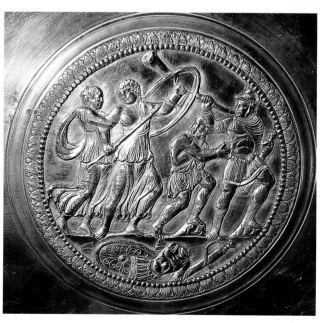

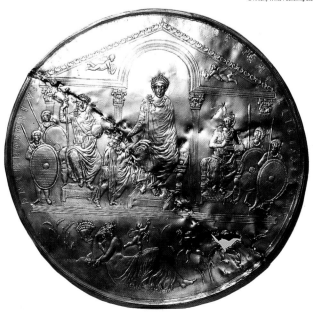

Roman Provincial Art and Architecture in the West

The diversity and richness of artistic output in the western provinces of the Roman Empire is too great to be easily summarized. At best, we can single out some of the most significant trends.

Where public buildings are concerned, of greatest general interest are those intended for showing popular spectacles, and accordingly built to hold large or even vast crowds. These structures conform to a common plan, although one modified here and there throughout the various regions. The chief building types of this kind were the circuses or hippodromes, the amphitheaters and the theaters.

Designed chiefly for chariot racing, circuses were so huge and costly to build that these oval structures tended to figure only in sizable cities such as Carthage in North Africa, Sremska Mitrovica in Pannonia and Arles in Gaul. Lack of interest in chariot racing might account for the absence of circuses in certain regions; Britain, for instance, holds no examples of this kind of building.

Amphitheaters were much more numerous. These buildings hosted a variety of largely bloody spectacles, especially gladiatorial combats and fights with wild beasts. Like circuses, some amphitheaters were built on a grand scale: the amphitheater at El Jem in North Africa is one of the largest after the Colosseum at Rome. Other amphitheaters came in various sizes. Some were free standing, some sunk in the ground, but all had a sober, strictly functional design. Amphitheaters proved especially popular in Proconsular Africa (present-day Tunisia), but numbers also appeared in Spain and Gaul. Some of the best preserved, at Arles and Nîmes, date from the early days of the Empire.

Theaters were even more plentiful than amphitheaters, partly because most required less massive construction. Here, actors performed plays, and singers and dancers put on popular shows along music-hall lines. Many a theater served a significant social purpose by providing a meeting point for a widely dispersed population. This helps to explain the diffusion of theaters throughout rural Gaul, at Sanxay for example. Some of these provincial buildings were hybrids, combining the features of an amphitheater and a theater in the same edifice.

All three building types demonstrated the skills of Roman architects, and a number of structures bore rich sculptural decoration, mainly statues. Theaters also featured reliefs on the wall at the back of the stage. However, such embellishments were generally more marked in the eastern provinces, as at Sabrathah in Tripolitania.

Architectural relief in general did not find equal favor everywhere in the west. It was relatively rare in Africa, where the ornate altar of the Gens Augusta at Carthage provides an exception. The numerous Roman triumphal arches of North Africa were quite plain, and similar arches appeared in the Danubian provinces. But decorated arches figure strongly in Gaul, as at Orange and Carpentras in the province of Narbonne, the Black Gate at Besancon and the Gate of Mars at Reims. The Column at Mainz provides another western example of an official structure bearing decorative relief.

Funerary monuments offered a special outlet for sculptors. Their handiwork figured in huge mausoleums like that at Glanum in Provence at the end of the 1st century B.C. and in later examples like the mausoleum of Igel in the Moselle valley and monuments discovered at Neumagen near Trier. Simpler examples feature in countless funerary or votive stelae expressing in a rich yet popular and naive style the religious beliefs of the dead and their place in society. The models for these sculptures often came from far away; for instance, the inspiration for certain Rhine valley sculptures can be traced back to northern Italy. Often local sculptors adapted classical models in ways that showed little appreciation of the canons of classical art, as with the funerary monuments at Ghirza in Tripolitania.

Of course many sculptures found in the western provinces were not made by local workshops at all. Two likely examples of imports are the imperial busts found at Markouna in Algeria and the sculptures of the villa at Matres-Tolosanes in southwest France. Sculptors and their works both journeyed afar, and many of the portrait busts, statues and sarcophagi discovered in Africa and France were manufactured in Rome.

The same applies to the paintings found in what were once Rome's western provinces. These fragile decorations often disappeared with the crumbling of the walls they adorned. However, modern archeological techniques have achieved some spectacular reconstructions of ancient murals at Narbonne and Famars and a 4th-century ceiling at Trier. This work has improved our understanding of how this kind of art evolved.

Much better preserved than the paintings are the many mosaic pavements produced in the west. This art form became so popular that there evolved truly regional schools, and we can distinguish mosaics made in Spain from those made in Gaul or in Africa.

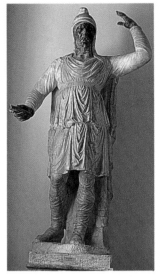

Above: Portrait statue of the Emperor Decius, *mid-3rd century (Museo delle Terme, Rome).*

A soldier from Pannonia, Decius was elected emperor by his own troops and was eventually killed by the Goths in Thrace. His portrait reflects how far the image of emperor had come from the Augustan classicism of the early Imperial period.

Below: *The amphitheater at Thysdrus, early 3rd century A.D., El Jem, Tunisia.*

El-Jem was settled as a Roman city by Caesar's veterans c.45 B.C. The amphitheater was the second largest Roman monument, surpassed in size only by the Colosseum in Rome.

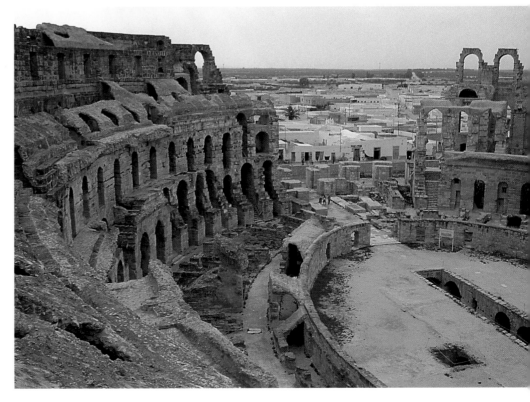

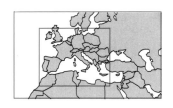

ROMAN PROVINCIAL ART AND
ARCHITECTURE IN THE WEST

- ■ Ampitheater
- ▫ Hippodrome
- ▫ Theater/ampitheater hybrid
- ▪ Architecture with sculptured relief
- ● Sculpture
- ○ Painting
- ◐ Wooden sculpture

*NORTH
SEA*

*ADRIATIC
SEA*

*AEGEAN
SEA*

MEDITERRANEAN SEA

1 Acholla
2 Ronda Vieja *Acinipo*
3 *Aequum*
4 Agbia
5 Aix-en-Provence *Aquae Sextiae*
6 *Alauna*
7 Aleria *Alalia*
8 *Alleans*
9 Amiens *Samarobriva*
10 Ampurias *Emporiae*
11 Angers *Iuliomagus*
12 Antibes *Antipolis*
13 *Aquae Segetae*
14 *Arennes*
15 Arles *Arelate*
16 *Argentomagus*
17 *Arlon*
18 Écija *Astigi*
19 *Augusta Raurica*
20 *Autricum*
21 Autun *Augustodunum*
22 Avenches *Aventicum*
23 *Bararus*

24 Besançon *Vesontio*
25 Béziers *Baeterrae*
26 *Bonnée*
27 Bordeaux *Burdigala*
28 Bourges *Avaricum*
29 *Bouzy*
30 *Brigetio*
31 Budapest *Aquincum*
32 *Bulla Regia*
33 Caerleon *Isca*
34 Caerwent *Venta*
35 Calahorra *Calagurris*
36 *Calleva*
37 *Canetonum*
38 Cáparra *Caperra*
39 Carmona *Carmo*
40 *Carnuntum*
41 Carpentras *Carpentorate*
42 *Carpi*
43 Carthage *Carthago*
44 Castra Traina
45 *Chamalières*
46 *Chemtou*

47 Chennevières
48 Cherchel *Caesarea*
49 Chester *Deva*
50 Chichester *Noviomagus*
51 Cimiez *Cenemelum*
52 *Clunia*
53 Colchester *Camulodunum*
54 Cologne *Colonia Claudia*
55 *Conimbriga*
56 Córdoba *Corduba*
57 *Corinium*
58 *Derventum*
59 Dougga *Thucca*
60 *Durnovaria*
61 El Jem *Thysdrus*
62 Evreux *Mediolanum*
63 Famars *Fanum Martis*
64 Flavia *Solva*
65 Fréjus *Forum Julii*
66 Gargaresh
67 *Gemellae*
68 Genainville

69 Gennes
70 Ghirza
71 *Glanum*
72 Grand
73 *Isorium Brigantium*
74 Santiponce *Italica*
75 *Lambaesis*
76 Le Kef *Sicca Veneria*
77 *Leptis Magna*
78 *Leptis Minor*
79 Les Bolards
80 Lillebonne *Iuliobona*
81 Limoges *Augustoritum*
82 *Lixus*
83 Locmariaquer
84 London *Londinium*
85 Lyon *Lugdunum*
86 *Mactaris*
87 Mainz *Mogontiacum*
88 Markouna
89 Martigny *Octodurus*
90 *Matres Tolosanes*

91 *Mauves*
92 Mérida *Emerita Augusta*
93 *Mesarfelta*
94 Metz *Divodurum*
95 *Micia*
96 *Moridunum*
97 Narbonne *Narbo Martius*
98 Néris *Aquae Neri*
99 Nijmegen *Noviomagnus*
100 Nîmes *Nemausus*
101 Nish *Naissus*
102 *Noviodunum*
103 *Noviomagus*
104 Sopron *Scarbantia*
105 Orange *Arausio*
106 Paris *Lutetia*
107 Périgueux *Vesunna*
108 Poitiers *Limonum*
109 *Porolissum*
110 *Pully*
111 *Pupput*
112 Reims *Durocortorum*

113 Rodez *Segodunum*
114 *Rutupiae*
115 Sabratha
116 Sagunto *Saguntum*
117 St Albans *Verulamium*
118 St-Bertrand de Comminges
 Lugdunum Convenarum
119 Saintes *Mediolanum*
120 *Salonae*
121 Santiago do Cacém
122 Sanxay
123 Sbeitla *Sufetula*
124 Saelices *Segobriga*
125 *Seressi*
126 Setif *Sitifis*
127 Seville *Hispalis*
128 *Silva Martis*
129 Sousse *Hadrumentum*
130 Sremska Mitrovica *Sirmium*
131 Tarragona *Tarraco*
132 Tebourba *Thuburbo Minus*
133 Tapso *Thapsus*

134 *Theveste*
135 *Thibari*
136 *Thignica*
137 *Thinae*
138 *Thuburbo Maius*
139 *Tigava*
140 *Tipasa*
141 Toledo *Toletum*
142 Toulouse *Tolosa*
143 Tours *Caesarodunum*
144 Trier *Augusta Treverorum*
145 *Triguières*
146 Espejo *Ucubi*
147 *Ulisippira*
148 *Uthina*
149 *Utica*
150 Vienna
151 *Virunum*
152 *Volubilis*
153 Welschbillig
154 Windisch *Vindonissa*
155 Xanten *Vetera*

© Antony White Publishing Ltd.

55

Roman Provincial Art and Architecture in the East

Greece, Asia Minor, Syria and Egypt – the Roman Empire's eastern regions bordering the Mediterranean – had their own splendid civilizations long before Rome asserted dominion over them. By then Athens was an old-established center of art and culture, and Hellenism had deeply and vigorously influenced the other regions' cultures, although the ancient pharaonic traditions still lingered in Egypt.

In Asia Minor, particularly, another factor modified the impact of Rome. This was the sheer number of cities and their political importance. The Romans let these keep their autonomy, indeed largely encouraged it, and for many of these centers the first centuries of the empire marked a period of prosperity. Cities rivaled one another on every front, vying to adorn themselves with monumental splendor. The grandest and most magnificent centers included Ephesus, Qalaat al-Mudik on the Nahr al-Asi, and Antioch. Many other towns were splendid on a more modest scale. Town planning paid for by the richest citizens was often elaborate, at Perge for example. In certain cases the impetus even came from the emperor himself. Hadrian, for instance, created a new quarter in Athens.

Under Roman rule, the larger eastern towns could boast vast colonnaded avenues (Apamea's was about 1.2 miles [2 km] long), fine public buildings, temples, markets, libraries and more – all splendidly adorned with sculptures. Eastern theaters such as those of Perge, Aphrodisias and Hierapolis bristled with a wealth of statues and reliefs that effectively turned these buildings into picture books carved out of stone.

Not all decoration was slavishly imported from Italy or Greece. The eastern provinces linked Rome to places open to artistic currents outside those familiar to the classical world. The clearest proof of this comes largely from funerary art reflecting beliefs strongly rooted in local traditions. Stelae from the rural plains of Phrygia are one such example. Then, too, a profoundly oriental art competed with Greco-Roman influence in some of the cities serving as terminals for Asian caravan routes. The monumental mountain tombs of Nabatean Petra in what is now Jordan derive their inspiration from the Hellenistic architecture of Alexandria, but funerary and monumental sculptures (for instance decorating the temple of Bel at Palmyra) escaped Roman influence and reflect an entirely different artistic tradition.

On the whole, though, the more spectacular artistic achievements owe most to Hellenism, which is noticeable mainly in architecture but also in the decorative arts. Remains of mural paintings are rare (the greatest number are to be found in the residential quarter of Ephesus) but Antioch and several other large cities abound in mosaics that attempt realistic pictorial effects. Complete scenes figure in floor mosaics dating from the empire's first three centuries.

The influences mentioned already appear in sculpture produced in the eastern empire. Apart from the city of Rome, the empire's other two major sarcophagus-manufacturing centers both lay in the east. One was Athens, the other, more widely dispersed, in Asia Minor, notably at Dokimeion in Phrygia. Phrygian sculptors

preferred decorative garlands to figure composition, but the Attic workshops of the A.D. 270s created vast monumental friezes with lines of figures each given individual treatment. These artefacts proved very popular and were exported throughout the Mediterranean.

Sculptors worked largely with marble. This stone was plentiful and quarried from Mount Pentelikon in Greece, on the island of Thasos and at Dokimeion. The abundance of marble helps to explain the remarkable development of Asia Minor's sculpture, which featured portraits, ornamental statuary and decorative and mythological reliefs. (In Syria, though, sculptors worked largely with limestone.)

Imperial reliefs were much scarcer than in the west but they included the 1st-century A.D. Sebasteion at Aphrodisias and the late 3rd-century Arch of Galerius at Thessaloniki in Greece.

The workshop at Aphrodisias enjoyed an especially magnificent development, as revealed by recent discoveries. Here sculptors employed white marble for statues, but colored, especially black, marble for decorative groups. This workshop's artefacts and sculptors (some known by their signed works) traveled throughout the Roman world. The output of Aphrodisias-based sculptors has cropped up in places as far apart as Rome (for instance the centaurs at Hadrian's Villa) and Shahat in North Africa. Discoveries like these highlight the importance of the eastern provinces in the development of Roman art.

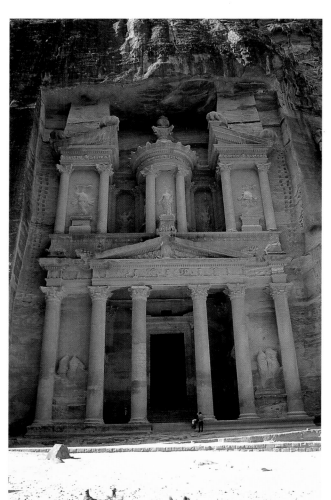

Left: Al-Khazneh (*The Treasury*), *1st–2nd century A.D., Petra, Jordan.*

One of the rock-cut temples of the Nabatean city of Petra, Al-Khazneh was possibly the tomb of Aretas IV. The city was built into sandstone cliffs colored red, purple and pale yellow, and the architectural style combined the base of a Corinthian temple with a fanciful mixture of decorative motifs.

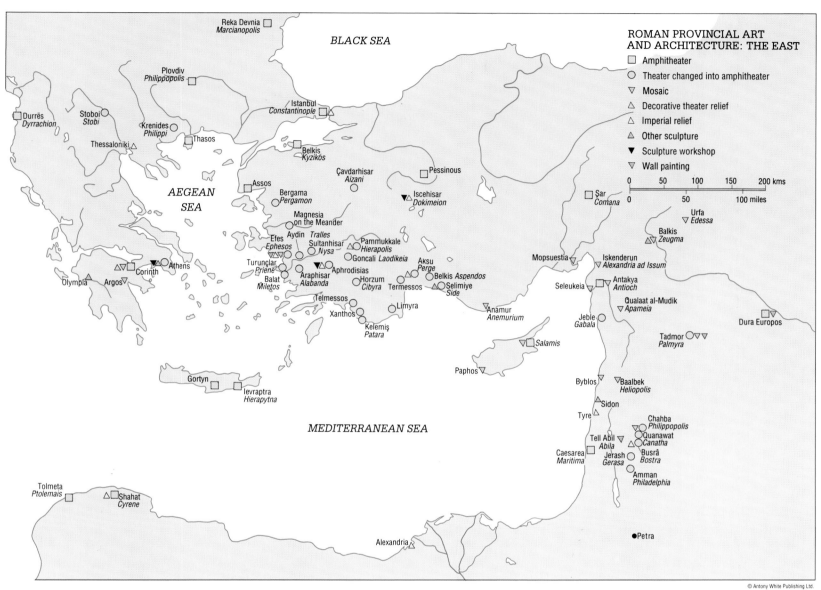

ROMAN PROVINCIAL ART AND ARCHITECTURE: THE EAST

□ Amphitheater
○ Theater changed into amphitheater
▽ Mosaic
△ Decorative theater relief
△ Imperial relief
△ Other sculpture
▼ Sculpture workshop
▽ Wall painting

| 0 | 50 | 100 | 150 | 200 kms |
| 0 | 50 | | 100 miles | |

BLACK SEA

Reka Devnia *Marcianopolis*

Plovdiv *Philippopolis*

Istanbul *Constantinople*

Durrës *Dyrrachion*
Stoboi *Stobi*
Krenides *Philippi*
Thessaloniki
Thasos

Belkis *Kyzikos*
Çavdarhisar *Aizani*
Pessinous

AEGEAN SEA

Assos
Bergama *Pergamon*
Iscehisar *Dokimeion*
Magnesia on the Meander
Aydin *Tralles*
Efes *Ephesos*
Sultanhisar *Nysa*
Pammukkale *Hierapolis*
Goncali *Laodikeia*
Aksu *Perge*
Turunçlar *Priene*
Aphrodisias
Balat *Miletos*
Araphisar *Alabanda*
Horzum *Cibyra*
Belkis *Aspendos*
Termessos
Selimiye *Side*
Telmessos
Limyra
Xanthos
Kelemiş *Patara*

Athens
Olympia
Argos
Corinth

Şar *Comana*
Urfa *Edessa*
Balkis *Zeugma*
Mopsuestia
Iskenderun *Alexandria ad Issum*
Seleukeia
Antakya *Antioch*
Qualaat al-Mudik *Apameia*
Dura Europos
Jeble *Gabala*
Tadmor *Palmyra*

Anamur *Anemurium*
Salamis
Paphos
Byblos
Baalbek *Heliopolis*
Sidon
Tyre
Chahba *Philippopolis*
Quanawat *Canatha*
Tell Abil *Abila*
Busrâ *Bostra*
Caesarea *Maritima*
Jerash *Gerasa*
Amman *Philadelphia*

MEDITERRANEAN SEA

Gortyn
Ievraptra *Hierapytna*

Tolmeta *Ptolemais*
Shahat *Cyrene*

Alexandria

●Petra

© Antony White Publishing Ltd.

Right: Dionysus in his Chariot, *relief sculpture from the theater at Perge, 1st century A.D., Turkey.*

The theater of Perge, the ancient city of Pamphylia, was decorated with a wealth of narrative statuary, of a style similar to that found also at Aphrodisias and Hierapolis.

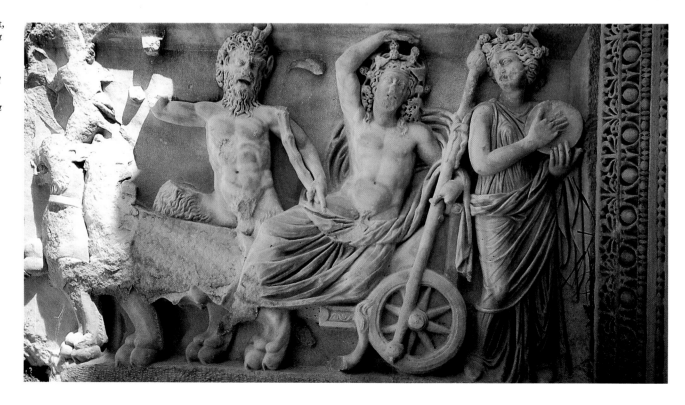

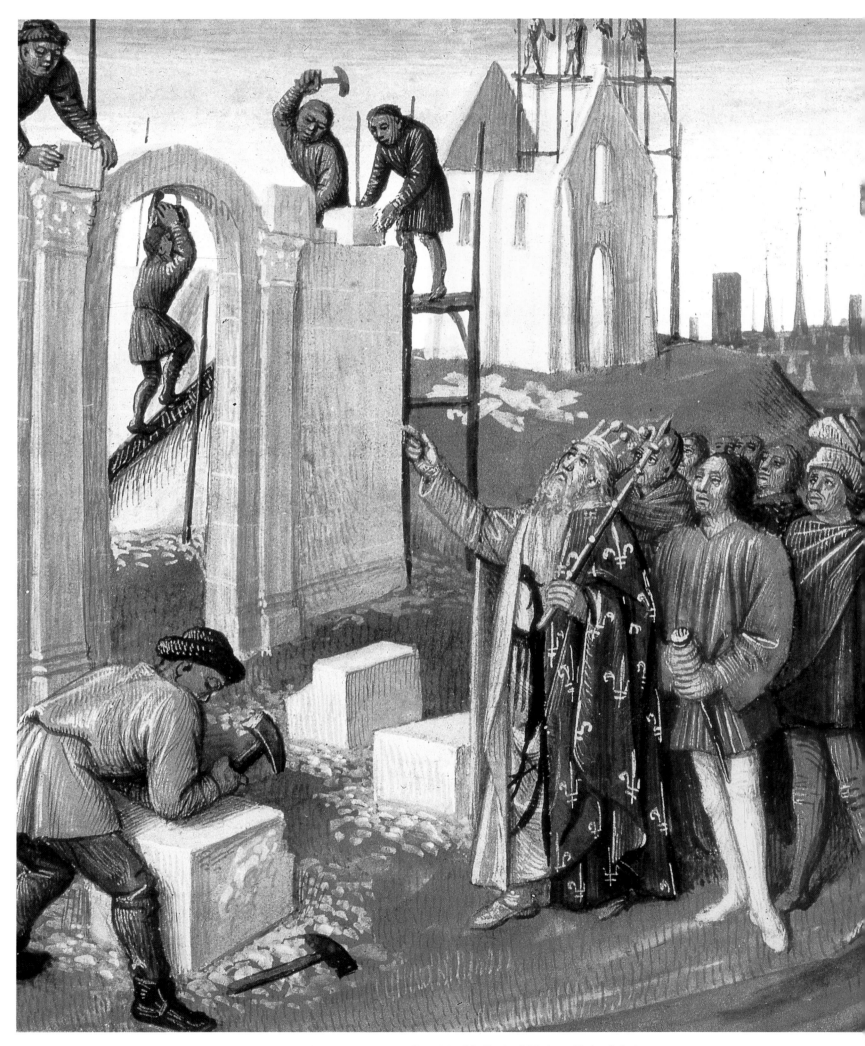

Above: The Construction of the Church at Aix-la-Chapelle by Charlemagne *from the* Chronicle of St. Denis *(Bibliothèque National, Paris).*

THE MEDIEVAL WORLD
4th – 15th Centuries

The Middle Ages began with the shift of power in the Roman Empire from Rome in the West to Byzantium (Constantinople) in the East – a move begun by Constantine in the 4th century and completed by the Sack of Rome by Alaric the Goth in 410.

The legacy of the art of Rome was preserved in two ways in the Early Middle Ages – through Constantinople on the one hand and by a gradual process of assimilation by the now settled barbarian peoples. This process was amply demonstrated in the career and achievement of Charlemagne, who refounded the Empire in the early 9th century. Carolingian art and architecture provided the basis for medieval painting, sculpture and building, infinitely susceptible to local style, nuance and need, that resulted in both the Romanesque and the Gothic which were to transcend national and feudal limitations for the next 600 years.

Above: Gilded Silver Casket from St. Cugat, *14th century, Spain (Museo Diocesano de Barcelona).*

Byzantine Europe

The Byzantine Empire, or East Rome, was born of the inability of the Roman imperial system to administer and control an empire that at its greatest extent stretched from the Atlantic to the Euphrates, and from the Scottish border to the Atlas Mountains. From the 2nd century A.D. the emperors had begun to divide the administrative burden, but the situation worsened with the vulnerability of the west to the barbarian invasions.

The Emperor Constantine addressed this problem in two ways. He physically moved his capital to the ancient city of Byzantium, renamed Constantinople, and also officially became a Christian. Constantinople was sited on the Bosphorus, the waters dividing Asia from Europe, and close to Rome's arch enemy, Persia. The establishment of Constantinople as the capital of a Christian empire gave it a proselytizing character that in the 9th century led to the conversion of the Slavs by the missionary saints Cyril (827–69) and Methodius (826–85). Hence, for a time, it maintained its authority in the Balkans and Russia.

The emperors in Constantinople never, however, perceived that they had abandoned the Roman world and the West; even after the establishment of the Visigothic Kingdom in Spain, the Ostrogothic Kingdom of Northern Italy, based at Ravenna, and, most seriously, of the Vandal capture of Rome's north African Empire. Rome itself adapted to the new situation, even though sacked by Alaric in 410. By the 6th century the Emperor Justinian (527–65) launched a series of campaigns to re-capture the West and took, for a period of time, both Italy (Rome occupied 536; Ravenna 538–40) and the African provinces (conquered 533–4). The culture and art of Byzantium were exported to Italy, although the tax-gatherers who accompanied them created little enthusiasm amongst the relics of the Roman landed aristocracy.

In the following century the Emperor Heraclius (610–41) definitively defeated the Persians on the eastern front and the future of the Empire might have seemed secure. But in reality the wars of reconquest, the expenditure and the continuous accompanying internecine religious feuding between the various developments of Christianity, particularly in the Middle East, left the Empire exhausted; and the defeat of the Persians left a huge vacuum of power that was filled in an incredibly short space of time by the rise of Islam in the late 7th and 8th centuries.

The Byzantine Empire, even after the Muslim conquests in the 7th and 8th centuries survived for a further 600 years. It became adept at balancing by diplomatic means the ever-growing threat of invasion and dismemberment. It became at once more Greek, more oriental and more antipathetic to what it saw as the barbarism of the new Christian and German west. It preserved a knowledge of classical Greek literature, and developed an art which became the norm for all orthodox Christian countries. Attacked on all fronts, even sacked by the Christians on crusade in 1204, Constantinople did not finally fall until 1453. It was once popular, and profoundly inaccurate, to say that the Renaissance began with the arrival of Greek scholars in Italy after 1453 – but it is certainly true that the knowledge and learning of these scholars showed that even in the 15th century Byzantium was the last direct heir of the classical world.

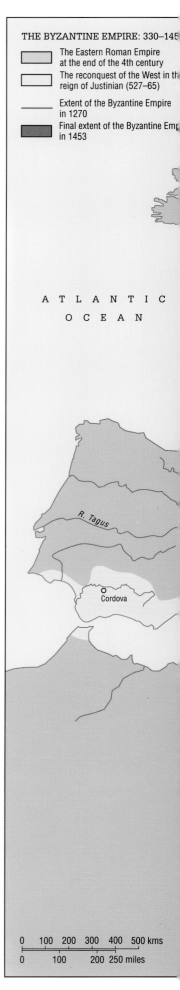

THE BYZANTINE EMPIRE: 330–145

The Eastern Roman Empire at the end of the 4th century

The reconquest of the West in th reign of Justinian (527–65)

Extent of the Byzantine Empire in 1270

Final extent of the Byzantine Emp in 1453

ATLANTIC
OCEAN

R. Tagus

Cordova

| 0 | 100 | 200 | 300 | 400 | 500 kms |
| 0 | 100 | 200 | 250 miles |

Above: Miniature from the Chronicle of John Scylitzes, *an episode from the siege of Thessaloniki by the Bulgars (Biblioteca Nacional, Madrid).*

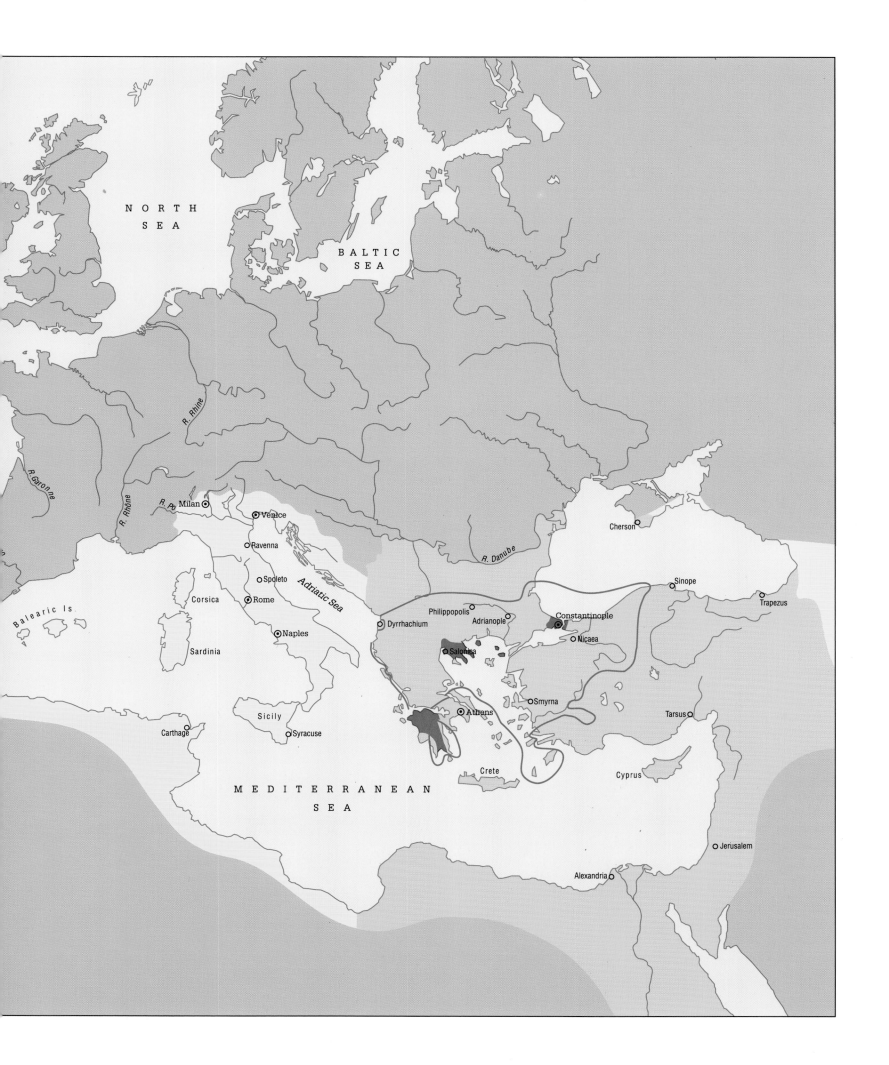

NORTH
SEA

BALTIC
SEA

R. Rhine

R. Garonne

R. Rhône

R. Po Milan

Venice

Ravenna

Spoleto

Corsica Rome

Balearic Is.

Sardinia

Naples

Adriatic Sea

R. Danube

Cherson

Sinope

Trapezus

Philippopolis

Dyrrhachium

Adrianople

Constantinople

Nicaea

Salonica

Sicily

Syracuse

Carthage

Smyrna

Athens

Tarsus

Crete

Cyprus

MEDITERRANEAN
SEA

Jerusalem

Alexandria

61

Early Medieval Europe and the Emergence of the Holy Roman Empire

The 4th to 5th centuries witnessed a process of ever-increasing barbarian migration, with whole tribes leaving their places of origin for numerous reasons, most often on account of changes in population and climatic factors. These migrations accelerated the disintegration of the Roman Empire which was replaced with a variety of emerging German kingdoms.

In 410, the Visigoths, under their leader Alaric, penetrated Italy and sacked Rome. The Vandals moved into Transylvania and Slovakia and then southwest into Gaul, Spain and Africa. The Burgundians advanced into the area of the Rhine and by the 6th century had firmly established a Burgundian kingdom. By the end of the 5th century the Visigoths controlled much of what are now Spain and France. England, abandoned by the Romans in the 5th century, was invaded by the Jutes, Angles and Saxons. The Franks, migrating southwards, first established themselves in the Low Countries and by the 6th century had suceeded in driving the Visigoths out of the area equivalent to modern France.

By the late 8th century, the center of Frankish power shifted east under Charlemagne who established an imperial court at Aachen. There is no question that this enigmatic Frankish warrior saw himself as the legitimate descendant of the Roman Emperors. He created an empire stretching into Saxony, Bohemia, Bavaria, into Italy as far as Lombardy and south west to the Pyrenees. Charlemagne's achievement, legitimized by the Papacy, was the origin of the Holy Roman Empire. By the time of his death in 814 Charlemagne had greatly expanded the Empire, with an administrative system far in advance of any other in his day.

By the late 9th century Charlemagne's domain had been partitioned several times, beginning with the Treaty of Verdun in 843 between Lothair I, Louis the German and Charles the Bald. From these divisions there emerged gradually the borders between Germany, France, Lorraine and Italy

The 11th century was one of disruption, with further Danish and Norman invasions of England. On the continent the long lasting Investiture struggle between the Emperor and the Papacy had begun. This controversy gave rise to the split between the Empire and the Papacy.

The 12th century saw the three Crusades of 1096–9, 1147–9 and 1189–92, combining pilgrimages to the Holy Land with a holy war against the infidel, bringing western Europe into contact with the art of the East and a knowledge of its artistic styles.

THE EUROPE OF CHARLEMAGNE 750–1054

- Frankish possessions and dependencies in 750
- Frankish expansion to 814
- Byzantine Empire in 814
- Other Christian regions in 814
- Regions added to Christendom by 1054
- Muslim regions at 1054
- Pagan regions at 1054

Areas still held by the Byzantine Empire c.750

0 100 200 300 400 kms
0 100 200 miles

ATLANTIC OCEAN

LEÓN-CAST

Porto R. Douro

SMALL

R. Tagus

MUS

Córdoba

Fez

AL MO

(from 1055)

Above: Charlemagne's Dream, *stained glass, 13th century (Chartres Cathedral, France).*

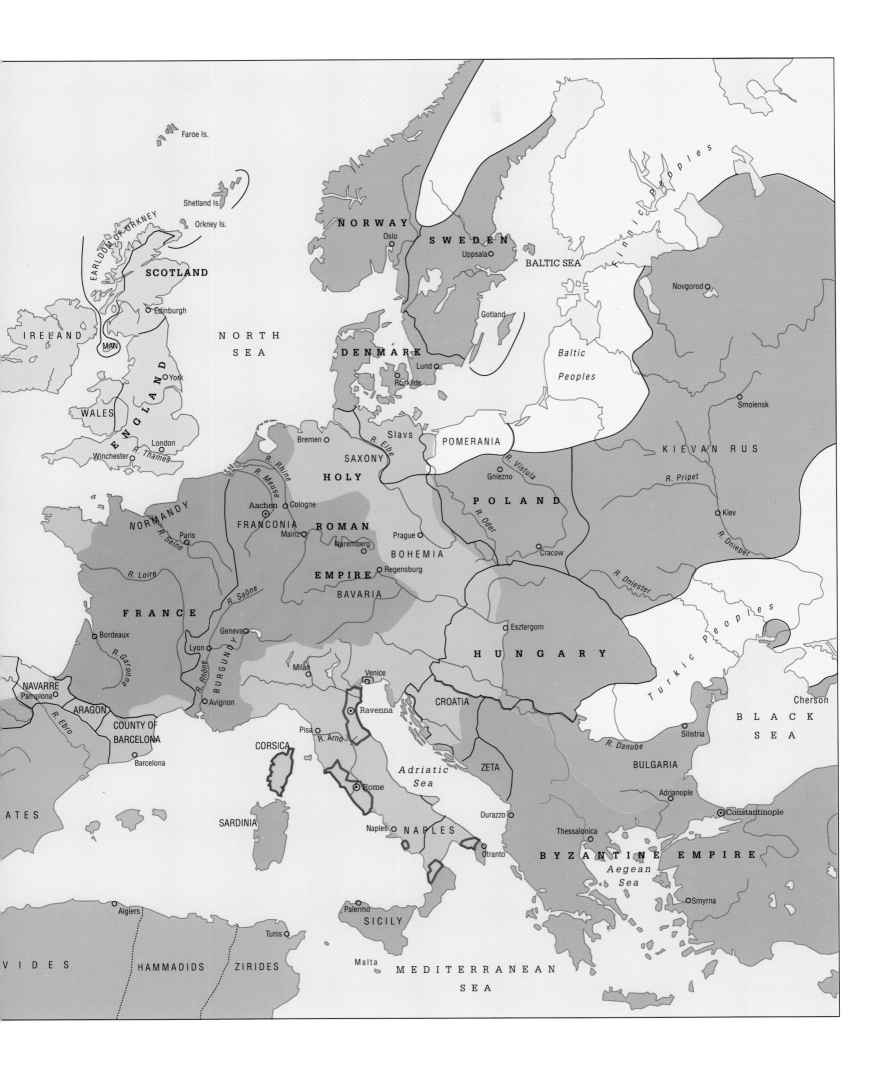

Faroe Is.

Shetland Is.

Orkney Is.

EARLDOM OF ORKNEY

SCOTLAND

Edinburgh

IRELAND

MAN

E N G L A N D

York

WALES

London

Winchester

R. Thames

N O R W A Y

Oslo

S W E D E N

Uppsala

Finnic Peoples

BALTIC SEA

Gotland

Novgorod

D E N M A R K

Lund

Roskilde

Baltic

Peoples

Smolensk

N O R T H

S E A

Bremen

R. Elbe

Slavs

POMERANIA

SAXONY

HOLY

R. Rhine

R. Meuse

Aachen

Cologne

FRANCONIA

Mainz

ROMAN

Gniezno

R. Vistula

P O L A N D

R. Pripet

K I E V A N R U S

Kiev

NORMANDY

Paris

R. Seine

Nuremberg

Prague

BOHEMIA

R. Oder

R. Dnieper

R. Loire

EMPIRE

Regensburg

BAVARIA

Cracow

R. Saône

F R A N C E

Bordeaux

R. Garonne

Geneva

Lyon

R. Rhône

B U R G U N D Y

Avignon

Milan

Esztergom

H U N G A R Y

Turkic Peoples

R. Dniester

NAVARRE

Pamplona

ARAGON

R. Ebro

COUNTY OF BARCELONA

Barcelona

Venice

Pisa

R. Arno

Ravenna

CROATIA

ZETA

Cherson

R. Danube

Silistria

B L A C K

S E A

CORSICA

SARDINIA

Adriatic

Sea

Rome

BULGARIA

Adrianople

Constantinople

A T E S

Naples

N A P L E S

Durazzo

Thessalonica

B Y Z A N T I N E E M P I R E

Otranto

Aegean

Sea

Smyrna

Algiers

Palermo

SICILY

Tunis

V I D E S

HAMMADIDS

ZIRIDES

Malta

M E D I T E R R A N E A N

S E A

Europe in the Fourteenth Century

The political and social history of Europe in the 14th century was conditioned by two catastrophes: the temporary collapse of the power of the Papacy on the one hand, and the Black Death on the other. The Papacy declined after Boniface VIII (1294–1303) had tried to maintain rigid Roman control. Shortly after his death, the papal court was forcibly removed to Avignon, where it remained a puppet of the French until 1377. The concept of the dual role of the Emperor-Pope was dead, and worse, on returning to Rome, the church was rent with schism that remained unresolved until 1417.

Paradoxically, popular piety was on the increase, not least because of the dramatic rise in mortality during the Black Death, the plague which spread across Europe from 1347–1350. The plague decimated the population of Europe, and labor shortages undoubtedly caused economic disruption. But they also raised prices and profits, and it is not purely coincidence that this period saw the growth of the wealth and political power of cities as far apart as Tuscany and the Hanseatic cities of the Baltic.

The third factor in 14th century history was the declining power of the Holy Roman Emperor, and the acceptance of the emperor's electability – giving increased powers to those clerics and nobles who formed the electoral college. This weakness allowed the German princes to make their territories more independent, and to increase them through dynastic marriages. The cities also jealously guarded their independent rights.

The Teutonic Knights took Prussia in 1283 and reached the height of their power in the late 14th century. Poland became powerful after its union with Lithuania in 1386. Spain completed the expulsion of the Moors, with the exception of the state of Granada. England was involved in the French wars and suffered with the weakness of its monarchy towards the end of the century. France under the Valois grew in power and centralization. In Italy the emerging states benefitted from the decline of the great international powers, and their wealth and ambition were to provide the catalyst that was to produce the early Renaissance.

EUROPE IN THE
FOURTEENTH CENTURY

- Aragonese possessions
- English possessions
- Lands of the Teutonic Knights
- Muslim territories
- Papal states

—— Boundary of Holy Roman Empire

0 100 200 300 400 kms
0 100 200 miles

ATLANTIC OCEAN

Santiago

Oporto R. Douro

PORTUGAL

Lisbon R. Tagus

Seville Córdoba

GRAN

Gibraltar Gran

Tangier Ceuta

MOROCCO

Left: Dreamer Enters the Garden *(British Museum, London).*

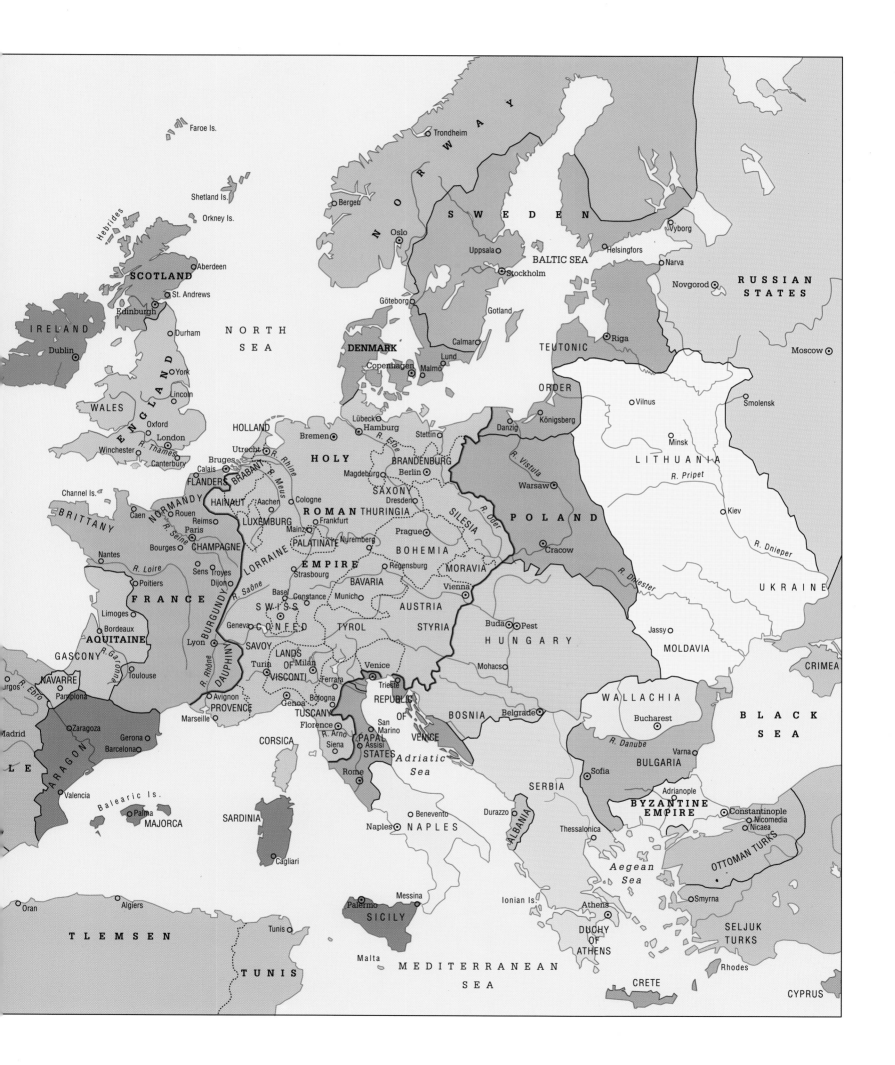

Faroe Is.

Shetland Is.

Orkney Is.

Hebrides

SCOTLAND

Aberdeen

St. Andrews

IRELAND

Edinburgh

Dublin

Durham

NORTH

SEA

Trondheim

NORWAY

Bergen

SWEDEN

Oslo

Uppsala

Stockholm

BALTIC SEA

Göteborg

Gotland

DENMARK

Copenhagen

Lund

Malmö

Calmar

Vyborg

Helsingfors

Narva

RUSSIAN
STATES

Novgorod

Moscow

TEUTONIC

Riga

ORDER

Vilnus

Königsberg

Smolensk

ENGLAND

WALES

York

Lincoln

Oxford

London

Winchester

Canterbury

Calais

Channel Is.

BRITTANY

NORMANDY

Caen

Rouen

HOLLAND

Utrecht

Bruges

FLANDERS

BRABANT

HAINAUT

LUXEMBURG

Bremen

Lübeck

Hamburg

Stettin

Danzig

Magdeburg

Berlin

BRANDENBURG

HOLY

ROMAN

Cologne

Aachen

SAXONY

Dresden

THURINGIA

SILESIA

R. Elbe

R. Rhine

R. Meus

R. Oder

R. Vistula

Warsaw

POLAND

LITHUANIA

R. Pripet

Minsk

Kiev

R. Dnieper

Reims

Paris

Mainz

Frankfurt

Nuremberg

Prague

BOHEMIA

MORAVIA

Cracow

R. Seine

CHAMPAGNE

LORRAINE

EMPIRE

Sens

Troyes

Dijon

Strasbourg

Regensburg

BAVARIA

Munich

Vienna

AUSTRIA

STYRIA

Bourges

PALATINATE

Nantes

Poitiers

FRANCE

Limoges

Bordeaux

AQUITAINE

GASCONY

R. Loire

R. Saône

Basel

Constance

SWISS

CONFED

Geneva

BURGUNDY

Lyon

DAUPHINÉ

SAVOY

Turin

LANDS

OF

Milan

VISCONTI

TYROL

Buda

Pest

HUNGARY

Mohacs

MOLDAVIA

Jassy

UKRAINE

CRIMEA

R. Dniester

Vienna

Venice

Ferrara

Trieste

Bologna

Genoa

REPUBLIC

OF

VENICE

BOSNIA

Belgrade

R. Danube

WALLACHIA

Bucharest

BLACK

SEA

NAVARRE

Pamplona

Burgos

R. Ebro

ARAGON

Zaragoza

Gerona

Barcelona

Valencia

Madrid

LE

R. Garonne

Toulouse

PROVENCE

Avignon

Marseille

TUSCANY

Florence

R. Arno

Siena

San

Marino

Assisi

PAPAL

STATES

Rome

Adriatic
Sea

SERBIA

Durazzo

ALBANIA

Thessalonica

Sofia

BULGARIA

Varna

Adrianople

BYZANTINE

EMPIRE

Constantinople

Nicomedia

Nicaea

Balearic Is.

Palma

MAJORCA

CORSICA

SARDINIA

Benevento

Naples

NAPLES

Aegean
Sea

Athens

DUCHY

OF

ATHENS

Smyrna

OTTOMAN TURKS

SELJUK

TURKS

Oran

Algiers

TLEMSEN

Tunis

TUNIS

Cagliari

Messina

Palermo

SICILY

Malta

MEDITERRANEAN

SEA

Ionian Is.

CRETE

Rhodes

CYPRUS

Late Antique, Early Christian and Byzantine Art and Architecture

The art of the Eastern Roman Empire, or Byzantium, founded by Constantine in the 4th century, although perceived as the heir to the art of Rome, developed in a more oriental and lavish style. Its church architecture, developed by the 6th century, was based on the dome and the cross-in-square, sumptuously decorated with mosaic.

In Rome itself the new Christian art, in terms of architecture, mural and mosaic, built on both the legacy of Rome, and also on the import of Byzantine style from Constantinople – particularly in the 6th century after the Emperor Justinian had briefly reconquered Italy and unified the Empire under the rule of Constantinople.

The art of the West was also mixed with the skill and style of the invading barbarians who settled within the Empire and created kingdoms for themselves. This intermingling of cultures achieved a diversity of styles and, in places such as Anglo-Saxon Northumbria, created some of the finest painting and decoration of the early medieval world.

Right: Initial to St. John's Gospel *from the* Lindisfarne Gospels, c.*700 (British Library, London).*

Below: *detail from* Projecta Casket, *Roman silver from the Esquiline Treasure, late 4th century (British Museum, London).*

67

Art and Architecture from Constantine to Theodoric

Constantine's victory at Chrysopolis reunited the Roman Empire under one emperor in 324; Theodosios divided it finally into East and West once more in 395. From then on, each went its separate way: the East to become Byzantium, the West split by a series of barbarian raids. Rome was sacked in 410, and gradually the remains of empire were divided into various kingdoms, culminating in the Ostrogothic kingdom of Theodoric (495–526), ruled from Ravenna.

Constantine's imposition of Christianity in 313 as the official religion of the Empire played a significant role in artistic development in the period covered by this map. Gradually the church's political and social status altered and grew to parallel administrative organization. As ritual and hierarchy became formalized, a new style of architecture was needed to reflect the Church's importance. The Roman basilica, or town hall, an example of which survives at Trier, combined religious connotations with official criteria. Variations on the theme of a basic rectangular box were developed: aisles, galleries, clerestories, entrances and apses can be seen in church remains throughout the empire – as at Aquileia in the West or Gerasa in the East. Other forms of building – cult shrines, martyria, places for baptism – and other shapes – notably circular and polygonal – were developed. Buildings tended to be simple outside but decorated inside with mosaic on walls and floors, marble and stucco, fittings of precious metals and textiles, all depending on local resources. Remains of such decoration survive today in the 4th-century mausoleum of Constantia in Rome, the mausoleum at Centcelles, near Tarragona, and in the 5th-century rotunda of St George and the apse mosaic of Hosios David in Thessalonike.

Solitary religious lifestyles and later more organised monasticism developed throughout the 4th and 5th centuries. From small cells to larger monasteries, the Egyptian desert and the Holy Land are littered with traces of monasticism: Sohag in Egypt, Qalat Sem'an near Antioch, and Alahan in Asia Minor. Religious controversy also was not slow to develop, influencing art and architecture.

Late Antique cities such as Ephesus, Sardis and Aphrodisias continued to flourish. Constantinople dominated the eastern part of the empire, though little beyond the imposing Theodosian land walls and the monastery of St. John Studion remains now. Antioch and Nicomedia were also political and cultural centers, (a significant array of mosaic pavements survive from Antioch), whilst Jerusalem and Alexandria were prominent religious capitals. In the West, Trier, Cologne and Milan all served as imperial residences, as did Ravenna, where Theodoric added several monuments to earlier 4th-century imperial buildings. Rome had gradually declined in political significance but remained a prominent religious center under the papacy; churches and catacombs survive from this period. In Milan, the bishopric of St. Ambrose, remains of five churches from the 4th century still exist; in Trier and Cologne, the original basilican churches have been incorporated into Romanesque cathedrals. Piazza Armerina in Sicily survives as an example of a 4th-century villa of a great

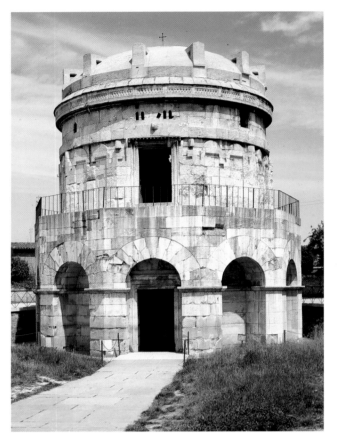

Left: The Mausoleum of Theodoric, *c.526, Ravenna, Italy.*

Theodoric the Great, King of the Ostrogoths, became the sole ruler of Italy in 493 and was the founder and ruler of the Ostrogothic kingdom of Italy until 526. This Germanic kingdom confirmed the downfall of the old Western Roman Empire, although the art of his capital, Ravenna, was firmly based on the Byzantine style already current in Italy. Theodoric's tomb is a two-storey circular structure of immense power, surmounted by a roof made of a single massive piece of stone.

landowner, with elaborate mosaic pavements. In Africa, lack of excavation makes it difficult to trace developments, but urban remains survive from Leptis Magna, and a church complex from Theveste. Carthage remained the largest and most important city.

Much surviving art from this period consists of so-called "minor arts": small, easily portable objects such as ivories, manuscripts and metalwork, whose provenance is unknown. The period is one in which there is no obviously recognizable set of artistic forms in distinctive combinations. There is no evolutionary curve in artistic development; instead, a variety of styles co-existed or erratically succeeded one another as Christian art sought to utilize Classical and Late Antique styles to its own ends, adapting pagan art forms for Christian purposes. Pagan ideas and motifs were taken over on a wide-ranging scale. The Arch of Constantine in Rome displays the co-existence of Classical and non-Classical aspects in one monument, while the obelisk of Theodosius (in what remains of the hippodrome in Constantinople) and the Madrid silver plate (Academia de la Historia, Madrid) reveal how contrasting styles could co-exist in separate but contemporary works. Fourth-century sarcophagi, such as that of Junius Bassus (Grotte Vaticane, Rome), display a purely Christian message in a different style from the frescoed classicizing ceilings from Trier; Projecta's casket (British Museum, London) combines pagan imagery and Christian message. The art of this period is not inferior, but different, serving a different purpose, perhaps more didactic, than that of the earlier periods from which it descends. Pagan characteristics are variously blended with new developments to create a Christian and imperial art.

Right: Ephesus, *general view from the* Theater *towards the harbor, Efes, Turkey.*

Ephesus was a Late Antique city which, like its neighbors Sardis and Aphrodisias, maintained its importance and wealth during the first centuries of the Christian Empire.

Far Right: Obelisk of Theodosius, *marble base, c.390, (At-Meidan, Istanbul).*

A key work of the late 4th century, showing, on the supporting base for an obelisk brought from Karnak, the Emperor Theodosius (379–95) and his family awarding the laurel wreath to the winner at the races.

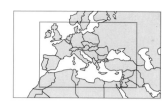

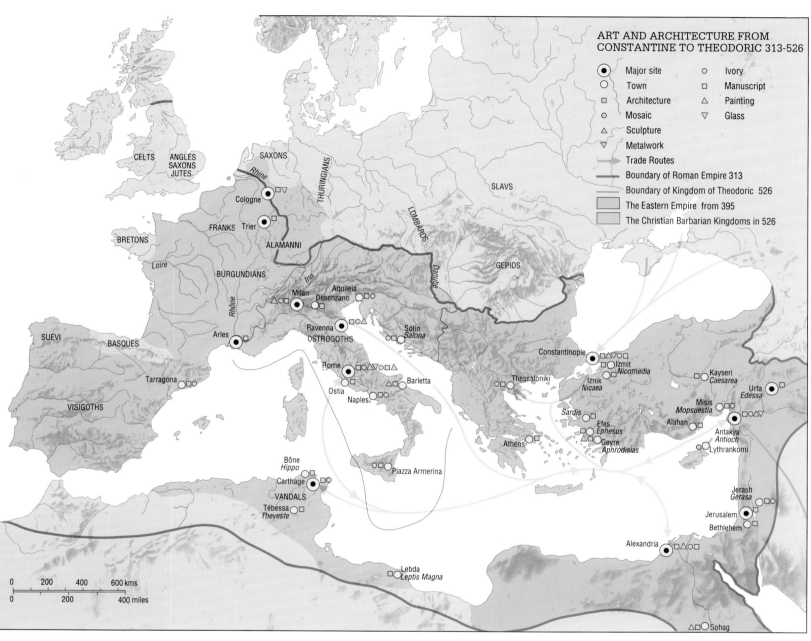

ART AND ARCHITECTURE FROM CONSTANTINE TO THEODORIC 313-526

● Major site
○ Ivory
○ Town
□ Manuscript
□ Architecture
△ Painting
○ Mosaic
▽ Glass
△ Sculpture
▽ Metalwork
→ Trade Routes
— Boundary of Roman Empire 313
— Boundary of Kingdom of Theodoric 526
The Eastern Empire from 395
The Christian Barbarian Kingdoms in 526

CELTS
ANGLES
SAXONS
JUTES
SAXONS
THURINGIANS
SLAVS
LOMBARDS
GEPIDS
Rhine
Cologne
FRANKS Trier
BRETONS
ALAMANNI
Loire
BURGUNDIANS
Inn
Danube
Rhône
Milan Aquileia
Desenzano
SUEVI
Ravenna Solin
BASQUES
Arles OSTROGOTHS Salona
Constantinople
Izmit
Nicomedia
Kayseri
Caesarea
Tarragona
Rome
Thessaloniki
Iznik
Nicaea
Urfa
Edessa
VISIGOTHS
Ostia Barletta
Sardis
Misis
Mopsuestia
Naples
Efes
Ephesus
Alahan
Antakya
Antioch
Athens
Geyre
Aphrodisias
Lythrankomi
Bône
Hippo
Piazza Armerina
Jerash
Gerasa
Carthage
VANDALS
Jerusalem
Tébessa
Theveste
Bethlehem
Alexandria
Lebda
Leptis Magna
Sohag

0 200 400 600 kms
0 200 400 miles

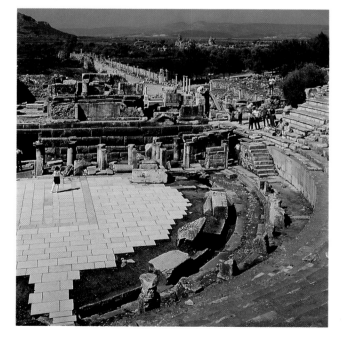

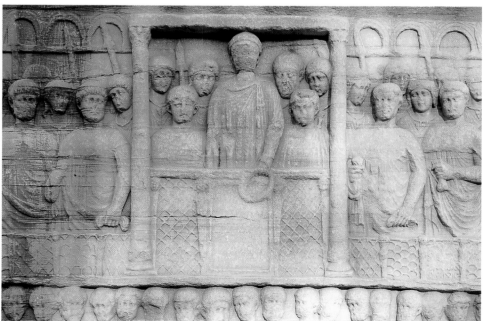

Christian Rome to 800

Following the adoption of Christianity as the official religion of the Roman Empire by Constantine in 312, secular building went into a gradual decline and patronage became centered on churches, most of which followed earlier Roman designs such as the basilica. Although Rome had ceased to be used regularly as an imperial residence, it nevertheless remained a major artistic center because of its prestige, the presence of wealthy senators and the burgeoning power of the papacy. The numerous Early Christian churches include funerary martyr-shrines, often located outside the city wall (such as S. Pietro, S. Lorenzo fuori le Mura and S. Paolo fuori le Mura), buildings which developed from the houses of worship of earlier private patrons (*tituli*, such as S. Clemente and S. Pudenziana) and major imperial foundations such as S. Costanza. By the 5th and early 6th centuries the popes themselves became increasingly important as patrons, and despite the sacking by the Visigoths and Vandals and Germanic rule after the fall of the Western Empire (476) high standards of architecture and decoration were maintained in churches such as S. Stefano Rotondo and S. Cosma e Damiano.

By the middle of the 6th century, however, Rome's wealth and population had shrunk dramatically as a result of the Gothic War (535–54), the eclipse of the Senate and the insecurity ushered in by the Lombard invasion (568). Although the most prominent classical buildings remained important landmarks, the reduced financial resources resulted in some being despoiled as sources of building materials. Others were converted into churches, such as the Pantheon, which, as the imperial property of the Byzantine Phocas, was given to Pope Boniface IV in 608, who reconsecrated it as a church dedicated to St. Mary and All Saints and Martyrs (S. Maria ad Martyres). Despite Rome's status as the capital of a duchy during the Byzantine period (*c.*536–727) and most popes being easterners *c.*650–750, the papacy exercised increasing control over the city from the pontificate of Gregory I (590–604) onwards. Artistic patronage was relatively small-scale and mostly confined to the small area of habitation along the banks of the Tiber beneath the Palatine Hill. However the official papal biographies of the *Liber Pontificalis* record important donations including textiles, icons and plate; and churches such as S. Maria Antiqua (a former imperial guard-house on the Forum) reflect eastern influences in their mosaics and frescoes. Ambulatory crypts were introduced to accommodate the growing number of relics and the pilgrims who visited them, churches were built as part of the charitable complexes known as *diaconiae*, and monasteries became numerous, particularly Greek foundations manned by refugees from the political and theological upheavals of the East.

In the wake of conflicts with the Byzantine empire over such issues as iconoclasm, the Popes strove from *c.*727 to set up an independent papal state in the city and surrounding area (*res publica Romana* or *S. Petri*). Following the forging of this new territory Byzantine influence remained evident, especially in the minor arts, but in art and architecture there was a reversion to Roman prototypes, such as the Constantinian basilicas. This was particularly marked during the period of close collaboration with the Franks, which commenced with the papally sanctioned anointing of Pepin III as king (751) and culminated with the coronation of his son Charles as Emperor in S. Pietro (Christmas Day 800).

Below left: Crucifixion, *fresco, late 8th century, S. Maria Antiqua, Rome.*

S. Maria Antiqua is the oldest Christian building in the Forum, *decorated with extensive frescoes reflecting oriental influence. Here the head of the crucified Christ is flanked by the sun and the moon, and the figures of St. John, the Virgin, Longinus with the lance and the soldier with the sponge.*

Below right: S. Sabina, *nave, 422-32, Rome.*

With the exception of S. Stefano Rotondo, most of the major Early Christian churches in Rome were basilican, rectangular in shape. S. Sabina, on the Aventine Hill, also incorporates in the nave very fine Corinthian columns and capitals.

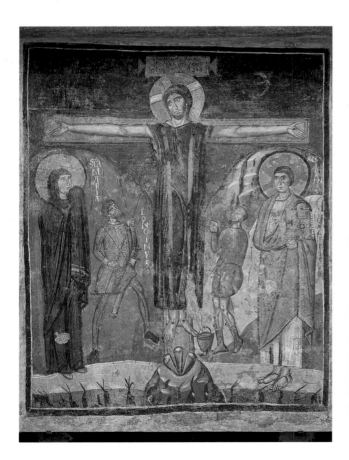

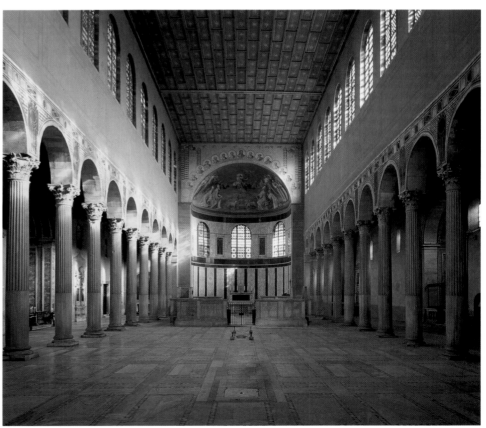

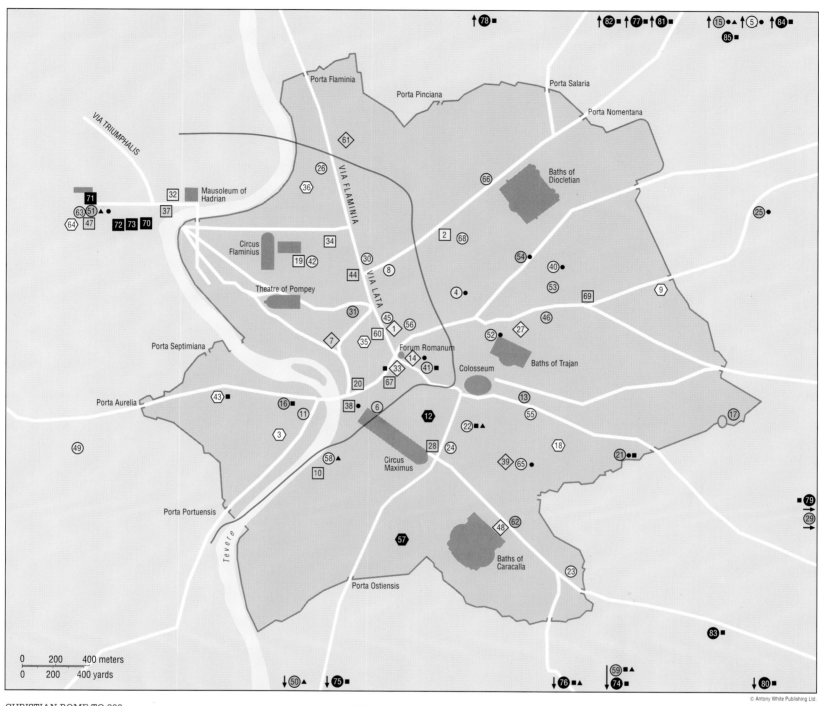

© Antony White Publishing Ltd.

CHRISTIAN ROME TO 800

Catacomb ●

Church ○

Church with diaconia ◇

Diaconia □

Greek monastery ⬟

Latin monastery ⬡

Schola (settlement for foreign pilgrims) ■

Mosaic •

Painting ▪

Sculpture ▲

Eastward limit of habitation in the Early Middle Ages

City wall

Period of architecture:

Classical building

4th century

4th–6th century

5th and early 6th century

Byzantine period c.536–727

Period of papal independence and Carolingian protectorate c.727–850

1 S.Adriano
2 S. Agata de Caballis
3 Ss. Agata e Cecilia
4 S. Agata dei Goti
5 S. Agnese fuori le Mura
6 S. Anastasia
7 S. Angelo in Pescheria
8 Ss. Apostoli
9 S. Bibiana
10 Ss. Bonifacio e Alessio
11 S. Cecilia in Trastevere

12 S. Cesareo
13 S. Clemente
14 Ss. Cosma e Damiano
15 S. Costanza
16 S. Crisogono
17 S. Croce in Gerusalemme
18 S. Erasmo
19 S. Eustachio
20 S. Giorgio in Velabro
21 Ss. Giovanni e Paolo
22 S. Giovanni in Laterano
23 S. Giovanni a Porta Latina
24 S. Gregorio Magno
25 S. Lorenzo fuori le Mura
26 S. Lorenzo in Lucina
27 S. Lucia in Selci
28 S. Lucia in Septem Via
29 Ss. Marcellino e Pietro
30 S. Marcello al Corso
31 S. Marco
32 S. Maria in Adriano
33 S. Maria Antiqua
34 S. Maria in Aquiro
35 S. Maria in Aracoeli
36 S. Maria in Campo Marzio

37 S. Maria in Caput Portici
38 S. Maria in Cosmedin
39 S. Maria in Domnica
40 S. Maria Maggiore
41 S. Maria Nova (S. Francesca Romana)
42 S. Maria Rotonda (S. Maria ad Martyres, Pantheon)
43 S. Maria in Trastevere
44 S. Maria in Via Lata
45 S. Martino
46 S. Martino ai Monti
47 S. Martino iuxta Beatum Petrum
48 Ss. Nereo e Achilleo
49 S. Pancrazio
50 S. Paolo fuori le Mura
51 S. Pietro
52 S. Pietro in Vincoli
53 S. Prassede
54 S. Pudenziana
55 Ss. Quattro Coronati
56 Ss. Quirico e Giulitta
57 S. Saba
58 S. Sabina
59 S. Sebastiano
60 Ss. Sergio e Baccho

61 S. Silvestro in Capite
62 S. Sisto
63 S. Stefano degli Abissini
64 S. Stefano Maggiore
65 S. Stefano Rotondo
66 S. Susanna
67 S. Teodoro
68 S. Vitale
69 S. Vito
70 Schola Saxonum
71 Schola Langobardorum
72 Schola Francorum
73 Schola Frisonum
74 Catacomba di S. Callisto
75 Catacomba di Comodilla
76 Catacomba di Domitilla
77 Catacomba dei Giordani
78 Catacomba di Panfilo
79 Catacomba di Pietro e Marcellino
80 Catacomba di Pretestato
81 Catacomba di Priscilla
82 Catacomba di Trasona
83 Catacomba di via Latina
84 Cimitero Maggiore
85 Villa Torlonia (Jewish)

Early Medieval Ravenna

In the Roman Empire, Ravenna was an important and cosmopolitan port-city with a large population of east-erners. Its cathedral was built by Bishop Ursus in the late 4th century, possibly replacing an earlier one in the har-bor suburb of Classe. Following the Emperor Honorius' transfer of the imperial capital there from Milan in 402, the status and walled area of the city increased dramat-ically and it became a major center of building activity and artistic patronage. Prominent buildings of the Late Roman period (402–76) include the basilica of S. Giovanni Evangelista, erected (424–34) by Galla Placidia (c.386–450), Queen of the Visigoths and, after 421, Roman Empress; the cruciform oratory wrongly known as the Mausoleum of Galla Placidia (she was almost certainly buried in the Theodosian family mau-soleum in St. Peter's Basilica, Rome, i.e., "Old St. Peter's"); and the Baptistery of the Orthodox, which was decorated with fine figural mosaics.

Building was continued under the Germanic king Odoacer (c.434–93) and his Ostrogothic successors (493–540), notably Theodoric (c.454–526), whose peaceful and prosperous reign lasted 33 years. The buildings associated with these Arian rulers are located in the German quarter in the eastern part of the city, and include the Baptistery of the Arians (Battistero degli Ariani), the Gothic Cathedral (S. Spirito), Theodoric's Palatine Chapel (redecorated with Orthodox mosaics c.550 and later renamed S. Apollinare Nuovo) and his Mausoleum in the form of a rotunda (later converted into a church with some ecclesiastical buildings nearby, including a monastery, S. Maria della Rotonda, demol-ished 1660).

Excavations early this century showed the Palace attributed to Theodoric to be an expanded remodeling of an earlier structure with rooms around a peristyle courtyard. Some Orthodox buildings were begun in this period under bishops such as Ecclesius, including the archiepiscopal palace and chapel, but the most distin-guished were completed only after the Byzantine conquest (540). Among these were churches partly financed by a famous banker of Byzantine origin, Julianus Argentarius. The church of S. Michele in Africisco no longer survives although the apse is partially preserved in Berlin; the church of S. Vitale was com-missioned in 526 by Bishop Ecclesius. Its octagonal plan is similar to the church of Ss. Sergius and Bacchus in Constantinople, and may have been inspired by Ecclesius' previous mission in that city. It is generally considered the work of an Italian architect, which features spectacular mosaics, including court scenes depicting portrait-like images of the Emperor Justinian and the Empress Theodora and the first prelate to receive the title of Archbishop of Ravenna, Maximian, who consecrated the church in 547–8. The church of S. Apollinare in Classe is a colonnaded basilica notable for its eastern marbles and its unusual apse mosaic of the Transfiguration. It was consecrated in 549 by Arch-bishop Maximian and dedicated to the first bishop of Ravenna. Maximian consecrated it only one year after that of S. Vitale, and its construction from the same type of bricks as that church indicates Argentarius' factory as the common source.

Artistic production declined sharply after the death of Justinian (565), largely as a result of the political and economic disruption caused by the Lombard invasions. Ravenna never again played a leading role in Italian cul-ture. One curious survival however is the so-called 'Palace of the Exarchs', probably identifiable with the façade of the narthex of the church of S. Salvatore 'ad Chalci' and datable to the late 7th or 8th century. Oth-erwise the later Byzantine period is notable only for a few sculptures (especially on re-used sarcophagi) and for mosaics in the apse of S. Apollinare in Classe com-memorating the granting of fiscal immunities in favor of the clergy to Archbishop Reparatus (671–77) by the Emperor Constantine IV (668–85). Again, the close rela-tionship with S. Vitale is illustrated, this time in the mosaic decoration, which shows Constantine dressed in the same clothes as the Emperor Justinian in S. Vitale, thus creating a visually resonant symbolic lineage.

Left: The Court of Justinian, c.540–8, S. Vitale, Ravenna.

S. Vitale was a centrally planned church commissioned when Ravenna was the Ostrogothic capital of Italy, but mainly built and redecorated after the reconquest of Italy by the Emperor Justinian for Constantinople. Here the Emperor is shown with members of his court and with Archbishop Maximian of Ravenna. The whole plan of the church and its decoration was intended to emphasize the re-establishment of imperial power in Italy.

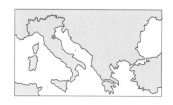

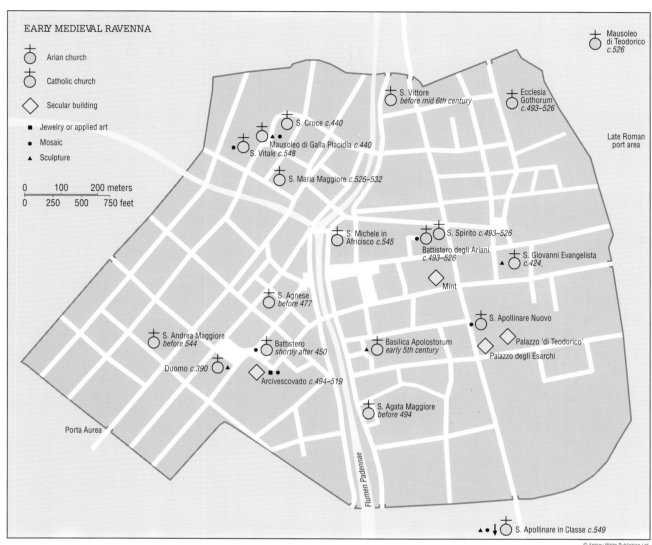

EARLY MEDIEVAL RAVENNA

✠⚲ Arian church

✠⚲ Catholic church

◇ Secular building

■ Jewelry or applied art

● Mosaic

▲ Sculpture

0 100 200 meters
0 250 500 750 feet

Mausoleo di Teodorico c.526

S. Vittore before mid 6th century

Ecclesia Gothorum c.493–526

Late Roman port area

S. Croce c.440

Mausoleo di Galla Placidia c.440

S. Vitale c.548

S. Maria Maggiore c.526–532

S. Michele in Africisco c.545

S. Spirito c.493–526

Battistero degli Ariani c.493–526

S. Giovanni Evangelista c.424.

Mint

S. Agnese before 477

S. Apollinare Nuovo

S. Andrea Maggiore before 544

Battistero shortly after 450

Basilica Apolostorum early 5th century

Palazzo 'di Teodorico'

Palazzo degli Esarchi

Duomo c.390

Arcivescovado c.494–519

S. Agata Maggiore before 494

Porta Aurea

Flumen Padennae

▲●↓✠⚲ S. Apollinare in Classe c.549

© Antony White Publishing Ltd.

Below left: S. Apollinare Nuovo, *late 5th century, mosaics early 6th century, Ravenna.*

A single-aisled basilican church, with extensive mosaics in the nave. Here a procession of saints and the three kings (in contemporary costume) lead up to the Virgin and Child enthroned.

Below right: The Mausoleum of Galla Placidia, *c.425-50, Ravenna.*

The redoubtable Galla Placidia, daughter of Theodosius the Great, hostage of Alaric the Goth, was the mother and regent of Valentinian III. She is supposed, probably incorrectly, to be buried in Ravenna in a tomb richly decorated with Byzantine mosaic.

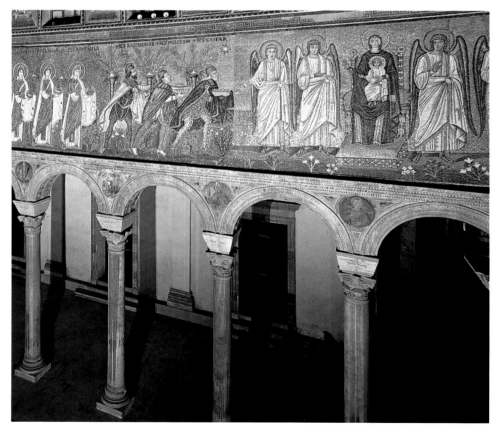

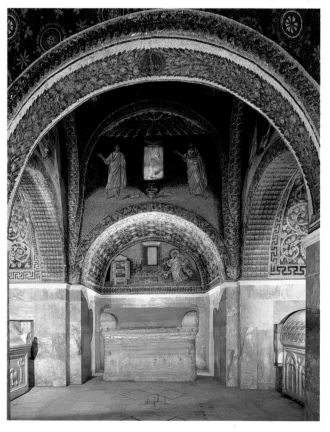

Constantinople 300–1453

In 324 the Christian Emperor Constantine I (306-37) moved his capital to Byzantium, situated on a promontory flanked by the Bosphorus, the Golden Horn and the Sea of Marmara. New fortification of the city (renamed Constantinopolis) included a land wall (lost) and sea walls of which fragments remain. In the mid-5th century Theodosius II built the existing land wall, which houses the Golden Gate used for triumphal entrances. The civic center was to the east, around the Imperial Palace, which was used throughout the Byzantine period with many stages of modification and rebuilding. Parts of the mosaic floor of the palace and the substructures of the Hippodrome are all that remain here, and monumental columns of Constantine, Arcadius (395–408) and Marcian (450–7) mark some of the public squares on roads to gates in the land wall. To the west was an area of monasteries and cemeteries, including the important mid-5th-century Monastery of John Studion. The ruined church here is a basilica, a standard form for early Byzantine churches; it was decorated, like most important churches throughout the Byzantine period, with marble panelling, carved capitals and cornices. Just inside Constantine's wall, the Church of the Holy Apostles (destroyed) served as the imperial mausoleum until the 11th century. Also in the west were some of the great cisterns needed by a city with no fresh-water supply within its walls – the Aqueduct of Valens is a remnant of an elaborate hydraulic system.

In the 6th century the Emperor Justinian I (527–65) was responsible for extensive building throughout the empire. Of his commissions in the capital there remain SS. Sergius and Bacchus (c.524) and the great patriarchal church of Hagia Sophia (537), which replaced an earlier church on the site. Carved white marble from quarries on the Sea of Marmara forms an important element in the decoration of both churches, and also that of St. Polyeuktos, built c.524 for the aristocrat Anicia Juliana, of which only foundations remain. All these churches are (or were) domed, signalling the beginning of a permanent change in Byzantine church architecture from the traditional roofed basilica. In these and many later churches of the city, mosaic decoration of the vaulting was for the most part lost when the churches were turned into mosques after the Ottoman conquest of 1453. S. Sophia however preserves areas of the 6th-century program, and of mosaics added from the 9th to the 13th centuries.

The empire declined during the 7th/8th-century "Dark Age" when much of Anatolia was lost to the Arabs. St. Eirene, rebuilt after 740, is one of the last churches built on the grand scale; its apse contains a mosaic cross, set up during the period of Iconoclasm (726–842) in deference to an imperial ban on the use of figural images in religious art. There was territorial recovery in the 9th century, but social upheaval had brought permanent changes in material culture. Most middle-Byzantine commissions of aristocratic patrons were for family monasteries with small domed churches. These include the Monastery of Constantine Lips (c.907), the Myrelaion of Romanus I Lecapenus (920–2), St. John in Trullo (10th century) and Christ Pantepoptes (c.1087). On a slightly larger scale are Gül Camii and the churches of the Pantocrator Monastery (1118–36). The latter, built by John II Comnenus, served as an imperial mausoleum and had a large hospital attached to it. From the 11th century onwards imperial families resided in the Blachernae Palace on the land wall, making its district a fashionable residential area.

Increasing numbers of Italian and Frankish traders settled in Galata and on both sides of the Golden Horn in the 11th and 12th centuries, a circumstance which facilitated the occupation of the capital by the Fourth Crusade in 1204 and sent the Byzantine ruling class into exile. Among remnants of the Latin presence is the earliest surviving cycle of the life of St. Francis of Assisi, painted in the church now known only as Kalenderhane Camii.

The recovery of the city in 1261 by Michael VIII Palaeologus initiated the final phase of its Byzantine existence. Aristocratic families restored old monasteries in the derelict city, such as those of Constantine Lips, St. Andrew in Krisei, Vefa Kilise Camii, the Theotokos Pammakaristos (Fetiye Camii) and the Chora Monastery (Kariye Camii) completed by 1321 for the Grand Logothete Theodore Metochites. The last two retain high-quality painting, mosaic and architectural sculpture. A palace known as Tekfur Sarayi, on the land wall, is a rare survival of secular architecture of the period. By the 15th century, however, the empire was no more than the city itself, which fell in 1453 to Mehmet the Conqueror.

Left: *Anthemios of Tralles and Isidore of Miletus,* Hagia Sophia *(Church of Holy Wisdom), interior, 532–7, Constantinople.*

Working on the orders of the Emperor Justinian, the architects produced the solution to the cross-in-square church design with a central dome. It became an inspiration for all eastern Christian church building.

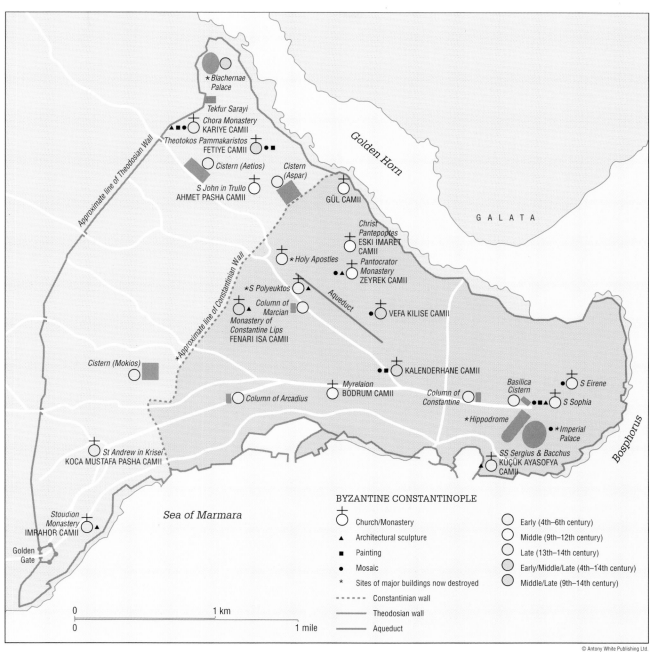

BYZANTINE CONSTANTINOPLE

- ☦ Church/Monastery
- ▲ Architectural sculpture
- ■ Painting
- ● Mosaic
- ★ Sites of major buildings now destroyed

- ◯ Early (4th–6th century)
- ◯ Middle (9th–12th century)
- ◯ Late (13th–14th century)
- ◯ Early/Middle/Late (4th–14th century)
- ◯ Middle/Late (9th–14th century)

····· Constantinian wall
——— Theodosian wall
——— Aqueduct

0 ———— 1 km
0 ———— 1 mile

© Antony White Publishing Ltd.

Map labels: ★*Blachernae Palace*; *Tekfur Sarayi*; *Chora Monastery* KARIYE CAMII; *Theotokos Pammakaristos* FETIYE CAMII; *Cistern (Aetios)*; *Cistern (Aspar)*; *S John in Trullo* AHMET PASHA CAMII; GÜL CAMII; GALATA; *Golden Horn*; *Christ Pantepoptes* ESKI IMARET CAMII; ★*Holy Apostles*; *Pantocrator Monastery* ZEYREK CAMII; ★*S Polyeuktos*; *Aqueduct*; *Column of Marcian*; VEFA KILISE CAMII; *Monastery of Constantine Lips* FENARI ISA CAMII; *Cistern (Mokios)*; KALENDERHANE CAMII; *Myrelaion* BODRUM CAMII; *Column of Arcadius*; *Column of Constantine*; *Basilica Cistern*; ☦*S Eirene*; *S Sophia*; ★*Hippodrome*; ★*Imperial Palace*; *Bosphorus*; *St Andrew in Krisei* KOCA MUSTAFA PASHA CAMII; SS *Sergius & Bacchus* KUÇÜK AYASOFYA CAMII; *Sea of Marmara*; *Stoudion Monastery* IMRAHOR CAMII; *Golden Gate*; *Approximate line of Theodosian Wall*; *Approximate line of Constantinian Wall*

Right: The Land Walls of Constantinople, *mid-5th century.*

Built of bands of brick and ashlar, the main Theodosian walls had 96 towers, an outer protecting wall with further towers, and a moat. They were technologically far in advance of the walls of Rome.

Byzantine Art and Architecture in Greece and Asia Minor

In the early 4th century Constantine I gave official sanction to Christianity and established a new capital in Byzantium which was renamed Constantinopolis (now Istanbul). Thus the Roman Empire became the Byzantine Empire, and Byzantine architecture is found all around the Mediterranean. In addition to Constantinople, there were important provincial centers, such as Thessaloniki, Nicaea, Caesarea and the patriarchal sees of Antioch and Alexandria. Monasticism, which began in Egypt in the 4th century and spread quickly into Palestine and Anatolia, gave rise to many venerated sites that attracted the building commissions of pious patrons. Most sites have (or had) timber-roofed basilicas, a standard form for the early Christian church.

The regions developed their own artistic traditions, but imperial commissions fueled interaction between capital and provinces. For example, Constantine I built churches at the Holy Places in Palestine. Networks of both political and ecclesiastical administration made possible the movement of artistic and architectural styles, craftsmen and sometimes materials. Marble from the quarries of Proconnesos on the Sea of Marmara, for instance, often in the form of finished architectural sculpture, was shipped to a multitude of locations, taking Constantinopolitan tradition eastwards. Conversely, the influence of the East, including Persia and even the Far East, found its way back to the capital.

In the 6th century, in the reign of Justinian (527–65), the building of domed churches in Constantinople signalled a change in ecclesiastical architecture, with the patriarchal church of Hagia Sophia as its most important example. Justinian's buildings extend throughout the empire – as far as Mount Sinai in Egypt – but he was the last emperor with the resources for such enterprise. Arab incursions into the eastern Mediterranean and Anatolia in the Dark Age of the 7th and 8th centuries overturned the old Roman order and considerably reduced the extent of Byzantine territory. The few remains from this time include scattered examples of domed churches in western Anatolia and Greece. The period ended with over a century of Iconoclasm (726–842), during which the use of human images in religion was prohibited by imperial decree. The ban was not uniformly obeyed and did not obliterate religious art, but there is evidence of image-destruction in a few buildings of Constantinople, Nicaea and Thessaloniki.

By the mid-9th century most of Anatolia had been recovered by the campaigns of a series of soldier-emperors. Monasticism became an increasingly important aspect of Byzantine social as well as religious life and produced many of the domed churches that now predominated in ecclesiastical architecture. Monastic centers grew up in areas such as Patmos, Olympus and Mount Athos. Middle-Byzantine churches were usually much smaller than the earlier basilicas and had ornate exteriors created with the brick and stone of their fabric. The survival rate of these buildings is poor and the few examples remaining in Anatolia must represent a great many more that are now lost. Most are ruins that have lost their interior decoration, but a large number of rock-cut churches of Cappadocia, in the Ürgüp/Belisirma region, retain their 9th to 12th-century painting.

Constantinople was looted by the Fourth Crusade in 1204 and was occupied for over half a century by the Latins. Byzantine art and architecture of the 13th century is therefore found chiefly in Arta, Thessaloniki, Trebizond and Nicaea, the areas to which the exiled Byzantine aristocracy fled. The capital was recovered in 1261, and Byzantine control was re-established in Greece, where towns such as Athens and Corinth became prosperous trading centers.

A Byzantine governor ruled from Mistra, which retains several Byzantine churches and a palace complex. By now, however, the Ottoman Turks had established a base in Bursa and by the mid-15th century had surrounded Constantinople, which fell in 1453. The Byzantine Empire came to an end but its cultural influence did not, for Hagia Sophia was the inspiration for a series of Ottoman imperial mosques and thus had a lasting effect on Islamic architecture.

Above: *Remains of the* Pillar of St Simeon Stylites, *5th century, Church of Qalat Siman, Syria.*

St Simeon Stylites (c.390–459) passed most of his life on top of a column, a man of piety and influence. His pillar became a center of pilgrimage, surrounded by an octagon with three-aisled exedrae.

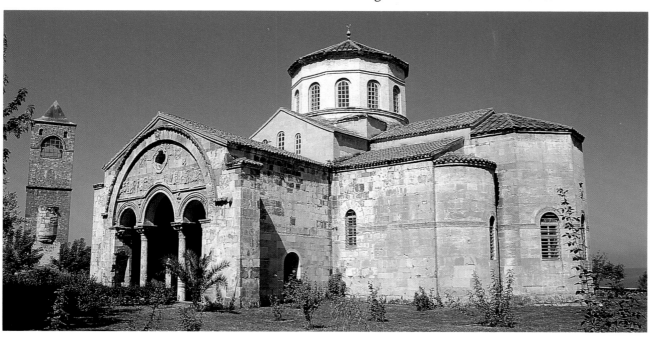

Left: Hagia Sophia, *13th century, Trebizond.*

A Black Sea port and state near Armenia, Trebizond was one of the centers of Byzantine art after the capture of Constantinople by the Fourth Crusade in 1204.

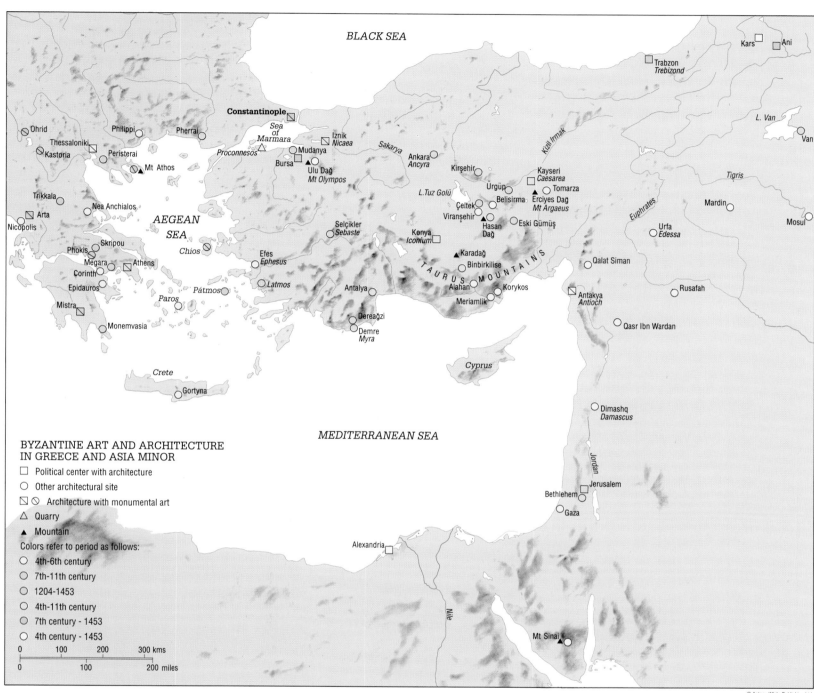

BLACK SEA

Kars
Ani

Trabzon
Trebizond

Constantinople

Ohrid
Philippi
Pherrai
Sea of Marmara
Iznik *Nicaea*
Sakarya
Kizil Irmak
L. Van
Van

Thessaloniki
Peristerai
Proconnesos
Mudanya
Bursa
Ankara *Ancyra*
Kirşehir
Kayseri *Caesarea*
Tigris

Kastoria
Mt Athos
Ulu Dağ *Mt Olympos*
Tomarza

Trikkala
Nea Anchialos
L.Tuz Golü
Ürgüp
Belisirma
Erciyes Dağ *Mt Argaeus*
Mardin

Arta
AEGEAN SEA
Çeltek
Hasan Dağ
Eski Gümüş
Urfa *Edessa*
Mosul

Nicopolis
Viranşehir

Skripou
Chios
Selçikler *Sebaste*
Konya *Iconium*
Karadağ
Qalat Siman
Rusafah

Phokis
Megara
Athens
Efes *Ephesus*
Binbirkilise
TAURUS MOUNTAINS

Corinth
Epidauros
Latmos
Alahan
Korykos
Antakya *Antioch*

Mistra
Paros
Pátmos
Antalya
Meriamlik
Qasr Ibn Wardan

Monemvasia
Dereağzi
Euphrates
Cyprus

Demre *Myra*

Crete
Gortyna

MEDITERRANEAN SEA
Dimashq *Damascus*

BYZANTINE ART AND ARCHITECTURE IN GREECE AND ASIA MINOR

□ Political center with architecture

○ Other architectural site

⬙ ⬗ Architecture with monumental art

△ Quarry

▲ Mountain

Colors refer to period as follows:

○ 4th-6th century

○ 7th-11th century

○ 1204-1453

○ 4th-11th century

○ 7th century - 1453

○ 4th century - 1453

Jordan
Jerusalem
Bethlehem
Gaza

Alexandria

Nile

Mt Sinai

| 0 | 100 | 200 | 300 kms |
| 0 | 100 | 200 miles |

© Antony White Publishing Ltd.

Right: *The church of* Qalat Siman, *5th century Syria.*

The basilica and building complex surrounding the pillar of St Simeon Stylites. An example of early Byzantine architecture in the uplands of Syria, its design is based on a mixture of Roman basilican layout and Byzantine central planning.

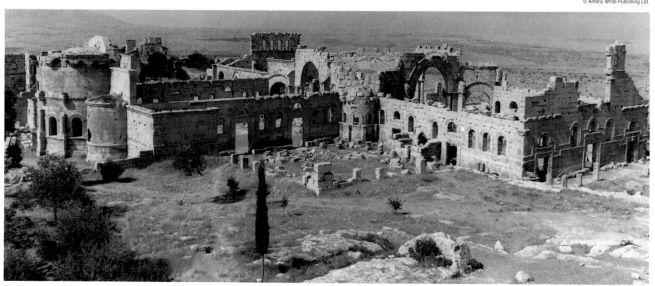

Byzantine Art and Architecture: the Slavs

In the 9th century the Byzantine empire sought to contain the threat of invasion by the barbarian tribes on its northern borders by bringing them into the fold of Orthodox Christianity. Missionaries Cyril and Methodius took Christianity northwards into the Balkans and Russia, spreading the Gospel and creating Cyrillic script so that it could be written in the Slav languages. Byzantine church art and architecture was absorbed along with the faith and the Byzantine Empire became a cultural model to which the northern nations aspired. Attempts on Byzantine territory continued, but cultural ties remained close because the ensuing conflicts were often settled by diplomacy, which included marriages between ruling Byzantines and Slavs. Further, while the Slav states were politically independent, they acknowledged the Patriarch of Constantinople as head of the Church.

By the 12th century Bulgar independence was established, with a new capital at Tirnovo. Paintings c.1259 in Byzantine style are found in the tomb chapel of Prince Kaloyan in Bojana, and 14th-century churches in Nessebar have features in common with the last phase of Byzantine architecture.

Russia formally entered Christendom in about 988, with the conversion of Vladimir of Kiev. There followed a virtual transplant of Byzantine art and architecture as Byzantine craftsmen travelled to Kiev to build and decorate churches. The church of Hagia Sophia in Kiev (completed c.1043) has much of its mosaic and painting intact. Byzantine artists continued to work at Russian sites until the early 12th century, and were responsible for the training of local craftsmen.

Russian art and architecture subsequently had its own development, but continued to absorb new Byzantine influences which came with contacts through trade, diplomacy and, above all, the Orthodox church. An icon of the Virgin, for example, brought from Constantinople in the mid-12th century, became one of the most sacred objects of the principality of Vladimir. As late as the end of the 14th century one of the most famous painters of Novgorod was Theophanes the Greek, who had worked in Constantinople before moving to Russia.

The Serbian nation emerged in the 12th century under the chieftain Stephen Nemanja (1169–96). He and his successors had no fixed capital, but the monasteries they founded, following Byzantine custom, became important centers. Architecturally the early Serbian churches were hybrids of Byzantine and Romanesque traditions, but their painted decoration followed Byzantine models closely, and was in many cases by Byzantine artists. The availability of such craftsmen would have increased after 1204, when the sack of Constantinople and the exile of the Byzantine patron class must have caused many artists of the capital to look for work elsewhere. Paintings in the mausoleum church at Mileševa, where Nemanja's son, Sava, was buried, are signed by artists with Greek names, and the decoration of the monastery at Sopocani founded in 1256 by Nemanja's grandson, Uros I, includes portraits of the Nemanjid dynasty which depend upon Byzantine imperial iconography.

Cultural ties with Byzantium were strengthened still further when Milutin (son of Uros I) married Simonis, daughter of the Byzantine emperor Andronikos II. The architecture of Milutin's monastery at Gračanica (1321) is closely related to contemporary developments in Constantinople and Thessaloniki. At St. Clement in Ohrid (1295), Čučer (c.1310) and Staro Narogičino (1317), work was done by painters named Michael and Eutychios, who may have come from Thessaloniki. Similar patterns of Byzantine influence are found in Peč, to which the Serbian archiepiscopate moved in the mid-13th century, the monastery of Dečani (1328), Psača (1366), Ravanica (c.1378) and Kalenič (1413–17).

The main source of Byzantine artists from the late 13th century was probably Thessaloniki rather than Constantinople, since the capital in this period was still recovering from the Latin occupation of 1204–61. There was probably more work for Byzantine artists in the Balkans than in the declining empire, and it is not impossible that some of the stylistic developments of late Byzantine painting had their origin in the Serbian commissions.

Below left: The Virgin *and other wall-paintings* c.1295, *apse and choir, church of the Peribletos (St. Clement), Ohrid, Macedonia.*

A prime example of metropolitan style from Constantinople used in a decorative scheme in a church in the Balkans.

Below: The Monastery Church of St. John the Baptist, c.*1321 Gračanica, north of Skopje, Macedonia.*

The Byzantine plan of the cross-in-square church, originated at Hagia Sophia in Constantinople, here reaches its ultimate form in 14th-century Serbia.

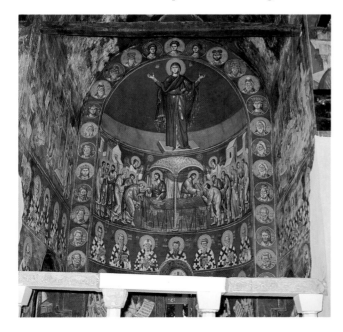

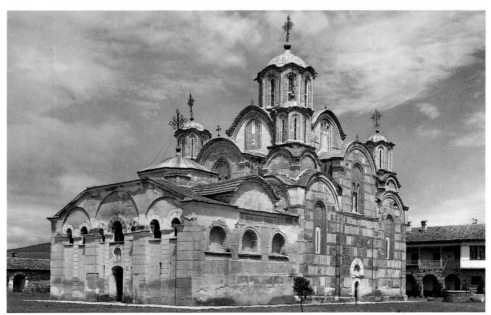

BYZANTINE ART AND ARCHITECTURE AND THE SLAVS

- ☐ Political center with architecture
- ○ Other architectural site
- ◩ ⦸ Architecture with monumental art

Colors refer to period as follows:
- ○ 9th - 12th century
- ○ 9th - 14th century
- ○ 13th - 14th century

| 0 | 100 | 200 | 300 kms |
| 0 | | 100 | 200 miles |

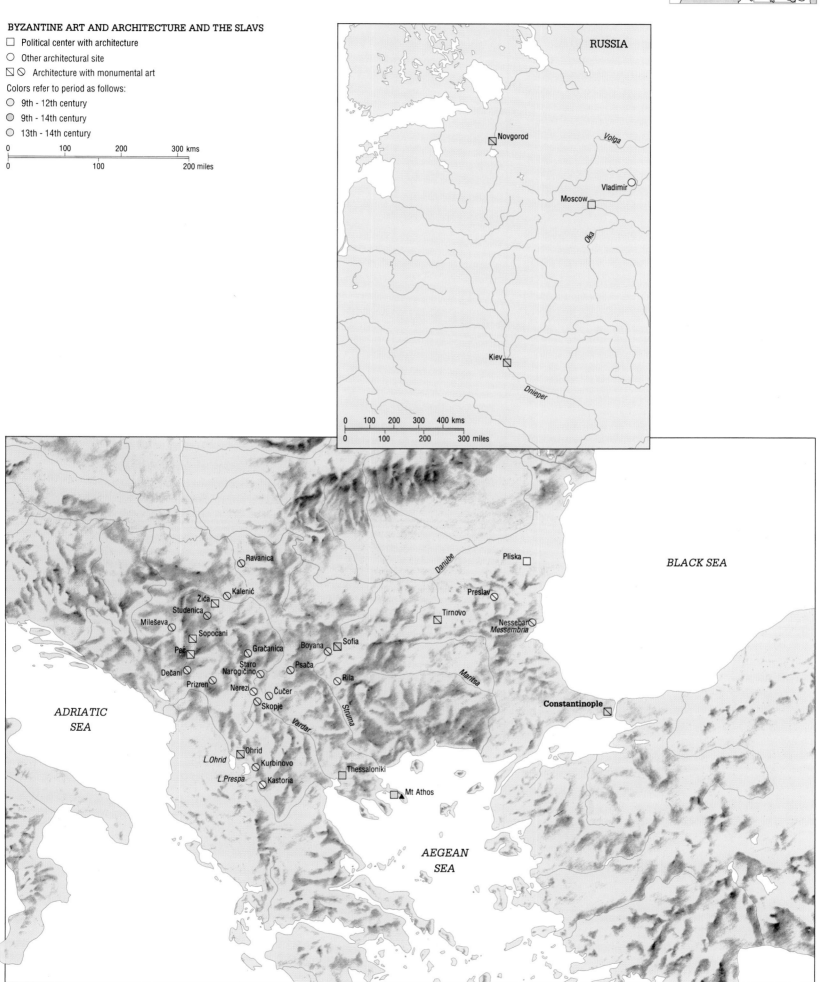

RUSSIA

Novgorod

Volga

Vladimir

Moscow

Oka

Kiev

Dnieper

| 0 | 100 | 200 | 300 | 400 kms |
| 0 | | 100 | 200 | 300 miles |

BLACK SEA

Pliska

Ravanica

Preslav

Kalenić

Tirnovo

Žiča

Nessebar
Messembria

Studenica

Mileševa

Sopoćani

Gračanica

Boyana

Sofia

Peć

Staro
Narogičino

Psača

Dečani

Prizren

Nerezi

Rila

Čučer

Skopje

Vardar

Struma

Maritsa

Constantinople

*ADRIATIC
SEA*

Ohrid

L.Ohrid

Kurbinovo

L.Prespa

Kastoria

Thessaloniki

Mt Athos

*AEGEAN
SEA*

Danube

© Antony White Publishing Ltd.

79

Byzantine Art and Architecture and its Influence on the West

From 330 to its fall in 1453, Constantinople was for much of the time the most prosperous and culturally active city in Europe, looked on with wonder and envy by westerners, who found in its monuments and the work of its craftsmen standards of excellence and opulence for the West to follow.

When the Goths entered Ravenna (493), the capital of the empire in the West, their king Theodoric had already spent ten years in Constantinople, and several aspects of the buildings constructed during his reign (e.g. S. Apollinare Nuovo) reveal eastern influence. When Justinian re-established Byzantine authority in 6th-century Ravenna, fascination with the form, methods of construction and mosaic decoration of Byzantine buildings increased, as with the Church of S. Vitale (c.530–c.550). Byzantine influence is also apparent in sculpture of this period, like the ivory chair of Archbishop Maximian (c.550; Museo dell'Arcivescovado, Ravenna).

Between the Justinianic period and the early 8th century, Christian Rome retained close relations with Byzantium. Where remains of papal projects survive, there are often indications of contributions by Greek-trained artists, such as the paintings created under John VII (705–7) in S. Maria Antiqua. There is a rare instance in provincial Italy of distinguished wall-painting by Greek artists at Castelseprio (probably c.700).

Charlemagne's re-creation of a western empire, following a prolonged suspension in contacts between Gaul and Constantinople, encouraged a renewed appreciation of Byzantine art. The chapel forming part of Charlemagne's palace complex at Aachen (begun 792) was clearly inspired by S. Vitale in Ravenna. The oratory and mosaics at Germigny-des-Prés (consecrated 806), built for a court adviser, were also inspired by Byzantine practice. In Carolingian illumination, the use of Byzantine models, though often misunderstood, was common. The painters of Charlemagne's *Coronation Gospels* (c.800; Schatzkammer, Vienna) may themselves have been Greeks. Imitating late antique painterly conventions, their style gave rise to strongly classicizing tendencies in illumination, which reached many western centers in the 9th century, including Reims and Tours.

Trading contacts between Scandinavia and Constantinople (through Russia) began by the early 9th century. Byzantine objects have been found in Viking sites like Lund and Hedeby, and Scandinavian coin types showing Byzantine influence may be traced from about 1045, when Harald Hardrada returned from Byzantium to become ruler of Norway. From the 11th century, Christian art in Russia shows close adherence to Byzantine models. Documentary evidence indicates that by the 14th century many Greek painters were working in Russian cities, including Moscow and Novgorod. The most celebrated was Theophanes (fl.c.1370–c.1411), who collaborated with the best-known early Russian painter, Andrei Rublev (c.1360–c.1430).

The close relationship between the imperial courts may be illustrated by the marriage in 972 of Otto II to a Byzantine princess, Theophano; both are represented on an ivory panel in Byzantine style (c.982; Musée de Cluny, Paris) which once decorated a western book-

cover. The practice of re-using precious Byzantine objects in western contexts became well established after this date; one example is an 11th-century Byzantine liturgical pattern converted into a reliquary in the 13th century (Cathedral Treasury, Halberstadt). Byzantine textiles were sometimes placed in important western tombs during this period. The Emperor Otto III, for example, introduced a 10th-century Byzantine silk with an elephant design into Charlemagne's tomb (Cathedral Treasury, Aachen) in 1000.

In the 11th century, southern Italy renewed contacts with Byzantium. Several cathedrals (e.g. Amalfi) commissioned bronze doors in Consantinople. Abbot Desiderius (d.1088) summoned Greeks, including mosaic workers and masons, to work at Montecassino and to train local craftsmen. Through links with the important monastery at Cluny, their influence possibly helped shape the character of much western art in the 12th century. Greek craftsmen were even called to work in Islamic Spain, as at Córdoba. In Sicily, the Norman kings had themselves portrayed like Byzantine emperors, summoning Greeks to execute mosaics at Palermo, Cefalù (c.1148) and Monreale (before 1183). Crusading activities helped to make this Siculo-Byzantine tradition known elsewhere. Its influence is evident, for instance, in the Winchester Bible (Cathedral Library), by an illuminator who probably executed paintings at Sigena (c.1200; now Museo de Arte de Cataluña, Barcelona). Painted Catalan altar-frontals of the 13th century (e.g. from Avía) continued this Byzantine trend.

Venice was another Byzantine center in Italy. Architecturally S. Marco (begun c.1063), which imitates the Apostoleion at Constantinople, proved influential at Périgueux (Saint-Front, after 1120) and Padua (S. Antonio, 1231). S. Marco's 12th- and 13th-century mosaics, though not slavish imitations of Byzantine models, were executed with understanding of contemporary fashions in Constantinople. Their style, perhaps transmitted through sketch-books (e.g. Herzog August Bibliothek, Wolfenbüttel), influenced painting in the German Empire, especially in Lower Saxony and Salzburg. Venice also supported the Western occupation of Constantinople (1204–61), resulting in significant Byzantine treasures reaching the west, such as the magnificent classical bronze horses, now decorating the façade of S. Marco. In France, the arrival of Byzantine ivories and relics in the 13th century helped stimulate developments in Gothic architecture, sculpture and stained glass, as at the Sainte-Chapelle in Paris (c.1242–8). The walls of Constantinople (408–50) even inspired the masonry of Caernarfon Castle in Wales (begun c.1283).

Because of the occupation, some painters left Constantinople to work in Serbia (e.g. at Studenica, 1209). Their technique and pictorial emotionalism contributed to developments in Tuscany and Rome, where renewed interest in mosaic decoration probably attracted Greek artists. Duccio's (c.1255–c.1318) *Maestà* (c.1308–11; Museo dell'Opera del Duomo, Siena) shows that a new generation of Byzantine sources had an important role to play in 14th-century Tuscan painting.

Above: The Palatine Chapel, *Aachen Cathedral, 792–805, Aachen (Aix-la-chapelle).*

Charlemagne's palace chapel modelled on S Vitale in Ravenna.

Above: *Duccio di Buoninsegna* (act. *1278–1318/9):* The Apparition of Christ through a Closed Door, *panel from the back of the Maestà for the High Altar of Siena Cathedral,* c.*1308–11 (Museo dell'Opera del Duomo, Siena).*

Siena's most famous Trecento painting, strongly Byzantine in detail and design.

THE INFLUENCE OF
BYZANTINE ART IN THE WEST

■ Architecture
▲ Sculpture
● Stained glass
■ Painting
▲ Applied arts
▼ Manuscript
● Mosaic
▼ Textile
✳ Site now destroyed
→ Major stylistic influences

0 200 400 600 800 kms
0 200 400 600 miles

ATLANTIC
OCEAN

NORTH
SEA

BALTIC
SEA

Novgorod

late 12th century

Vladimir
Moscow
Garde

Mammen
Lund
Maalov

Hedeby

Caernarfon

St Albans
Winchester
Canterbury

12th century

Brunswick
Paderborn
Goslar
Halberstadt

Cologne
Stavelot
Aachen
Trier
Bamberg

St Denis
Reims
Paris
Germigny-
des-Prés
Sens
Strasbourg
Tours
Cluny
Berzé-la-Ville
Hohenbourg
Regensburg
Augsburg
Rhine

Prague

14th century

Salzburg

Klosterneuburg
Esztergom

Kiev

Vistula

Oder

Elbe

Périgueux
Lyons
Milan
Le Puy
Rhône
Po
Castelseprio

Torcello
Poreč
6th century
Padua
Venice
Bologna
11th-14th
century
Pisa
Ravenna
6th
century
Siena
13th century
13th-14th century
Rome
Montecassino
Sant'Angelo
in Formis
Salerno
Amalfi
Atrani
11th century

Danube

Milesevo
Studentiča
Sopoćani
Nerezi
Ohrid
Kurbinovo
Mt Athos

13th
century

11th-12th century

BLACK SEA

11th-12th century

11th-12th century

Constantinople

11th-15th century

Artaiz
Oreilla
Artajona
Sigena
Avía
Lluça

Douro
Ebro
Tagus

Córdoba

late 12th century

7th-13th century

11th century

12th
century

Rossano

Messina

Monreale
Cefalù
Palermo

Mistra

Dnieper

Antioch

Asinou
Paphos
Lagoudera

10th-12th century

Acre

12th-13th century

Jerusalem

Mt Sinai

MEDITERRANEAN SEA

© Antony White Publishing Ltd.

81

Art and Architecture in the West
600–1024

The Roman Empire had included much of Western Europe until the 5th century. Rome had become the center of the Western church but remained a powerful symbol of empire. Early medieval Europe was politically fluid and culturally diverse. By 600 the mostly Germanic invaders of the empire had settled as ruling elites, establishing kingdoms and adopting Christianity. The religious art and architecture of these kingdoms drew on Late Antique Christian traditions and often the settlers' taste for bright color and abstract design. The principal kingdoms were those of the Franks under the Merovingian kings (running from modern France to the western part of Germany), the Visigoths in Spain, the Lombards in Italy and the Anglo-Saxons. Anglo-Saxon expansion in Britain probably stimulated the settlement of British émigrés in Brittany, a continental outpost of Celtic culture. The work of conversion in the north led to some fruitful cultural contacts: the Roman mission of 597 to England; northern pilgrims in Rome; Irish and Anglo-Saxon ecclesiastical foundations on the continent (7th–9th centuries).

The Arab invasion of Spain in 711 quickly brought an end to the Visigothic kingdom and for a time threatened the southern half of France. (The traditions of the Visigothic kingdom were to some extent preserved by the Asturias in northern Spain, for example in 10th- and 11th-century monuments in Oviedo, Naranco and Lena.) The Arab conquest of Sicily took place between 827 and 902 and like Spain it became an important center of Islamic culture. The Byzantine Empire retained territory in southern Italy and Byzantine influence was strong in Rome itself under Greek and Syrian popes during part of the 7th and 8th centuries.

In the mid-8th century the Carolingian dynasty replaced the Merovingians as kings of the Franks. Charlemagne (768–814) built up a large empire through his conquests and in 800 was crowned by Pope Leo III as Emperor of the Romans, reviving the idea of a Roman Empire in the West. Whatever the precise meaning of this ceremony was, much of the more "official" art and architecture of the "Carolingian Renaissance" draws on Late Antique sources. The use of such sources and the more general classicism of Carolingian art were no doubt intended to recall the beginnings of the Christian Roman Empire under Constantine. In the later part of his reign Charlemagne settled his court at Aachen and established there an ambitious imperial palace, a Byzantizing chapel and a school of manuscript production.

The unity of the Carolingian Empire did not survive long. The Treaty of Verdun of 843 confirmed a division of the empire into three parts: French and German kingdoms with the kingdom of Lotharingia between. The empire was also increasingly subject to devastating attack from outside by Magyars, Arabs and Vikings (pagan Scandinavian raiders and colonists who maintained the older Germanic taste for animal patterns).

The German kingdom grew in power during the 10th century. Otto I defeated the Magyars at Lechfeld in 955, pushed the frontier east and also gained control of much of Italy; in 962 he was crowned emperor by the Pope. This revived empire, based now on Germany, saw itself as successor to that of Charlemagne and rival to the Byzantine Empire. The architecture of the great churches of the Ottonian Empire, such as St. Michael's at Hildesheim, both looked back to and developed Carolingian traditions. Ottonian book decoration drew on Byzantine, Early Christian and Carolingian models to form a distinctive and sumptuous style which blended the hieratic and the classical.

The 10th and 11th centuries saw a great revival of interest in monasticism, with older foundations reformed along Benedictine lines and the foundation of many new monasteries, the most influential of which was the great Burgundian abbey of Cluny (910). The Burgundian chronicler, Raoul Glaber (c.1000–c.1046), captured something of massive outburst of church building and rebuilding in the years around 1000 with his image of the world covering itself with a white robe of churches. Experiments in southern Europe in the application of stone vaulting to basilican church buildings led to the "First Romanesque" style during the 10th and early 11th centuries. At the end of the period early stages in the Romanesque integration of sculpture into architectural design can be seen, for example at St. Bénigne in Dijon.

The three broad periods indicated by color coding on the map (7th and 8th centuries; 9th century; and 10th century to 1024) correspond crudely to distinguishable phases in Western European art and architecture: the early medieval interaction of the "barbarian" north with Christian traditions of the south; the century of the Carolingian "Renaissance"; the period of the traditionalist Ottonian Empire and of early experimental stages in the Romanesque style.

Above: Carved Capital, *St. Bénigne, the lower church, late 10th century, Dijon.*

The crypt is all that remains of the centrally planned Romanesque basilica built by William of Volpiano. Designed as a colonnaded octagon, it showed knowledge of both Charlemagne's chapel at Aachen, and the buildings of the Holy Land. The capitals are decorated with primitive carvings of palmettes, monsters and people.

Left: Charles the Bald, *manuscript in gold uncials, c.842–69, (Ms. Lat. 1152, fol.3v, Bibliothèque Nationale, Paris).*

Charles the Bald (823–77) was king of France and briefly Holy Roman Emperor. Although a disastrous ruler in the period of the break-up of the Carolingian Empire, he collected manuscripts such as this one which was a fusion of the styles of Reims and Tours.

ART AND ARCHITECTURE IN EUROPE 600-1024

- ● Site
- ■ Anglo-Saxon and Irish centers on mainland Europe
- ▢ Architecture
- △ Sculpture
- ▽ Metalwork
- ○ Window-glass
- ▨ Wall-painting
- ⊘ Mosaic
- ◹ Inscribed monument
- ⬗ Ivory
- ⊟ Manuscript
- ▢ 7th and 8th century
- ▢ 7th to 9th century
- ▢ 7th century to 1024
- ▢ 9th century
- ▨ 9th century to 1024
- ▨ 10th century to 1024

0 100 200 300 kms
0 100 200 miles

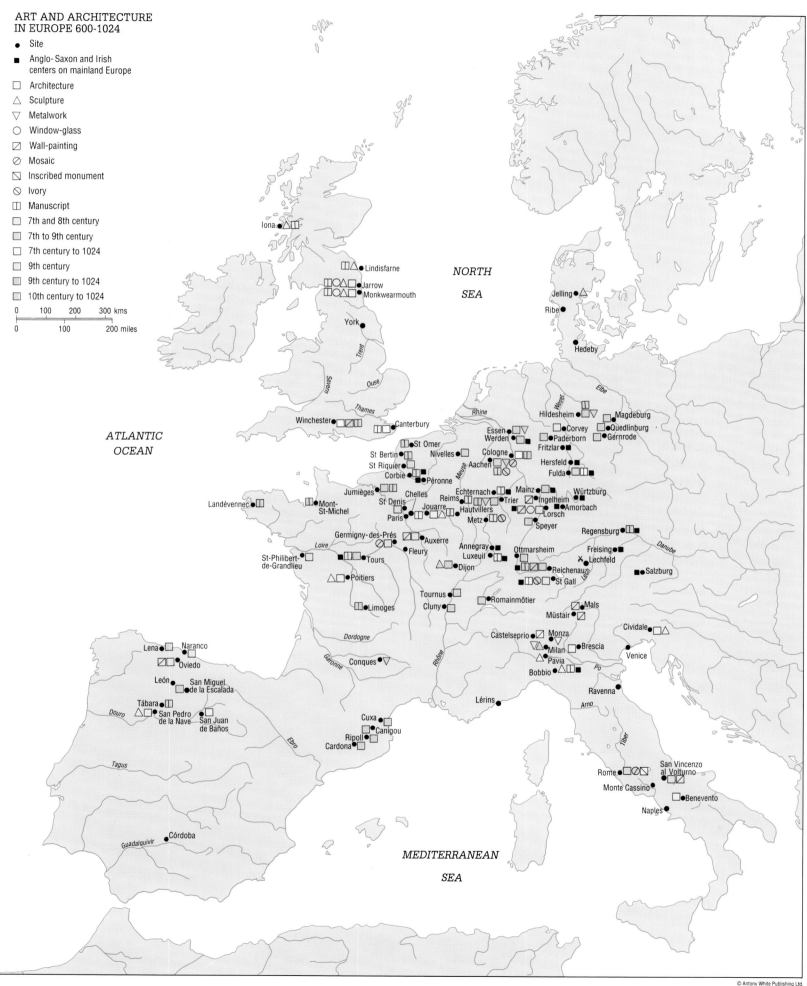

NORTH SEA

ATLANTIC OCEAN

MEDITERRANEAN SEA

Iona
Lindisfarne
Jarrow
Monkwearmouth
York
Winchester
Canterbury
St Omer
St Bertin
St Riquier
Corbie
Péronne
Jumièges
Mont-St-Michel
Landévennec
St Denis
Chelles
Paris
Jouarre
Hautvillers
Metz
Germigny-des-Prés
Auxerre
Fleury
St-Philibert-de-Grandlieu
Tours
Poitiers
Limoges
Tournus
Cluny
Romainmôtier
Conques
Lena
Naranco
Oviedo
León
San Miguel de la Escalada
Tábara
San Pedro de la Nave
San Juan de Baños
Cuxa
Canigou
Ripoll
Cardona
Córdoba
Nivelles
Cologne
Aachen
Werden
Essen
Paderborn
Fritzlar
Hildesheim
Corvey
Magdeburg
Quedlinburg
Gernrode
Hersfeld
Fulda
Mainz
Echternach
Reims
Trier
Ingelheim
Würzburg
Amorbach
Lorsch
Speyer
Regensburg
Annegray
Luxeuil
Ottmarsheim
Freising
Lechfeld
Dijon
Reichenau
St Gall
Salzburg
Mals
Müstair
Castelseprio
Monza
Milan
Pavia
Brescia
Cividale
Venice
Bobbio
Ravenna
Lérins
Rome
San Vincenzo al Volturno
Monte Cassino
Benevento
Naples
Jelling
Ribe
Hedeby

Rhine
Meuse
Elbe
Weser
Trent
Ouse
Thames
Severn
Loire
Dordogne
Garonne
Rhône
Danube
Lech
Po
Arno
Tiber
Douro
Tagus
Ebro
Guadalquivir

© Antony White Publishing Ltd.

Art and Architecture in Britain and Ireland 600–1066

Ireland and Britain north of the Antonine Wall had been little affected by the Roman occupation of southern Britain and much of later Iron Age Celtic culture was preserved, whereas further south the monuments and memory of Roman occupation remained. There were three linguistically distinct Celtic populations: the Irish (whose colony of Dalriada in Scotland eventually expanded to absorb the Pictish kingdom), the Picts (who lost their political and cultural independence in the mid-9th century), and the Britons (who had lost England but still controlled Wales and, until the middle of this period, Strathclyde and Cornwall).

By c.600 the Anglo-Saxons, in origin Germanic settlers from northern Germany and Denmark, controlled most of England as well as southeastern Scotland. The world of a pagan English ruler is vividly evoked in the splendid grave-goods from an early 7th-century ship-burial at Sutton Hoo.

The adoption of Christianity by the ruling classes brought contacts with the continent as well as between the Celts and Anglo-Saxons. By 600 Christianity was well established among the Britons and the Irish; the Irish monastery of Iona in the Western Isles of Scotland was one of the channels that brought Christianity to the Picts. The Anglo-Saxon kingdoms were evangelized both by missionaries from the Roman church, who arrived in Kent in 597, and by the Irish, who founded the Northumbrian monastery of Lindisfarne from Iona in the 630s. This coming together of Irish and Anglo-Saxons led to the formation of a shared artistic style, the "Hiberno-Saxon" or "Insular" style, which fused Celtic and Anglo-Saxon motifs as well as drawing on Mediterranean models. It can be seen, for example, in the Lindisfarne Gospels of c.700. The fusion could be so complete that the origins of some of the great manuscripts and pieces of metalwork of about the 8th-century, for example, the Book of Kells, still remain controversial. The influence of Christian Gaul and Italy was sometimes direct, for example when in the 670s and 680s the Northumbrian Benedict Biscop imported continental masons and glassworkers, as well as paintings and a major collection of books, for the monasteries that he had founded at Monkwearmouth and Jarrow.

Despite these close contacts the national and local artistic traditions remained distinct, clearly seen in the variety of standing stone monuments raised throughout the British Isles. At first incised (with crosses, symbols, inscriptions or, later, ornament), from c.700 they bore more sophisticated carvings in relief. These commonly took the form of free-standing crosses, which could reach over 20 ft. (6–7 m.) in height. They often bear elaborate figure-carving (for example, those at Ruthwell and Bewcastle in 8th-century Northumbria, and Moone, Clonmacnoise, Monasterboice and Kells in 9th- and 10th-century Ireland). Sometimes they are designed to imitate the form and ornament of precious metalwork (Iona). Pictish sculpture demonstrates the cultural distinctiveness of the Picts: the earlier incised monuments (class I) display enigmatic and unparalleled "Pictish symbols"; class II monuments are cross-slabs rather than the more usual free-standing cross; they are carved in

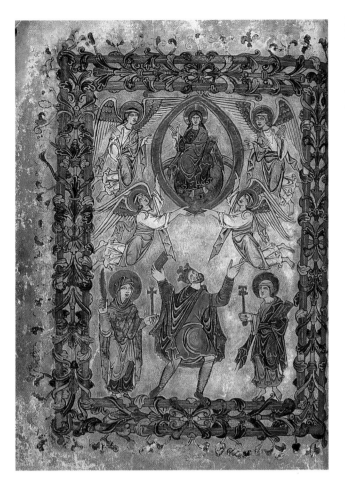

Left: *Winchester School*, King Edgar offering Charter to Christ, *from the New Minster Charter, illuminated manuscript 966 (MS Cotton Vesp. A viii), British Museum, London.*

King Edgar is shown dedicating the New Minster at Winchester to Christ. Under Bishop Aethelwold Winchester became the center of an Anglo-Saxon school of manuscript illumination which showed the influence of Carolingian art, especially from St. Gall and Tours, rather than that of the earlier Northumbrian school.

relief and combine the symbols with Christian and other motifs. The distributions of classes I and II seem to illustrate Pictish loss of western lands to the Scots.

The Scandinavian "Vikings" first appear in the late 8th century as booty-hunters, especially at wealthy monasteries such as Lindisfarne and Iona. From about the mid-9th century they began to settle in northern and eastern England, Caithness, Orkney, Shetland, the Western Isles and Man, and in colonies in Ireland (Dublin, Wexford, Waterford and Limerick). Organized monasticism was greatly disrupted, in England almost totally. Some sculpture of the 10th and 11th centuries (e.g. carvings on Man and at Gosforth, "Hogback" grave markers) illustrates the tastes of the recently converted Scandinavian settlers. In England the resistance to the Vikings was led by the kingdom of Wessex under King Alfred (871–99) and his successors, who gradually gained control over the whole country. Alfred promoted educational reforms and in the second half of the 10th century there was a major revival of monasticism in southern and central England, led, with royal support, by SS. Dunstan, Aethelwold and Oswald and inspired by the Benedictine reform movement on the continent. Similarly the art, particularly the manuscripts of the so-called "Winchester School", and architecture of the later Anglo-Saxon period have more in common with the area of the former Carolingian Empire than with earlier insular traditions. The influence of continental Romanesque architecture began to be seen shortly before the Norman conquest in 1066, for example in Edward the Confessor's rebuilding of Westminster Abbey.

Above: Sompting Church, *West Sussex, early 11th century.*

The tower of Sompting Church is a good example of Anglo-Saxon architecture on the eve of the Norman Conquest – with its height accentuated by vertical pilaster strips and an unusual pitched roof.

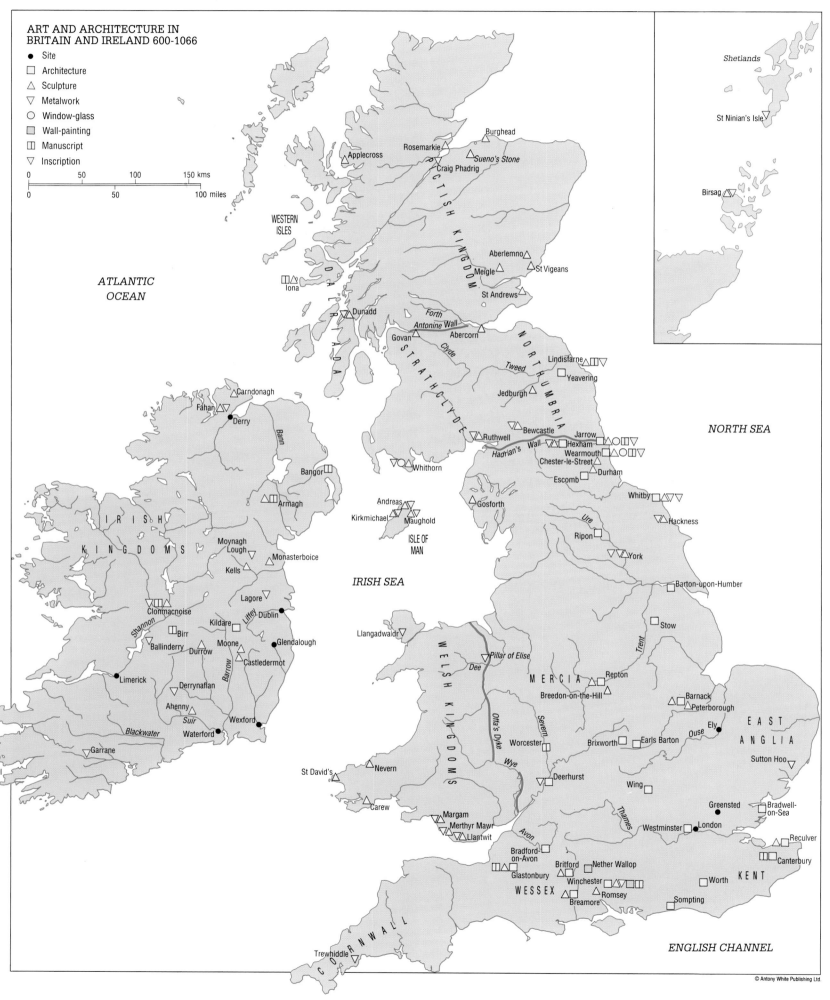

ART AND ARCHITECTURE IN BRITAIN AND IRELAND 600-1066

- ● Site
- □ Architecture
- △ Sculpture
- ▽ Metalwork
- ○ Window-glass
- ▣ Wall-painting
- ⊞ Manuscript
- ▽ Inscription

```
0        50        100       150 kms
0              50           100 miles
```

ATLANTIC OCEAN

Shetlands

St Ninian's Isle

Birsag △▽

Burghead

Applecross Rosemarkie △ Sueno's Stone △
 Craig Phadrig

PICTISH KINGDOM

WESTERN ISLES

Iona ⊞⊞△

Dunadd

Aberlemno △
Meigle △ St Vigeans △
St Andrews △

Govan Forth Antonine Wall Abercorn
STRATHCLYDE Clyde

DAL RIADA

Lindisfarne ⊞⊞▽
Tweed Yeavering
NORTHUMBRIA
Jedburgh △

NORTH SEA

Carndonagh △
Fahan △▽
Derry ●

Bann

Bangor ⊞

Armagh ⊞⊞

IRISH KINGDOMS

Ruthwell ▽ Bewcastle △ Jarrow △△○△⊞▽
Whithorn ▽ Hadrian's Wall Hexham △▽○▽ Wearmouth △△○▽
 Chester-le-Street
Escomb □ Durham △

Whitby △▽△▽
Hackness ▽△

Ripon □
Ure York ▽△

Barton-upon-Humber □

Andreas △
Kirkmichael △ Maughold △
ISLE OF MAN

IRISH SEA

Moynagh Lough
Kells △ Monasterboice △
 ▽

Lagore ▽
Clonmacnoise ▽△△□ Kildare
Birr ⊞ Moone △
Ballinderry Durrow Castledermot △
Limerick ● Derrynaflan ▽
Ahenny △
Suir Wexford
Waterford ● Garrane ▽
Skellig Michael □

Llangadwaldr ▽

Stow □

Repton □△
Breedon-on-the-Hill △
MERCIA

Barnack △
Peterborough △
Ely ●
EAST ANGLIA

WELSH KINGDOMS

Dee Pillar of Elise ●
Offa's Dyke

Worcester □
Brixworth □ Earls Barton □
Severn Ouse Sutton Hoo ▽

St David's △ Nevern △
Carew △

Wing □
Greensted ● Bradwell-on-Sea □
Westminster □ London ●
Reculver □△

KENT

Margam △
Merthyr Mawr ▽
Llantwit △△
Bradford-on-Avon □
Britford □ Nether Wallop ▣
Glastonbury □ Winchester □▽△▽⊞⊞
Breamore □△ Romsey △
WESSEX
Sompting □
Worth □

CORNWALL

Trewhiddle ▽

ENGLISH CHANNEL

© Antony White Publishing Ltd.

85

Islamic Art 632–1100

When the Prophet Muhammad died in A.D. 632, a Muslim state was already established in a large part of Arabia. One hundred years later, Charles Martel checked the advance of Islam at Poitiers (732), although it was the move of the capital from Damascus to Baghdad in the 750s that proved the ultimate brake. Often unrecognized in Western art, the impact of that whirlwind advance from the desert-bound towns of Mecca and Medina into the heart of Europe echoes down the centuries.

The centrality of the pen and the written word permeates Islamic art. Figural representation, widespread in secular art, is excluded from a religious context; the elegant Arabic script thus takes the place of the Western holy image, so bitterly disputed within Byzantium, Islam's immediate neighbor and rival to the West. And it was from the debased Classical heritage of Byzantium that Islam took another of its pervasive characteristics, the arabesque. Ultimately derived from the acanthus scroll, the arabesque's organic form undulates through Western art to the present day. The last immediately recognizable element of Islamic art is geometric pattern whose relationship to Insular interlace and "carpet" pages is still not clear.

The routes by which Islamic art reached the West were forged by pilgrimage, diplomatic exchange, trade, and later, crusade. The great symbol of Islam and its first architectural monument, the Dome of the Rock (692), still dominates the city of Jerusalem. Located between the Church of the Ascension on the Mount of Olives and the Holy Sepulcher, it too marks a holy site. The reasons why the Umayyad caliph Abd al-Malik chose to build the octagonal sanctuary have been severally interpreted, but a deliberate challenge to Christian architecture seems indisputable; pilgrims through the centuries remarked on its beauty and it was used by the Knights Templar as their headquarters during the Christian occupation (the city was regained for the Muslims in 1187 by Saladin).

Islam was seen as a Christian heresy in the medieval period; its tenets were either misunderstood or deliberately misrepresented. Perhaps because of the passion the Muslim faith aroused, its artefacts were preserved in the treasuries of the great Western churches. Silks from the Far East wrapped the bodies of saints or holy relics collected in the Holy Land (e.g. the cover of the "Veil of Our Lady," Chartres Cathedral). The precious materials (whose associated names – cotton, divan, sofa, damask, muslin and so on – indicate their origin), with their reputation for incorruptibility and brilliant color, were also used for ceremonial vestments or venerated in their own right ("Veil of St Anne," Apt, Vaucluse, with the name of the Fatimid Caliph al-Must'ali from Damietta, Egypt c.1097; cloak made for Roger II of Palermo 1133 subsequently worn as the coronation robe of Holy Roman Emperors until 1806). Liturgical objects too were fashioned out of Islamic originals, such as the rock crystal ewer with the name of the Fatimid Caliph al-'Aziz Bi'llah 975-96 in the Treasury of S. Marco, Venice. Paintings of the Virgin show her dressed in or framed by Islamic silks. Images taken from them adorn the capitals of French pilgrimage churches and Arabic script appears on the wooden doors of Notre-Dame de Puy and in the borders of the Apocalypse of St. Sever (Bibliothèque Nationale, Paris).

It is not possible to be sure of the precise route of this cultural invasion. It came either from the East with the spices that were vital to the Western diet, up the leg of Italy from the Islamic stronghold of Sicily (Messina was recaptured by the Norman Roger de Hauteville in 1060) or from Muslim Spain.

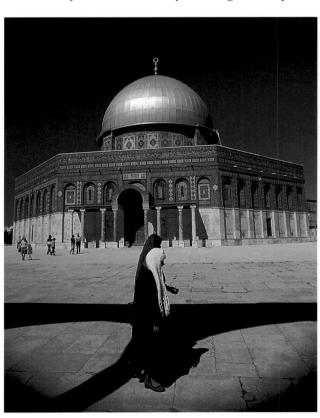

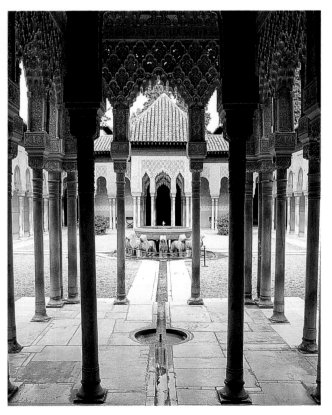

Far left: The Dome of the Rock, *completed 692, Jerusalem.*

Built in the third most holy city of Islam, occupied by the Templars during the Crusades, it is a key building in the history of architecture; its octagonal form appears in medieval and Renaissance art in the West as the Templum Dei.

Near left: The Court of the Lions, *late 14th century, the Alhambra, Granada.*

Named after the central fountain, which is supported by lions (probably with a Solomonic significance). The delicate pillars, intricate interlocking spaces and rich arabesque decoration were particularly appreciated by 19th-century travelers.

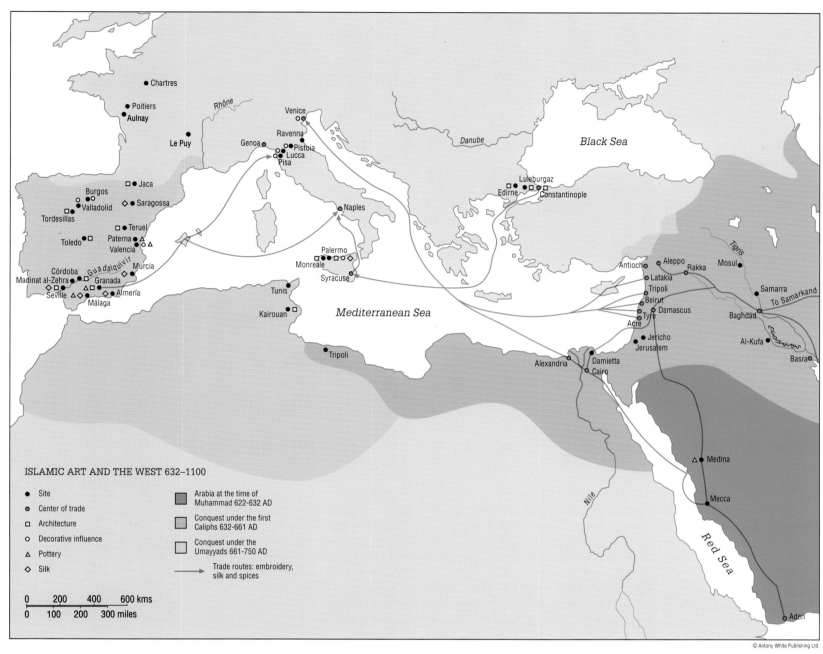

ISLAMIC ART AND THE WEST 632–1100

- ● Site
- ◉ Center of trade
- □ Architecture
- ○ Decorative influence
- △ Pottery
- ◇ Silk

- ▨ Arabia at the time of Muhammad 622-632 AD
- ▨ Conquest under the first Caliphs 632-661 AD
- □ Conquest under the Umayyads 661-750 AD
- → Trade routes: embroidery, silk and spices

```
0    200    400    600 kms
0  100   200   300 miles
```

Chartres · Poitiers · Aulnay · Le Puy · Rhône · Venice · Ravenna · Genoa · Pistoia · Lucca · Pisa · Jaca · Burgos · Valladolid · Saragossa · Tordesillas · Teruel · Toledo · Paterna · Valencia · Córdoba · Murcia · Madinat al-Zehra · Granada · Seville · Almería · Málaga · Tunis · Kairouan · Naples · Palermo · Monreale · Syracuse · Tripoli

Black Sea · Danube · Luleburgaz · Edirne · Constantinople

Mediterranean Sea

Antioch · Aleppo · Rakka · Mosul · Latakia · Tripoli · Beirut · Damascus · Samarra · To Samarkand · Tyre · Acre · Baghdad · Jericho · Jerusalem · Al-Kufa · Basra · Alexandria · Damietta · Cairo · Tigris · Medina · Mecca · Nile · Red Sea · Aden

© Antony White Publishing Ltd.

Right: *The* Alhambra *and the* Alcazaba, *view from the west, 1338–90, Granada.*

The greatest and last of the Muslim palaces of Spain, the Alhambra was built by the Nasrid dynasty which survived the Catholic reconquest until 1492. The palace runs along the lip of a narrow promontory with the Alcazaba, the fort and ancient citadel, at its tip. The Catholic Emperor Charles V built a complex in the center of the palace as a symbol of Christian supremacy over the vanquished Moors.

87

Viking Art

The spread of Viking art affected much of northwestern Europe from the late 8th to the 11th centuries as the Scandinavians expanded beyond their own territories. This expansion manifested itself in a variety of ways, ranging from raiding ventures and diplomatic envoys to trade and settlement. The application of a homogeneous set of Viking style names for the whole of northwestern Europe, namely Broa/Oseberg, Borre, Jellinge, Mammen, Ringerike and Urnes, in itself reflects the political power, underpinned by military might, of the Vikings. Thus the traditional view of a conflict of images existing between the skilled Scandinavian craftsman and his neighbor.who went marauding needs to be treated with caution, for it was the latter who provided the expanding market for the former, and the former who provided the equipment and displays of prestige necessary to achieve those aims.

The study of Viking art does not simply illuminate the ingenious creations of a few exceptional craftsmen and their workshops, but rather stylistic developments which reflect the political and economic achievements of the day, with strains of foreign influence appearing in an ever-expanding repertoire. In an age when artefacts rarely carry datable inscriptions, it is impossible to be precise about the exact place of origin of a particular stylistic movement – a picture further blurred by busy trading networks and the itinerant life style known to have been practised by craftsmen. Ethnic association with stylistic trends is further complicated by Viking emigration and settlement outside Scandinavia. However, expansion of this nature is distinctively, if subtly, reflected in stylistic assimilation, the degree and manner in which the art of the Scandinavian homelands is affected providing a primary source of information for any discussion of the nature of that settlement, whether in Dublin to the west or Gnezdovo to the east. Such cultural interfaces are complicated further by the art of many of the areas settled by the Vikings having a common ancestry in Germanic Migration art. Viking art therefore developed into distinct though inter-related styles in the different regions affected.

Viking art is primarily the application of stylized animal ornament to a vast range of functional objects, though naturalistic sketches and narrative scenes also feature in some regions. Although most raw materials required by the craftsman could be traded at a cost, the carving of stone was restricted to areas with suitable natural outcrops, such as the Ryedale valley north of York, and Uppland in Sweden where rune stones abound. Precious metals were naturally restricted to those who could afford them, whilst base-metal trinkets and evidence of their mass-production are frequently recovered from towns such as Ribe, Birka, Hedeby, York and Lund, where large ready markets existed and trade could provide access to other customers. These popular items of jewelry display a high degree of standardization, not only in their use of motif but also in their association with a particular class of object, be it a trefoil brooch with Borre-style gripping beasts, or a Jellinge-style backward-glancing creature on a convex disc pendant. This may be significant in the light of Viking art being primarily the application of ornament to functional objects, the motif and style of execution possibly having some long-lost symbolic function or simply an established association.

The chronology of styles indicated on the map should be treated with some caution, for recent dendrochronological studies have highlighted the limitations of such a strictly defined sequence. Styles quite clearly flourished in different areas at different times and for varying durations, depending upon the cultural and social infrastructure. The Borre grave find of harness mounts had probably long been buried before its counterpart at Gnezdovo was placed in the earth. Furthermore, the names of the stylistic phases on the map reflect the limitations of a later generation of art historians using them merely as tools for classification; as such they give little indication of transitional phases or the individualism of regional expression. The "Dublin School," characteristically rendered in wood, is quite distinct from, though clearly related to, depictions of the same Ringerike style on stone monuments from that area in Norway.

Although trading centers provided for an obvious point of interchange and stylistic diffusion between different areas of the Viking world, in artistic terms they were generally characterized by unremarkable mass-produced pieces of craftsmanship. The more exclusive examples of Viking art, from which the styles have taken their names, are without exception masterpieces commissioned by patrons of the highest standing, and have been recovered from impressive burials or royal sites and not established trading centers. Their importance is not thereby diminished, since they instigated stylistic trends that eventually filtered through the different strata of society in a still recognizable form, to be reproduced en masse in urban workshops. The map therefore indentifies not only the high-status find locations, but also the main trading centers of the period where many of these styles were subsequently mirrored, albeit in cheaper metals and less ambitious techniques. Thus the map gives an insight into both the geographic and the social diffusion of Viking art styles.

Above: Part of a runic inscription, *Norway.*

Left: Decoration on a bronze · Viking matrix, c.*1.5 inches square,* c.*9th century (Statens Historiska Museum, Stockholm).*

An unusual narrative scene from Nordic mythology on a matrix, possibly used in the manufacturing and decoration of helmet plaques.

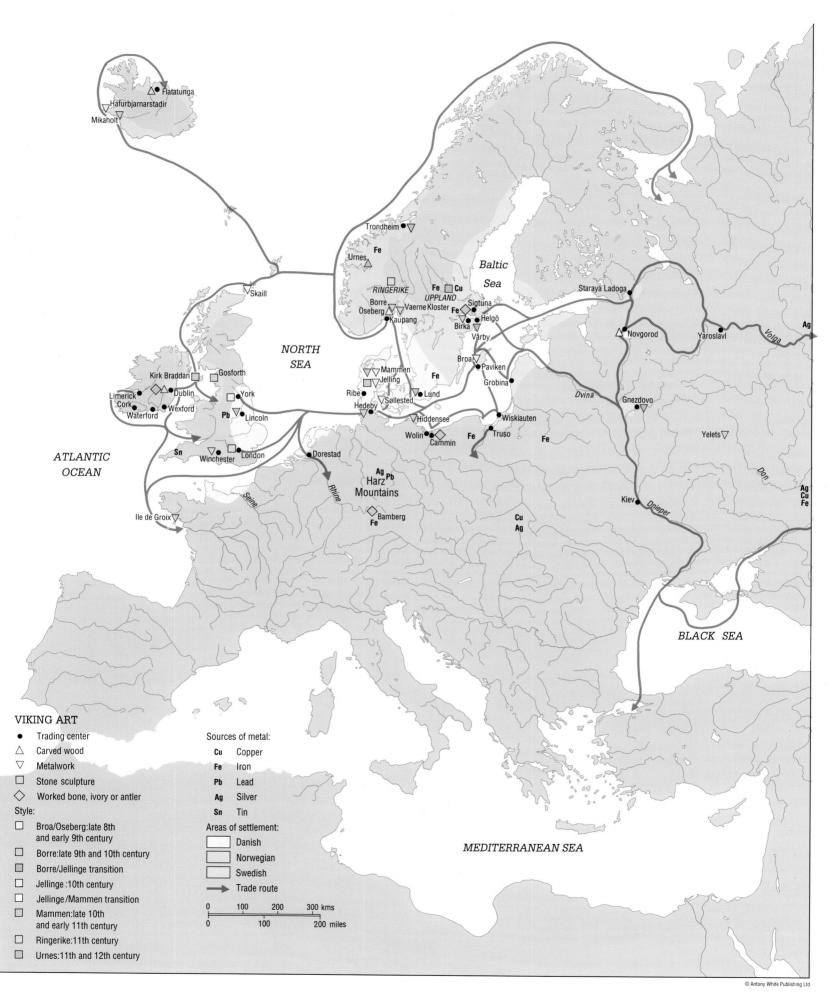

Flatatunga ●

▽ Hafurbjarnarstadir
▽ Mikaholt

Trondheim ● ▽

Fe
Urnes ▽

RINGERIKE □
Borre △
Oseberg ▽ △
Kaupang ●
Vaerne Kloster △
UPPLAND
Fe □ Cu □
Sigtuna ●
Fe
Birka ◇
Helgö ▽
Vårby ▽

Baltic
Sea

Staraya Ladoga ●

△ Novgorod

Yaroslavl ▽

Volga

Ag

Skaill ▽

*NORTH
SEA*

Broa ▽
Paviken ●
Fe

Grobina ●

Mammen ▽
Jelling ▽
Ribe ●
Søllested ▽
Hedeby ▽
Lund ▽
Hiddensee ▽
Wolin ●
Cammin ◇
Fe
Truso ●
Wiskiauten ▽

Dvina

Gnezdovo ▽

Yelets ▽

Kirk Braddan □
Gosforth □
Limerick ● ◇ △ ▽
Cork ●
Dublin ●
Waterford ●
Wexford ●
York □
Lincoln
Pb
Sn
▽ Winchester
London □

*ATLANTIC
OCEAN*

Dorestad ●

Seine

Rhine

Ag Pb
Harz
Mountains

◇ Bamberg
Fe

**Cu
Ag**

Kiev ●
Dnieper
Don

**Ag
Cu
Fe**

Ile de Groix ▽

BLACK SEA

MEDITERRANEAN SEA

VIKING ART

- ● Trading center
- △ Carved wood
- ▽ Metalwork
- □ Stone sculpture
- ◇ Worked bone, ivory or antler

Style:
- □ Broa/Oseberg: late 8th and early 9th century
- □ Borre: late 9th and 10th century
- □ Borre/Jellinge transition
- □ Jellinge: 10th century
- □ Jellinge/Mammen transition
- □ Mammen: late 10th and early 11th century
- □ Ringerike: 11th century
- □ Urnes: 11th and 12th century

Sources of metal:
- **Cu** Copper
- **Fe** Iron
- **Pb** Lead
- **Ag** Silver
- **Sn** Tin

Areas of settlement:
- □ Danish
- □ Norwegian
- □ Swedish
- → Trade route

0 100 200 300 kms
0 100 200 miles

Romanesque Art and Architecture

Romanesque building of the 10th and 11th centuries is characterized by rounded arches, clearly articulated ground plans and elevations, basilican layout and both barrel vaults and early rib vaults. Stylistically the Romanesque reflected the art of ancient Rome, and also that of the new Rome in Byzantium. There was a vast increase in church building during the 11th century and Europe was covered with examples of this austere and beautiful style, often decorated with narrative murals of immense expressive power combined with almost abstract patterning.

Painting and sculpture were closely interlinked with manuscript illumination and were strong, somewhat hieratic and frequently carried a political, moral or religious message.

Surviving metalwork is mainly religious including elaborate altar vessels, altar frontals, jeweled book covers, candelabra and bronze doors – as well as shrines and reliquaries to house the remains of the saints, most notably on the pilgrimage routes.

Right: Abbey Church, *interior view of nave, 11th century, St. Savin-sur-Gartempe, France.*

Below: The Eltenberg Reliquary, *copper gilt enriched with champlevé, enamel and set with walrus ivory carvings, 12th century (Victoria and Albert Museum, London).*

Romanesque Architecture and Sculpture

Romanesque was the first international style, prevailing from Sicily in the south to almost the Arctic circle in Norway, and from the Atlantic seaboard in Portugal to Hungary and Poland in the east (it was also carried to the Holy Land by the Crusaders and even made isolated inroads into Russia). It emerged more or less simultaneously in several countries – France, Germany, Italy, Spain – in about 1000 and continued well into the 13th century in some areas, although by this time it was being supplanted by the Gothic style. There were pronounced regional differences in the style, but throughout Europe Romanesque buildings were characterized by a new ambition and scale that clearly set them apart from those of the immediately preceding centuries. They did, indeed, revive something of the heroic spirit of ancient Roman buildings, and the word *Romanesque* was coined (in the 18th century) to designate a style based on Roman architecture but distinct from it.

Around 1000 Europe was recovering from a period of political and economic instability and the Church from a period of decay and corruption, so there was renewed wealth and energy to direct into building. In particular the great monastic orders expanded rapidly: the Carthusian, Cistercian and Cluniac orders were all founded in the 10th and 11th centuries. The development of more elaborate liturgical practices – particularly by the Cluniac order – encouraged an increase in the size and complexity of churches, for larger choirs and more chapels were required. At the same time there was an improvement in building techniques: whereas previously, roughly-hewn rubble was usually employed, from the 11th century properly-squared blocks (*ashlar*) became virtually the norm.

The stylistic currents of Romanesque art were extremely complex as earlier traditions – Carolingian, Ottonian, Byzantine – and local forms fused into a new synthesis, but certain features are common in most areas, even though they are expressed in different ways. Apart from the round arch that is the trademark of the style, one of the most obvious is a love of towers, whether paired at the west end, as was common in England (Durham; Lincoln), in the free-standing campaniles of Italy (Pisa – the Leaning Tower; Pomposa), or as formidable groups of four or more, as favored in Germany (Limburg-on-the-Lahn; Maria Laach). Common decorative motifs include interlacing arches, as on the exterior of Monreale Cathedral in Sicily, and zigzag patterns, often seen in doorway surrounds, as at Lérida Cathedral in Spain. More fundamentally, Romanesque buildings are characterized by a sense of physical substance. Walls are thick, windows fairly small, and pillars and piers massively bulky. There were two reasons why stone vaulting was preferred, one esthetic, one practical: esthetically, a vault provided a more magnificent and consistent effect, appropriate to the glorification of God; practically, wooden roofs were a fire hazard, and there are many accounts of fires in medieval chronicles – the choir of Canterbury Cathedral, for example, was gutted in 1174. Stone vaults require very substantial support to carry the weight; the technique of building them had been virtually lost in Western Europe since the Romans,

but Romanesque masons rediscovered it, and appropriately some of the earliest experiments in vaulting were made in Italy (particularly Lombardy), where there were Roman remains to act as inspiration.

The simplest form was the *barrel vault* (or *tunnel vault* – a semi-circle like the roof of a tunnel). Some of the most majestic examples are in France (Notre-Dame-du-Port at Clermont-Ferrand, St. Sernin at Toulouse), but France also favored other solutions. In the southwest of the country, for example, is a group of churches that use a series of domes; Périgueux Cathedral has five over a basically Greek-cross plan, and Angoulême Cathedral has a procession of four over the nave and crossing. The most momentous development in vaulting took place at Durham Cathedral (begun 1093), which is regarded by many as the supreme masterpiece of Romanesque architecture. Here for the first time rib vaults were used, pointing forward to the Gothic style.

The wealth of sculpture in the Romanesque period was almost as remarkable as that of architecture. Virtually all large-scale sculpture was architectural – conceived as an inseparable part of the building for which it was created. Such monumental carving had been dormant in Europe since the fall of the Roman Empire, some 600 years earlier. A Romanesque speciality is the carved *tympanum* (the semi-circular space between the lintel of a door and the arch over it). The favorite subject for this position was The Last Judgement, one of the most famous examples being that of the west doorway (*c.*1125) of Autun Cathedral in Burgundy. The name of the tympanum sculptor at Autun is known, because he proudly carved it beneath the central figure of Christ – *Gislebertus hoc fecit* ("Gislebertus made this"). He must also have carved most of the rest of the sculpture in the cathedral, for it displays the same technical and expressive mastery, and it is thought that he also worked at Cluny (the largest of all Romanesque churches, of which little survives) and Vézelay. Other sites of great sculptural ensembles where the name of the sculptor has survived include the façade of Modena Cathedral (*c.*1100) by Wiligelmo and the Pórtico de la Glória (1188) at Santiago de Compostela by Master Mateo.

Above: The Nave, Durham Cathedral, *1093–1133.*

Durham is one of the most masculine of church designs built in the modular unit of the old northern sajère *(seven feet). In the construction of the nave, it was demonstrated for the first time that ribbed high vaulting was possible and practical over high spans.*

Below: The Baptistery and Cathedral, *Pisa.*

The Baptistery, designed by Diotisalvi, and begun 1152 is schematically like the Rotunda of Anastari in Jerusalem, but the detail is Pisan. The exterior decoration included sculpture by Nicola and Giovanni Pisano. The cathedral (background) was begun c.1089 and, although unfinished, consecrated in 1118.

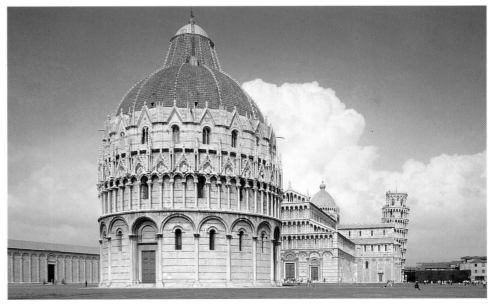

ECCLESIASTICAL ROMANESQUE
ARCHITECTURE AND SCULPTURE

□ Abbey
□ Abbey with sculpture
○ Cathedral
○ Cathedral with sculpture
○ Parish church
○ Parish church with sculpture

0 100 200 300 400 kms
0 100 200 300 miles

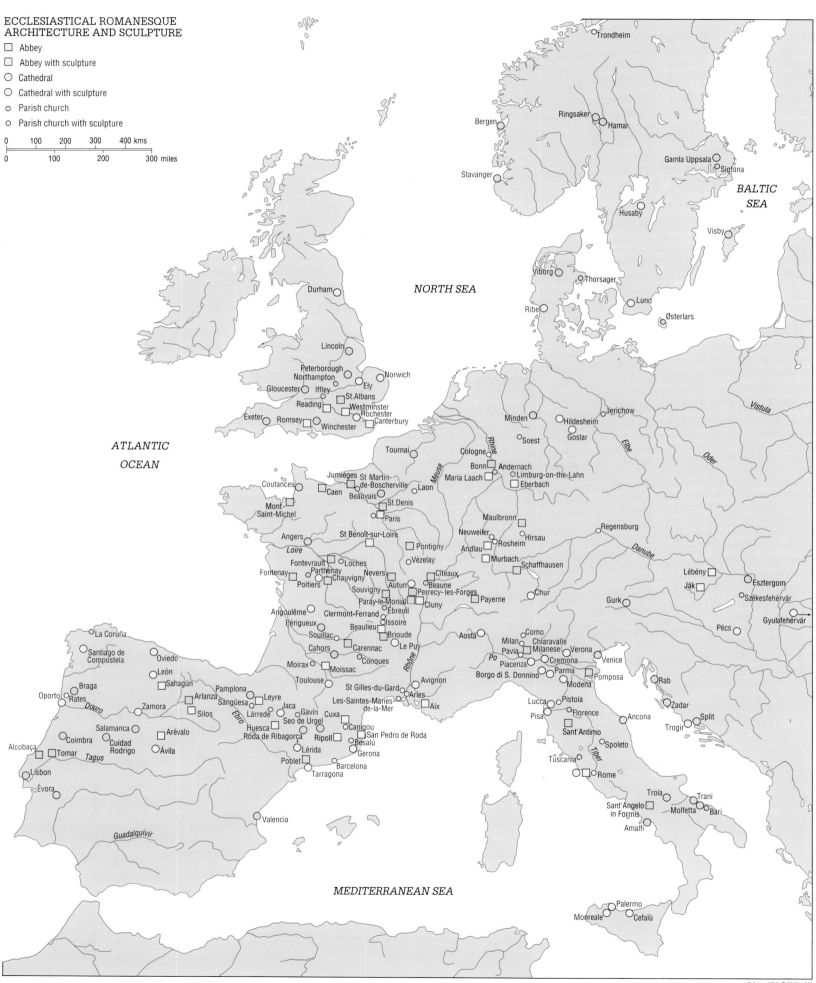

NORTH SEA

BALTIC SEA

ATLANTIC OCEAN

MEDITERRANEAN SEA

Trondheim

Bergen
Ringsaker
Hamar
Stavanger

Gamla Uppsala
Sigtuna
Husaby
Visby

Viborg
Thorsager
Ribe
Lund
Østerlars

Durham

Lincoln

Peterborough
Northampton
Gloucester Iffley Ely Norwich
Reading St.Albans
Westminster
Exeter Romsey Rochester Canterbury
Winchester

Minden
Hildesheim
Jerichow
Soest Goslar

Tournai
Cologne
Bonn Andernach
Laon Maria Laach Limburg-on-the-Lahn
Eberbach

Jumièges St Martin-de-Boscherville
Coutances Caen Beauvais
St.Denis
Mont-Saint-Michel Paris

Maulbronn
Neuweiler Hirsau Regensburg
Andlau Rosheim
Murbach Schaffhausen

Angers
St Benoît-sur-Loire
Loire Pontigny
Fontevrault Loches Vézelay
Fontenay Parthenay Nevers Cîteaux
Chauvigny Autun Lébény
Poitiers Beaune Ják
Souvigny Percy-les-Forges
Angoulême Paray-le-Monial Cluny Esztergom
Périgueux Clermont-Ferrand Ébreuil Payerne Székesfehérvár
Beaulieu Issoire
Souillac Brioude Chur Gurk Pécs
Cahors Carennac Le Puy Aosta Gyulafehérvár
Moirax Conques Como
Moissac Milan Chiaravalle
Toulouse Pavia Milanese Verona
St Gilles-du-Gard Piacenza Cremona Venice
Pamplona Les-Saintes-Maries- Avignon Borgo di S. Donnino Parma Pomposa
Leyre de-la-Mer Arles Modena Rab
Arlanza Jaca Cuxa Aix Lucca Pistoia
Sangüesa Gavin Pisa Florence Ancona Zadar
Lárrede Canigou Sant'Antimo Split
Huesca San Pedro de Roda Trogir
Roda de Ribagorça Ripoll Spoleto
Arévalo Besalú Tuscania Rome
Lérida Gerona Troia
Poblet Barcelona Sant'Angelo Trani
Tarragona in Formis Molfetta Bari
Amalfi

La Coruña
Santiago de Compostela Oviedo
León
Braga Sahagún
Oporto Rates Zamora
Salamanca
Coimbra Cuidad Rodrigo Ávila
Alcobaça Tomar
Lisbon
Évora

Valencia

Rhine *Meuse* *Elbe* *Oder* *Vistula*
Danube
Rhône *Po* *Tiber*
Douro *Ebro* *Tagus* *Guadalquivir*

Palermo
Monreale Cefalù

© Antony White Publishing Ltd.

Medieval Secular Architecture

Secular medieval architecture has never received the same attention from scholars or enthusiasts as religious medieval architecture. The great cathedrals and churches of Europe have claimed the lion's share of admiration on account of their beauty and the evident abilities of their architects. By contrast castles and other secular buildings are in general rated for functional qualities – their ability to withstand attack against the challenging weapons of the Middle Ages – rather than for their beauty.

Such an attitude fails to take into account the main concern of the men who commissioned medieval Europe's great secular buildings. Kings, prelates and noblemen demanded palaces and castles that would, by their sheer beauty and splendor, reflect the status of their owners as well as fulfilling the utilitarian concerns of providing adequate living accommodation for a considerable number of people and being adequately defensible.

A supreme example of this type of building is Caernarvon Castle, built in Wales in the early 14th century. Here the architect's brief was to design a building which would convey to the spectator Edward I's concept of his role as monarch. So its walls are constructed in alternating layers of differently colored stone creating horizontal stripes, in the same way as those of Constantinople, the city of the first Christian Roman Emperor, Constantine the Great; and, in case that association be lost, three Roman eagles in gold were set up above the ramparts of the King's Tower. The castle's towers, which functioned as private residences for Edward I and his court, informed the viewer about the power structure within the castle walls, with the King's Tower rising high above those of the Queen and courtiers.

Both written and pictorial sources indicate that medieval patrons wished their residences to be objects of beauty, both externally and internally. The White Tower in the Tower of London was so called for its gleaming limewashed walls which King Henry III ordered should be protected from the stains of rainwater. The royal palaces of the French kings in the 14th century were meticulously recorded for the Duc de Berry by his artists, the Limbourg brothers, within the pages of his private prayer book, the *Très Riches Heures*. Like medieval religious architecture, the styles of secular architecture transcended national boundaries. Architects of castles, palaces and important city buildings traveled widely: for instance the designer of Edward I's Welsh castles, James of St. George, came from Savoy, the Papal Palace at Avignon was designed by architects from outside the region and its internal decorators came from Italy, and the English King Richard Coeur-de-Lion brought Frankish veterans from the Third Crusade, who advised him on his castle building.

Patrons also traveled, bringing back to their own regions ideas of the latest designs and in this way style and fashion spread quickly. The *Keep* or *Donjon*, a rectangular building which contained within its thick walls not just its Lord's residence, but store rooms, public reception rooms and areas for a garrison, spread throughout England from Northern France after the Norman conquest of 1066. Dissemination of style sometimes depended on key buildings, which were the focus of attention from potential patrons, not all of it friendly. The French king Philip Augustus attacked King Richard Coeur-de-Lion's Château Gaillard in Normandy and was so impressed by its design of huge round (drum) defensive tower and concentric walls, which allowed it to withstand his siege of eight months, that he built at Falaise a castle to the same design in 1204 and the style spread through Europe in the following hundred years. One of the most visited buildings during the Middle Ages, from the date of its creation in the 14th century, was the Papal Palace at Avignon, to which came Kings, high-ranking churchmen, diplomats and noblemen. Small surprise, therefore, that echoes of its elegant architectural features and design turn up in the residences of the great right across Europe well into the 15th century.

Below left: Caernarvon Castle, King's Tower *(or Eagle Tower)*, *1285–1322.*

The castle towers were the royal residences within this castle built both to symbolize the conquest of Wales by Edward I, and to maintain English military control.

Below: Palace of the Popes, *Avignon 1334–52.*

Built by Pope Benedict XII (1334–42), and enlarged by Pope Clement VI (1342–52), this fortified palace was built to house the papal court during the captivity at Avignon.

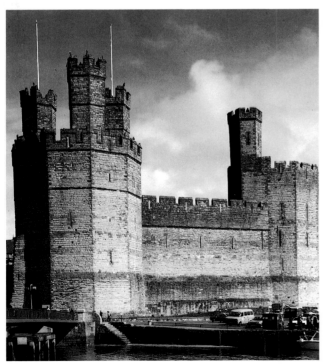

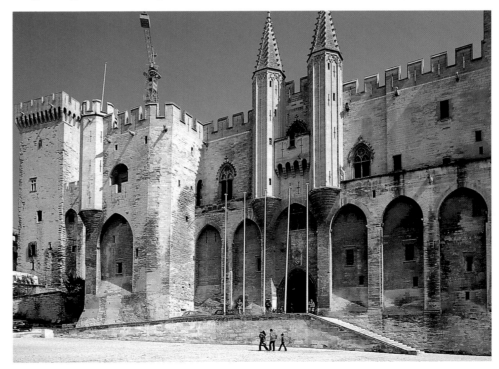

MEDIEVAL SECULAR ARCHITECTURE

□ Castle

Colors refer to period:

□ 11th and 12th century
□ 11th to 13th century
□ 11th to 15th century
□ 13th century
□ 13th to 15th century
□ 14th to 15th century

○ Palace
● Town house
□ Civic building
■ Fortified monastery/bishop's palace
□ City wall and/or gate
■ Hospital
△ College building
▲ Kitchen
⌂ Bridge
✳ Building now destroyed

```
0    100   200   300 kms
0        100       200 miles
```

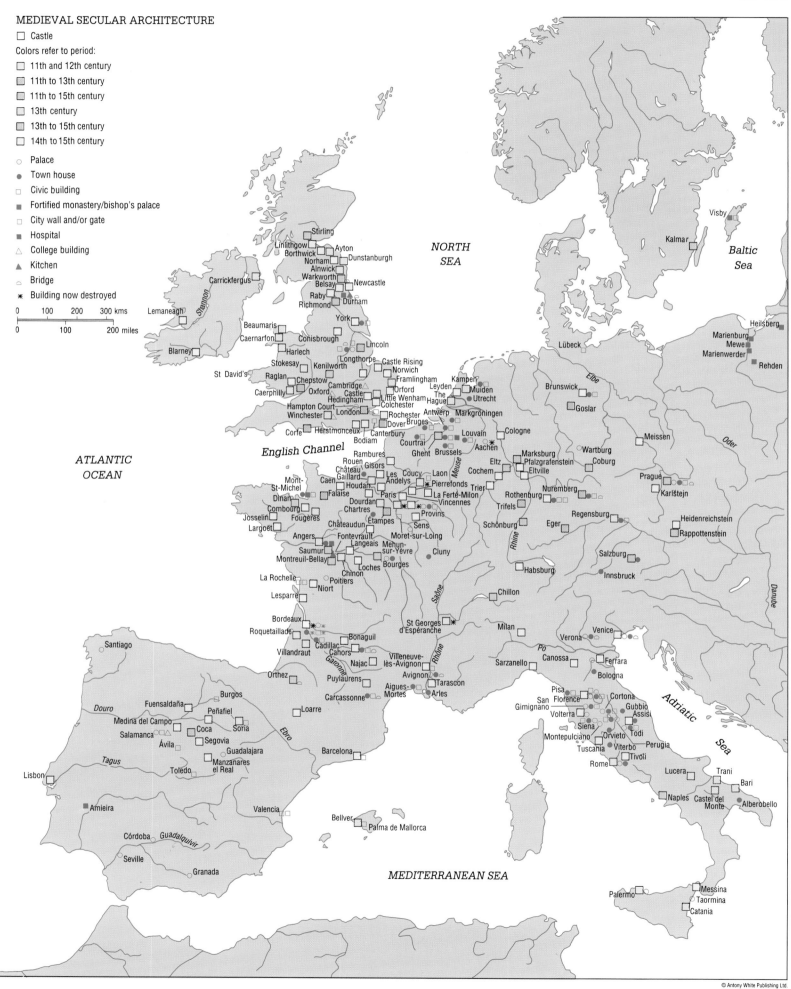

NORTH SEA

Baltic Sea

ATLANTIC OCEAN

English Channel

MEDITERRANEAN SEA

Adriatic Sea

Rivers and water bodies: Shannon, Elbe, Oder, Rhine, Meuse, Saône, Rhône, Garonne, Ebro, Douro, Tagus, Guadalquivir, Po, Danube

Stirling, Linlithgow, Borthwick, Ayton, Dunstanburgh, Norham, Alnwick, Warkworth, Belsay, Newcastle, Raby, Richmond, Durham, Carrickfergus, Lemaneagh, Beaumaris, Conisbrough, York, Lincoln, Caernarfon, Blarney, Harlech, Stokesay, Kenilworth, Castle Rising, Norwich, St David's, Raglan, Chepstow, Framlingham, Caerphilly, Oxford, Cambridge, Castle Hedingham, Orford, Little Wenham, Colchester, Hampton Court, Rochester, London, Bruges, Antwerp, Markgröningen, Winchester, Dover, Canterbury, Corfe, Herstmonceux, Bodiam, Bruges, Louvain, Cologne, Aachen

Leyden, Muiden, Utrecht, The Hague, Kampen, Courtrai, Ghent, Brussels

Brunswick, Goslar, Lübeck, Meissen, Prague, Karlštejn, Wartburg, Coburg, Marksburg, Pfalzgrafenstein, Eltville, Cochem, Eltz, Trier, Nuremberg, Rothenburg, Trifels, Schönburg, Regensburg, Eger, Heidenreichstein, Rappottenstein, Habsburg, Salzburg, Innsbruck

Visby, Kalmar, Heilsberg, Marienburg, Mewe, Marienwerder, Rehden

Rambures, Rouen, Gisors, Château Gaillard, Les Andelys, Laon, Coucy, Pierrefonds, Caen, Houdan, Paris, La Ferté-Milon, Vincennes, Mont-St-Michel, Dinan, Falaise, Dourdan, Chartres, Moret-sur-Loing, Combourg, Etampes, Sens, Provins, Josselin, Châteaudun, Largoët, Fougères, Angers, Fontevrault, Langeais, Mehun-sur-Yèvre, Cluny, Saumur, Montreuil-Bellay, Loches, Bourges, Chinon, La Rochelle, Poitiers, Niort, Lesparre, Bordeaux, Roquetaillade, Bonaguil, Cadillac, Villandraut, Cahors, Najac, Villeneuve-lès-Avignon, Orthez, Puylaurens, Aigues-Mortes, Carcassonne, Avignon, Tarascon, Arles, St Georges d'Espéranche, Milan, Chillon, Habsburg

Santiago, Fuensaldaña, Burgos, Medina del Campo, Peñafiel, Salamanca, Coca, Soria, Ávila, Segovia, Guadalajara, Manzanares el Real, Toledo, Lisbon, Amieira, Valencia, Bellver, Palma de Mallorca, Córdoba, Seville, Granada, Barcelona, Loarre

Venice, Verona, Po, Canossa, Ferrara, Bologna, Sarzanello, Pisa, Florence, San Gimignano, Volterra, Cortona, Gubbio, Assisi, Siena, Montepulciano, Orvieto, Todi, Perugia, Tuscania, Viterbo, Rome, Tivoli, Lucera, Trani, Bari, Naples, Castel del Monte, Alberobello, Palermo, Messina, Taormina, Catania

© Antony White Publishing Ltd.

The Art and Architecture of the Holy Land and its Influence on the West

The Crusades to the Holy Land can be viewed as armed pilgrimages, with the aim of liberating Jerusalem and the sacred sites associated with Christ's life from Islamic infidels. Triggered by the request for help by the Byzantine Emperor Alexius I against the Seljuk Turks in 1095, the First Crusade captured Jerusalem in 1099, and the Latin Kingdom of Jerusalem, with the Christian states of Edessa and Antioch in northern Syria, was established. Jerusalem remained in Latin hands until recaptured by Saladin in 1187. Latin settlements were retained in Syria until the final collapse of the coastal port of Acre in 1291.

Art and architecture of the late 11th to the late 13th centuries, produced for the colonial settlers in the Latin east, must be viewed in the context of cultural interaction between east and west in the Mediterranean. Three major communication routes contributed to this exchange: pilgrimage, trade and war. The routes taken by the armies of the First to Sixth Crusades show a combination of overland and sea travel. Trade routes around the Mediterranean, in the hands of Italian merchants from Venice, Pisa and Genoa, carried everything from armaments to spices and gold. Other channels of communication included embassies and various forms of political negotiation such as marriage alliances. Family, social, feudal and religious networks were maintained, invariably across political boundaries. Friars, especially the Franciscans, traveled extensively. The movement of artists and works of art would have followed these channels of communication, although artistic influences often defy over-precise mapping.

Amongst Latin settlers in the Near East royal patrons, the military orders (Templars and Hospitallers), the Church, families and individuals commissioned both indigenous Syrian Christian and western artists, architects and sculptors.

A focal monument in Jerusalem was the Church of the Holy Sepulcher which, from the Early Christian period, had been an architectural blueprint for Western Europe. This influence continued after its remodeling in the 12th century (reconsecration 1149), which incorporated Roman sculptural elements. The round churches of London and Cambridge are reflections of the Holy Sepulcher rotunda. Other churches and castles were similarly constructed upon earlier foundations: Krak des Chevaliers in Syria, built on Byzantine remains, is particularly well preserved.

Some manuscripts produced in the Scriptorium attached to the Holy Sepulchre also proved extremely influential. For example, scenes from the psalter ascribed to the patronage of Queen Melisende, probably 1130s–40s (London, B.L. Egerton MS 1139), were copied into a lavish Syriac lectionary at Melitene, an area which, together with related work in Cilician Armenia (especially Hromgla), developed the traditions in manuscript painting established in Jerusalem earlier in the century. The psalter's lavish and eclectic decoration testifies to the possibility that eastern Christians were employed in the scriptorium.

The Church of the Nativity in Bethlehem is a major pilgrim shrine dedicated to the Virgin. Both these aspects are reflected in one of the column paintings dated 1130,

which shows the affectionate Virgin and Child (known as the *Glykophilousa*), with the kneeling figures of two women and a man whose prayers are inscribed in Latin. Other portraits include the western saints Pope Leo, King Olaf of Norway and King Knut of Denmark, as well as an unidentified pilgrim wearing the badge of St. James of Compostela, all datable to before 1169 when the mosaics were completed. Some of the mosaic Christological scenes recur at Monreale in Sicily (also dedicated to the Virgin), positing direct artistic contact between the Holy Land and Sicily, contemporaneously with the influence of wall-painting in southern Italy.

Nazareth was another influential pilgrimage center, where capitals (1170s) from the Church of the Annunciation were rediscovered in 1908. The key to the iconography of their carved decoration lies with Christian responsibility for the defense of the Holy Land. Stylistically the capitals are closest to a carved capital at Plaimpied in the Rhône valley, suggesting that the artist was a Frank influenced by French ideas. The destroyed English Chapel of Our Lady at Walsingham, built between 1131–53, was planned as a reproduction of the House of the Virgin at Nazareth.

The first half of the 13th century saw an upturn in the fortunes of Latin settlement in the east. The Fourth

Above: King David Playing his Harp, *from the Psalter of Queen Melisende, 1130s–40s, (Ms. Egerton 1139, fol.23v, British Library).*

The lavish decoration of this manuscript, produced in the Scriptorium at the Holy Sepulchre, exemplifies royal paintings in the Latin kingdom in the 12th century.

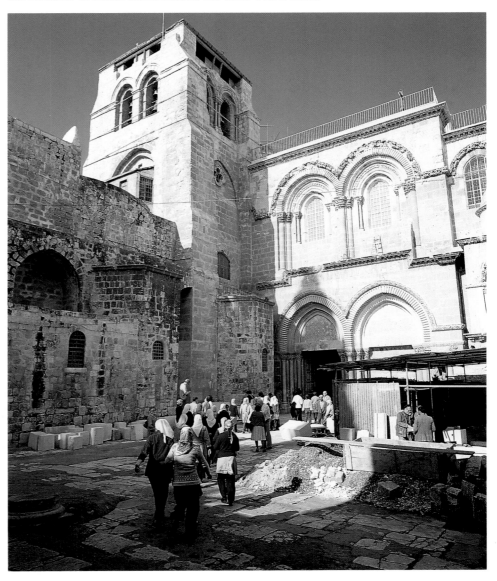

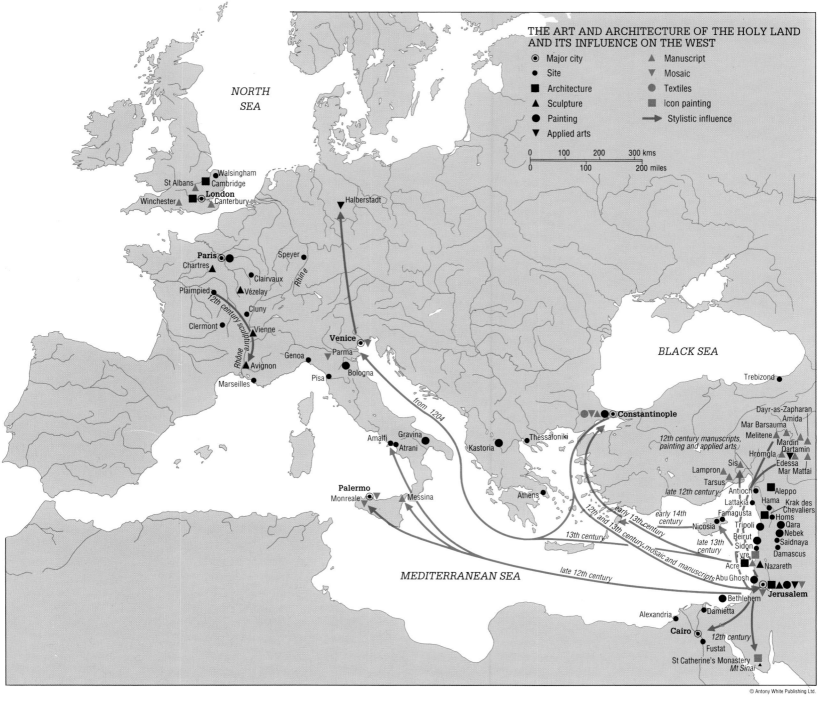

THE ART AND ARCHITECTURE OF THE HOLY LAND AND ITS INFLUENCE ON THE WEST

- ⊙ Major city
- ● Site
- ■ Architecture
- ▲ Sculpture
- ● Painting
- ▼ Applied arts
- ▲ Manuscript
- ▼ Mosaic
- ● Textiles
- ■ Icon painting
- → Stylistic influence

0 100 200 300 kms
0 100 200 miles

NORTH SEA

BLACK SEA

MEDITERRANEAN SEA

© Antony White Publishing Ltd.

Left: Church of the Holy Sepulcher, *South entrance, façade and courtyard, 12th century, Jerusalem.*

Founded by Constantine, the Church of the Holy Sepulchre was the most sacred site of Christendom. It was rebuilt by the Crusaders in the 12th century, notably with a new choir and a tall entrance façade on the south side. Stylistically it mixes the Romanesque of the west with native Levantine decorative detail.

Crusade, distracted from its aim, resulted in the sack of Constantinople. Treasure and relics were looted and transported to the West (e.g. the Byzantine enamels of the Pala d'Oro now in San Marco, and the reliquaries now in the Cathedral Treasury at Halberstadt). The outcome of Latin control of Asia Minor and Greece until 1261 is seen by the influence of contemporary French Gothic art and architecture in the East. For example, paintings uncovered during the excavations in the St. Francis Chapel at Kalenderhane Cami, in Istanbul, reveal stylistic similarities with the Arsenal Old Testament (Paris, Bibl. de l'Arsenal 5211), an illustrated bible in vernacular French, currently attributed to the patronage of St. Louis at Acre in the mid-13th century.

An important aspect of 13th-century art associated with the Crusades is icon painting, of which the major collection is that at St. Catherine's Monastery, Mount

Sinai. Despite being an attribute of eastern liturgical practice, their use was adopted by westerners. Amongst the icons of military saints is one with the kneeling pilgrim-donor, named in Greek (presumably the language of the Orthodox artist) as George of Paris. From Kastoria in Frankish Greece and now in the Byzantine Museum in Athens, is a wooden relief of the standing St. George, flanked by scenes of his life, another demonstration of the belief in the efficacy of eastern military saints. Other 13th-century icons were made in the Muslim areas of Egypt and Syria, the latter with its cult center of Saidnaya with its old and revered icon of the Virgin and Child, and artistic contacts with the Latin port of Tripoli. However, once the end came for the Latin Syrian coastal settlements in 1291 the impetus moved to Cyprus, and – from the early 14th century – Rhodes.

Norman Sicily

Arguably no other region of 12th-century Europe shows a level of cultural diversity comparable to Sicily. Its geographical situation, poised between the Western, Byzantine and Islamic worlds, enabled it to act as a channel through which the artistic richness of Byzantium and the Islamic world gained wider appreciation and influence in northern Europe. The catalyst in this process was the arrival of the Norman invaders, who throughout the 12th century produced an art and architecture which drew together many hitherto disparate elements of mediterranean and levantine design.

The Norman conquest of Sicily began in 1060, and the in following year Count Roger de Hautville (1031–1101) with only a small army took Messina. By the end of the 11th century the island was entirely controlled by the Normans, who ruled until Sicily became part of the German Empire of Henry VI of Swabia in 1194. Henry VI (1165–97) claimed the island in the name of his wife Constance, daughter of Roger II (c. 1093–1154) who had been crowned king of Sicily in 1130.

The Norman genius, as elsewhere in Europe, permitted existing cultures to flourish. From the second generation of Norman rule Byzantine, Islamic and Norman Romanesque traditions were combined to create a remarkable level of cultural heterogeneity, producing monuments of originality and great beauty. Artistic fashions were set by the royal court, the taste of which produced both secular and ecclesiastical buildings amongst the most sumptuous monuments of 12th-century Europe. Their richness is largely manifested in the use of mosaic decoration, the work of Byzantine artists brought to the island by Norman patrons keen to exploit the rich artistic traditions of the East. The cathedrals of Cefalù (begun 1131) and Monreale (1174–82), and the Cappella Palatina (Palatine Chapel) at Palermo (1129–43) are among the greatest achievements of Norman Sicily. With walls designed to give maximum space for mosaics, their interiors are enlivened by the changing effects of light, producing an impression of overpowering religious drama. This quality is also created by the organization of the iconography, with overall emphasis placed on a dominating central scene such as Christ as Pantocrator, as at Cefalù and Monreale.

The general influence of Romanesque architecture can be clearly seen in the plans of the cathedrals of Cefalù, Messina (completed by Roger II but largely destroyed by earthquake in 1908), Monreale and Palermo (completed 1185). During the 12th century Greek Orthodox churches and mosques also continued to be built. La Martorana in Palermo (completed 1143), which is of Byzantine design and was dedicated to Theotokos, was built by Admiral George of Antioch (d.1151), an influential figure at the court of Roger II. The Normans were also happy to construct secular buildings of almost purely Islamic character, such as the palaces of La Zisa and La Cuba in Palermo. Undiluted Islamic influence is also evident in the elaborate inlaid decoration of the exterior of Monreale Cathedral and the intricate wooden honeycomb ceiling of the Cappella Palatina.

The sculpture of the cloisters of Cefalù and Monreale

shows parallels with the strongly classicizing styles of Romanesque sculpture in southern Italy; the direct influence of the Antique can be seen in the porphyry royal tombs at Monreale and Palermo.

The art and architecture of Norman Sicily reflected the position of the island between East and West – drawing on sources that were at once classical Greek and Roman, Byzantine and Muslim. The Normans here, as in Northern Europe, demonstrated an ability to provide the political background for an advanced and flourishing international culture. In Sicily this created the society which was to reach further heights of achievement in the following century, both in the decorative arts and in the poetry of the *Scuola Siciliana*.

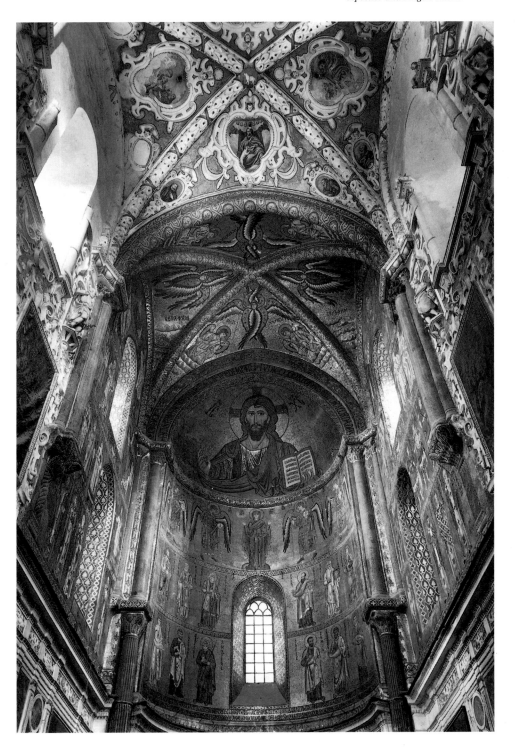

Below: *Mosaics in the choir and apse,* Duomo, *Cefalù, 12th century.*

Built on a basilican plan, without a dome, the traditional Byzantine mosaic of the Christ Pantocrator (the all powerful Creator) had to be placed in the apse. Christ is portrayed as youthful and above all humane – as are the Virgin, Apostles and Angels below.

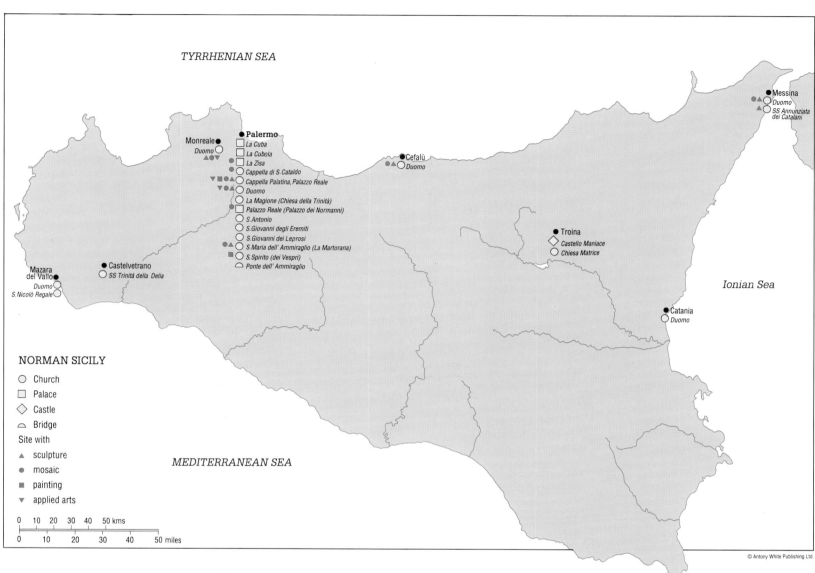

TYRRHENIAN SEA

Messina
▲▲ ○ *Duomo*
▲▲ ○ *SS Annunziata dei Catalani*

Monreale ●
Duomo ○
▲● ▼

Palermo
□ *La Cuba*
□ *La Cubola*
● ○ *La Zisa*
○ *Cappella di S.Cataldo*
▼ ■ ● ▲ ○ *Cappella Palatina, Palazzo Reale*
▼ ▲▲ ○ *Duomo*
○ *La Magione (Chiesa della Trinità)*
□ *Palazzo Reale (Palazzo dei Normanni)*
○ *S.Antonio*
○ *S.Giovanni degli Eremiti*
○ *S.Giovanni dei Leprosi*
▲● ○ *S.Maria dell' Ammiraglio (La Martorana)*
■ ○ *S.Spirito (dei Vespri)*
⌒ *Ponte dell' Ammiraglio*

● ○ *Cefalù*
▲ ○ *Duomo*

● *Troina*
◇ *Castello Maniace*
○ *Chiesa Matrice*

Ionian Sea

Mazara
del Vallo ●
Duomo ○
S.Nicolò Regale ○

● *Castelvetrano*
○ *SS Trinità della Delia*

● *Catania*
○ *Duomo*

NORMAN SICILY

○ Church
□ Palace
◇ Castle
⌒ Bridge

Site with

▲ sculpture
● mosaic
■ painting
▼ applied arts

0 10 20 30 40 50 kms
0 10 20 30 40 50 miles

MEDITERRANEAN SEA

© Antony White Publishing Ltd.

Right: *Mosaic,* Rebecca at the Well, *nave of Abbey Church, Monreale, before 1183.*

The Abbey Church of Monreale was built at great speed by William II between 1174 and 1183. It was decorated with mosaics in the Byzantine tradition representing a history of the Christian religion.

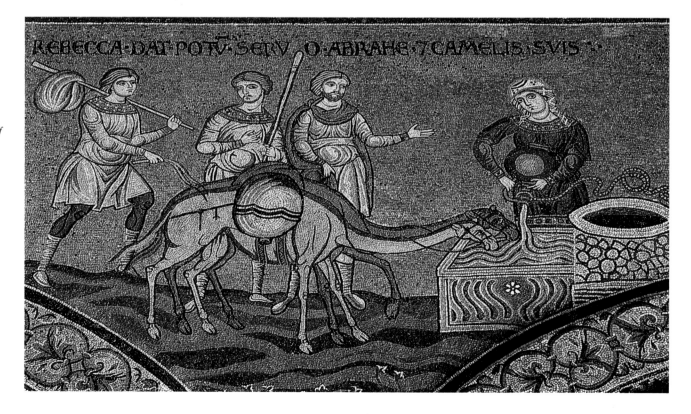

The Art of the Pilgrimage Routes

There were many places of Christian pilgrimage in the Middle Ages, but three stood out above all others: Jerusalem, Rome and Santiago de Compostela. The attraction of the first two is obvious – one was the scene of Christ's Passion and the other the capital of the western Church – but the importance of Santiago de Compostela needs some explanation. "Santiago" is the Spanish form of "St. James", and the St. James in this case is James the Greater, one of the twelve Apostles. He was beheaded in Jerusalem in about A.D. 44 (the first of the Apostles to suffer martyrdom and the only one whose death is recorded in the New Testament); then, according to legend, his body was put on a ship that – without rudder or sail – miraculously bore it to Spain. After many marvelous events the body was buried, but all memory of the hallowed spot was lost during barbarian invasions. In 835, so the story continues, Theodomir, Bishop of Iria, discovered the tomb, being guided there by a star (the name Compostela is said by some authorities to derive from the Latin *campus stellae* – "plain of the star").

By 713 the Moors had conquered most of Spain, and the discovery of the saint's remains in the small area that still remained Christian provided a rallying point for the Reconquista – the campaign to drive the Muslims out of the country. At a battle at Clavijo, alleged to have taken place in 844, a vision of St. James mounted on a white charger is said to have inspired the Christians to rout the enemy; he was dubbed *Matamoros* "Moor-slayer" and "Santiago!" became the battle cry of the Spaniards. As the cult grew, James was seen not only as the champion (and patron saint) of Spain, but also as the defender of all Christendom against the threat of the infidel.

A chapel was erected over St. James's tomb soon after its discovery and a more substantial church was begun in 868, but this was destroyed by the Moors in 997. The saint's relics were unharmed, however, and a splended new cathedral was begun in 1078, the building being consecrated in 1211 (extensions and alterations continued to be made until the 18th century, when the ornate Baroque west front was added). A local pilgrimage to the shrine is recorded as early as 844, and by the 11th century men and women flocked to the shrine in such numbers from all over Europe that the roads seemed crowded with as many people as there were stars in the heavens – the popular Spanish phrase for the Milky Way is *El Camiño de Santiago* "The Road to Santiago". These people needed accommodations and facilities for worship on their long journeys; and the wealth that they generated enabled churches to be built or rebuilt at the major stopping points – places that were often important shrines themselves.

Four routes to Santiago were particularly popular, their starting points being at Paris, Vézelay, Le Puy and Arles. These four routes were described by a 12th-century priest in a manuscript now known as the Pilgrim's Guide; it gives an account of the shrines along the way and ends with a commentary on the cathedral of Santiago as it was in about 1130. On each of these four routes there was one church that stood out above the others for size and splendor – at Conques (St. Foy), Limoges (St. Martial), Toulouse (St. Sernin) and Tours

(St. Martin). Although they vary greatly in detail, these "pilgrimage churches" are similar in conception to Santiago Cathedral – large and spacious to accommodate the throngs of pilgrims (although St. Foy at Conques is not as huge as the others), with a long nave, broad transepts, an ambulatory at the east end to allow easy circulation around the building, and numerous chapels for worship and the display of relics. They all have (or had, for St. Martial in Limoges and St. Martin in Tours have been destroyed) barrel vaults and rich sculptural decoration. Of all the sacred treasures these churches contained, the most famous is at Conques – the golden reliquary of St. Foy (St. Faith in English), whose remains were acquired by the monks there in the late 9th century. The reliquary was made about a century later and takes the form of a full-length life-size figure of the saint seated on a throne. The head is a re-used late Roman ceremonial helmet into which enameled eyes have been set, and the figure is studded with precious stones presented by pilgrims in honor of the saint over the centuries.

Three of the four great routes to Santiago converged on the pass at Roncesvalles to cross the Pyrenees; the other, southernmost route crossed at Somport and joined the others at Puente-la-Reina. From here they all took the same road, passing through Burgos, León and Villafranca (although in the early days a northern route via Oviedo was sometimes adopted). There were hostels about every 20 miles along the roads – a convenient day's travel – and pilgrims were protected by civil and ecclesiastical laws. The outward and return journey might take anything from four months (some English priests, for example, were allowed 16 weeks' leave of absence to visit Santiago) to two years or even more, depending on how long was spent at particular shrines. Pilgrims to Santiago traditionally wore a scallop shell badge; the origin of this device (which is often seen in portrayals of St. James) is obscure.

Above: *Jost Amman (1539–91):* Two Pilgrims on their way to Santiago de Compostela, *1568, woodcut from the* Panoplia Omnium Artium, *printed in Nuremburg.*

Jost Amman's popular woodcut illustration shows that the pilgrimage was still popular in the 16th century. Note the scallop shells which identify the travelers as pilgrims.

Below: Tympanum of the central portal, c.*1118, the Abbey Church at Vézelay.*

One of the greatest masterpieces of medieval relief sculpture. The Savior is shown transmitting his redeeming grace to all the world; St. John the Baptist is on the median jamb and the apostles are set above the lateral columns.

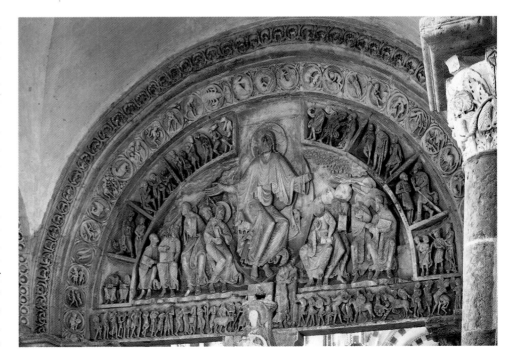

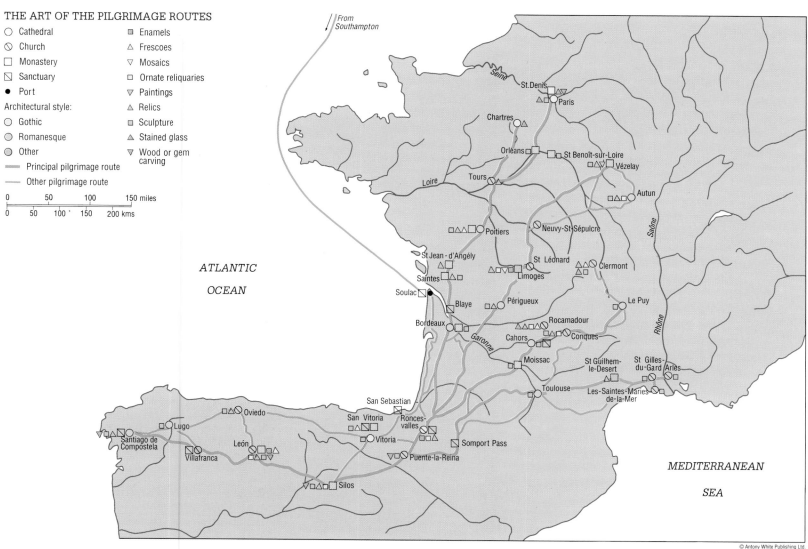

Legend:

- ◯ Cathedral
- ◔ Church
- ▢ Monastery
- ◨ Sanctuary
- ● Port

Architectural style:
- ◯ Gothic
- ◔ Romanesque
- ◕ Other

— Principal pilgrimage route
— Other pilgrimage route

- ▢ Enamels
- △ Frescoes
- ▽ Mosaics
- ▢ Ornate reliquaries
- ▽ Paintings
- △ Relics
- ▢ Sculpture
- △ Stained glass
- ▽ Wood or gem carving

0 50 100 150 miles
0 50 100 150 200 kms

From Southampton

ATLANTIC OCEAN

MEDITERRANEAN SEA

St.Denis
Paris
Chartres
Orleans
St Benoît-sur-Loire
Vézelay
Tours
Autun
Neuvy-St-Sépulcre
Poitiers
St Jean - d'Angély
St Léonard
Clermont
Saintes
Limoges
Soulac
Blaye
Périgueux
Le Puy
Rocamadour
Bordeaux
Cahors
Conques
Moissac
St Guilhem-le-Desert
St Gilles-du-Gard Arles
Toulouse
Les-Saintes-Maries-de-la-Mer
San Sebastian
San Vitoria
Ronces-valles
Oviedo
Lugo
Vitoria
Somport Pass
Santiago de Compostela
León
Puente-la-Reina
Villafranca
Silos

Seine
Loire
Saône
Rhône
Garonne

© Antony White Publishing Ltd.

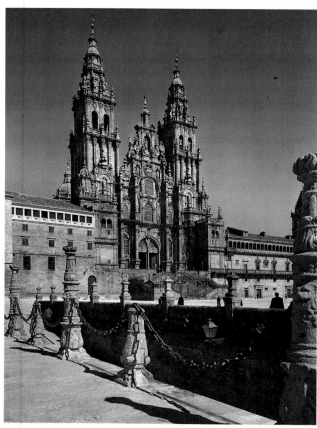

Far right: Detail from the Portico de la Gloria, *Santiago de Compostela.*

The portal sculptures, installed between 1168–88 by Master Matthew, are a late flowering of beautiful pilgrimage sculpture, freely inspired by the Cluniac portal at Vézelay.

Right: The cathedral of Santiago de Compostela, c.*1075–1211.*

The western façade is flanked by the relatively simple structures of the archbishop's palace (north) and the cloister edifice (south). The much later façade is 524 feet (160 meters) in width – a fitting reception for the multitudes of pilgrims.

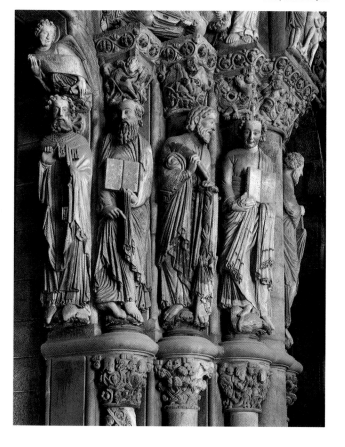

Cistercian Architecture

By 1100 the relatively comfortable life offered by well-established Benedictine monasteries failed to satisfy many who wished to pursue a more stringent monastic vocation. In various corners of Europe (and particularly in France) religious settlements appeared which provided greater seclusion and the opportunity for more rigorous observance. Out of this period of eremitical fervor came several new "orders", based on the monasteries at La Grande Chartreuse (1084), Grandmont (1076), Cîteaux (1098), Tiron (1105), Savigny (1116), Prémontré (1120), Sempringham (1131), and so on. The most successful of these was Cîteaux. During the 12th century, Cistercian influence spread rapidly across Europe, regardless of political boundaries, and by the end of the Middle Ages almost 750 monasteries were affiliated to the order.

The success of the Cistercians was based on an efficient system of government, built around an annual meeting of the abbots at Cîteaux. Each community was founded from a mother house, creating a series of "dynasties", ultimately dependent on the early houses at Cîteaux (1098), La Ferté (1113), Pontigny (1114), Clairvaux (1115) and Morimond (1115). Within the larger groups there were many sub-families, like that of Mellifont in Ireland or Aumône in France, the latter monastery having an extensive affiliation in England. Although the distribution of the families overlapped, the map illustrates the dominant position of Clairvaux (355 houses), especially in Britain and Spain, a dominance which is largely explained by the inspired leadership of St. Bernard, abbot of Clairvaux between 1115 and 1153. It also shows the extent of Morimond's colonization in Germany and eastern Europe. The reputation of the Cistercians as effective farmers, together with their willingness to accept previously uncultivated land, made them particularly attractive to potential benefactors on the fringes of feudal Europe, such as Poland or Ireland.

The art-historical interest of the Cistercians centers on the extent to which their buildings reflected the ethos of the order, with its stress on simplicity and austerity. The abbey churches, or "workshops of prayer" as the monks called them, often had a utilitarian flavor, with the beauty of the building residing in well-judged proportions and good-quality masonry. In contrast to other orders, the Cistercians developed clear views about the role of art and architecture, and a series of statutes proscribed painting and sculpture (1122/35), along with stone bell towers (1157) and multi-colored glass windows (1159). This legislation was essentially negative in character, amounting to a series of attempts (often unsuccessful) to halt the spread of "superfluities" and decorative excesses which, it was argued, were contrary to the monastic vocation. The Burgundian church of Fontenay (consecrated 1147) fulfilled the ideals of the order in a striking manner and is thought to reflect architectural thinking at Clairvaux and Cîteaux (both destroyed).

The Burgundian origin of the Cistercians ensured that in the middle years of the 12th century some Burgundian techniques, such as the rectilinear planning of the churches or the preference for pointed barrel-vaulting,

spread to daughter houses elsewhere in Europe. Nevertheless, Cistercian monasteries were mostly built in local styles. What made the buildings identifiable as Cistercian was a manner rather than a style, a degree of reticence and restraint which becomes obvious when they are compared with neighboring cathedral designs. The wealth acquired by the order ensured that some churches – Altenburg in Germany, for example, or the choir of Rievaulx in England – became almost indistinguishable from the most sophisticated monuments of their day. Although their building was often far from progressive, there is no doubt the Cistercians helped to break down the cultural barriers of Europe and to spread Gothic styles to some of its more remote outposts.

Below: The Abbey Church of Sénanque, *second half of the 12th century, Vaucluse.*

An example of the spread of Cistercian building south to Provence. This abbey is situated in a remote mountain valley in Vaucluse. The church is designed around a nave with aisles, and a semi-circular apse and large transepts, seen here from the exterior.

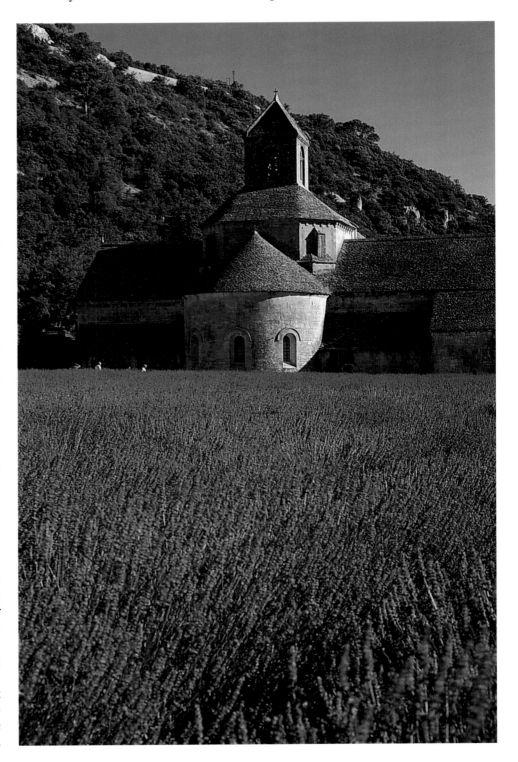

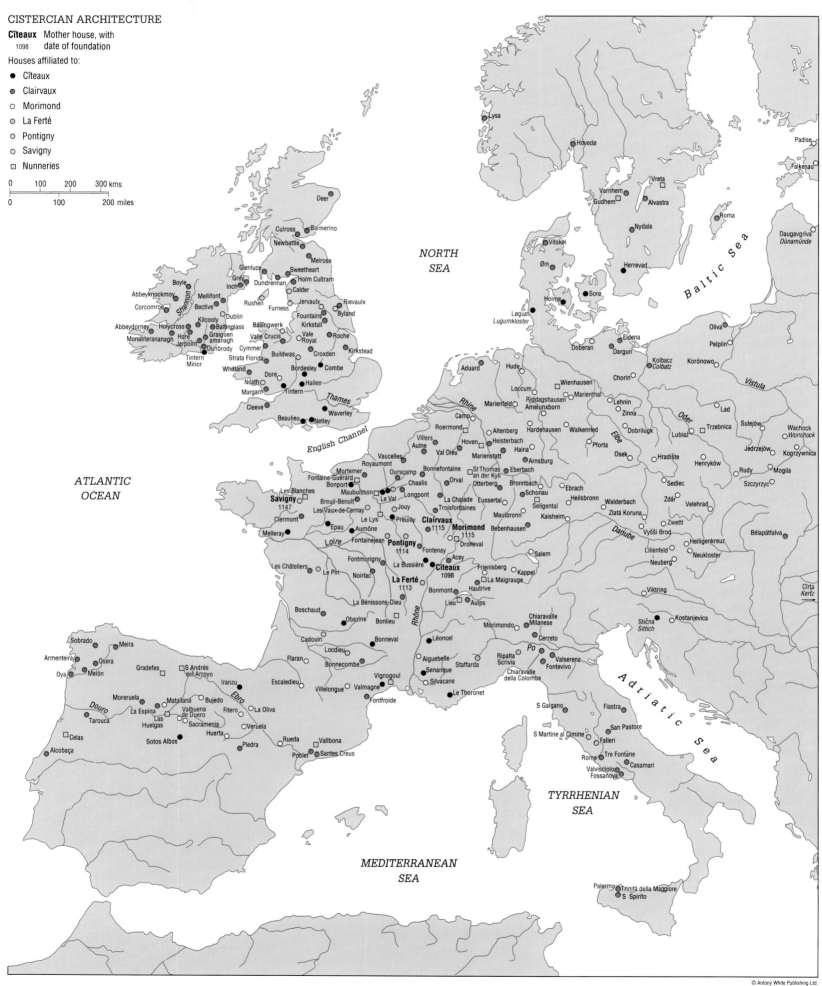

Romanesque Mural Painting and Manuscript Illumination

Romanesque painting is characterized by its diversity. Itinerant artists, losses through redecoration, war and misfortune leave an unbalanced picture. In Sicily a few relatively poorly published survivals are supplemented by the most influential Byzantine mosaic programs in Europe (the Capella Palatina, the Martorana, and Monreale, all in or near Palermo, and Cefalù). In southern Italy, the influence of the great monastic scriptorium of Monte Cassino can be seen in the murals at S. Angelo in Formis and later at S. Maria della Libera in Foro Claudio and S. Maria Maggiore in Pianella.

Rome remained a conservative center whose influence is seen at S. Elia in Nepi and S. Pietro in Tuscania. By 1100 new Byzantine types were being used in Rome (S. Clemente, the Scriptorium of S. Maria in Trastevere and S. Croce in Gerusalemme). Sicilian influences can be found at S. Silvestro in Tivoli. Romans traveled to Umbria (Ferentillo) and the artist of the SS. Quattro Coronati in Rome is also found at Anagni Cathedral. Few fragments survive in Tuscany (Pistoia, Lucca and Pisa, now Museo Civico), but Pisan artists left works in Sardinia (Saccaragia). In Emilia, the Baptistery at Parma may reflect the influence of Byzantine art through lost Genoese intermediaries; the same workmanship may have traveled as far as Aime in Savoy. That Milan must have been a center is suggested by survivals at Galliano and Novara. These and the great cycle at Civate (S. Pietro al Monte, c.1095) can be related to the Master of Pederet in Catalonia. The few later survivals include Novate and S. Giorgio in Como, c.1152–90. In Piedmont, Aosta and Ravello indicate further links with Catalonia, while in the Veneto, Aquileia and S. Fosca near Pola (Pula, Croatia) are typical of a pre-Veneto-Byzantine phase before Venice became predominant by the end of the 12th century. Verona may have acted as a link between the Veneto and Salzburg; Burgusio and Müstair show signs of a combination of northern and Byzantine styles, although Zillis (Switzerland) remains completely Northern in approach.

Attempts to clarify the stylistic situation in France have been misleading. At Le Puy, Brioude and Lavaudieu, a sub-Italo-Byzantine style can be found in the late 11th century while Berzé-la-Ville suggests connections with the scriptorium of Cluny and does not relate well to other Burgundian works. Most survivals are found in the lower Loire, Touraine, Poitou, Anjou and Berry. Stained glass in the Cathedral of Le Mans suggests a connection with St. Gilles-Montoire. North of Poitiers, St. Nicholas-Tavant is part of a group in the Berry-Burgundy area. A later phase is represented by St. Jean-du-Liget in Chamille-sur-Indrois. Most late developments are represented by survivals of stained glass in the Anjou, Maine and Orléannais areas: Montmorillon (c.1200) is one of the most significant survivals. In the south, key works have been lost: St. Sernin in Toulouse is the only survival of the first quarter of the 12th century. In the Pyrenees St. Plancard shows Catalan links and Rousillon (Rusellon), Fenouillar and L'Ecluse (La Clusa) are more properly considered with Catalonia.

Both wall and panel painting have survived well in Catalonia but much has been lost in other areas. The Barcelona area is represented by late survivals by the Master of Espinelvas, the Master of Polina and the Master of Barbara. In the West the work at León again shows strong French influences during the 1165–1200 period. The Sala Capitular at Sigena (Huesca) is another instance of an English artist working in other parts of Europe; he may have originated at Winchester.

Painting in England during this period is largely known through the great monastic centers of manuscript illumination (Canterbury, Winchester, Bury St. Edmunds and St. Albans). Important wall-paintings have survived in St. Gabriel's Chapel and St. Anselm's Chapel, Canterbury, and recent discoveries at Winchester and Norwich have clarified the 12th-century material. The artist of the Lambeth Bible must also have worked in Flanders (Lissies).

Links with Sicily are also found in the Mosan region at Tournai Cathedral. The so-called *weichfliessende Stil* is more locally based and can be found at Cologne, Schwarzrheindorf, Brauweiler and Essen. In North and Central Germany the scriptoria of Fulda, Corvey, Helmarshausen, Halberstadt and Hildesheim provide evidence for lost murals. The Helmarshausen style can be found at Idensen (1120–30) and reached as far as Denmark and Sweden. Hersfeld shows more direct contacts with Byzantine art and the artists of Quedlinburg Castle knew Italian models. In southwest Germany and Swizerland, St. Gall, Strasbourg and Weingarten were also centers. The late Ottonian phase of Reichenau is reflected in several Swiss survivals. Salzburg was the most important center for Austria where the Nonnberg preserves late 12th-century murals.

Above: Christ in Majesty *(Pantocrator)* with Angels and symbols of the Evangelists, *fresco, c.1123, S. Clemente de Tahull, Catalonia..*

The style of the S. Clemente master has strong links with both fresco and manuscript painting in southwest France, as well as with the Mozarabic style. It is thought that he was Aragonese and that he also worked at Huesca.

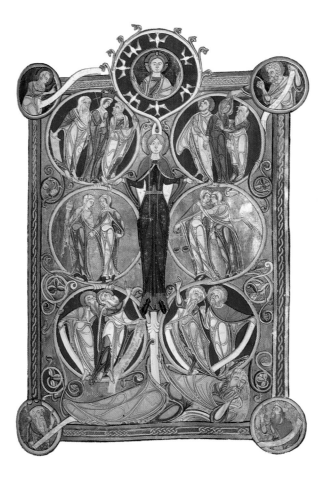

Left: The Tree of Jesse, *from the Lambeth Bible, English manuscript, c.1140–50 (Lambeth Palace Ms.3 fol.198, London).*

English 12th-century manuscripts of the highest quality were produced in monastic scriptoria such as Canterbury, Winchester, Bury St. Edmunds and St. Albans. There are clear stylistic links with Spain, Sicily and (with the illumination of the Lambeth Bible) Flanders.

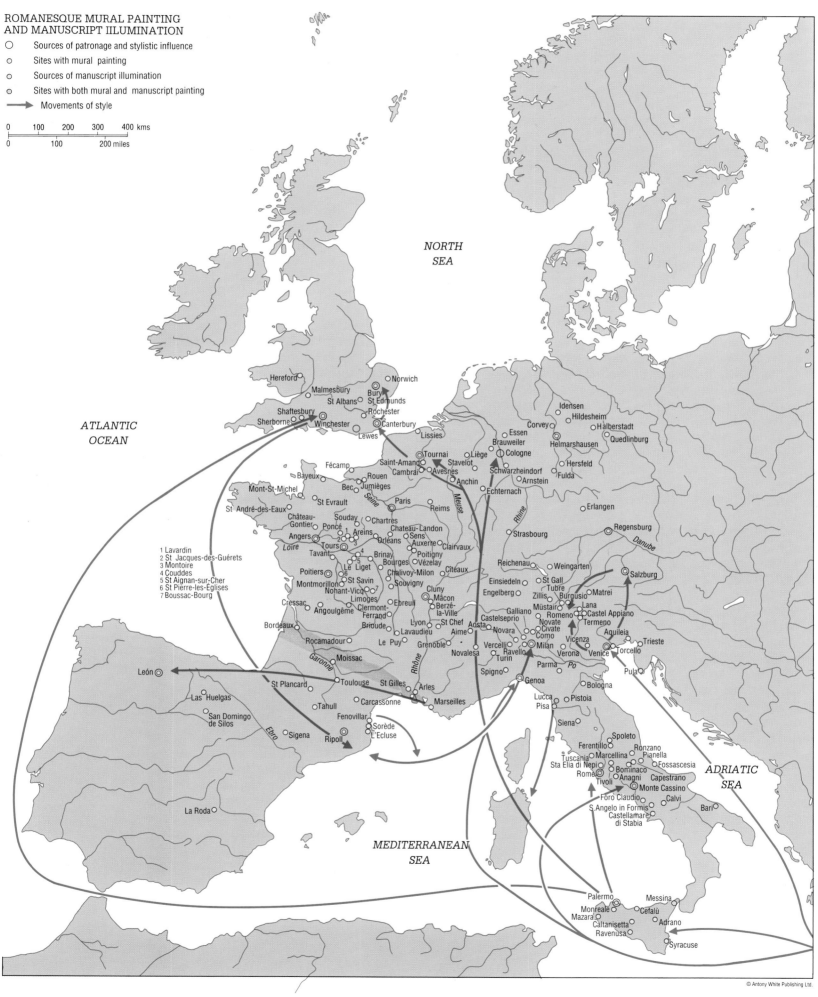

ROMANESQUE MURAL PAINTING AND MANUSCRIPT ILLUMINATION

○ Sources of patronage and stylistic influence
○ Sites with mural painting
○ Sources of manuscript illumination
◎ Sites with both mural and manuscript painting
→ Movements of style

0 100 200 300 400 kms
0 100 200 miles

NORTH SEA

ATLANTIC OCEAN

Hereford
Malmesbury
St Albans Bury St Edmunds
Shaftesbury Rochester
Sherborne Winchester Canterbury
Lewes

Idensen
Corvey Hildesheim
Essen Halberstadt
Brauweiler Helmarshausen Quedlinburg
Cologne
Liège Hersfeld
Schwarzheindorf Fulda
Arnstein
Echternach
Erlangen

Lissies
Saint-Amand Tournai Stavelot
Cambrai Avesnes Anchin

Fécamp
Bayeux Rouen
Mont-St-Michel Jumièges
Bec
St Evrault
St André-des-Eaux
Château-Gontier Souday Chartres
Poncé Orléans
Angers Tours Château-Landon
Loire Sens
Tavant Brinay Auxerre Clairvaux
Poitigny
Poitiers Le Liget Bourges Vézelay Cîteaux
Montmorillon St Savin Chalivoy-Milon Cluny
Nohant-Vicq Souvigny Mâcon
Limoges Ebreuil Berzé-la-Ville
Cressac Clermont-Ferrand
Angoulême Brioude Lyon St Chef
Bordeaux Le Puy Lavaudieu Aime
Rocamadour Grenoble
Garonne Moissac Novalesa

Reims
Meuse
Rhine
Strasbourg
Regensburg
Danube

Reichenau Weingarten
Einsiedeln St Gall Salzburg Matrei
Engelberg Tubre Burgusio
Zillis Müstair Lana Castel Appiano
Galliano Romeno Termeno
Castelseprio Novate Civate
Novara Como Aquileia Trieste
Vercelli Vicenza Venice Torcello
Aosta Milan Verona Pula
Turin Ravello
Spigno Parma Po
Genoa Bologna
Lucca Pistoia
Pisa
Siena

1 Lavardin
2 St Jacques-des-Guérets
3 Montoire
4 Couddes
5 St Aignan-sur-Cher
6 St Pierre-les-Eglises
7 Boussac-Bourg

León
Las Huelgas
San Domingo de Silos
St Plancard
Tahull
Fenovillar
Sorède
L'Ecluse
Toulouse St Gilles Arles
Carcassonne Marseilles
Sigena Ripoll
Ebro
La Roda

MEDITERRANEAN SEA

ADRIATIC SEA

Spoleto
Ferentillo Ronzano Pianella
Tuscania Marcellina Fossascesia
Sta Elia di Nepi Bominaco Capestrano
Rome Anagni
Tivoli Monte Cassino Calvi
Foro Claudio
S. Angelo in Formis Castellamare di Stabia Bari

Palermo Messina
Monreale Cefalù
Mazara Adrano
Caltanisetta
Ravenusa Syracuse

© Antony White Publishing Ltd.

105

Romanesque Metalwork and Related Arts

Most of the surviving metalwork from the Romanesque period (roughly 1000–1200) was made for ecclesiastical purposes. Religious reforms instigated by the monks of Cluny led to a much greater demand for liturgical vessels and ornament – the Cluniacs encouraged long church services, rich in ceremony. Apart from eucharistic vessels, golden altar frontals, jewelled book-covers, candelabra and bronze doors were made. The cult of relics was also expanding, with many elaborate shrines being constructed to serve as the focus for pilgrimages.

The distribution of surviving objects depends on several factors, not least the fortunes of war and religious change. The location of ore and access to rivers for transport was significant, particularly in the development of the outstanding metalworking industries in the Sambre-Meuse-Rhineland area. When Abbot Suger (1122–51) was adorning the royal abbey of St. Denis he had to call in metalworkers from Lotharingia (i.e. Sambre-Meuse).

Theophilus Presbyter, probably the pseudonym for Roger of Helmarshausen (*fl.*1100), wrote the foremost medieval treatise on metalworking and other artistic techniques. His account is based on practical experience as he describes how to set up a workshop, how to make tools, and how to execute all the techniques employed by Romanesque metalworkers, such as wire drawing, engraving, soldering, applying niello, enamelling and casting. Roger used many of the same techniques himself on the two altars at Paderborn.

A soft classicizing style of figurative metalwork, called Mosan, developed in the Sambre-Meuse valley. A magnificent early example is the bronze font (1107–18) of St. Bartholomew of Liège, made by Rainer of Huy (11th–12th centuries). Rainer's classicising influence pervaded the 12th century and is found on the shrine of St. Hadelin at Vise. The description of Suger's great Mosan crucifix foot made for St. Denis (destroyed) shows that it was very similar to the cross base of St. Bertin (now St. Omer). With Nicholas of Verdun (pre-1150–*c.*1217), the "Transitional" style emerged from the Mosan area. The style is characterized by a graceful naturalism and is first seen on the Klosterneuburg altar frontal (1181), made of 45 enamel plaques of Old and New Testament scenes. Nicholas also made part of the impressive shrine of the Three Kings at Cologne (1170–1230) and the shrine of St. Mary, Tournai Cathedral (1205).

Massive figurative bronze doors, deriving from Roman prototypes, are an important feature of Romanesque metalwork. The doors from Plock (1141; now in Novgorod) were cast at the important bronze workshop in Magdeburg and close comparisons with S. Zeno Maggiore, Verona (1138) and with objects at Klosterneuberg and Hamburg suggest these also had the same source. The Gniezno doors (after 1127) show many stylistic similarities with the Sambre-Meuse region and were probably designed by artists from the West. In Italy a group of bronze doors was either made by Byzantine craftsmen or transported as completed plaques from the Byzantine Empire. They are now to be found at Amalfi, Atrani, Montegargano and S. Marco, Venice.

Metalwork in the Weser area was dominated by the lavish patronage of Henry the Lion (1129–95). Outside his castle in Brunswick he placed a monumental bronze lion (1166); he had a reliquary of Emperor Henry II made, embellished with figures of saintly kings (Louvre, Paris); he brought back several more relics from his trip to Constantinople in 1173 and five arm reliquaries were made for these, in silver, gold and jewels. He may also have given the niello and engraved chalice to Trzemezno as he had close diplomatic connections with its patrons in the Polish royal family (Gniezno Cathedral). The head reliquary of St. Oswald (Hildesheim Cathedral) is decorated with the images of many English kings but they are depicted in the eclectic style of north Saxony. The Gloucester candlestick (1104–13, Victoria and Albert Museum, London) is made of cast bronze-gilt openwork in an English style but it derives its shape from the Bernward candlesticks at Hildesheim.

Apart from the ostentatious and eclectic patronage of Abbot Suger, of which little survives, France lacked major metal workshops until the end of the 12th century. Then the prolific industrial production of Limoges enamels began to supply relatively cheap but decorative ornaments to poorer churches throughout Europe. The cultural unity of north Spain and south-west France makes it hard to establish where the workshops began, but they may have moved between Silos and Limoges.

Norse traders provided the main source of ivory in the Romanesque period as trade with Africa and India was restricted by the Arabs. Walrus ivory was frequently used to make ivory plaques for jewelled book-covers. Christianity took the pennant design from Viking ships to make the Scandinavian open-work weathervanes for churches, like the one from Tingelstad.

The Romanesque period was one of great cultural expansion and its art flourished with the dynamic exchange of ideas and designs.

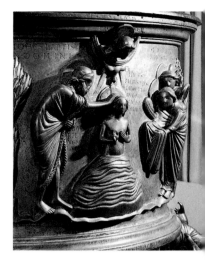

Above: *Rainer de Huy,* Baptismal Font, *bronze, 1107–18 (St. Barthélemy, Liège).*

Rainer was a goldsmith from the Meuse area (Mosan). Carving and metalwork in this area were encouraged by Abbot Suger of St. Denis and Wibald Stavelot, and showed a gentle classicizing figurative style.

Below: Tingelstadt Weathervane, *bronze, 11th century (Universitets Oldsaksamling, Oslo).*

A typical bronze Scandinavian weathervane, with a perforated zoomorphic Viking pattern.

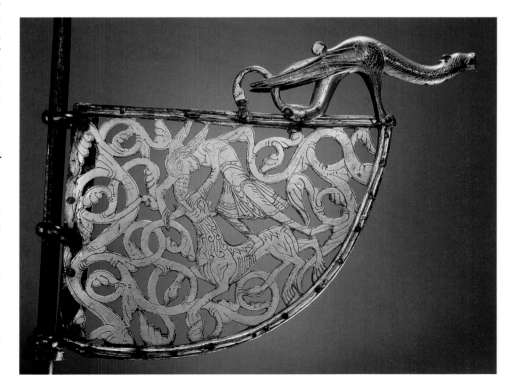

ROMANESQUE METALWORK AND RELATED ARTS

- ⊙ Center of patronage
- ● Site
- **Cu** Copper
- **Pb** Lead
- **Ag** Silver
- **Sn** Tin
- **Zn** Zinc ore (calamine)
- → Stylistic influences
- → Trade route

0 100 200 300 kms
0 100 200 miles

North Sea

BALTIC SEA

Cu
Falun

Lisbjerg

Lyngsjö

Durham

Pb
Ag

Hamburg

Brunswick

Hildesheim

Weser

Gloucester

Bury St Edmunds

Winchester

Canterbury

Sn

ATLANTIC OCEAN

English Channel

St Bertin

Tournai

Rhine

Paderborn

Cologne

Helmarshausen

Goslar

H A R Z

Magdeburg

Gniezno

Trzemeszno

Płock

Liège

Cu Ag

Elbe

Oder

Seine

St Denis

Paris

Meuse

Walrus ivory and whalebone from Norway and Greenland

Loire

Danube

Klosterneuburg

Cluny

St Maurice d'Agaune

A L P S

Limoges

Rhône

Milan

Verona

Venice

León

Po

Burgos

Silos

Arab gold and oriental gems

P Y R E N E E S

Pisa

Rome

Arab gold and oriental gems (rubies sapphires pearls)

Monte Gargano

Tyrrhenian Sea

Atrani

Amalfi

MOSAN AREA

Meuse

Cologne Deutz

Zn

Rhine

Aachen

Visé

Liège

Huy

Zn

Stavelot

Sambre

Dinant

Meuse

St Hubert

Trier

MEDITERRANEAN SEA

© Antony White Publishing Ltd.

107

Gothic Art and Architecture

The Gothic period in European art and architecture lasted from the early 12th century until the mid-15th century, although it continued later in some areas of Europe where the influence of the Renaissance took longer to arrive. The name Gothic, an insult, implied crudeness and lack of learning – but in fact Gothic art represented the flowering of the Middle Ages in Europe, an art that was Christian in aspiration with a technique, especially in architecture, that triumphantly solved the problems posed by the search for height, lightness and decoration in church building.

Gothic architecture was characterized by the use of the pointed arch, the rib vault and the flying buttress. Born near Paris at the Abbey of St. Denis in the 1140s under the patronage of Abbot Suger, it had spread through Europe within a hundred years, producing building of soaring height with magnificent complex decorative schemes of sculpture and vast areas of stained glass. A wide diversity of national style also emerged, particularly in France, England, Germany and Spain.

Manuscript illumination, metalwork and jewelry also flourished with expressive narrative scenes both of religious and secular courtly subjects. The technical virtuosity was often of the highest quality and originality.

Right: The Meeting of Tristan and Iseult, *from the* Roman des Chevaliers Galaad, Tristan et Lancelot, *early 15th century (Musée Condé, Chantilly, France).*

Below: Abbey Church of St. Denis, *interior view of nave looking east, c.1135–55, St. Denis, France.*

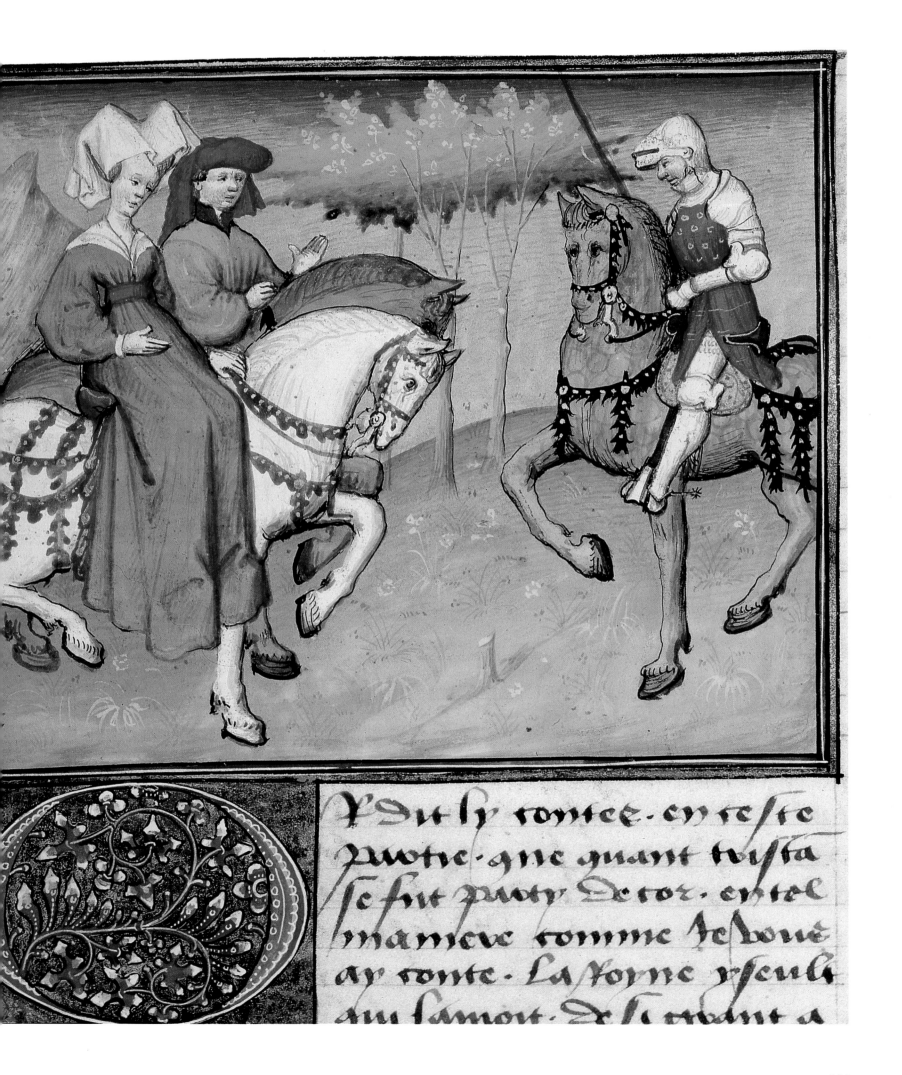

Y Du ly contee · en reste
puotie · ene quant tusta
se fut puoir de cor · en tel
maniere comme Je voue
ay conte · La royne rseuli
au samour · de so ouant a

The Île de France and the Creation of the Gothic

Early Gothic architecture has with some justification been called the Romanesque of the tardy Île de France. In the 11th and early 12th centuries, when most of France put on its "white robe of churches", in Raoul Glaber's phrase, and great basilicas, incorporating new developments of plan or tower design or articulation, arose in Burgundy, Languedoc, the Loire and Normandy, northeast France – the Île de France, Picardy and Champagne – lay architecturally fallow. There was very little building, except for piecemeal replacement of Carolingian churches, and what there was simply perpetuated Carolingian traditions established some two centuries earlier. Suddenly, in the 1120s and 1130s, the region began to catch up, with a series of buildings, mainly in the Oise and Vexin to the north of Paris, with clearly defined bays and heavy rib vaults springing from massive composite piers, with all the solidity and heavy decorative quality that the term Romanesque conveys, but Gothic in that they were essentially designed around the rib vaults, probably adopted from neighboring Normandy. This type of building is epitomized by the narthex of the abbey of St. Denis.

The west end of St. Denis, built on the orders of Abbot Suger (1081–1151), also revitalized the traditional Carolingian *clocher-porche*, incorporating it with twin west towers in the Norman Romanesque fashion. Similar attempts were made around the same time at Reims and Chartres cathedrals. Suger's west front boasted novelties that were to be highly influential in the Île de France, such as a rose window – the inspiration for which may have been Italian – and a splendid triple portal carrying iconographically complex sculpture, for which the sources were Romanesque portals in Italy, Burgundy and Languedoc.

In the early 1140s two buildings – Suger's choir at St. Denis and the cathedral of Sens – introduced a newly fluid approach to internal space. Both rejected the heavy composite piers and definite bay compartments of the first generation, replacing them with elegant columns and *en délit* shafts. At St. Denis a double ambulatory, flooded with light from large windows, surrounded the sanctuary with an aureole of luminous space; and at Sens a sexpartite vault swept over and united double bays and stressed the spatial grandeur of the unusually wide main vessel. The spaciousness and elegance which both buildings shared, and which makes us feel that both are indubitably Gothic, were made possible by a technical assurance that seems to be new in the Île de France, and (at Sens at least) by a technical innovation – the flying buttress.

This sudden outburst of ecclesiastical building activity in northeast France is partly symptomatic of substantial economic growth in the area. The centers of activity in the 1140s and 1150s also suggest that, at this early stage, connection with the ruling Capetian dynasty was in some way important. Paris was their caput; St. Denis their burial church; Reims their coronation church; Sens the metropolitan over much of their domain lands; and Chartres a bishopric with which they usually maintained close relationships. The importance of the Capetian connection as a galvanizing factor for building activity is clear from two other important early centers, Senlis and Étampes.

Two new elements distinguish the buildings of *c*.1160–90. First, their size: this is the point at which soaring height became an issue. Here Notre Dame at Paris took the lead, with vaults of around 100 ft. (30 m.), hanging above smooth sheets and curves of eggshell-thin wall. Second, the geographical distribution of building activity widens, and new centers develop to the north and east of Paris, in Champagne (Reims, Provins, Troyes), eastern Picardy (Laon, Noyon, Soissons, Braine) and French Flanders (Cambrai, Arras, Valenciennes). The growing wealth and population of the Artois, Cambrésis and Champagne, waxing rich on the cloth trade and industry in the late 12th century, provided ideal conditions for major building campaigns to flourish, and the counts of Champagne, particularly Henri le Libéral, were generous patrons. It is less clear why buildings in the Laonnois and Soissonnais, usually called the Aisne Valley group, should have been quite so impressive, in both quality and quantity. Perhaps patronage provides the clue. There was no duke or count to provide a regional power focus in Picardy, as there was in Normandy, Flanders or Champagne. Instead, Picardy was dominated by magnate families whose power and patronage were relatively local and fiercely patriotic.

Just before the turn of the century, the cathedrals of Bourges and Chartres opened a new phase of church building, drawing on the ideas of the previous generation – Chartres on Laon, and Bourges on Paris – but on a new and overwhelming scale. It used to be thought that the invention of the flying buttress, ascribed to Paris in the 1180s, was the technical breakthrough that allowed this immensity of scale – Chartres 120 ft. (36.5 m.) to the vault, Amiens 140 (42.5), Beauvais 157 (48) – and the size of the stained-glass windows. But the flying buttress was used in the 1140s at Sens, and technical innovation does not really explain the gigantic churches of the early 13th century. The mysterious smoky spaces of Bourges, five-aisled with stepped elevations, had their adherents – at Le Mans and Coutances, for instance. But the simpler Chartrain solution carried the day in the Île de France, and a series of massive cathedrals, especially Reims and Amiens, reproduced its flat walls, with the simplest of triforium passages, its quadripartite vault and distinctive pier type, the *pilier cantonné*. But this type of design depended on scale for its impact, and most smaller structures – abbey churches (which remained the preferred object of lay patronage) and collegiate churches – continued to experiment with wall passages and other spatial subtleties of the late 12th century. At Beauvais, it was clear that the giant cathedral, begun in the 1220s, had overreached itself both technically and economically; and around 1230 in the Parisis, particularly in the rebuilding of St. Denis, and to an extent at least in connection with the court of Blanche of Castile and King Louis IX, the scale of building was toned down considerably, and a new concentration on elegance, charm, intimacy and complicated window tracery earned the soubriquet "the rayonnant style" from 19th-century art historians.

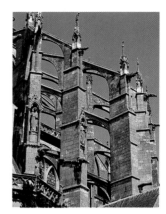

Above: Le Mans Cathedral, exterior of the choir with flying buttresses, 1217–54.

The ground plan and elevation, and the complex buttresses, of the choir of Le Mans represent the technological culmination of the tradition of the French Gothic traceable from St. Denis and Notre Dame in Paris.

THE ÎLE DE FRANCE AND THE CREATION OF THE GOTHIC

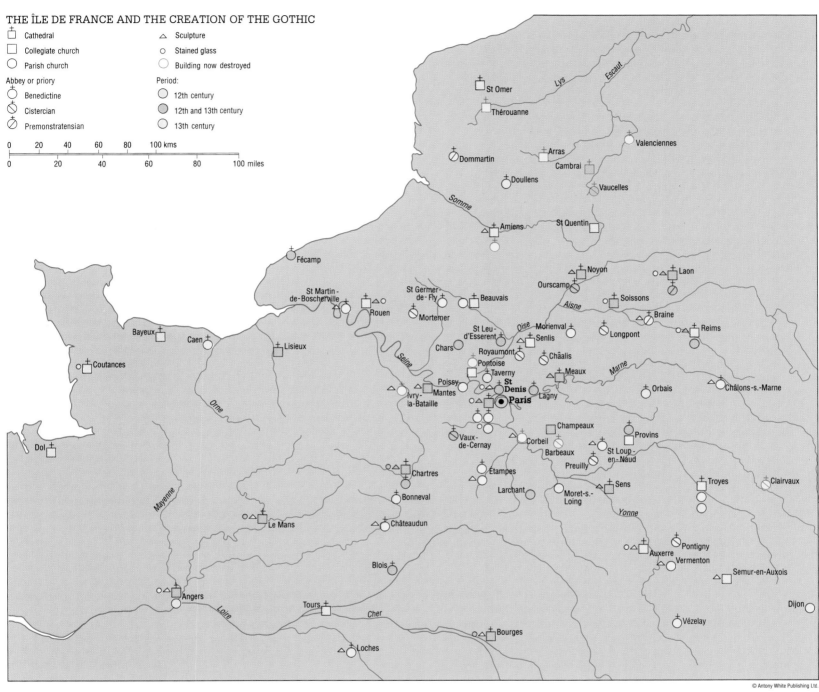

Cathedral

Collegiate church

Parish church

Abbey or priory

Benedictine

Cistercian

Premonstratensian

Sculpture

Stained glass

Building now destroyed

Period:

12th century

12th and 13th century

13th century

© Antony White Publishing Ltd.

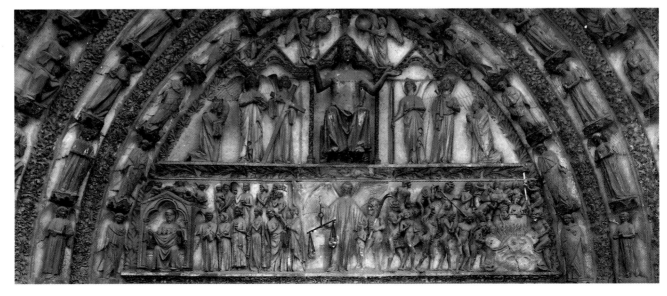

Right: *Sculptured tympanum
from the West Front at* Bourges
Cathedral, *c.1190–1275.*

*The west façade was the
culmination of the rebuilding in
the Gothic style of the old
Romanesque cathedral of Bourges.
Its decoration centered on the*
Christ in Majesty *in the
tympanum above the main
doorway.*

European Gothic Architecture, Painting Sculpture and Stained Glass

From about 1150 until 1450, the period known as the "Gothic" flourished in much of Europe. The art that immediately preceded their more "enlightened" period was so labelled by Renaissance historians, alluding to the barbaric tribe, the Goths. Italian resistance to this style, both during and after the Gothic period, established it as a product of northern Europe. Not until the 18th century did medieval revivalists begin to re-evaluate its complexity and ignored elegance. The period of transformation and growth that began in the late 12th century produced a plethora of styles and innovations; as the "Middle Ages" rapidly pushed towards the "modern era", the European economy, politics and religion also changed.

During the Gothic period certain cities like Paris emerged as artistic centers. Gothic architecture was born near Paris at the Abbey of St. Denis in the 1140s. The innovations devised by Abbot Suger and his architect spread throughout France. By 1163 flying buttresses appeared at Notre-Dame in Paris. Greater height promoted the extensive use of stained glass; the programs at Chartres (1205), St.-Germain-des-Prés (1243) and across the channel at Canterbury (1180) are some of the most outstanding examples. In Germany and Spain, architects followed French models in cathedrals like Münster (1221), Avila (1181) and Toledo (1226).

The sculpture decorating these buildings set the changing stylistic tone for the period. The serene and staid columnar figures of the west portal at Chartres (1150) gave way to more movement and independence in the north transept only decades later. Drapery and expressive gesture typify these figures and those at Senlis and Reims cathedrals. On the west façade at Reims the elegantly playful figures of the "Joseph Master" contrast with the heavily-draped and classicized women of the Visitation scene. The reliance on antique models in this latter group is similar to the metalwork of Nicolas of Verdun, a prolific and influential artist of the Meuse valley. In German examples like the *Wise and Foolish Virgins* at Magdeburg (1245), the conservative grace of the French models acquired a solidity and expressiveness that fluctuated between frank realism and the grotesque.

In important workshops like those of Master Honoré and Jean Pucelle (*d.*1334), Parisian manuscript painting reached a peak at the close of the 13th century. Through the use of architectural motifs and gracefully curved figures, these ateliers refined the French "court style". In England scriptoria in Oxford, St. Albans and Peterborough, among others, produced a variety of works. In Germany, Byzantinizing elements such as the "Zackenstil" ("zig-zag style") persisted. The ceiling paintings in St. Michael's church at Hildesheim (1230) are one of the best surviving examples of this sharp and energetic drapery that engulfed so many 13th-century German figures. Further south in Barcelona, the painter Ferrar Bassá (1285–1348) executed a series of frescoes that reflected a fusion of both Northern and Italian styles.

Later, prominent patrons were the French dukes at Dijon and Paris who sponsored such figures as the illuminators the Limbourg brothers (*fl.c.*1410) and the Burgundian sculptor Claus Sluter (*c.*1345–1406). When

the papacy fled to Avignon in 1305, this city became a flourishing center for both northern and southern artists. Under Charles IV Prague became an important city, both politically and artistically. The castle at Karlstejn included an elaborate wall program of fresco, encrusted jewels and other three-dimensional detailing that made it one of the most impressive decorative schemes of the medieval period.

Papal schisms and such heretical movements as the Waldensians in Toulouse created religious unrest. This instability enabled the mendicant orders like the Franciscans and Dominicans to gain more control over religious communities and popularize a more introspective and personal form of devotion. The writings of mystics such as Francis of Assisi (1182–1226), Meister Eckhart of Cologne (1260–1328) and Julian of Norwich (1342–*c.*1416) guided laymen and clergymen alike in their pursuit of a closer relationship with God. Private chapels and personal devotional art and literature became popular. In certain areas like Cologne, where there was a large concentration of lay orders and an economically strong merchant class, new devotional art forms appeared. The *Pietà* and *Christ and John* groups are two isolated motifs used for contemplation. The sensual realism suggested in both the agony of grief and the intimacy of companionship reveal the pervasive conflation of the spiritual and profane in this later period.

Above: The Three Magi and an Angel, *1180–1200, stained glass from the north choir aisle, Canterbury Cathedral.*

The scene shows the Magi in a dream warned by an angel not to return to Herod. It was one of a series of stained glass windows on Old and New Testament themes in the choir and Trinity Chapel at Canterbury. The glass here is equal in quality to that produced early in the Gothic period in France.

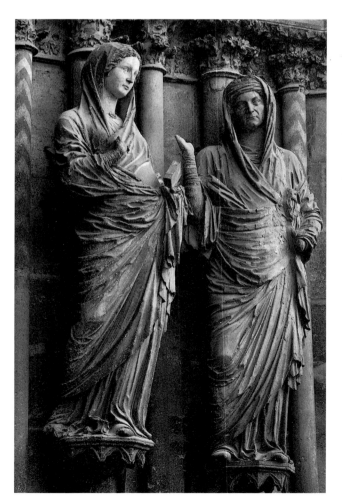

Left: The Visitation, *1230–40, sculpture from the west façade, Reims Cathedral.*

These two pillar figures of the Virgin and St. Elizabeth, the mother of John the Baptist, show the extent to which Gothic sculpture has developed in the 80 years since the west portal of Chartres. Here the figures show a knowledge of classical form, weight and drapery, combined with an intense realism of narrative and expression.

EUROPEAN GOTHIC ARCHITECTURE, SCULPTURE, PAINTING AND GLASS

- ● Site
- □ Architecture
- △ Sculpture
- ▽ Mural and panel painting
- ○ Stained glass

Dating:
- □ 12th century
- ▨ 12th and 13th centuries
- ▨ 13th century
- ▨ 13th and 14th centuries
- □ 14th century

0 100 200 300 kms
0 100 200 miles

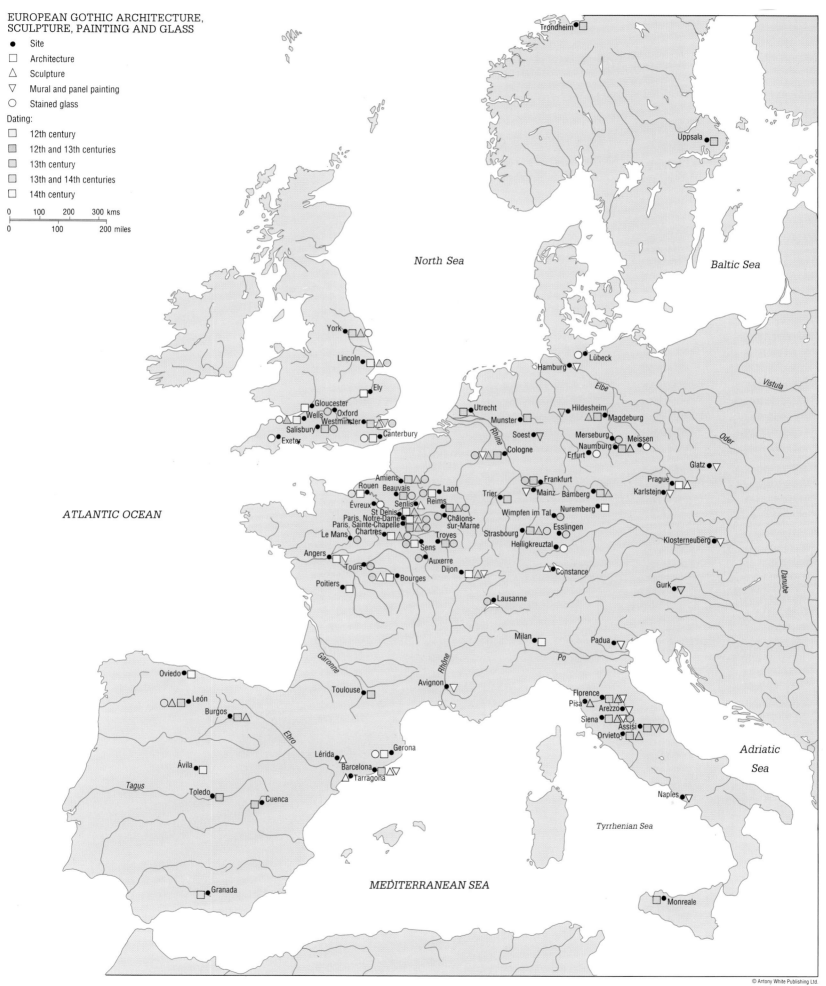

North Sea

Baltic Sea

ATLANTIC OCEAN

Vistula

Elbe

Oder

Rhine

Danube

Trondheim

Uppsala

Lübeck
Hamburg

York
Lincoln
Ely
Gloucester
Wells Oxford
Salisbury Westminster
Exeter Canterbury

Utrecht
Munster
Soest
Cologne

Hildesheim
Magdeburg
Merseburg Meissen
Naumburg
Erfurt

Glatz

Prague
Karlstejn

Klosterneuburg

Amiens
Rouen Beauvais
Évreux Laon
St Denis Senlis Reims
Paris, Notre-Dame Châlons-sur-Marne
Paris, Sainte-Chapelle
Le Mans Chartres Troyes
Sens
Angers Auxerre
Tours Dijon
Poitiers Bourges

Frankfurt
Trier Mainz Bamberg
Wimpfen im Tal Nuremberg
Strasbourg Esslingen
Heiligkreuztal
Constance

Lausanne

Milan

Gurk

Padua

Rhône

Po

Garonne

Toulouse

Avignon

Florence
Pisa Arezzo
Siena Assisi
Orvieto

Oviedo
León
Burgos
Ávila

Tagus

Toledo Cuenca

Ebro

Lérida
Gerona
Barcelona
Tarragona

Granada

Adriatic Sea

Naples

MEDITERRANEAN SEA

Tyrrhenian Sea

Monreale

© Antony White Publishing Ltd.

113

Gothic Architecture, Sculpture and Glass in the British Isles

The most significant Gothic architecture occurred in the richest and most developed region of the country, southeast of a line from Yorkshire to South Wales. Notable buildings elsewhere were mostly English or French imports. Early Gothic spread from three centers, Canterbury, Wells and Yorkshire, to form, c.1200, the Early English style. The choir (1174–80) of Canterbury Cathedral, England's first purely Gothic structure, represented a series of quirky compromises, effectively denying the English a French copybook model.

Wells formulated its own style c.1180: monochrome, pointed throughout, and with rib vaults supported by a Romanesque frame. Low-lying and predominantly horizontal, the scale and archaic construction suited English needs and pockets. Yorkshire produced an angular style influenced by north-French Cistercian: monochrome and heavily perforated (Ripon, Byland). Numerous buildings even dispensed with that essential Gothic ingredient, the stone vault. Flat-topped and square-framed elevations supported wooden roofs or wooden vaults (York Minster transepts). The abandonment of masonry vaults relieved the English of any need to comprehend proper vault technology and buttressing systems.

The Early English style, seen evolving at Lincoln c.1195, concentrated upon linear effects, the plastic wall and sculptural enrichment. Linear vault design became an English specialty, with secondary ribs, ridge-ribs, and eventually non-structural elements called liernes; English interiors became essays in patterning. Even Westminster Abbey (from 1245), with its Frenchified elevation, tall clerestory and flyers, failed to alter the prevailing taste for heavily encrusted, elaborately vaulted, thick-walled buildings. Westminster popularized tracery, which became yet another decorative element: added to Early English architectural structures, it led to the Decorated style, as at Exeter (1290s), a long, low, multi-colored building where spreading vaults and tracery variations were offered in exchange for French height and austerity. The reversed ogee curve, adopted from 1292 (St. Stephen's, Westminster), added a swirling and unsettling note to existing complexities. English plans and interior arrangements were also often unexpected (Bristol choir, Wells retrochoir, the Ely octagon, all c.1290–1330). In the Ely Lady Chapel (1320s) the undulating wall surfaces were encrusted with painted sculpture, while great stained-glass programs once filled the huge multi-paneled windows.

Reaction to such exotic polychromy came with Perpendicular (Gloucester transepts and choir, 1330s). Severe, reticulated, monochrome interiors became the fashion, with a preference for minuscule architectural elements and mesh vault patterns. Repetition of the rectangular panel, glazed or solid, together with an avoidance of ogees and circles, gave England a rigid approximation of late 13th-century French buildings (St. George's, Windsor). Tracery panels covered every surface – even, with fan vaulting, the ceilings (Gloucester Cathedral cloisters, 1350s; King's College Chapel, Cambridge, 1512–15).

Other areas of the British Isles were slow to adopt Gothic, and buildings were for the most part simple and unvaulted. The West Country influenced Ireland (Dublin), though Wales proved resistant to almost all English influence. In Scotland, a pointed late-Romanesque style remained popular (Jedburgh), with only Elgin and Glasgow attempting the richness and complexity of English building. Perpendicular gained little foothold, the Scots in particular preferring a more mainstream Flamboyant style (Melrose Abbey transept).

English Gothic sculpture enjoyed a considerable reputation throughout Europe, especially tombs and Nottingham alabasters, which are still found in considerable numbers. Stone figure sculpture has suffered widespread depredations, though major 13th-century cycles survive at Wells, Westminster and Lincoln, and major 14th-century works at Exeter, Lincoln and Westminster. Later free-standing figure cycles survive at Canterbury and York, c.1510. Funerary effigies achieved high standards in stone, Purbeck marble, alabaster and bronze or latten gilt – Canterbury, Westminster, etc. Architectural sculpture represents a major loss, though surviving work at Wells (1180–1239) and Warwick (1450s) suggests it was first-rate. Foliate sculpture, particularly naturalistic, was widespread – typically hedgerow plants (Southwell, c.1280) and seaweed (Ely Lady Chapel, c.1320).

The stature of British stained glass is complicated by lack of survivals. Although Canterbury (1180–1220) formed an important link in the history of French glass, little evidence existed elsewhere before 1300 (Lincoln, York). English late-Gothic glass shared a similar development with European – small dark panels giving way to taller, lighter-toned, single figures within niches (Gloucester c.1340). Silver-stain dominated, contrasting with the dark hues of draperies (Warwick). Perpendicular grid-plan windows favored the standing figure, and ranks of repeated saints were a favorite scheme (New College, Oxford; Canterbury Cathedral). After 1475, narrative scenes returned, spreading over the mullions, and later displayed early Renaissance detailing (Fairford, King's College; Cambridge).

Above: *Nicholas Broker and Godfrey Prest,* The head of the effigy of Richard II, *gilded bronze, 1394–5, Chantry Chapel of Henry V, Westminster Abbey.*

Despite political turbulence and instability of his reign, Richard II's reign saw considerable achievements in English craftsmanship, not least in his own tomb and that of his wife Queen Anne of Bohemia.

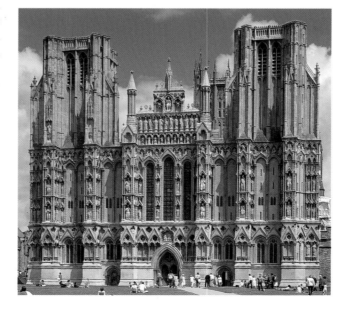

Left: Wells Cathedral, *west façade, c.1215–39, Wells, Somerset.*

Begun c.1175, work on Wells reached the westernmost bays of the nave by 1215. Although built at the same period as Canterbury, which was so close in style to French Gothic, Wells is more insular; in particular its screen-like façade covered with sculpture.

GOTHIC ARCHITECTURE, SCULPTURE AND GLASS IN THE BRITISH ISLES

○ Architecture
⊘ Architecture with sculpture
⊘ Architecture with stained glass
◉ Architecture with sculpture and stained glass
△ Stained glass only
▽ Sculpture only

Period :

○ Early
○ Decorated
○ Perpendicular
○ Early and decorated
○ Decorated and perpendicular
○ Early and perpendicular
○ Early, decorated and perpendicular

0 50 100 150 kms
0 50 100 miles

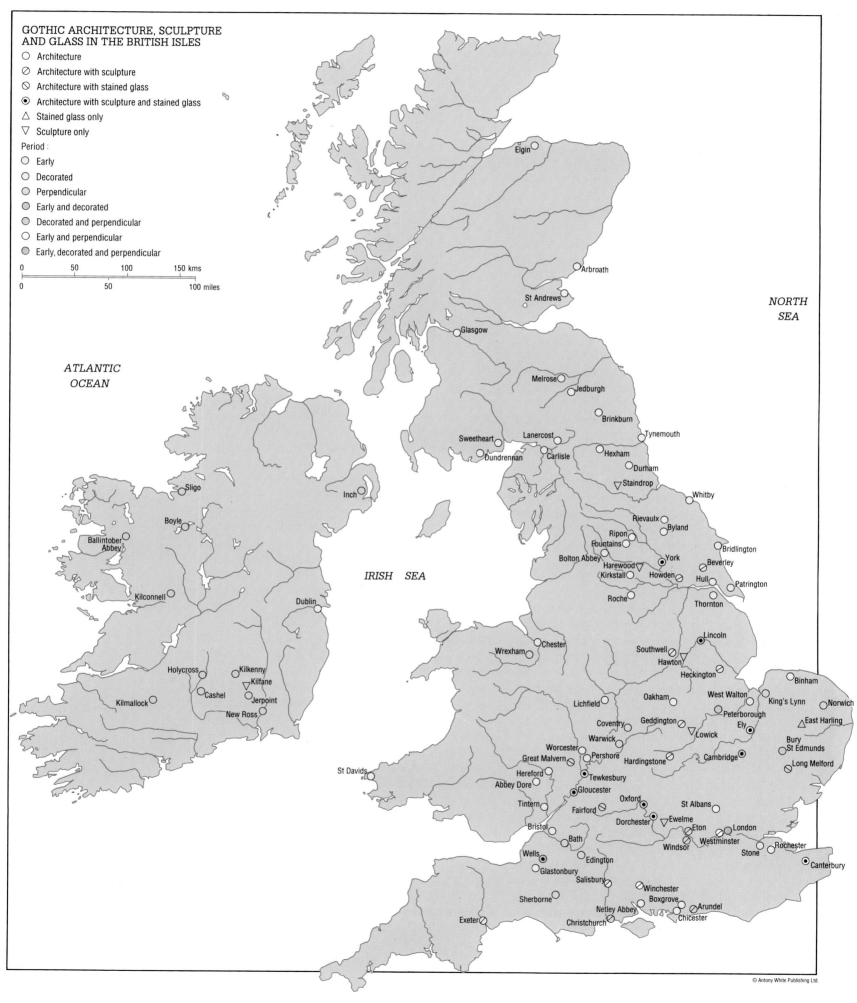

ATLANTIC OCEAN

NORTH SEA

IRISH SEA

Elgin

Arbroath

St Andrews

Glasgow

Melrose
Jedburgh
Brinkburn
Sweetheart Tynemouth
Lanercost
Dundrennan Carlisle Hexham
 Durham
 Staindrop
 Whitby
Sligo Inch
 Rievaulx
 Ripon Byland
Boyle Fountains Bridlington
Ballintober Bolton Abbey York Beverley
Abbey Harewood
 Kirkstall Howden Hull
Kilconnell Roche Patrington
Dublin Thornton

 Chester
Wrexham Lincoln
 Southwell
 Hawton
Holycross Heckington
Kilkenny
Kilfane Binham
Cashel Jerpoint Oakham West Walton King's Lynn Norwich
Kilmallock Lichfield Peterborough
New Ross Coventry Geddington Ely East Harling
 Warwick Lowick Bury
 Worcester St Edmunds
 Great Malvern Pershore Hardingstone Cambridge Long Melford
St Davids Hereford
 Abbey Dore Tewkesbury
 Gloucester Oxford St Albans
 Tintern Fairford Dorchester Ewelme
 Bristol Eton London
 Bath Windsor Westminster Stone Rochester
 Wells Canterbury
 Glastonbury Edington
 Salisbury Winchester
Sherborne Boxgrove
 Netley Abbey Arundel
Exeter Christchurch Chicester

© Antony White Publishing Ltd.

115

Gothic Architecture, Sculpture and Glass in Central Europe

Medieval Germany never achieved the political cohesion of England and France and the imperial title brought with it less and less actual power. The real centers of authority and artistic patronage lay in the secular and ecclesiastical electorates (Cologne, Mainz, Trier, the Palatinate, Bohemia and Brandenburg), in the reforming monastic orders (principally Cistercians and friars), and in the towns, united in the southwest by the Swabian League and in the north and east by the Hanseatic.

Political confusion did not impair economic progress and there was ample employment for artists and architects. Leading talents gained wider reputations and moved more freely. Some, like Veit Stoss(1447–1533), emigrated from Nuremberg to distant Kraków; all profited from intense regional and local rivalries. Generous and competitive patronage encouraged high standards of craftsmanship and gave the Germans a reputation throughout later medieval Europe for sound workmanship and technical virtuosity. The fundamental artistic division in medieval Germany lay not between east and west – indeed German colonization in the 12th and 13th centuries had ensured the spread of *deutsche Kultur* as far as the eastern Baltic, southern Poland and present-day Romania – but between north and south – between the brick architecture of the lowlands of Mecklenburg, Brandenburg and the territory of the Knights of the Teutonic Order, and the stone-building areas of the Rhineland, Swabia and Austria.

The vitality of German Romanesque architecture delayed the import of French Gothic. The first systematic attempts to imitate it occurred as late as *c*.1200 in the cathedrals of Limburg an der Lahn, Magdeburg and the Cistercian church of Maulbronn. Most early Gothic in Germany relied on traditional thick walls and Romanesque massing of towers and choirs. The emotional and naturalistic character of French Gothic sculpture found an immediate response. The master of Naumburg, working *c*.1240–50 at Mainz and then in the western choir of Naumburg cathedral, took the sculpture of Reims as a starting-point for explorations into human psychology and narrative drama without parallel in European sculpture until the late 14th century.

It was the Paris-educated and Francophile bishops of the Rhineland who were the first to demand pure French Gothic. The choir of Cologne cathedral and the nave of Strasbourg cathedral (both in building *c*.1250–80) are in effect pastiches of the Rayonnant and High Gothic of the Île de France; their foreign style was referred to by a contemporary German chronicler as simply *opus francigenum*. Their rich stained-glass works, with tall figures contained in elaborate architectural canopies, also ultimately derived from Rayonnant France. By the end of the century, however, in the façade projects of both cathedrals (preserved in exquisite parchment drawings), the Germans were already moving beyond their French masters in the virtuoso handling of window tracery and in their emphasis on colossal steeples.

At a less ambitious level, the consciously simple architecture of the friars, with their tall chapel-like choirs, became the model for hundreds of parish and collegiate churches. In the north, however, Lübeck and its

Hanseatic sister towns of the southern Baltic continued to build brick basilicas of cathedral scale. The real contribution of the brick-building lowlands to the creation of the Late Gothic style was the very early introduction, perhaps under English influence, of decorative vaulting, especially favored in the territories of the Knights of the Teutonic Order in East Prussia. Their vast headquarters, the brick castle of Marienburg, is one of the masterpieces of medieval secular architecture.

Much more influential on the formation of German Late Gothic were Peter Parler (*d*.1399) and the dynasty of Parler masons and sculptors working in southern Germany in the later 14th century. Under the patronage of Charles IV, Peter's choir of Prague cathedral radically revised the Rhenish Rayonnant of Cologne and Strasbourg, while his choir of the Holy Cross church at Schwäbisch Gmünd became an archetype for the later German hall church. The ingenuities of Parler's tracery were soon incorporated into the new colossal steeples built as status symbols of the free imperial southwest German towns (Ulm, Strasbourg), while his skill with decorative vaults fascinated the architects of the municipal hall churches of Bavaria and Austria.

Such halls were perfect settings for the huge wooden sculptured altarpieces of the later 15th century. In the hands of two brilliant generations of sculptors, beginning with Michael Pacher (*c*.1435–98) and continuing with Tilman Riemenschneider and Veit Stoss, the soft, mystical character of much Parler-influenced sculpture gave way, under the impact of Netherlandish painting, to a more realistic, domestic and expressive style. Canopies in the form of intertwining branches dominate the stained glass of Peter Hemmel in Munich and Nuremberg, the tops of altarpieces and the niches of sacrament houses; sometimes even vault ribs are transformed into branches.

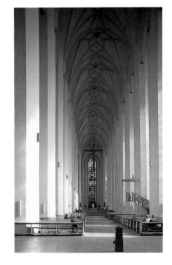

Above: *Jorg Ganghofer:* Frauenkirche *(Church of Our Lady), nave, 1466–88, Munich.*

A vast example of a Bavarian Late Gothic hall church, with the tall nave and aisles of equal height. The Frauenkirche is built of somber red brick on the exterior, and a startling white stone inside.

Below: Cologne Cathedral, *choir and transept from the south, begun 1284, Cologne.*

Cologne was the clearing house for the influence of French Gothic architecture in Germany – seen particularly in the choir and nave. However the design for the towers at the west end were the models for the new German style first seen at Freiburg and Strasbourg.

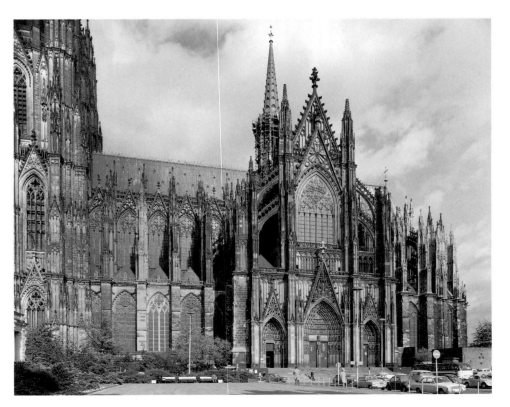

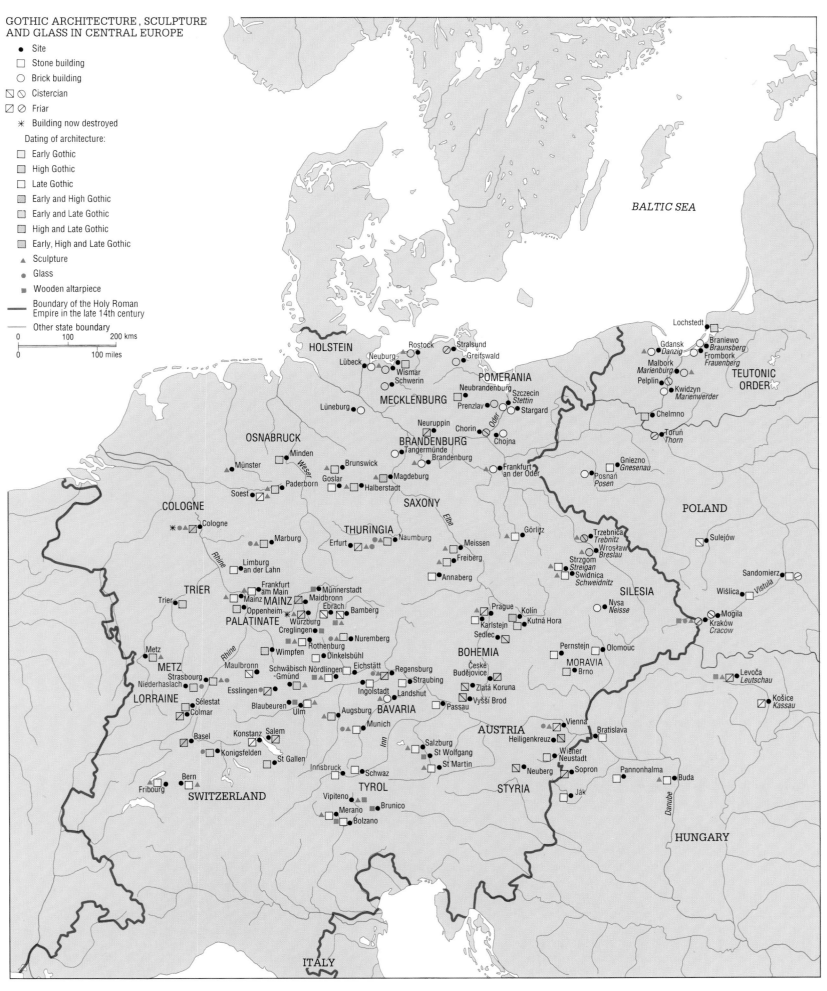

GOTHIC ARCHITECTURE, SCULPTURE AND GLASS IN CENTRAL EUROPE

- ● Site
- □ Stone building
- ○ Brick building
- ◨ ◖ Cistercian
- ◧ ◔ Friar
- ✳ Building now destroyed
- Dating of architecture:
- □ Early Gothic
- □ High Gothic
- □ Late Gothic
- □ Early and High Gothic
- □ Early and Late Gothic
- □ High and Late Gothic
- □ Early, High and Late Gothic
- ▲ Sculpture
- ● Glass
- ■ Wooden altarpiece
- ▬ Boundary of the Holy Roman Empire in the late 14th century
- ── Other state boundary

0 100 200 kms
0 100 miles

BALTIC SEA

HOLSTEIN
Rostock Stralsund
Lübeck Neuburg Greifswald
Wismar
Schwerin
POMERANIA
Neubrandenburg
Lüneburg Prenzlav Szczecin *Stettin*
MECKLENBURG Stargard
Neuruppin Chorin
BRANDENBURG
Tangermünde Chojna
Minden Tangermünde
Brandenburg
OSNABRUCK
Münster Brunswick Magdeburg Frankfurt an der Oder
Goslar
Paderborn Halberstadt
Soest
SAXONY
COLOGNE
Cologne THURINGIA
Marburg Erfurt Naumburg Meissen
Limburg an der Lahn Freiberg
Annaberg
TRIER Frankfurt am Main Münnerstadt
Trier Mainz MAINZ Maidbronn
Oppenheim Ebrach Bamberg
Würzburg
PALATINATE Creglingen
Metz Nuremberg
Rothenburg
METZ Wimpfen Dinkelsbühl
Maulbronn Eichstätt
Strasbourg Schwäbisch Nördlingen Regensburg
Niederhaslach -Gmünd Straubing
LORRAINE Esslingen Ingolstadt Landshut
Sélestat Blaubeuren Augsburg Passau
Colmar Ulm BAVARIA
Basel Konstanz Salem Munich
Konigsfelden Salzburg
Bern St Gallen Innsbruck Schwaz
Fribourg St Wolfgang
SWITZERLAND Vipiteno St Martin
Merano TYROL
Brunico
Bolzano

Gdansk *Danzig* Lochstedt
Braniewo *Braunsberg*
Malbork *Marienburg* Frombork *Frauenberg*
Pelplin TEUTONIC ORDER
Kwidzyn *Marienwerder*
Chelmno
Toruń *Thorn*
Gniezno *Gnesenau*
Posnań *Posen*
POLAND
Görlitz Sulejów
Trzebnica *Trebnitz*
Wrosław *Breslau*
Strzgom *Streigan* Sandomierz
Swidnica *Schweidnitz* Wiślica *Vistula*
SILESIA
Prague Kolín Nysa *Neisse* Kraków *Cracow*
Karlstejn Kutná Hora Mogila
Sedlec
BOHEMIA Pernstejn Olomouc
České MORAVIA
Budějovice Brno Levoča *Leutschau*
Zlatá Koruna
Vyšší Brod Košice *Kassau*
Vienna
AUSTRIA Bratislava
Heiligenkreuz
Wiener Sopron Pannonhalma Buda
Neustadt
Neuberg Ják
STYRIA
HUNGARY
Danube

ITALY

117

Spanish and Portuguese Ecclesiastical Art and Architecture

Spain is a large country, cut off from the rest of Europe by the Pyrenees. Its major centers were widely spread out over the peninsula and subject to diverse outside influences. Most obviously, the south of Spain was under Moorish rule and the style there was Islamic. Until Madrid became the capital in 1561 (Philip II chose it partly because of its geographical centrality) there was no single, settled court to act as a focus of artistic ideas.

Early Spanish Gothic architecture, referred to as *Transitional*, was mostly associated with the Cistercians; pointed arches were incorporated in buildings essentially still Romanesque. The Cistercians founded their first abbey in Spain at Moreruela in 1131 (it is now a picturesque ruin) and others rapidly followed at – for example – La Oliva, Poblet and Veruela, all in the north of the country. They soon penetrated much further into the peninsula, and the abbey of S. Maria at Alcobaça in Portugal (begun 1178) is one of the Cistercians' grandest foundations in all Europe.

An early Spanish Gothic building is the cathedral of Avila, begun in about 1180; as well as pointed arches, it makes use of the two other great distinctive features of the style – flying buttresses and rib vaults. It is still massive in construction and sober in feeling, but in the early 13th century a more daring, skeletal type of Gothic architecture, based on the most up-to-date French models, was introduced. This development is associated with the rise of Castile under Ferdinand III (king of Castile 1217–52; king of León 1230–52), a religious zealot who campaigned vigorously against the Moors and permanently won back a great deal of territory from them (he was canonized in 1671). Building great churches in the most modern style was a way of expressing the Christian victory over the Moors as well as Castile's pre-eminence within Spain, and the cathedrals of Burgos (begun 1221) and Toledo (begun 1227) are the supreme monuments of Ferdinand's reign. Slightly later, at León Cathedral (begun 1255), with its vast array of traceried windows, the French *Rayonnant* style arrived.

Burgos, Toledo and León are thoroughly French not only in structure but also in decoration. Sculpture is concentrated on portals (the west portal at León Cathedral includes one of the most celebrated figures in medieval Spanish art – "La Virgen Blanca") and there is lavish use of stained glass, especially at León, which has the finest array in Spain (much of Toledo's was destroyed in 1936 during the Civil War). After this High Gothic period, however, French influence declined. Stained glass henceforward played a fairly minor role (windows in Spanish churches tend to be small compared with those in France because the sunlight is so intense) and the main efforts of sculptors were devoted not to portals but to tombs and altarpieces. Huge altarpieces rising from floor to ceiling became a Spanish speciality, and although Spain is a country rich in stone and relatively poor in wood, a splendid tradition of virtuoso woodcarving developed, expressed in highly elaborate choirstalls as well as in altarpieces.)

At the end of the 13th century, a distinctive, specifically Spanish type of Gothic architecture was developed in Catalonia. Catalan Gothic differs from the classic French style most obviously in its sense of proportion, breadth rather than height being stressed. Gerona Cathedral (begun 1312), for example, has the widest nave of any Gothic church in Europe – 74 ft (22 m). Other great Catalan churches include Barcelona Cathedral (begun 1298) and Palma Cathedral (begun 1314) on the island of Majorca. Because there is generally less rainfall in Spain than in northern Europe, Spanish Gothic churches tend to have roofs that are much less steep than those of their French counterparts, and this – together with the emphasis on width – typically gives them a more chunky, box-like outline. Chapels were often inserted between buttresses, increasing the sense of external flatness. The tendency reached its culmination in Seville Cathedral (begun 1402), which has the largest floor area of any medieval church – roughly 400 ft by 250 ft (120 m x 75 m). The shape was partly dictated by the fact that it was built on the site of a mosque, some of whose remains it incorporated. Moorish decorative elements often featured in Spanish Gothic art; Christian art produced by Islamic craftsmen is called *Mudéjar* (from the Arabic for "one permitted to stay" or "vassal").

There was a strong influx of German influence (indeed northern influence in general) in the 15th century. Most notably Juan de Colonia (John of Cologne) built the western towers of Burgos Cathedral in 1442–57 in a style that is completely German, recalling similar structures at Freiburg, Regensburg and Ulm. The lacy openwork design of these towers is typical of the trend in late Gothic art throughout Europe towards highly ornamental surface effects. In Spain this culminates in the Plateresque style, in which ornament is applied so lavishly that the underlying structure is sometimes almost lost in a riot of carving. The term *Isabelline* (or *Isabelline Plateresque*), alluding to the reign of Isabella I (1474–1504), is sometimes applied to the early phase of Plateresque, the later phase being distinguished as *Renaissance Plateresque*, when Italianate motifs were included in the decorative mixture. *Plateresque* means "silversmith-like", referring to the delicacy of the carving, which sometimes seems more appropriate to metalwork than stonework. In Portugal a similar style is *Manueline*, named after Manuel I (1495–1521).

Above: The Cistercian convent of Las Huelgas, *founded in 1187 by Alfonso VIII, Burgos.*

One of Spain's richest monasteries, founded at the behest of Alfonso's wife Eleanor, daughter of England's Henry II. In 1219 Saint Ferdinand III started here the custom of Castilian kings being knighted into the order of Santiago. The church also serves as a royal Pantheon of Castilian kings and royal ladies.

Below: Tomb of John II and his wife, Isabella of Portugal, *La Cartuja de Miraflores, Burgos.*

Commissioned by Isabel la Católica as a memorial to her parents, and sculpted by the great Gil de Siloé the elaborately detailed tomb took four years to create and the alabaster carving of the effigies' robes is outstanding.

SPANISH AND PORTUGUESE ECCLESIASTICAL GOTHIC ART AND ARCHITECTURE

Architecture

- ☐ Transitional, Salamantine or Cistercian
- ☐ Early Gothic, High Gothic, Rayonnant or Catalan Gothic
- ☐ **Late Islamic or Mudéjar**
- ☐ Late Gothic or Isabelline
- → Movement of artists

- △ 'Angevin' vaults
- ◆ Choirstalls
- ■ Painting
- ▼ Reredos
- ☐ Royal pantheon
- ▲ Sculpture
- ○ Shrine
- ● Stained glass

Scale: 0 — 100 — 200 — 300 kms
0 — 100 — 200 miles

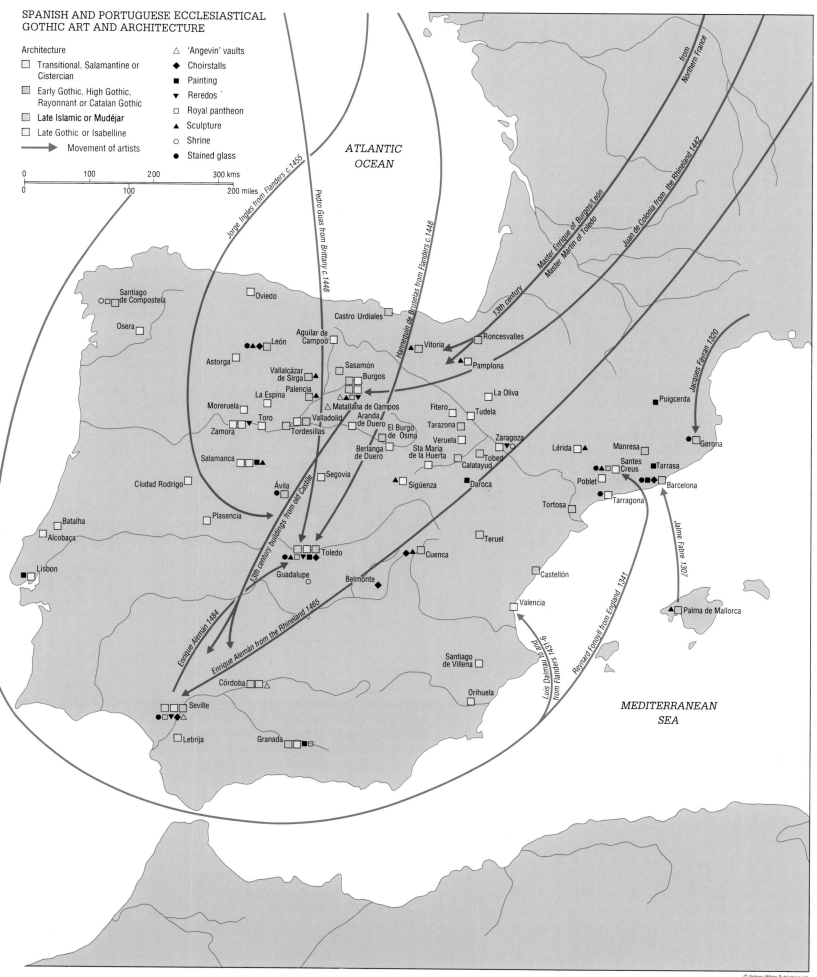

ATLANTIC OCEAN

MEDITERRANEAN SEA

Jorge Inglés from Flanders c.1455
Pedro Guas from Brittany c.1448
Hannequin de Bruselas from Flanders c.1448
13th century
Master Enrique of Burgos/León
Master Martín of Toledo
from Northern France
Juan de Colonia from the Rhineland 1442
Jacques Favran 1320
13th century buildings from old Castile
Enrique Alemán 1484
Enrique Alemán from the Rhineland 1465
Jaime Fabre 1307
Luis Dalmau from Flanders 1431-6
Reynard Fonoyll from England 1341

Santiago de Compostela
Osera
Oviedo
Castro Urdiales
Aguilar de Campoo
León
Astorga
Vallalcázar de Sirga
Sasamón
Burgos
Vitoria
Roncesvalles
Pamplona
La Espina
Palencia
La Oliva
Moreruela
Matallana de Campos
Fitero
Tudela
Toro
Valladolid
Aranda de Duero
Tarazona
Zamora
Tordesillas
El Burgo de Osma
Veruela
Zaragoza
Puigcerda
Gerona
Salamanca
Berlanga de Duero
Sta Maria de la Huerta
Tobed
Lérida
Manresa
Ciudad Rodrigo
Segovia
Calatayud
Poblet
Santes Creus
Tarrasa
Ávila
Sigüenza
Daroca
Barcelona
Plasencia
Tortosa
Tarragona
Batalha
Alcobaça
Toledo
Cuenca
Teruel
Castellón
Lisbon
Guadalupe
Belmonte
Valencia
Palma de Mallorca
Córdoba
Santiago de Villena
Seville
Orihuela
Lebrija
Granada

© Antony White Publishing Ltd.

119

Gothic Manuscript Illumination, Metalwork and Other Decorative Arts

From the early 13th century artists were less likely to belong to religious communities, a development which encouraged greater travel and the acceptance of commissions far from their regions of origin. One example is the metalworker Nicholas of Verdun (pre-1150–c.1217), who in 1181 completed a pulpit in champlevé enamel at Klosterneuburg. Nicholas subsequently worked in Cologne and Tournai, where his distinctive style, inspired by Classical and Byzantine sources, was imitated by local illuminators. Another well-traveled artist was Villard de Honnecourt (*fl.c.*1220– *c.*1240), whose sketch-book (Bibliothèque Nationale, Paris), containing drawings of architecture, sculpture and metalwork, helps to explain how artistic ideas associated with particular centers were taken up elsewhere and in different media. The drawings show that Villard, who came from northern France, visited many of the major cathedrals then under construction, including Reims, Chartres and Lausanne, and traveled as far as Hungary.

By *c.*1250 Paris emerged as the most influential center for the production of illuminated manuscripts, and probably also for arts such as ivory-carving, a position it retained until the early 15th century. Paris's pre-eminence was partly a result of royal patronage: a series of lectionaries, for example, commissioned for use in the Sainte-Chapelle in Paris, a foundation of Louis IX (1226–70), illustrates the change from a classicizing to a broader form of drapery, a conspicuous feature of the figurative art which lasted until the 1400s. The Parisian style soon influenced development abroad. A French *Bible moralisée* sent to Toledo in the mid-13th century, for instance, helped to shape the style of illuminators at the court of Alfonso X of Castile (1252–84). By the 1290s, illuminators in Paris, like Master Honoré (end of the 13th century), had found new ways of enlivening their work with ever more graceful figures and subtle modeling of draperies, developments widely imitated abroad, notably at St. Florian.

Parisian supremacy in metalwork is only clear from the 14th century with works like the statuette of the pilgrim Geoffroy Coquatrix, a citizen of Paris, who gave the piece to the cathedral of Santiago de Compostela in 1321. Before this period the taste for precious ecclesiastical metalwork enabled craftsmen to flourish in many centers, particularly in the Meuse/Rhine region. The most influential center, however, was Limoges. Throughout the 13th century its metalworkers manufactured small objects in champlevé enamel such as reliquary caskets, which were distributed and imitated throughout Europe. Craftsmen trained in the Limoges tradition also worked on enamels for use in tombs at Burgos, Paris and Westminster, London. But the most impressive examples of 13th-century metalwork are the shrines of popular saints, which from the mid-13th century directly imitated large-scale Gothic architecture and sculpture. An early example is the shrine of St. Taurin at Évreux (*c.*1250).

To some extent the development of illumination in late medieval England reflects that in France. Monastic centers like Winchester and St. Albans remained important, but with the rise of court patronage and the

universities by *c.*1250, centers like Westminster and Oxford became equally prolific. Around 1300, much of the finest English illumination may be associated with East Anglia; there is evidence that East Anglian illumination was esteemed as far afield as Lorraine and Avignon. Between *c.*1250 and *c.*1350 English ecclesiastical embroidery (*opus Anglicanum*) also established a reputation abroad, particularly at the papal courts in Rome and Avignon. Several popes gave English embroidered copes to the cathedrals of their former dioceses; one example is at Ascoli Piceno (given by Nicholas IV in 1288). During the later Gothic period English alabaster altarpieces were much in demand throughout western Europe. The principal centers for alabaster carving seem to have been Nottingham, Chellaston and York, and the products were exported through the ports of Hull, Boston and Southampton.

In Italy the production of illuminated manuscripts remained in monastic control longer than in France. During the 13th century Byzantinizing styles predominate, but the rise of the mendicant orders helped stimulate influence from France, and by *c.*1280 San Francesco at Assisi, the Franciscans' mother church, possessed examples of Parisian illumination and metalwork. Centers where Dominicans had major convents, like Bologna and Genoa, and where rulers had dynastic connections with France, like Milan and Naples, also found inspiration in French work. In 14th-century Tuscany, however, illuminators increasingly imitated work by leading wall and panel painters. This was also the case with Sienese metalworkers, who by *c.*1290 were using translucent enamel, a technique which facilitated more painterly effects. Their influence is evident in work produced in Avignon, Palma, Barcelona and other western Mediterranean centers.

Sienese painting also shaped the development of Parisian illumination, beginning with Jean Pucelle (*d.*1334). Around 1400 Paris remained the leading European center for illumination and metalwork, setting standards which were widely followed, especially in recently established centers in the Netherlands. Artists such as the Limbourg brothers (*fl.c.*1410) were attracted to Paris from all over Europe.

Above: Bible Moralisée, *French 13th century (Pierpont Morgan Library, New York).*

This page from a French illuminated Bible, which was sent to Toledo in the 13th century, was probably made in a royal workshop whose artists must also have worked on stained glass. The architectural settings show contemporaneous building construction.

Below: The Syon Cope (opus Anglicanum), *English 1300–20 (Victoria and Albert Museum, London).*

This is the finest cope from this golden age of English embroidery and from the evidence of the armorial bearings was probably made near Coventry. The cope is of linen (4ft 8ins wide x 9ft 7ins in length: 1.5 x 3m) and the embroidery is worked in colored silks and gold and silver thread.

GOTHIC MANUSCRIPT ILLUMINATION, METALWORK AND OTHER DECORATIVE ARTS

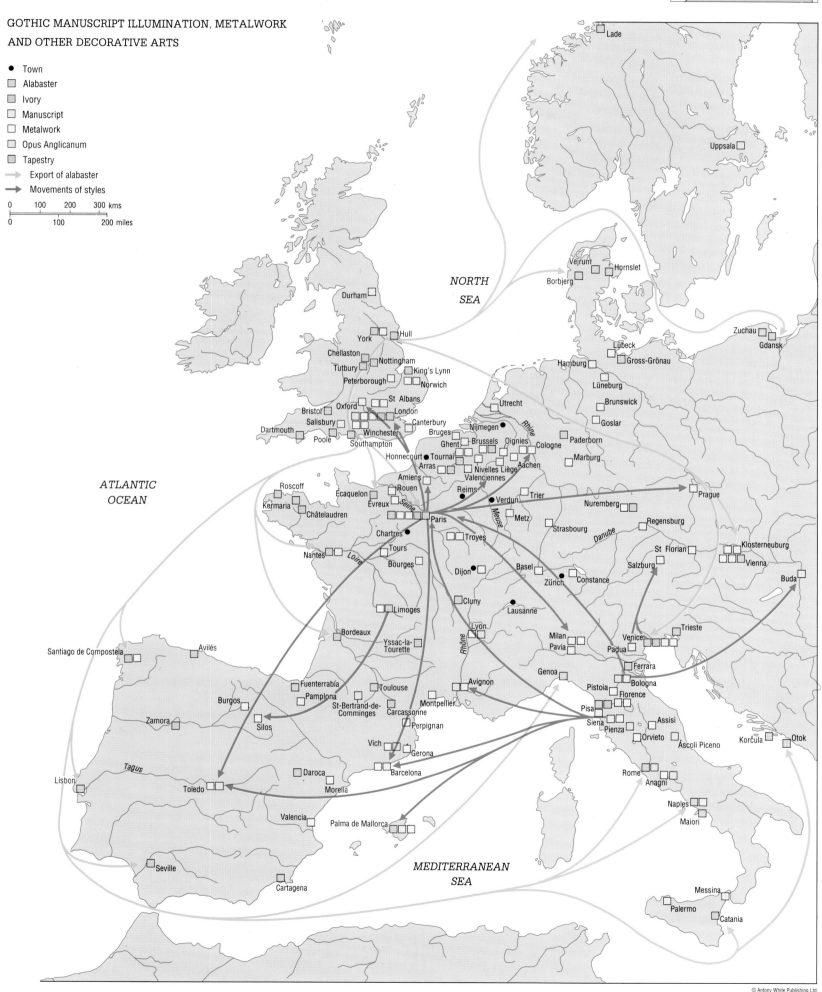

- ● Town
- ▢ Alabaster
- ▢ Ivory
- ▢ Manuscript
- ▢ Metalwork
- ▢ Opus Anglicanum
- ▢ Tapestry
- → Export of alabaster
- → Movements of styles

0 100 200 300 kms
0 100 200 miles

NORTH SEA

ATLANTIC OCEAN

MEDITERRANEAN SEA

Lade
Uppsala
Vejrum
Hornslet
Borbjerg
Zuchau
Gdansk
Lübeck
Gross-Grönau
Hamburg
Lüneburg
Brunswick
Goslar
Durham
Utrecht
Paderborn
York Hull
Chellaston
Nottingham King's Lynn
Tutbury Norwich
Peterborough
St Albans Nijmegen Rhine Cologne
Bristol Oxford London Bruges Ghent Brussels Oignies Marburg
Salisbury Canterbury Nivelles Liège Aachen
Dartmouth Winchester Honnecourt Tournal
Poole Southampton Arras Valenciennes Prague
Amiens Reims Verdun Trier Nuremberg
Roscoff Écaquelon Rouen Metz Regensburg
Kermaria Évreux Seine Strasbourg Danube St Florian Klosterneuburg
Châtelaudren Paris Meuse Vienna
Chartres Troyes Basel Salzburg Buda
Tours Dijon Zürich Constance
Nantes Loire Bourges Cluny Lausanne Trieste
Limoges Lyon Milan Venice
Bordeaux Pavia Padua
Avilés Yssac-la-Tourette Avignon Genoa Ferrara
Santiago de Compostela Fuenterrabía Montpellier Pistoia Bologna Florence
Pamplona Toulouse Carcassonne Pisa Assisi
Burgos St-Bertrand-de-Comminges Perpignan Siena Pienza Orvieto Ascoli Piceno Korčula Otok
Zamora Silos Vich Gerona Rome Anagni
Tagus Daroca Barcelona Naples
Lisbon Toledo Morella Maiori
Valencia Palma de Mallorca
Seville Messina
Cartagena Palermo
Catania

Trecento Italy

During the 14th century, Italy was not the single cultural and political unit we know today but an amalgamation of separate city states whose allegiances varied and whose fortunes changed over the century. For most of the Trecento the residue of the Ghibelline and Guelph conflict of the previous century rumbled on, by this time representing the struggle for supremacy between despotism and democracy. The five main powers of the time were the duchy of Milan, the kingdom of Naples, the republics of Florence and Venice, and the papacy, centered in Rome (except during 1309–77 when it was at Avignon). These cities, with the exception of Rome, were the leading artistic centers of the period, together with Siena, the university towns of Padua, Bologna and Perugia, Orvieto and the pilgrimage town of Assisi. The map shows the distribution of artistic activity in three main areas: the south, centered around Naples and including Sicily, then under Aragonese control; the center, mainly the Papal States, but including Florence, Siena and Pisa; and the north based around Milan and Padua, both, though autonomous, still under German imperial control. Venice was separate, as was Genoa with whom Venice vied for naval supremacy in the Mediterranean.

Although there was some homogeneity, particularly in architecture where the century saw the development of an indigenous Gothic throughout the peninsula, there were differences of emphasis and style in all the arts which reflected the different cultural backgrounds of the several centers. These differences were modified somewhat by the fact that artists moved fairly freely between cities in spite of political circumstances, so that Giotto (*c.* 1266–1337), for example, worked in all three of the main areas, in Naples, Padua and Florence.

In Naples, Santa Chiara and Santa Maria Donna Regina reflect the Angevin roots of the city's culture, whereas in painting the presence of Giotto, the Roman Pietro Cavallini (*fl.*1273–1308) and the Sienese Simone Martini (*c.*1284–1344) in the first half of the century, displayed an awareness in the city of contemporary advances elsewhere in Italy. In sculpture, too, Naples relied on outsiders, mainly of Tuscan origin.

In the center, Florence and Siena gave the lead in all three fields. The scale and grandeur of their cathedrals, raised in competition with each other, were only challenged at the time by the elegance of that at Orvieto.All three cities vied for supremacy in sculpture also, although the craftsmen in Orvieto were probably from the two major centers. In Florence and Siena, painting made the greatest advances in the first half of the century, with the establishment of the two most significant schools headed by Giotto and Duccio (*c.*1255–*c.*1315) respectively. Assisi provided work for the Sienese painters Simone Martini and Pietro Lorenzetti (*fl.c.*1306–45), and for followers of Giotto. Important buildings in the Italian Gothic style were initiated at Perugia and Bologna (which lies between the central and north areas). A school of miniature painting thrived here and the painters Vitale da Bologna (*c.*1309–*c.*1361) and Tommaso da Modena (*c.*1325–*c.*1379) matched the Florentines and Sienese.

In the north, Milan began its cathedral around 1386 and was therefore able to emulate its northern European counterparts in design and intention. In painting and sculpture also Milan tended to look to France, although the Visconti monument by Bonino da Campione (*d.*1397) has a rugged Italian quality. Padua's main building at this time was the hard-to-categorize Palazzo della Ragione, but in painting the legacy of Giotto's early presence can be seen throughout the century in the work of the native Guariento (*fl.*1338–70), the Florentine Giusto de'Menabuoi (*d.*1393) and Altichiero (14th-century) from Verona. In Verona itself the Scaliger tombs at Santa Maria Antica register the passing of a 14th-century dynasty.

Finally Venice, whose trade with the East encouraged a Byzantinism in its painting, was well to the fore in architecture. The two mendicant churches of SS. Giovanni e Paolo and Santa Maria Gloriosa dei Frari not only demonstrate the importance of the Dominican and Franciscan orders in the dissemination of the Gothic style throughout Italy at this time, but also show how that style was assimilated by the Italians and made their own. The Palazzo Ducale, decorated by Guariento in the 1360s, is perhaps the masterpiece of secular architecture of the century.

The development of art and architecture in Italy in the Trecento was interrupted by the Black Death in the 1340s which affected its continuity, particularly in Florence and Siena. However, it is a century in which, in art and architecture as in scholarship and literature, the foundations for the Italian Renaissance were securely laid.

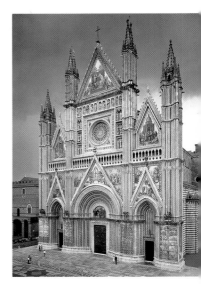

Above: *Lorenzo Maitani (fl.1302–1330),* Duomo, Orvieto, façade begun 1310.

The Umbrian city of Orvieto produced the finest of all the façades of Italian trecento architecture. Designed by a Sienese, Lorenzo Maitani, its style was a creative mixture of native Italian Romanesque and French Gothic. It is decorated with a magnificent program of relief sculpture.

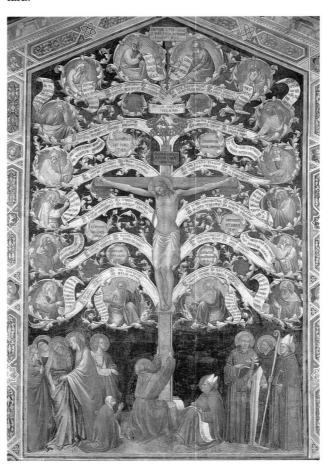

Left: *Taddeo Gaddi (fl.1332–66)* Tree of Life, *fresco, c.1340–50, Refectory of S. Croce, Florence.*

Gaddi was a follower of Giotto, although his art became increasingly emotionally religious, a development common to all Italian art as the century progressed, particularly after the devastation of the Black Death.

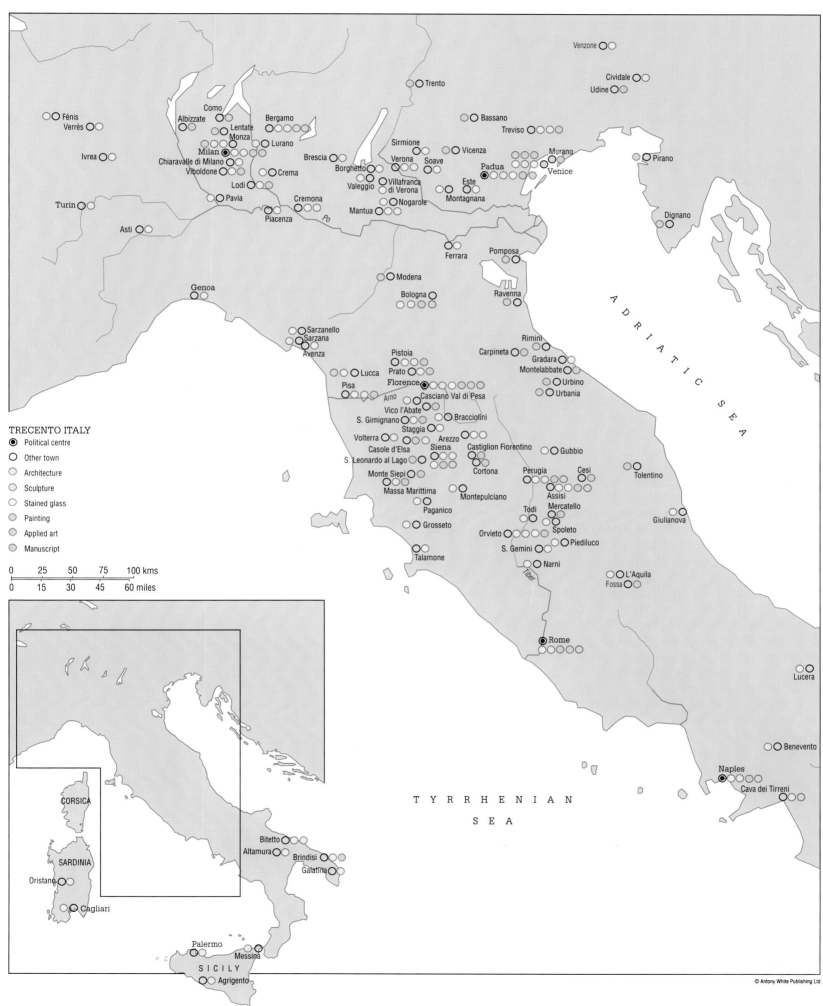

TRECENTO ITALY

- ◉ Political centre
- ○ Other town
- ○ Architecture
- ○ Sculpture
- ○ Stained glass
- ○ Painting
- ○ Applied art
- ○ Manuscript

```
0    25   50   75   100 kms
0    15   30   45   60 miles
```

Venzone

Trento

Cividale
Udine

Fénis
Verrès
Como
Albizzate
Bergamo
Lentate
Monza
Lurano
Milan
Chiaravalle di Milano
Viboldone
Lodi
Pavia
Piacenza
Ivrea
Crema
Brescia
Borghetto
Cremona
Mantua
Nogarole

Bassano
Treviso
Sirmione
Vicenza
Verona
Soave
Murano
Villafranca di Verona
Este
Venice
Valeggio
Montagnana
Padua

Pirano
Dignano

Turin
Asti

Ferrara
Pomposa
Modena
Ravenna
Bologna

ADRIATIC SEA

Genoa
Sarzanello
Sarzana
Avenza
Lucca
Pisa
Arno
Pistoia
Prato
Florence
Casciano Val di Pesa
Vico l'Abate
S. Gimignano
Staggia
Bracciolini
Volterra
Arezzo
Casole d'Elsa
Siena
Castiglion Fiorentino
S. Leonardo al Lago
Cortona
Monte Siepi
Massa Marittima
Montepulciano
Paganico
Grosseto
Talamone

Rimini
Carpineta
Gradara
Montelabbate
Urbino
Urbania
Gubbio
Perugia
Cesi
Tolentino
Assisi
Mercatello
Todi
Spoleto
Orvieto
Piediluco
S. Gemini
Narni
L'Aquila
Fossa
Giulianova

Tiber

Rome

Lucera

TYRRHENIAN
SEA

Benevento
Naples
Cava dei Tirreni

CORSICA

SARDINIA

Oristano
Cagliari

Bitetto
Altamura
Brindisi
Galatina

Palermo
Messina
SICILY
Agrigento

© Antony White Publishing Ltd.

Medieval Rome

From the 12th century topographical descriptions, such as those contained in the *Mirabilia* or in Master Gregory's *De mirabilis urbis Romae*, held the buildings and monuments of Rome, both pagan and Christian, in considerable veneration. In fact very few new churches were founded during this period, but a great deal of architectural and decorative work was carried out on established foundations, in particular on the seven main pilgrimage churches: S. Pietro, S. Giovanni in Laterano, S. Maria Maggiore, S. Croce in Gerusalemme, S. Lorenzo fuori le Mura, S. Paolo fuori le Mura and S. Sebastiano. In the secular field, the conflict between long- and newly-established families provided the city with a proliferation of domestic structures. Such buildings included the Castello Savelli at the foot of the Aventine Hill, the Castello Orsini at the Campo dei Fiore and the Castello Caetani in Trajan's Forum. In the public sphere, the most important building to be either built or renovated was the Palazzo dei Senatori on the Capitol. In the Vatican, the palace built by Innocent III (1198–1216) was enlarged and made more luxurious between 1277 and the end of the century.

This period is not, however, straightforward. The fortunes of Rome fluctuated to such an extent that it may be divided into two distinct parts. From *c.*1250 to 1307 the city was dominated by the presence of the Papal Court, which was attempting to re-establish its political and spiritual control. Then from 1307 (the year of the papacy's removal to Avignon) to *c.*1400, it is characterized by the absence of the papacy and by the more mundane ambitions of the great families striving to assert their authority. In this latter period the social situation was never stable enough to allow for the kind of patronage of the arts that had graced the later years of the previous century.

The artistic story of late medieval Rome is therefore concentrated mainly in the last three decades of the 13th century, when the great commissions from the various popes and their cardinals envisaged a city worthy to be

seen again as the *caput mundi*. The principal means of decoration were mosaic, for its durability, in the tradition of the existing Early Christian churches, and painting, which had also been used in earlier structures but had not survived in such quantities. In mosaic, the lead had been given early in the century with the decoration of the apse of S.Pietro by Innocent III. In emulation, Nicholas III (1277–80) adorned the rebuilt Chapel of the Sancta Sanctorum in the old Lateran Palace with mosaics and murals. There are other such mosaics, culminating in the great *Coronation of the Virgin* (1290s) by the Roman master Torriti (late 13th century) in the apse of S. Maria Maggiore.

The period also reveals to us the names of individual masters. Those of Roman origin include (as well as Torriti) Rusuti (*act.* 1317–21), who worked on the façade mosaics of S. Maria Maggiore at the same time, and Cavallini (*fl.*1273–1308), who as both mosaicist and painter provided decoration for, among others, the trasteverine churches of S. Maria and S. Cecilia in the last decade of the century. Among non-Roman artists, the period provides work by Giotto (*c.*1266–1337), who was commissioned by Cardinal Stefaneschi to paint the high altar of S. Pietro and to design the great *Navicella* in mosaic for the atrium. The Florentine sculptor Arnolfo di Cambio (1232–1302) made the tomb chapel of Boniface VIII (1294–1303) at S. Pietro and designed and carved the two Gothic-inspired ciboria for S. Paolo fuori le Mura and S. Cecilia in Trastevere.

With the background of such outstanding work it is a shame that, in the same century that witnessed the crowning of the poet Petrarch with a laurel wreath in the audience hall on the Capitol (1341), Rome was unable to sustain its artistic impetus once the papacy was removed to Avignon for the most of the rest of the 14th century.

Below left: *Taddeo di Bartolo (1363–1422):* Map of Rome, *fresco, 1413–14, (Town Hall, Siena).*

This late medieval topographical study of Rome shows all the major classical monuments.

Below: *Giotto (c.1267–1337) and followers: rear panels of* High Altar of Old S. Pietro, *(Vatican Museum, Rome).*

Work on the decoration of the early Christian basilica of S. Pietro continued until its destruction in the Renaissance. Here St. Peter, in the central panel, is seated in the church itself.

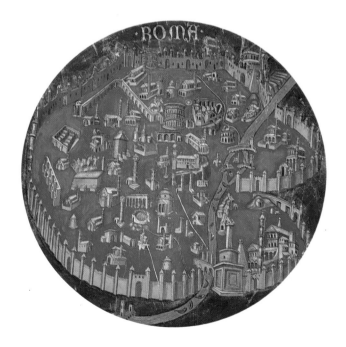

MEDIEVAL ROME

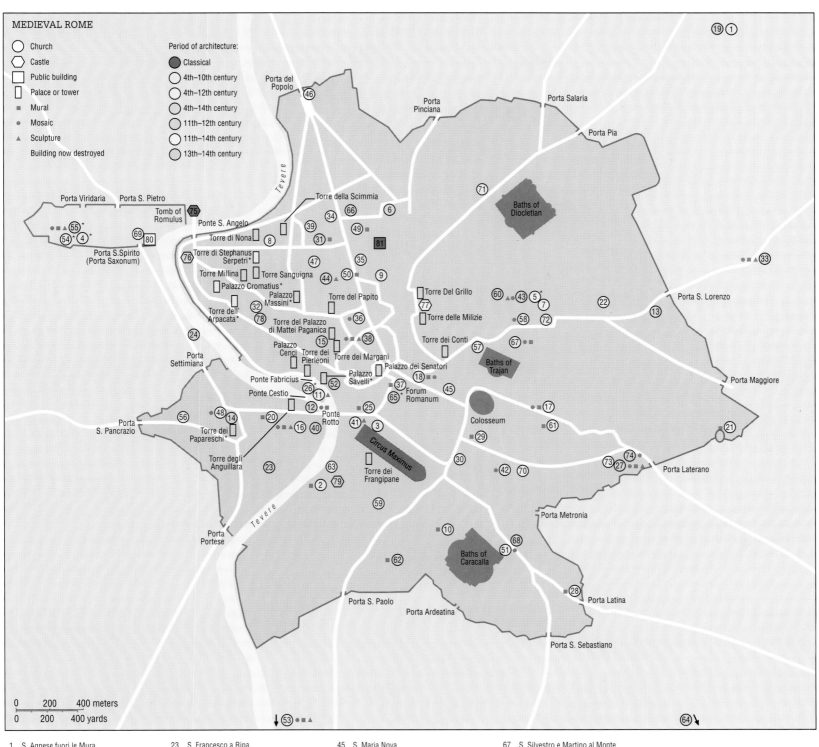

Church
Castle
Public building
Palace or tower
Mural
Mosaic
Sculpture
Building now destroyed

Period of architecture:
Classical
4th–10th century
4th–12th century
4th–14th century
11th–12th century
11th–14th century
13th–14th century

0 200 400 meters
0 200 400 yards

1 S. Agnese fuori le Mura
2 S. Alessio
3 S. Anastasia
4 S. Andrea
5 S. Andrea in Catabarbara
6 S. Andrea delle Frate
7 S. Antonio Abate
8 S. Apollinare
9 Ss. Apostoli
10 S. Balbina
11 S. Bartolomeo
12 S. Benedetto in Piscinula
13 S. Bibiana
14 S. Callisto
15 S. Caterina dei Funari
16 S. Cecilia in Trastevere
17 S. Clemente
18 Ss. Cosma e Damiano
19 S. Costanza
20 S. Crisogono
21 S. Croce in Gerusalemme
22 S. Eusebio

23 S. Francesco a Ripa
24 S. Giacomo in Settignano
25 S. Giorgio in Velabro
26 S. Giovanni Calabita
27 S. Giovanni in Laterano
28 S. Giovanni a Porta Latina
29 Ss. Giovanni e Paolo
30 S. Gregorio Magno
31 S. Gregorio Nazianzeno
32 S. Lorenzo in Damaso
33 S. Lorenzo fuori le Mura
34 S. Lorenzo in Lucina
35 S. Marcello al Corso
36 S. Marco
37 S. Maria Antiqua
38 S. Maria d' Aracoeli
39 S. Maria in Campo Marzio
40 S. Maria in Cappella
41 S. Maria in Cosmedin
42 S. Maria in Domnica
43 S. Maria Maggiore
44 S. Maria sopra Minerva

45 S. Maria Nova
46 S. Maria del Popolo
47 S. Maria Rotonda (Pantheon)
48 S. Maria in Trastevere
49 S. Maria in Via
50 S. Maria in via Lata
51 Ss. Nereo e Achilleo
52 S. Nicola in Carcere
53 S. Paolo fuori le Mura
54 S. Petronilla
55 S. Pietro
56 S. Pietro in Montorio
57 S. Pietro in Vincoli
58 S. Prassede
59 S. Prisca
60 S. Pudenziana
61 Ss. Quattro Coronati
62 S. Saba
63 S. Sabina
64 S. Sebastiano
65 Ss. Sergio e Bacco
66 S. Silvestro in Capite

67 S. Silvestro e Martino al Monte
68 S. Sisto
69 S. Spirito in Sassia
70 S. Stefano Rotondo
71 S. Susanna
72 S. Vito
73 Battistero di S. Giovanni
74 Capella di S. Lorenzo
75 Castel S. Angelo
76 Castello di Giovanni Orsini
77 Castello Caetani
78 Castello Orsini
79 Castello Savelli
80 Ospedale di S. Spirito
81 Fontana di Trevi

Trecento Siena

By the beginning of the 14th century Siena enjoyed comparatively stable government, which, despite some internal feuding, remained the pattern for most of the century. This enabled the Sienese to develop the city in such a way that it challenged Florence in civic grandeur and cultural prestige. In fact the first half of the century, before the Black Death of 1348 decimated it, may be the most seminal in Siena's long history, for it was at this time that the physical form of the city, which remains in essence to the present day, was established. This form may be characterized as a kind of equilibrium between religious and secular, represented by the complementary positioning of the cathedral with its piazza and the Palazzo Pubblico with the Piazza del Campo on either side of the main thoroughfare. The cathedral, built on higher ground and dedicated to Siena's protectress, the Virgin Mary, appropriately dominates the city.

These twin emblems of Siena's cultural life were established in their present form in the 14th century and are epitomized by two complementary towers which dominate the city's skyline: the campanile of the cathedral, raised to its present height on the base of an earlier Romanesque structure in the late 13th and early 14th centuries, and the elegant Torre del Mangia (1338–48) adjacent to the Palazzo Pubblico. The cathedral itself, though founded in 1196 and raised in the 13th century, was brought to its present form during the Trecento; the Baptistery, which abuts its northern side, was built between 1316 and 1325. The Palazzo Pubblico was built between 1297 to 1315, and amplified in the following 30 years.

In addition to these principal buildings, the architecture of Siena, both ecclesiastical and secular, flourished. The period saw, for example, the erection of several new churches: S. Francesco was begun in 1326, and the other mendicant church, S. Domenico, was extensively altered and enlarged. Several palaces were built, including the Palazzo Salimbeni and, late in the century, that of the Buonsignori family. The gates of the city, in particular the Porta Romana and the Porta Pispini, were built, and fountains were constructed and maintained.

In painting, the period from c.1300 to 1348 saw the flourishing of a school begun by Duccio di Buoninsegna (c.1255–c.1315). Duccio's own *Maestà* for the high altar was carried in jubilant procession from his workshop to the cathedral in 1311. Other works were made by artists such as Simone Martini (c.1284–1344), Lippo Memmi (d.1357) and the brothers Lorenzetti to adorn chapels in the cathedral. Pietro (fl. c.1306–45) and Ambrogio Lorenzetti (fl.1319–47) executed paintings for the Palazzo Pubblico, including the frescoes of the so-called *Good and Bad Government* (1338–40) by Ambrogio, who also painted a series of frescoes for S. Francesco. The demise of many artists in the Black Death cut short this early flowering so that the later half of the century did not enjoy the same abundance of artistic talent.

In sculpture the story is different: at this time the Sienese were not eminent in this field. A monument of 1317–18 by the Sienese sculptor Tino di Camaino (c.1285–c.1337) stands in the cathedral, but the most significant project was the Cappella di Piazza beneath the Torre del Mangia in the Campo, begun in 1352.

Although in architecture Siena contributed to the development and spread of the Italian Gothic style of building during the Trecento, its main achievement in this period is in its painting, the realism and refinement of which profoundly affected artists elsewhere, particularly in northern Europe in the next two centuries.

Right: The Piazza del Campo, with the Palazzo Pubblico (begun 1297) and the Torre del Mangia (1338–48).

Known simply as il Campo, the Piazza was the political and civic center of Siena, as opposed to the Duomo, the religious center, up the hill to the west. Of concave shape, the piazza is dominated by the Palazzo Pubblico, the town hall.

Below left & right: *Ambrogio Lorenzetti* (fl. 1319–47): Allegory of Good Government, 1337 (left) and The Effects of Good and Bad Government, 1337–9 (right) (both Palazzo Pubblico, Siena).

Two allegorical frescoes extolling the virtues of good government. Stylistically the artist was in close touch with the Florentine art of Giotto – but as subject these paintings are aimed as an inspiration to the citizens of Siena.

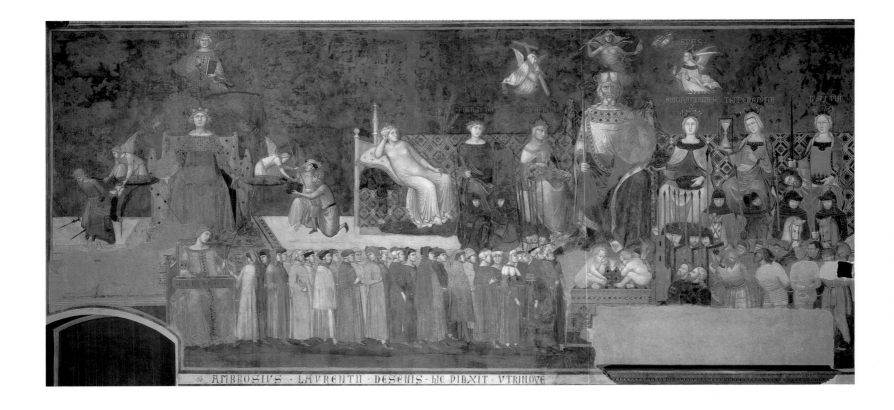

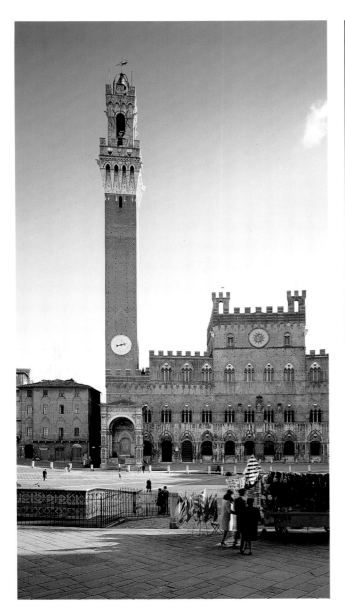

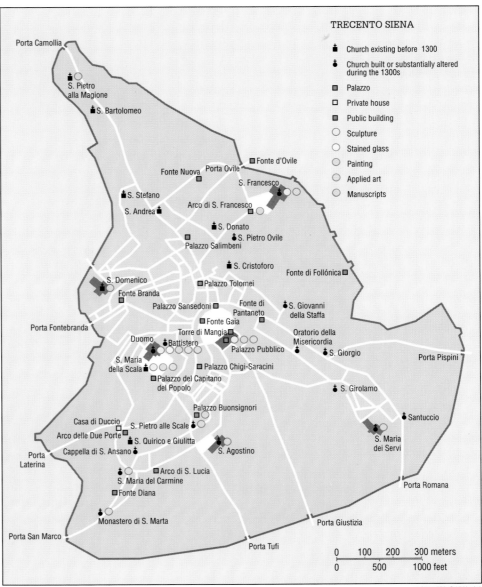

TRECENTO SIENA

- ⬥ Church existing before 1300
- ⬥ Church built or substantially altered during the 1300s
- ▪ Palazzo
- ▫ Private house
- ▪ Public building
- ○ Sculpture
- ○ Stained glass
- ○ Painting
- ○ Applied art
- ○ Manuscripts

Porta Camollia

S. Pietro alla Magione

S. Bartolomeo

Fonte Nuova
Porta Ovile
Fonte d'Ovile
S. Francesco
S. Stefano
Arco di S. Francesco
S. Andrea
S. Donato
S. Pietro Ovile
Palazzo Salimbeni
S. Cristoforo
Fonte di Follónica
S. Domenico
Fonte Branda
Palazzo Tolomei
Palazzo Sansedoni
Fonte di Pantaneto
S. Giovanni della Staffa
Porta Fontebranda
Fonte Gaia
Torre di Mangia
Oratorio della Misericordia
Duomo
Battistero
Palazzo Pubblico
S. Giorgio
S. Maria della Scala
Palazzo Chigi-Saracini
Porta Pispini
Palazzo del Capitano del Popolo
S. Girolamo
Palazzo Buonsignori
Santuccio
Casa di Duccio
S. Pietro alle Scale
Arco delle Due Porte
S. Quirico e Giulitta
S. Maria dei Servi
Cappella di S. Ansano
S. Agostino
Porta Laterina
Porta Romana
S. Maria del Carmine
Arco di S. Lucia
Fonte Diana
Porta Giustizia
Monastero di S. Marta
Porta San Marco
Porta Tufi

| 0 | 100 | 200 | 300 meters |
| 0 | 500 | | 1000 feet |

© Antony White Publishing Ltd.

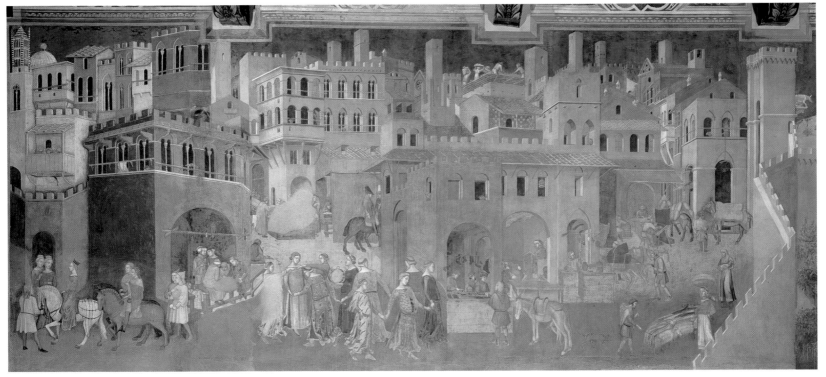

International Gothic

Around 1400 European art displayed a remarkable homogeneity of style, which has come to be generally – although not entirely satisfactorily – known as International Gothic. The style is so called because it shares characteristics with Gothic art, notably its refinement and love of ornament, and because it transcends geographical and political boundaries. Once regarded as merely a transitional phase between the art of the High Middle Ages and that of the Renaissance, it is now recognized as an important style in its own right, which originated about 1380, reached its height about 1400–25, and continued to be influential in some centers, notably northern Italy, as late as 1450, flourishing concomitantly and not necessarily in conflict with the art of the Early Renaissance. In fact one of the prime concerns of International Gothic was naturalism, shared by the Renaissance, and in Italy some of the foremost International Gothic artists, Lorenzo Ghiberti (1378–1455), Gentile da Fabriano (c.1370–1427) and Antonio Pisanello (1395–1455), were also exponents of the Renaissance style.

Although the masterpieces associated with the above three artists are large-scale works, such as Ghiberti's first set of Florentine Baptistery Doors (1403–24), Gentile's altarpiece of the *Adoration of the Magi* (1423; Uffizi, Florence,) and Pisanello's fresco of *St. George and the Princess* (1437; S. Anastasia, Verona), the art forms of the International Gothic are more often small and portable, accounting in part for the spread of the style.

Typically, they comprise illuminated manuscripts, notably books of hours like the Limbourg brothers' *Très Riches Heures* of Jean, Duc de Berry (c.1410; Musée Condé, Chantilly); small panel paintings such as the *Wilton Diptych* (c.1400; National Gallery, London) produced for Richard II of England; ornaments of precious metal, enamel and gems, notably the *Goldenes Rössel* (1404; Altötting, Bavaria) made for Charles VI of France; and tapestry, such as the *Apocalypse* (before 1384; Angers Castle), designed by Jean de Bandol (*fl.*1368–81) for Louis, Duke of Anjou.

International Gothic is often associated with courtly art. Elegant, decorative and optically rich in appearance, comprising the most costly and lavish art forms of the day, the style was naturally in keeping with aristocratic taste. It was by no means restricted to court circles, however, but also flourished in the Italian republics, notably Florence, Siena and Venice, and in the mercantile cities of the Netherlands and Germany where, for example, Master Francke (*fl.c.*1405–34) painted his *St. Thomas Altarpiece* (c.1424; Kunstalle, Hamburg) for the Company of English Seamen in Hamburg.

Artists' movements contributed to the international character of the style. The foremost artists employed at the courts of Paris, Dijon and Bourges were Netherlandish, while at Prague there was an influx of French and German artists. It must be borne in mind that for some parts of Europe, such as the Netherlands and Bohemia, the documentation and survival of works of art are considerably poorer than for others, such as Italy, giving an imbalanced picture of their relative cultural importance at the time. Many of the most representative and beautiful International Gothic works are by anonymous masters, notably the so-called Fair Madonnas, produced throughout Austria and Bohemia, which, elegantly poised, delicately naturalistic in observation and with lyrically curving draperies, epitomize the character of International Gothic art.

Above: *Anonymous,* Fair Madonna, *statuette, early 15th century, (Kunsthistorisches Museum, Vienna).*

Fair Madonnas, gently pious naturalistic devotional statues, were common in the early 15th century in Bohemia and Austria.

Left: *Limbourg brothers, Pol Hennequin and Herman de (all d. by 1410),* August, *from the* Très Riches Heures *of Jean, Duc de Berry, Manuscript, c.1416, (Musée Condé, Chantilly).*

Illuminated manuscripts, such as this exceptionally rich book of hours made for the brother of the Duke of Burgundy, were particularly suited to the minute naturalistic observation and the decorative detail of International Gothic art.

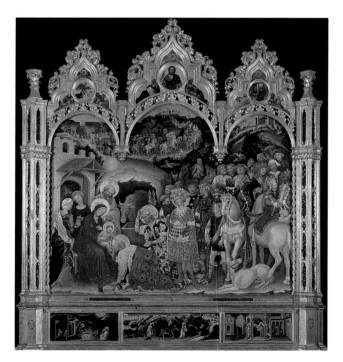

Near left: *Gentile da Fabriano (c.1370–1427),* Adoration of the Magi, *panel, 1423, (Uffizi, Florence).*

A large-scale example of courtly art, made for the powerful Strozzi family in Florence. Gentile also worked in Venice, Siena, Orvieto and Rome.

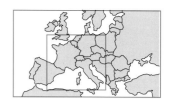

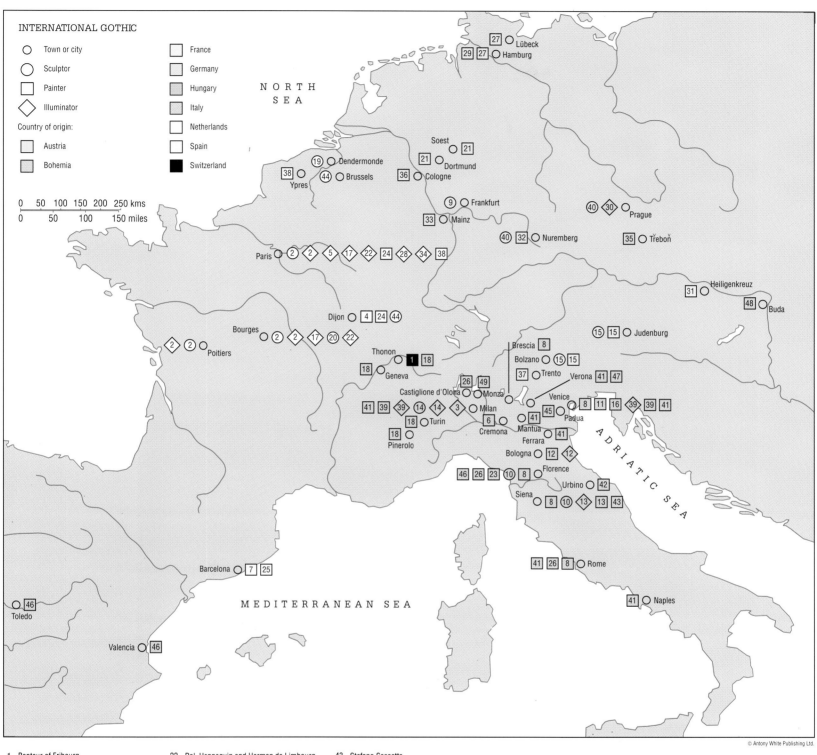

INTERNATIONAL GOTHIC

Symbols:
- ○ Town or city
- ◯ Sculptor
- ☐ Painter
- ◇ Illuminator

Country of origin:
- Austria
- Bohemia
- France
- Germany
- Hungary
- Italy
- Netherlands
- Spain
- ■ Switzerland

0 50 100 150 200 250 kms
0 50 100 150 miles

NORTH SEA

ADRIATIC SEA

MEDITERRANEAN SEA

Lübeck 27
Hamburg 29 27
Soest 21
Dortmund 21
Dendermonde 19
Brussels 44 36 Cologne
Ypres 38
Frankfurt 9
Mainz 33
Nuremberg 40 32
Prague 40 30
Třeboň 35
Paris 2 2 5 17 22 24 28 34 38
Heiligenkreuz 31
Buda 48
Dijon 4 24 44
Bourges 2 2 17 20 22
Judenburg 15 15
Poitiers 2 2
Thonon 1 18
Geneva 18
Brescia 8
Bolzano 15 15
Trento 37
Verona 41 47
Castiglione d'Olona 26 49
Monza
Milan 41 39 39 14 14 3
Venice 8 11 16 39 39 41
Padua 45
Turin 18 6
Cremona
Mantua 41
Ferrara 41
Pinerolo 18
Bologna 12 12
Florence 46 26 23 10 8
Urbino 42
Siena 8 10 13 13 43
Barcelona 7 25
Toledo 46
Valencia 46
Rome 41 26 8
Naples 41

© Antony White Publishing Ltd.

1 Bapteur of Fribourg	22 Pol, Hennequin and Herman de Limbourg
2 André Beauneveu	23 Lorenzo Monaco
3 Belbello da Pavia	24 Jean Malouel
4 Henri Bellechose	25 Bernardo Martorell
5 Jean Bondol	26 Masolino da Panicale
6 Bonfazio Bembo	27 Master Bertram
7 Luis Borrassá	28 Master of the Boucicaut Hours
8 Gentile da Fabriano	29 Master Francke
9 Madern Gertner	30 Master of Hasenburg
10 Lorenzo Ghiberti	31 Master of Heiligenkreuz
11 Michele Giambono	32 Master of the Imhoff Altarpiece
12 Giovanni da Modena	33 Master of the Ortenberg Altarpiece
13 Giovanni di Paolo	34 Master of the Rohan Hours
14 Giovannino de' Grassi	35 Master of Trebon (Wittingau)
15 Hans von Judenburg	36 Master of St Veronica
16 Jacobello del Fiore	37 Master Wenceslaus
17 Jacquemart de Hesdin	38 Melchior Broederlam
18 Jacquerio	39 Michelino da Besozzo
19 Jacques de Baerze	40 Peter Parler
20 Jacques de Cambrai	41 Antonio Pisanello
21 Konrad von Soest	42 Lorenzo and Jacobo Salimbeni

43 Stefano Sassetta	
44 Claus Sluter	
45 Francesco Squarcione	
46 Gherardo Starnina	
47 Stefano da Zevio/da Verona	
48 Thomas of Kolosvár	
49 Zavattari family	

Above: *Michelangelo Buonarroti (1475–1564)* Piazza del Campidoglio, *Rome.*

THE RENAISSANCE

The art of the Renaissance sought to achieve the portrayal of reality. Painters and sculptors tackled the problem in two ways, by the study of newly excavated classical statuary, particularly in Italy, and by the precise observation of the physical world, particularly in Flanders and the North. At the same time the rediscovery of Greek and Roman texts and learning in Italy provided the scholarly background to a deeper knowledge of the classics. Architectural style was built on archeological research: for instance the Capitol of Rome, with its piazza laid out by Michelangelo in the heart of the ancient city, flanked by Renaissance classical buildings and incorporating the great equestrian Roman bronze sculpture of Marcus Aurelius, epitomized the marriage of archeological research and Renaissance urban planning.

Above: Two Renaissance Pendant Jewels.

Politics in Renaissance Europe

The decline of German imperial power in the second half of the 14th century, the schism within the Church and the ravages of the Black Death brought about a political fragmentation which evolved into a new dynamic series of alliances. This revolutionary political system of a balance of power originated in Italy (see p141) and was transferred to the rest of Europe in 1495 when the Emperor Maximilian I, King Ferdinand of Aragon, Pope Alexander VI, the republic of Venice and the Duchy of Milan formed the Holy League in order to curtail the political aspirations of Charles VIII, King of France.

In the opening decade of the 16th century, for example, Venice was at the center of the European power struggle. The immense economic power of the republic, and its increasing expansion at the expense of the Papal States was threatening the whole of Europe. To counter it, the Pope, the Emperor, Ferdinand of Aragon and Henry VIII of England joined in the League of Cambrai but the defection of the French from the Venetian camp tipped the balance. This was immediately redressed in the alliance of the Papacy with its former enemy Venice together with Spain and the Swiss against France.

For the rest of the century the political history of Europe was one long series of negotiated alliances. The Habsburgs, holding Spain, Milan and the Netherlands as well as the Empire, had effectively put a circle around the kingdom of France. The resulting epic struggle between the kings of France and the Habsburg emperors was conducted as much through diplomatic relations as through military intervention, with the other European states ranging themselves behind one or the other great power, often supporting first one side and then the other.

Given this political system, it is not surprising that the art of diplomacy, which also originated in Italy, spread to the national monarchies of Europe. It was obviously necessary to know in advance the economic, military and dynastic resources of each state, and their immediate political intentions. Following the custom of the Venetian republic, other states began to send permanent ambassadors abroad. These, with their retinues of secretaries, agents, hired informants and *agents provocateurs* were instrumental in the negotiations of the ever shifting alliances.

By mid-century the balance of power altered radically; the great voyages of discovery had opened up worldwide trade and shifted economic power away from the Mediterranean and Baltic countries to Spain and Portugal on the Atlantic seaboard. This shift conditioned the European power struggle as it developed in the 17th century.

EUROPE IN THE EARLY
SIXTEENTH CENTURY

Genoese possessions

Lands of the church

Ottoman Empire

Papal States

Spanish possessions

Venetian possessions

Boundary of Holy Roman Empire

0 100 200 300 400 kms

0 100 200 miles

ATLANTIC

OCEAN

Oporto R. Douro Va

Lisbon R. Tagus S

PORTUGAL

Seville

Gibraltar Gra

Tangier Ceuta

MOROCCO

Above: *Paolo Uccello (1397–1475):* The Rout of San Romano, *1455/7 (National Gallery, London).*

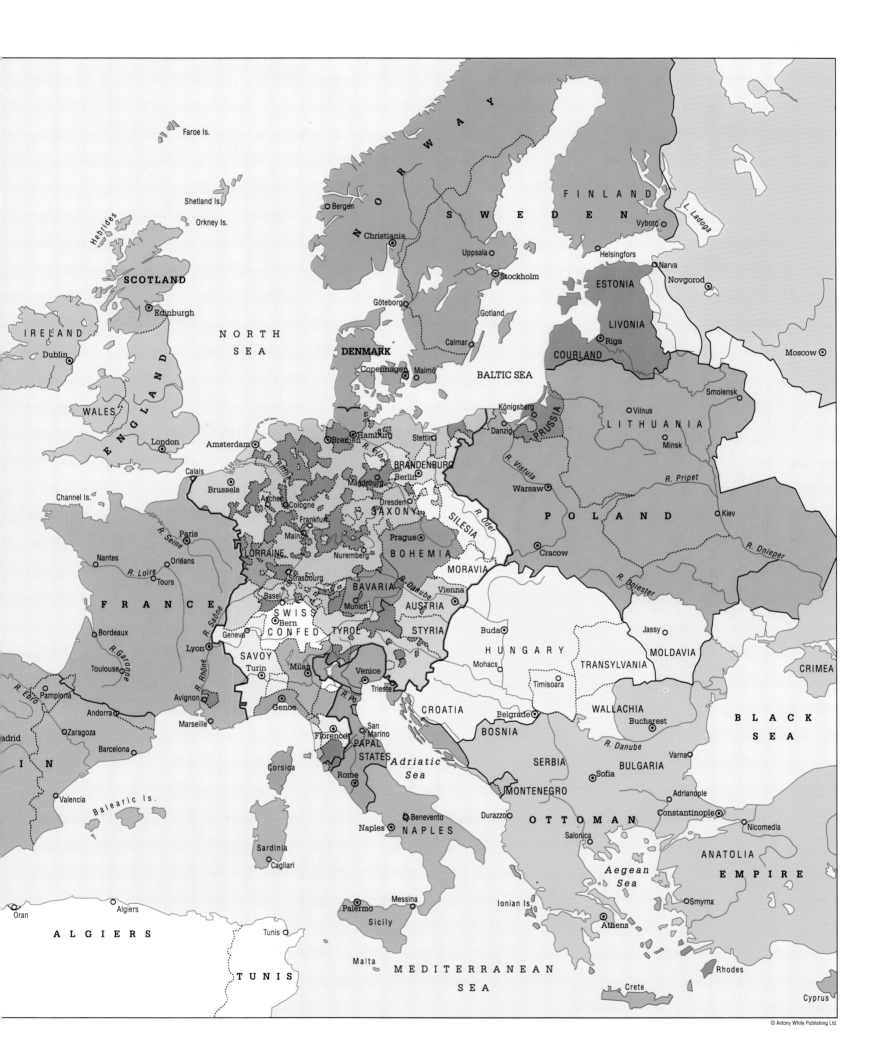

FAROE Is.

Shetland Is.

Orkney Is.

Hebrides

SCOTLAND

Edinburgh

IRELAND

Dublin

WALES

London

ENGLAND

Channel Is.

Calais

Brussels

Amsterdam

NORTH SEA

Bergen

NORWAY

Christiania

Göteborg

SWEDEN

Uppsala

Stockholm

Calmar

Gotland

Copenhagen

Malmö

DENMARK

FINLAND

Vyborg

L. Ladoga

Helsingfors

Narva

Novgorod

ESTONIA

LIVONIA

Riga

COURLAND

BALTIC SEA

Königsberg

Danzig

PRUSSIA

Vilnus

Minsk

LITHUANIA

Moscow

Smolensk

Kiev

R. Pripet

R. Vistula

Warsaw

POLAND

Cracow

R. Dnieper

R. Dniester

Bremen

Hamburg

Stettin

BRANDENBURG

Berlin

Magdeburg

R. Elbe

Dresden

SAXONY

SILESIA

R. Oder

R. Rhine

Aachen

Cologne

Frankfurt

Mainz

Nuremberg

BOHEMIA

Prague

MORAVIA

Vienna

Paris

R. Seine

Orléans

Nantes

Tours

R. Loire

FRANCE

LORRAINE

Strasbourg

Basel

BAVARIA

Munich

AUSTRIA

STYRIA

R. Danube

Bordeaux

R. Garonne

Lyon

R. Saône

SWISS CONFED

Bern

Geneva

TYROL

Buda

HUNGARY

Mohacs

Timisoara

Jassy

MOLDAVIA

TRANSYLVANIA

CRIMEA

R. Rhône

SAVOY

Turin

Milan

Venice

Trieste

R. Po

Avignon

Toulouse

Pamplona

R. Ebro

Andorra

Zaragoza

Madrid

Barcelona

Marseille

Genoa

San Marino

Florence

PAPAL STATES

CROATIA

Belgrade

WALLACHIA

Bucharest

R. Danube

Varna

BLACK SEA

BOSNIA

SERBIA

Sofia

BULGARIA

Adriatic Sea

Rome

Valencia

Corsica

MONTENEGRO

Durazzo

Adrianople

OTTOMAN

Constantinople

Nicomedia

Balearic Is.

Benevento

Naples

NAPLES

Sardinia

Cagliari

Salonica

ANATOLIA

EMPIRE

Aegean Sea

Messina

Palermo

Sicily

Ionian Is.

Smyrna

Athens

Oran

Algiers

ALGIERS

Tunis

TUNIS

Malta

MEDITERRANEAN SEA

Rhodes

Crete

Cyprus

Major sites of Humanist Learning 1400–1600

In the Middle Ages scholarly activity had taken place almost exclusively within the universities. In the Renaissance it was the great collections of classical manuscripts and later the printing presses of scholar printers that provided important sites for humanist scholarship.

Between 1400–1600 a new learning, focused on the study of Latin, Greek and Hebrew texts, transformed the culture and literature of western Europe. From the late Trecento, scholars copied and edited the classical manuscripts, employing the rigorous textual criticism of the new learning. They discovered in the writings of the classical *auctores* new ideals and a new awareness of the power of language, especially from the civic eloquence of Cicero.

In Florence the early Latin humanists gathered in the gardens of the great scholar chancellor Coluccio Salutati (1331–1406) to share their excitement in the new learning. They thus established a tradition of informal scholarly exchanges in circles modeled on the gatherings of ancient Greece. These circles and learned academies became very typical sites of Renaissance learning.

The rediscovery of the Latin classical world inevitably led towards the culture of ancient Greece. In the early 15th century Italian scholars travelled to Constantinople to learn Greek under the Byzantine scholar Johannes Argyropoulos (1415–87) while many Byzantine scholars came to Europe, attending the Church Councils, and were teaching in northern Europe as early as 1408 when Manuel Chrysoloras (1350–1431) visited the French, English and Spanish courts.

Florence became the earliest center in Western Europe for the study of Greek. From 1396 to 1400 Chrysoloras held the first chair of Greek at the Florentine *studium*. By mid-century the *studia humanitatis*, which included rhetoric as well as Latin and Greek, were well established in Italian universities at Ferrara, Pavia, Padua and Naples. At Careggi, outside Florence, the villa of the young Greek scholar Marsilio Ficino (1433–99) became the center for Platonic studies. Scholars from all over Europe came to this Platonic Academy, as it was later called, and to other Italian academies: the informal gatherings of Cardinal Bessarion (1395–1472) in Rome, the more formal Roman Academy of the 1450s in the house of Pomponio Leto (1428–98), the Accademia Pontaniana in Naples. Humanists, especially from Germany, returned to their own cities to teach Greek and re-create informal circles and academies similar to those in Italy.

The initial phase of Hebrew studies in the Renaissance also spread through personal contact between scholars. Johann Reuchlin (1455–1522) studied at the two great Italian collections of Hebrew manuscripts, the papal collection in Rome, and that of Pico della Mirandola (1463–94) in Florence. John Colet (*c.*1467–1519) studied in Florence and returned to England to implement the new methodology of textual criticism, promoting the intense activity of biblical scholarship that characterizes 16th-century humanist work outside Italy. Lefèvre d'Étaples (1437–1536) also completed his studies with the 'Italian tour' and, back in Paris, applied the teachings of Lorenzo Valla (1406–57) to biblical stud-

Above: *Woodcut showing Cristoforo Landino (1424-92), Florentine humanist and member of the Platonic Academy. Appointed in 1458 to the chair of poetry and rhetoric he is shown here teaching at the studium.*

Left: *Early sixteenth century press at work, the mark of the Parisian scholar printer Jodocus Badius (1462-1535). His editions of the Latin classics emulated the scholarship of Manutius and with the Estiennes and the Dolets brought France into the forefront of book printing.*

ies. At the University of Alcalá, under the direction of Cardinal Ximenes de Cisneros (1437–1517), a host of scholars was working on the Complutensian Polyglot Bible, printed in parallel columns of Hebrew, Greek and Latin.

At the close of the 15th century humanist scholarship was revolutionized by the advent of printing, and the presses of the great scholar-printers became the major sites of scholarship. In Venice Aldus Manutius (*c.*1450–1515) printed over 20 first editions of the major Greek authors. The Neakademia circle of scholars working at his Aldine Press was the most renowned humanist center for Greek studies. Venice was also one of the main centers for Hebrew scholarship, at the press of Daniel Bomberg (*d.*1549). In Antwerp at the press of Christophe Plantin (1514–89) scholars under the direction of the Spanish humanist Arias Montano (1527–98) were at work on a further version of the Polyglot Bible. In Basel the press and home of the printer Joannes Auerbach (1443–1519) was a meeting place of humanists as was the press of Johann Froben (1460–1527). At Louvain the Collegium Trilingue founded by Desiderius Erasmus (1469–1536) drew many celebrated Hellenist and Hebraist scholars as did the university press which specialized in the new science of cartography. By the mid sixteenth century, printing in the vernacular had begun to outstrip the classical languages. Antonio de Nebrija (1442–1522) the author of the first Spanish grammar dedicated this work to Isabella of Castile with the maxim: "language accompanies empire". Not only the language, but also the culture and ideals of the Golden Age of western Europe was to develop from the humanist learning of the Renaissance.

Above: *Printer's mark of William Caxton (c.1427-91).*

Printing first in Bruges and then in London, Caxton published over half his books in the vernacular, a major factor in the standardization of the language, as were the many vernacular translations of the Bible printed by Hans Lufft (1495-1584) in Wittenberg.

MAJOR SITES OF HUMANIST LEARNING 1400-1600

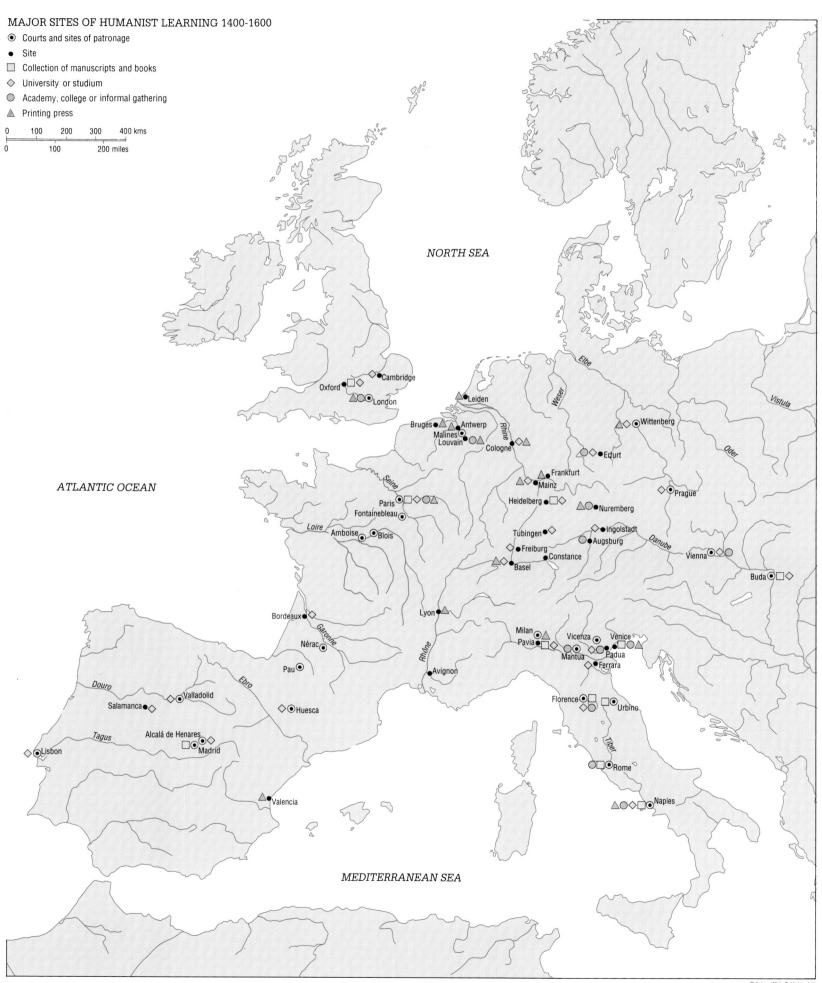

- ⊙ Courts and sites of patronage
- ● Site
- ▫ Collection of manuscripts and books
- ◇ University or studium
- ⬤ Academy, college or informal gathering
- ▲ Printing press

0 100 200 300 400 kms
0 100 200 miles

NORTH SEA

ATLANTIC OCEAN

Elbe

Weser

Vistula

Oder

Rhine

Seine

Loire

Danube

Rhône

Garonne

Ebro

Douro

Tagus

Tiber

MEDITERRANEAN SEA

Cambridge
Oxford
London
Leiden
Bruges
Antwerp
Malines
Louvain
Cologne
Wittenberg
Edurt
Frankfurt
Mainz
Heidelberg
Nuremberg
Prague
Paris
Fontainebleau
Amboise
Blois
Tübingen
Ingolstadt
Freiburg
Augsburg
Constance
Basel
Vienna
Buda
Bordeaux
Nérac
Pau
Lyon
Avignon
Milan
Pavia
Vicenza
Venice
Mantua
Padua
Ferrara
Valladolid
Salamanca
Huesca
Florence
Urbino
Alcalá de Henares
Madrid
Lisbon
Rome
Valencia
Naples

135

© Antony White Publishing Ltd.

Artists' Travels in the Renaissance

The Royal Princes and their courts, and those of kings queens and emperors were a main attraction for artists, so that at different periods northern artists, such as Roger van der Weyden visited the D'Este Court at Ferrara, while Italians such as Leonardo, Andrea del Sarto, Primaticcio and Rosso visited France, stimulated by the patronage of Francis I. Subsequently also the young Sforza protegé, Zanetto Bugatto, was sent north to become an apprentice of Roger van der Weyden after his own return from Ferrara. Titian encountered German artists when in 1548 and 1550 he visited Augsburg on the invitation of the Emperor Charles V. The Court of Margaret of Austria at Malines was likewise a center for visiting artists and for an exchange of ideas which encouraged the "Romanisation" of Flemish art.

Likewise there was a flourishing exchange of artists between Spain, the Netherlands and Italy, which reflected both the search for training and commissions and also the complex political interrelationship between these countries in the Renaissance period.

Equally, however, artists visited each others' workshops and traveled to different cities because they were established centers of artistic excellence. Dürer's two visits to Venice were an example of this and likewise, at least in part, his later visit to the Netherlands.

German artists are, however, a different case because the *wanderjahre,* the practice of traveling extensively in their apprentice years, was an etablished part of a Master's training.

In the first half of the 16th century the development of the *nouveau riche* city of Antwerp as a center for an art trade in the modern sense added a new dimension to the international exchange of works of art.

Above: *Albrecht Dürer (1441–1528):* Castle Courtyard, Innsbruck *(Albertina, Vienna).*

ARTISTS' TRAVELS IN THE RENAISSANCE

● Town or city

Artists from:

○ France
○ Germany and Eastern Europe
○ Iberian peninsula
○ Italy
○ Low Countries
⟶ Travel of artist

1 Andrea del Sarto (1486–1530)
 1518–19 Florence to Fontainebleau
2 Antonello da Messina (c.1430–79)
 1475–76 Naples to Venice and possibly to the Netherlands
3 Melchior Broederlam (c.1381–c.1409)
 1390 and 1395 Ypres to Paris
 1399 Ypres to Dijon
4 Zanetto Bugatto (fl. 1458–74)
 1460/3 Milan to Brussels
 1463 back to Milan
 1465 to Savoy and Milan
 1466–68 (unclear when) went to Savoy
5 Petrus Christus (d.c.1473)
 1453/5 possibly Bruges to Venice
6 Alonso Sanchez Coello (1531/2–88)
 1550 Lisbon to Brussels
7 Jacques Coene (fl.1398–1411)
 1399 Paris to Milan
8 Corneille de Lyon (fl. 1534–74)
 c.1533 The Hague to Lyon
9 Michiel Coxie (1499–1592)
 1531 Malines to Rome
 Malines to Brussels
10 Diego di Siloe (c.1495–1563)
 1517–19 Burgos to Naples
 1528 Burgos to Granada
11 Albrecht Dürer (1471–1528)
 1490–94 Nuremberg to Colmar, Basel and Strasbourg
 1494–95 Nuremberg to Venice
 1505–07 Nuremberg to Venice
 1520–21 Nuremberg to Aachen, Brussels, Malines, Cologne, Middelburg, Bruges and Ghent
12 Domenico Fancelli (1469–1519)
 1510 Genoa to Seville
 1513 Genoa to Ávila
13 Jehen Fouquet (c.1420–c.1481)
 1446/7 Tours to Rome (possibly left already 1444)
 1461 Bruges to Paris
 1472 Tours to Blois
14 Nicolaus Gerhaerdt von Leyden (fl. 1463–c.1473)
 1463–67 Trier to Strasbourg
15 Jan Gossaert (Mabuse) (d.c.1533)
 1508 Malines to Rome
16 Juan Gruas
 c.1430 Brussels to Toledo
17 Hans Holbein the Older (c.1465–1524)
 1517–19 Augsburg to Lucerne
18 Hans Holbein the Younger (1497–1543)
 1515 Augsburg to Basel
 1517–19 Basel to Lucerne (and Italy – not certain)
 1526–28 Basel to Antwerp, to London
 1532 Basel to London
19 Joos van Ghent (van Wassenhove) (fl. 1460–1480)
 1473–74 Ghent to Urbino and Rome
20 Juan Battista de Toledo (d.1567)
 Toledo to Naples
 1459 Naples to Madrid
21 Juan de Herrera
 1547–61 Valladolid to Brussels
22 Leonardo da Vinci (1452–1519)
 1482/3–99 Florence to Milan
 1506–13 Florence to Milan
 1513–16 Florence to Rome
 1516 Florence to Amboise
23 Matthias of Arras
 1344 Avignon to Prague

24 Anthonis Mor (c.1517/21–76/7)
 c.1549 Brussels to Rome
 1554 Brussels to London
 1559 Brussels to Spain (possibly Toledo)
25 Francesco Primaticcio (c.1504–70)
 1532 Mantua to Fountainebleau
26 Rosso Fiorentino (1494–1540)
 1523–27 Florence to Rome
 1530 Rome to Fontainebleau
27 Andrea Sansovino (c.1467–1529)
 1491–93 Florence to Lisbon
 (1493–95 back in Florence)
 1496–1501 to Bacalhoa (Lisbon), to Toledo
 1513 to London
28 Michiel Sittow (1468–1525/6)
 1495/6 Bruges to Simancas (Burgos)
 1514 Bruges to Denmark
 1515 Bruges to Valladolid
29 Claus Sluter (fl. 1380–c.1406)
 1379 Haarlem to Brussels
 1390 Haarlem to Dijon
30 Andrea Solario (fl. 1495–1522)
 1507 Milan to Gaillon (Normandy)
31 Hans Stetheimer von Burghausen (c.1350/60–1432)
 1408 Landshut to Salzburg
32 Veit Stoss (c.1440/50–1533)
 1477 Nuremberg to Cracow
33 Titian (c.1490–1576)
 1545–46 Venice to Rome
 1548–49 and 1550–51 Venice to Augsburg
34 Pietro Torrigiano (1472–1528)
 1494 Bologna to Rome
 1509 to Malines
 1511 and 1520 to London
 1522 to Granada
35 Jan Vermeyen (c.1500–59)
 1530 Malines to Augsburg
 1533/4 Malines to Spain
 1535 Barcelona to Tunis
 1539/40 Burgos to Brussels
36 Felipe Vigarni
 1498–50 Langres (Burgundy) to Burgos, to Salamanca
37 Rogier van de Weyden (c.1400–64)
 1449–50 Brussels to Ferrara, to Milan
38 Conrad Witz (c.1410–c.1446)
 c.1435 Rottweil to Basel

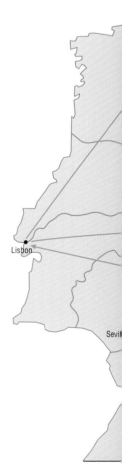

Lisbon

Sevil

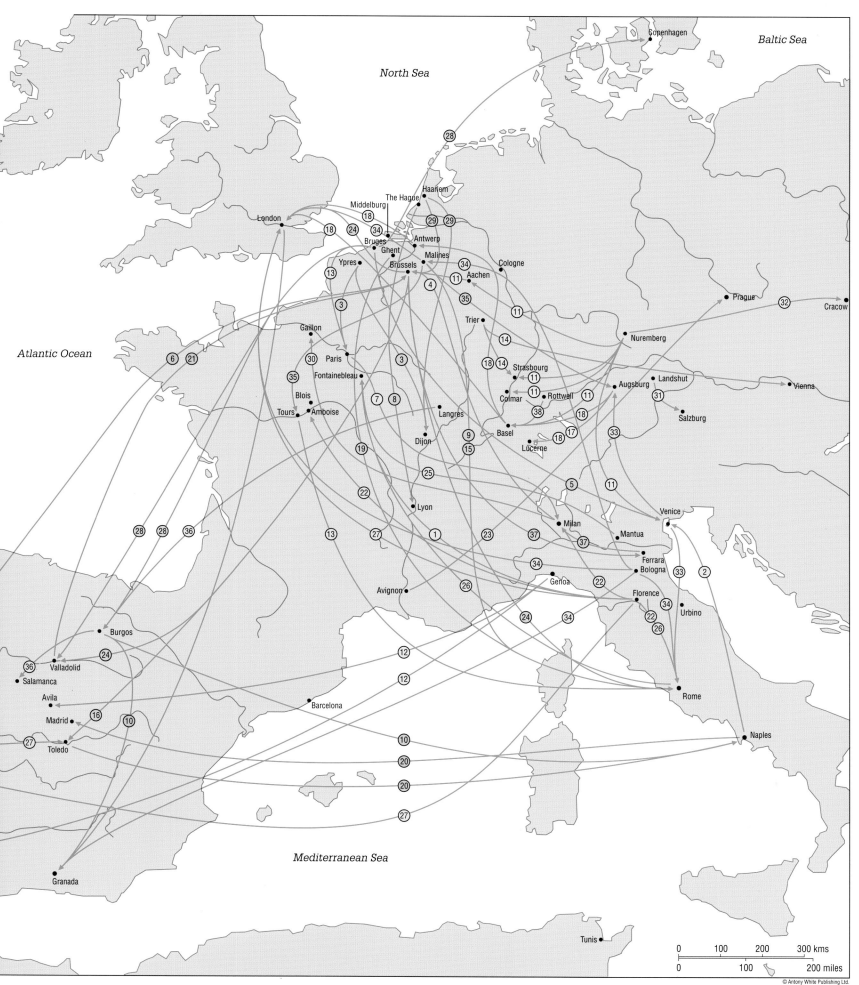

North Sea

Baltic Sea

Copenhagen

(28)

Haarlem
The Hague
Middelburg
London
(18)
(18) (24) (34) (29) (29)
Bruges
Ghent
Antwerp
Malines
Ypres
Brussels
(34)
Cologne
(13)
(11) Aachen
(4)
(35)
(3)
Prague
(32)
Cracow
Trier
(11)
(14)
Atlantic Ocean
Gaillon
Nuremberg
(6) (21)
(30) Paris
(3)
(18) (14) Strasbourg
Landshut
(35) Fontainebleau
(11)
Augsburg
Blois
(7) (8)
(11) Colmar (11)
(31)
Vienna
Tours Amboise
(38)
(18)
Salzburg
Langres
(18) (17)
(33)
Dijon
(9) Basel
(19)
(15) (18)
Lucerne
(25)
(22)
(5)
(11)
Venice
Lyon
(13)
(27)
(1)
(23)
(37)
Milan
(37)
Mantua
Avignon
(26)
(34)
Ferrara
Bologna
(33)
(2)
Genoa
(22)
Florence
(24)
(34)
(22)
Urbino
Burgos
(26)
(34)
(24)
Valladolid
(36)
Salamanca
(12)
Rome
Avila
(12)
(16)
Madrid
(10)
Barcelona
(27)
Toledo
(10)
Naples
(20)
(20)
(27)

Mediterranean Sea

Granada

Tunis

0 100 200 300 kms

0 100 200 miles

© Antony White Publishing Ltd.

137

The Reformation

The failure of several reform movements in the Middle Ages left great dissatisfaction with the Church of Rome. Throughout Europe moral abuses were denounced by many liberal Catholic humanist scholars such as John Colet (c.1467–1519) from England, the Frenchman Jacques Lefèvre d'Étaples (1455–1526), the Spaniards Juan de Valdés (1490–1532) and Cardinal Ximenes de Cisneros (1437–1517), the German Johann Reuchlin (1455–1522), and the great international scholar Erasmus of Rotterdam (1469–1536). The evangelical reforms they advocated, coupled with the flood of translations of the Bible into the Vernacular, added momentum to the growing movement which coalesced around the figure of Martin Luther (1483–1546), whose writings became by 1520 a systematic denunciation of the Church of Rome.

Luther revolutionized Latin Christendom. At the Peace of Augsburg in 1555 the fiercely Catholic emperor, Charles V (1519–56), was forced to allow each member state of the Holy Roman Empire to choose between Catholicism and Lutheranism. In Eastern Europe Lutheranism spread among German speakers. By the 1530s the Scandinavian monarchies had embraced Protestantism, and in England in 1534 during the reign of Henry VIII (and in 1541 for Ireland) Parliament passed an act repudiating the supremacy of the Pope.

The effect of the Lutheran reformation on German art was profound. Its attitude to the value of religious imagery was at best ambiguous and the market for altarpieces virtually disappeared. Waves of iconoclasm, as at Augsburg, led to the destruction of many paintings and sculptures. Attempts were made, notably in the Cranach workshop in Saxony, to evolve a specifically Protestant iconography, but they were only partly successful.

Luther's writings were widely circulated and discussed in Paris and the circle of humanists who gathered around Guillaume Briçonnet (1470–1534), Bishop of Meaux, such as Lefèvre d'Étaples, the king's reader Guillaume Budé (1468–1540) and his sister Marguerite of Navarre. In Italy too Luther's writings were on sale and avidly discussed. The first Bible in Italian was published in Tuscany by Antonio Bruccioli in 1532. In Naples the Spaniard de Valdés stimulated interest in the evangelical movement, and Luther's writings were introduced in Spain itself, which experienced a period of Erasmian liberalism in the 1520s.

Huldreich Zwingli (1484–1531)introduced a radical form of Protestantism in Zurich which gained great following and spread through south Germany. After his death his lead was taken on by the great reformer John Calvin (1509–64) who in Geneva created a city 'the most godly since the days of the apostles'. The spread of Calvinism after 1550 revived the Protestant movement. Several German Lutheran states, notably the Palatinate and Brandenburg, changed their official religion to Calvinism; in Scotland it was established by Parliament in 1560; it spread to Hungary. In France the first Calvinist church was founded in Paris in 1555, and in 1598 142 towns, mostly in the south, were designated Huguenot (Protestant) safe areas by the Edict of Nantes.

In the Netherlands the evangelical tradition favored the spread of Calvinism, which played a major part in the War of Independence which freed the United Provinces from Spanish dominion. In 1622 Calvinism was established there as the official religion. Both Calvinism and the other radical reformation movements considered religious imagery in churches to be prohibited by the Old Testament ban on graven images and therefore 'godless'. Its use was confined to book illustration and polemical tracts.

As early as the 1530s the Church of Rome had launched a vast movement of moral and spiritual renewal. By the 1540s it was directed against Protestantism and became a true Counter-Reformation, thus destroying the more liberal trends of the earlier humanist scholars. A Council at Trent in 1542 redefined the doctrine and reformed the discipline of the Church, and new religious orders, notably the Society of Jesus founded in 1534 by Ignatius Loyola (1491–1556), sought to win back those countries which had embraced Protestantism.

In Italy, and subsequently in the rest of Europe during the second half of the 16th century this religious revival led to a return to a sober and didactic art which responded to the decrees on art of the Council of Trent, published in 1563. In the 17th century this grew into the assertive emotionalism of the Baroque, which flourished in all Catholic countries. A truly Protestant religious art developed only in the Netherlands in the 17th century.

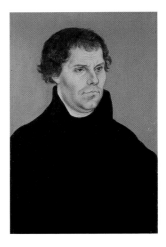

Above: *Lucas Cranach (1472–1553):* Portrait of Luther, *oil on panels, 1526 (National Museum, Stockholm).*

One of a pair of portraits, and painted on the occasion Luther's marriage to Katharina von Bora.

Below: *Wolf Huber (1490–1553): detail from* Allegory of Redemption, *(Kunsthistorisches Museum, Vienna).*

A negative influence on religious art, the Reformation inspired a didactic iconography, as seen here.

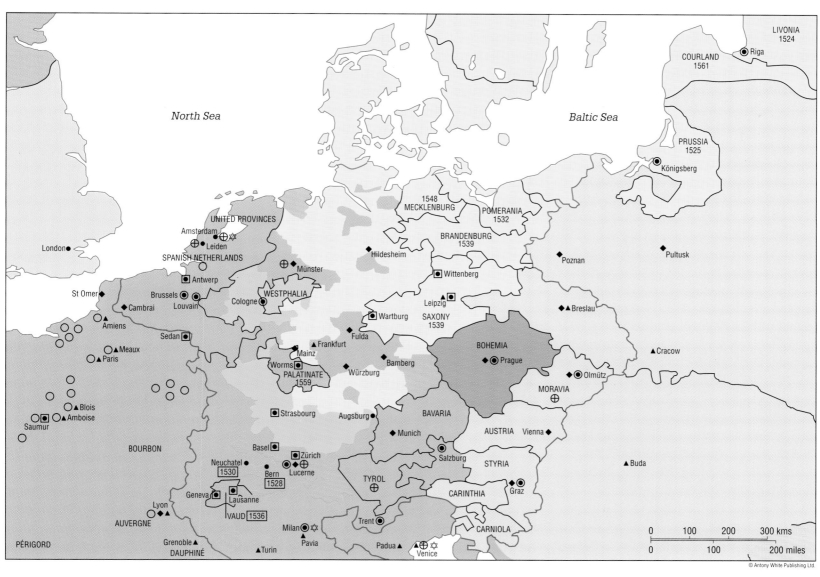

North Sea

Baltic Sea

LIVONIA
1524

COURLAND
1561

● Riga

PRUSSIA
1525

● Königsberg

1548
MECKLENBURG

POMERANIA
1532

BRANDENBURG
1539

◆ Pultusk

◆ Poznan

Hildesheim ●

UNITED PROVINCES

Amsterdam ⊕ ⊕ ✡
● Leiden

SPANISH NETHERLANDS

London ●

◆ Münster

Wittenberg ▣

◆ Antwerp

WESTPHALIA

St Omer ◆

Brussels ◉ ◉

Louvain

Cologne ●

Wartburg ▣

Leipzig ▲ ▣

SAXONY
1539

◆ Breslau

◆ Cambrai

▲ Amiens

Sedan ▣

◆ Fulda

▲ Frankfurt

BOHEMIA

◆ ◉ Prague

▲ Cracow

○ ○

Meaux ●

Worms ▣

Mainz

Bamberg ●

◉ Olmütz

○ ○

▲ Paris

PALATINATE
1559

Würzburg ●

MORAVIA ⊕

○ ○

Blois ▲

Strasbourg ▣

Augsburg ●

BAVARIA

AUSTRIA Vienna ◆

Amboise ▲

Basel ▣

◆ Munich

Saumur

○

Zürich ▣

Salzburg ◉

STYRIA

BOURBON

Neuchatel ●
1530

Bern ◆ ⊕
1528 Lucerne

▲ Buda

Geneva ▣

Lausanne

CARINTHIA

Graz ◆ ◉

Lyon ◆ ▲

VAUD 1536

Milan ● ✡ ☆

Trent ◆

CARNIOLA

AUVERGNE

Grenoble ▲

Pavia

Padua ▲ ⊕ ☆

PÉRIGORD

DAUPHINÉ

▲ Turin

Venice

0 100 200 300 kms

0 100 200 miles

© Antony White Publishing Ltd.

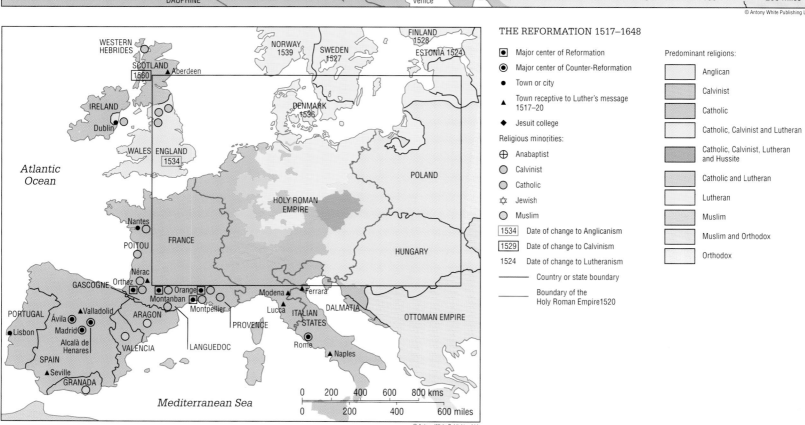

WESTERN
HEBRIDES

NORWAY
1539

SWEDEN
1527

FINLAND
1528

ESTONIA 1524

SCOTLAND
1560 ▲ Aberdeen

THE REFORMATION 1517–1648

Predominant religions:

IRELAND

Dublin ●

DENMARK
1536

▣ Major center of Reformation

Anglican

◉ Major center of Counter-Reformation

Calvinist

Atlantic
Ocean

WALES

ENGLAND
1534

POLAND

● Town or city

Catholic

HOLY ROMAN
EMPIRE

▲ Town receptive to Luther's message
1517–20

Catholic, Calvinist and Lutheran

◆ Jesuit college

Catholic, Calvinist, Lutheran
and Hussite

Nantes ●

FRANCE

Religious minorities:

Catholic and Lutheran

POITOU

HUNGARY

⊕ Anabaptist

Lutheran

Nérac ▲

○ Calvinist

Muslim

Orthez

Orange ○

Modena ▲

Ferrara ▲

○ Catholic

Muslim and Orthodox

GASCOGNE

Montanban ○

Montpellier

Lucca ▲

☆ Jewish

Orthodox

PORTUGAL

Ávila ▲

Valladolid ▲

ARAGON

Provence

ITALIAN
STATES

DALMATIA

○ Muslim

1534 Date of change to Anglicanism

Madrid ◉

Rome ◉

OTTOMAN EMPIRE

1529 Date of change to Calvinism

Lisbon ●

Alcalà de
Henares ◉

VALENCIA

LANGUEDOC

1524 Date of change to Lutheranism

SPAIN

▲ Seville

Naples ▲

Country or state boundary

GRANADA

Boundary of the
Holy Roman Empire 1520

Mediterranean Sea

0 200 400 600 800 kms

0 200 400 600 miles

© Antony White Publishing Ltd.

139

Italy in the Renaissance

Italy during the period 1400 to 1550 consisted of a number of separate states which were kept in precarious balance by internal power struggles and, after the French invasion of 1494, became a battleground for the rival monarchies of France and Spain. The papacy sought to retain its independence, but after the final defeat of the French and the sack of Rome in 1527 became, like the rest of the peninsula, subject to Spanish influence.

In the 15th century the power, wealth and international prestige of the Republics, especially Florence through banking and Venice through trade, was immense and resulted in territorial as well as commercial expansionism, so that Venice extended her rule westwards across the *terra firma* until it reached Lombardy and the borders of the Duchy of Milan, while Florence eventually absorbed Pisa, Lucca and Siena: all of which were originally republics in their own right.

Conversely the Duchy of Milan under the Visconti tried to extend its territories southwards and would have liked to dominate the peninsula. Florentine power prevented this, but a further factor was the technical suzereinty of the Holy Roman Emperor over many of the territories, which helped to assure the independence of smaller units like the Marquisate of Mantua. Culturally this diversity was important because it provided a plurality of patronage and, particularly after 1455 when the diplomacy of Lorenzo de' Medici, the *de facto* ruler of Florence, brought peace to the peninsula, and allowed ideas and styles to rove freely. Renaissance humanists and artists were just as at home in the principalities as in the republics or the papal court.

In the 16th century, this pluralistic political system was upset by foreign invasions and, after the peace imposed by Charles V at Bologna in 1530, only Venice retained any degree of republican independence. Spain favoured autocratic rule and ultimately through Spanish arms the Medici turned Florence into an hereditary dukedom. Italian culture continued to dominate Europe but by the 1550s an increasing artificiality reflecting courtly values contrasts with the diversity of earlier periods.

Below: *Benozzo Gozzoli (c.1421–97):* Journey of the Magi to Bethlehem *(Palazzo Medici-Riccardi, Florence).*

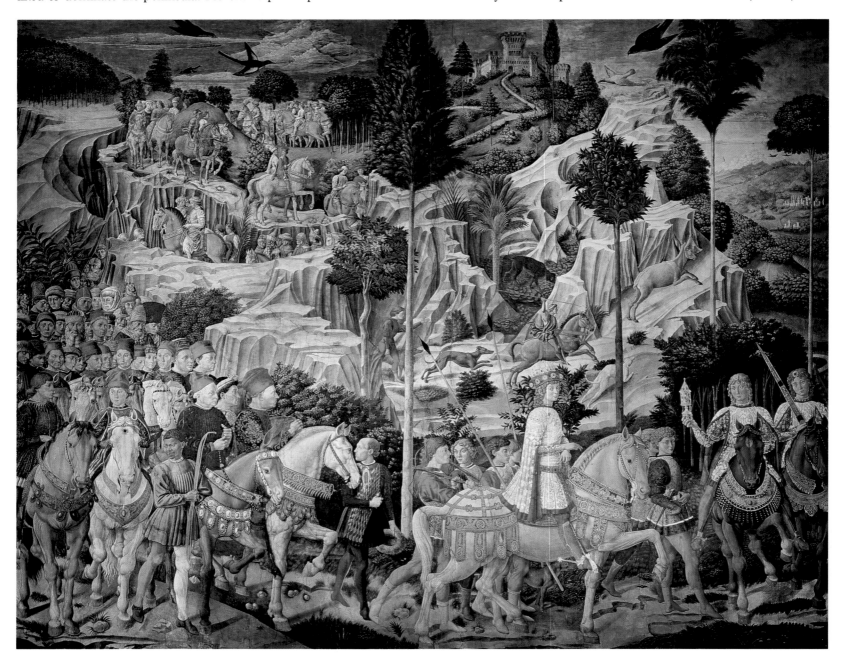

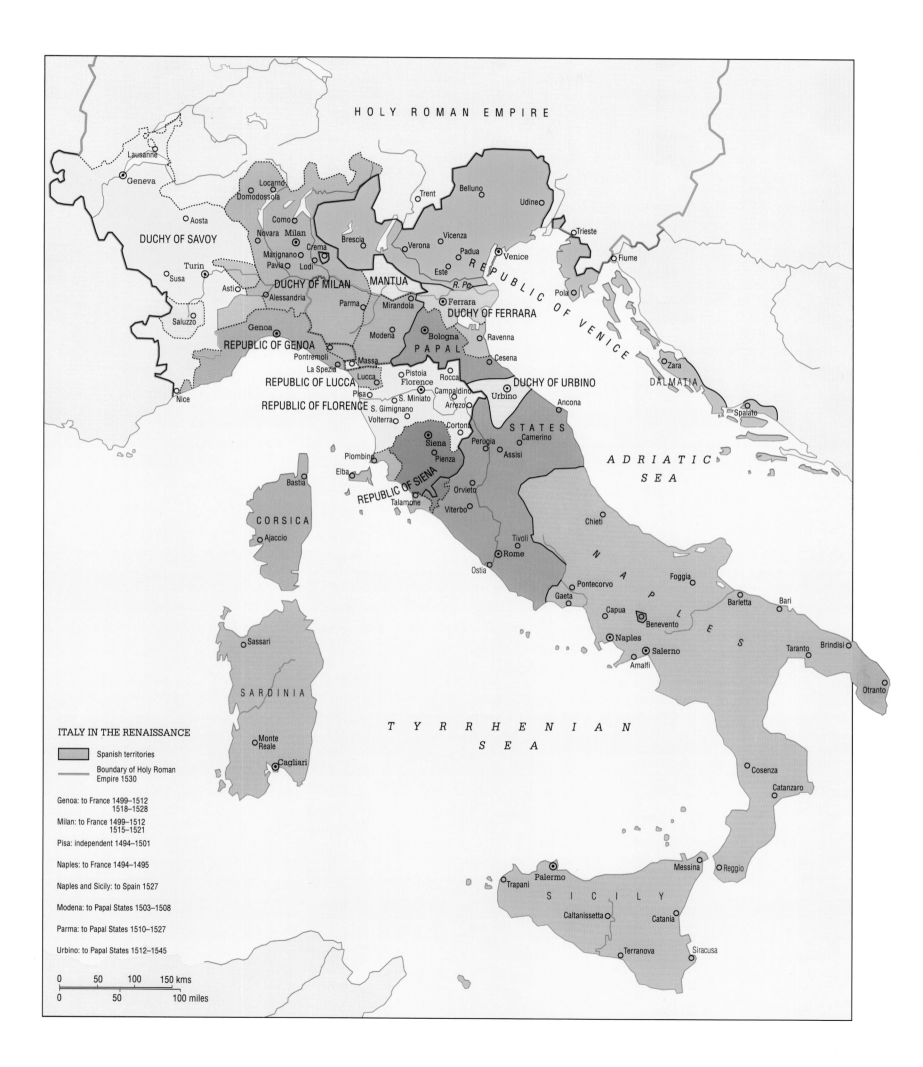

HOLY ROMAN EMPIRE

Lausanne

Geneva

Locarno
Domodossola
Aosta

DUCHY OF SAVOY

Como
Novara Milan
Crema
Marignano
Pavia Lodi
Turin
Susa
Asti
Alessandria
Saluzzo

DUCHY OF MILAN
Parma
Mirandola
Modena
Genoa

REPUBLIC OF GENOA
Pontremoli
Massa
La Spezia
Lucca

REPUBLIC OF LUCCA

Nice

MANTUA

Trent
Belluno
Udine

Brescia
Verona Vicenza
Padua Venice
Este
R. Po
Ferrara

DUCHY OF FERRARA

Bologna
Ravenna
PAPAL
Cesena

R E P U B L I C O F V E N I C E

Fiume
Pola

Trieste

Zara

DALMATIA

Spalato

Pistoia
Florence
Rocca
Pisa
Campaldino
S. Miniato Arrezo
Volterra

REPUBLIC OF FLORENCE
S. Gimignano

Cortona

Piombino
Elba

Siena
Pienza

REPUBLIC OF SIENA
Talamone

DUCHY OF URBINO
Urbino
Ancona

S T A T E S
Camerino
Perugia
Assisi

Orvieto
Viterbo

Chieti

A D R I A T I C
S E A

CORSICA

Ajaccio

Tivoli
Rome

Ostia

Pontecorvo
Gaeta

Capua
Benevento

Naples
Salerno
Amalfi

Foggia

Barletta Bari

Taranto Brindisi

Otranto

Bastia

Sassari

SARDINIA

Monte
Reale

Cagliari

T Y R R H E N I A N
S E A

N
A
P
L
E
S

Cosenza

Catanzaro

ITALY IN THE RENAISSANCE

Spanish territories

Boundary of Holy Roman
Empire 1530

Genoa: to France 1499–1512
 1518–1528

Milan: to France 1499–1512
 1515–1521

Pisa: independent 1494–1501

Naples: to France 1494–1495

Naples and Sicily: to Spain 1527

Modena: to Papal States 1503–1508

Parma: to Papal States 1510–1527

Urbino: to Papal States 1512–1545

Messina
Reggio

Trapani Palermo

S I C I L Y

Caltanissetta
Catania

Terranova
Siracusa

0 50 100 150 kms

0 50 100 miles

Central Italian Art in the 15th Century

Just as art in Northern Italy was dominated by the two large and rich centers of Milan and then Venice with smaller, rival artistic centers in the same orbit, so Central Italy had smaller satellites scattered between the twin centers of Florence, and then Rome. Florence formed a focus for Central Italian art in the 15th century, not only because her storehouse of artworks provided useful models, but also because of the lively patronage available there. But she, like smaller centers, began to lose pre-eminence as Rome gradually gained strength for the vigorous patronage of projects on a scale larger than even the Florentines could manage.

Occasionally rich men in very small cities were able to rival the patronage of the Church, the Medici and the various guilds in Florence: for example Sigismondo Pandolfo Malatesta (1417–68) at Rimini (where his own scholars were buried in *all'antica* sarcophagi along the exterior flanks of the church of San Francesco), and the Montefeltro at Urbino, especially under Duke Federigo (1444–82), where much of the art collection still remains in the Ducal Palace to reflect some of that court's glory and range.

However, other small centers became progressively too feeble to resist the rising power of their neighbors, and found their local artistic traditions subsumed. Pisa was conquered by Florence in 1405, and her decline thus confirmed. Siena fell to Florence in 1555. Arezzo, similarly under Florentine control, also suffered a reduction in autonomy and population.

As well as so-called "private" patronage by a magnate or *de facto* ruler, city states and religious organizations also viewed art as a worthwhile collective investment: Siena, for example, in rivalry with Florence, invited Florence's artists, as well as employing her own, to decorate the city and its buildings.

We should therefore be careful to acknowledge the extent to which artists and architects travelled during the Renaissance; not only was the "reach" of some patrons transalpine, but some artists, and even more architects, would not have survived without moving to their work. Therefore, as a result of a collegiality of ideas and ideals the Liberal Arts from one center found a ready reception elsewhere. This is reflected in the peripatetic career of Baldassare Castiglione (1478–1529), a scholar who spent time at the Italian courts of Mantua and Urbino (this latter the setting for his work *The Book of the Courtier*), and the court of Charles V in Spain where he was Papal Nuncio.

Nevertheless, it is the manners of the great centers of Florence, Rome and Venice which dictated fashionable artistic tastes elsewhere in the peninsula – so much so that many histories of art concentrate overmuch upon them. But it would be difficult fully to understand "big city" taste without considering centers such as Siena for their Quattrocento and Cinquecento works. For example, Siena Cathedral not only incorporates the Piccolomini Library, whose interior is covered with Pinturicchio's frescoes (1502–09), but contains Andrea Bregno's altar (1481–5), and also the great marble mosaic pavement which marches the full length of the building, and took from 1369 to 1547 to complete.

Florentine-trained artists were in demand: witness the words of Cardinal Caraffa (*d.*1511), who engaged Filippino Lippi (*c.*1457/8–1504) to paint his chapel at S. Maria sopra Minerva (1488–93), and noted that he "having been commended by Lorenzo the Magnificent, we would have placed him above an Apelles, or all Italy…we would not exchange him for all the painters that ever were in ancient Greece".

Of course, the nature of the art in each center depended upon existing traditions, but this was often modified by ideas imported by "foreign" artists, and also by the widespread ethos of the imitation of the antique. Thus Siena updated her characteristic but, from the perspective of Florence, outdated manner, by the employment of Florentines such as Ghiberti in 1425–27 and Donatello in 1427. Jacopo della Quercia (*c.*1374–1438), a native of Siena, sculpted the *Fonte Gaia* here in 1419, in a mixture of the classical and sinuously Gothic manners – an approach which was later to attract Michelangelo (1475–1564).

Urbino welcomed not only the Florentine manner, but also the Flemish one, which produced interesting results in the work of, for example, Piero della Francesca (*c.*1410/20–1482) and Pedro Berruguete (*fl.*1483–*d.*1503). And in Rimini, the monastic church of S. Francesco was re-cased on the exterior by Alberti (an exiled Florentine) in 1450, and the interior was remodelled by the Veronese Matteo de' Pasti in the same period. It was decorated with sculpture by Agostino di Duccio (1418–before 1498), from Florence, and a fresco by Piero della Francesca (1451), from San Sepolcro in Umbria. The church already contained a panel attributed to Giotto (*c.*1305, uncertain), another Florentine.

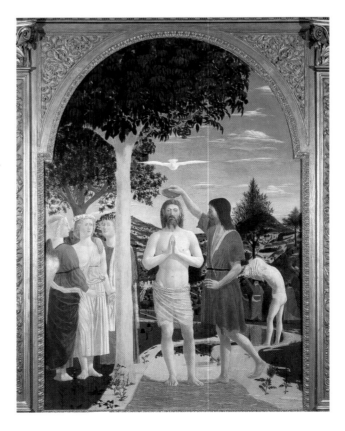

Left: *Piero della Francesca (c.1410/20–1492):* The Baptism of Christ *(National Gallery, London).*

An example of Piero's early work, originally the central panel of a triptych in the Duomo at Borgo San Sepolcro, his home town in Umbria. The balance and calm beauty of his style is in complete contradiction to the prevailing taste in Florence, where he is first recorded as working in 1439.

Painters and Sculptors and Sites of their Major Works

○ Painter
□ Sculptor

Arezzo
○ Piero della Francesca (*c.*1410/20–92)
Bologna
○ Lorenzo Costa (*c.*1460–1535)
○ □ Michelangelo (1475–1564)
□ Niccolò dell'Arca (*act.*1462–94)
○ □ Jacopo della Quercia (*c.*1374–1438)
Carrara
○ □ Michelangelo (1475–1564)

Florence
○ Andrea del Castagno (*c.*1421–57)
□ Benedetto da Maiano (1442–97)
○ Botticelli (1444/5–1510)
□ Filippo Brunelleschi (1377–1446)
□ Desiderio da Settignano (1428/31–61)
□ Donatello (1386?–1466)
□ Lorenzo Ghiberti (1378–1455)
○ Domenico Ghirlandaio (1449–94)
○ Filippino Lippi (*c.*1457–1504)
○ Filippo Lippi (*c.*1406–69)
○ Masaccio (1401–28)
○ Masolino (*c.*1383–1447?)
○ □ Michelangelo (1475–1564)
□ Michelozzo (1396–1472)
□ Nanni di Banco (*d.*1421)
○ □ Antonio Pollaiuolo (*c.*1432–98)
○ Luca della Robbia (1399/1400–82)
○ Paolo Uccello (1396/7–1475)
○ □ Andrea del Verrocchio (*c.*1435–88)
Lucca
○ Domenico Ghirlandaio (1449–94)
○ Flippino Lippi (*c.*1457–1504)
□ Jacopo della Quercia (*c.*1374–1438)
□ Andrea della Robbia (1435–1528)
Monte Oliveto Maggiore
○ Luca Signorelli (1441?–1523)
Montepulciano
□ Michelozzo (1396–1472)
Naples
□ Donatello (1386?–1466)
□ Giuliano da Maiano (1432–90)
□ Francesco Laurana *et al* (*c.*1430–1502?)
□ Michelozzo (1396–1472)
□ Pietro Perugino (*c.*1445/50–1523)
□ Antonio Rossellino (1427–79)

Orvieto
○ Gentile da Fabriano (*c.*1370–1427)
Perugia
□ Agostino di Duccio (1418–81)
○ Pietro Perugino (*c.*1445/50–1523)
○ Raphael (1483–1520)
○ Jacopo (*d.*1427) and Lorenzo (*fl.*1593–1609) Salimbeni
Pisa
○ Masaccio (1401–28)
Prato
□ Donatello (1386?–1466)
□ Mino da Fiesole (1429–84)
□ Andrea Della Robbia (1435–1528)
□ Antonio Rossellino (1427–79)
○ Paolo Uccello (1396/7–1475)
Rimini
□ Agostino di Duccio (1418–81)
San Gimignano
□ Benedetto da Maiano (1442–97)
○ Domenico Ghirlandaio (1449–94)
○ Benozzo Gozzoli (*c.*1421–97)
○ □ Antonio Pollaiuolo (*c.*1432–98)
San Sepolcro
○ Piero della Francesca (*c.*1410/20–92)
Siena
□ Donatello (1386?–1466)
□ Lorenzo Ghiberti (1378–1455)
○ Pinturicchio (*c.*1454–1513)
□ Jacopo della Quercia (*c.*1374–1438)
□ Bernardo Rossellino (1409–64)
Spello
○ Pinturicchio (*c.*1454–1513)
Spoleto
○ Filippo Lippi (*c.*1406–69)
Todi
○ Masolino (*c.*1383–1447?)
Urbino
○ Botticelli (1444/5–1510)
○ □ Francesco di Giorgio (1439–1501/2)
□ Pietro Lombardo (*c.*1435–1515)
○ Piero della Francesca (*c.*1410/20–92)
○ Jacopo (*d.*1427) and Lorenzo (1374–*c.*1420) Salimbeni

CENTRAL ITALIAN ART IN THE FIFTEENTH CENTURY

⊙ Major site
● Other site
○ Decorative arts
◐ Mural painting
△ Quarry
○ Religious painting
□ Religious sculpture
○ Secular painting
□ Secular sculpture

| 0 | 25 | 50 | 75 | 100 kms |
| 0 | 15 | 30 | 45 | 60 miles |

© Antony White Publishing Ltd.

Right: *Jacopo della Quercia (c.1374–1438):* Tomb of Ilaria del Carretto c.1406 (Duomo, Lucca).

This tomb is the first documented work of Siena's greatest 15th-century sculptor. It combines a use of classical Roman putti *with a knowledge of Burgundian sculpture and motifs from northern art.*

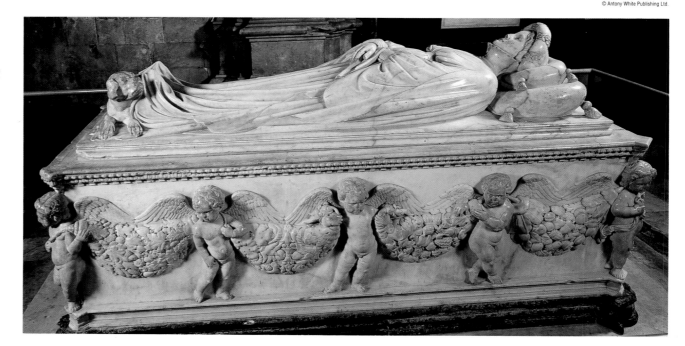

Central Italian Art in the 16th Century

In Naples, the artistic complexion varied according to the rulers – the Angevins until 1442, then the Aragonese until 1503, when the Kingdom fell to Spain. As elsewhere, artists were imported – an interesting and little-visited example being the church of Sant'Angelo a Nilo, which contains the tomb (1426–8) of Cardinal Rinaldo Brancaccio by Florentines Donatello and Michelozzo, of which a quarter had been completed in Pisa. Indeed this north-south trade in art had a much earlier precedent: Nicola Pisano (d.c.1284), who founded the Pisan school of sculptors, may originally have come from Naples.

Although the question continues to be debated, the Quattrocento was a period of declining prosperity, in which case the high proportion of artworks produced is at first sight the more remarkable. In Rimini by 1511, for example, the population was probably less than half that immediately following the Black Death in the late 1340s. This, of course, meant that the Tempio Malatestiano was built from a declining money supply because of reduced revenues. Obviously, art and architecture

were not, therefore, considered luxuries, to be cut in times of impecunity, but essentials of civic pride. This glorious propaganda apertained even in the villas, the decoration of which was rarely simply antiquarian – witness, for example, the close parallels drawn between the Medici history and antiquity in Franciabigio's (1482/3 –1525) and Alessandro Allori's (1535–1607) frescoes in the Salone of the Villa Reale at Poggio a Caiano outside Florence.

Another paradox we have inherited from the Renaissance is the conception of "high art", and this from a period when what we call the "decorative arts" were important, as may well be seen from inlaid woodwork. To Riccio's choirstalls in the Cathedral at Siena (1567–9) we might add those of Giovanni da Verona in the convent church at Monte Oliveto Maggiore (1503–5), those by the Bencivenni (1530) in the choir of the Duomo at Todi, and the stalls in the Collegio del Cambio in Perugia, beneath the frescoes of Perugino, who may have designed these *intarsie*, as well as those in the choir of S. Agostino, also in Perugia.

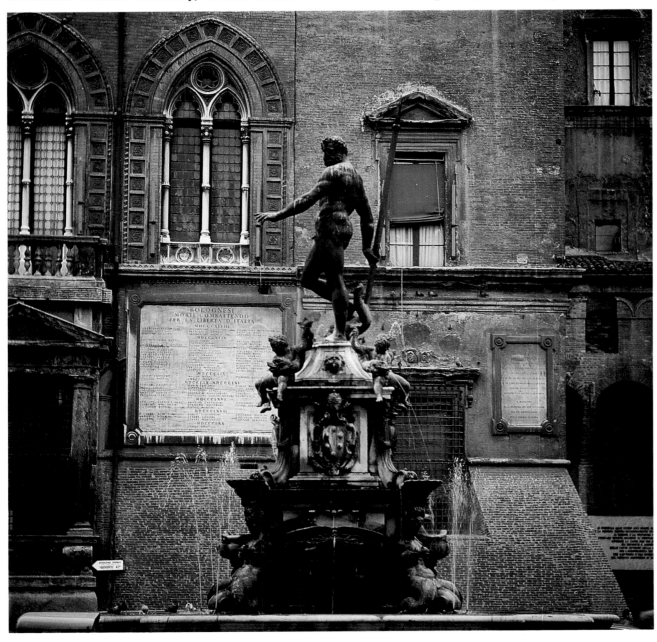

Left: *Giambologna (Jean de Boulogne) (1529–1608):* The Fountain of Neptune, *1563–6, Bologna.*

Born in Douai and trained in Flanders, Giambologna arrived in Italy c.1555. He worked in Florence, Rome and Bologna and was the leading Mannerist sculptor after the death of Michelangelo. The Fountain of Neptune *was originally designed for the Loggia dei Lanzi in Florence, but the competition for this commission was won by Bartolommeo Ammanati.*

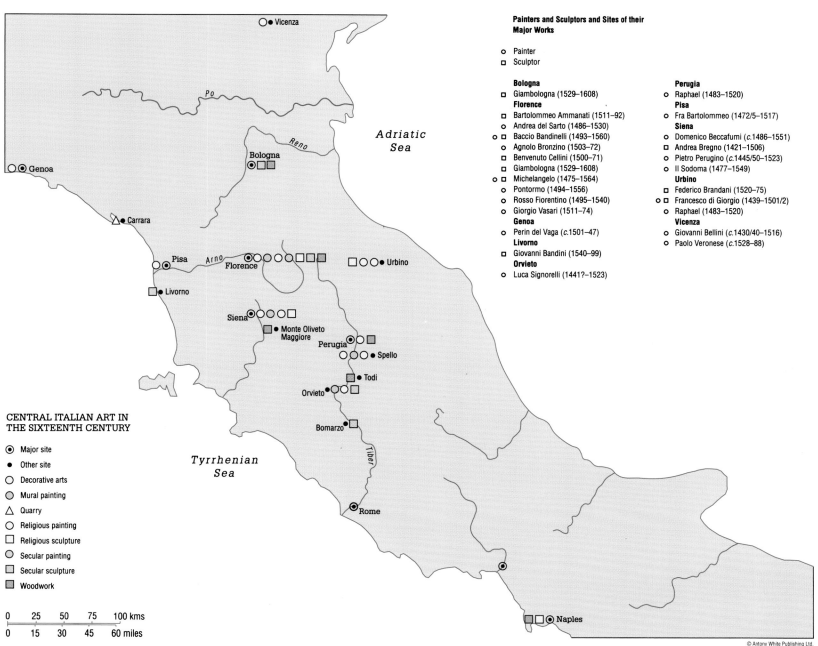

Painters and Sculptors and Sites of their Major Works

○ Painter
□ Sculptor

Bologna
□ Giambologna (1529–1608)
Florence
□ Bartolommeo Ammanati (1511–92)
○ Andrea del Sarto (1486–1530)
○ □ Baccio Bandinelli (1493–1560)
○ Agnolo Bronzino (1503–72)
□ Benvenuto Cellini (1500–71)
□ Giambologna (1529–1608)
○ □ Michelangelo (1475–1564)
○ Pontormo (1494–1556)
○ Rosso Fiorentino (1495–1540)
○ Giorgio Vasari (1511–74)
Genoa
○ Perin del Vaga (c.1501–47)
Livorno
□ Giovanni Bandini (1540–99)
Orvieto
○ Luca Signorelli (1441?–1523)

Perugia
○ Raphael (1483–1520)
Pisa
○ Fra Bartolommeo (1472/5–1517)
Siena
○ Domenico Beccafumi (c.1486–1551)
□ Andrea Bregno (1421–1506)
○ Pietro Perugino (c.1445/50–1523)
○ Il Sodoma (1477–1549)
Urbino
□ Federico Brandani (1520–75)
○ □ Francesco di Giorgio (1439–1501/2)
○ Raphael (1483–1520)
Vicenza
○ Giovanni Bellini (c.1430/40–1516)
○ Paolo Veronese (c.1528–88)

CENTRAL ITALIAN ART IN THE SIXTEENTH CENTURY

◉ Major site
● Other site
○ Decorative arts
◐ Mural painting
△ Quarry
○ Religious painting
□ Religious sculpture
◐ Secular painting
▪ Secular sculpture
▪ Woodwork

0	25	50	75	100 kms
0	15	30	45	60 miles

It is clear that central Italian artistic centers decline in importance from the late 15th century and into the 16th century. Why did originally vigorous local schools die? Partly because of what one guidebook calls "the servile imitation of the masters" – that is, the superficial adoption of others' styles without the essential understanding which ultimately gives a work its inner vitality; but also a result not only of war and civil strife, but of the greater scale on which the Papacy and the Roman aristocracy could commission. So while important work was still executed in Florence after the establishment of the (Medici) Duchy in 1530, neither it, nor the smaller courts, could compete with Venice or, especially, with Rome, where the grandest and largest commissions often lay. Such attractions notwithstanding, small centers often retain large quantities of artworks commissioned from "metropolitan" artists: San Gimignano is one such, noted for its medieval towers, but with the church of S. Agostino containing not only an altar by Benedetto da Maiano (1494) but also frescoes by Ghirlandaio (1475)

and Benozzo Gozzoli (1456) and a panel painting by Piero del Pollaiuolo (1483).

Nevertheless, important artworks are to be found throughout the region – Pinturicchio's (c.1454–1513) frescoes in the Baglioni Chapel in S. Maria Maggiore, Spello (1501), Rosso Fiorentino's (1495–1540) frenetically tragic *Deposition* (1521) in the Pinacoteca Communale at Volterra. Urbino produced the great Mannerist Federico Barocci (1526–1612), and it still retains many of his works – but other important works are in Rome. The area also "exported" artists, largely from Rome, the new center for the whole of Italy, and not only following the Sack of Rome in 1527: Giulio Romano went to Mantua in 1524; Benvenuto Cellini refused an invitation to go to England in 1519, but spent 1537 and 1540–5 in the service of François Iᵉʳ of France (1494–1547); and Serlio, born in Bologna, fled to Venice after the Sack of Rome and went to France in 1540 to help with the building of Fontainebleau.

Central Italian Architecture in the 15th Century

As with the great cathedrals of the Middle Ages in Northern Europe, so with the religious and civic buildings of Renaissance Italy: those who commissioned them considered architecture a prestigious and permanent way of proclaiming their taste and their glory. Not only did buildings last, but they were both essential tools of rivalry and vessels for decoration by painters and sculptors. The rivalry was usually civic, whether the building was a civic or a religious one, and we should remember that towns separated by fewer than 90 miles could belong to different states. A state or its ruler made a good impression on its own people, on diplomats and travellers, by enhancing the appearance of prosperity and thereby encouraging trading confidence. The Medici in Florence, from about 1429, were instrumental in the beautification of "their" city by reworking churches (San Lorenzo, largely by Brunelleschi, completed internally in 1469) and palaces (Palazzo Medici-Riccardi by Michelozzo, 1444ff., or Palazzo Strozzi by Benedetto da Maiano, 1466ff.)

The Quattrocento built to the new level of amenity postulated in the late Middle Ages with new squares, walls, fountains and paved streets intended to cater for a population often increasing and often increasingly affluent. Some projects, like the Dome of Florence Cathedral begun in 1294, took several generations to complete.

Connected with the concept of "gloria" (and partly its source) is the popularity of styles of architecture derived from classical antiquity, standing examples of which were probably much more widespread than they are today. As with the Papacy in Rome, reference to antiquity was one way of re-affirming a state's or city's link with the past, and therefore of underlining its continuing importance. The use of large, rough-faced blocks – rustication – was one way of emphasizing permanency and the past; and paraphrases of the antique (such as Alberti's Cappella Rucellai, 1460ff., his Tempio Malatestiano at Rimini, 1447–60, or the vertical triumphal arch on the Ducal Palace at Urbino by Laurana, 1468–72 were another. Explicit comparisons with the antique were often intended: the Tempio Malatestiano stands not 200 meters (220 yards) from a Roman triumphal arch set in Rimini's medieval walls, and another, the Arch of Trajan, is just down the coast at Ancona.

It was not only the ideas that spread, but the forms as well, and the people to build them. Siena, now in decline, still continued to commission works from outsiders, such as the Palazzo Piccolomini (1469ff.), possibly from designs by Bernardo Rossellino (1409–64).

Federigo da Montefeltro (1444–82), wishing to build a suitable monument in Urbino, looked first to Tuscany for an architect, but declared (in a Patent of 1468) that Luciano Laurana (d.1479) (from Dalmatia) should "make in our city of Urbino a beautiful residence worthy of the rank and fame of our ancestors and our own stature". That the manner Laurana adopted was not unusual can be seen from the similar courtyard in the ducal Palace at nearby Gubbio, possibly designed by the Sienese architect and painter Francesco di Giorgio Martini (1439–1501/2).

Left: *Bernardo Rossellino (1409–64):* Piazza Pio II, Cathedral *(1459–62) and* Palazzo Piccolomini *(1459–63),* Pienza.

Pope Pius II (Aeneas Silvius, the humanist pope and member of the Piccolomini family) rebuilt his home town of Pienza – a prime example of 15th-century Renaissance urban planning.

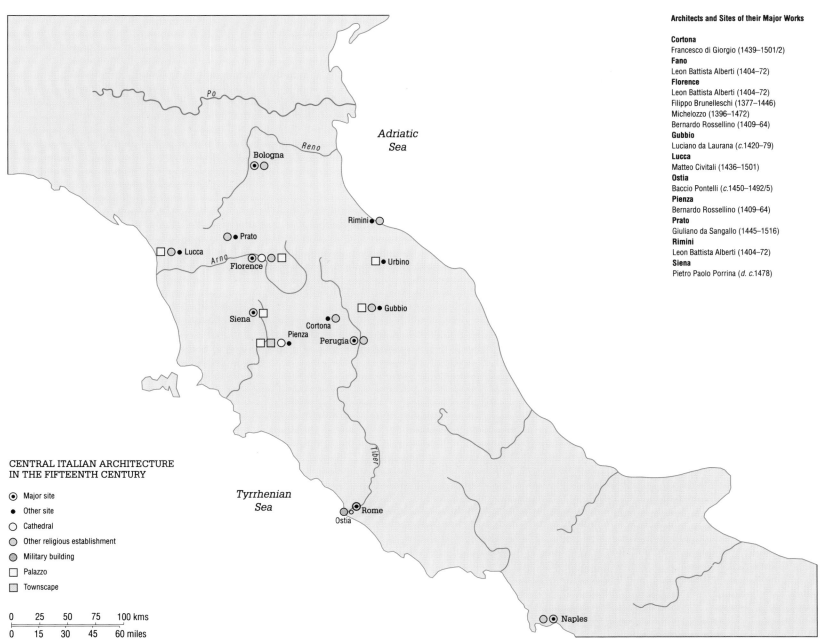

Architects and Sites of their Major Works

Cortona
Francesco di Giorgio (1439–1501/2)
Fano
Leon Battista Alberti (1404–72)
Florence
Leon Battista Alberti (1404–72)
Filippo Brunelleschi (1377–1446)
Michelozzo (1396–1472)
Bernardo Rossellino (1409–64)
Gubbio
Luciano da Laurana (c.1420–79)
Lucca
Matteo Civitali (1436–1501)
Ostia
Baccio Pontelli (c.1450–1492/5)
Pienza
Bernardo Rossellino (1409–64)
Prato
Giuliano da Sangallo (1445–1516)
Rimini
Leon Battista Alberti (1404–72)
Siena
Pietro Paolo Porrina (d. c.1478)

CENTRAL ITALIAN ARCHITECTURE IN THE FIFTEENTH CENTURY

- ⊙ Major site
- ● Other site
- ○ Cathedral
- ◐ Other religious establishment
- ◕ Military building
- □ Palazzo
- ▢ Townscape

| 0 | 25 | 50 | 75 | 100 kms |
| 0 | 15 | 30 | 45 | 60 miles |

© Antony White Publishing Ltd.

Right: *Leone Battista Alberti (1404–72):* S. Francesco (Tempio Malatestiano), *begun 1450, Rimini.*

Alberti's severely classical design created a monument to the enlightened tyrant of Rimini, Sigismondo Malatesta and his family.

Far right: *Villa di Paolo Guinigi, begun 1418, Lucca.*

A very early 15th- century example of a Renaissance town villa in Lucca.

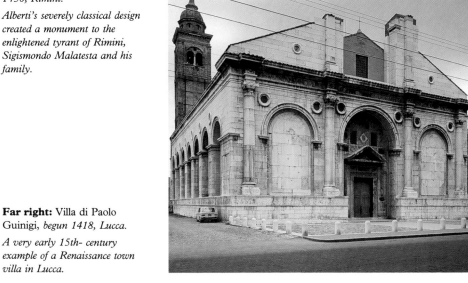

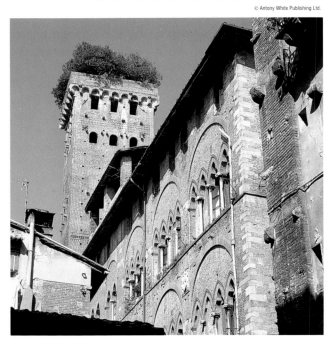

147

Central Italian Architecture in the 16th Century

Prestige, once earned, had to be fought for, and many cities famous for civil and religious buildings also built walls and fortresses. Lucca was given her third circuit of walls from 1504; Siena, immediately after the fall of the Republic in 1559, had imposed upon it the Fortezza Medicea, and Pope Julius II (1503–13) had Michelangelo build the fortress at Civitavecchia in 1502. A most impressive example of "redesign" is to be found at Perugia which passed from the Baglioni family to the Papacy in 1540, when Paul III (1534–49) constructed the Rocca Paolina by enclosing a substantial section of the lower slopes of the city. The medieval streets and houses (Via Baglioni, etc.) may still be visited inside, although the top of the fort was reworked in the 19th century.

Nevertheless, the increasing number of villas over the 15th and 16th centuries shows the development of a safer life, although some of these (Caprarola, Bomarzo) were clearly defensible. While most Italian centers (unlike England, France or Burgundy) were too small to have peripatetic rulers, whole courts might be accommodated in any of the extensive Medici villas around Florence (Petraia, Castello, Artimino, Careggi, Poggio a Caiano), and the villa was a suitable location not just for relaxation away from the heat, importunities and perhaps dangers of the city, but also for entertainment, such as plays, poetry and music. Palladio in the north of Italy may be the great popularizer of the villa, but he is far from being the originator of its Renaissance form, let alone its intellectual horizons.

An increasingly important element in such country living was the garden. Within urban areas there were also gardens, the most prestigious example being the Boboli Gardens in Florence, decorated by renowned designers and sculptors in a scheme which became very influential abroad (for example, in the 17th century at Versailles). Through the statues and set-pieces they contained, gardens could tell stories: the Orsini villa at Bomarzo has a "Park of Monsters" or "Sacred Wood" (1564ff.) with mythological figures, and the Villa d'Este at Tivoli has a garden designed by Pirro Ligorio, the

excavator of the nearby Hadrian's Villa, who took at least some of his tips for water organization and fountains, for which the Villa d'Este is famous, from the Roman layout.

It is frequently the smaller centers which offer not just charm, but also information on Renaissance intentions which are less than clear in cities. Pienza, designed by Rossellino from 1459 for his patron Pope Pius II, a native of these parts who ascended the papal throne in 1458, gives an excellent idea of Renaissance planning and architectural ideals because it was built quickly and is all of a piece.

In church architecture, a better idea of the kind of structure Bramante (and Raphael) intended for St Peter's in Rome than that presented by the present basilica is given by other buildings, such as Sta. Maria della Consolazione at Todi (1508ff., authorship disputed), Giuliano da Sangallo's Sta. Maria delle Carceri at Prato (1484–95), Francesco di Giorgio Martini's La Madonna del Calcinaio at Cortona (1485ff.), or Antonio da Sangallo's S. Biagio at Montepulciano (1518ff.). All these show a concern for a regular, centralized plan crowned by a dome, in a style which is classically based and superbly simple in its plain walls, stark orders and basic volumes (cube, sphere, half-sphere and cylinder).

Such suave simplicity did not survive the contribution of Michelangelo, whose more sculptural approach to light, shade and volume, and more exuberant attitude to decoration, provided models for others to imitate. Once again, the lead in architecture is provided by architects employed in Rome by the Papacy and the great families, the pre-eminent figures being Bramante, Raphael, Michelangelo himself, and Giulio Romano, and then Vignola. As with painting, Rome then exported her architects – even adopted ones like Vignola, whose Gesù in Rome (1568ff.) became the model for scores of churches in central Italy and further afield. The same might be said for the Villa Aldobrandini at Frascati (1598–1603), built by Giacomo della Porta, best known for finishing Michelangelo's main dome for St. Peter's.

Below left: Begun by Cola da Caprarola, probably on a design by Bramante (1444–1514) inspired by Leonardo da Vinci (1452–1519): S. Maria della Consolazione, 1508–1607, Todi.

Below: Giacomo Vignola (1507–73): Palazzo Farnese, begun 1559 on the foundations of a fortress built by Antonio da Sangallo (1485–1546), at Caprarola, a village north of Rome.

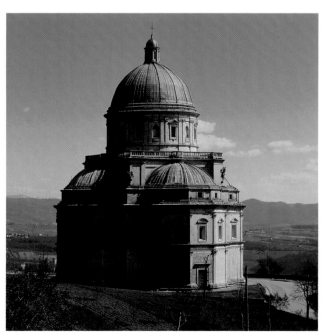

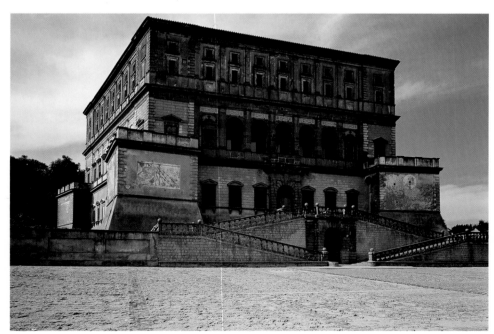

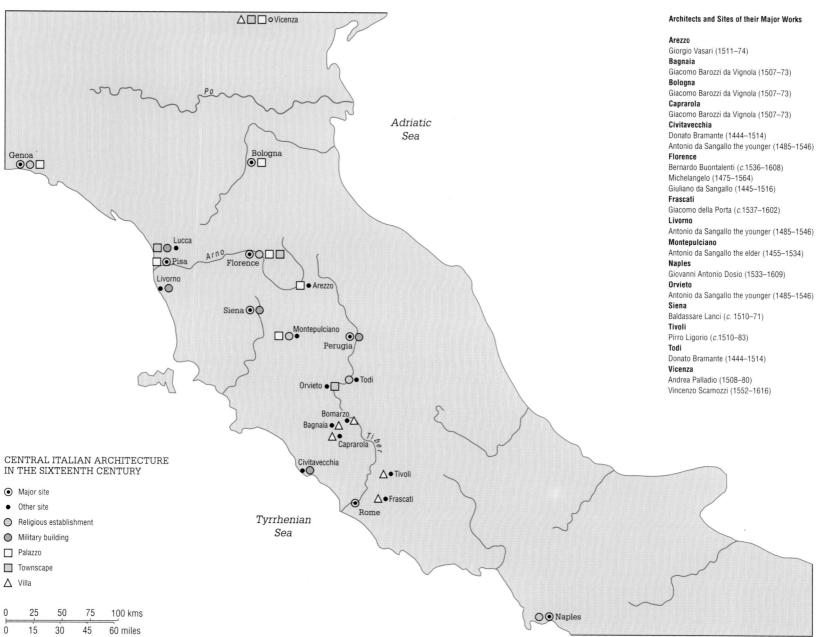

Adriatic
Sea

Po

Genoa

Bologna

Lucca
Arno
Pisa
Florence
Livorno

Arezzo

Siena

Montepulciano
Perugia

Orvieto
Todi

Bomarzo
Bagnaia
Tiber
Caprarola

Civitavecchia

Tivoli

Rome
Frascati

Tyrrhenian
Sea

Vicenza

CENTRAL ITALIAN ARCHITECTURE
IN THE SIXTEENTH CENTURY

⊙ Major site
● Other site
◯ Religious establishment
● Military building
☐ Palazzo
▩ Townscape
△ Villa

0	25	50	75	100 kms
0	15	30	45	60 miles

Naples

Architects and Sites of their Major Works

Arezzo
Giorgio Vasari (1511–74)
Bagnaia
Giacomo Barozzi da Vignola (1507–73)
Bologna
Giacomo Barozzi da Vignola (1507–73)
Caprarola
Giacomo Barozzi da Vignola (1507–73)
Civitavecchia
Donato Bramante (1444–1514)
Antonio da Sangallo the younger (1485–1546)
Florence
Bernardo Buontalenti (*c*.1536–1608)
Michelangelo (1475–1564)
Giuliano da Sangallo (1445–1516)
Frascati
Giacomo della Porta (*c*.1537–1602)
Livorno
Antonio da Sangallo the younger (1485–1546)
Montepulciano
Antonio da Sangallo the elder (1455–1534)
Naples
Giovanni Antonio Dosio (1533–1609)
Orvieto
Antonio da Sangallo the younger (1485–1546)
Siena
Baldassare Lanci (*c*. 1510–71)
Tivoli
Pirro Ligorio (*c*.1510–83)
Todi
Donato Bramante (1444–1514)
Vicenza
Andrea Palladio (1508–80)
Vincenzo Scamozzi (1552–1616)

Right: *Pirro Ligorio (c.1510–83):* Villa d'Este and Gardens, *1565–72, Tivoli, near Rome.*

The Este family commissioned Ligorio to rebuild the villa and to create an exquisitely ornamental garden on their estate in the hills above Rome at Tivoli. The elaborate fountains, waterworks, hydraulic organs and rusticated classical statuary create the most elaborate and original of all 16th-century gardens. Ligorio's use of water in a rural setting anticipated the later Baroque fountains of the city of Rome.

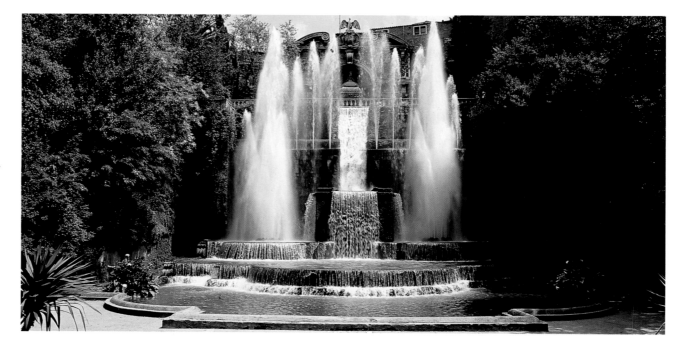

Northern Italian Painting in the 15th Century

These two maps, which show the main centers of patronage and the artists who worked there, demonstrate the richness of painting in northern Italy in this period. Politically the area was dominated by the land empire of Venice, which reached its fullest extent in 1454 and was only briefly eclipsed in 1509–11 when temporarily overrun by the forces of the Emperor Maximilian I and Pope Julius II at the time of the League of Cambrai. Venice's chief political and territorial rival was the duchy of Milan, but what is striking in both centuries is the vitality of the individual cities and provinces, many of which boasted quasi-independent schools of painting. Examples are Brescia and Verona within the Venetian sphere, and Piedmont within the Milanese. These schools both drew on and fed the art of the main metropolitan centers.

To the south of these territories were the duchy of Ferrara under the Este family, where a highly individual school flourished from the mid-15th to the mid-16th century, and Parma, which after its independence from Milan became, partly because of its papal connections, an important point of contact with the Roman High Renaissance, producing in Correggio (c.1494–1534) and Parmigianino (1503–40) two major artists who were both deeply responsive to Central Italian art.

Mantua under the Gonzaga family is interesting because, while having no significant school of painting of its own, it was, through their enlightened patronage, a major center for the successive styles of the period: first International Gothic with Pisanello (1395–1455); then Early Renaissance through the humanist and architect L.B. Alberti (c.1404–72) and the Paduan painter Mantegna (c.1431–1506); and finally, with Giulio Romano (c.1492–1546) and, to a lesser extent, Titian (c.1488–1576), High Renaissance art in both its Roman and Venetian manifestations.

Taken individually, the maps demonstrate the intermingling of styles and influences in the different periods. The main centers of late Gothic art were Milan under the Visconti (Michelino da Besozzo Fl.1388–1442), Verona under the Scaligeri family (Stefano da Zevio c.1375–1451, Pisanello c.1395–1455) and Venice. Of great importance was the visit to Venice of the Central Italian painter Gentile da Fabriano (c.1370–1427) who worked in fresco in the Grand Council Chamber of the Palazzo Ducale. The courtly and decorative values of his art, tempered by naturalism, humor and an atmospheric approach to light, were much admired – the Venetians flocked to see the frescoes – and greatly influenced Pisanello.

The second half of the century saw the gradual spread, initially under the influence of visiting artists from Tuscany (e.g. Donatello c.1386–1466, Castagno c.1423–57, Uccello c.1397–1475) of the new Renaissance style with its emphasis on three-dimensional values and the rational treatment of space and light. Religious subject-matter was humanized and treated, under the influence of the revived study of antiquity, with a gravity that contrasts with Gothic sweetness. Metropolitan Venice and its dependency Padua with its university are, from c.1430, the main centers for this development, and Padua, which had its own school, produced in Mantegna the first great

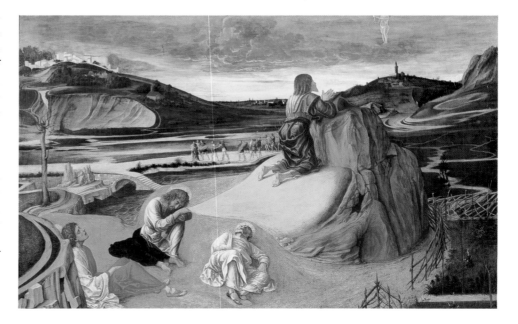

North Italian Renaissance painter. He aimed, even in religious paintings, at an almost archeological reconstruction of the ancient world; under Gonzaga patronage at Mantua he extended the range of painting to historical and allegorical subjects *all'antica*.

In Venice the transition from Gothic to Renaissance took place gradually in successive generations of two families, the Vivarini and the Bellini. Giovanni Bellini (c.1430–1516) in particular established, during one of the longest and most revolutionary developments in the history of painting – he lived to be over 80 – the pictorial and poetic values which, with an emphasis on light and landscape, became the chief visual characteristics of the Venetian School.

Above: *Giovanni Bellini (act.1459): The Agony in the Garden, possibly late 1460s (National Gallery, London).*

Below: *Andrea Mantegna (1431–1506): detail decoration of the Camera Degli Sposi (Bridal Chamber) for the Gonzaga family, completed 1474 (Ducal Palace, Mantua).*

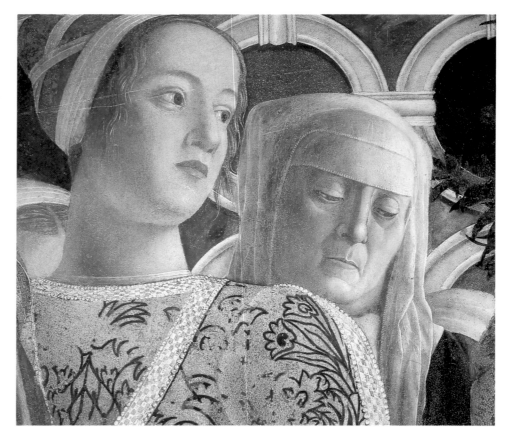

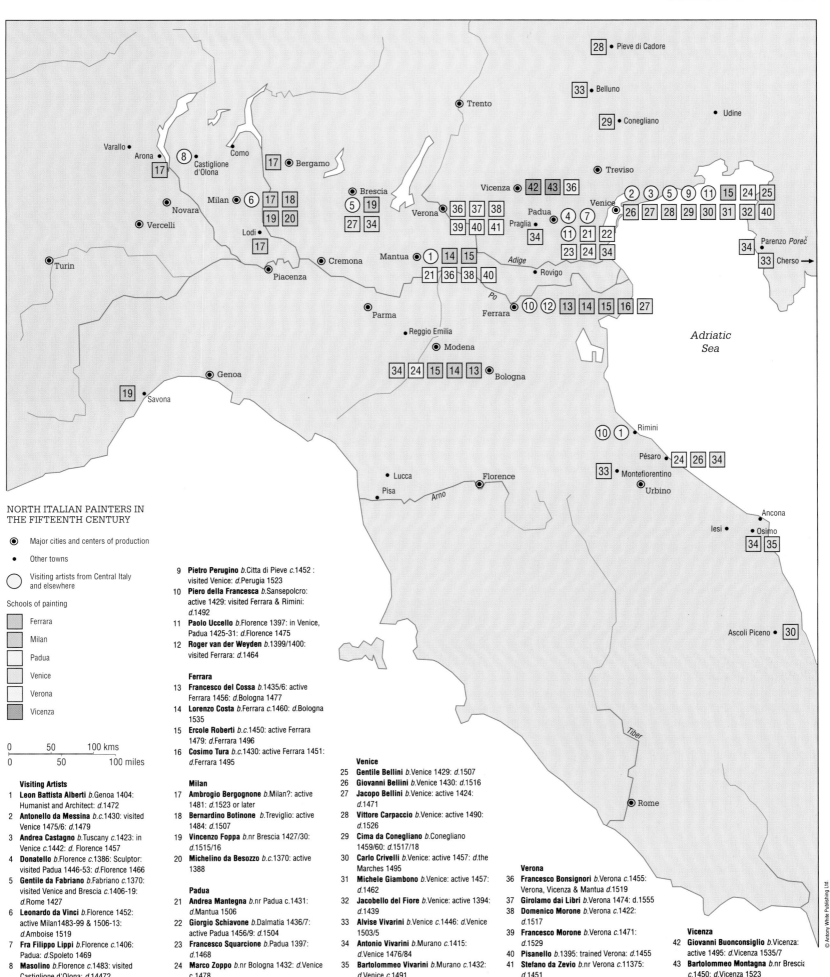

NORTH ITALIAN PAINTERS IN
THE FIFTEENTH CENTURY

⊙ Major cities and centers of production

• Other towns

◯ Visiting artists from Central Italy and elsewhere

Schools of painting

▢ Ferrara

▢ Milan

▢ Padua

▢ Venice

▢ Verona

▢ Vicenza

| 0 | 50 | 100 kms |
| 0 | 50 | 100 miles |

Map labels (towns and cities):

Pieve di Cadore — 28
Belluno — 33
Conegliano — 29
Udine
Trento
Varallo
Arona — ⑧ 17
Como
Castiglione d'Olona
Bergamo — 17
Treviso
Vicenza — 42 43 36
Milan — ⑥ 17 18 / 19 20
Novara
Vercelli
Brescia — ⑤ 19 / 27 34
Verona — 36 37 38 / 39 40 41
Venice — ② ③ ⑤ ⑨ ⑪ 15 24 25 / 26 27 28 29 30 31 32 40
Padua — ④ ⑦ / ⑪ 21 22 / 23 24 34
Praglia — 34
Lodi — 17
Turin
Cremona
Piacenza
Mantua — ① 14 15 / 21 36 38 40
Adige
Rovigo
Parenzo Poreč — 34
Cherso — 33
Parma
Po
Ferrara — ⑩ ⑫ 13 14 15 16 27
Adriatic Sea
Genoa
Reggio Emilia
Modena
Savona — 19
Bologna — 34 24 15 14 13
Rimini — ⑩ ①
Pésaro — 24 26 34
Montefiorentino — 33
Lucca
Pisa
Florence
Urbino
Arno
Ancona
Iesi
Osimo — 34 35
Ascoli Piceno — 30
Tiber
Rome

Visiting Artists

1 **Leon Battista Alberti** b.Genoa 1404: Humanist and Architect: d.1472

2 **Antonello da Messina** b.c.1430: visited Venice 1475/6: d.1479

3 **Andrea Castagno** b.Tuscany c.1423: in Venice c.1442: d. Florence 1457

4 **Donatello** b.Florence c.1386: Sculptor: visited Padua 1446-53: d.Florence 1466

5 **Gentile da Fabriano** b.Fabriano c.1370: visited Venice and Brescia c.1406-19: d.Rome 1427

6 **Leonardo da Vinci** b.Florence 1452: active Milan1483-99 & 1506-13: d.Amboise 1519

7 **Fra Filippo Lippi** b.Florence c.1406: Padua: d.Spoleto 1469

8 **Masolino** b.Florence c.1483: visited Castiglione d'Olona: d.1447?

9 **Pietro Perugino** b.Citta di Pieve c.1452 : visited Venice: d.Perugia 1523

10 **Piero della Francesca** b.Sansepolcro: active 1429: visited Ferrara & Rimini: d.1492

11 **Paolo Uccello** b.Florence 1397: in Venice, Padua 1425-31: d.Florence 1475

12 **Roger van der Weyden** b.1399/1400: visited Ferrara: d.1464

Ferrara

13 **Francesco del Cossa** b.1435/6: active Ferrara 1456: d.Bologna 1477

14 **Lorenzo Costa** b.Ferrara c.1460: d.Bologna 1535

15 **Ercole Roberti** b.c.1450: active Ferrara 1479: d.Ferrara 1496

16 **Cosimo Tura** b.c.1430: active Ferrara 1451: d.Ferrara 1495

Milan

17 **Ambrogio Bergognone** b.Milan?: active 1481: d.1523 or later

18 **Bernardino Botinone** b.Treviglio: active 1484: d.1507

19 **Vincenzo Foppa** b.nr Brescia 1427/30: d.1515/16

20 **Michelino da Besozzo** b.c.1370: active 1388

Padua

21 **Andrea Mantegna** b.nr Padua c.1431: d.Mantua 1506

22 **Giorgio Schiavone** b.Dalmatia 1436/7: active Padua 1456/9: d.1504

23 **Francesco Squarcione** b.Padua 1397: d.1468

24 **Marco Zoppo** b.nr Bologna 1432: d.Venice c.1478

Venice

25 **Gentile Bellini** b.Venice 1429: d.1507

26 **Giovanni Bellini** b.Venice 1430: d.1516

27 **Jacopo Bellini** b.Venice active 1424: d.1471

28 **Vittore Carpaccio** b.Venice: active 1490: d.1526

29 **Cima da Conegliano** b.Conegliano 1459/60: d.1517/18

30 **Carlo Crivelli** b.Venice: active 1457: d.the Marches 1495

31 **Michele Giambono** b.Venice: active 1457: d.1462

32 **Jacobello del Fiore** b.Venice: active 1394: d.1439

33 **Alvise Vivarini** b.Venice 1446: d.Venice 1503/5

34 **Antonio Vivarini** b.Murano c.1415: d.Venice 1476/84

35 **Bartolommeo Vivarini** b.Murano c.1432: d.Venice 1491

Verona

36 **Francesco Bonsignori** b.Verona c.1455: Verona, Vicenza & Mantua d.1519

37 **Girolamo dai Libri** b.Verona 1474: d.1555

38 **Domenico Morone** b.Verona c.1422: d.1517

39 **Francesco Morone** b.Verona 1471: d.1529

40 **Pisanello** b.1395: trained Verona: d.1455

41 **Stefano da Zevio** b.nr Verona c.11375: d.1451

Vicenza

42 **Giovanni Buonconsiglio** b.Vicenza: active 1495: d.Vicenza 1535/7

43 **Bartolommeo Montagna** b.nr Brescia c.1450: d.Vicenza 1523

© Antony White Publishing Ltd

151

Northern Italian Painting in the 16th Century

The themes covered in the 16th-century map already begin in the 15th century, notably the presence of Leonardo (1452–1519), who arrived in Milan as early as 1483 and, even after the expulsion of his Sforza patron in 1499, was there intermittently until 1513. His art rapidly supplanted the existing 15th-century School of Borgognone (c.1445–1523), but the School of Piedmont to the west continued quasi-independently from the 15th into the 16th century and then produced, in Gaudenzio Ferrari (c.1470–1546), a major master. A feature of his work, as of Piedmontese and Lombard painting generally, is the narrative fresco cycle (of the Passion or the lives of the saints), and such cycles, e.g. that in Cremona Cathedral, were often major enterprises and attracted artists, e.g. Pordenone (c.1484–1539), from outside the region. They represent a more popular, dramatic and devotional type of religious art than that of the princely courts or the large metropolitan centers such as Rome and Venice. Lorenzo Lotto (c.1480–c.1556), for instance, who although a Venetian by birth and a painter mainly of altarpieces was an artist of this stamp, worked mostly in the provinces and had little popularity in Venice.

None the less it was the style of metropolitan Venice, formed by the great masters Giorgione (c.1477–1510), Titian (c.1485–1576) and Palma Vecchio (c.1480–1528), that dominated the Venetian *terra firma* in the 16th century. In itself it provided a sensuous and poetic alternative to the High Renaissance art of Central Italy, which in Titian's hands became no less epic and mon-

umental. He traveled widely within the region and the neighboring principalities, and even the major local schools, the Brescian for example, show despite their individuality the indelible imprint of his influence. However the influence goes both ways. Palma Vecchio came from Bergamo to Venice and, in the second half of the century, the color of Veronese (1528–88), often considered the apogee of Venetian "colorito", owes much to what the the regional painting of Verona had inherited from Mantegna.

By this time painting as a whole had, however, become much more international, with a conscious blending of Venetian and Roman strains, even in Titian's work. This happens in the 1540s and is signalized by the visits to Venice of a number of Central Italian artists, including Vasari (1511–74). But, as the map suggests, Venice was constantly receptive to artists from elsewhere and it showed a continuous capacity to transform them. Thus the great flowering of Venetian painting at the end of the century was produced by Titian from Cadore, Veronese from Verona, the native-born Tintoretto (1519–94), and Jacopo Bassano (c.1510–92), who in fact produced some of his greatest work for the provincial city of Bassano where his family themselves constituted the local school.

Below left: *Gaudenzio Ferrari (c.1470–1546):* The Martyrdom of St Catherine, *late work (Pinacoteca di Brera, Milan).*

An exceptionally fine example of action-packed North Italian Mannerist painting. Ferrari worked throughout Piedmont and Lombardy but rarely in the leading centers; a major artist whose work can be found throughout the region.

Below: *Lorenzo Lotto (c.1480–c.1556):* Marsilio and His Wife, *1523 (Prado, Madrid).*

Lotto was a highly idiosyncratic painter. This portrait was in the private collection of Rubens and then passed to the Spanish Royal Collection. Lotto studied with Giorgione and Titian and, like Ferrari, worked in many places in Central and Northern Italy.

Above: *Titian (c.1485–1576):* St Sebastian, *1522 (Ss. Nazzaro e Celso, Brescia).*

Titian, who was the greatest Venetian painter, became over a very long working life one of the first supremely successful international European artists. This work was part of a high altar in Brescia.

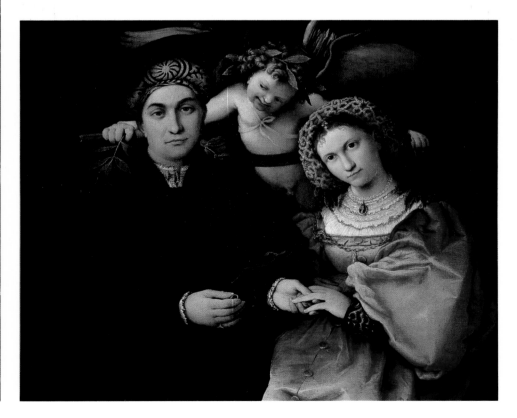

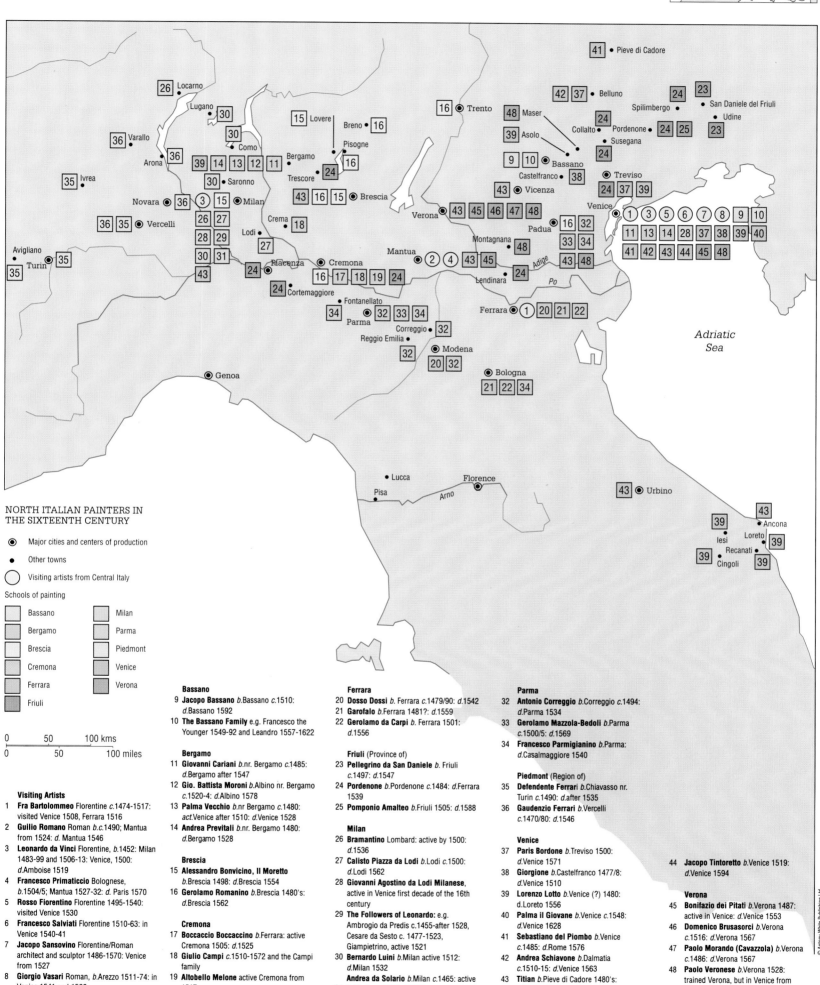

**NORTH ITALIAN PAINTERS IN
THE SIXTEENTH CENTURY**

◉ Major cities and centers of production

● Other towns

◯ Visiting artists from Central Italy

Schools of painting

Bassano		Milan
Bergamo		Parma
Brescia		Piedmont
Cremona		Venice
Ferrara		Verona
Friuli		

0 50 100 kms
0 50 100 miles

Visiting Artists

1 **Fra Bartolommeo** Florentine c.1474-1517: visited Venice 1508, Ferrara 1516

2 **Guilio Romano** Roman b.c.1490; Mantua from 1524: d. Mantua 1546

3 **Leonardo da Vinci** Florentine, b.1452: Milan 1483-99 and 1506-13: Venice, 1500: d.Amboise 1519

4 **Francesco Primaticcio** Bolognese, b.1504/5; Mantua 1527-32: d. Paris 1570

5 **Rosso Fiorentino** Florentine 1495-1540: visited Venice 1530

6 **Francesco Salviati** Florentine 1510-63: in Venice 1540-41

7 **Jacopo Sansovino** Florentine/Roman architect and sculptor 1486-1570: Venice from 1527

8 **Giorgio Vasari** Roman, b.Arezzo 1511-74: in Venice 1541 and 1566

Bassano

9 **Jacopo Bassano** b.Bassano c.1510: d.Bassano 1592

10 **The Bassano Family** e.g. Francesco the Younger 1549-92 and Leandro 1557-1622

Bergamo

11 **Giovanni Cariani** b.nr.Bergamo c.1485: d.Bergamo after 1547

12 **Gio. Battista Moroni** b.Albino nr.Bergamo c.1520-4: d.Albino 1578

13 **Palma Vecchio** b.nr Bergamo c.1480: act.Venice after 1510: d.Venice 1528

14 **Andrea Previtali** b.nr.Bergamo 1480: d.Bergamo 1528

Brescia

15 **Alessandro Bonvicino, Il Moretto** b.Brescia 1498: d.Brescia 1554

16 **Gerolamo Romanino** b.Brescia 1480's: d.Brescia 1562

Cremona

17 **Boccaccio Boccaccino** b.Ferrara: active Cremona 1505: d.1525

18 **Giulio Campi** c.1510-1572 and the Campi family

19 **Altobello Melone** active Cremona from 1517

Ferrara

20 **Dosso Dossi** b. Ferrara c.1479/90: d.1542

21 **Garofalo** b.Ferrara 1481?: d.1559

22 **Gerolamo da Carpi** b. Ferrara 1501: d.1556

Friuli (Province of)

23 **Pellegrino da San Daniele** b. Friuli c.1497: d.1547

24 **Pordenone** b.Pordenone 1484: d.Ferrara 1539

25 **Pomponio Amalteo** b.Friuli 1505: d.1588

Milan

26 **Bramantino** Lombard: active by 1500: d.1536

27 **Calisto Piazza da Lodi** b.Lodi c.1500: d.Lodi 1562

28 **Giovanni Agostino da Lodi Milanese**, active in Venice first decade of the 16th century

29 **The Followers of Leonardo:** e.g. Ambrogio da Predis c.1455-after 1528, Cesare da Sesto c. 1477-1523, Giampietrino, active 1521

30 **Bernardo Luini** b.Milan active 1512: d.Milan 1532

Andrea da Solario b.Milan c.1465: active

31 in Venice c.1500: d.1524

Parma

32 **Antonio Correggio** b.Correggio c.1494: d.Parma 1534

33 **Gerolamo Mazzola-Bedoli** b.Parma c.1500/5: d.1569

34 **Francesco Parmigianino** b.Parma: d.Casalmaggiore 1540

Piedmont (Region of)

35 **Defendente Ferrari** b.Chiavasso nr. Turin c.1490: d.after 1535

36 **Gaudenzio Ferrari** b.Vercelli c.1470/80: d.1546

Venice

37 **Paris Bordone** b.Treviso 1500: d.Venice 1571

38 **Giorgione** b.Castelfranco 1477/8: d.Venice 1510

39 **Lorenzo Lotto** b.Venice (?) 1480: d.Loreto 1556

40 **Palma il Giovane** b.Venice c.1548: d.Venice 1628

41 **Sebastiano del Piombo** b.Venice c.1485: d.Rome 1576

42 **Andrea Schiavone** b.Dalmatia c.1510-15: d.Venice 1563

43 **Titian** b.Pieve di Cadore 1480's: d.Venice 1576

44 **Jacopo Tintoretto** b.Venice 1519: d.Venice 1594

Verona

45 **Bonifazio dei Pitati** b.Verona 1487: active in Venice: d.Venice 1553

46 **Domenico Brusasorci** b.Verona c.1516: d.Verona 1567

47 **Paolo Morando (Cavazzola)** b.Verona c.1486: d.Verona 1567

48 **Paolo Veronese** b.Verona 1528: trained Verona, but in Venice from c.1550: d.Venice 1588

*Adriatic
Sea*

© Antony White Publishing Ltd

153

North Italian Architecture and Sculpture in the 15th and 16th Centuries

This map identifies the major monuments of the period according to type. The commentary is designed to draw attention within each type – churches, civic buildings, etc. – to major innovations and innovators within the general development from Gothic to Early Renaissance and then to High and Late Renaissance styles.

Churches. The cruciform plan remained standard across changes of style, and earlier buildings were often updated by a new stylistic dress, e.g. in S.Benedetto al Po where the remodeling architect was Giulio Romano and the patron the Gonzagas. A major development was the popularity of the centralized plan (usually circular or Greek cross) which, although not liturgically convenient, appealed to the Renaissance predilection for perfect geometric forms and for antique or early Christian precedents. It was used extensively for funerary chapels and for remodeling the east end of originally cruciform churches, but already with Alberti's S.Sebastiano and then extensively in the later 15th and 16th centuries independently for votive churches, churches functioning as mausolea and shrines.

Civic Buildings. A Palazzo Civico or town hall around which other civic buildings were often grouped has always provided a center for Italian cities and represented the beginnings of town planning. Earlier buildings were often rebuilt or, in the Renaissance, remodeled in classical dress. New types of building – hospitals, libraries and civic theaters – were constructed according to rational Renaissance principles but have only rarely survived. Town gates were also an important locus for civic display. Private palaces, especially their façades, played as important a role as civic buildings, and to build them was part of every wealthy patrician's duty to his city.

Palaces and Castles. The Italian term *palazzo* applies as much to the town houses of leading citizens as to great palaces of the ruling dynasties, but as architectural types the two may be distinguished. Family palaces of varying degrees of splendor, often rivaling one another, had early formed points of focus in the different localities of Italian cities, and many representing all styles have survived, not least in smaller towns like Cremona or Vercelli. The richest Renaissance examples are in Verona and, often by Palladio, in Vicenza. Coherence and convenience of plan were as important as display in a Renaissance town palace, but can often be more easily studied from plans than from the buildings themselves. Dynastic palaces mostly have medieval origins and were then, like the Castello Gonzaga, extended beyond recognition in the Renaissance and enriched with painting and sculpture. Others, like the Visconti/Sforza castles in Milan and Pavia, remain medieval. In the 16th century most princes built pleasure palaces, either in the country or on the outskirts of their cities.

Villas. These were, in northern Italy, mostly a 16th-century development, inspired by the Renaissance conception of rural tranquility as an escape from the world and the classical idealization of pastoral values. Although not confined to the Veneto – the Milanese built villas – they were there, under the auspices of Palladio, at their richest and most developed.

The developments in sculpture can be analyzed by type: movable sculpture which flourished in the Renaissance is not mappable and the lists refer mostly to sculpture on or in buildings, apart from independent monuments like the equestrian statues of Donatello and Verrocchio. In the interior of churches, the most common surviving type of sculpture is the wall tomb, both Gothic and Renaissance. In the Renaissance such tombs were often given the character and attributes of classical triumphal arches, and combine *all'antica* images of fame with traditional Christian iconography: winged victories with the Resurrected Christ. Externally, sculpture, especially in the Gothic and Early Renaissance periods, sometimes played a major role in the adornment of church façades, as is apparent in the transitional Certosa di Pavia, but as the Renaissance progressed architectural forms tended to dominate. On the skyline of Renaissance palaces, e.g. Palladio's Palazzo Chiericati and churches, and especially on many Venetian buildings, sculpture was often used. The development of narrative reliefs, whether of religious or antique subjects, was an important aspect of Renaissance sculpture, since it combined, through the medium of marble or bronze, story-telling with ideality of form. Such reliefs often had a public function on tombs or shrines or as the decoration for an entire chapel. Sculptural decorations often appeared on palace façades, possibly in stone, plaster or terracotta, the last especially at Cremona.

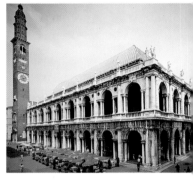

Above: *Andrea Palladio (1508–80):* The Basilica, or Palazzo della Ragione, *begun 1549. Vicenza.*

The work and influence of Palladio spread rapidly across Northern Italy, and then Europe – as a designer not just of villas, but of civic buildings as well, particularly in his home town, Vicenza. His career had been helped by Giangiorgio Trissino, the poet, philosopher and mathematician who took him to Rome to study classical art and theory. On his return to Vicenza he won the commission for the Basilica, a building which instantly created the Palladian style.

Left: *Pietro Lombardo (c.1435– c.1516):* The Tomb of Doge Pietro Mocenigo, *funerary monument, c.1476–81 (Ss. Giovanni e Paolo, Venice).*

Pietro Lombardo, from Lombardy, worked in Padua, Treviso, Florence, Ravenna and Venice. With his sons Tullio and Antonio, his workshop created some of the most accomplished sculpture in 15th-century Venice, his monuments being classical in both construction and figure work. Pietro was also an architect who designed the church of S. Maria dei Miracoli (1481–9) in Venice.

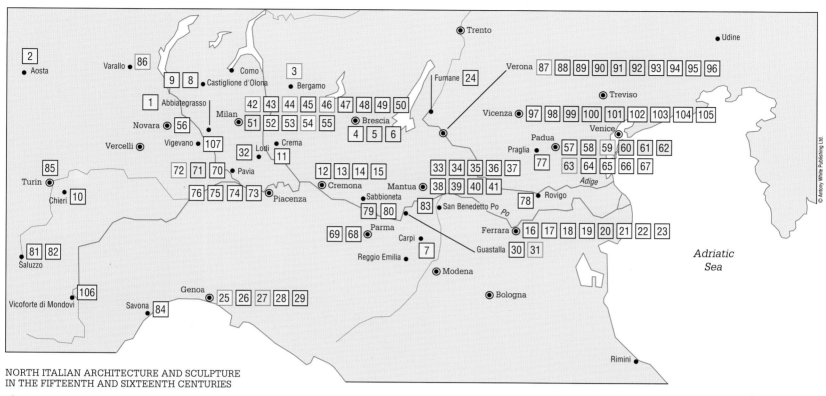

NORTH ITALIAN ARCHITECTURE AND SCULPTURE
IN THE FIFTEENTH AND SIXTEENTH CENTURIES

- ◉ Major cities and centers of production
- • Other towns
- ▢ Church
- ▢ Civic building
- ▢ Palace or castle
- ▢ Villa
- ▢ Building with sculpture

```
0        50        100 kms
0        50        100 miles
```

Major Architectural Sites

1 S. Maria Nuova: cloistered courtyard 1497 by Bramante
2 Priory of S. Orso 1494-1506 (Franco-Lombard)
3 Cathedral. Cappella Colleoni 1470-73 by G. A. Amadeo
Extensive sculpture by same
4 S. Maria dei Miracoli begun 1488 (Lombard Venetian, centrally planned)
5 Loggia del Monte di Pietà 1484-9 (Lombard-Venetian)
6 Palazzo Communale. Loggia c.1490-1510 (High Renaissance). 2nd storey 1550-60
7 S. Nicolò from 1453 by pupils of Bramante and later by Peruzzi
8 Collegiata from 1421 (Lombard-Gothic)
9 Chiesa di Villa 1430-41 (style of Brunelleschi)
10 Cathedral Baptistery: 15th century remodelling (Piedmontese)
11 S. Maria della Croce begun 1493, centralized pilgrimage church by G. Battagio
12 S. Abbondio Cloister: late 15th century
13 S. Margarita built and frescoed by Giulio Campi 1547
14 Numerous late 15th and early 16th century palaces including Palazzo Fudri and Palazzo Raimoni-Fieschi
15 S. Sigismondo begun 1463 by Bartolomeo Gaddio. Dynastic Sforza church transformed by 16th century decorations.
16 Campanile of S. Giorgio 1480-85 by B. Rossetti

17 Cathedral Apse 1498-99 by B. Rossetti Campanile on design by Alberti
18 S. Francesco 1494 by B. Rossetti
19 S. Cristoforo 1498, Carthusian church by B. Rossetti
20 Addizione Ercole, plan for the extension of the city by B. Rossetti
21 Palazzo Schifanoia begun 1462 by P. Benvenuto di Ordini
22 Numerous 15th and 16th century palaces, including Palazzo dei Diamanti c.1492 by B. Rossetti
23 Casa Rossetti, 1490s by B. Rossetti
24 Villa della Torre by Michele Sanmicheli (mortuary chapel)
25 Cathedral: Chapel of S. Giovanni Battista 1451-65 by Elia and Giovanni Gaggini (Early Renaissance)
Funeral Chapel of Giuliano Cibo.
Sculpture: Altar of the Apostles by Guglielmo della Porta et al 1533-1537
Sculpture 15th century: Matteo Civitale et al
Sculpture 16th century: Andrea Sansovino by 1503
26 S. Maria Assunta di Carignano, signed 1549 by Galeazzo Alessi
27 Strada Nuova 1558-1570 planned by Galeazzo Alessi
Sculpture: University: S. Francesco di Castelleto. 12 figures and 6 scenes by Giovanni Bologna
28 16th century palaces on the Strada Nuova including Palazzo Doria Turci by Rocco Lurago begun 1564 and Palazzo Cambiaso 1565 by Alessi
29 Villa Cambiaso, 1548 by Galeazzo Alessi
30 Cathedral late 1560s by Francesco da Volterra
31 Piazza Mazzini. Sculpture: statue of Ferrante Gonzaga by Leone Lioni 1564
32 The Incoronata 1480-1490 by Battagio and Dolcebuono. Centralized pilgrimage church
33 S. Sebastiano. Centralized votive church begun 1460 by Alberti
34 S. Andrea begun 1470 by Alberti
35 Cathedral remodeled by Giulio Romano after 1540
36 Palazzo Ducale: Rebuilding of Castel S. Giorgio (including Camera Picta by Mantegna from 1459)
37 Casa di Mantegna 1476
38 Domus Nova c.1480 by L. Fancelli

39 Palazzo Del Té begun 1525 by Giulio Romano
40 Cavellerizza: Estivale Façade c.1539 by Giulio Romano
41 Casa di Giulio Romano c.1540
42 Cathedral begun 1386
Lombard Gothic building deliberately continued into the 16th century in N. Gothic style.
Extensive sculpture
43 S. Ambrogio. Cloister by Bramante 1452
44 S. Eustorgio. Portinari chapel by Michelozzo (Florentine) 1462-8
Sculpture by Amadeo
45 S. Maria presso S. Satiro begun 1478 by Bramante
46 S. Maria presso S. Celso. 1490, centrally planned church by Dolcebuono, Solari and Amadeo, façade by Galeazzo Alessi 1570.
Sculpture by Annibale Fontana 1586
47 S. Maria delle Grazie. Choir by Bramante begun 1493. Nave by Guiniforte Solari begun 1463
48 S. Fedele, begun 1569 by Pellegrino Pellegrini
49 S. Lorenzo, rebuilt from 1574 by Martino Bassi
50 Banco Mediceo designed by Michelozzo c.1460s. Demolished
51 Ospedale Maggiore. Founded 1457. Work by Filarete and Solari c.1460-5
52 Castello Sforzesco. Rebuilt from 1450 onwards with involvement of Filarete 1452-4
53 Palazzo Marini 1558 by Galeazzo Alessi
54 Casa degli Omenoni. Sculpture and façade by Leone Leoni, its owner
55 Villa Simonetta after 1547 Domenico Giunti
56 Casa della Porta
57 S. Maria, rebuilt by A. Moroni and A. della Valle. Begun 1532
58 Cathedral, rebuilt by A. della Valle from 1552
59 S. Antonio (The Santo)
Sculpture: High Altar (demolished) reconstructed by Donatello c.1447.
Monument of Antonio Roselli by P. Lombardo finished 1467.
Cappella dell'Arca del Santo. Chapel begun 1500.

Relief and altar extended throughout 16th century.
Reliefs of Life of S. Antony by T. Lombardo, J. Sansovino and others.
Other sculpture by Aspetti, Bellano, Pietro di Niccolò Lamberti, Sanmicheli and Vittoria
60 Loggia del Consiglio. Lombardo-Venetian staircase begun 1501
61 Porta S. Giovanni 1528 by G.M. Falconetto
62 Porta Savonarola 1530 by G.M. Falconetto
63 Piazza del Santo. Sculpture Gattamelata monument by Donatello 1443-53
64 Palazzo dei Diamanti by B. Rosetti
65 Numerous other 15th and 16th century palaces
66 Casa Rosetti 1490s by B. Rosetti
67 Palazzo Giustiniani formerly Cornaro Loggia and Odeon by G.B. Falconetto 1524-1530
68 S. Giovanni Evangelista rebuilt 1493-1520 by B. Zaccagni
69 Madonna della Stellata begun 1521, centralized votive church by B. & G. Zaccagni
70 Cathedral replanned before 1450 with involvement of Bramante. Model by Cristoforo Rocchi
71 Collegio Borromeo by Pellegrino Pellegrini founded 1561
72 Certosa di Pavia. Lombardo Gothic and Renaissance by brothers Solari completed 1473
Present façade from 1453 by Amadeo and Mantegazza
Extensive sculpture by Amadeo and others
73 S. Sisto begun after 1499 by Antonio Tramelli
74 S. Sepolcro, church and monastery by A. Tramelli from 1510
75 S. Maria di Campagna central plan church begun 1522 by Antonio Tramelli. Palazzo Farnese begun 1558 by G.B. da Vignola
77 Abbey Church of the Assumption remodeled 1490-1543 by Tullio Lombardo
78 Palazzo Roncali 1555 by Michele Sanmicheli
79 Theatre 1588-90 V. Scamozzi
80 Palazzo Ducale from 1568

81 Cathedral 1491-1501 (Franco-Piedmontese)
82 Casa Cavassa
83 Abbey Church rebuilt on Gonzaga commission 1445. Remodeled by Giulio Romano after 1540
84 Palazzo della Rovere 1495 by Giuliano da Sangallo (unfinished)
85 Cathedral 1491-8 Meo da Caprino (Romano-Piedmontese)
86 Sacro Monte (Pilgrimage site: complexes of painting and sculpture)
87 S. Anastasia: Capella Pellegrini Sculpture terracotta by Michele di Firenze 1430-1455
Altar of Venetian General G. Fregose by Danese Cattaneo 1565
88 S. Bernadino: Capella Pellegrini (mortuary chapel) 1529-51 by Michele Sanmicheli
89 Madonna di Campagna circular pilgrimage church begun 1559 by Michele Sanmicheli
90 Palazzo & Loggia del Consiglio 1474-93 (Lombard-Venetian)
91 Porta Nuova 1533-34
92 Porta Palio c.1555-60 by Michele Sanmicheli
93 Palazzo Canossa begun c.1532
94 Palazzo Guastaverza begun 1555
95 Palazzo Pompeli 1550s
96 Palazzo Bevilaqua c.1553 all by Michele Sanmicheli
97 S. Corona. Chancel and sanctuary rebuilt 1479-1504 by Lorenzo da Bologna
98 Basilica of Monte Berico, begun 1428. Building 15th and 16th centuries. Remodeled 18th century.
99 Basilica from c.1550 remodeled by Palladio with two-storey loggia
100 Loggia del Capitano begun 1570-71 by Palladio
101 Teatro Olimpico. 1579-84 by Palladio
102 Palazzo Chiericati, begun 1550 by Palladio
103 Palazzo Thiene, begun 1545-50 by Palladio
104 Palazzo Iseppo-Porto, begun before 1552 by Palladio
105 Palazzo Valmarana, 1565-6 by Palladio
106 S. Maria begun 1596 by Ascanio Vitozzi (centralized oval pilgrimage church)
107 Castello & Piazza Ducale, early 1490s probably by Leonardo

© Antony White Publishing Ltd.

The Villas of the Veneto

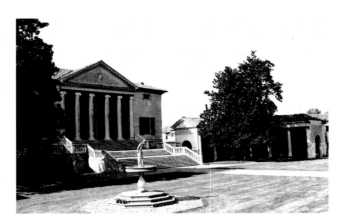

Left: *Andrea Palladio (1508–80): Villa Badoer, 1568–70, Fratta Polesine.*

A typical Palladian villa with a central courtyard and curved wings, anchored on a pedimented block.

In the long peace that followed the wars with the League of Cambrai in the early l6th century there was great building activity in the Veneto countryside, in which most famously Andrea Palladio (1508–80) made his career. The map represents only a fraction of this; it shows primarily the incidence of villas by Palladio (preponderantly to the north and south of Vicenza, in the Alto and Basso Vicentino) and some other architects (notably Michele Sanmichele, c.1484–1550), and of villas containing 16th-century frescoes, mostly by followers of Paolo Veronese (c.1528–88). Their pattern largely reflects the nature of the countryside: not surprisingly, the finest villas are in both fertile and beautiful country among foothills – alpine foothills to the north of Verona, Vicenza and Treviso, the Monti Berici south of Vicenza, and the Colli Euganei south of Padua. Even making allowance for losses, there were probably always fewer fine country houses on the dreary plains beside the lagoon, despite Palladio's Villa Zen at Cessalto, Jacopo Sansovino's (1486–1570) Villa Garzoni at Pontecasale, and Palladio's Villa Badoer at Fratta Polesine.

Palladio's designs proved remarkably influential, both abroad (through their publication in his *Four Books of Architecture*) and locally – some of the most "Palladian" villas in the Veneto date from the 17th and 18th centuries. Palladio himself drew on ideas by other architects and on local tradition; the trend to build grand houses on country estates extended throughout central and northern Italy and went back certainly to the 15th century and probably earlier. The earliest surviving "country palace" in the Veneto is the Castello Porto-Colleoni at Thiene, due north of Vicenza (completed 1453, architect unknown).

Palladio's villas are generally associated with a "switch to the land" (away from mercantilism and the sea) by Venetian patricians, but Venetians who bought estates on the mainland and built on them were following a mainland fashion. Though Palladio's most imposing villas were for Venetian clients, he evolved their style and principles for landowners around Vicenza. Two important trend-setting patrons were Alvise Cornaro in Padua and Giangiacomo Trissino in Vicenza; they prepared for Palladio the decisive mix of central Italian High Renaissance influence and archaeological observation of classical remains. (Note also the proximity of Mantua, where Giulio Romano (c.1492–1546) was active for the Gonzaga court.) Previously, great families had kept appropriate state by building castles or castle-like structures, such as the battlemented Porto-Colleoni or the Castello Giustinian at Roncade near Treviso.

The Veronese Michele Sanmichele built some important villas now lost, notably La Soranza near Castelfranco. La Soranza was also important for the nature of its fresco decoration by Paolo Veronese (some detached fragments survive); they antedate his more famous frescoes in Palladio's Villa Barbaro at Maser. Large numbers of Veneto villas contain 16th-century frescoes, by Veronese's leading follower Battista Zelotti (1526–78) and by others. Most, but not all, garden and roof-line sculpture was introduced after the Renaissance period; fireplaces and the like also survive.

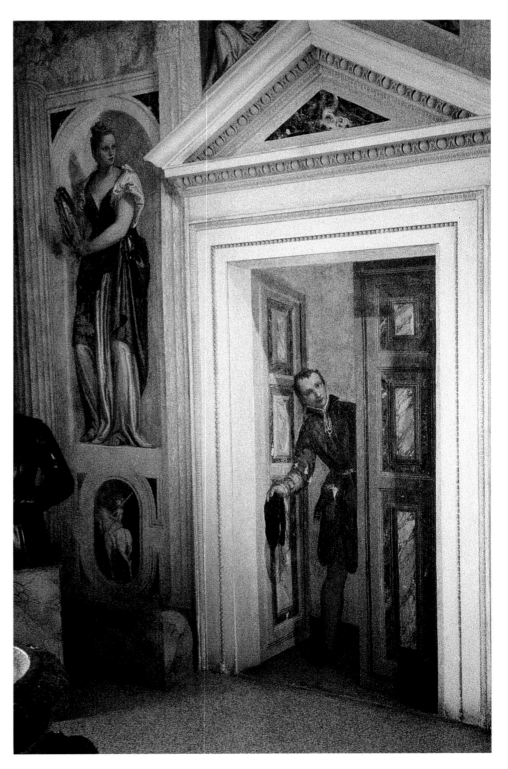

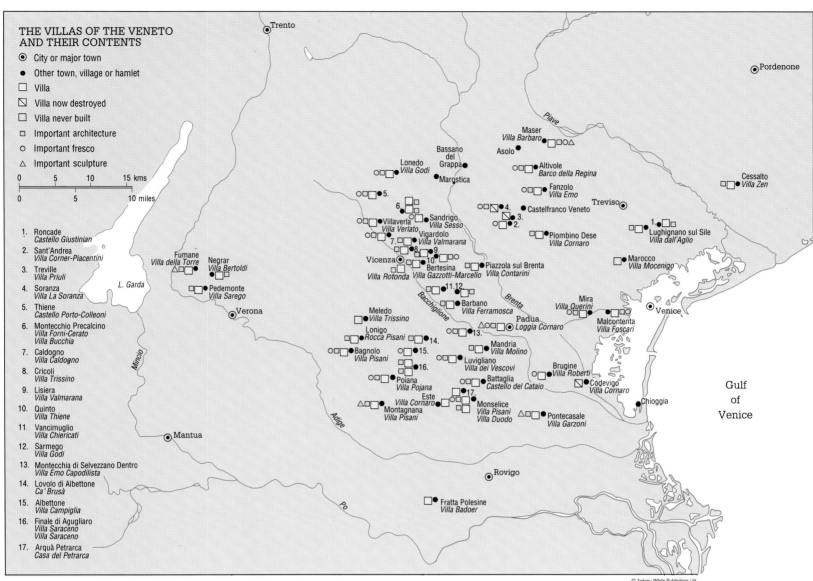

THE VILLAS OF THE VENETO AND THEIR CONTENTS

- ◉ City or major town
- ● Other town, village or hamlet
- □ Villa
- ◿ Villa now destroyed
- □ Villa never built
- ▫ Important architecture
- ○ Important fresco
- △ Important sculpture

0 5 10 15 kms
0 5 10 miles

1. Roncade
 Castello Giustinian
2. Sant'Andrea
 Villa Corner-Piacentini
3. Treville
 Villa Priuli
4. Soranza
 Villa La Soranza
5. Thiene
 Castello Porto-Colleoni
6. Montecchio Precalcino
 Villa Forni-Cerato
 Villa Bucchia
7. Caldogno
 Villa Caldogno
8. Cricoli
 Villa Trissino
9. Lisiera
 Villa Valmarana
10. Quinto
 Villa Thiene
11. Vancimuglio
 Villa Chiericati
12. Sarmego
 Villa Godi
13. Montecchia di Selvezzano Dentro
 Villa Emo Capodilista
14. Lovolo di Albettone
 Ca' Brusà
15. Albettone
 Villa Campiglia
16. Finale di Agugliaro
 Villa Saraceno
 Villa Saraceno
17. Arquà Petrarca
 Casa del Petrarca

© Antony White Publishing Ltd.

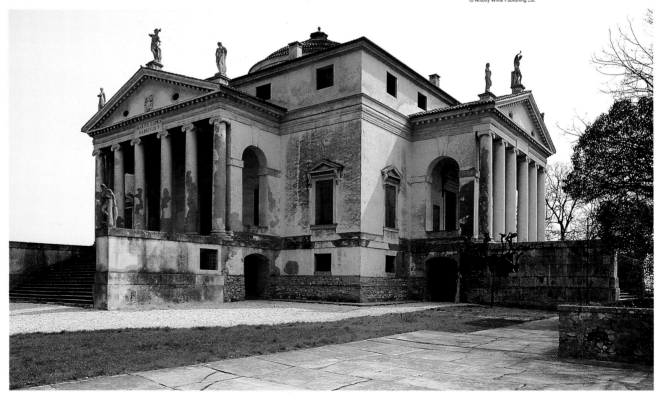

Left: *Bernardino India (c.1528–90): frescoes in the* Villa Pojana *by Andrea Palladio (1508–80) c.1549, Poiana Maggiore.*

Bernardino India and Anselmo Canera (fl. 1566–75) decorated the Villa Pojana with illusionistic frescoes typical of the interior decorative schemes of Palladian villas.

Right: *Andrea Palladio (1508–80):* Villa Rotonda, *begun c.1550, near Vicenza.*

The most elaborate example of Palladio's symmetrical and centrally planned villas. It was particularly influential on English Palladian architecture in the 18th century.

Florentine Art and Architecture: the Trecento

The growth of Florence was defined over the centuries by the construction of three sets of fortified walls. The square core of the city was Roman with the present Duomo (Cathedral) and Baptistery complex in the northeast corner. In the 12th century the Roman walls were replaced by longer walls crossing the river and enclosing a much larger area. The third set of walls, mentioned by Dante and in part supervised by the chronicler Giovanni Villani, were built between 1284 and 1334 and enclosed an area far greater than was then currently inhabited. They were therefore an expression of the civic pride and ambition of Florence which followed the establishment of the Signoria in 1282 and the, albeit short-lived, democratic government of the city by merchants and laborers (nobility excluded), organized in guilds. The planners of the early 14th century saw their new walls as a protection against their multitude of enemies (indeed they had already helped keep out the Emperor Henry VII in 1312), and also as allowing ample room for growth.

The distinction between Late Medieval and Renaissance Florentine art has always been blurred, but there were clearly three main periods of activity: from 1282 to the Black Death in the 1340s; the rise of the Medici in the 15th century; and the restoration of the republic (1498–1528), followed by the imposition of autocratic Medici rule in 1530. These three periods are reflected in the next three maps.

The Trecento map shows programs of building and decoration that reflect the growth of the idea of the city state. The Cathedral complex showed the ecclesiastical side. The Duomo [3] was begun by Arnolfo di Cambio (1232–1302) in 1296, the Campanile [2] by Giotto (c.1266–1337), and the Baptistery [1] was adorned with bronze doors (begun 1330) by Andrea Pisano (c.1290–1348). To the south and east, but still within the 12th-century walls, were the Palazzo del Podestà [57] (now the Bargello, 1256–1346), symbol of the defeat of the nobility, and the Palazzo dei Priori, a meeting place for the ruling representatives of the guilds (now the Palazzo Vecchio [54], begun by Arnolfo di Cambio in 1298).

The city was flanked to the northwest and southeast respectively by the two great friars' churches: S. Maria Novella (Dominican, 1246–1300) [31],with frescoes by Orcagna (c.1308–68) amongst others; and S. Croce (Franciscan, begun 1295 by Arnolfo di Cambio) [4], which contained also the great fresco cycles of Giotto in the Bardi and Peruzzi chapels.

After the great flood of 1333 the four bridges (Ponte Vecchio, Ponte S. Trinità, Ponte alla Carraia and Ponte alle Grazie) were all restored. After the Black Death, although the pace of building slackened, Orcagna in 1359 built his exquisite sculptured tabernacle in Orsanmichele [37], and the Loggia dei Lanzi (1374–81) [53] was built in the Piazza della Signoria next to the Palazzo Vecchio as an open arcade for speechifying.

Top: *Andrea Orcagna (c.1308–68),* The Tabernacle in Orsanmichele, *1359.*

Orcagna built this tabernacle, a type of monumental reliquary, to house a miraculous image.

Middle: *Giotto (c.1266–1337),* The Deathbed of St. Francis, *fresco, after 1320, Bardi Chapel, S. Croce, Florence.*

Giotto's painting combined narrative skill and a new monumental realism.

Bottom: *The Baptistery (11th and 12th centuries) with the* Duomo *(begun 1290s) and* Campanile *(designed by Giotto 1334–59).*

The Baptistery was a Romanesque building embellished with sculpture in the Trecento and Quattrocento; the building of the Duomo culminated in Brunelleschi's Dome (completed 1467).

FLORENCE IN THE FOURTEENTH CENTURY

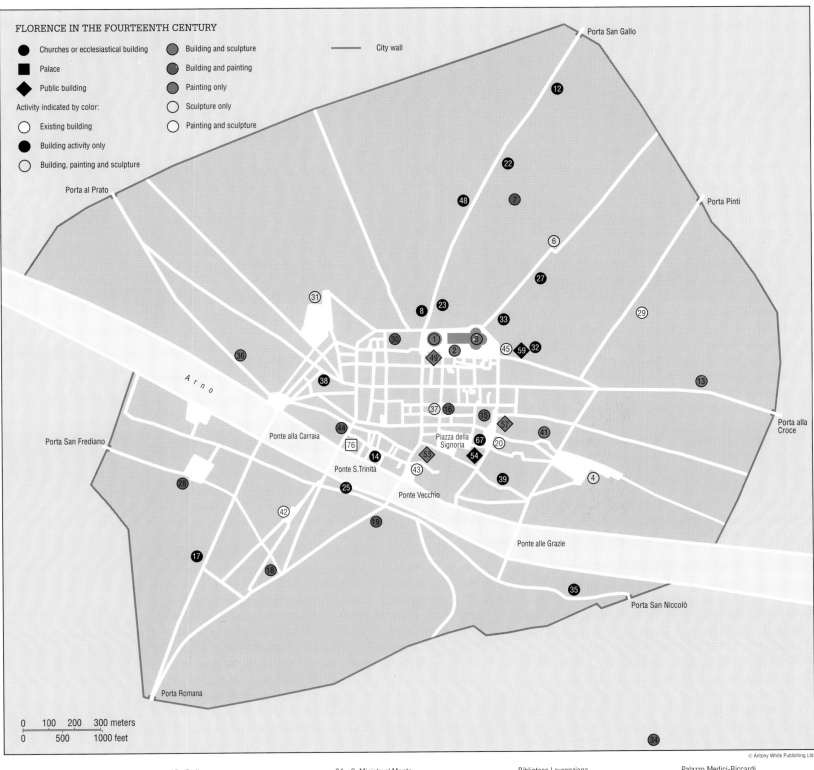

● Churches or ecclesiastical building

■ Palace

◆ Public building

Activity indicated by color:

○ Existing building

● Building activity only

○ Building, painting and sculpture

● Building and sculpture

● Building and painting

● Painting only

○ Sculpture only

○ Painting and sculpture

—— City wall

Porta San Gallo

Porta al Prato

Porta Pinti

Porta San Frediano

Ponte alla Carraia

Arno

Ponte S. Trinità

Ponte Vecchio

Piazza della Signoria

Porta alla Croce

Ponte alle Grazie

Porta San Niccolò

Porta Romana

0 100 200 300 meters

0 500 1000 feet

© Antony White Publishing Ltd.

Cathedral Complex
1 Battistero
2 Campanile
3 Duomo
S. Croce area
4 S. Croce
 Cappella de' Pazzi
S. Marco area
6 SS. Annunziata
7 S. Marco
S. Lorenzo area
8 S. Lorenzo
 Sagrestia Vecchia
 Sagrestia Nuova
 Cappella dei Principi
Other churches or ecclesiastical buildings
12 S. Agata
13 S. Ambrogio
14 Ss. Apostoli

15 Badia
16 S. Carlo dei Lombardi
17 S. Elisabetta delle Convertite
18 S. Felice
19 S. Felicita
20 S. Firenze
 S. Frediano in Cestello
22 S. Giovannino dei Cavalieri
23 S. Giovannino degli Scolopi
 S. Giuseppe
25 S. Jacopo sopr' Arno
 S. Margherita de' Ricci
27 S. Maria degli Angeli
28 S. Maria del Carmine
29 S. Maria Maddalena dei Pazzi
30 S. Maria Maggiore
31 S. Maria Novella
32 S. Maria Nuova
33 S. Michelino

34 S. Miniato al Monte
35 S. Niccolò sopr' Arno
36 Ognissanti
37 Orsanmichele
38 S. Pancrazio
39 S. Remigio
 S. Salvatore al Monte
41 S. Simone
42 S. Spirito
43 S. Stefano
44 S. Trinita
45 Museo dell' Opera del Duomo
 Palazzo Arcivescovile
 Chiostro degli Scalzi
48 Cenacolo di S. Apollonia
Civic buildings
49 Loggia del Bigallo
 Misericordia
 Ospedale degli Innocenti

 Biblioteca Laurenziana
53 Loggia dei Lanzi
54 Palazzo Vecchio
55 Uffizi
 Mercato Nuovo
57 Palazzo del Podestà (Bargello)
 Palazzo di Parte Guelfa
59 Ospedale di S. Maria Nuova
Palaces
 Palazzo Grifoni
 Casino Mediceo
 Casa Buonarotti
63 Palazzo degli Alberti
 Palazzo Antinori
 Palazzo Bartolini-Salimbeni
 Palazzo Busini
67 Palazzo Davanzati
 Palazzo Gondi
 Palazzo Guadagni

 Palazzo Medici-Riccardi
 Palazzo Pandolfini
 Palazzo Pazzi-Quaratesi
 Palazzo Pitti
 Palazzo Rosselli del Turco
 Palazzo Rucellai
76 Palazzo Spini
 Palazzo Strozzi
Fortresses
 Fortezza da Basso
 Fortezza del Belvedere

Florentine Art and Architecture: the Quattrocento

The map opposite corresponds in time to the rise of the Medici, who reached their peak during the rule of Lorenzo the Magnificent (1469–91), and were temporarily halted by Savonarola in 1494. Work continued on the centers of civic life. A further set of bronze doors for the Baptistery were made (1403–24) by Ghiberti (1378–1455), major sculptural projects were undertaken for the Duomo, including singing galleries by Luca della Robbia (1400–82) and Donatello (c.1386–1466), and the external niche sculptures at Orsanmichele included works by Nanni di Banco (c.1384–1421), Ghiberti, Donatello, Verrocchio (c.1435–c.1488) and others. Above all Brunelleschi (1377–1446) crowned the Duomo with a dome (completed 1436) and lantern (completed 1467) which epitomize the art of Renaissance Florence.

Medici projects were centered on their headquarters, the Palazzo Medici [70] (now Medici-Ricardi, begun 1444, with frescoes in the chapel (1459–60) by Benozzo Gozzoli, 1420–97). They were patrons of their local church, S. Lorenzo [8], to which at this period they commissioned Brunelleschi to add the Old Sacristy (1419–28) [9], his first building. Slightly to the north, they paid for the rebuilding by Michelozzo (1396–1472) of the convent of S. Marco (1437–52), and Cosimo the Elder, 'pater patriae', prayed in the cells decorated with the frescoes of Fra Angelico (1387–1455). In the early 1460s Antonio Pollaiuolo (c.1432–98) was painting a series of *The Labors of Hercules* in the Palazzo Medici; and later the allegorical paintings of Botticelli (c.1445–1510), especially *Primavera* (c.1477/8) and *The Birth of Venus* (late 1470s), clearly had some relationship to the thought of the humanist circle at one of the cadet branches of the family.

Medici prosperity led to a huge growth in the building of palaces for nobles, bankers and merchants throughout the city, such as the Palazzo Gondi [68] (begun 1490), the Palazzo Pitti [73] (begun 1457), the Palazzo Rucellai [75] (begun 1446 on designs by Alberti, c.1404–72), the Palazzo Strozzi [77] (begun 1489) and the Palazzo Pazzi [72] (1462–72, by Giuliano da Maiano, 1432–90). The Pazzi family also had Alberti build their funerary chapel, the Cappella de' Pazzi [5] (begun 1430), in the grounds of S. Croce.

Church building in 15th–century Florence reached its height with Alberti's façade for S. Maria Novella [31] (1456–70) and Brunelleschi's S. Spirito [42] (begun 1436). Painting of all kinds flourished: from fresco cycles, e.g. Masaccio (1401–c.1428) in the Brancacci Chapel in S. Maria del Carmine [28] (1425–8), to the panel paintings of Leonardo (1452–1519).

Above: *Donatello (c.1386–1466)* Habakkuk, *marble, c.1434–6, from the* Campanile *(now in the Museo del Opera del Duomo, Florence).*

Below: *Sandro Botticelli (c.1445–1510)* Primavera *(Spring), 1477–8, Uffizi, Florence.*

FLORENCE IN THE FIFTEENTH CENTURY

- ● Churches or ecclesiastical building
- ■ Palace
- ◆ Public building

Activity indicated by color:
- ○ Existing building
- ● Building activity only
- ◑ Building, painting and sculpture

- ◑ Building and sculpture
- ◑ Building and painting
- ● Painting only
- ○ Sculpture only
- ◑ Painting and sculpture

— City wall

Porta San Gallo
Porta al Prato
Orti Oricellari
Porta Pinti
Arno
Porta San Frediano
Ponte alla Carraia
Piazza della Signoria
Porta alla Croce
Ponte S. Trinità
Ponte Vecchio
Ponte alle Grazie
Porta San Niccolò
Porta Romana

0 100 200 300 meters
0 500 1000 feet

© Antony White Publishing Ltd.

Cathedral Complex	15 Badia	34 S. Miniato al Monte	Biblioteca Laurenziana
1 Battistero	16 S. Carlo dei Lombardi	35 S. Niccolò sopr' Arno	53 Loggia dei Lanzi
2 Campanile	17 S. Elisabetta delle Convertite	36 Ognissanti	54 Palazzo Vecchio
3 Duomo	18 S. Felice	37 Orsanmichele	55 Uffizi
S. Croce area	19 S. Felicita	38 S. Pancrazio	Mercato Nuovo
4 S. Croce	20 S. Firenze	39 S. Remigio	57 Palazzo del Podestà (Bargello)
5 Cappella de' Pazzi	21 S. Frediano in Cestello	40 S. Salvatore al Monte	58 Palazzo di Parte Guelfa
S. Marco area	22 S. Giovannino dei Cavalieri	41 S. Simone	59 Ospedale di S. Maria Nuova
6 SS. Annunziata	23 S. Giovannino degli Scolopi	42 S. Spirito	**Palaces**
7 S. Marco	S. Giuseppe	43 S. Stefano	Palazzo Grifoni
S. Lorenzo area	25 S. Jacopo sopr' Arno	44 S. Trinita	Casino Mediceo
8 S. Lorenzo	26 S. Margherita de' Ricci	45 Museo dell' Opera del Duomo	62 Casa Buonarroti
9 Sagrestia Vecchia	27 S. Maria degli Angeli	Palazzo Arcivescovile	63 Palazzo degli Alberti
Sagrestia Nuova	28 S. Maria del Carmine	Chiostro degli Scalzi	64 Palazzo Antinori
Cappella dei Principi	29 S. Maria Maddalena de' Pazzi	48 Cenacolo di S. Apollonia	Palazzo Bartolini-Salimbeni
Other churches or ecclesiastical buildings	30 S. Maria Maggiore	**Civic buildings**	66 Palazzo Busini
12 S. Agata	31 S. Maria Novella	49 Loggia del Bigallo	67 Palazzo Davanzati
13 S. Ambrogio	32 S. Maria Nuova	Misericordia	68 Palazzo Gondi
14 Ss. Apostoli	33 S. Michelino	51 Ospedale degli Innocenti	Palazzo Guadagni
			70 Palazzo Medici-Riccardi
			Palazzo Pandolfini
			72 Palazzo Pazzi-Quaratesi
			73 Palazzo Pitti
			Palazzo Rosselli del Turco
			75 Palazzo Rucellai
			76 Palazzo Spini
			77 Palazzo Strozzi
			Fortresses
			Fortezza da Basso
			Fortezza del Belvedere

Florentine Art and Architecture: the Cinquecento

This map shows Florence from the end of the 15th century, which closed with the iconoclastic and penitential regime of the monk Savonarola, and the expulsion of the Medici until 1512. The republic was restored until 1530, although from 1512 dominated again by the Medici. As before, the revived republic concentrated on the twin centers of civic life, the Duomo and the Palazzo Vecchio. Michelangelo's (1475–1564) *David* (1501–4) symbolically stood outside the latter; his *Twelve Apostles* (begun 1503, and never finished) were destined for the former. Both Michelangelo and Leonardo (1452–1519) were commissioned in 1504 to paint battle scenes for the new Hall of the quasi-democratic Great Council in the Palazzo Vecchio; neither were completed.

After the Sack of Rome in 1527 the republic survived for three more years, but the combination of the Medici Pope Clement VII and the Emperor Charles V then established the Medici family as autocratic rulers of Tuscany in perpetuity, a rule epitomized by the power of Duke Cosimo (1519–74). The major schemes of the Florentine 16th century, both High Renaissance and Mannerist, were Medici-inspired, and in particular related to the S. Lorenzo complex. Michelangelo, having completed the Sistine Chapel, returned from Rome in 1516 to work for the Medici Pope Leo X, first on the new façade for S. Lorenzo (unrealized); then the New Sacristy [10] (begun 1521, its monumental sculptures left incomplete in 1530); and from 1524 on the plans for the Laurentian Library [52], his finest Mannerist architectural statement. The contrast between these and the later Cappella dei Principi [11] (designed 1561–8 by Vasari (1511–74) for Duke Cosimo, although not begun until 1605) shows self-aggrandizement degenerating into bombast. Painting during the last republican period included Andrea del Sarto's (1486–1530) frescoes in the Chiostro degli Scalzi [47] (1511–26) and Pontormo's (1494–1566) in S. Felicità [19] (*Annunciation* and *Desposition*).

Palace architecture continued throughout the century: for example, the Palazzo Guadagni [69] (begun 1503), the Palazzo Pandolfini [71] (by Raphael (1483–1520), begun 1520), the Palazzo Rosselli del Turco [74] (1517, by Baccio d'Agnolo (1462–1543), originally with frescoes by Pontormo, Primaticcio (c.1504–70) and Granacci, c.1469–1543), and the Palazzo Grifoni [61] (built 1557–75 by Bartolomeo Ammanati (1511–92) for Ugolino Grifoni, who made his money as an administrator for Duke Cosimo). Duke Cosimo redecorated the Palazzo Vecchio, his administrative center, and built next to it the Uffizi [55] (1560–80) to house the magistrature of the new Tuscan state.

The Medici also extended the fortifications of the city. These had been added to by Michelangelo during the crisis of 1527/8. Later extensions included the Fortezza da Basso [78] (begun 1534) to the north, and the Fortezza del Belvedere [79] (1590–5). These were aimed as much against the Florentines themselves as against any external enemy.

Top: *Jacopo Pontormo (1494–1566),* Annunciation, *fresco, 1530s, S. Felicita, Florence.*

Above: *Bernardo Buontalenti (1536–1608),* Fortezza del Belvedere, *1590–5.*

This Medici fortress dominates the high ground to the south of the city.

Left: *Michelangelo Buonarotti (1475–1564) and others,* The New Sacristy, 1519–59, *with Michelangelo's* Tomb *of Lorenzo de Medici with the figures of* Dawn *and* Dusk, *1519–34, S. Lorenzo, Florence.*

The first of two burial chapels of the Medici, part of the S. Lorenzo complex.

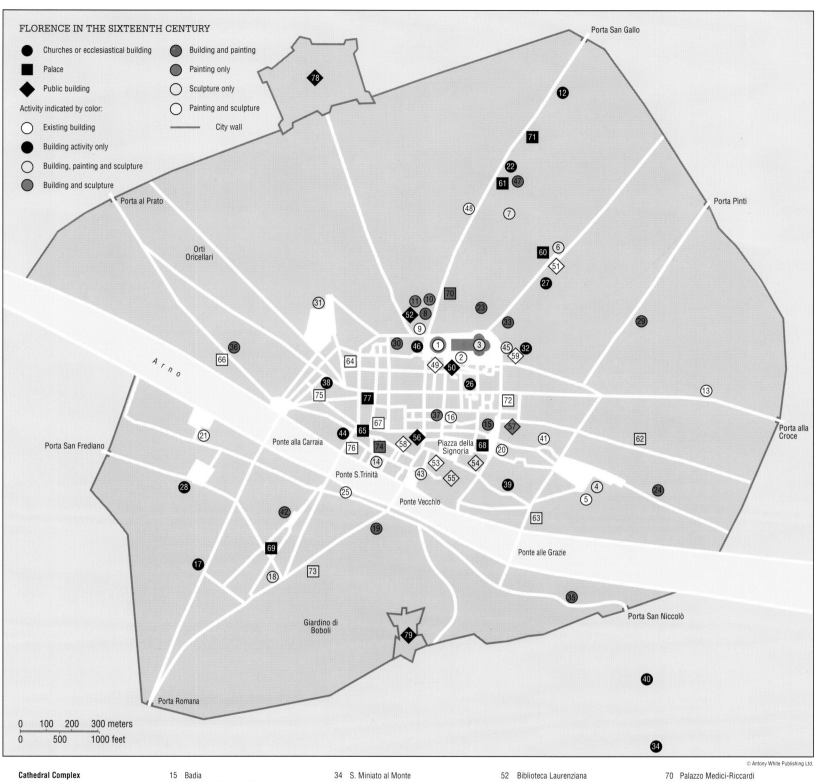

FLORENCE IN THE SIXTEENTH CENTURY

- ● Churches or ecclesiastical building
- ■ Palace
- ◆ Public building

Activity indicated by color:
- ○ Existing building
- ● Building activity only
- ○ Building, painting and sculpture
- ● Building and sculpture

- ◑ Building and painting
- ● Painting only
- ○ Sculpture only
- ○ Painting and sculpture
- — City wall

Porta San Gallo

Porta al Prato

Porta Pinti

Orti Oricellari

Arno

Porta San Frediano

Ponte alla Carraia

Piazza della Signoria

Porta alla Croce

Ponte S.Trinità

Ponte Vecchio

Ponte alle Grazie

Porta San Niccolò

Giardino di Boboli

Porta Romana

| 0 | 100 | 200 | 300 meters |
| 0 | 500 | | 1000 feet |

© Antony White Publishing Ltd.

Cathedral Complex
1 Battistero
2 Campanile
3 Duomo
S. Croce area
4 S. Croce
5 Cappella de' Pazzi
S. Marco area
6 SS. Annunziata
7 S. Marco
S. Lorenzo area
8 S. Lorenzo
9 Sagrestia Vecchia
10 Sagrestia Nuova
11 Cappella dei Principi
Other churches or ecclesiastical buildings
12 S. Agata
13 S. Ambrogio
14 Ss. Apostoli

15 Badia
16 S. Carlo dei Lombardi
17 S. Elisabetta delle Convertite
18 S. Felice
19 S. Felicita
20 S. Firenze
21 S. Frediano in Cestello
22 S. Giovannino dei Cavalieri
23 S. Giovannino degli Scolopi
24 S. Giuseppe
25 S. Jacopo sopr' Arno
26 S. Margherita de' Ricci
27 S. Maria degli Angeli
28 S. Maria del Carmine
29 S. Maria Maddalena dei Pazzi
30 S. Maria Maggiore
31 S. Maria Novella
32 S. Maria Nuova
33 S. Michelino

34 S. Miniato al Monte
35 S. Niccolò sopr' Arno
36 Ognissanti
37 Orsanmichele
38 S. Pancrazio
39 S. Remigio
40 S. Salvatore al Monte
41 S. Simone
42 S. Spirito
43 S. Stefano
44 S. Trinita
45 Museo dell' Opera del Duomo
46 Palazzo Arcivescovile
47 Chiostro degli Scalzi
48 Cenacolo di S. Apollonia
Civic buildings
49 Loggia del Bigallo
50 Misericordia
51 Ospedale degli Innocenti

52 Biblioteca Laurenziana
53 Loggia dei Lanzi
54 Palazzo Vecchio
55 Uffizi
56 Mercato Nuovo
57 Palazzo del Podestà (Bargello)
58 Palazzo di Parte Guelfa
59 Ospedale di S. Maria Nuova
Palaces
60 Palazzo Grifoni
61 Casino Mediceo
62 Casa Buonarroti
63 Palazzo degli Alberti
64 Palazzo Antinori
65 Palazzo Bartolini-Salimbeni
66 Palazzo Busini
67 Palazzo Davanzati
68 Palazzo Gondi
69 Palazzo Guadagni

70 Palazzo Medici-Riccardi
71 Palazzo Pandolfini
72 Palazzo Pazzi-Quaratesi
73 Palazzo Pitti
74 Palazzo Rosselli del Turco
75 Palazzo Rucellai
76 Palazzo Spini
77 Palazzo Strozzi
Fortresses
78 Fortezza da Basso
79 Fortezza del Belvedere

Venetian Architecture

The Venetian lagoons were settled in the 6th century. By the 9th century the present configuration of the city had already evolved. The center of commerce was at the Rialto around the only bridge across the Grand Canal, and the center of state was at Piazza S. Marco, the state church, and the Ducal Palace, residence of the Doge and seat of government. Many surviving parishes with their *Campi* (the Venetian name for a small square: only S. Marco is a *Piazza*) date from this period, although their churches have almost all been rebuilt, many in the 17th and 18th centuries. The earliest surviving church is probably S.Giacomo di Rialto, founded according to legend in 421 but now 11th century in fabric. By this time palaces already lined the Grand Canal, but the earliest surviving buildings, in brick with marbled façades in a Venetian variant of the Byzantine style, date from the 13th century. S. Marco, the most splendid manifestation of this Veneto-Byzantine style, was founded in c.828, when the relics of the saint, stolen from Alexandria, arrived in the city. The present building dates from the 11th century, with Gothic additions.

The city underwent its first transformation in the 14th century when the mendicant orders in particular introduced the Gothic style. The Franciscan church, S.Maria Gloriosa dei Frari, and the imposing Dominican church, Ss.Giovanni e Paolo, both begun in the 1330s, were on a much larger scale than earlier buildings, cutting across the existing parishes to provide new points of focus within the city; they still dominate its skyline.

The Palazzo Ducale, whose south block towards the Riva was begun in the 1340s and whose western extension down the Piazzetta towards S. Marco followed from 1424, is, with its open arcades and shimmering, diapered surfaces, a specifically Venetian manifestation of the Gothic style. It mingles northern forms with oriental influence, notably in its use of the ogee arch much favored in secular Venetian Gothic. Its size changed the scale of the city, dwarfing S.Marco almost to the status of an attendant chapel, which in one sense, as the state church, it is. Many surviving palaces on the Grand Canal and elsewhere in the City are in this style, often, like Ca'Foscari, built as an expression of wealth and power by politically successful families. Most famous, but exceptional rather than typical, is the Ca'd'Oro, or "House of Gold", where the marbling of the Veneto-Byzantine tradition is combined with Gothic interlace to magical effect. By the 15th century the *Scuole Grande*, charitable clubs of prominent laymen, had become centers of social life. Each occupied a different quarter, with buildings on a scale which imposed themselves on their surroundings.

The earliest Renaissance building in Venice was probably the library of the Benedictine monastery of S. Giorgio Maggiore, begun in 1450 by the Florentine Michelozzo, but this is entirely lost. By 1469 a major architect, Mauro Codussi, had begun, for the Camaldolese Benedictines of the Isola di San Michele, a church entirely Early Renaissance in idiom although already adapted to the Venetian taste for light and color, and the new style spread rapidly. The Porta della Carta (1438) which completes the west wing of the Palazzo Ducale is still elaborately Gothic. The Arco Foscari (completed 1470s) and the east wing (begun in 1483), with the Scala dei Giganti (sculpture by Antonio Rizzo) are essentially early Renaissance with surviving Gothic elements.

This Early Renaissance style often appears less revolutionary in Venice than elsewhere because it so easily assimilated native elements from the Veneto-Byzantine tradition. The shrine-like church of S.Maria dei Miracoli, erected by Pietro Lombardo in 1481–89 to house a miraculous image of the Virgin, is as richly marbled as S.Marco, only more regular in its articulation, and the Greek-cross plan of Codussi's S.Maria Formosa – the plan so loved by Renaissance architects because of its geometrical perfection – is based on that of the original Veneto-Byzantine church.

From 1500 a new impulse is evident. Palazzo Dario, begun 1487 for an ex-Ambassador to the Turkish court, still looks like a Veneto-Byzantine building wearing a Renaissance mask. Codussi's Palazzo Vendramin-Calergi, originally Loredan (1502–9), is not only much grander, as befits the family status, but also more classical. Its detailed forms are still Venetian but the breadth with which they are used is already Roman. It was a center for the new art, with frescoes by Giorgione and paintings by Sebastiano and Titian.

The "Romanization" of Venice was entirely appropriate to her imperial ambitions and involved a transformation of the City as radical as that in the Gothic period. It began in good earnest in the 1530s under the auspices of the Florentine sculptor and architect Jacopo Sansovino, who arrived in Venice in 1527 after the Sack of Rome. He brought about the development of the public spaces of the city into the form we know today. He started in 1536 with the Zecca (the Mint), which replaced the old warehouses on the Molo in a fortress-like style with heavy classical rustication which matches its function. Originally it was only two stories and did not then over-top his second and far more important public building, the Marciana Library. This cunningly balances the Palazzo Ducale across the Piazzetta, matching the Gothic with the Renaissance style and the plane, shimmering surfaces of the Palazzo with deeply cut classical arcading, which is given depth and substance by the light. Its skyline is crowned with classical statues as against the crenellations of the Palace.

The final architect of the 16th-century transformation of the city was Palladio. He replanned the courtyard for the Monastery of the Carità in 1561, one side only of which was built; but most importantly he rebuilt from 1565 the ancient Benedictine monastery on the island of S.Giorgio, one of the most prominent sites in the City, matching it later with the church of the Redentore on the Guidecca, which was put up by the Signoria (1577-92) as a votive offering for deliverance from the plague. Executed in white marble, in pure, but dynamically interlocking classical forms, the façades of the two churches represent the most perfect marriage of *all'antica* architecture wlth the rippling water and open skies of the lagoon. Solemnity and drama combine in an organic interpretation of classical architecture that is Palladio's own.

Above: S. Maria Gloriosa dei Frari, *1338–1443, Venice.*

The interior of this Franciscan church has cylindrical stone piers, tied together with wooden beams and supporting an arcade of pointed arches and brick vaulting.

Right: Ss. Giovanni e Paolo, *begun c.1333, Venice.*

A Dominican church of historic import, which contains the tombs of the Doges. The exterior is of beautiful brickwork, with a clerestory of lofty proportions. The dome is of a later date.

Far right: Ca'd'Oro, *1424–36, Venice.*

This fine design, although appearing to lack one wing, is by Giovanni and Bartolomeo Buon. The window grouping is in the Venetian manner and the arcades are filled with delicate tracery.

VENETIAN ARCHITECTURE 1300–1600

- ⛪ Church
- ◆ Palace
- ■ Public building
- ▲ School
- —— Wall

Date of architecture:
- ⬤ Pre–1300
- ○ 1300–1450
- ⬤ 1450–1500
- ⬤ 1500–1600

Scale:
0 250 500 meters
0 1000 2000 feet

S. Michele in Isola

S. Alvise

Madonna del Orto

S. Cristoforo della Pace

Palazzo Mastelli

S. Giobbe

S. Marziale

Scuola Vecchia della Misericordia

S. Geremia

Palazzo Vendramin Calergi

Canal Grande

S. Felice

Fondaco dei Turchi

Ca d'Oro

S. Giovanni Decollato

Palazzo Sagredo

SS. Apostoli

S. Maria dei Miracoli

S. Giacomo dell'Orio

S. Cassiano

Scuola di S. Marco

S. Maria Mater Domini

Ca' da Mosto

SS. Giovanni e Paolo

Fabbricche Nuove

Scuola di S. Orsola

Scuola di San Giovanni Evangelista ▲

S. Giacomo di Rialto

S. Giovanni Crisostomo

S. Francesco della Vigna

S. Rocco

I Frari

Fondaco dei Tedeschi

Arsenale

Scuola di S. Rocco ▲

S. Silvestro

Ponte di Rialto

S. Polo

S. Salvatore

S. Maria Formosa

S. Pantalon

S. Toma

Palazzo Grimani

Scuola di S. Giorgio degli Schiavoni

Ca' Foscari

Procuratie Vecchie

Loggetta

S. Marco

Scuola di S. Giorgio dei Greci

S. Maria dei Carmini

S. Samuele

S. Geminiano

S. Zaccaria

S. Martino

S. Nicolo dei Mendicoli

S. Barnaba

S. Stefano

S. Moisè

S. Giovanni in Bragora

S. Pietro di Castello

S. Sebastiano

S. Vitale

S. Maria del Giglio

Palazzo Ducale

Palazzo Corner ◆

Zecca

Scuola della Carità ▲

Biblioteca Marciana

S. Trovaso

Palazzo Dario

S. Gregorio

Procuratie Nuove

S. Giuseppe di Castello

S. Giorgio Maggiore

S. Elena

S. Eufemia

Il Redentore

© Antony White Publishing Ltd.

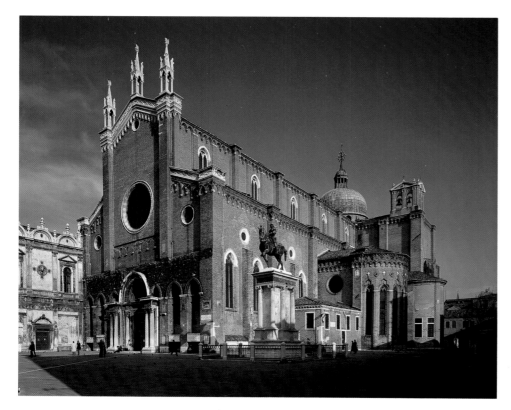

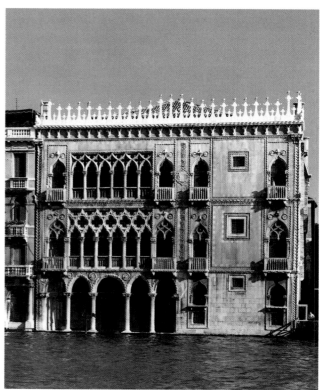

Rome in the Quattrocento

Rome was a place of anarchy during the Middle Ages, with a small population, warring nobles often ensconced in fortified ancient monuments (or in towers such as we still see in San Gimignano, Bologna or Pisa), and the order previously attempted by the Papacy once again lacking. Not only did the Great Schism keep the Popes in Avignon from 1305 until 1417, but inherent weaknesses in the previous centuries hastened the degradation of the city. Martin V, Pope from 1417, was a Roman (a Colonna), who entered the war- and earthquake-battered city in 1420. He and his successors, acting as *de facto* secular princes, undertook the slow enactment of measures (from street cleaning to policing and town planning), chiefly to beautify the city, with the vision of making it and the Papacy worthy successors to the Rome of the Emperors. Accordingly both the Popes and the great families from which they sprang sought to build a new city on top of, and with the remains of, the old: in Hobbes' marvellous phrase, "the Papacy is not other than the Ghost of the deceased Roman Empire, sitting crowned upon the grave thereof".

The population of Rome in 1420 was tiny, surely no more than one-fiftieth of the (supposed) one million of the early Roman Empire. Water was no longer to be had from most of the aqueducts, which were long broken (causing frequent mires because of faulty or blocked drainage). The population continued to congregate, as it had during the Middle Ages, in the bend of the Tiber and nearly at river level, leaving the rest of the area within the walls to fields and isolated monasteries – and to a multitude of ancient monuments which served as convenient quarries for the new buildings. The urban developments of the 15th and following centuries were therefore essential, not only to make the city function almost as an ancient Roman city would have functioned, but also to spread the population well beyond the bend in the Tiber. Therefore fountains and water basins became necessary, and any decoration was a bonus.

Rome was much tardier than cities in Central Italy in the organization of a plentiful water supply: compare the magnificent sculptured fountains in Perugia or Siena. Wells were also necessary, and the obvious highlight is Antonio da Sangallo's Well of S. Patrizio, Orvieto, which is 62 meters in depth.

Although, after Mussolini's sanitization of whole neighborhoods around the Forum Boarium, we can no longer picture the full aspect of Renaissance Rome, the water supply problems did have one important effect on Renaissance art. Whole sections of the city, uninhabitable because waterless (the Palatine, the Capitoline, parts of the Quirinal) or marshy (the Forum), were left to the ancient monuments; therefore contemporary art could seek its models from the old, burrowing underground where need be, as with the discovery of Nero's Golden House, which provided artists such as Perugino (*c.*1445/50–1523), Pinturicchio (*c.*1454–1513), Raphael (1483–1520) and Giulio Romano (1492/9–1546) with a plethora of motifs.

The new city was built after the example, and often with the materials, of the ancient one. There are probably few Renaissance buildings which do not contain ancient blocks, whether structural or decorative, and there is good evidence of the systematic dismantling of monuments for large building projects, such as those associated with the Jubilees declared by the Church. Equally, the impressive remains of the Roman Empire – physical and intellectual, as well as organizational – provided models which the Renaissance could imitate. For physical models, the remains were not only within the walls (fora, baths, and early Christian and medieval churches), but outside them, in the campagna, and at Tivoli, with the extensive remains of the Temple of Hercules Victor and Hadrian's Villa. Rome, the very seat of the Empire, developed several antique-derived models in painting, sculpture and architecture which were to influence art in the rest of the peninsula and the world.

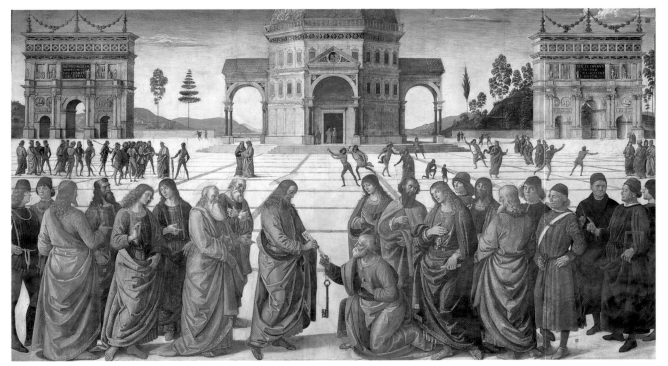

Left: *Pietro Perugino (1445/50–1523),* Giving of the Keys to St. Peter, *1481, fresco (Sistine Chapel, Vatican, Rome).*

Perugino, a native of Perugia, studied in Florence under Verrocchio. In 1481 he was contracted in Rome, along with Botticelli, Ghirlandaio and Cosimo Roselli, to produce frescoes for the walls of the Sistine Chapel. His Roman work therefore drew on the schools of Central Italy and Florence, and also of Flemish painters, whose use of landscape he admired.

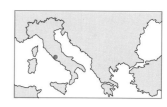

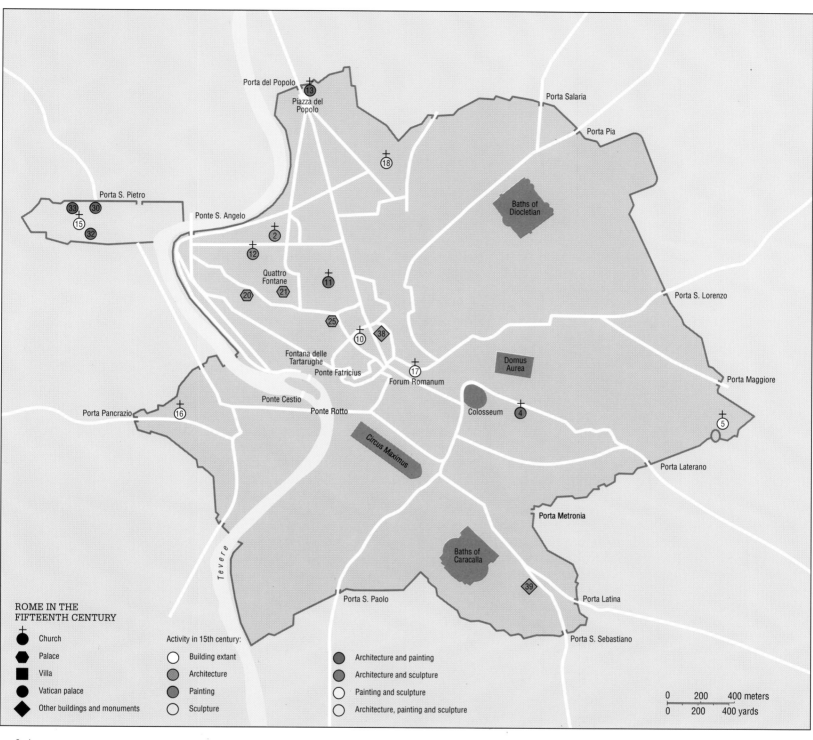

ROME IN THE
FIFTEENTH CENTURY

		Activity in 15th century:		
✚	Church	○ Building extant		◐ Architecture and painting
⬠	Palace	◑ Architecture		◐ Architecture and sculpture
■	Villa	◑ Painting		○ Painting and sculpture
●	Vatican palace	○ Sculpture		○ Architecture, painting and sculpture
◆	Other buildings and monuments			

0 200 400 meters
0 200 400 yards

Gesú
2 S. Agostino
S. Andrea in Via Flaminia
4 S. Clemente
5 S Croce in Gerusalemme
S. Eligio degli Orefici
S. Giovanni dei Fiorentini
S. Luigi dei Francesi
Sta Maria degli Angeli
10 Sta Maria d'Aracoeli
11 Sta Maria sopra Minerva
12 Sta Maria della Pace
13 Sta Maria del Popolo
Sta Maria in Valicella
15 S. Pietro
16 S. Pietro in Montorio
17 S. Pietro in Vincoli
18 Trinità dei Monti
Palazzina di Pio IV
20 Palazzo della Cancelleria
21 Palazzo Capranica
Palazzo Farnese

Palazzo Massimo alle Colonne
Palazzo Spada
25 Palazzo Venezia
Villa Farnesina
Villa Madama
Villa Medici
Villa di Papa Giulio
30 Appartamento Borgia
Belvedere
32 Cappella di Nicolò V
33 Cappella Sistina
Casina di Pio IV
Logge
Stanze
37 Campidoglio
38 Casa dei Cavalieri di Rodi
39 Casa del Card Bessarione
Collegio Romano
Obelisco di Piazza del Popolo
Obelisco di Piazza S. Pietro
Piccola Farnesina

Palazzo della Cancelleria

Left: Palazzo della Cancelleria, 1485–1513.

One of the masterpieces of the early Roman Renaissance, it was built for Cardinal Raffaele Rianio, the nepherw of Pope Sixtus IV.

167

Rome in the Cinquecento

New building got off to a slow start in the Quattrocento, not least because Rome (unlike, for example, Siena, Florence or Perugia) was a city whose population had not filled its walls for centuries, and which therefore had a large stock of housing and religious buildings (often very dilapidated). Church building and decoration, and then palaces and villas, formed a focus for artistic enrichment during the 15th and 16th centuries. Splendid palaces were erected, such as that for Cardinal Riario, now the Cancelleria (date uncertain), the Casa dei Cavalieri di Rodi (the priory of the Knights of Rhodes, restored *c.*1470), or the Palazzo Farnese (1534–46) by Antonio da Sangallo (1485–1546) and Michelangelo (1475–1564).

The complement to palaces, as life outside city walls grew safer, were villas, where Renaissance potentates with their "courtly" retinues of intellectuals, philosophers, musicians and artists, could imitate with lavish sophistication their antique models in countrified leisure – Raphael's Villa Madama (*c.*1516*ff.*), Vignola's Villa di Papa Giulio (1550–5) or the Villa Lante at Bagnaia which he completed in 1578, or the Villa Farnesina (1508–11), built by Baldassare Peruzzi for Agostino Chigi, Pope Leo X's banker, and decorated by Raphael, Giulio Romano, Sodoma (1477–1549) and others. In at least one case (Palestrina), the Villa Colonna had already been built in the 12th century directly on top of a Roman temple; and many Renaissance villas probably followed closely the layout of their ancient models, examples of which were available around the Bay of Naples. The fashion prospered so much that Frascati became a Roman "villa capital" in the 17th century.

From about 1500 until the Sack of 1527, Rome was, as the presence of Leonardo (1452–1519), Raphael and Michelangelo attests, the only place to be. She had few native artists, but the masters she imported created the High Renaissance, which was then, as a style, exported throughout the peninsula and further afield.

The Sack of Rome scattered artists (assuredly to the advantage of other peninsular and foreign centers), and also caused a drastic, albeit temporary, decline in the city's population. However, it did not blight for long the urge to improve the urban environment and to build. Pope Paul III (1534–49) commissioned from Michelangelo the rationalization of the Campidoglio, the Capitol, which he did by placing the antique statue of Marcus Aurelius centrally within a trapezoidal piazza flanked by much-imitated palaces.

From 1555, the Counter Reformation induced a new vigor into church building. Pope Sixtus V planned new and straight streets (Via Sistina, Via delle Quattro Fontane, Via Panisperna) and interesting crossroads (the Quattro Fontane themselves) for the city, with the aim of joining up the seven important pilgrimage churches. He saw to the completion of the dome of St Peter's, and also had the water of the Acqua Felice brought to the Esquiline Hill (thereby rendering it habitable once more), and displayed in a fountain by Domenico Fontana (1588). Sixtus' policy of political neutrality, continued in the following centuries, was also of incalculable value for fostering art and architecture in the city.

The Vatican had long had its own walls, and the popes, beginning in earnest with Nicholas V (1447*ff.*), sought to rival aristocrats and plutocrats by the building and decoration of a palace suitable for the supreme pontiff. Papal patronage often meant importing artists from the family homelands (*cf.* Leo X, 1513–22, and Clement VII, 1523–34, the two Medici popes), although quality was always the overriding consideration. Pope Sixtus IV (1471–84), with notably eclectic taste, employed Ghirlandaio and Botticelli from Florence and Signorelli and Perugino from Umbria to decorate the walls of the Sistine Chapel in the 1480s. Pope Julius II summoned Bramante and Michelangelo from Florence and Raphael from Urbino to create in the project for the new St Peter's – the Sistine Ceiling and the Stanze – the great founding works of the High Renaissance. The palace was enhanced by a collection of antiquities from Rome and the Papal territories, the prestige and influence of which continued well into the 19th century. Bramante provided an antique-inspired design for a great court climbing the hill to the Belvedere, and Michelangelo and Pirro Ligorio (*c.*1510–83) completed a design which, unfortunately, has been rendered incomprehensible by later constructions.

The Vatican Palace was complemented, although physically overshadowed, from 1506 by the building of the new St Peter's, to which all the greatest architects were to contribute: in this period Bramante (1444–1514), Raphael, Antonio da Sangallo, Peruzzi (1481–1536), Michelangelo and Vignola (1507–73). Here again the influence of antique architecture and of consequent Renaissance theories about central-plan buildings contributed to the original plan and the elevation, not least in Bramante's noble yet impossible idea of lifting a version of the single skin dome of the Pantheon on four great clusters of pillars. The respect for the antique that such antiquarianism implied was mitigated by the initial decision to tear down Constantine's basilica, and this and other ambitious Roman projects were fed by demolishing countless antique monuments for their cut, ready-to-use stone. If new Rome was built on top of the ruins of the old – it also helped to destroy old Rome in the process.

Above: Francesco Penni *(c.1488–c.1528) and others, based on a design by Raphael (1483–1520),* The Council of the Gods, *1518/19, fresco, Sala di Psiche, Villa Farnesina, Rome).*

The story comes from the Latin writer Apuleius. Raphael's design produced one of the grandest decorative schemes of the Italian Renaissance.

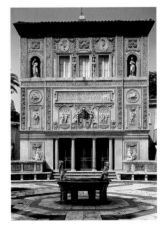

Above: Pirro Ligorio *(c.1510–83, the* Casina of Pius IV, *1559–62, the Vatican Gardens, Rome.*

Ligorio, painter, archeologist, garden designer and architect, used elaborate stucco decoration for this miniature palace for Medici Pope Pius IV.

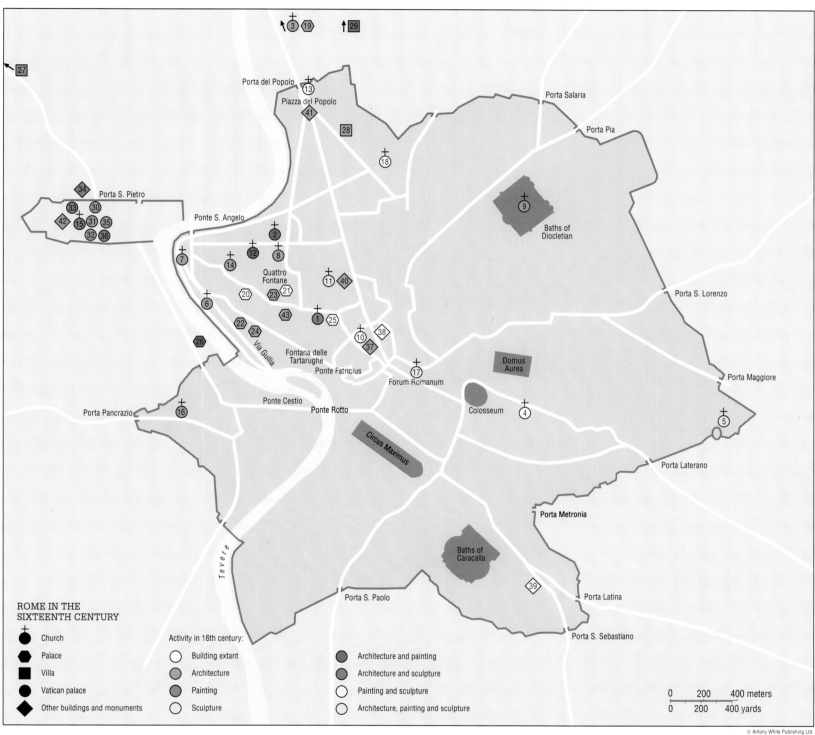

ROME IN THE SIXTEENTH CENTURY

- ✚ Church
- ⬟ Palace
- ■ Villa
- ⬤ Vatican palace
- ◆ Other buildings and monuments

Activity in 16th century:
- ◯ Building extant
- ◓ Architecture
- ◑ Painting
- ◯ Sculpture

- ◔ Architecture and painting
- ◒ Architecture and sculpture
- ◯ Painting and sculpture
- ◯ Architecture, painting and sculpture

0 — 200 — 400 meters
0 — 200 — 400 yards

© Antony White Publishing Ltd.

1 Gesú	23 Palazzo Massimo alle Colonne	
2 S. Agostino	24 Palazzo Spada	
3 S. Andrea in Via Flaminia	25 Palazzo Venezia	
4 S. Clemente	26 Villa Farnesina	
5 S Croce in Gerusalemme	27 Villa Madama	
6 S. Eligio degli Orefici	28 Villa Medici	
7 S. Giovanni dei Fiorentini	29 Villa di Papa Giulio	
8 S. Luigi dei Francesi	30 Appartamento Borgia	
9 Sta Maria degli Angeli	31 Belvedere	
10 Sta Maria d'Aracoeli	32 Cappella di Nicolò V	
11 Sta Maria sopra Minerva	33 Cappella Sistina	
12 Sta Maria della Pace	34 Casina di Pio IV	
13 Sta Maria del Popolo	35 Logge	
14 Sta Maria in Valicella	36 Stanze	
15 S. Pietro	37 Campidoglio	
16 S. Pietro in Montorio	38 Casa dei Cavalieri di Rodi	
17 S. Pietro in Vincoli	39 Casa del Card Bessarione	
18 Trinità dei Monti	40 Collegio Romano	
19 Palazzina di Pio IV	41 Obelisco di Piazza del Popolo	
20 Palazzo della Cancelleria	42 Obelisco di Piazza S. Pietro	
21 Palazzo Capranica	43 Piccola Farnesina	
22 Palazzo Farnese		

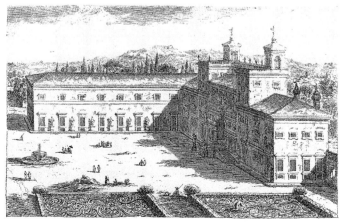

Veduta della Villa Medici sul Monte Pincio

Left: The Villa Medici on the Pinician Hil, *18th century etching by F. Piranesi of the villa which was rebuilt in 1564.*

The Commerce in Building Stone, Italy 1400–1600

No stone has enjoyed a more extensive market than the white marble of Carrara. From here came the famous Luni for the great architectural programs of the Roman Empire, whose buildings continued to be plundered throughout the early Middle Ages as sources of ready-fashioned materials. However, the commerce in stone in medieval Europe was to take some time before it reached the level of organization it had enjoyed under the Emperors, if indeed it ever did.

The dramatic drop in stone production experienced with the fall of the Roman Empire did not start to pick up again until the 11th century, when the demand was created by the great ecclesiastical building projects together with the desire for more permanent fortifications. Nevertheless the majority of stone was still quarried for local markets. The main reason for this was the debilitating cost of transportation, which might add as much as 50 per cent to the price. Those quarries that produced stone for more distant markets were invariably located near rivers or the sea.

It should be borne in mind that during these renascent days of stone production there was no real commercial structure. The ordinary quarry had little economic value for a landowner because of the restrictive labor cost involved in the industrial process of cutting the stone. Therefore he would lease or sell the quarry direct to the patron responsible for an individual project, leaving him to organize everything from the labor force to the trans-portation himself. It was not until the early 16th century that operations at Carrara took on a more commercial demeanor when the Genoese, renowned for their business acumen and shipping enterprise, instituted a form of administration and dealership at the site.

Regardless of the quality of the stone at Carrara, local quarrying activities sprang up in response to the demand for good-quality stone with no premium added for long-distance transportation. Cities with access to such stone naturally stood to benefit architecturally. An example is Florence which was particularly fortunate in this respect. No other city in Europe had a more ready supply of stone. Its quarries of *Pietra Serena* and *Pietra Forte*, some of them located within the city walls (the Boboli Gardens were laid out on the site of a former quarry), were so abundant that the entire process of production, from quarrying to delivery of finished products, was made possible.

The majority of quarries were located in the northern half of Italy, in the vicinity of precisely those cities that were to play so great a part in the development of Renaissance architecture. While the access to stone is by no means the only governing factor responsible for this development, it is one that should not be overlooked.

Brick, the other stock building material of the period, was produced in kilns in the environs of the major cities, fired along with limestone to extract the lime necessary in the manufacture of mortar.

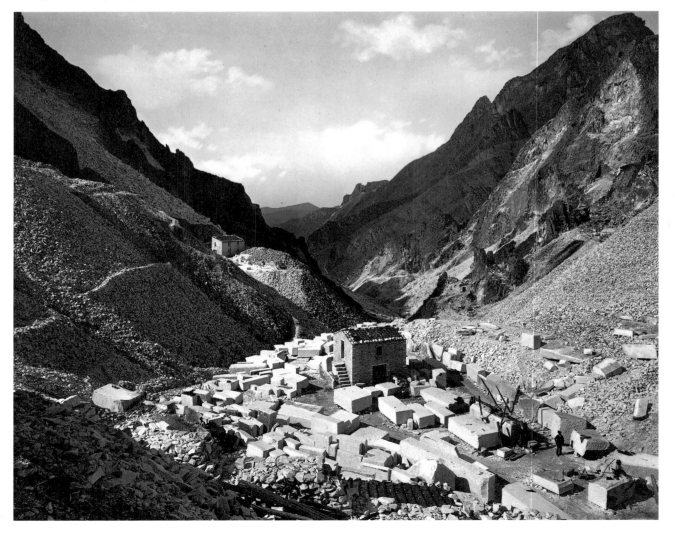

Left: *The Marble Quarries, Carrara.*

High-quality marble had been quarried at Carrara since Roman times; its position near to the Mediterranean coast just north-west of Pisa at the mouth of the river Arno, made it an essential supplier, particularly for Tuscany in the Romanesque, Gothic and Renaissance periods.
Much of the marble for the sculpture of Michelangelo came from Carrara, the artist selecting his own blocks of stone and often undertaking their preliminary working while still in the quarry.

Right: *Michelangelo Buonarroti (1475–1564):* A Prisoner, *unfinished marble sculpture (Galleria Dell'Accademia, Florence).*

ITALIAN ART: SOURCES OF STONE

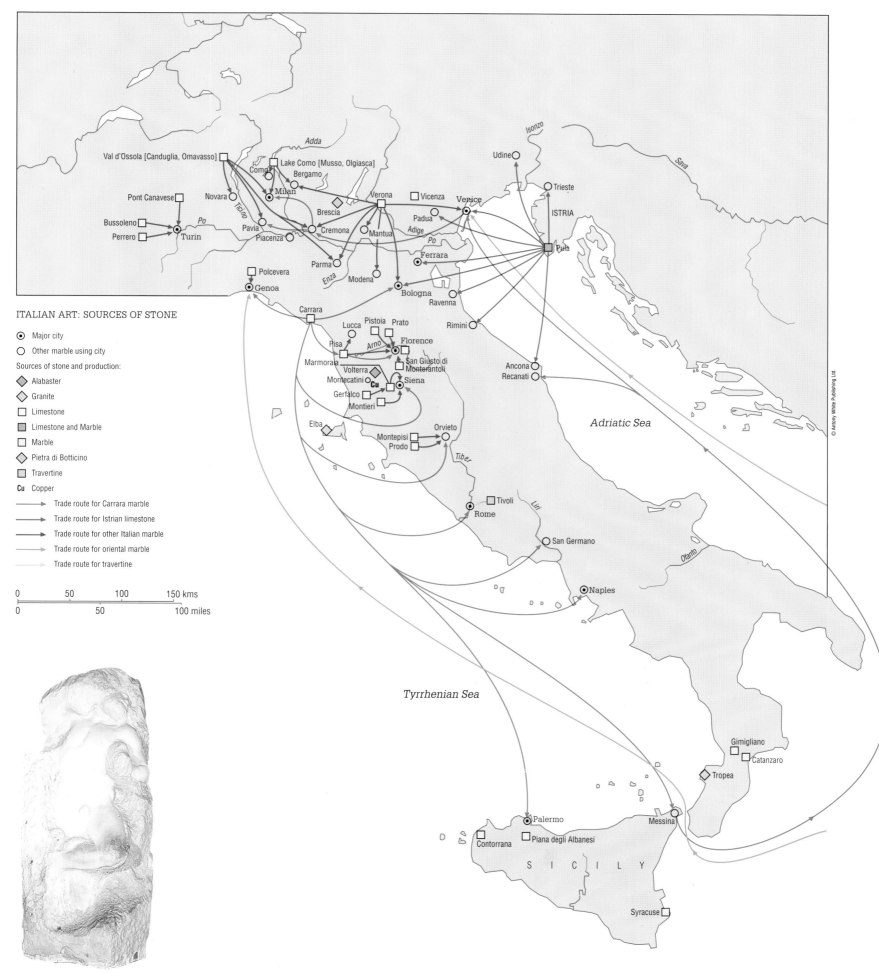

- ⊙ Major city
- ○ Other marble using city

Sources of stone and production:

- ◆ Alabaster
- ◇ Granite
- ▢ Limestone
- ▦ Limestone and Marble
- ▫ Marble
- ◈ Pietra di Botticino
- ▤ Travertine
- **Cu** Copper

→ Trade route for Carrara marble
→ Trade route for Istrian limestone
→ Trade route for other Italian marble
→ Trade route for oriental marble
→ Trade route for travertine

```
0        50        100       150 kms
0             50            100 miles
```

Adda

Val d'Ossola [Canduglia, Omavasso]
Como
Lake Como [Musso, Olgiasca]
Bergamo
Pont Canavese
Novara
Milan
Verona
Vicenza
Venice
Bussoleno
Ticino
Brescia
Po
Perrero
Turin
Pavia
Cremona
Mantua
Adige
Piacenza
Padua
Isonzo
Udine
Trieste
ISTRIA
Pula
Sava
Parma
Enza
Modena
Po
Ferrara
Polcevera
Genoa
Bologna
Ravenna
Carrara
Lucca
Pistoia
Prato
Rimini
Pisa
Arno
Florence
San Giusto di Monterantoli
Marmoraia
Volterra
Cu
Montecatini
Siena
Ancona
Recanati
Gerfalco
Montieri
Elba
Montepisi
Prodo
Orvieto
Tiber
Adriatic Sea
Tivoli
Liri
Rome
San Germano
Ofanto
Naples
Tyrrhenian Sea
Gimigliano
Catanzaro
Tropea
Palermo
Messina
Contorrana
Piana degli Albanesi
S I C I L Y
Syracuse

France, Burgundy and the Netherlands in the Fifteenth Century

Although in the early part of the 14th century the monarchy in France was strong and well organized, it was almost destroyed by the fluctuations of the Hundred Years War. Between 1402 and 1430, Henry V of England, allied to the separatist Duke of Burgundy, Philip the Bold (1342–1404), was in control of the whole of northern France after the battle of Agincourt (1415). In 1429, due to Joan of Arc, he lost Champagne and the support of the Duke of Burgundy who transferred to France and ensured the expulsion of the English. Through the economic and political reorganizations of Charles VII (1422-61), a coherent state with strong leanings to centralization and absolutism was created.

Burgundy, under the four dukes of Valois became a European power, controlling as the map shows, Picardy, Flanders, Brabant, Holland, Zeeland, Luxembourg and, under Charles the Bold (1433–77), the province of Lorraine. Hostilities with France increased at the marriage of Philip the Bold to Margaret, heiress of Flanders when Burgundy became one of the richest countries in Europe. The dukes carved out for themselves a territory roughly equivalent to the old kingdom of Lorraine which had first emerged sandwiched between France and Germany, at the break-up of Charlemagne's empire in the 9th century.

Both Philip and his son John the Fearless (1371–1419) aspired to gain control of France, but after the murder of the latter, Philip the Good (1419–67), ceded his claim to the English at the Treaty of Troyes (1420) and concentrated on his acquisitions in the Low Countries. His court was a center of chivalry and one of the most magnificent in Europe. His son, Charles the Bold (1433–77) incurred the hostility of Louis XI of France who annexed Burgundy to France by the Treaty of Arras in 1482 while the main bulk of the Burgundian domains in the Low Countries went to the Habsburgs. But during the 15th century the Dukes of Burgundy had provided the political background and wealth with which Flemish artists could flourish, and could work and study in the Low countires, Burgundy, Paris, Germany and indeed even in Italy.

The scene was now set for the Spanish Habsburg opposition to the French and the replacement of Burgundian power by Spanish rule in the Netherlands. The 16th century was also to see a further increase in the power, wealth and patronage of the French monarchy.

Below: the French King, Charles IV receives the English Envoys, *taken from Froissart's Chronicles (British Library, London).*

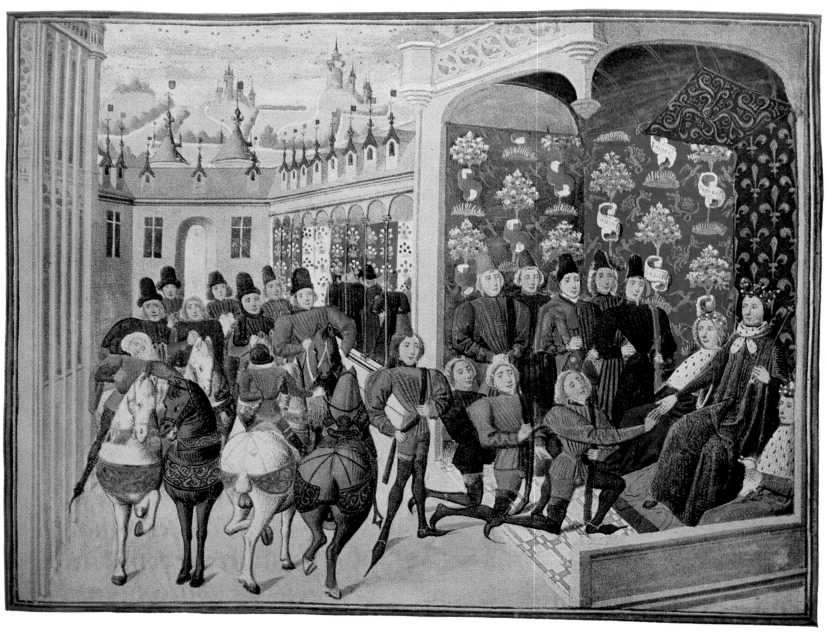

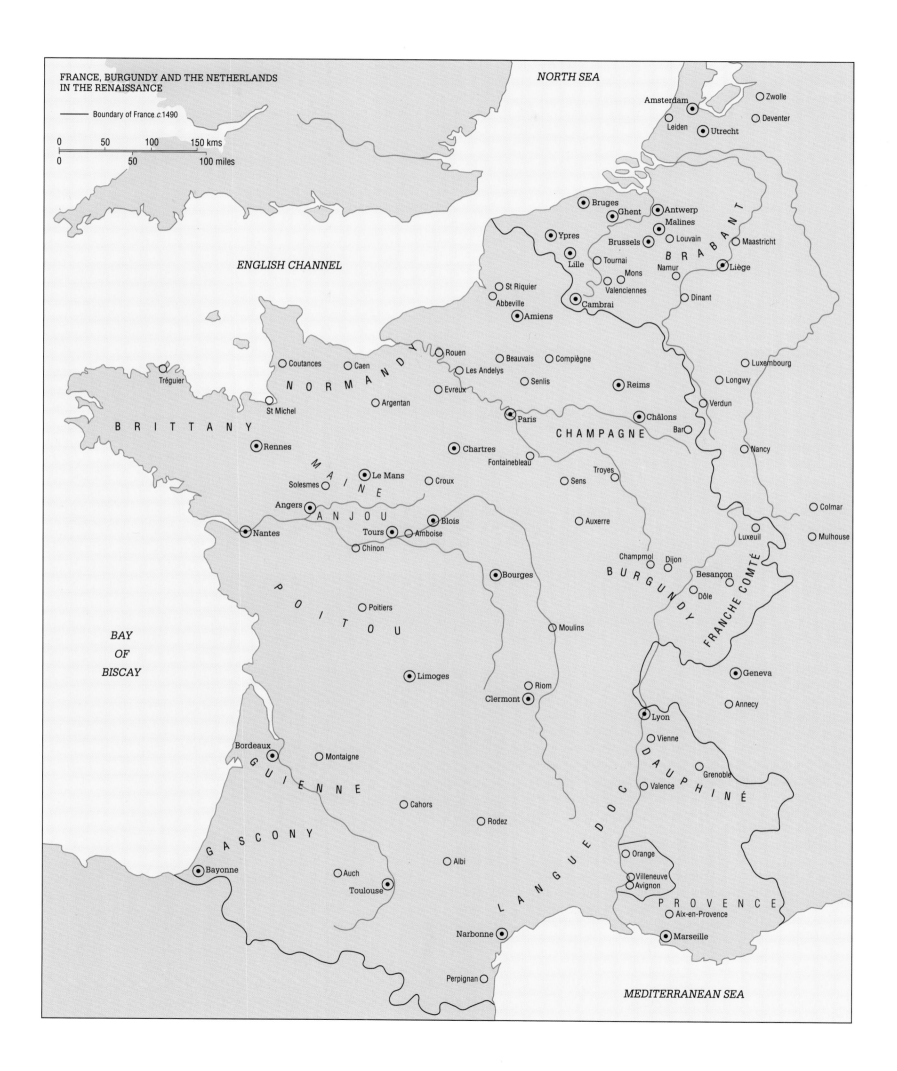

FRANCE, BURGUNDY AND THE NETHERLANDS
IN THE RENAISSANCE

Boundary of France c.1490

0 50 100 150 kms
0 50 100 miles

NORTH SEA

ENGLISH CHANNEL

BAY

OF

BISCAY

MEDITERRANEAN SEA

Zwolle
Deventer
Amsterdam
Leiden
Utrecht

Bruges
Ghent
Ypres
Antwerp
Malines
Brussels
Louvain
Lille
Tournai
Mons
Namur
Valenciennes
Cambrai
Dinant
Liège
Maastricht
BRABANT

St Riquier
Abbeville
Amiens

Luxembourg
Longwy
Verdun

Coutances
Caen
Rouen
Beauvais
Compiègne
Senlis
Les Andelys
Evreux
NORMANDY

Tréguier
St Michel
Argentan
Paris
Reims
Châlons
Bar
CHAMPAGNE
Nancy

BRITTANY
Rennes
Chartres
Fontainebleau
Troyes
Colmar

MAINE
Le Mans
Croux
Sens
Luxeuil
Mulhouse

Solesmes
Angers
ANJOU
Blois
Auxerre

Nantes
Tours
Amboise
Chinon
Champmol
Dijon
Besançon
BURGUNDY
FRANCHE COMTÉ
Dôle

Bourges

POITOU
Poitiers

Moulins

Limoges
Riom
Clermont
Geneva
Annecy

Bordeaux
Montaigne
Lyon
Vienne
DAUPHINÉ
Grenoble
Valence

GUIENNE
Cahors
Rodez

GASCONY
Albi
LANGUEDOC
Orange

Bayonne
Auch
Villeneuve
Avignon
PROVENCE
Aix-en-Provence

Toulouse
Narbonne
Marseille

Perpignan

173

Early Netherlandish Art

The scarcity of contemporary written sources combined with the destructive consequences of 16th-century iconoclasm and of numerous wars fought in the Low Countries as late as this century have taken their toll on the geography of early Netherlandish art.

Although relative obscurity surrounds artistic output in the Low Countries around 1400, it is a testimony to the ability of artists in the region that the leading painters and sculptors employed at the courts of France and Burgundy were principally Netherlandish. It was at Dijon, seat of the Dukes of Burgundy, that the Haarlem-born sculptor Claus Sluter (c.1345–1405) worked between 1385 and 1405 on the ducal monastery and mausoleum, the Chartreuse de Champmol. The powerful characterization, drama and illusion of Sluter's Champmol portal and *Well of Moses* make them seminal precursors of 15th-century Netherlandish art.

In the 14th and 15th centuries the Dukes of Burgundy gradually acquired a large number of wealthy Netherlandish provinces. About 1420 Philip the Good transferred his seat from Dijon to the Low Countries. This was doubly propitious for the course of Netherlandish art on its native soil. First, artists seeking employment at the ducal court could remain in the Netherlands, as is evidenced by Philip's patronage of Jan van Eyck (c.1389–1441), who initially worked for him in Lille before settling in Bruges in 1432, and of Rogier van der Weyden (c.1399–1464) at Brussels. Second, leading artists became more accessible to local patrons outside court circles.

The new style, which is associated primarily with paintings of van Eyck, Campin (c.1375–1444) and Rogier, owes much to the wealthy merchants and corporate bodies of the south Netherlandish towns. Patrons of this class include Joos Vijd, for whom Hubert (d.1424) and Jan van Eyck painted the Ghent altarpiece, and the Great Archers' Guild of Louvain, who commissioned Rogier's *Descent from the Cross*. Symptomatic of civic wealth and pride was the construction of extravagant town halls, whether in the flamboyant Gothic styles of the 15th century, as at Louvain and Bruges, or in the 16th-century Italianate manner seen at Antwerp. Didactic paintings of justice scenes were commissioned for town halls, notably from Rogier (since destroyed) at Brussels and Dirk Bouts (c.1415–75) at Louvain. While painted altarpieces were increasingly in demand, the carved and polychromed wooden type, such as Jan Borman's (1491–1541) altarpiece of St. George, still remained popular.

Notwithstanding the artistic importance of Ghent, Brussels and the university town of Louvain in the 15th century, Bruges, then Europe's most vital mercantile center, played a pre-eminent artistic role among the Netherlandish towns. The patronage offered by its prosperous cosmopolitan society – foreign, particularly Italian, merchants were among the keenest enthusiasts of Netherlandish painting – attracted painters from outside the city, notably Jan van Eyck, Hans Memlinc (c.1430–94) and Gerard David (d.1523) from the environs of Maastricht, Cologne and Gouda respectively. The export of paintings and tapestries (the latter manufactured chiefly in Tournai and Arras) was a feature of Bruges' commercial activity.

Around 1500 changing economic factors and political upheavals, combined with the silting-up of the Zwin, the crucial artery linking it to the sea, caused Bruges to be superseded by Antwerp. Indicative of its new status was the transfer there of Quentin Metsys (1465–1530) from his native Louvain. For the chapter of the Joiners Guild in Antwerp Cathedral, Metsys painted his St. John altarpiece in 1508–11. Unlike Bruges, Antwerp produced several native artists of distinction, notably Pieter Brueghel the Elder (c.1525–69), the most inspired and profound of 16th-century Netherlandish painters. It also became a center for the developing trade in works of art and for the specialization of artists in different genres, e.g. landscape, still life.

In the early 16th century the court, which had been peripatetic during the 15th century, became established at Malines under the regency of Margaret of Austria, but subsequently the center of government transferred to Brussels. The ruling Burgundian dynasty had become extinct with the death in 1482 of Mary of Burgundy, commemorated in a refined bronze monument in Bruges. Through Mary's husband, Maximilian of Austria, the Burgundian Netherlands passed to the Habsburgs and was ruled by a succession of regents. The last decades of the 16th century were overshadowed by religious conflict, detrimental to the arts, culminating in the split between the Protestant Dutch provinces in the north and the Catholic south, which remained in Habsburg hands.

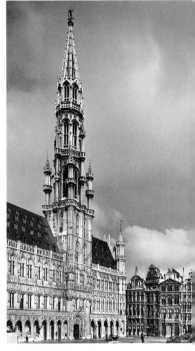

Above: *Jakob van Thienen:* Town Hall, *begun 1402: with tower (1448–63) by Jan van Ruysbroeck, Brussels.*

Throughout the Netherlands in the 15th century, civic wealth was expressed in a series of magnificent, lavish and ornate town halls.

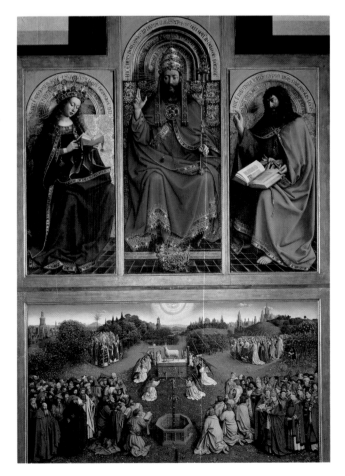

Left: *Hubert (d.1424) and Jan (c.1389–1441) van Eyck:* The Ghent Altarpiece (The Adoration of the Lamb), *completed 1432, Ghent Cathedral.*

Jan van Eyck was the most famous of the Early Netherlandish School, in whose work the art of oil painting reached a peak of technique with the use of rich colors and minute realistic detail. The Adoration of the Lamb, an apocalyptic theme, is the central inner scene of a folding panel painting from the high altar of the cathedral of St. Bavo in Ghent.

EARLY NETHERLANDISH ART 1400-1575

- ◉ Major sites
- • Other sites
- ▢ Painting
- ▢ Architecture
- ▢ Sculpture
- ▢ Glass
- ▢ Metalwork
- ▢ Tapestry

Scale:
0 100 200 300 kms
0 100 200 miles

Antwerp
1 Quentin Metsys (c.1464–1530): St. John Altarpiece 1508–11
2 Bernard van Orley (c.1491–1541): The Last Judgement 1518–25
3 Pieter Brueghel the Elder (c.1525–69): The Labours of the Months*, 1565
4 Frans Floris (1518–70): The Fall of the Angels, 1554
5 Cathedral of Our Lady, 1532–1584
6 Town Hall, 1564
7 Tomb of Isabella of Bourbon, 1476

Arras
8 Jacques Daret (d. post 1468) and others: Altarpiece of St.Vaast* ,1433-5

Beaune
9 Roger van der Weyden (c.1400–64): The Last Judgement, c.1446
10 Hotel-Dieu

Bruges
11 Jan van Eyck (act.1422–41): Altarpiece of Canon van der Paele, 1436
12 Hans Memlinc (c.1430–94): Altarpiece of the two Saints John, 1479
13 Hans Memlinc (c.1430–94): The Reliquary of St Ursula, 1489
14 Gerard David (d.1523): Triptych of the Baptism of Christ, c.1507
15 Town Hall, 1376–1433
16 Basilica of the Holy Blood, 15th century
17 Old Chancellery, 1535
18 Tomb of Mary of Burgundy, (1491–8)

Brussels
19 Rogier van der Weyden (c.1400–64): The Justice of Trajan and Herkinbald*, 1439
20 Bernard van Orley (c.1491–1541): Altarpiece of St. Thomas and St. Matthias, c.1512
21 Hieronymus Bosch (c.1450–1516): The Garden of Earthly Delights*, 1503–04
22 Bernard van Orley (c.1491–1541): Sablon Tapestries, 1518
23 Town Hall, 1402–1454

Dijon
24 Claus Sluter (act. c.1345–1405): The Well of Moses, 1395-1403
25 Claus Sluter (act. c.1380–1406): Portal of the Chartreuse de Champmol
26 Melchior Broederlam (act. 1381–1409) and Jacques de Baerze: Altarpiece of the Chartreuse de Champmol, 1397
27 Claus Sluter (act. c.1380–1406) and others: Tombs of Philip the Bold and John the Fearless, 1381–1410; c.1450

Ghent
28 Jan (c.1422–41) and Hubert van Eyck (act. 1420's): The Ghent Altarpiece, finished
29 1432
 Justus of Ghent (act. 1460–75) Triptych of the Calvary, 1466
30 Castle of the Counts of Flanders 1180 onwards
31 Town Hall, 1515–28

Haarlem
32 Geertgen tot Sint Jans (act. c.1482–93): Triptych of the Passion*, c.1480
33 Maerten van Heemskerck (1498–1574): St. Luke painting the Virgin, before 1532

Hertogenbosch
34 Cathedral of St John, 15th century

Leiden
35 Lucas van Leyden (1494–1533) The Last Judgement, 1526

Liège
36 Church of St. Jacques, 16th century
37 Bishop's Palace, 1526
38 Reliquary of Charles the Bold, 1471

Louvain
39 Roger van der Weyden (c.1400–64): The Descent from the Cross*, c.1435
40 Dirk Bouts (c.1415–75): Altarpiece of the Sacraments ,1464-8
41 Dirk Bouts (c.1415–75): The Justice of the Emperor Otto*, 1468–73
42 Quentin Metsys (c.1464–1530): Altarpiece of St. Anne*, 1509
43 Town Hall, 1448–63
44 Collegiate Church of St. Peter, begun 1425
45 Jan Borman (act. 1479–1522) Altarpiece of St. George, 1493

Malines
46 Church of St. Romuald, 15th century
47 Palace of St. Margaret of Austria, 1517

St.Omer
48 Simon Marmion (act.1449–89): Altarpiece of St. Bertin*, c.1459

Tournai
49 Robert Campin (c.1375---1444): and Jean Delemer (act. c.1428): The Virgin and the Archangel Gabriel, 1428

* work no longer in original location

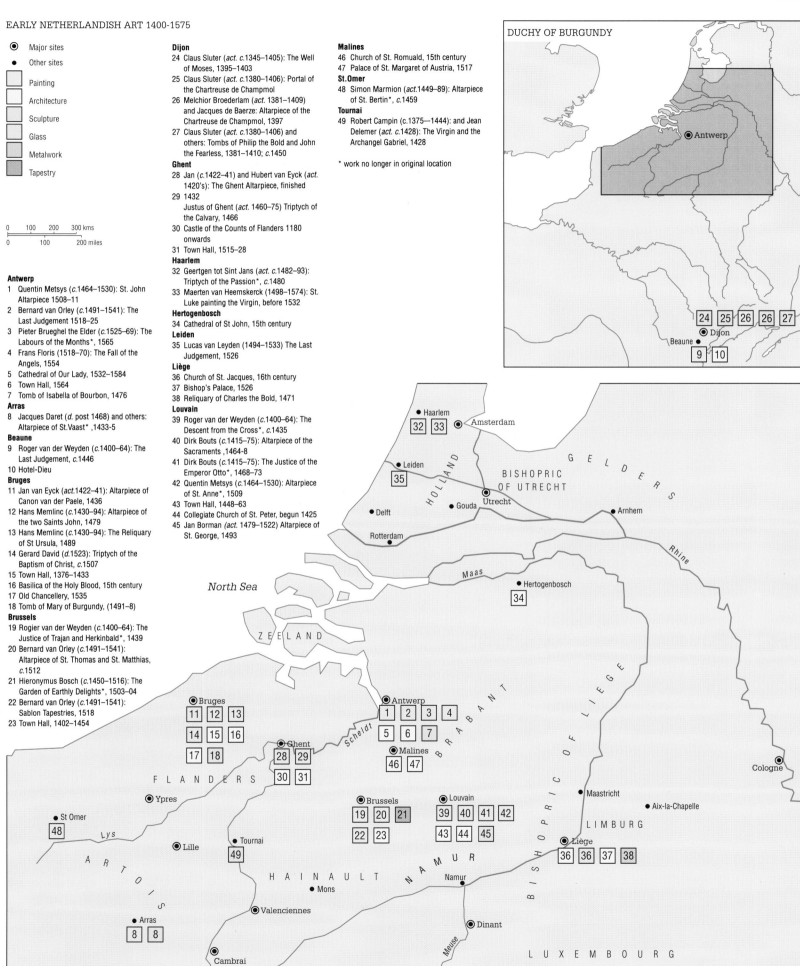

© Antony White Publishing Ltd.

French Renaissance Châteaux

In France Renaissance art reached its highest peaks in the architecture and décor of the numerous châteaux built during the 16th century. The Italian campaigns, waged by Charles VIII, Louis XII and Francis I from l494 until the catastrophe of 1525, had brought the kings and their entourages into direct contact with Italian art and artists. Upon their return to the Loire Valley, the kings attempted to graft onto their medieval castles the range of decorative motifs and symmetry of design in the façades which they had admired on the other side of the Alps.

Charles VIII transformed the château of Amboise in about l494 and Louis XII that of Blois in 1498, but it was Francis I who brought a new architecture to Blois. Between 1515 and 1524 the original Gothic structure of Blois was redesigned on a classical model imported from Italy.

The first structural changes appear between 1510 and 1530 in three Loire châteaux which were built for rich bourgeois who had connections with the Court. They are Chenonceaux (1515–22), Azay-le-Rideau (1518–24) and, above all, Bury (pre-1515, now in ruins). Here the traditional layout of a medieval castle is regularized, distributing the various parts of the building around a court. Despite the moats and towers, these residences now completely lose the appearance of a fortified castle and open onto their gardens through a series of bays. The last glorious building of this period is the huge château of Chambord built by Francis I. Conceived with the assistance of Leonardo da Vinci (1452–1519), it displays the new architectural methods of the Italian Renaissance (symmetry of design, façades adorned with pilasters), without distorting all the hackneyed features of a medieval castle, such as moats, towers, keep and spiral staircase.

After his defeat at Pavia in 1525 and subsequent return from captivity, Francis left the Loire for the Île de France. There, under the direction of French master masons, such as Pierre Chambiges (d.1544) and Gilles Le Breton (fl.1530), he soon undertook the building or modernization of many châteaux including Madrid, Saint-Germain, Fontainebleau and Villers-Cotterêts. Their art, at times unskilled, cannot of course be put on the same plain as the sumptuous decorations realized at Fontainebleau between 1530 and 1570 by Rosso (1494–1540), Primaticcio (c.1504–70) and Niccolò dell'Abbate (c.1512–71).

This Italian team was joined in 1514 by Sebastiano Serlio (1475–1554), the great architect and theoretician who was supervising the publication in France of his treatise L'Architettura. The château of Ancy-le-France, begun in 1545 to his plans, shows the architect's ability to adjust his style to local requirements. The château marks a new style in the formation of national architecture, which had been started in the reign of Henry II by Philibert Delorme (c.1515–70) and Pierre Lescot (c.1500–78).

For Henry II's mistress, Diane de Poitiers, Delorme had built the famous château of Anet (1547–52) in which he achieved a perfect synthesis of French and Italian Renaissance architectural styles. He was above all concerned with the perfection of sizes, and here he reworked the hierarchical systems of forms first roughed out at Bury. In his Architecture published in 1567, he championed the originality of French architecture and confidently created a "French" order to complement the five orders of Greek and Roman architecture. In the building of the Louvre, begun in 1546, Pierre Lescot gave great emphasis to ornament but created a type of projecting façade which would be used for generations as a model by architects.

In the second half of the century, the new architecture spread to the provinces where it underwent various interpretations adapted to regional needs. There was a veritable flowering of châteaux, only barely checked by the Wars of Religion. Jean Bullant (c.1520–78) and Jacques Androuet du Cerceau the Elder (c.1515–c.l585) dominated the epoch. Bullant, shaped by Rome and infatuated by classical architecture, grafted a monumental portico inspired by the Pantheon onto the château d'Écouen (1556–7) and created the gallery of Fère-en-Tardenois in the manner of a Roman aqueduct. Du Cerceau is best known for Les plus excellents bastiments de France (2 vols 1576–9) which contains the most beautiful engravings of French châteaux. It played a considerable role in the spread of the new architecture and provided a strong case for a truly national architecture freed from Italian influence.

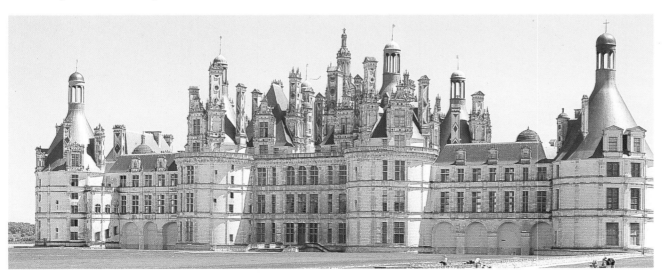

Left: Château of Chambord, *1519–47.*

Chambord, built by Francis I, is the most monumental and original of the Loire châteaux. The basically medieval ground plan was given a Renaissance feel and flamboyance by Domenico da Cortona's original model, which was possibly inspired by Leonardo da Vinci.

FRENCH RENAISSANCE CHÂTEAUX

- ☐ Royal château
- ☐ Royal château with decorated interior
- ○ Other château
- ○ Other château with decorated interior
- ○ ☐ Château now in ruins
- ✳ Château now destroyed
- —— Boundary of France in 1500

0 50 100 150 kms
0 50 100 miles

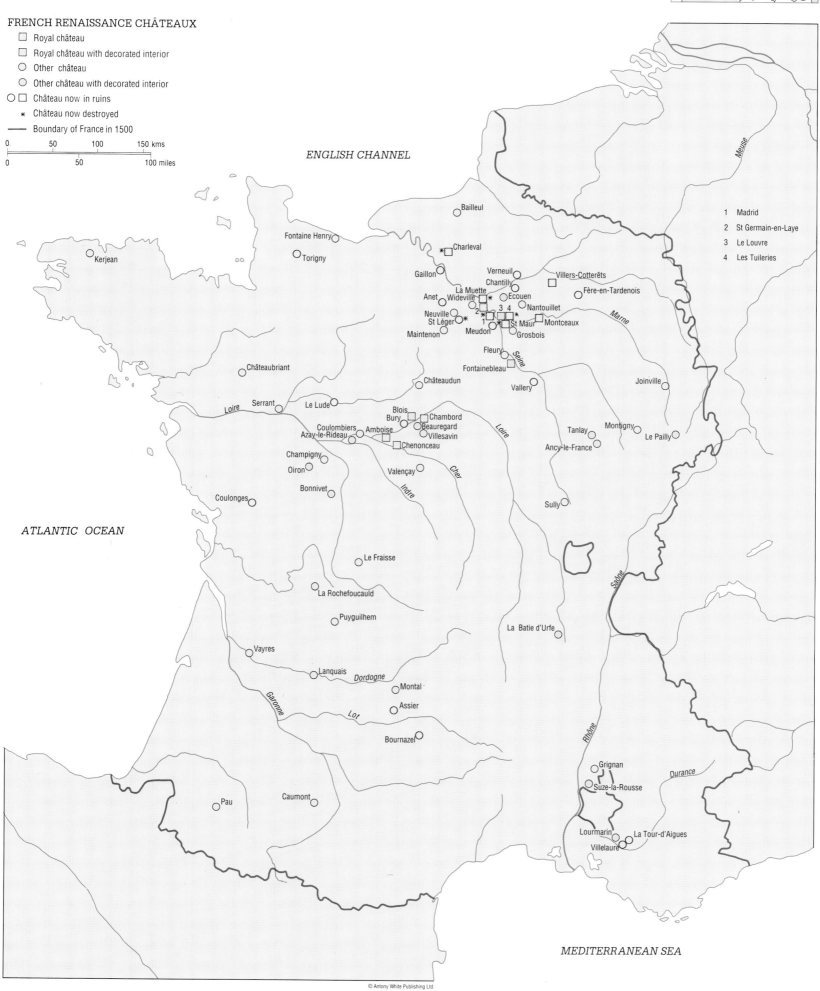

ENGLISH CHANNEL

ATLANTIC OCEAN

MEDITERRANEAN SEA

1 Madrid
2 St Germain-en-Laye
3 Le Louvre
4 Les Tuileries

Bailleul

Fontaine Henry

Kerjean

Torigny

Charleval

Gaillon

Verneuil
Chantilly
Villers-Cotterêts

La Muette
Anet Widderville
Ecouen
Fère-en-Tardenois

Neuville
St Léger
2
3 4
Nantouillet

Maintenon
1 St Maur
Montceaux

Meudon
Grosbois

Fleury

Châteaubriant

Châteaudun
Fontainebleau

Serrant
Le Lude

Loire
Vallery
Joinville

Blois
Bury
Chambord

Coulombiers
Azay-le-Rideau
Amboise
Beauregard
Villesavin

Chenonceau

Champigny
Oiron

Valençay

Tanlay
Montigny
Le Pailly

Ancy-le-France

Bonnivet

Coulonges

Cher

Indre

Sully

Le Fraisse

La Rochefoucauld

La Batie d'Urfe

Puyguilhem

Vayres

Lanquais
Dordogne

Montal

Garonne
Lot
Assier

Bournazel

Rhône
Saône

Grignan

Suze-la-Rousse

Durance

Pau
Caumont

Lourmarin
La Tour-d'Aigues

Villelaure

Meuse
Marne
Seine

Spain and Portugal: Manueline and Plateresque Style

In the late 15th and early 16th centuries, Spain and Portugal evolved distinctive national styles known respectively as Plateresque and Manueline. The terms refer primarily to architecture, but they are sometimes used – by extension – to embrace other arts of the period. "Plateresque" means literally "silversmith-like" and refers to the intricacy of the carved ornament that characterizes architecture in this style, suggesting that it is more like metalwork than stonework; in Spanish the word ("plateresco") was first used in this sense in 1539. "Manueline" refers to King Manuel I of Portugal, with whose prosperous reign (1495–1521) the style roughly coincided.

The distinguishing feature of Plateresque architecture is that extremely lavish relief ornament appears almost to have been stuck onto the surface of the building – in other words it is purely decorative and is organically unrelated to the structure underneath. Some writers on the subject divide the style into two phases – Gothic Plateresque and Renaissance Plateresque. The first flourished during the reign of Isabella of Castile (1474–1504) and is sometimes known by the alternative term "Isabelline"; the second extends up to the middle of the 16th century.

Gothic Plateresque flourished mainly in Castile, particularly in Burgos, Toledo and Valladolid. Gothic and Moorish elements were freely combined in the decoration, and heraldic motifs were also often prominent. Several of the architects or sculptors who were leading exponents of the style came from families of artists that had immigrated from Flanders, France and Germany, such as Juan Gas (d.1496), who was of French descent, and Enrique Egas (d.1534), who came from a Flemish family; they were successively master mason at Toledo Cathedral. In Burgos, three generations of the Colonia family (from Cologne, as the name suggests) worked on the cathedral. Juan de Colonia (d.1481), his son Simón de Colonia (d.c.1511) and Simón's son Francisco de Colonia (d..1542). The Renaissance Plateresque style is found throughout Spain, important centers including Cuenca, Granada, Salamanca, Seville, Toledo and Valladolid, and was less dependent on immigrant artists than the earlier phase. Diego de Siloé (c.1495–1563), a sculptor as well as an architect, was one of the leading artists of the period. He travelled in Italy as a young man and in about 1519 settled in Burgos; for the cathedral there he designed the Escalera Durado (Golden Stairway) of 1519–23 and made several fine sculptural works. The most characteristc sculptural form of the age was the huge altarpiece (often rising from floor to ceiling) in polychromed wood; superb examples of the type are in the cathedrals of Toledo (1498–1504) and Seville (1482–1525).

The sense of ostentation and lure of rich ornament that characterizes the work of the period is a recurring feature of Spanish art (seen in its most extravagant form in the Churrigueresque style of the 17th and 18th centuries). Portugal, too, grew wealthy because of its success in maritime exploration and trade, and the Manueline style is similar to the Plateresque in its abundance and vigor of decoration. In Manueline architecture, however, the decoration is not principally confined to flat surfaces, but extends to such features as columns, pinnacles, tracery and vaults. As in Plateresque architecture, Gothic, Moorish and Renaissance elements are mixed, and Indian influence has been detected in some of the more exotic examples of Manueline. the most common feature is a twisted rope motif. Little is known of the architects of the period, but Diogo Arruda (active 1508–31) stands out. He was responsible for what is generally regarded as the masterpiece of the Manueline style – the rebuilding of the Church of the Military Order of Christ at Tomar (1510–14), where the carving includes many allusions to Portugal's maritime greatness – coral and seaweed are among the motifs as well as ropes and sails. Among the important buildings in the capital, Lisbon, are two great works in the Belém quarter, on the waterfront. The Monastery of the Hieronymiles (Jerónimos) (begun 1502) and the Tower of Belém (1515–21), built to protect the entrance to the Tajus estuary. It was designed by Francisco Arruda (active 1510–47), brother of Diogo.

Painting and sculpture also flourished in Portugal during this period. Gregório Lopes (c.1490–c.1550), court painter to Manuel I and his successor John III (1521–57), was one of the leading artists of the time; his work, which shows strong influence from the Italian Renaissance, is well represented in the Museu Nacional de Arte Antiga in Lisbon. The great masterpiece of Portuguese Renaissance painting is slightly earlier, however; it is the St. Vincent polyptych (also in the Museu Nacional) by Nuño Gonçalves (active 1450–71). This is a powerfully naturalistic work, with a splendid array of weighty figures, many of them portraits of members of the court, and it compares with the finest Netherlandish painting of the time.

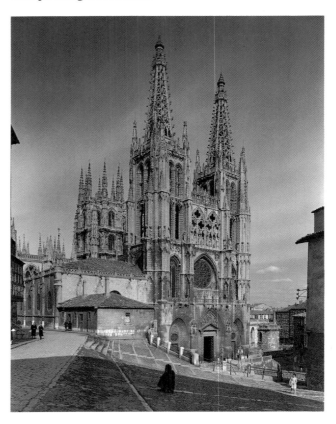

Left: Burgos Cathedral, Spain *1221–60, viewed from the north west.*

The Cathedral was was originally built in the French manner, however, the addition of the cimborio 1539–68, transformed the building.

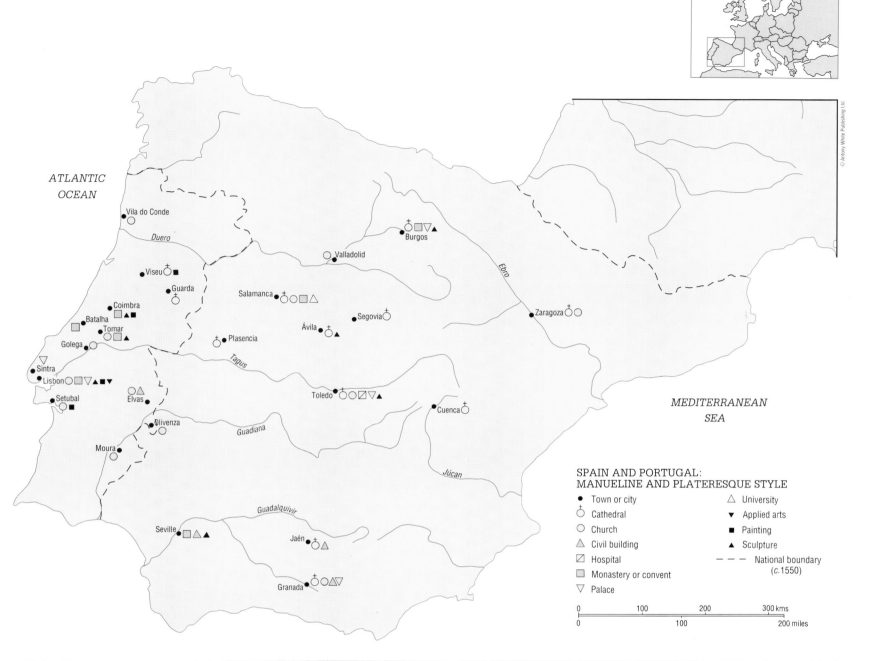

ATLANTIC
OCEAN

Vila do Conde

Duero

Viseu
Guarda

Coimbra
Batalha
Tomar
Golega

Sintra
Lisbon
Setubal
Elvas
Olivenza

Moura

Valladolid

Burgos

Salamanca

Ávila
Segovia

Plasencia

Tagus

Toledo

Cuenca

Guadiana

Zaragoza

Ebro

MEDITERRANEAN
SEA

Júcan

Guadalquivir

Seville

Jaén

Granada

SPAIN AND PORTUGAL:
MANUELINE AND PLATERESQUE STYLE

- ● Town or city
- ◌ Cathedral
- ○ Church
- △ Civil building
- ⊡ Hospital
- ▢ Monastery or convent
- ▽ Palace
- △ University
- ▼ Applied arts
- ■ Painting
- ▲ Sculpture
- – – – National boundary (c.1550)

| 0 | 100 | 200 | 300 kms |
| 0 | | 100 | 200 miles |

Right: *Diogo Boytac (fl.1490–1525 and João de Castillo (fl.1515–52):* The Cloisters of the Jeronymite church, *1502–19, Belém, Portugal.*

The Cloisters are part of the most extraordinary building of the period in Portugal. The church illustrates the international composition of Manueline architecture with medieval Plateresque and North European forms intermingling everywhere.

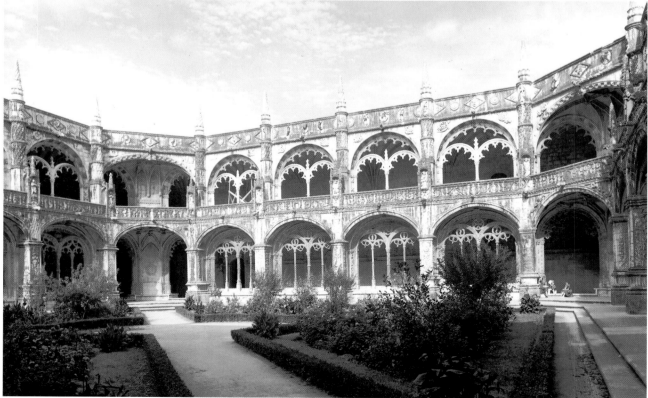

179

Salamanca in the 16th Century

Salamanca is the Plateresque city par excellence. Capital of Salamanca province in León in western Spain, it is one of the country's oldest and greatest cities, with a history stretching back to Roman times. In the first half of the 16th century it witnessed a building boom which coincided with an intellectual blossoming centered in the university. It was one of the oldest in Europe, founded in 1218, and at this time was at the peak of its prestige; in the 16th century the student population rose to more than 6000.

In religious architecture, the New Cathedral (1513–18th century) dominated the period. Various artists were involved in its planning and building including Juan Gil de Hontañón (d.1526) who was appointed Master of the Works in 1512, and his son Rodrigo, who followed him in 1538. Work continued into the 18th century, and the cathedral is an intriguing mixture of Gothic, Renaissance and Baroque elements. The Old Romanesque cathedral, thought by the inhabitants too "small, dark and squat" for their growing city was not demolished, so Salamanca has the unusual distinction of having two cathedrals adjoining one another.

Another outstanding educational building is the Colegio del Arzobispo Fonseca, founded in 1521 and also known as the Colegio de los Irlandeses because many Irish students attended. Three of the leading architects of the day were involved in its construction. Diego de Siloé (c.1495–1563), Rodrigo Gil de Hontañón (c.1500–1577) and Juan de Alava (fl.1505–37). The outstanding feature of the building, however, is the large two-storey courtyard (1529–34), the work of Diego de Siloé, who had studied in Italy early in his career.

The Plateresque façade of the university, completed in 1529, is the most famous and magnificent monument in Salamanca. The variety and richness of the carving makes it look like a great stone altarpiece. There are encrusted pilasters and friezes and figures standing out in relief, including portrayals of King Ferdinand and Queen Isabella, under whom Spain was unified, and

Pedro de Luna who, in 1411, ordered the extension to the university. The most prominent coat of arms is that of Charles V (Charles I of Spain) who ruled at the time the façade was built.

Apart from the cathedral, the most imposing work of religious architecture of the time is the church of the Dominican monastery of San Esteban which was designed by Juan de Alava and begun in 1524. Although Gothic in form, Plateresque features were introduced as it progressed, and its façade rivals that of the university in its profuse and minutely sculpted detail.

Other noteworthy religious buildings of the time include the Convento de las Ursulas or de la Anunciación (founded 1522), and the Convento de las Dueñas, founded in 1419 but built in its present form in 1533. In addition to new buildings in the style, Plateresque features were added to many older buildings, for example the church of San Julian y Santa Basilia, the church of San Martin and the church of San Martin de los Caballeros.

Salamanca is just as rich in domestic buildings, the most impressive being, the Palacio de Monterrey, begun in 1539 as the residence of Alonso de Acevedo y Zuniga, Count of Monterrey; the designers were Rodrigo Gil and Martin of Santiago. Magnificent though it is, the palace as we see it is only a fragment of that originally planned; it was intended to be about four times as big, with eight towers rather than the two that exist. The lower storeys are severe, but the top storey is richly articulated with windows and half-columns. Also well-known is the Casa de las Conchas (House of the Shells) built for Rodrigo Arias Maldonado in 1514, with ornamentation added at the beginning of the 16th century. The façade is covered with carved scallop shells (the emblem of pilgrims to Santiago de Compostela – Maldonado was a Knight of Santiago) and the windows have intricate tracery and decorative panels above and below them. Also among the carving is the coat of arms of Ferdinand and Isabella (Maldonado was a counsellor to Isabella).

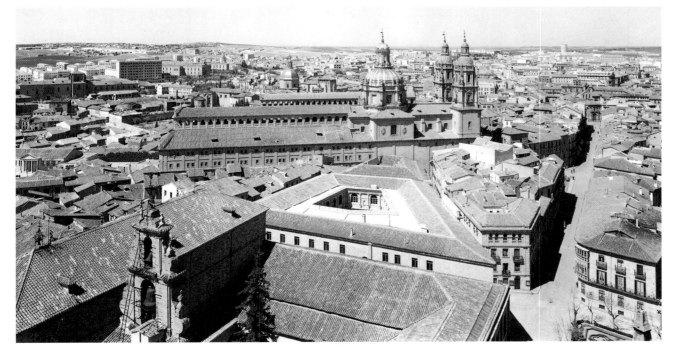

Left: *View of Salamanca from the Cathedral tower.*

Shows the university buildings. Founded before 1230 by Alfonso IX of León, the university was originally housed in the old cathedral. These buildings, dating from the 15th century comprise lecture rooms surrounding an interior courtyard.

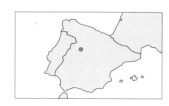

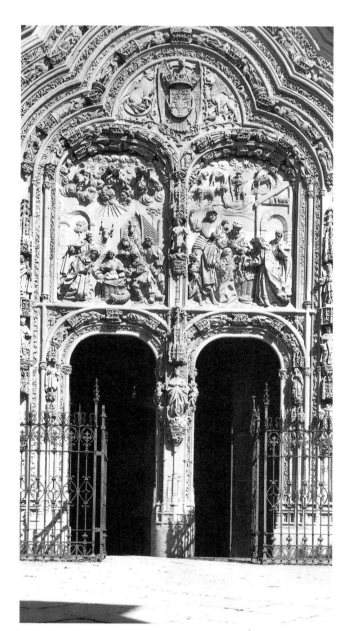

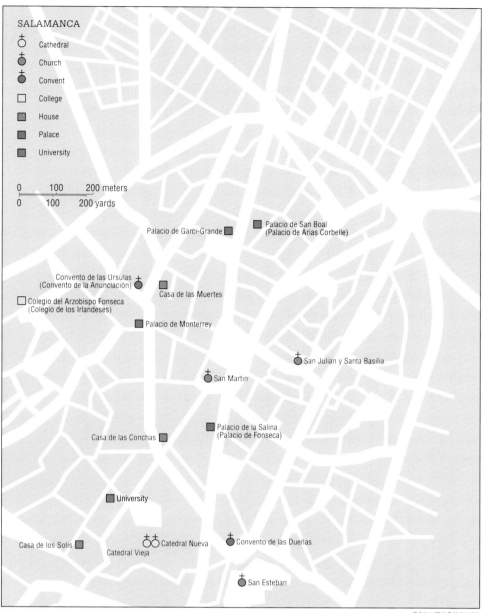

SALAMANCA

☩ Cathedral
☩ Church
☩ Convent
☐ College
■ House
■ Palace
■ University

0 100 200 meters
0 100 200 yards

Palacio de Garci-Grande ■

■ Palacio de San Boal
(Palacio de Arias Corbelle)

Convento de las Ursulas ☩
(Convento de la Anunciación) ◐ ■
 Casa de las Muertes

☐ Colegio del Arzobispo Fonseca
(Colegio de los Irlandeses)

■ Palacio de Monterrey

☩ San Julian y Santa Basilia ◐

San Martin ☩ ◐

■ Palacio de la Salina
(Palacio de Fonseca)

Casa de las Conchas ■

■ University

Casa de los Solis ■ ☩☩ ☩ Catedral Nueva ☩ Convento de las Dueñas ◐
 Catedral Vieja

☩ San Esteban ◐

© Antony White Publishing Ltd.

Above: Façade of west door, *Salamanca New Cathedral, 1513–.*

An extravagant example of late Gothic decoration with sculptured panels of the Adoration of the Shepherds and the Magi. attributed to Juan de Juni (1507–77) and Gaspar Becerra (1520–70).

Right: The New Cathedral *(Catedral Nueva), 1513–, Salamanca*

This imposing Gothic building was begun in 1513 by Juan Gil de Hontañón and completed by his son Rodrigo, assisted by Juan de Alava.

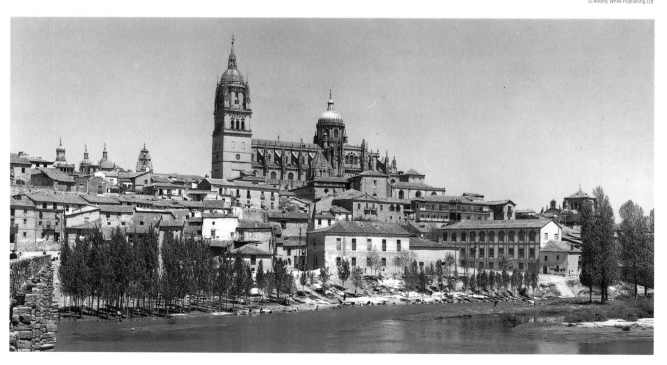

German Painting and Sculpture in the 15th Century

Painting and sculpture in the Holy Roman Empire was distinguished above all by its diversity, and whereas the Empire had little political reality, the *idea* of the Empire did. The imperial office descended from Charlemagne (742–814) who was himself seen as the direct descendant of the Roman Emperors of antiquity. It therefore held a special place in Christian polity, standing for divinely established secular authority in the same way as the popes in Rome stood for spiritual authority; indeed the office inspired a sacerdotal reverence. In German painting, notably in Dürer's (1471–1528) *Landauer Altar* (1511, Kunsthistorisches Museum, Vienna) and his *Feast of the Rose Garlands* (1506, National Gallery, Prague), the two authorities are often juxtaposed and it was this image of imperial power and the network of allegiances, authorities and responsibilities that went with it that held the Empire together. This is true as much in the visual arts as in other areas and, despite influences from France, Burgundy and the Netherlands on one side and from Italy on the other, the art of the Empire (meaning Germany and modern Austria) had, for all its diversity, its own character and dynamic. At the beginning of the 15th century this was, however, still subsumed within the European-wide style known as *International Gothic*.

By the 1440s the impulse towards a more realistic and three-dimensional art, which we find at the same period in the Netherlands, manifested itself in Cologne in the work of Stefan Lochner (*fl.*1442–*d.*1451), most notably in his *Triptych of the Three Kings* (1450), now in Cologne Cathedral. Lochner's work is still rich and courtly and grows directly out of the preceding Late Gothic style. Such smooth transitions are common in the development of German art, which does not lend itself to easy stylistic labeling.

At the same period, on the upper reaches of the Rhine near Lake Constance, a similar impulse manifested itself in a quite different way in the work of Konrad Witz (*c.*1400–1444/6). His paintings are often realistically sited – in his *Altarpiece of St Peter* (1444, Musée des Beaux Arts, Geneva) the Lake of Geneva itself is famously represented – and he developed a narrative style which, although his figures are squat and wooden, is full of human feeling. Light is treated with great visual truth, but also acts as a metaphor of the spiritual forces at work. The "distortions" of both figures and space show that his art is primarily designed to make the spectator *feel*. Such affective purpose is indeed a general characteristic of German art, and often a controlling factor in her artists' approach to representing the world. It even continues in the latter half of the 15th century, when German painting fell under the influence of the detailed, factual realism of the Flemish school of Rogier van der Weyden (1399/1400–64).

Similar things happened in German sculpture, which *c.*1400–50 was still a branch of International Gothic, with the usual emphasis on statues of beautiful Madonnas. German examples are perhaps individualized only by the broadness of their smiles, as in the works of Nikolaus Gerhaert (*fl.*1462–*d.*1473) at Strasbourg and Hans Multscher (*fl.*1427–*c.*1467) at Ulm. These artists founded a tradition of carving in both stone and wood which continued into the 16th century and produced some of the greatest masterpieces of European sculpture. Gerhaert came from Leiden but settled on the Rhine; and his career, like that of Multscher – who, although from Ulm and the founder of a school there, nonetheless did some of his most important work at Vipiteno in the South Tyrol – shows how peripatetic German masters could be. The practice of *wanderjahre*, by which young artists spent three or four years as freelance traveling apprentices before they settled down as masters, also contributed to this phenomenon which spread styles and standards across the Empire.

A particular feature of German painting and sculpture from the 1460s onwards was the winged *retable* or altarpiece: a complex of painting and carving, colored, gilded and often in an elaborate, pinnacled Late Gothic frame which opened and shut, sometimes with as many as three different displays. An altar of 1493–4 at Blaubeuren by Michael (*fl.*1469–1518) and Gregor Erhart (*c.*1465–*d.*1540), which continued the traditions of Multscher and Bernhardin Strigel (1460/1–1528), a painter from neighboring Memmingen, typifies the collaborative production: carved figures of the Virgin and saints at the core of the retable, and painted wings which, when shut (as they would normally have been except on Feast Days), showed the complete Passion sequence.

One of the most elaborate of these altars is that by Michael Pacher (*fl.*1471–*d.*1498) at St. Wolfgang in Salzkammergut (1471–81). Both painting and sculpture are from the same workshop and the shrine is a deeply carved, immensely elaborate *Coronation of the Virgin* which, when revealed by the opening of its wings, must have seemed like a segment of heaven presented to the worshipers' gaze. The same style of enriched realism is to be found also in north Germany, in a school of carvers centered on Hanseatic ports like Lübeck. This style spread across the Baltic to Scandinavia, where Bernt Notke's (*fl.*1467–*d.*1509) free-standing, equestrian *St. George* at Stockholm (1489, Storkyrka) is a leading work.

Above: *Erasmus Grasser (1450–1518):* Morris Dancer, *painted wooden sculpture, 1480 (Stadtmuseum, Munich).*

One of a group of figures originally in the Council Chamber of the Old Town Hall of Munich. This delightful figure in a performance of genial and graceful burlesque shows a very German interest in the eccentric rather than in the idealized.

Below: *Konrad Witz (c.1400–44/6):* The Miraculous Draft of Fishes, *1444, oil on wood (Musée d'Art et d'Histoire, Geneva).*

With its view over Lake Geneva this is probably one of the first landscape paintings, and is one of the remaining four panels from the St. Peter altarpiece.

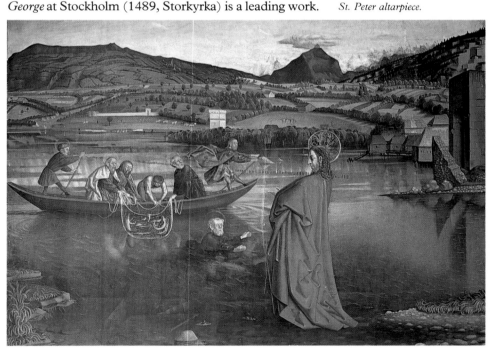

GERMAN PAINTING AND SCULPTURE : 15TH CENTURY

- ● Town or city
- ○ Painter
- ◉ Painter/engraver
- ◐ Painter/sculptor
- ◉ Painter/sculptor/woodcutter
- ◐ Painter/woodcutter
- ☐ Sculptor
- * Work no longer in situ

0 100 200 300 kms
0 100 200 miles

NORTH SEA

BALTIC SEA

Bälinge ● 29
Stockholm ● 22
Tallinn ● 22 29 *
Reval
* 29 Tuna ● 29 Sorunda
Aarhus 22 ●

29 22 ● Lübeck
Hamburg ● 4 7
10 7 Lüneburg

Leiden ● 2 ● Wessel
14 Kalkar ●
15 2 Münster ●
14 ● Brussels
2 ● Dortmund
Einbeck 26 *
Northeim 26 * Halberstadt
Göttingen 26 *
26

Cologne ●
Aachen ● 13 17 18 30 31
1

Wrocław ● 24
Breslau

Frankfurt ● 12
Trier ● 8
28 Münnerstadt ● 24 ● Hof
Maidbronn 28 35 Bamberg ●
Würzburg 28 28 10 Heiligenstadt
Creglingen 28 24 35 37 Nuremberg
Schwäbisch Hall ● 2
Tiefenbrunn ● 33 1 Cracow ☐ 35
Baden-Baden ● 8 20 5
Strasbourg ● 8 Nördlingen ● 12 Regensburg
Tübingen 21 Kaisheim 11
Blaubeuren ● 3 4 25 Weihenstephan 5 6 16
Colmar ● 32 5 Freising Kefermarkt
Issenheim 32 * 25 9 19 16
Weingarten 3 12 Munich Passau Klosterneuburg 6
Basel 36 ● 5 6 Laufen 23 27 * 8 ● Vienna
L. Constance Salzburg ● 5 23 27 *
St Wolfgang 23
27 * Innsbruck ● Heiligenblutt
L. Geneva
34 21 Vipiteno *Danube*
Geneva ● 36 Nenstift 27 *
23 Bolzano

Florence ☐ 35

1 Schwabach 37
2 Rothenburg ob der Tauber 11 28
3 Augsburg ☐ 3 12
4 Ulm ☐ 3 21 38

1 Master of the Aachen Altar (-fl.1520)
2 Derick and Jan (c.1475/80-fl.1520) Baegert
3 Michael Erhart (fl.1469-fl.1518)
4 Master Franke (fl.c.1405-24)
5 Rueland Frueauf the Elder (c.1440-1507)
6 Rueland Frueauf the Younger (c.1465/70-c.1545)
7 Hinrik Funhof (fl.1475-c.1490)
8 Nicolaus Gerhaerts (fl.1462-d.1473)
9 Erasmus Grasser (fl.1480, d.1518)
10 Master of Heilingenstadt (active 1480)
11 Friedrich Herlin (fl.1459-c.1500)
12 Hans Holbein the Elder (c.1460/5-1524)
13 Master of the Holy Kinship (fl.c.1475-post 1514)
14 Jan Joest van Kalkar (c.1455/60-1519)
15 Johann Koerbecke (c.1415-fl.1460s)
16 Martin Kriechbaum (fl.1470s)
17 Master of the Life of the Virgin (fl.1460-90)
18 Stephan Lochner (fl.1442-d.1451)
19 Mair von Landshut (c.1450-fl.1504)
20 Lucas Moser (fl.c.1441)
21 Hans Multscher (fl.1427- d.1467)
22 Bernt Notke (fl.1467- d.1509)
23 Michael Pacher (fl.1471-d.1498)
24 Hans Pleydenwurff (c.1420-72)
25 Jan Polack (fl.c.1475-d.1519)
26 Hans Raphon (fl.1490s-D.1512)
27 Marx Reichlich (c.1460-fl.1520)
28 Tilman Riemanschneider (fl.1478-d.1531)
29 Herman Rode (c.1430-1504)
30 Master of the St Ursula Legend (fl.1495,fl.1505)
31 Master of St Veronica (fl.1405-40)
32 Martin Schöngauer (c.1450-91)
33 Hans Schuclin (fl.1468-1505)
34 Master of the Sterzing Altar (fl.1427-57)
35 Veit Stoss (1438-47-1533)
36 Konrad Witz (1400/10-1444/6)
37 Michael Wolgemut (fl.1472-fl.1507)
38 Bartolomeus Zeitblom (1455/60-1518/22)

German Painting and Sculpture in the 16th Century

German Renaissance works rarely fit into categories developed for other European schools. This is true of the great sculptors of Würzburg and Nuremberg, Tilman Riemenschneider (*fl.*1478–*d.*1531) and Veit Stoss (1438/47–1533), both of whose works span the turn of the century. While using late Gothic rhythms and patterns, they did so with such openness and plasticity that a new sculptural language was created: one which utilized and activated the space around the sculpture as well as the positive forms of the sculpture itself. In moving from the decorative towards greater simplicity and clarity, Riemenschneider stopped painting his limewood carvings, exploiting instead the luminescent qualities of the polished wood to gain his effects. Conversely, the Bavarian sculptor Hans Leinberger (*c.*1480/5–*c.*1531/5) often used color, as in his altar at Moosburg, but in an illusionistic way which fused the carving pictorially with its surroundings. In both cases this new unity was essentially of the Renaissance.

In painting, the transition from an old to a new style is somewhat clearer but it must not be attributed, as used to be done, simply to Italian influence or to the Italian journeys of Dürer. Humanism was a European movement and Germany's own fiercely nationalistic character included, among other things, an appreciation of German landscape (directly influential on the Danube School) with little intervention from Italy. In the southern German cities of Augsburg and Nuremberg, Italian influence was more strongly felt but was initially assimilated to German aims. Dürer's development of the graphic media of engraving and woodcutting occurred in the intellectual context of the great northern publishing houses in Basel and Nuremberg. His treatment, even of classical subjects, always has a specifically German character, unlike anything else in Europe.

Neither were the graphic projects which Dürer and his colleagues undertook for Emperor Maximilian I (1459–1519) – which included illustrations to his autobiographical writings and independent woodcuts like the vast *Triumphal Arch* (1517–18) and *Triumphal Procession* (1518) – at all *all'antica*. Maximilian's dynastic funerary monument at Innsbruck, took a Burgundian form – the tomb with mourners placed in niches on its sides – and projected it on a grand scale in space, with the mourners as free-standing, over life-size bronze statues, processionally grouped in relation to the tomb itself.

The other great focus for the German Renaissance was the Rhine. Cologne had ceased by the 16th century to be of much artistic importance, replaced by the humanistically inclined cities, notably Basel and Strasbourg. Here the Archbishop-Elector of Mainz, Albert of Brandenburg, employed in Grünewald (*c.*1475/8–1528) the greatest painter of the Northern Renaissance. It is characteristic of the continuities in German art that his most famous work, the altarpiece from the Antonite Hospital at Isenheim (now at Colmar Museum), is still a winged retable, but as a dazzling, visual display, using all the new techniques of pictorial representation to dramatic and devotional ends, it breaks all the then existing norms for religious imagery and is, in its kind, as original as Michelangelo's Sistine ceiling.

On the other side of the Rhine, in Freiburg, Hans Baldung Grien (*c.*1480–1545) painted the *Coronation of the Virgin* (1523/6) while the Master HL (*fl.*1480) was producing carved and painted sculpture. Baldung, whose individuality is striking to the point of eccentricity, also painted small cabinet pictures, usually of female nudes accompanied by Death or scenes of witchcraft. These were a new kind of painting for a new kind of clientele: small scale, to a degree learned, and personal.

Conrat Meit (*fl.*1496–*d.*1550/1) contemporaneously developed small-scale bronze sculptures on the Italian model. These objects, for the cabinet or study, cannot be mapped because, as patronage moved away from the cities to the princely courts, German sculptors followed. This move, the main feature of the last phase of the German Renaissance, was caused by the Reformation.

At a much earlier date (1504–5), Lucas Cranach the Elder (1472–1553) had moved to become, in effect, court painter to the Dukes of Saxony and his style had modified in response to court taste. This movement became more general; many artists, including Burgkmair (*fl.*1488–1531) and Breu (1475/6–1537) from Augsburg and Altdorfer (*c.*1480–1538) from the Danube region, worked for William IV of Bavaria, who undoubtedly saw himself as a new Maecenas.

Of this last phase of the German Renaissance, the greatest master is Hans Holbein the Younger (1497/8–1543) who, after a very successful career as a civic artist in Basel, where he was in close contact with humanist and publishing circles, ultimately settled in England for economic reasons. In contact first with a circle of Hanseatic merchants and then with the court of Henry VIII (1491–1547), he produced some of the major masterpieces of Renaissance portraiture, before political and religious circumstances brought the German Renaissance to an end.

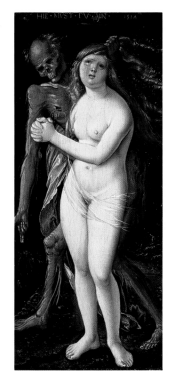

Above: *Hans Baldung Grien (c.1480–1545):* Death and the Maiden, *Tempera paint on wood, 1517 (Kunstmuseum, Basel).*

Grien, from Frieburg, trained with Dürer as both painter and graphic artist. His masterpiece was the High Altar for Freiburg Cathedral, but he also created a new type of painting for a new type of client, learned, but mildly erotic, featuring nudes, death and witchcraft.

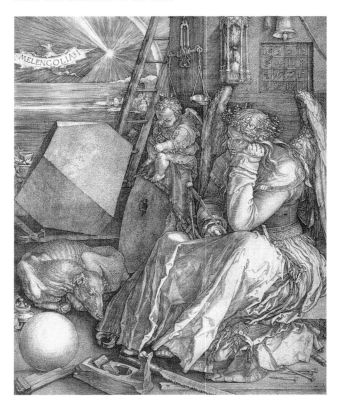

Left: *Albrecht Dürer (1471–1528):* Melancholia, *woodcut, 1514 (Guildhall Library, London).*

Of all northern artists of the late 15th and 16th centuries Dürer's interests most neatly encompassed all aspects of Renaissance scholarship and vision: the search for ideal beauty, perspective, proportion, classical and contemporary learning were all studied by him in both Germany and Italy. But his woodcuts – such as Melancholia, *with its amazing technical virtuosity (far surpassing that of Mantegna, whose engravings he studied), and its wealth of symbol and image in a deeply emotional cause – were the most purely German of all the achievements of Renaissance art.*

GERMAN PAINTING AND SCULPTURE :16TH CENTURY

- ● Town or city
- ○ Painter
- ◉ Painter/engraver
- ◉ Painter/woodcutter
- ◉ Painter/engraver/woodcutter
- ◉ Painter/woodcutter/stained glassmaker
- ☐ Sculptor
- ▨ Sculptor/engraver/woodcutter
- * Work no longer in situ

0 100 200 300 kms
0 100 200 miles

NORTH SEA

BALTIC SEA

1 Nordlingen (36)
2 Kaisheim [12] *
3 Bieselbach [27]
4 Augsburg (1) (7) 9 [12] [18]
5 Wettenhausen (35) *
6 Ulm [16] [27] * (35)
7 Blaubeuren (39)
8 Memmingen [30] * (39) *
9 Mindelheim (39) *
10 Freiburg (3) (21) (25) [43]
11 Breisach [19]

1 Christoph Amberger (c.1505-1562)
2 Hans Backoffen (1470s-1519)
3 Hans Baldung Grien (1484/5-1545)
4 Bartel Beham (1502-1540)
5 Hans Brüggemann (c.1485/90-fl.1523)
6 Bartel Bruyn (1493-1555)
7 Hans Burgkmair (fl.1488-1531)
8 Lucas Cranach (1472-1553)
9 Hans Daucher (1486-1538)
10 Benedikt Dreyer (c.1485-fl.1555)
11 Albrecht Dürer (1471-1528)
12 Gregor Erhart (c.1465-1540)
13 Peter Flötner (1490s-1546)
14 Hans Fries (c.1460-1523)
15 Mathis Gothardt Neithardt, called Grünewald (c.1475/8 -1528)
16 Niclas Hagnower (c.1445-fl.1501)
17 Henning von der Heide (fl.1487-c.1536)
18 Loy Hering (c.1484-c.1555)
19 Master HL (c.1480-c.1532)
20 Ambrosius Holbein (c.1494-c.1519)
21 Hans Holbein the Younger (1497/8-1543)
22 Adam Kraft (c.1460-1508/9)
23 Hans von Kulmbach (c.1475/80-1522)
24 Hans Leinberger (c.1480/5-c.1531/5)
25 Hans Leu (c.1490-1531)
26 Nikolaus Manuel Deutsch (1484-1530)
27 Daniel Mauch (1477-1540)
28 Conrat Meit von Worms (fl. 1496-d.1550/1)
29 Master of Messkirch (c.1500-fl.1538)
30 Master of Ottobeuron (fl.c.1515-1530)
31 Georg Pencz (c.1500-1550)
32 Jörg Ratgeb (c.1480-1526)
33 Master of St Bartholomew (fl.1475-fl.c.1520)
34 Master of St Severin (fl.c.1495-1510)
35 Martin Schaffner (1478-1546/9)
36 Hans Schäufelein (c.1480/5-1537/40)
37 Gilig Sesselschreiber (c.1460/5-fl.1516)
38 Hans Seyfer (fl.1491-d.1509)
39 Bernhard Strigel (1460/1-1528)
40 Wolf Traut (c.1480-1520)
41 Peter Vischer the Elder (c.1460-1529)
42 Hans Witten (fl.1490s-pre.1525)
43 Hans Wydyz (fl.1497-fl.c.1514/15)

© Antony White Publishing Ltd.

185

The Danube School

The Danube School describes collectively a number of artists who worked in or near the reaches of the Danube between Regensburg and Vienna in the period *c*.1500 to *c*.1530. The region was located between the major commercial and artistic centers of Nuremberg and Augsburg to the west and Vienna, an imperial capital, to the east. On the river were Regensburg, a free imperial city of great importance since the Middle Ages; the Castle of Neuburg am Inn, the seat of the counts of Salem which was renovated in the Renaissance style (1521–31) by Graf Niklas II; and Passau, an important bishopric, wonderfully sited at the confluence of the Danube and the Inn. In addition there was a wealth of rich and splendid monastic houses which provided the impetus for much of the art of the Danube School, most notably Melk, Zwettl, Aggsbach, Kremsmunster, Guttenstettin, St. Florian and Oberaltaich.

The river itself was a natural artery for travelers, including artists, many of them on their "Wanderjahre", the period of prolonged travel usually undertaken by young German artists as part of their training. Such an artist may have been Jörg Breu (*c*.1475–1537), who came from Augsburg but in the period 1500–2 painted a sequence of expressive, highly-charged altarpieces for monasteries in Lower Austria, notably Melk, Aggsbach and Zwettl. He and Rueland Frueauf the Younger (*c*.1470–*c*.1545), who came from Passau and worked in the monastery at Klosterneuberg, are usually considered the precursors of the School.

The work of its main masters – Lucas Cranach the Elder (1472–1553), who arrived on the Danube from Franconia *c*.1500 and stayed only until 1505, and Albrecht Altdorfer (*c*.1480–1538), a native Danubian from Regensburg – shows them to have been overwhelmed by the wild beauty of the Danube landscape: its rocks, water, fir trees, misty atmosphere and spectacular effects of light and weather, which form the settings for many of their paintings at this period. Its third master was Wolf Huber (*c*.1485–1553), a native of Feldkirch in the Vorarlberg who settled in Passau. He was inspired by the landscape of the Wachau, a picturesque defile of the Danube between Melk and Krems, and the Mondsee. He shared with the others the lyrical, almost pantheistic, approach to nature which defined the school.

Another important factor was German humanism, which gave a Teutonic slant to the revival of classical studies. Vienna University (where Conrad Celtis was a leading figure) was a center for such studies, and among Cranach's early works are portraits, set in landscapes, of two of its leading academics and their wives. It is tempting to suppose that some of the small cabinet pictures which are an innovative feature of the school, e.g. those of Altdorfer, which include the first pure landscapes in European art, were intended for such patrons. The artists' drawings after nature (e.g. Huber's Mondsee scenes or Altdorfer's view of Sarmingstein on the Danube) seem also to have been collectable items.

The chief works of the school were, however, religious paintings which reinterpreted traditional subjects – the Life of the Virgin in Huber's *St. Anne Altar* (for Feldkirch: now Feldkirch and Bregenz) or the Passion in Altdorfer's *St. Florian Altar* – with a realism so forceful and uncompromising that it is easy to think of it, quite wrongly, as caricature. Each of the figures was individually motivated, playing a clear psychological role in the drama as a whole. Settings, whether architectural or landscape, were wholly contemporary and by means of asymmetrical composition and variegated, often vertiginous, perspectives became expressive in themselves. A lyrical freedom in the handling of line and color deriving from late Gothic art gave a decorative dimension, often touched with fantasy, to Danube School painting and the term *realisme fantastique* is sometimes used to describe it.

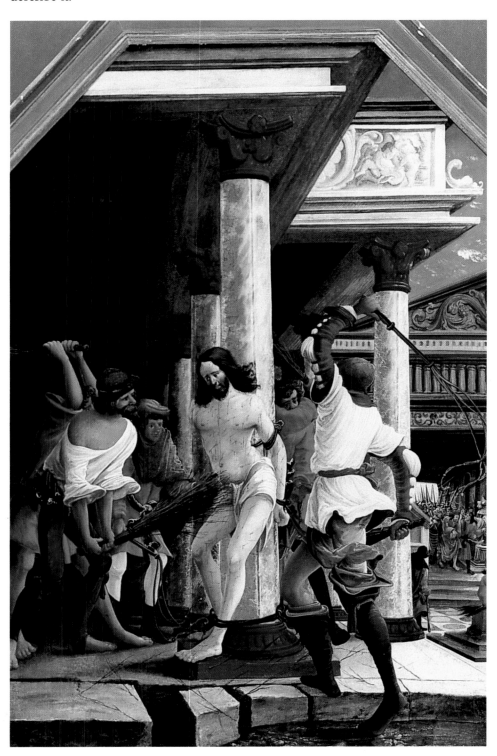

Below: *Albrecht Altdorfer (c.1480–1538):* The Flagellation of Christ, *from the* St. Florian Altar, *1518 (Abbey Museum, St. Florian).*

The great Augustinian abbey of St. Florian provided the wealthy and culturally sophisticated milieu for the creation of Altdorfer's high altar, his masterpiece. Now dismantled, most parts are at either St. Florian or Vienna.

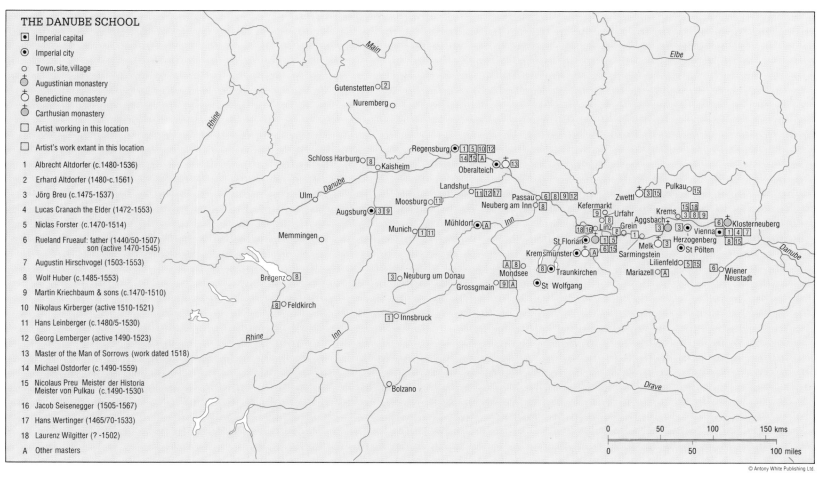

THE DANUBE SCHOOL

- ◉ Imperial capital
- ⊙ Imperial city
- ○ Town, site, village
- ⊕ Augustinian monastery
- ✢ Benedictine monastery
- ✢ Carthusian monastery
- ☐ Artist working in this location
- ☐ Artist's work extant in this location

1. Albrecht Altdorfer (c.1480-1536)
2. Erhard Altdorfer (1480-c.1561)
3. Jörg Breu (c.1475-1537)
4. Lucas Cranach the Elder (1472-1553)
5. Niclas Forster (c.1470-1514)
6. Rueland Frueauf: father (1440/50-1507) son (active 1470-1545)
7. Augustin Hirschvogel (1503-1553)
8. Wolf Huber (c.1485-1553)
9. Martin Kriechbaum & sons (c.1470-1510)
10. Nikolaus Kirberger (active 1510-1521)
11. Hans Leinberger (c.1480/5-1530)
12. Georg Lemberger (active 1490-1523)
13. Master of the Man of Sorrows (work dated 1518)
14. Michael Ostdorfer (c.1490-1559)
15. Nicolaus Preu Meister der Historia Meister von Pulkau (c.1490-1530)
16. Jacob Seisenegger (1505-1567)
17. Hans Wertinger (1465/70-1533)
18. Laurenz Wilgitter (? -1502)
A. Other masters

0 50 100 150 kms
0 50 100 miles

© Antony White Publishing Ltd.

Right: *Albrecht Altdorfer (c.1480–1538):* The Danube near Regensburg, c.1510, *(Private Collection).*

Altdorfer became a citizen of Regensburg in 1505, and later the Surveyor of the city's buildings. The steeply wooded stretch of the Danube below the city, with the castle of Worth, appears in several Altdorfer paintings.

Far right: *Wolf Huber (c.1485–1553):* Landscape near Feldkirch, *drawing, 1527 (Staatliche Graphische Sammlungen, Munich).*

Huber was a native of Feldkirch, the subject of this drawing and the setting for his St. Anne Altar *(1521).*

European Ceramics

The words "ceramics" and "pottery" are generally interchangeable, "ceramics" deriving from the Greek word for potter's clay. Pottery is one of the oldest and most widely practised of crafts, but in Europe, however, little of esthetic importance survives between the Fall of the Roman Empire and the Renaissance, and the great age of European ceramics does not begin until the early 18th century, when the secret of porcelain manufacture – previously known only in the Orient – was discovered in the West.

Porcelain is one of the three main classes into which pottery is divided, the other two being earthenware and stoneware. Earthenware is pottery that has been fired at a fairly low temperature, so that the clay has not vitrified (turned glassy). Stoneware is more complex, with fusible (easily melted) stone added to the clay, producing a harder, less porous substance. Porcelain is the finest and most luxurious type of ceramic material. It is made from kaolin (a fire clay that melts only at very high temperature) and a kind of rock known as petuntse or china-stone, ground to a powder.

The revival of pottery in Europe took place mainly in Italy, where a type known as maiolica (from its reputed origin on Majorca) was extemely popular in the 14th, 15th and 16th centuries. Maiolica was often extremely richly decorated in bright colors, frequently with scenes copied or adapted from paintings or engravings. There were factories in several Italian cities, including Cafaggiolo, Deruta, Faenza, Florence, Gubbio, Urbino and Venice. In the Low Countries, Delft replaced Antwerp as the most important pottery center during the 17th century, and the term "delftware" is used to describe Dutch maiolica decorated in blue and white.

The first true porcelain to be manufactured in Europe was made in about 1708 at Meissen in Germany, where a factory was set up in 1710. Meissen was not only the first European manufacturer, but also – by common consent – the best, setting the standard of taste and technical accomplishment for the next half century (its products were emulated even in China). The Meissen factory made a much wider range of products than was traditional in China and was as renowned for its figurines as for its tableware; other articles manufactured there included cane-handles, chamber-pots, ink-stands and snuff-boxes. Johann Joachim Kändler (1706–75) was chief modeler at the factory from 1733 until his death, and his work – vivacious, delicate and charming – epitomizes the Rococo style.

By the middle of the 18th century porcelain was being made throughout Europe. Next in fame to Meissen is probably the Sèvres factory in France which has always been in the forefront of fashion. It was established at Vincennes in 1738, moved to Sèvres in 1756, was taken over by Louis XV in 1759, became state property in 1793 and moved to Saint-Cloud in 1876. Another name that is practically synonymous with porcelain is Capodimonte. The factory was founded in Naples in 1743 by the king of Naples, who in 1759 became King Charles III of Spain and transferred the factory (including the craftsmen and equipment) to Madrid, where it became the Buen Retiro factory. Other famous factories include the St. Petersburg Imperial Porcelain Factory (founded in 1744 and taken over by the state after the 1917 revolution), which originally made only luxury products for the court, the Royal Danish Porcelain Factory in Copenhagen (founded 1774), whose products included reproductions of figures by the celebrated Danish sculptor Bertel Thorvaldsen, and those at Vienna (founded 1719), the first after Meissen to make true porcelain in Europe, and Limoges (founded 1736), now France's main center of porcelain production.

In England the first porcelain factories were founded in the mid-1740s at Bow and Chelsea, both in London. They were taken over by the Derby factory in 1775 and 1769 respectively. The heart of the British pottery industry is in Staffordshire, where in 1759 Josiah Wedgwood (1730–95) founded the famous factory that bears his name at Burslem, now part of Stoke-on-Trent. The sculptor John Flaxman was among the designers who created the distinctive Neoclassical Wedgwood style.

Above: Bust of a girl *from a model (c.1761) by Franz Anton Bustelli (1723–63). Marked with impressed heraldic shield of Bavaria. Nymphenburg porcelain (Victoria and Albert Museum, London).*

The factory at Nymphenburg from the mid-18th century produced exceptionally fine white hard-paste porcelain. Bustelli was their chief modeler from 1754–63.

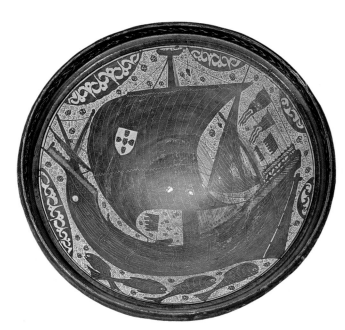

Far left: Manises bowl *painted with a ship, early 15th century. (Victoria and Albert Museum, London).*

An example of luster ware from Valencia. Hispano-Moresque pottery was made in Muslim Spain from the 8th century to the Reconquista. Luster ware, an iridescent metallic surface, was a speciality of Manises, a suburb of Valencia.

Left: Maiolica roundel, *painted by Giorgio Andreoli, 1525, Gubbio (Victoria and Albert Museum, London).*

Maiolica tin-glazed earthenware, technically close to Hispano-Moresque ware, was produced in Italy from the 14th century, and frequently decorated, as here, with adaptations of famous paintings.

EUROPEAN CERAMICS

- ● Town or city
- ◉ Creamware
- ◐ Earthenware
- ◯ Porcelain
- ◑ Stoneware
- ○ Tin-glazed earthenware

North Sea

Mediterranean Sea

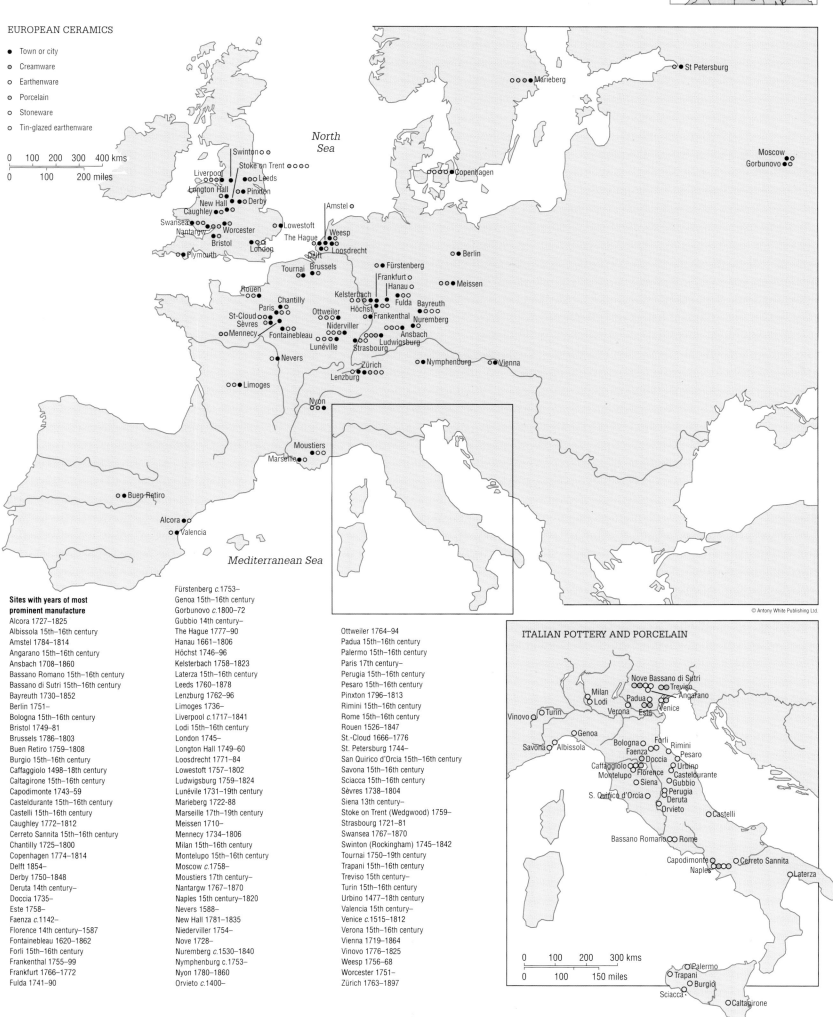

Marieberg
St Petersburg
Copenhagen
Moscow
Gorbunovo
Swinton
Stoke on Trent
Leeds
Liverpool
Longton Hall
Pinxton
New Hall
Derby
Caughley
Swansea
Nantgarw
Worcester
Lowestoft
Amstel
Weesp
Bristol
The Hague
Loosdrecht
London
Delft
Berlin
Plymouth
Tournai
Brussels
Fürstenberg
Rouen
Frankfurt
Hanau
Meissen
Chantilly
Kelsterbach
Paris
Höchst
Fulda
Bayreuth
St-Cloud
Ottweiler
Frankenthal
Nuremberg
Sèvres
Niderviller
Mennecy
Fontainebleau
Ansbach
Lunéville
Ludwigsburg
Nevers
Strasbourg
Nymphenburg
Vienna
Zürich
Lenzburg
Limoges
Nyon
Moustiers
Marseille
Buen Retiro
Alcora
Valencia

© Antony White Publishing Ltd.

Sites with years of most prominent manufacture

Alcora 1727–1825
Albissola 15th–16th century
Amstel 1784–1814
Angarano 15th–16th century
Ansbach 1708–1860
Bassano Romano 15th–16th century
Bassano di Sutri 15th–16th century
Bayreuth 1730–1852
Berlin 1751–
Bologna 15th–16th century
Bristol 1749–81
Brussels 1786–1803
Buen Retiro 1759–1808
Burgio 15th–16th century
Caffaggiolo 1498–18th century
Caltagirone 15th–16th century
Capodimonte 1743–59
Casteldurante 15th–16th century
Castelli 15th–16th century
Caughley 1772–1812
Cerreto Sannita 15th–16th century
Chantilly 1725–1800
Copenhagen 1774–1814
Delft 1854–
Derby 1750–1848
Deruta 14th century–
Doccia 1735–
Este 1758–
Faenza c.1142–
Florence 14th century–1587
Fontainebleau 1620–1862
Forli 15th–16th century
Frankenthal 1755–99
Frankfurt 1766–1772
Fulda 1741–90

Fürstenberg c.1753–
Genoa 15th–16th century
Gorbunovo c.1800–72
Gubbio 14th century–
The Hague 1777–90
Hanau 1661–1806
Höchst 1746–96
Kelsterbach 1758–1823
Laterza 15th–16th century
Leeds 1760–1878
Lenzburg 1762–96
Limoges 1736–
Liverpool c.1717–1841
Lodi 15th–16th century
London 1745–
Longton Hall 1749–60
Loosdrecht 1771–84
Lowestoft 1757–1802
Ludwigsburg 1759–1824
Lunévile 1731–19th century
Marieberg 1722–88
Marseille 17th–19th century
Meissen 1710–
Mennecy 1734–1806
Milan 15th–16th century
Montelupo 15th–16th century
Moscow c.1758–
Moustiers 17th century–
Nantargw 1767–1870
Naples 15th century–1820
Nevers 1588–
New Hall 1781–1835
Niderviller 1754–
Nove 1728–
Nuremberg c.1530–1840
Nymphenburg c.1753–
Nyon 1780–1860
Orvieto c.1400–

Ottweiler 1764–94
Padua 15th–16th century
Palermo 15th–16th century
Paris 17th century–
Perugia 15th–16th century
Pesaro 15th–16th century
Pinxton 1796–1813
Rimini 15th–16th century
Rome 15th–16th century
Rouen 1526–1847
St.-Cloud 1666–1776
St. Petersburg 1744–
San Quirico d'Orcia 15th–16th century
Savona 15th–16th century
Sciacca 15th–16th century
Sèvres 1738–1804
Siena 13th century–
Stoke on Trent (Wedgwood) 1759–
Strasbourg 1721–81
Swansea 1767–1870
Swinton (Rockingham) 1745–1842
Tournai 1750–19th century
Trapani 15th–16th century
Treviso 15th century–
Turin 15th–16th century
Urbino 1477–18th century
Valencia 15th century–
Venice c.1515–1812
Verona 15th–16th century
Vienna 1719–1864
Vinovo 1776–1825
Weesp 1756–68
Worcester 1751–
Zürich 1763–1897

ITALIAN POTTERY AND PORCELAIN

Nove Bassano di Sutri
Treviso
Angarano
Milan
Padua
Lodi
Venice
Verona
Este
Vinovo
Turin
Genoa
Bologna
Forli
Rimini
Savona
Albissola
Faenza
Doccia
Pesaro
Caffaggiolo
Urbino
Montelupo
Florence
Casteldurante
Siena
Gubbio
Perugia
Deruta
S. Quirico d'Orcia
Orvieto
Castelli
Bassano Romano
Rome
Capodimonte
Cerreto Sannita
Naples
Laterza
Palermo
Trapani
Burgio
Sciacca
Caltagirone

189

European Furniture and Furnishings

The words "furniture and furnishings" are not always clearly defined or differentiated, but the former is generally taken to mean objects that are both functional and portable, such as beds, chairs and tables, whereas the latter is a broader term including such articles as carpets and wall-hangings. Because they have generally been made of materials that decay fairly easily, the survival rate from past ages is low. There are numerous interesting exceptions (including Egyptian furniture found in Tutankhamun's tomb), but it is only from about 1400 that there is enough surviving evidence to trace a continuous history of European furniture and furnishings.

Wood has been far and away the most common material for furniture, and it has often been embellished with gilding, painting or inlay with semi-precious substances, as well as by carving. In the Middle Ages, oak was the wood most commonly used, but more decorative varieties later came to be preferred, especially from the 17th century, when veneering became common. Mahogany, which was imported from the West Indies from about 1720, became the classic wood for European furniture in the 18th century.

In the Gothic period the forms and decoration of furniture often imitated those of architecture, particularly in the use of tracery, but in the 15th century in Flanders a novel type of ornament was invented. This was linenfold, a stylized representation of a piece of linen arranged in vertical folds, and it became immensely popular in northern Europe for the decoration of wall paneling and furniture, especially chests and doors of wardrobes. The main centers of furniture production during this period were the great royal and ducal courts, such as Paris, Dijon, Urbino and the cities of southern Germany, and the major trading ports such as Antwerp, Barcelona, Genoa and Venice.

The spread of styles and motifs was helped not only by international commerce, but also – from the 16th century – by the publication of pattern-books of various kinds. This became a feature of the history of furniture; the three most famous names in British furniture of the 18th century, for example, are noteworthy for their publications rather than their craftsmanship: Thomas Chippendale (1718–79); George Hepplewhite (d.1786); Thomas Sheraton (1751–1806).

In the 16th and 17th centuries styles were often massive and rich, with elaborate carvings, forms imitating classical architecture, and an abundant use of inlay in expensive materials. Craftsmen in Augsburg and Nuremberg, for example, specialized in extremely luxurious cabinets with a multitude of small drawers. The 18th century, in contrast, was the supreme age of elegance in furniture, above all in France, Jean-Henri Riesener (1734–1806) being perhaps the most revered figure in the history of his craft; his work is as supreme in craftsmanship as it is in design.

It was in the 18th century, too, that the idea developed of designing an interior as a complete unity, the architect Robert Adam (1728–92) taking a lead in this. His work included the design of carpets, and it was only in this period that they became common as floor coverings, in Europe. Earlier, rushes and rush matting had

generally been used for this purpose, and carpets had been used in other ways, notably to cover beds and tables. Turkey and Persia are famous for their carpets, and until the 17th century the best examples used in Europe were imported. The first important European carpet factory was the Savonnerie factory, founded in Paris by Louis XIII in 1627; until the late 18th century it worked chiefly for the Crown, supplying superb products for the royal residences. Among the other great carpet factories are two famous ones in England – Axminster in Devon, founded in 1755, and Wilton in Wiltshire, founded in about 1740.

Some factories produced tapestries as well as carpets, a famous example being at Aubusson in France, the country that has the richest traditions in the art. The technique of tapestry had been known in the ancient world, but the early history of the art is obscure; from the late 14th century, however, numerous examples survive. Tapestries were an essential part of interior decoration in the late Middle Ages and Renaissance, and they continued to be popular until about the mid-18th century, when cheaper coverings such as wallpaper began to replace them. Well-known factories in France were in Paris (the Gobelins factory, established in the early 17th century and re-organized by Louis XIV in 1662), Beauvais (officially founded in 1664, although tapestries had been woven there much earlier) and Arras (established in the late 13th century).

Outside France, the most famous factories were probably in Brussels, where the industry was well established by the end of the 15th century. In 1516–19 Brussels weavers made a series of tapestries for the Sistine Chapel in the Vatican from designs by Raphael (1483–1520). This was a turning-point in the history of tapestry, because from now on the designer, rather than the weavers, was accorded the main credit for the work. Peter Paul Rubens (1577–1640) was prominent among the major artists who designed important series of tapestries.

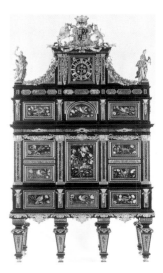

Above: *The Badminton Cabinet, 18th century, Florentine.*

Made for the 3rd Duke of Beaufort, this massive and magnificent cabinet is surmounted with Beaufort arms, supporters and motto in ormolu, lapis and red jasper. The lightly draped ormolu figures emblematic of the four seasons are by Girolamo Ticciati.

Below: *The Mirror Room at the Grand Trianon, Versailles.*

The decoration of the Grand Trianon was originally planned in the time of Louis XIV.

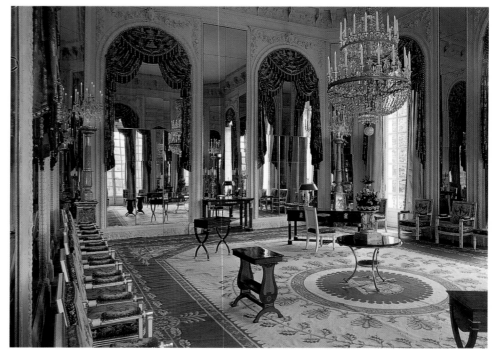

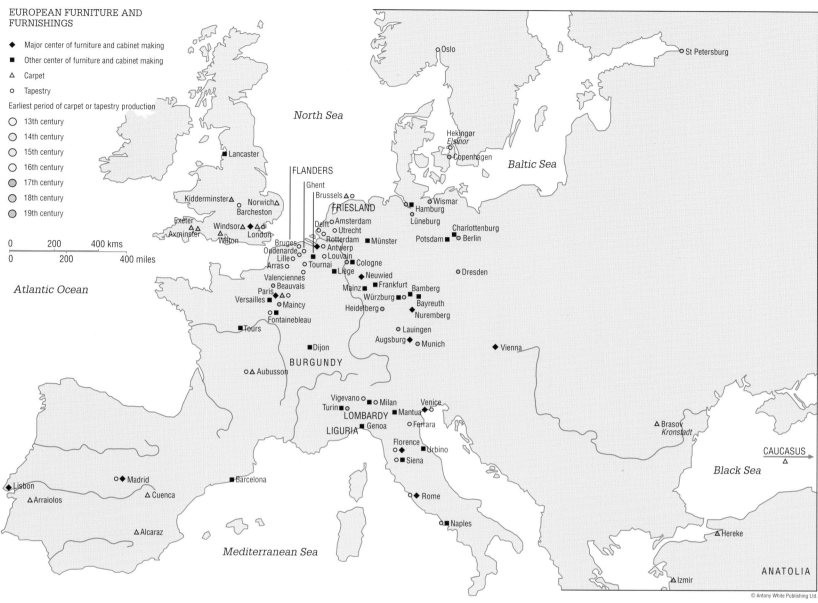

EUROPEAN FURNITURE AND FURNISHINGS

◆ Major center of furniture and cabinet making
■ Other center of furniture and cabinet making
△ Carpet
○ Tapestry

Earliest period of carpet or tapestry production

○ 13th century
○ 14th century
○ 15th century
○ 16th century
○ 17th century
○ 18th century
○ 19th century

0 200 400 kms
0 200 400 miles

North Sea

Atlantic Ocean

Baltic Sea

Mediterranean Sea

Black Sea

Oslo
St Petersburg
Helsingør *Elsinor*
Copenhagen
FLANDERS
Ghent
Brussels △
FRIESLAND
Wismar
Hamburg
Lüneburg
Lancaster
Kidderminster △
Norwich △
Barcheston
Exeter
Axminster
Windsor △ △ △
Wilton
London
Delft
Amsterdam
Utrecht
Rotterdam
Münster
Charlottenburg
Potsdam
Berlin
Bruges
Oudenarde
Antwerp
Lille
Louvain
Cologne
Neuwied
Dresden
Arras
Tournai
Liège
Valenciennes
Beauvais
Mainz
Frankfurt
Paris △ △
Versailles
Maincy
Würzburg
Bamberg
Bayreuth
Heidelberg
Nuremberg
Fontainebleau
Lauingen
Tours
Augsburg
Munich
Dijon
Vienna
BURGUNDY
Aubusson
Vigevano
Milan
Venice
Turin
Mantua
LOMBARDY
Genoa
Ferrara
LIGURIA
Brasov *Kronstadt*
Florence
Urbino
Siena
Rome
CAUCASUS △
Madrid
Barcelona
Lisbon
Arraiolos
Cuenca
Naples
Hereke
Alcaraz
Izmir
ANATOLIA

© Antony White Publishing Ltd.

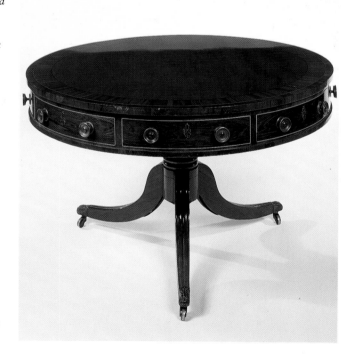

Right: *George IV mahogany and rosewood drum table, late 18th century, English.*

A typical example of a severe, yet popular and practical, table design, also known as a capstan or rent table.

Far right: *Chippendale (1718–79): Mahogany chairs c.1760, English.*

These fine chairs show carved, pierced and fluted splats, serpentine top rail with "C" scrolls, flame molding and foliage on cabriole legs in paw feet.

Metalwork and Jewelry

A great variety of metals, minerals and other substances have been employed in jewelry and the decorative arts. The properties and uses of those appearing on the map are briefly discussed below in alphabetical order.

Amber is a translucent, yellowish fossil resin derived from various trees. The main deposits are on the southern shores of the Baltic Sea, although it is found elsewhere throughout the world. It has been prized as a luxury material since the ancient world, and there was a golden age of amber carving in the 17th century, when it was used for such objects as vases and for decorating furniture. Now it is used almost exclusively for jewelry.

Brass is an alloy of copper and zinc. Its most noteworthy use in art has been for funerary monuments, especially popular in England (about 7000 survive from the 13th to the 16th century). Various functional and decorative objects, such as candlesticks and furniture mounts were made from brass, particularly in Dinant in Belgium. Bronze is also an alloy of copper and tin (and often small amounts of other metals). It has been used since prehistoric times in a great number of ways because of its durability, versatility (it can be worked hot or cold in a variety of ways) and beauty (its color varies from silverish to a rich coppery red depending on the proportion of metals present). Apart from sculpture, it has been used for such articles as bells, coins ("copper" coins are usually bronze), mirrors, weapons and architectural ornament.

A cameo is a relief carving (often a portrait) on a gemstone or similar small surface; often multicolored or banded stone is used, with one color being used for the background and the other for the carving. Cameos were highly developed by the Greeks and Romans. The art had a second great flowering in the Italian Renaissance, and a further revival by the Victorians.

Copper was one of the first metals used by man; it is beautifully colored, easy to beat into shape, and – because of its excellent conductivity of heat – a useful material for cooking-vessels. However, it easily corrodes and so has usually been used alloyed with other metals. In its pure form it has been used in jewelry.

Coral is a stony substance formed by the skeletons of various marine organisms. It is found in various colors (especially orange, pink or white) and can be carved, filed and polished. Jewelry is the most common use for coral, but it has also been employed for statuettes and for religious objects such as rosaries, especially in Italy, where coralwork had its greatest flourishing in the 17th and 18th centuries.

Electroplate refers to metalwork that has been coated with silver by electrolysis, a technique patented by the Birmingham manufacturer George Richards Ellington (1801–65) in 1840, a few months before a similar process was patented in Paris. The technique revolutionised the silver trade, replacing Sheffield plate (which was more difficult to make) as a cheap substitute for solid silver.

Enamel is a smooth, glossy substance made by fusing glass to a prepared surface (usually metal). It was used by the ancient Egyptians, Greeks, Romans and Byzantines, and in the Christian Middle Ages was employed in a great variety of ecclesiastical art – book covers, crucifixes, reliquaries, and so on.

Gold has been the most prized of metals throughout recorded history, valued for its beauty, durability (it does not corrode or tarnish) and the ease with which it can be worked. Pure gold is very soft, so is usually alloyed with other metals (the purity is measured in carats, 24 carats being pure gold, 12 carats a half-and-half alloy).

Iron is a very common and useful metal. There are usually impurities present in it (by accident or design) and they affect its malleability. The type of iron most associated with decorative work is wrought iron, which has a very low carbon content and can be hammered into complex shapes. It has been used particularly for architectural features such as balconies, gates and grilles.

Ivory refers mainly to the tusks of elephants, but also to other animal products such as rhinoceros horn and whales' teeth (in fact the most abundant source of ivory was for centuries not the elephant but the fossil tusks of the extinct mammoth found in Siberia). Since the ancient world ivory has been prized as a luxury material; it has been used for small-scale statuary and a wide variety of decorative objects.

Jet is a hard black stone, similar to coal but capable of being carved. It has long been believed to be able to ward off evil and has therefore often been used to make amulets. It was popular in medieval Spain, Villaviciosa being the site of the main deposits and Santiago de Compostela, with its famous shrine, a center of manufacture for rosaries and figures of saints sold to pilgrims. The other great center of jet carving was Whitby in Yorkshire, where more than a thousand people were employed in the industry during its peak period in the 19th century, when Queen Victoria helped to popularise jet mourning jewelry after the death of Prince Albert.

Ormolu is a kind of gilded bronzework, used especially in the ornamentation of furniture, but also for such objects as candlesticks and chandeliers. An expensive luxury craft, ormolu reached its highest peak artistically and technically in 18th-century France.

Pearl shell (or mother-of-pearl) is the iridescent lining of the shells of oysters or similar marine creatures. Since ancient times it has been used in a wide variety of ways – in jewelry, as inlay on furniture and musical instruments, and for small decorative objects.

Pewter is an alloy of tin, copper and sometimes lead (the more lead, the lower the quality) with a low melting point and so easily cast. In the Middle Ages it was much used for utilitarian goods such as bowls and plates and from the 16th century it was employed for similar articles intended for decoration – "display pewter".

Rock crystal, a kind of quartz, resembles glass but is harder and retains a better polish. It has been used for jewelry, drinking vessels and various types of ornament. Bohemia (now part of Czechoslovakia) has the richest tradition of rock crystal carving, and it also flourished in Renaissance Italy.

Silver – like gold – has always been prized for its beauty, scarcity and versatility. Again like gold, because it is soft in its pure state it is usually alloyed with other metals, most commonly copper.

Above: *Painted enamel crucifix, 12th century, Limoges (Poldi Pezzoli, Milan).*

Limoges was a productive center (c.12–14th centuries) for painted enamel candlesticks, reliquaries and crucifixes. Examples of Mosan enamels, using the champlevé *techniques, were given to Abbot Witald of Stavelot, near Limoges, in 1134.*

EUROPEAN METALWORK AND JEWELRY

- ● Town or city
- △ Amber
- ▫ Brass
- ▫ Bronze
- △ Cameo
- ◇ Cast iron and steel
- ▫ Copper
- △ Coral
- ○ Electroplate
- ○ Enamels
- ▣ Gold
- ◇ Gold and silver
- ○ Iron chiselling
- ◉ Iron and steel jewelry
- △ Ivory
- ◇ Jet
- ▫ Lead
- ○ Ormolu
- △ Pearl shell
- ◇ Pewter

- △ Rock crystal
- ▫ Silver
- ○ Wrought iron

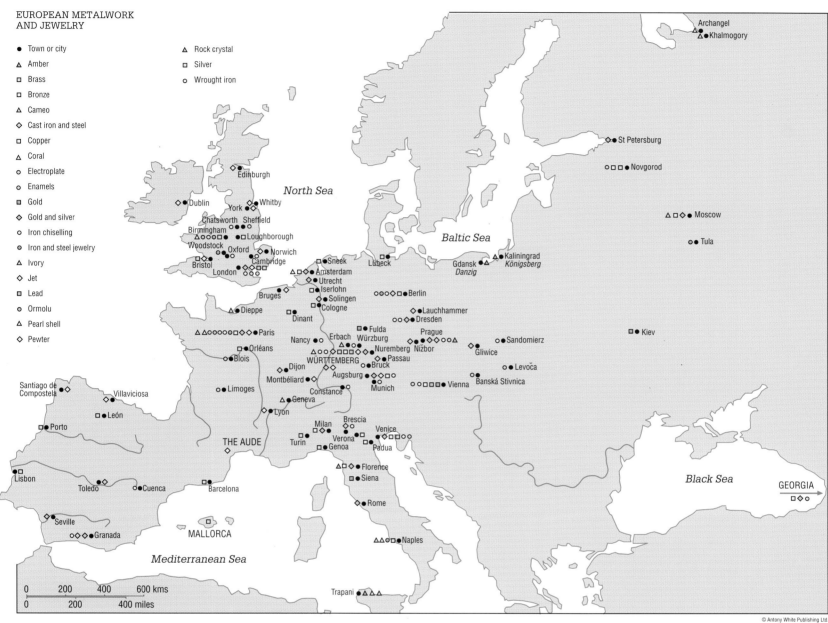

North Sea

Baltic Sea

Black Sea

GEORGIA

Mediterranean Sea

| 0 | 200 | 400 | 600 kms |
| 0 | 200 | 400 miles |

© Antony White Publishing Ltd.

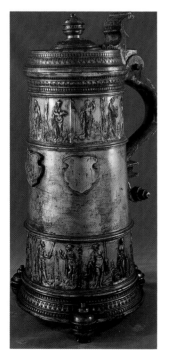

Left: *Silvered pewter guild tankard, c.1570, Saxony (Victoria and Albert Museum, London).*

Cast in relief by Peter Flötner of Nuremberg (1493–1546), it features religious, mythical and allegorical figures. The maker's mark is of Paul Weise (Weysse) of Zittau in Saxony.

Right: *Gold frame of crown, c.1700, Prussia (Schloss Charlottenburg, Berlin).*

The stripped-down frame of the crown of Queen Sophie Charlotte of Prussia, consort of King Frederick I of Prussia, and worn at their coronation in 1701.

Above: The Baroque Library, *completed 1744, Wiblingen Monastery, Baden Württemburg, Germany.*

BAROQUE AND ROCOCO

1600–1789

Baroque art and architecture was born out of the Counter-Reformation and the translation of High Renaissance, and later Mannerist style, into an art that served a new Europe – divided religiously by Catholic and Protestant, and dominated by the rise of the great nation states – creating a genuinely classical style in painting, sculpture and architecture. Rococo art grew out of the Baroque in three directions: in the intensely catholic South Germany and Bohemia towards a rhythmic, ecstatic, deeply emotional religious art; in the France of the Enlightenment into an increasingly frivolous virtuoso decorative style; and for all the great enlightened despots in Prussia, Austria and Russia into a resplendent international palace architectural style.

Above: *Christoph Dientzenhofer (1655–1722):* Cupola of the Church of St. Nicholas, *1703–11, Malá Strana, Prague, Czechoslovakia.*

Europe in the Seventeenth Century

1648 saw the signing of the Treaty of Westphalia, which brought to an end the epic Thirty Years' War. The treaty had important implications for the German states and was to influence European diplomatic relations until well into the next century. The Thirty Years' War had had five main stages: as well as the civil war in Germany there was the Bohemian war (1618–20) between Bohemian Protestant rebels and the Catholic Emperor; the Danish war, with Denmark stepping in to defend German Protestantism; the Swedish War fought between Sweden and Austria for control of the Baltic and Northern Germany and also the war between France and both Habsburg Spain and Austria.

Under Henri IV there was a slow reversal in French fortunes. Reportedly believing "a kingdom to be worth a mass", Henri converted to Catholicism, but his assassination in 1610 marked the end of a period of retrenchment. Louis XIII's minority, under the regency of Marie de Médicis, Henri's wife, was disastrous, yet ironically, the man who reversed France's fortunes during Louis' majority, Cardinal Richelieu, had originally been Marie's creature.

Richelieu's main ambition was to defeat Habsburg Spain. This was a hard struggle. The reverses of 1639, which saw the Spanish army poised to enter Paris, were symptomatic of France's weakness and the relative strength of Spain. But Richelieu established a winning formula in foreign policy,

continued by his successor Cardinal Mazarin under Louis XIV. By the Treaty of Westphalia the threat posed to France by the Spanish-Austrian Habsburg alliance was removed.

Spain in contrast suffered decades of debt and disaster. During Philip IV's long reign the reality of Spanish Habsburg decline became apparent: financial disaster with the fall in bullion from the American colonies and the disproportionate economic burden felt by Castile were main causes of decline. Even the court paintings of Velázquez make little attempt to hide the decline. Abroad a series of depressing defeats were suffered by Spanish armies and in 1648 Spain officially recognised the independence of the United Provinces.

England was in a state of civil war eventually to culminate in the success of Cromwell and the Roundheads, and the execution of Charles I in 1643.

Along with Sweden and France, the Dutch Republic was the real winner from the political ferment caused by the Thirty Years' War. Much of the Republic's success lay in its economic power: trade with the Baltic and the Spanish and Portuguese imperial possessions was important, along with the foundation of the East India Company (1602) and West India Company (1621). The speed with which the federal republic established itself was one of the great phenomena of the 17th century, even though, as with Sweden, the initial level of success was not maintained.

EUROPE IN 1648

- Austrian Hapsburg possessions
- Ottoman Empire
- Small German states within the Holy Roman Empire
- Spanish possessions
- Swedish possessions
- Boundary of Holy Roman Empire (without nominal possessions in Italy)

0　100　200　300　400 kms
0　　　100　　　200 miles

ATLANTIC OCEAN

Above: *Diego Rodriguez de Silva y Velázquez (1599–1660):* Surrender of Breda, *1634–35 (Prado, Madrid).*

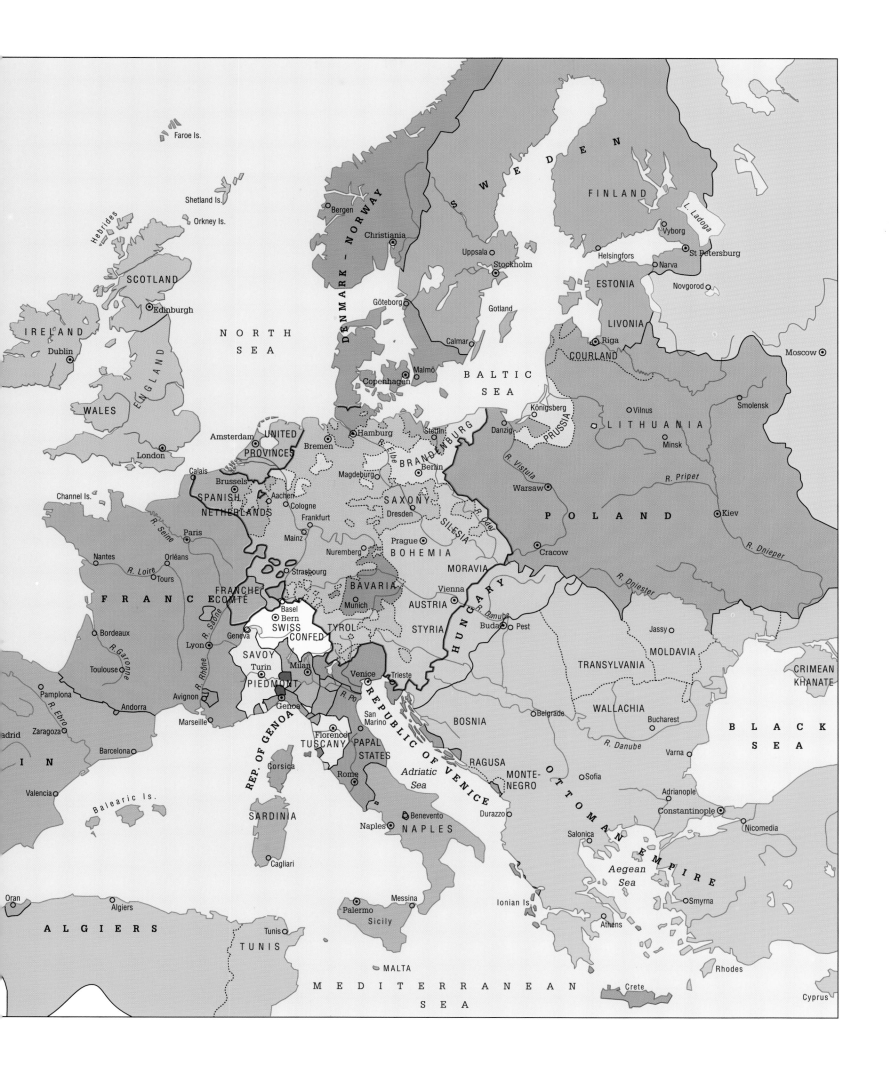

Faroe Is.

Shetland Is.

Orkney Is.

Hebrides

SCOTLAND

○ Edinburgh

IRELAND

Dublin ○

NORTH
SEA

Bergen ○

Christiania ⊙

Uppsala ○

Göteborg ○

DENMARK – NORWAY

S W E D E N

FINLAND

L. Ladoga

Vyborg ○

Helsingfors ○

St Petersburg ⊙

Narva ○

Novgorod ○

ESTONIA

Stockholm ⊙

Gotland

Calmar ○

BALTIC
SEA

LIVONIA

COURLAND

Riga ⊙

Moscow ⊙

WALES

ENGLAND

London ⊙

Channel Is.

Amsterdam ○
UNITED
PROVINCES

Bremen ○

Calais ○

Brussels ○

SPANISH
NETHERLANDS

Aachen ○

Cologne ○

Paris ⊙

Hamburg ⊙

BRANDENBURG

R. Elbe

Magdeburg ○

Stettin ○

Berlin ⊙

Königsberg ○

PRUSSIA

Danzig ○

Vilnus ○

LITHUANIA

Minsk ○

Smolensk ○

Warsaw ○

R. Vistula

R. Pripet

Copenhagen ⊙

Malmö ○

SAXONY

Dresden ○

SILESIA

Frankfurt ○

Mainz ○

Nuremberg ○

Prague ⊙

BOHEMIA

R. Oder

POLAND

Kiev ⊙

Cracow ○

R. Dnieper

FRANCE

Nantes ○

Orléans ○

Tours ○

R. Loire

R. Seine

Strasbourg ○

FRANCHE
COMTÉ

R. Saône

MORAVIA

BAVARIA

Munich ○

Vienna ⊙

AUSTRIA

HUNGARY

STYRIA

R. Dniester

Jassy ○

MOLDAVIA

Bordeaux ○

Toulouse ○

Pamplona ○

Andorra ○

R. Garonne

R. Ebro

Zaragoza ○

Barcelona ○

Valencia ○

Lyon ○

R. Rhône

R. Saône

Geneva ○

Basel ○
Bern ⊙
SWISS
CONFED

TYROL

SAVOY

Turin ○

Avignon ○

Marseille ○

PIEDMONT

Milan ○

Genoa ○

REP. OF GENOA

Balearic Is.

SARDINIA

Corsica

TUSCANY

Florence ⊙

R. Po

Venice ○

Trieste ○

REPUBLIC OF VENICE

San
Marino ○

PAPAL
STATES

Rome ⊙

Adriatic
Sea

RAGUSA

Buda ⊙ ○ Pest

R. Danube

TRANSYLVANIA

WALLACHIA

Belgrade ○

BOSNIA

R. Danube

Bucharest ○

CRIMEAN
KHANATE

B L A C K
S E A

Cagliari ○

Benevento ○

Naples ○

NAPLES

Messina ○

Palermo ○

Sicily

Durazzo ○

MONTE-
NEGRO

OTTOMAN EMPIRE

Sofia ○

Varna ○

Adrianople ○

Constantinople ⊙

Nicomedia ○

Salonica ○

Aegean
Sea

Smyrna ○

Ionian Is.

Athens ○

Oran ○

Algiers ○

A L G I E R S

Tunis ○

TUNIS

⊙ MALTA

Crete ○

Rhodes ○

Cyprus ○

M E D I T E R R A N E A N
S E A

Madrid ⊙

I N

Europe from Louis XIV to the Eighteenth Century

The period 1648–1721 saw the undisputed ascendancy of France and the Bourbon dynasty in Europe. Louis XIV began to assume real power in the early 1660s, developing an absolutist government based around the person of the King, *Le Roi Soleil*. In 1685 he revoked the Edict of Nantes which had granted religious freedom to France's Protestant subjects, and established Catholicism as the one religion of France.

Louis' rule was centered on the rituals of the Court. In 1685 king and court moved to the new palace of Versailles, formerly a hunting lodge of his father's, which he had completely rebuilt by a team of French designers in a classicist style that became, throughout Europe, a symbol of absolutism.

Louis XIV was the aggressor in four wars which were to escalate in scale and end in a virtually European-wide coalition against him. Europe was appalled by his policy of expansionism and Louis did not help by failing to come to the aid of the Emperor Leopold in his struggle against the infidel Turks.

His attacks on the United Provinces (partly the result of the distaste of a Catholic monarchy for a Protestant republic), his policy of *Réunions* which led him to expand northwards and eastwards to occupy Flanders, Luxembourg and Alsace and, above all, his support of a Bourbon candidate, Philip of Anjou, for the Spanish throne led to the Grand Alliance of England, the Netherlands, Hanover, Prussia, Austria and Portugal against him. This resulted in two major European Wars, the War of the League of Augsburg (1688–97) and the War of the Spanish Succession (1701–14), in which Great Britain, because of her sea power and also because of the leadership of two great generals, William of Orange and James Churchill, later Duke of Malborough, for the first time played a major role in continental power politics.

In the end Philip was recognised as King of Spain and her colonies, but the Spanish Netherlands went to Austria and the balance of power was radically altered, Great Britain and Sweden in particular benefitting from the peace.

In 1715 Louis XIV died and the next decade beginning with the regency of Philip of Orléans saw, under Louis XV, a decline in French power, although her cultural influence remained dominant. The Rococo art of the French 18th-century court became more playful and exquisite, and far less classical than that of Louis XIV. Great Britain, after the Act of Union of England and Scotland and the peaceful succession of the Hanoverians in 1714, provided an alternative in her parliamentary government and her party system, to the imperial despotisms of the Continent. England thus became an important political inspiration to thinkers, such as Voltaire and Rousseau, in the movement known as the Enlightenment and the century introduced to power politics an ideological dimension of great importance in the age of revolutions that followed.

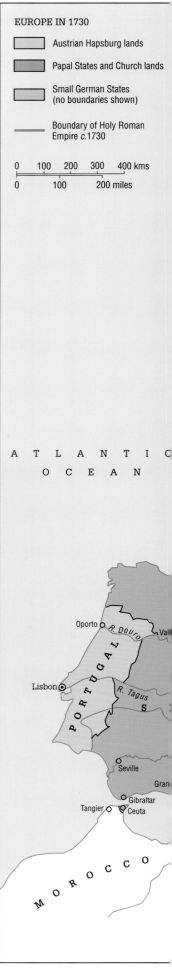

EUROPE IN 1730

Austrian Hapsburg lands

Papal States and Church lands

Small German States (no boundaries shown)

Boundary of Holy Roman Empire *c.*1730

0 100 200 300 400 kms
0 100 200 miles

Above: *François Boucher (1703–70):* Diana getting out of her bath *(Louvre, Paris).*

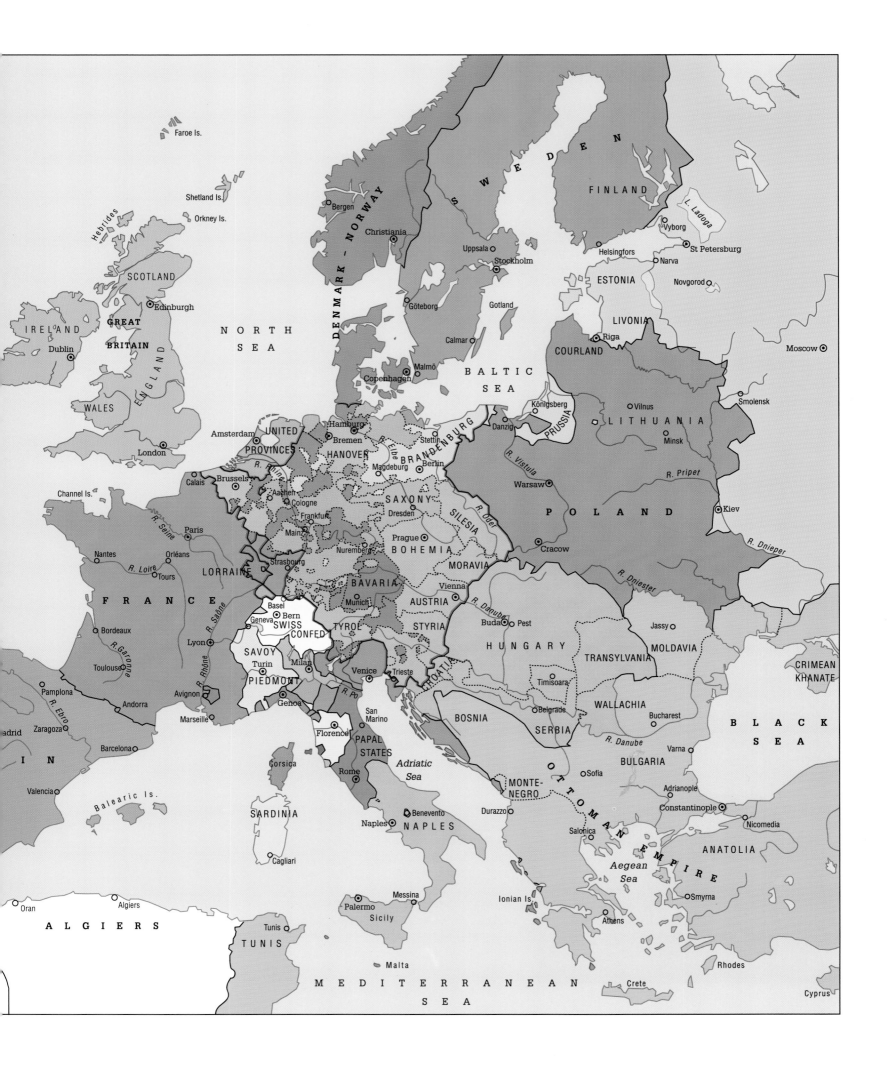

IRELAND

SCOTLAND

Hebrides

Shetland Is.

Orkney Is.

Faroe Is.

Dublin

Edinburgh

GREAT
BRITAIN

WALES

ENGLAND

London

Channel Is.

NORTH
SEA

DENMARK – NORWAY

Bergen

Christiania

S W E D E N

FINLAND

L. Ladoga

Vyborg

St Petersburg

Narva

Novgorod

Uppsala

Stockholm

Helsingfors

Gotland

Göteborg

Calmar

ESTONIA

LIVONIA

Riga

COURLAND

Moscow

BALTIC
SEA

Smolensk

Königsberg

Vilnus

LITHUANIA

Minsk

Amsterdam

UNITED
PROVINCES

Hamburg

Bremen

HANOVER

Danzig

PRUSSIA

BRANDENBURG

R. Elbe

Stettin

Berlin

R. Vistula

R. Pripet

Calais

Brussels

Aachen

Cologne

Magdeburg

R. Rhine

Paris

Nantes

Orléans

R. Seine

R. Loire

Tours

Frankfurt

Mainz

Nuremberg

SAXONY

Dresden

SILESIA

R. Oder

Warsaw

P O L A N D

Kiev

R. Dnieper

LORRAINE

Strasbourg

Prague

BOHEMIA

MORAVIA

Cracow

F R A N C E

R. Saône

BAVARIA

Munich

Vienna

AUSTRIA

R. Danube

Buda

Pest

R. Dniester

Jassy

Bordeaux

Basel

Bern

Geneva

SWISS
CONFED

TYROL

STYRIA

Lyon

R. Rhône

SAVOY

Turin

Milan

PIEDMONT

Venice

Trieste

CROATIA

HUNGARY

TRANSYLVANIA

MOLDAVIA

CRIMEAN
KHANATE

Pamplona

Andorra

Toulouse

R. Garonne

Avignon

Genoa

R. Po

San
Marino

Timisoara

WALLACHIA

Bucharest

Marseille

Florence

PAPAL
STATES

BOSNIA

Belgrade

SERBIA

R. Danube

B L A C K
SEA

adrid

Zaragoza

Barcelona

Corsica

Rome

Adriatic
Sea

MONTE-
NEGRO

Varna

BULGARIA

Sofia

Valencia

I N

Balearic Is.

SARDINIA

Benevento

Naples

NAPLES

Durazzo

Salonica

OTTOMAN EMPIRE

Adrianople

Constantinople

Nicomedia

ANATOLIA

Aegean
Sea

Smyrna

Cagliari

Oran

Algiers

A L G I E R S

Tunis

TUNIS

Palermo

Sicily

Messina

Malta

Ionian Is.

Athens

M E D I T E R R A N E A N
SEA

Crete

Rhodes

Cyprus

Artists' Travels in the 17th Century

Ever since the early Renaissance northern artists, especially those from the Netherlands, had come to regard a journey to Italy as a desirable and enriching experience. Study of the famous monuments of antiquity as well as contact with current artistic developments came to be seen as an essential part of an artist's education. By the early 17th century it was sufficiently the norm for both Rembrandt (1606–69) and Jan Lievens (1607–74) to be asked why they had not made the journey south. Most young artists did travel as part of their education. Some, such as Nicolas Poussin (1594–1665) and Claude (1600–82), became so enamored with what they found that they settled permanently in Rome.

Another reason for travel was the artist's search for work. With the rise of the aristocratic courts in London, Paris and Madrid, and their patronage of the arts, there was great inducement for the artist to attach himself to a royal patron. Kings competed to lure major artists to become court painters but many preferred to stay at home: Rubens (1577–1640) was the most sought-after artist of the century, yet the most successful in receiving royal commissions without court attachment. Italian artists were no less in demand: Bernini (1598–1680) and Romanelli (1610–62) visited Paris; Orazio Gentileschi (1563–1639) and his daughter, and later Antonio Verrio (1639–1707), all moved to London. In Rome the growth of papal and church patronage at the beginning of the 17th century enabled the foreign artist to find work while completing his artistic education, either as a member of a master's studio, or from individual commissions.

With the rise of realistic landscape painting, artists, especially those from the Netherlands, were motivated to travel in order to find inspiration from foreign scenery. Although the landscape of Italy, with its Classical associations, remained the major attraction, there were numerous instances of sketching journeys in France, England, Germany and Switzerland. Encouraged by the expansion of world trade and the growth in colonialism, some artists travelled further: Allart van Everdingen (1621–75) went to Scandinavia and Frans Post (c.1612–80) to Brazil.

Above: *Frans Post (c.1612–80): detail from* Brazilian Village with Native Feast *(Harold Samuel Collection, Corporation of London).*

ARTISTS' TRAVELS IN THE SEVENTEENTH CENTURY

● Town or city

Artists from:
○ England
○ France
○ Germany and Eastern Europe
○ Iberian peninsula
○ Italy
○ Low Countries
→ Travel of artist

1 Stefano della Bella (1610–64)
Florence to Paris 1639–49
2 Gianlorenzo Bernini (1598–1680)
Rome to Paris 1665
3 Gerard ter Borch (1617–81)
Haarlem to London 1635
Haarlem to Münster 1646–48
4 Jacques Callot (1592/3–1635)
Nancy to Rome between 1608–11, to Florence 1611–21
Nancy to Brussels 1625
5 Michelangelo Merisi da Caravaggio (1573–1610)
Naples to Malta 1607–08
6 Claude Gellée, called Le Lorrain (1600–82)
Nancy to Rome c.1613, where he settled
7 Francis Cleyn (1582?–1658)
Rostock to Denmark 1611, to Italy 1611–17 (4 years in Rome)
Rostock to Copenhagen 1617
Rostock to London 1625, where he settled
8 Jan Cossiers (1600–71)
Antwerp to Aix-en Provence, 1623–24, to Rome 1624–26
9 Antoine Coypel (1661–1708)
Paris to Rome 1672–75, North Italy 1776
10 Lambert Doomer (1624–1700)
Amsterdam to Nantes, Paris, Rouen, Le Havre 1646
Amsterdam to France, England, Germany and Italy c.1661
11 Anthony van Dyck (1599–1641)
Antwerp to London 1620/1
Antwerp to Italy 1621–27
Antwerp to London 1632 where he settled (Antwerp 1634–35, Paris 1640 and 1641)
12 Adam Elsheimer (1578–1610)
Frankfurt to Venice c.1598 and Rome 1600–10
13 Allart van Everdingen (1621–75)
Haarlem to Stockholm early 1640's
14 Charles de la Fosse (1636–1716)
Paris to Rome 1658–60, to Venice 1660–63
Paris to London 1689–92
15 Joannes Fyt (1611–61)
Antwerp to Paris 1633–34, to Venice, to Rome; back in Antwerp 1641
16 Artemisia Gentileschi (1597–after 1651)
Naples to London 1638–40
17 Orazio Gentileschi (1563–1638)
Genoa to Paris 1624–26, to London 1626–38
18 Hendrick Goltzius (1558–1617)
Haarlem to Hamburg. Venice, Bologna, Florence, Rome and Naples 1590–91
19 Wenceslaus Hollar (1607–77)
Prague to Stuttgart 1627–28, Strasbourg 1629, Frankfurt 1631–32, Cologne 1632–36, London 1636, where he settled
London to Antwerp 1644–52
20 Samuel van Hoogstraten (1627–78)
Dordrecht to Vienna, 1651, Rome 1652, Vienna 1653
Dordrecht to London before 1662–after 1666
21 Sir Godfrey Kneller (1646–1723)
Lübeck to Amsterdam c.1663
Lübeck to Rome and Venice 1672–75; Lübeck to London 1676 where he settled
London to Paris 1684
London to Rijswijk and Brussels 1697

22 Nicolas de Largillière (1656–1746)
b. Paris, to Antwerp as child, from Antwerp to London 1674–80
settled in Paris 1682
Paris to London 1685
23 Charles Lebrun (1619–90)
Paris to Rome 1642–46
24 Sir Peter Lely (1618–80)
Haarlem to England 1641 or 1643, settled
25 Jan Lievens (1607–74)
Amsterdam to London 1631–32
26 Claude Mellan (1598–1688)
Paris to Rome 1624–36
27 Jan Miel (1599–1663)
Antwerp to Rome mid 1630s–1657, to Turin 1658
28 Pierre Mignard (1612–95)
Paris to Rome 1636–57 (Venice 1654–55)
29 Francisque Millet (1642–79)
Antwerp to Paris 1659, where he settled
30 Frans Post (c.1612–80)
Haarlem to Brazil 1637–44
31 Nicholas Poussin (1594–1655)
Paris to Rome 1624, where he settled
Paris 1641–42
32 Mattia Preti (1613–99)
Naples to Malta 1661–69
33 Pierre Puget (1620–94)
Marseille to Rome and Florence 1640–43
Toulon to Rome 1646–47
Paris to Genoa 1661–67
34 Jusepe de Ribera (1591–1652)
Valencia to Rome, settling in Naples by 1616
35 Giovanni Francesco Romanelli (1610?–62)
Rome to Paris 1646–47
Rome to Paris 1655–57
36 Peter Paul Rubens (1577–1640)
Antwerp to Mantua 1600–08 (Venice 1600, Florence 1600, Rome 1601–02, Spain 1603, Rome 1605–06, Genoa 1606 and 1607, Rome 1608)
Antwerp to Paris, 1622, 1623, 1625, 1627, Antwerp to Madrid 1628–29, Paris 1629, London 1629–30
37 Joachim von Sandrart (1608–88)
Frankfurt to Prague 1621–22
Frankfurt to London 1627, Venice 1629, Rome 1629–35/6 (Naples, Messina, Palermo and Malta c 1630–31)
Frankfurt to Holland 1636–37
38 Jacques Sarrazin (1588–1660)
Paris to Rome 1610–c.1627
39 Roelant Savery (1576–1639)
Amsterdam to Prague c.1604–12
Amsterdam to Vienna, Munich, Salzburg and Brixen 1614–18
40 Godfried Schalcken (1643–1706)
Dordrecht to London 1692–97?
41 Willem Schellinks (1627–78)
Amsterdam to Nantes, Paris, Rouen and Le Havre 1646
Amsterdam to France, England, Germany and Italy 1661
42 Jan Siberechts (1627–c.1703)
Antwerp to London by 1674, settled
43 Frans Snyders (1579–1657)
Antwerp to Rome by 1608, Milan 1608–09
44 Diego Velazquez (1599–1660)
Madrid to Genoa, Venice, Rome and Naples 1629–31 and 1648–51
45 Willem van de Velde II (1633–1707)
Amsterdam to London 1672, settled
46 Antonio Verrio (1639?–1707)
Naples to Toulouse 1666, to Paris 1671, to London 1672, settled
47 Claude Vignon (1593–1670)
Paris to Rome 1616–24
48 Simon Vouet (1590–1649)
Paris to London ? c.1605
Paris to Constantinople 1612, to Venice 1612/3, to Rome 1613–20, 1622–47, to Genoa 1620–21
49 Michael Wright (1617–94)
London to Rome c.1642–56
London to Dublin 1680
London to Rome 1685

North Sea

Baltic Sea

to Stockholm ⑬

Copenhagen ●

⑦

⑦ ● Rostock

Dublin ●

㉑

Lübeck

㉑

Hamburg ●

⑱

⑱

Haarlem ③ ㉔

Amsterdam

㉑

⑱

Rijswijk

③ ● Münster

⑲

⑲

Prague ●

Dordrecht

London

⑪ ㉒ ㊷ ㉕ ㊺

⑳ ㊵ Antwerp

⑳ ㊴ ㊴

Brussels ●

⑲ Cologne

㊲

㉑

⑲ Frankfurt

⑲

Le Havre

Rouen ● ㉒

㉑

⑭ ㉒

⑰

㊱ ㉙ ⑮

㊻ Paris

㊲ ● Trier

⑫

㊲

④

⑲

Stuttgart

⑲

⑩

㊶

Nancy

Vienna ●

⑩ ㊶

Strasbourg ● ⑲

Nantes

Munich ● Salzburg ●

㊱ ㊻ ㊱

Atlantic Ocean

�23 ⑧ ⑪

㉗

㊸ ④ ⑥

⑮

⑦

①

② ● Milan

㉛

Venice

Mantua

⑰ ㉟

⑨ ㊸

⑭ Turin

㉓

㉖ Genoa

Bologna

⑭ ⑫

㉑ ⑮

㉘

㉛

Florence

㊲

㊹

㊺

⑳

from Constantinople

Toulouse ●

⑯

Aix-en-Provence

Marseille

Toulon

⑧ ㉝ ㉝

㊸ ㊹

④

㊹

Rome ㉞ ㊹

㊸

Madrid ●

㊻

㉞

Naples ●

⑤

㉜

Valencia ●

㊸ to Constantinople

Mediterranean Sea

Palermo ● ● Messina

0 100 200 300 kms

0 100 200 miles

MALTA

© Antony White Publishing Ltd.

201

The Grand Tour in the Eighteenth Century

From the 16th century onwards the practice in northern Europe of making a visit to Italy had gradually developed, but it only became widely popular in the 18th century, when – up to the time that the French marched into Rome in 1798 – the Grand Tour, especially for the British, became the conventional conclusion to a gentleman's education. To assist the visitor to develop greater appreciation of what he saw, Jonathan Richardson the Elder published his guide book *(An Account of the Statues, Bas-Reliefs, Drawings and Pictures in Italy etc., 1722)*, which offered instruction in the rules of connoisseurship. But although such distinguished figures as the third Earl of Burlington, Richard Payne-Knight, William Beckford, the Comte de Caylus, Charles de Brosses and Johann Wolfgang von Goethe in different ways benefited from the overwhelming experience of the Grand Tour, for others it was merely an excuse for idle pleasure and dissipation.

The Grand Tour offered a wide range of cultural opportunities according to the tastes and interests of the traveller. Depending on the route chosen, the sites of France or of the Netherlands and Germany were succeeded by the awesome experience of crossing the Alps into northern Italy, where Venice and Florence (among other cities) were visited before the traveller inevitably made his way to Rome. Many continued their journey south to Naples and some went as far as Sicily. Most settled in Rome for a period, where if they were disposed to treat their visit seriously they would hire a cicerone, of whom the most knowledgeable and sought after was Johann Winckelmann, appointed director-general of Roman antiquities in 1763. From its heyday as a center of artistic activity Rome had now become more visited as a museum. In acknowledgment of this tendency Clement VII opened the first museum of antiquities, the Museo Capitolino, in 1734. This was followed by Cardinal Alessandro Albani's unrivalled collection which was arranged by Winckelmann at the Cardinal's villa on the outskirts of Rome, and continued with the construction of the Vatican museum. The study of Roman antiquity was greatly stimulated by the publication of Giovanni Battista Piranesi's (1720–78) sets of etchings, the *Vedute di Roma* (1748) and *Le antichite romane* (1756), and by the *Monumenti antichi inediti...* (1767) by Winckelmann, who preached the artistic preeminence of Greek art over Roman. This passionate debate about the Classical past was directly related to the rise of Neoclassicism in contemporary art. In addition to study, some Grand Tourists, such as Charles Townley, the Earl of Burlington and Thomas Coke of Norfolk, took the opportunity to purchase antiquities or other works of art, which formed the basis of their future collections.

A visit to Italy, and above all to Rome, as the desirable conclusion to an artist's training had already become established practice in the 17th century, but now artists came not only in larger numbers but also with a different purpose. The decline in the native Roman school meant that far fewer (among whom may be included Allan Ramsay and Gavin Hamilton) came to study with their Italian contemporaries. It is symptomatic that

Anton Raphael Mengs' ceiling painting for the Villa Albani (1761) can be regarded as the most important secular decoration executed in Rome during the 18th century. Many more artists came to study the antique and the art of the Renaissance. The most influential of these was Sir Joshua Reynolds. At the French Academy (founded by Louis XIV in 1666) the *pensionnaires* were primarily occupied with copying the antique. A substantial number of foreign artists came to study the scenery of Rome and the landscape of the Campagna. Unlike their predecessors during the height of the Baroque period, artists were now far more dependent on patronage from other foreign visitors. As a result, the Grand Tour became directly responsible for the creation of a large number of portraits of the tourists and their companions and of topographical landscapes, which often led to subsequent commissions after both artist and patron had returned to their native country.

Left: *Johan Heinrich Wilhelm Tischbein (1751–1829),* Goethe in The Campagna, *oil on canvas, 1786–88 (Städelsches Kunstinstitut, Frankfurt).*

Tischbein, from Hamburg, met Goethe in Rome in 1786, and painted this romantic portrait posed in a classical landscape.

Below: *Johann Zoffany (1733–1810),* The Tribuna of the Uffizi, *oil on canvas, 1772–80 (Royal Collection, London).*

Zoffany, a German who settled in London, was sent by George III to Florence in 1772.

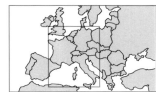

THE GRAND TOUR

- ◉ Major city
- ◎ Other city or town
- ○ Other site
- ▲ Mountain
- ▬ Most frequented routes

The Grand Tour: Foreign artists in Italy in the Eighteenth Century

America
Benjamin West (1738-1820)

Denmark
Erasmus Carstens (1754-98) **1783, 1792–98**

England
Alexander Cozens (1717-86) **1746**
John Robert Cozens (1752-97) **1776–79, 1782–3**
John Downman (1750-1824) **1773-c.1775**
Gavin Hamilton (1723-98) **1748–51, 1752–98**
Thomas Jones (1742-1803) **1776–83**
William Marlow (1740-1813) **1740–68**
William Pars (1742-82) **1770, 1775–82**
Thomas Patch (1732-82) **1747–82**
Joshua Reynolds (I723-92) **1750–52**
George Romney (1738-1802) **1773–75**
John 'Warwick' Smith (1749-1831) **1776–81**
Francis Towne (c.1739/40-1816) **1780–81**
Richard Wilson (1713/14-82) **1750–57**
Joseph Wright (1734-1797) **1773–75**

France
Louis-Gabriel Blanchet (1705-72) *c.*1728–72
François Boucher (1703-70) **1727–32**
Charles Michel-Ange Challe (1718-78) **1741–49**
Charles-Louis Clérisseau (1721-1820) **1746–66**
Jacques Louis David (1748-1825) **1775–81**
Jean Honoré Fragonard (1732-1806) **1756–61**
Jean Baptiste Greuze (1725-1805) **1756–57**
Charles Joseph Natoire (1700-77) **1721–30, 1751–77**
Hubert Robert (1733-1808) **1754–65**
Pierre Subleyras (1699-1749) **1728–49**
Pierre-Henri de Valenciennes (I750-18I8) **1769, 1777–81, 1817**
Claude Joseph Vernet (1714-89) **1734–53**

Germany
Jacob Philipp Hackert (1737-1807) **1768–1807**
Anton Raphael Mengs (1728-1779) **1740–46, 1747–51, 1751–61, 1769–75, 1776–79**
Johann Heinrich Wilhelm Tischbein (1751–1829) **1779, 1783–99**
Johann Zoffany (1733-1810) **early 1750's**

Ireland
James Barry (1741-1806) **1766–71**

Netherlands
Daniel Dupré (1751-1817) **1783–92**
Jean Grandjean (1752-81) **1779–81**

Poland
Franciszek Smuglewicz (1745-1807) **1763–84**

Scotland
David Allan (1744-96) **1764–77**
John Brown (1752-87) **1771–81**
Jacob More (1740-93) **1773–93**
Allan Ramsay (1713-84) **1736–38, 1754–57, 1775–77, 1782–84**
Alexander Runciman (1736-85) **1766–71**

Spain
Francisco Goya (1746-1828) *c.*1770–71

Switzerland
Louis Ducros (1748-1810) **1776-1807**
Johann Heinrich Füssli (1741-1825) **1770–78**
Angelica Kauffmann (1741-1807) **1763–64, 1781–1807**
Jean Etienne Liotard (1702-89) *c.*1738

© Antony White Publishing Ltd.

The Environs of Naples

Naples, which according to Pliny was founded as a Greek colony, was popular with the 18th-century traveler both for its natural beauties and for its Classical associations. The view of the Gulf of Naples facing west towards the islands of Ischia, Procida and, above all, Capri with the remains of Tiberius' villas, provided an idyllic setting admired by all who visited it. To the southeast, Vesuvius dominated; an ascent up to its crater, with Pliny's description of the fatal eruption in AD 79 at the back of the mind, was an essential experience for every educated visitor. Its contemporary eruptions were watched with keen interest. At the foot of the mountain, the newly excavated ruins at Pompeii and Herculaneum (discovered in 1709 as the result of statuary being found near the casino at Portici, which belonged to Prince Emanuel-Maurice Elboeuf) were a source of serious study, and the decorations found at Pompeii had great influence on Neoclassical taste throughout Europe.

To the west of Naples was the richest area of what Addison described as "classic ground". Traveling through a region of extinct volcanoes called the Campi Phlegraei, a wild landscape recalling the work of Salvator Rosa (1615–73) to the 18th century, the visitor reached Posillipo, where Virgil lived and wrote the *Eclogues* and the *Georgics*. Virgil's tomb, also a place of interest, stood above the famed Roman tunnel or Grotto, which was still in use at this time. The continuation of the road along the Gulf of Pozzuoli presented the richest associations with Classical mythology, history and literature. It was the legendary home of the Cimmerians and Aeneas was supposed by Virgil to have landed at Baia, later entering Hades through the Grotto of the Cumaean sybil at Lake Avernus in the wild volcanic region to the north. During the imperial age Baia, praised by Horace for its "soothing waters", was the site of luxurious villas, belonging to Julius Caesar, Caligula and Nero among others; its reputation for extravagance and immorality, at its height during the reign of Nero,

was not forgotten. And nearby stood the circular temple of Venus, a building intently studied by many of the artists of the 18th century.

Naples' natural beauties and its agreeable life-style devoted to pleasure attracted the residence of a number of distinguished foreign visitors. At the beginning of the 18th century the third Earl of Shaftesbury lived there. From 1764 until 1800 Sir William Hamilton was in residence as British envoy and plenipotentiary. With his collection of antiquities and in the company of his second wife, Emma, he was probably the most celebrated foreigner there, visited among others by William Beckford and Goethe. In 1759 Ferdinand IV succeeded Charles III, who during his reign as King of Naples and Sicily had commissioned the building of Caserta as a rival in size and grandeur to Versailles. By comparison, Ferdinand IV offered a welcoming if dull court during the second half of the century.

Below: *Thomas Jones (1742–1803):* Houses in Naples, *oil on paper, 1776–83 (British Museum, London).*

As well as the attraction of the Roman ruins, and the romance of the setting in the shadow of Mt. Vesuvius, foreign artists in Naples also studied, as here, the atmosphere of the modern city – a romantic mixture of wealth and dilapidation.

Left: *William Pars (1742–82):* The Temple of Venus, Baia, *watercolor (City Museum and Art Gallery, Birmingham).*

The Temple of Venus at Baia, the landing place of Aeneas and the site of a luxurious Roman imperial villa, was one of the favorite subjects of the 18th-century artist.

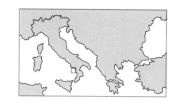

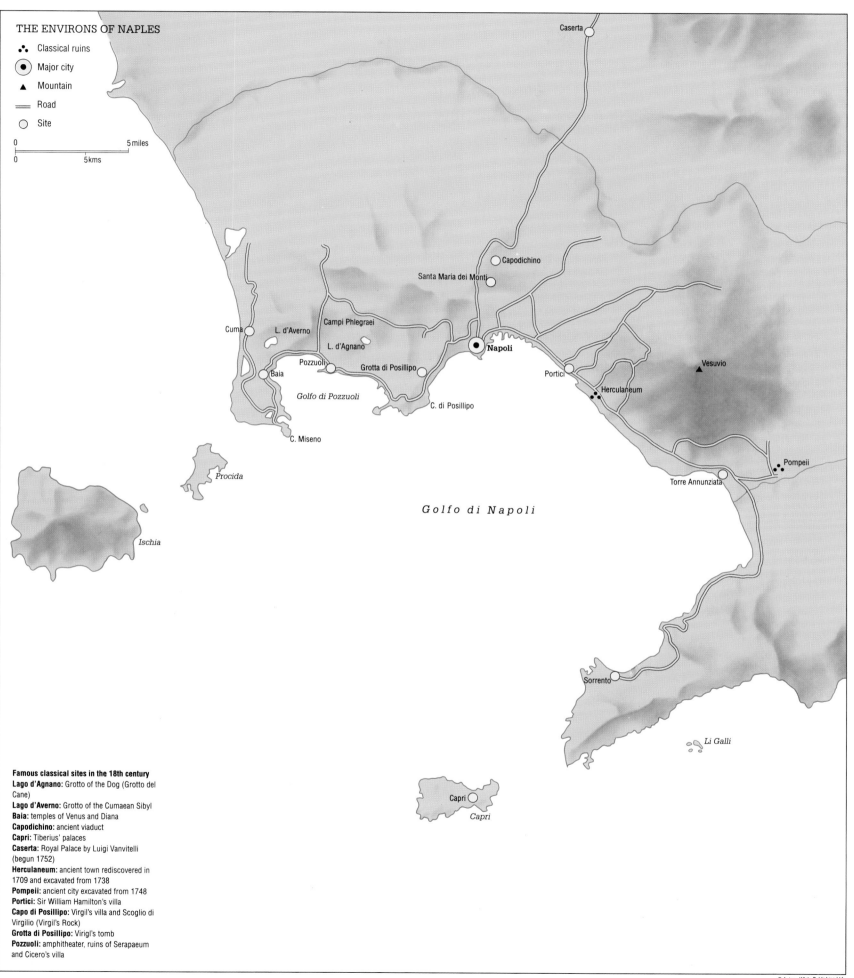

THE ENVIRONS OF NAPLES

- ∴ Classical ruins
- ⊙ Major city
- ▲ Mountain
- — Road
- ○ Site

0 ————————— 5 miles
0 ————————— 5kms

Caserta

Capodichino

Santa Maria dei Monti

Cuma
L. d'Averno
Campi Phlegraei
L. d'Agnano
Pozzuoli
Grotta di Posillipo
Napoli
Baia
Portici
Vesuvio
Golfo di Pozzuoli
Herculaneum
C. di Posillipo
C. Miseno

Pompeii

Procida
Torre Annunziata

Golfo di Napoli

Ischia

Sorrento

Li Galli

Capri
Capri

Famous classical sites in the 18th century
Lago d'Agnano: Grotto of the Dog (Grotto del Cane)
Lago d'Averno: Grotto of the Cumaean Sibyl
Baia: temples of Venus and Diana
Capodichino: ancient viaduct
Capri: Tiberius' palaces
Caserta: Royal Palace by Luigi Vanvitelli (begun 1752)
Herculaneum: ancient town rediscovered in 1709 and excavated from 1738
Pompeii: ancient city excavated from 1748
Portici: Sir William Hamilton's villa
Capo di Posillipo: Virgil's villa and Scoglio di Virgilio (Virgil's Rock)
Grotta di Posillipo: Virigl's tomb
Pozzuoli: amphitheater, ruins of Serapaeum and Cicero's villa

© Antony White Publishing Ltd.

Environs of Rome

Rome is surrounded by an extensive plain called the Campagna (the word is simply Italian for "country"), bounded on the west by the Tyrrhenian Sea and on the other sides virtually circled by the Sabine and Alban hills. It was traversed by such ancient roads as the Via Appia and the Via Nomentana. From ancient times the region has had rich artistic and literary associations and has been regarded as a place of pleasant retreat from the bustle of the city.

Rome's most important resident – the pope – had his summer home in the picturesque town of Castel Gandolfo, where the emperor Domitian (A.D. 81–96) had a magnificent villa, remains of which are still visible. The papal palace was built mainly in 1623–6 for Urban VIII (1623–44) around a medieval castle; Carlo Maderno (c.1556–1629) and Gianlorenzo Bernini (1598–1660) may have worked on the building. (Bernini designed the exquisite little church of S. Tomaso di Villanova, (1658–61) that stands in front of the palace and also the more elaborate S. Maria dell' Assunzione (1662–4) at nearby Ariccia – two little–known masterpieces by the greatest of Italian Baroque artists.) Among the other outstanding residences in the hills outside Rome are the Villa Aldobrandini, built in 1598–1604 for Cardinal Pietro Aldobrandini, and the Villa d'Este at Tivoli, built for Cardinal Ippolito d'Este, who acquired the site in 1550. The Villa d'Este is famous not so much for its architecture as for its gardens – the most spectacular in Italy.

Pirro Ligorio (1513/14–83), a learned architect, painter and antiquary, was the mastermind behind the gardens, which originally were even more impressive than they are today. Some of the fountains made musical sounds and there were also water jokes *giochi d'acqua* – unsuspecting visitors could be sprayed with water from concealed pipes. The hydraulic technology involved was extremely ingenious. Originally, too, the gardens boasted a superb display of statuary, much of it ancient work taken from the Villa of Hadrian, about four miles (6 km) away.

The word "villa" in this context is misleading, for the summer home of the emperor Hadrian (A.D. 117–38) was a palace on a vast scale (almost a small city), with sumptuous surroundings and gardens. Its remains are still impressive, and in the 17th and 18th centuries the picturesque ruins and the beautiful (often rugged) surrounding countryside were favorite subjects with artists. The German painter and writer Joachim von Sandrart (1606–88), who lived in Rome from 1629 to 1635, recalled later that he was working "brush in hand, in Tivoli, in the wild rocks at the famous cascade" when he met Claude Lorrain (1600–82), the most famous and influential landscape painter of the age.

Although earlier artists had painted the Campagna, it was the Frenchman Claude (who lived in Rome permanently from 1627) who made the subject his own. He went on sketching expeditions into the countryside, sometimes with his friend Nicolas Poussin (1594–1665), and drew from nature all his life. Like many other artists, he made drawings of the ancient remains that were so abundant in the region, but it was nature that really fascinated him. Sandrart records that "when he had well

contemplated one or other in the fields, he prepared his colors accordingly and applied them to his works with much greater naturalness than anyone had ever done."

Claude, Poussin, and Poussin's brother-in-law, Gaspard Dughet (1615–75), set the tone for classical landscape painting into the 19th century. Claude evoked a poetic world of pastoral serenity; Poussin depicted a magnificent vision of the ancient world; and Dughet emphasized the more rugged aspects of nature.

At the French Academy Charles-Joseph Natoire, director from 1751–1774, actively encouraged the *pensionnaires* to sketch directly from nature both in the city itself and in the surrounding Campagna. Views of the Roman landscape both in oil and watercolor, were greatly in demand as souvenirs of the Grand Tour and formed an essential part of 18th century art.

Perhaps the most poignant Roman landscapes of the 18th century, however, are those of the Villa d'Este by the French painter Jean-Honoré Fragonard (1732–1806), who visited Italy in 1756–61 and 1773–4. By this time the gardens had long fallen into picturesque decay, and their magical, melancholy beauty haunted and inspired him for the rest of his life.

Below: *Jean-Honoré Fragonard (1732–1806):* Waterfalls at Tivoli, *1760, oil on canvas (Louvre, Paris).*

For many years attributed to Fragonard's friend and fellow-painter Hubert Robert, this work may have originally belonged to Saint-Non, with whom Fragonard travelled from Rome to Paris in April–September 1761.

THE ENVIRONS OF ROME

- ⊙ City
- ▲ Mountain
- ═══ Road
- ○ Site

```
0  1  2  3  4  5  6  7 kms
0     1     2     3     4    5mls
```

Lago d'Albano: Emissarium amd Galleria di Sopra

Via Appia: Grotto della Ninfa Egeria, tombs of Cecilia Metella and the Horatii, Villa of the Quintilii

Ariccia: town bought by Chigi (1661): Palazzo Chigi (formerly Savelli) modernised by Bernini (from 1661), S. Maria dell'Assunzione by Bernini (1662–64)

Castelgandolfo: Papal Palace by Carlo Maderno (1623–26), S. Tomaso di Villanova by Bernini (1658–61)

Frascati: Villa Aldobrandini (completed 1603) with Stanza di Apollo painted by Domenichino (1616–18)

Genzano: Palazzo Cesarini, Capuchin monastery

Grottaferrata: abbey, dome frescoed by Domenichino (1608–10)

Licenza: Horace's villa

Nemi: Castle of the Orsini

Lago di Nemi: grove and temple of Diana

Tivoli: Villa d'Este, Falls, temples of the Sibyl (Vesta) and Tiberius, Grotto of Neptune, Villa of Maecenas, tomb of Plautius

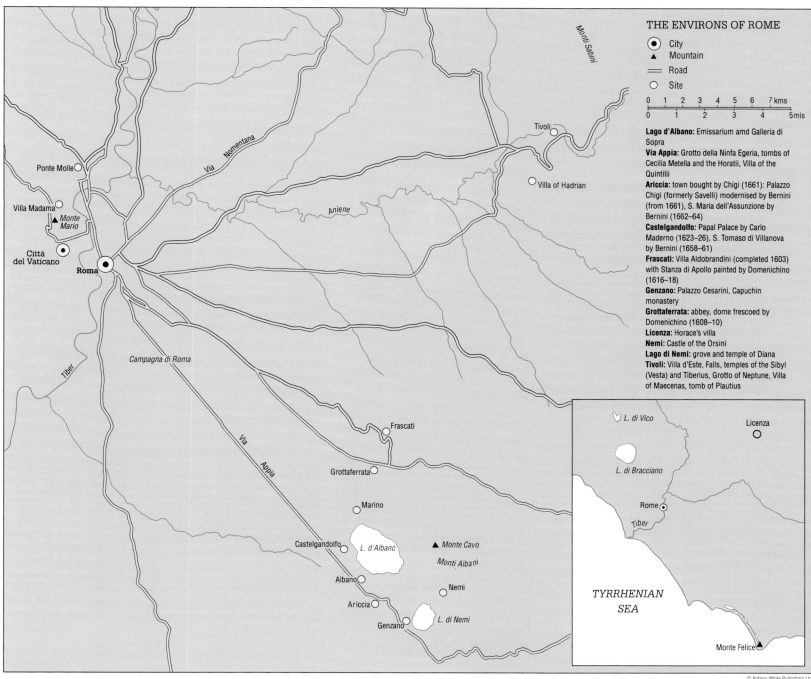

Right: *Richard Wilson (1714–82): detail from* The Via Nomentana, *1754, black chalk and stump, heightened with white, on grey paper (Paul Mellon Collection, Yale Center for British Art).*

One of the most important English portrait and landscape painters before Turner and Constable, Wilson went to Italy in 1750 and returned to London seven years later. He was commissioned by the Earl of Dartmouth to produce a series of finished landscape drawings in chalk, mainly around Rome and Naples.

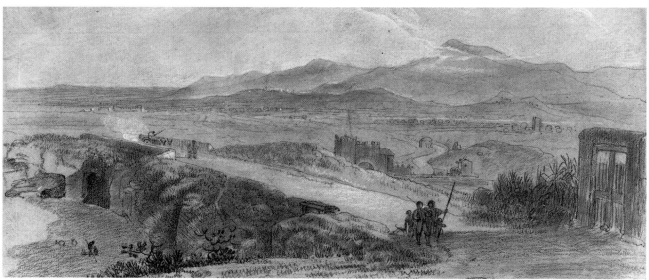

Baroque Rome

Following the architecturally barren years after the Sack of Rome in 1527, two important developments took place which paved the way for the emergence of the Baroque in about 1620. Sixtus V (1585–90) had transformed the city through a major piece of town planning, creating a number of long straight avenues linking various central points, including most spectacularly the three streets leading inwards from the Porta del Popolo; and under Paul V (1605–21) the nave of St. Peter's was finally completed. The city and its principal church were ready for adornment. The next hundred years – above all during the papacies of Gregory XV (1621–3), Urban VIII (1623–44), Innocent X (1644–55) and Alexander VII (1655–67), who were supported by their Ludovisi, Barberini, Pamphili and Chigi relatives – witnessed as great a flowering of the arts as there had been at any time during Rome's long history. (The new Orders – the Jesuits, the Theatines, the Oratorians and the Barnabites – also played an important role.) Palaces, churches and other religious buildings were built and lavishly decorated; continuing what Sixtus V had begun, the streets were enriched with piazze, fountains and obelisks. Today the Baroque style, more than any other, dominates Rome's appearance.

The quality and invention of the new-style fresco decoration had been established by Annibale Carracci (1560–1609) in the Palazzo Farnese in 1597. From 1600 to 1620 a number of followers, principally Guido Reni (1575–1642), Domenichino (1581–1641) and Francesco Albani (1578–1660), carried out a series of large-scale fresco cycles in new churches, which set a standard for the remainder of the century. But the principal figures in mid-century who, more than any others, were responsible for the creation of the full Baroque style were Gianlorenzo Bernini (1598–1680) in architecture and sculpture (he also painted), Francesco Borromini (1599–1667) in architecture and Pietro da Cortona (1596–1669) in architecture and painting. Much of Bernini's career was devoted to the embellishment of St. Peter's under Urban VIII and Alexander VII, but he also carried out numerous other architectural and sculptural works. Borromini's major period of papal patronage occurred during the reign of Innocent X, when work on the palace and church in the Piazza Navona and the restoration of the Lateran were set in train, but his most complete works were carried out for ecclesiastical patrons. Pietro da Cortona succeeded in attracting work from all three papal families. Not every commission was on a monumental scale and some of the smaller works, such as Bernini's S. Andrea al Quirinale and Borromini's S. Carlo alle Quattro Fontane, are the most distinctive and original creations of the period.

The Baroque style continued in a modified form, more appropriately described as *barocchetto* than Rococo, well into the 18th century when the major commissions were concentrated on the building of the façades of the Lateran church and Sta. Maria Maggiore as well as such decorative ventures as the Fontana di Trevi and the Spanish Steps. By the mid-1700s Neoclassicism had gained supremacy. At the same time Rome's dominance in the arts had passed elsewhere.

Left: *Gianlorenzo Bernini (1598–1690): The Ecstasy of St. Teresa, 1645–52 (S. Maria della Vittoria, Rome).*

The ultimate in Roman Baroque sculpture, Bernini's rendering of the mystical experience of St. Teresa of Avila combines the use of multi-colored marbles, a single viewpoint and intense drama.

Below: *The* Piazza del Popolo *with the churches of S. Maria di Monte Santo (by Carlo Rinaldi with Bernini, begun 1662) on the left and S. Maria dei Miracoli (by Carlo Rinaldi, begun 1662) on the right. Etching from* Roma Moderna *by Ridolfino Venuti Cortonese, Rome, 1766.*

The three streets radiating out towards central Rome, anchored by an ancient Egyptian obelisk, show one of the most spectacular examples of the urban planning of Pope Sixtus V (1585–90), and provide the perfect setting for later Baroque building.

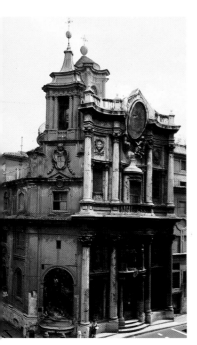

Above: *Francesco Borromini (1599–1667):* S. Carlo alle Quattro Fontane, *façade 1665–7.*

Borromini's first major achievement, a tiny church but exquisitely geometrically planned, rhythmic and sculptural. The later façade has a concave-convex-concave plan.

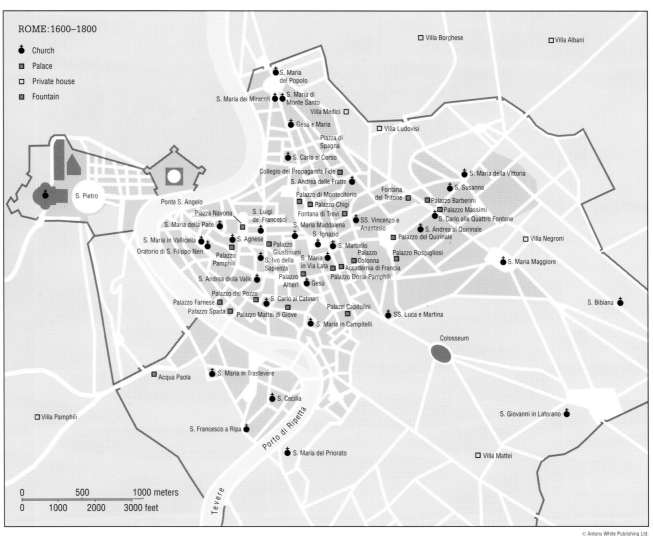

ROME: 1600–1800

- ● Church
- ■ Palace
- □ Private house
- ▪ Fountain

© Antony White Publishing Ltd.

Public buildings

Acqua Paola, by Flaminio Ponzio (1610–14)

Churches

S. Agnese in Piazza Navona, begun by Girolamo and Carlo Rainaldi (1652), and completed by Borromini (from 1653)

S. Andrea delle Fratte, dome and campanile by Borromini (1654–65); sculpture by Bernini (1668–71)

S. Andrea della Valle, by Giacomo della Porta (1591–1621); dome frescoed by Giovanni Lanfranco (1625–7)

S. Andrea al Quirinale, by Bernini (1658–70)

S. Bibiana, by Bernini (1624); frescoes by Pietro da Cortona (1624–6)

S. Carlo ai Catinari, by Rosato Rosati (begun 1611); Cappella di S. Cecilia by Antonio Gherardi (1691)

S. Carlo al Corso, dome by Pietro da Cortona (begun 1668)

S. Carlo alle Quattro Fontane, by Borromini, begun 1634

S. Cecilia, frescoes by Sebastiano Conca (1725)

S. Francesco a Ripa, Albertoni chapel decorated by Bernini (1674) and Baciccio (1675)

Gesù, nave frescoed by Baciccio (1674–9); altar of S. Ignazio by Andrea Pozzo (1696)

Gesù e Maria, interior by Carlo Rainaldi (begun 1675)

S. Giovanni in Laterano, nave by Borromini (1646–9); façade by Alessandro Galilei (1733–6)

S. Ignazio, nave ceiling frescoed by Andrea Pozzo (1685–94)

S. Ivo della Sapienza, by Borromini (1642–50)

SS. Luca e Martina, by Pietro da Cortona (begun 1635); home of the Accademia S. Luca

S. Luigi de'Francesci, paintings in Contarelli Chapel by Caravaggio (1599–1602); frescoes by Domenichino (1616–17)

S. Marcello, façade by Carlo Fontana (1682–3)

S. Maria in Campitelli, by C. Rainaldi (1663–7)

S. Maria Maddalena, by Giuseppe Sardi (1733)

S. Maria Maggiore, Cappella Paolina designed by Flaminio Ponzio (1605–11), and painted by Cavaliere d'Arpino and Guido Reni (1610–12); façade by Ferdinando Fuga (1741–3)

S. Maria dei Miracoli, by Carlo Rainaldi (begun 1662)

S. Maria di Monte Santo, by Carlo Rainaldi with Bernini (begun 1662)

S. Maria della Pace, façade and dome by Pietro da Cortona (1656–7)

S. Maria del Popolo, paintings in Cerasi Chapel by Caravaggio (1600–1); sculpture in Chigi Chapel by Bernini (1655–61); Cappella Cibo by Carlo Fontana (1681–3)

S. Maria del Priorato, by Giovanni Battista Piranesi (begun 1764)

S. Maria in Trastevere, Cappella Avila by Antonio Gherardi (before 1686)

S. Maria in Vallicella, façade by Fausto Rughesi (1605); altarpieces by Rubens (1608); ceiling frescoes by Pietro da Cortona (1647–65)

S. Maria in Via Lata, façade and vestibule by Pietro da Cortona (1658–62)

S. Maria della Vittoria, Cappella Cornaro by Bernini (late 1640s)

Oratorio di S. Filippo Neri, by Borromini (1637–40)

S. Pietro, completion of nave (1605) and façade (1614) by Carlo Maderno; baldacchino (begun 1624), Cathedra Petri (1657–65) and Scala Regia (1663–5) with Constantine (1654–68) by Bernini; tombs of Urban VIII (1628–47) and Alexander VII (1671–8) by Bernini, Leo XI (1634–44) by Alessandro Algardi, and Gregory XIII (1719–25) by Camillo Rusconi

S. Susanna, façade by Carlo Maderno (1603)

SS. Vincenzo e Anastasio, by Martino Longhi (1646–50)

Fountains

Fontana del Tritone, by Bernini (1642–3)

Fontana di Trevi, by Nicola Salvi (1732–45)

Palaces

Accademia Francese (from 1725)

Collegio di Propaganda Fide, by Borromini (from 1646)

Palazzo Altieri, Great Hall frescoed by Carlo Maratti (after 1673)

Palazzo Barberini, begun by Carlo Maderno (1628) completed by Bernini with assistance from Borromini; Gran Salone ceiling frescoed by Pietro da Cortona (1633–9); frescoes by Andrea Sacchi (1629–31); collection of antique sculpture and paintings of Cardinal Matteo Barberini (later Urban VIII)

Palazzi Capitolini, sculpture collection formed by Clement XII (1733)

Palazzo Chigi, façade (now altered) by Bernini (begun 1664)

Palazzo Colonna, gallery by Antonio del Grande (begun 1654); frescoes by Giovanni Coli and Filippo Gherardi (1675–8)

Palazzo Doria-Pamphili, façade on Corso by Gabriele Valvassori (1731–4); collection of Camillo Pamphili

Palazzo Farnese, gallery painted by Annibale Carracci (begun 1597); collection of antique sculpture

Palazzo Giustiniani, collection of antique sculpture and paintings of Marchese Vincenzo Giustiniani (d.1638)

Palazzo Massimi (later Albani), collections of Cardinal Camillo Massimi (d.1677) and Cardinal Alessandro Albani

Palazzo Mattei di Giove, by C. Maderno (begun 1598); paintings by Francesco Albani (1606–7)

Palazzo di Montecitorio, begun by Bernini (1650) finished by Carlo Fontana (1694)

Palazzo Pamphili, by Girolamo Rainaldi and Borromini (begun 1646); gallery ceiling frescoed by Pietro da Cortona (1651–5); library ceiling frescoed by Francesco Cozza (1667–73)

Palazzo del Pozzo, museum

Palazzo del Quirinale, fresco by Pier Francesco Mola (1657)

Palazzo Rospigliosi, ceiling in Casino, *Aurora*, painted by Guido Reni (1613)

Palazzo Spada, colonnade by Borromini (1652–3)

Piazze

Piazza Navona, Fountain of the Four Rivers, by Bernini (1648–51)

Piazza di S. Ignazio, by F. Raguzzini (1727–8)

Piazza di Spagna, by F. de Sanctis (1723–5)

Bridge

Ponte S. Angelo, sculpture by Bernini and others (1670)

Port

Porto di Ripetta, steps by Alessandro Specchi (1704)

Villas

Villa Albani (Torlonia) by Carlo Marchionni (1756–62); ancient sculpture collection of Cardinal Alessandro Albani

Villa Borghese, begun by Flaminio Ponzio (1605); frescoes by Giovanni Lanfranco (1624–5); collection, including sculptures by Bernini, of Cardinal Scipione Borghese

Villa Ludovisi, Casino ceiling, *Aurora*, frescoed by Guercino (1621–3); ancient sculpture collection of Cardinal Ludovisi

Villa Mattei, collection of antique sculpture

Villa Medici, collection of antique sculpture

Villa Pamphili, collection of antique sculpture

Villa Sacchetti (destroyed), Casino (the Pigneto) by Pietro da Cortona (before 1630)

Painting and Architecture in Venice 1600–1797

The early Seicento was a period of decline from the peaks of achievement of Titian (*c*.1487–1576) and Tintoretto (1518–94), although Palma the Younger (*c*.1548–1628) evoked Tintoretto's masterly control of light and volume. Sebastiano Ricci (1659–1734) links the seicento painters with Tiepolo's Baroque. Some of his work matches the heroic scale of Veronese (*c*.1528–88), while his dramatic perspectives and color anticipate G.B. Tiepolo. Piazzetta (1683–1754) and Tiepolo (1696–1770), however, took Baroque decoration to new heights; Piazzetta's palette was more somber than Tiepolo's and his art serious and richly painted, but Tiepolo has no equal as the most skilful and inventive artist of the Settecento. His long and prolific career dominated Baroque painting as Longhena's did architecture, and his style is best seen in the frescoes at Palazzo Labia and the Scuola dei Carmini, where audacious *trompe l'œil* combines with technical mastery. There are many altarpieces.

Much of Tiepolo's work was of a religious or allegorical nature; the other flourishing genre in settecento Venice was view-painting. Gian-Antonio Guardi (1698–1760) developed a light, fluid approach to religious works, a technique adapted by his brother Francesco (1712–93) in an extensive output of *vedute* and *capricci*, another particularly Venetian genre. Canaletto (1697–1768), the other notable *vedutisto*, developed a style of flat planes and draftsman-like linearity, in sharp contrast to Guardi's free touch. Much of Canaletto's work was exported to England by the Consul, Joseph Smith, and there is virtually no work of his (and little of Guardi's) left in Venice today. Finally, we should mention the charming, rather naive, genre paintings of Pietro Longhi (1702–85), many of them now at Ca' Rezzonico.

In architecture, Baldassare Longhena (1598–1682), Scamozzi's pupil, was the outstanding figure of the Seicento. He left Scamozzi's (1552–1616) rather academic Classicism to develop a rich Baroque style, reaching its peak at Sta. Maria della Salute (1631–87), a grandiose church with a centralized dome; here the skilful plan links a central octagon with subsidiary volumes using a Palladian vocabulary, while the exterior is a *tour de force* which dominates the mouth of the Grand Canal. Longhena's other major works are Ca' Pesaro and Ca' Rezzonico, both monumental palaces later completed by Gaspari and Massari. Other exponents of mature Baroque include Sardi (*c*.1630–99), with the façades of the Scalzi and the Ospedaletto; Rossi (1678–1742), with the Gesuiti and the more classical Palazzo Corner della Regina; and Tremignon (17th century), with the extraordinary façade of S. Moisè, the richest in the city.

By 1700, a Neo-Palladian reaction against such excesses had begun, evinced by the work of Tirali (1660–1737) at the Tolentini and S. Vidal, and by the long career of Massari, embracing both the later Baroque and the Classical revival. His own palaces include the restrained but imposing Palazzo Grassi, and the churches of the Fava, the Pietà, the Gesuiti and S. Marcuola. Gaspari (*c*.1670–*c*.1730), his contemporary, built palaces in a disciplined late Baroque style, including the Palazzo Giustiniani at Murano and the Albrizzi and Zenobio houses in Venice, whose exteriors give little hint of the extravagant stucco decoration inside.

Eighteenth-century sculpture is dominated by Canova (1757–1822), whose own Neoclassicism developed great refinement and technical skill, and whose idealized Classical beauty found favor with Napoleon after the fall of the Republic.

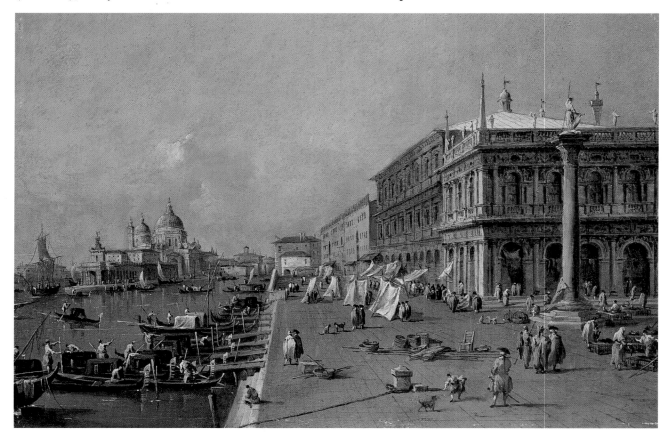

Left: *Francesco Guardi (1712–93):* Venice, with the Molo, the Libreria, the Punta della Dogana and S. Maria della Salute *(Private Collection).*

The view in the 18th century from the waterfront of Piazza S. Marco, looking across to the Church of S. Maria della Salute, Baldassare Longhena's Baroque building with Palladian motifs which dominates the entrance to the Grand Canal.

Right: *Giovanni Antonio Guardi (1698–1760):* Il Ridotto *(Ca' Rezzonico, Venice).*

Although the main achievements of Venetian art were over by the 18th century, both the social life and appearance of the city were recorded in Venetian paintings sold to the ever-increasing numbers of foreign visitors.

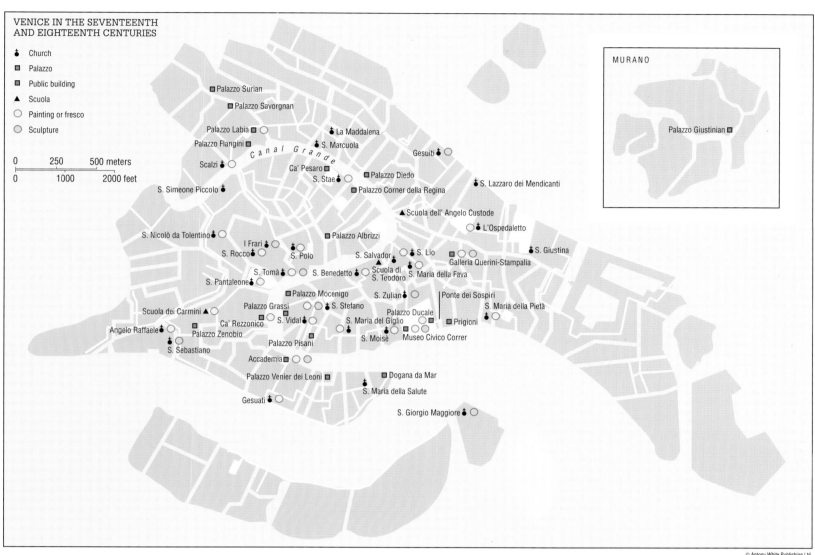

VENICE IN THE SEVENTEENTH AND EIGHTEENTH CENTURIES

- Church
- Palazzo
- Public building
- Scuola
- Painting or fresco
- Sculpture

0 250 500 meters
0 1000 2000 feet

Palazzo Surian

Palazzo Savorgnan

Palazzo Labia
Palazzo Flangini
La Maddalena
S. Marcuola

Scalzi
Ca' Pesaro
Gesuiti

Canal Grande
S. Stae
Palazzo Diedo

S. Simeone Piccolo
Palazzo Corner della Regina
S. Lazzaro dei Mendicanti

Scuola dell' Angelo Custode

L'Ospedaletto

S. Nicolò da Tolentino
Palazzo Albrizzi

I Frari
S. Salvador
S. Lio
S. Giustina

S. Rocco
S. Polo
Galleria Querini-Stampalia

S. Tomà
S. Benedetto
Scuola di
S. Maria della Fava

S. Pantaleone
S. Teodoro

Palazzo Mocenigo
S. Zulian
Ponte dei Sospiri

Palazzo Grassi
S. Stefano
Palazzo Ducale
S. Maria della Pietà

Scuola dei Carmini
Ca' Rezzonico
S. Vidal
Palazzo Ducale
Prigioni

Angelo Raffaele
Palazzo Zenobio
S. Maria del Giglio
Museo Civico Correr

S. Sebastiano
Palazzo Pisani
S. Moisè

Accademia

Palazzo Venier dei Leoni
Dogana da Mar

Gesuati
S. Maria della Salute

S. Giorgio Maggiore

MURANO

Palazzo Giustinian

© Antony White Publishing Ltd.

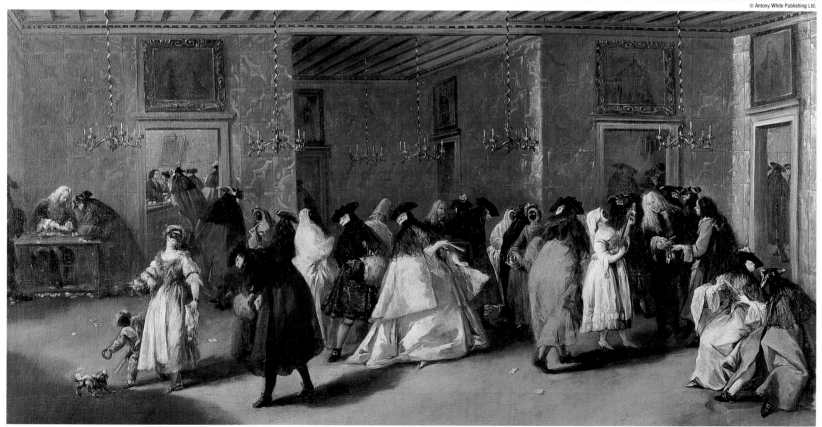

The Spread of Caravaggism

Caravaggio's (1571–1610) distinctive qualities of clarity of design, intense light and a precise rendering of detail described in bright local colors are already apparent in his earliest works, principally of still-life subjects, painted after his arrival in Rome. His first public work there, the decoration of the Contarelli chapel in S. Luigi dei Francesi, caused the artist great problems in satisfying the commission given by Cardinal del Monte. The first altarpiece was rejected and the two canvases on the side walls had to be extensively repainted. It set a pattern of response that recurred in most of his religious commissions, which attracted much hostility and criticism largely on the grounds of decorum. At the same time the artist was the subject of much general comment and interest; and his rejected paintings were eagerly acquired by cardinals and noblemen.

Caravaggio's style consists of a rejection of idealization in favor of a seeming realism vividly depicted in contemporary costumes and settings. Solidly defined figures are represented with expressive and often violent gestures, in unusual and dramatically arresting groups composed within a shallow foreground space; his pictures are realized in a powerful chiaroscuro which emphasizes the three-dimensional form. His method of painting was regarded as revolutionary; instead of following the traditional procedure of working from drawings and sketches (no drawings by Caravaggio exist), he painted directly from the posed model on to the canvas, often making changes as he advanced. As a consequence, his works succeed in creating an immediate and sometimes startling effect on the beholder.

After fleeing from Rome in 1606, Caravaggio was constantly on the move, working briefly in Naples, Malta and Sicily. Despite his short life, and the fact that no artist was his pupil and few knew him personally, his impact throughout Europe, much of it at second hand, is one of the most remarkable features of 17th-century art. No artist understood or absorbed the totality of his conception, but each took the aspect of his art that personally appealed and for the most part re-created it in a watered-down manner. In Rome his influence was immediate; it is evident, for example, in Rubens' first religious commission painted immediately after his arrival in 1601. At first his effect was primarily felt in paintings of genre subjects of cardplayers, lute players and drinkers, and it was only in the second decade of the century that Caravaggesque painters started to receive commissions for religious works. But the phenomenon had run its course by 1620, when those influenced had either died or returned home. The latter, such as Simon Vouet, either reverted to a native style or continued to reflect something of the master's style, thereby creating new centers of influence.

In Italy, Naples remained the most lasting bastion of Caravaggio's influence; it was reflected in the work of both native artists and foreigners such as Ribera, who followed the master's taste for violent subjects and strong chiaroscuro. A no less important center perpetuating Caravaggio's achievement was established in Utrecht by artists, notably Terbrugghen and Honthorst, who on their return from Rome retained the basic contrast of light and shadow; but they increasingly lightened the tone in their religious and genre pictures.

However, the most effectual and creative influence was felt in the work of those artists – Georges de la Tour, Rembrandt and Velazquez – who probably gained their knowlege of Caravaggio's style at second hand from other followers rather than from direct contact with original works. Of the three, la Tour came closest both in his choice of subject matter and in his use of chiaroscuro. Rembrandt, probably through his knowledge of paintings by Rubens as well as by the Utrecht School, eventually developed his own very personal chiaroscuro from his early absorption of the Caravaggesque lighting effects. Caravaggio may also be the source at one remove of Velazquez' early *bodegons* and religious pictures. Although by the middle of the 17th century Caravaggio's demonstrable influence had largely disappeared, he can be regarded as an ultimate source of inspiration for many artists of later generations.

Below: *Georges de la Tour (1593–1652):* A Woman Catching Fleas. *Oil on canvas (Musée Historique, Nancy).*

De la Tour, as with Rembrandt and Velazquez, made the most creative use of the lessons of Caravaggism. This painting combines chiaroscuro and candlelight with an uncompromising realism, and achieves a surprising intimacy of feeling.

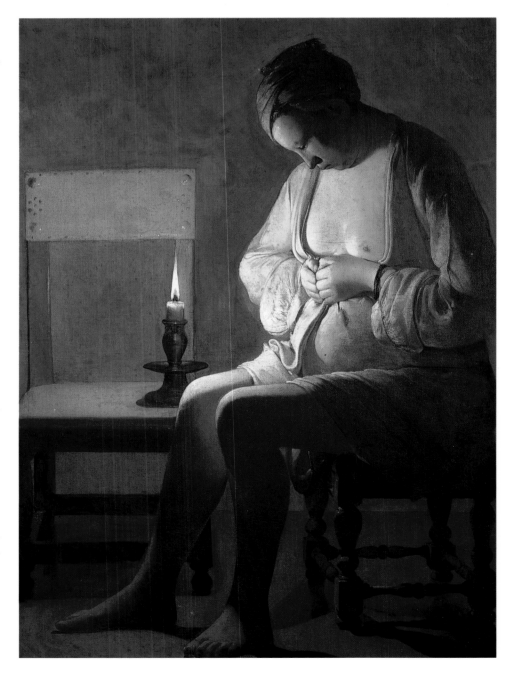

THE SPREAD OF CARAVAGGISM

○ Center of Caravaggism

◉ Center of Caravaggio's work and dates of stay

0 100 200 kms
0 100 miles

NORTH SEA

Oldenburg Wolfgang Heimbach (*active* 1636–78)

Amsterdam
Claes Cornelisz Moeyaert (*c.*1590/1–1655)
Rembrandt van Rijn (1606–69)

Jan Lievens (1607–74)
Leiden
Rotterdam
Crijn Volmarijn (*c.*1604–45)
Gorkum
Gerard van Kuyl (1604–73)
Bruges
Louis Finson (*before* 1580–1617)
Jacob van Oost I (1601–71)

Utrecht
Dirck van Baburen (*by* 1595–1624)
Abraham Bloemart (1564–1651)
Paulus Bor (*c.*1600–59)
Jan van Bylert (1598–1671)
Gerrit van Honthorst (1590–1656)
Hendrick Terbrugghen (1588–1629)

Malines
Adam de Coster (*c.*1586–1643)

Antwerp
Jan Cossiers (1600–71)
Abraham Janssens (*c.*1576–1632)
Theodoor Rombouts (1597–1637)
Peter Paul Rubens (1577–1640)
Gerard Seghers (1591–1651)

Paris
Claude Mellan (1598–1688)
Claude Vignon (1593–1670)
Simon Vouet (1590–1649)

Nancy Jean le Clerc (*c.*1587/8–1633)
Lunéville Georges de la Tour (1593–1652)

Dijon
Philippe Quantin (*c.*1600–36)

Toulouse
Nicolas Tournier (1590–1639)

Milan
Caravaggio (1584–88)

Venice
Johann Liss (1597–1631)

Bologna
Lionello Spada (1576–1622)

Lucca
Pietro Paolini (1603–81)

Siena
Rutilio Manetti (1571–1639)

ADRIATIC SEA

Port' Ercole
Caravaggio (*d.*1610)

Rome
Caravaggio (1592–1606)
Giovanni Baglione (*c.*1573–1644)
Trophîme Bigot (*c.*1600–after 1650)
Orazio Borgianni (*c.*1578–1616)
Artemisia Gentileschi (1593–1639)
Orazio Gentileschi (1578–1610)
Adam Elsheimer (1563–*c.*1652)
Bartolommeo Manfredi (*c.*1587–1621)
Guido Reni (1575–1642)
Nicolas Régnier (1591–1667)
Carlo Saraceni (*c.*1580–1620)
Valentin de Bollogne (1591–1632)

Naples
Caravaggio (1606–07, 1609)
Giovanni Battista Caracciolo (1578–1635)
Mattia Preti (1613–99)
Jusepe de Ribera (1591–1652)
Carlo Sellitto (1580–1614)

MEDITERRANEAN SEA

Messina
Caravaggio (1609)
Mathias Stomer (*c.*1600–*c.*1650)

Palermo
Caravaggio (1609)

SICILY

Syracuse
Caravaggio (1609)

MALTA
Valetta
Caravaggio (1607–8)

© Antony White Publishing Ltd.

Spain and Portugal in the 17th and 18th Centuries

The map of Spain and Portugal in the 17th and 18th centuries demonstrates the artistic importance of the central province of Castile, where the court was established and artistic patronage was focused. Towns of artistic importance spiral out from the Castilian capital, Madrid. Almost all successful Castilian artists and architects spent part of their creative lives there and were able to win commissions and establish themselves. Having won the favor of a royal or noble patron, they might then be employed on projects outside the capital, occasionally far afield. Francisco de Zurbarán from Seville, for instance, was commissioned to provide a cycle of paintings for the important pilgrimage center, Santiago de Compostela.

Madrid was thus the focus of artistic life from the 17th century when the court became fully established there. Architects and artists working for Philip III (1598–1621) and Philip IV (1621–65) included Giovanni Battista Crescenzi, Juan Gómez de Mora, Vicente Carducho, Diego Velázquez and Zurbarán , who were all employed on royal projects in Madrid – the Palacio Real, for instance, built on the site of the Alcázar, or the Palacio del Buen Retiro. In the 18th century this pattern was repeated, the members of the important Churriguera family and court artists such as Francisco de Goya y Lucientes spending a significant part of their working lives in Madrid.

Outside Madrid, the main Castilian centers of royal patronage were the royal palaces of El Pardo, El Escorial, La Granja and Aranjuez. El Escorial was extended in the 17th century by Gómez de Mora, Carbonell and Crescenzi (who also finished building the Pantheon for Philip IV in 1654), and decorated by court artists such as Velázquez and Claudio Gello. Aranjuez and La Granja, developed in the 18th century, were reconstructed by royal architects such as Teodoro Ardemans and decorated by Luca Giordano (1632–1705), Francisco Bayeu (1734–95) and Anton Raphael Mengs (1728–79).

Wealthy patrons in important Castilian centers slightly further from Madrid were also able to attract talented artists and architects, frequently during their careers at court. At Valladolid, Segovia and Salamanca the wealthiest patrons were ecclesiastical, commissioning artists to work on the long-established churches in these towns, in which in the 18th century the dominant influence of the Churriguera family could be seen. Salamanca, for example, employed José Benito de Churriguera on the high altar retable of the church of San Estebán, and his brothers Joaquín, in the crossing dome of the cathedral and the Seminario de Calatrava, and Alberto to develop the Plaza Mayor in 1728. Valladolid, an important center and former capital of Castile, commissioned Alberto to work on Juan de Herrera's (1530–97) cathedral from 1735, and employed Ventura Rodríguez on the Casa de los Agostinos Filipinos from 1760. Segovia employed José Churriguera on the Capilla del Sagrario, where Rodríquez and Filippo Juvarra were also working.

Elsewhere in Castile, ecclesiastical patrons commissioned cycles of religious paintings, most notably the Monasterio del Paular, which employed Carducho and Zurbarán on an extensive cycle of work (1626–1632), and the Monasterio del Guadalupe. Castile thus provided a focus for Spanish art, but outside this center there was considerable regionalization. Andalucía, for instance, was a province with distinct traditions and culture, and although artists such as Velázquez moved from there to Madrid, Castilian artists never attempted to establish a career in Andalucía.

The foremost artists in Andalucía were employed on prestigious ecclesiastical commissions. Alonso Cano (1601–67), in particular, the polychrome wood sculptor and artist, traveled through the region, working in the cathedrals at Seville and Granada. Similarly, the artist Juan de Valdés Leal had received commissions for a retable for the Córdoban Carmelite Church, for the Hospital de la Caridad in Seville, and for the churches of S. Maria and S. Miguel in Arcos de la Frontera and Jerez de la Frontera respectively. Cities such as Valencia further demonstrated the regionalization which was characterisic of Spanish art by their employment of native artists Francisco Ribalta and Pedro Orrente.

Portugal, ruled by Spain until 1640, suffered a drain of artists to Castile. This depletion of the country's indigenous skill was aggravated by its employment of artists from the Netherlands and Italy. The country was divided into two distinct areas: northern Portugal – particularly around Oporto – with its Netherlandish influence; and the southern region around the capital, Lisbon. A modest flowering of Portuguese art occurred c.1715–35, under John V, with Lisbon as the country's foremost cultural and artsitic center.

Above: *Juan Martínez Montañes (1568–1649):* Christ of Clemency, *polychrome wood sculpture, 1603–6, Seville Cathedral, Andalucia.*

A masterful carver and the most famous Spanish sculptor of the 17th century, Montañes worked mostly in Seville. However he was also summoned to Madrid by Philip IV, was painted by Velázquez and influenced the paintings of Velázquez and Zurbarán.

Left: *Filippo Juvarra (1678–1736) and Giovanni Battista Sacchetti (1700–64):* The Royal Palace, Main Staircase, *1735–64, Madrid.*

Originally commissioned by Philip V in 1735 from Juvarra, work was taken over on his death by Sacchetti who based his single-court solution on Bernini's unbuilt plans for the palace of the Louvre in Paris.

SPAIN AND PORTUGAL IN THE SEVENTEENTH AND EIGHTEENTH CENTURIES

- ● Town/city
- □ Architecture 17th century
- ○ Architecture 18th century
- □ Painting 17th century
- ○ Painting 18th century
- □ Sculpture 17th century
- ○ Sculpture 18th century

1 El Pardo
⬚⬚⬚⬚

2 El Escorial
⬚⬚⬚

3 Loeches
⬚⬚

0 100 200 kms
0 100 miles

MEDITERRANEAN
SEA

1 Carbonell, Alonso (active 1620-60)
2 Churriguera, Alberto de (1676-1750)
3 Churriguera, Joaquín de (1674-1724)
4 Churriguera, José Benito de (1665-1725)
5 Crescenzi, Giovanni Battista (1591?-1652)
6 Gomez de Mora, Juan (1585-1628)
7 Juvarra, Filippo (1678-1736)
8 Rodriguez, Ventura (1717-85)
9 Tomé, Narciso (active 1715-42)
10 Carducho, Vicente (1576-1638)
11 Goya, Francisco de G.y Lucientes (1746-1828)
12 Murillo, Bartolomé Estebán (1617/8-82)
13 Ribera, José (1591? -1652)
14 Valdés Leal, Juan de (1622-90)
15 Velazquez, Diego (1599-1660)
16 Zurbarán, Francisco de (1598-1664)

© Antony White Publishing Ltd.

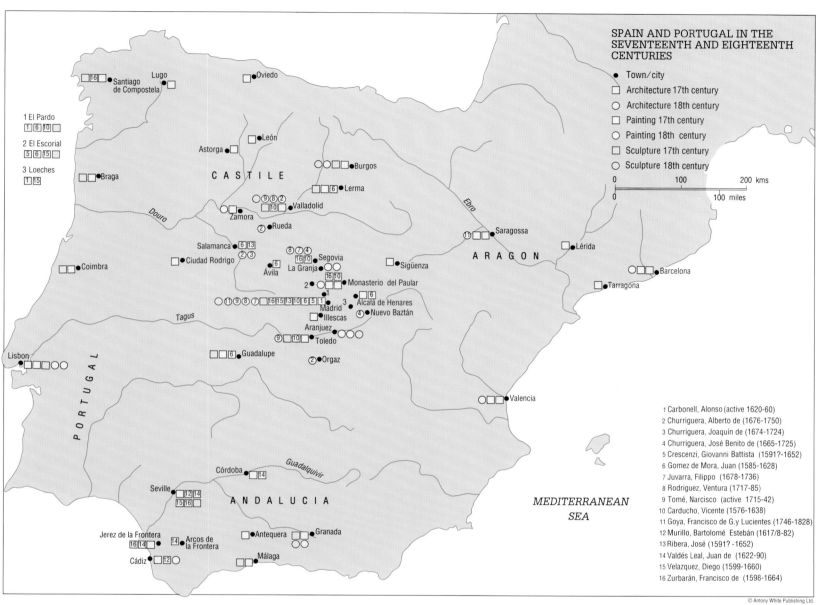

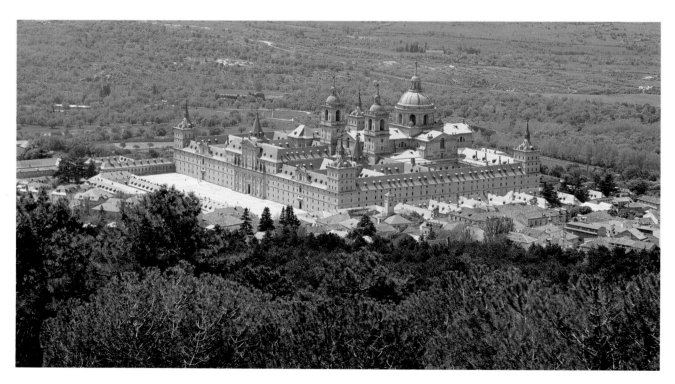

Right: *Juan Bautista de Toledo (d.1567), Juan de Herrera (c.1530–97) and others: The Escorial, 1562–82, near Madrid.*

Philip II commissioned this enormous complex of buildings to serve as palace, college, monastery and church. The domed church, by Herrera, was an austere Spanish rendering of an Italian design. Additional building work by Carbonells, Crecsenzi and Gómez de Mora was commissioned in the 17th century, when the palace was also decorated by Velázquez and Claudio Gello amongst others. The Escorial is built in yellowish-gray granite, which color emphasizes the severity of the design.

215

Madrid

The development of Madrid reflected its assumption of the role of capital and foremost city in Spain. Until the 17th century, building schemes were piecemeal and sporadic, tending to occur during the period of court residence. Throughout the 17th and early 18th centuries, however, there began a major program of expansion, reflecting Madrid's predominance as the administrative and bureaucratic capital, as well as the center of the court. Formerly a tightly-knit series of roads radiating from the central Plaza Mayor to the Alcázar in the west and to the area round the Palacio del Buen Retiro in the east, the city pushed both north and southwards with the rapidly expanding population.

The most significant period of artistic activity, known as the "Golden Age", occurred in the 17th century. Artists from all over Spain and abroad clustered round the court, where lucrative commissions and posts could be won. Velázquez, Zurbarán and Carducho all worked for Philip IV, notably collaborating on a series of paintings for the Salón de Reinos in the new Palacio del Buen Retiro. Peter Paul Rubens (1577–1640) received a royal commission for a series of tapestry cartoons for the Convento de las Descalzas Reales. In 1700 the accession of the grandson of Louis XIV of France, Philip V, ensured the influence of foreign artists in Madrid such as Corrado Giaquinto (1703–65) and G. B. Tiepolo (1696–1770), who both helped to redecorate the new Palacio Real.

The most important building programs were for royal, aristocratic and ecclesiastical purposes. The Alcázar palace, originally a Moorish fortress built on the highest western point of Madrid, was expanded and developed between the 16th and the 18th centuries. Juan Bautista de Toledo (d.1567), the architect from 1561, was followed in 1626 by Gómez de Mora who super-

vised a new program of interior decoration. This building, however, was destroyed by fire in 1734, after which Juvarra was commissioned to design the new Palacio Real. At the eastern end of the city a simultaneous expansion program was carried out: the royal apartments in the church of S. Geronimo el Real, which had been expanded by Philip II, were superseded by a palace complex, the Palacio del Buen Retiro, designed by Carbonell and Crescenzi (1623–9) as a royal retreat. It was largely destroyed by fire in 1640, leaving only the wing now incorporated in the Museo del Ejército (Army Museum).

Foremost among non-royal palaces was the Palacio de Uleda, built c.1613–18 for the wealthy son of the Duke of Lerma, followed in the 18th century by the Palacio da Miraflores, the Palacio de Liria and the Palacio del Marqués de Ugena.

There were numerous ecclesiastical foundations during this period. Two of the most prestigious convents were royal foundations, the Convento de las Descalzas Reales (1556) and the Real Monasterio de la Encarnación (1611). Many other churches were built or redecorated during the 17th century, most notably the S. Isidro Cathedral and the Church of S. Juan, founded in 1609.

Simultaneous with the proliferation of palaces and eccelesiastical buildings in Madrid was the growth in public buildings. These were situated in the center of the growing city, conveniently grouped around the Plaza Mayor, and within easy reach of the Alcázar. The Casa de la Villa/Ayuntamiento, for instance, which had been begun by Gómez de Mora, was extended by Ardemans in 1690 and decorated with frescoes by Antonio Palomino y Velasco (1655–1726).

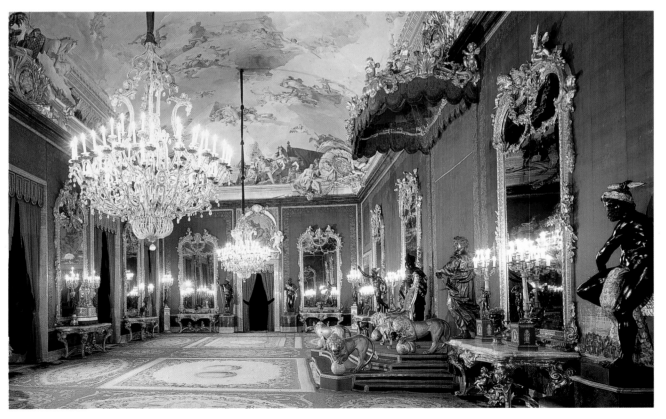

Left: Throne Room (Salón del Trono), Royal Palace (Palacio Real), Madrid

The gilt bronze lions were cast in Naples in 1651 by Firelli, the mirrors were designed by Ventura Rodríguez and the ceiling painting, representing the majesty of Spain (1764), is by Tiepolo, then aged 68.

Right: Royal Palace, East Front (1738–64), Madrid.

Initially commissioned by Philip V in 1735 from Filippo Juvarra (1678–1736), who planned to have three courtyards. Juvarra's successor, Sacchetti, used Bernini's design for the Louvre, with only one court, as his model.

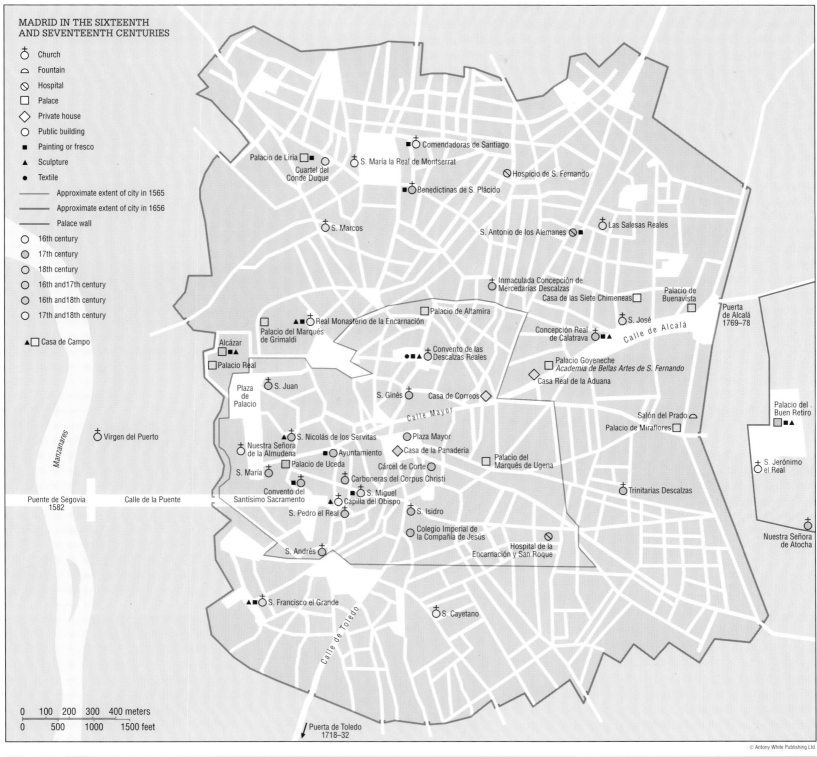

MADRID IN THE SIXTEENTH
AND SEVENTEENTH CENTURIES

☩ Church
⌂ Fountain
⊘ Hospital
□ Palace
◇ Private house
○ Public building
■ Painting or fresco
▲ Sculpture
● Textile

— Approximate extent of city in 1565
— Approximate extent of city in 1656
— Palace wall

○ 16th century
○ 17th century
○ 18th century
○ 16th and17th century
○ 16th and18th century
○ 17th and18th century

▲□ Casa de Campo

Comendadoras de Santiago ■☩

Palacio de Liria □■ ○

Cuartel del Conde Duque

S. María la Real de Montserrat ☩

Hospicio de S. Fernando ⊘

Benedictinas de S. Plácido ■⊘

S. Marcos ☩

S. Antonio de los Alemanes ⊘■

Las Salesas Reales ☩

Inmaculada Concepción de ☩
Mercedarias Descalzas

Casa de las Siete Chimeneas □

Palacio de Buenavista □

Puerta de Alcalá 1769–78

Palacio de Altamira □

Real Monasterio de la Encarnación ▲■☩

Palacio del Marqués de Grimaldi

Alcázar □ ■▲

Palacio Real □

Convento de las ●■▲☩ Descalzas Reales

S. José ☩

Concepción Real ☩■
de Calatrava ▲■

Calle de Alcalá

Palacio Goyeneche ○
Academia de Bellas Artes de S. Fernando

Casa Real de la Aduana ◇

Plaza de Palacio

S. Juan ☩

Virgen del Puerto ☩

Nuestra Señora ☩
de la Almudena ○

S. Nicolás de los Servitas ▲☩

S. Ginés ☩

Casa de Correos ◇

Calle Mayor

Plaza Mayor ○

Casa de la Panadería ◇

Palacio de Miraflores ○

Salón del Prado ⌂

Palacio del Buen Retiro □
■▲

S. Jerónimo ☩
el Real ○

Manzanares

Puente de Segovia 1582

Calle de la Puente

S. María ☩

Palacio de Uceda □

Ayuntamiento ■○

Convento del Santísimo Sacramento ☩

S. Pedro el Real ☩

Capilla del Obispo ▲☩

S. Miguel ☩

Cárcel de Corte ○

Carboneras del Corpus Christi ☩

Palacio del Marqués de Ugena □

Trinitarias Descalzas ☩

S. Isidro ☩

S. Andrés ☩

Colegio Imperial de ○
la Compañía de Jesús

Hospital de la ⊘
Encarnación y San Roque

Nuestra Señora ☩
de Atocha

S. Francisco el Grande ▲■☩

Calle de Toledo

S. Cayetano ☩

0 100 200 300 400 meters
0 500 1000 1500 feet

Puerta de Toledo 1718–32

© Antony White Publishing Ltd.

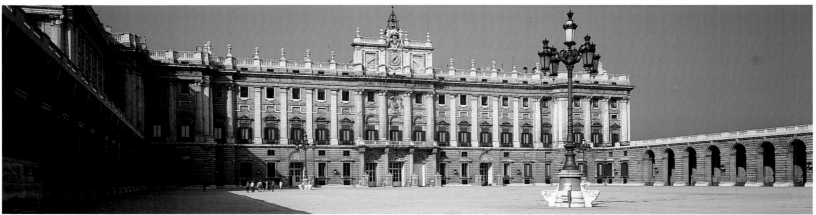

French Art and Architecture 1600–1789

Louis XIV's ambitious artistic programs, centered on Versailles, combined with the decline of Antwerp and Spain as centers of patronage, made France the culturally dominant power. Whereas up to c.1650 she had imported painters, thereafter she became self-sufficient. By the middle of the 18th century French artists and academic theory were sought after throughout Europe.

Artistic activity was centered around Paris or Versailles, reflecting the demands of the French monarchy and its court. Numerous hotels were built in Paris from the 1620s, including the Hôtel de Sully (1624–9) by Jean du Cerceau (c.1590–after 1649). Major Paris building projects included the Palais du Luxembourg begun in 1615 by Salomon de Brosse (1571–1626), and the Place des Vosges, begun in 1605, which consisted of standard design houses around a square. This last concept was to be adopted throughout Europe, as well as at Richelieu, a new town planned by Jacques Lemercier (c.1585–1654) for Cardinal Richelieu. The exceptionally wealthy continued to build outside Paris, Fouquet's château at Vaux-le-Vicomte (1657–61) built by Louis Le Vau (1612–70) being the prime example. When Fouquet fell in 1661, the team of artists employed there were transported to Versailles.

The 1660s were a turning-point in the geographical orientation of French patronage. In the 1620s Rubens (1577–1640) had created the Medici cycle at the Luxembourg Palace, but thereafter it became less usual to employ foreign painters. Simon Vouet (1590–1649), who returned from Rome in 1629, and then Charles Le Brun (1619–90), took over Rubens' role as decorator on the monumental scale, but it was largely Vouet's assimilation of contemporary Roman art which earned him his status. From the 1660s, however, French artists looked to Rome not for lessons from their contemporaries, but from the antique and the Renaissance masters. Somewhat surprisingly, however, France's two greatest 17th-century painters, Nicholas Poussin (1594–1665) and Claude Lorraine (1600–1682) lived almost permanently in Rome. Poussin spent two years in Paris, 1640–42, but he was never happy there.

Bernini's abortive project for the Louvre (1664–6) was abandoned for the more classicizing style of the arts resulting not just from the centripetal force of Paris and Versailles economically and politically, but also from the granting in 1662 to the Académie Royale de Peinture et Sculpture, founded in Paris in 1648, of monopoly rights in respect of both teaching and crown patronage. Although the first monopoly was undermined in 1705, the Academy encouraged the concentration of talent in and around the capital. The foundation in 1671 of an Academy of Architecture contributed to this development, which was scarcely affected by the persecution of the Huguenots in the 1680s.

The later 17th century saw significant royal commissions at the châteaux of Meudon and Marly, but from around 1700 royal patronage tended to be replaced by that of the financiers who profited from Louis XIV's wars. Paris saw considerable building development at its then western limit in the early 18th century, including sumptuous hotels built around Hardouin-Mansart's

(1646–1708) uniform façade at the Place Vendôme.

From the period of the Régence (the regency during the minority of Louis XV, 1715–23) until the end of the Ancien Régime a two-way traffic in artists' movements developed. Virtually every French artist of talent came to Paris to study. Jean-Antoine Watteau (1684–1721) arrived in 1702 from Valenciennes, a Flemish town which had only recently become French. Watteau's early death oreculded any visit to Rome, the city which remained the finishing school for French artists who either then returned to Paris or sought work at foreign courts. The Empress Catherine II of Russia was particularly receptive to French painting and sculpture and although never so dominant as during the reign of Louis XIV, French artistic prestige was thus increased and Paris remained the artistic capital of Europe.

Top: *Nicolas Poussin (1593/4–1665):* Et in Arcadia Ego, *oil, c.1650 (Louvre, Paris).*

Poussin's second version of this subject of death in Arcadia has a weighty treatment of the figures and drapery with a deliberate reduction of movement to subtle rythmn.

Bottom: *Jean-Antoine Watteau (1684–1721):* Les Comédiens Italiens, *oil, 1720 (National Gallery of Art, Washington).*

The outstanding painter of the French Rococo, Watteau became associated early in his career with the Commedia dell'Arte.

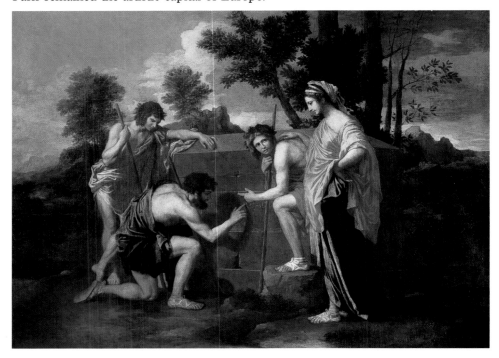

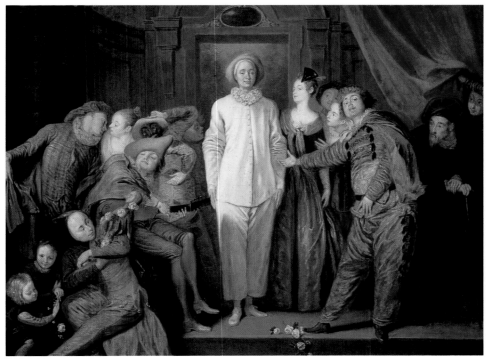

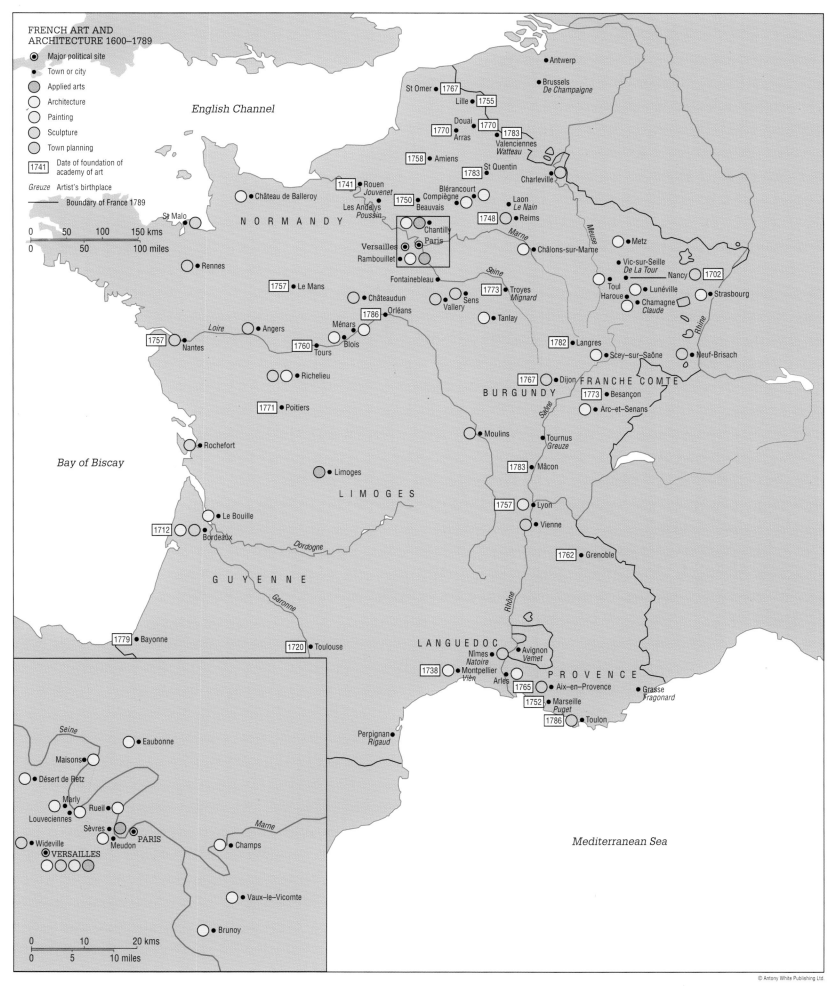

FRENCH ART AND ARCHITECTURE 1600–1789

- ⊙ Major political site
- • Town or city
- Applied arts
- Architecture
- Painting
- Sculpture
- Town planning
- 1741 Date of foundation of academy of art
- *Greuze* Artist's birthplace
- —— Boundary of France 1789

English Channel

0 50 100 150 kms
0 50 100 miles

St Omer • 1767
Lille • 1755
Douai • 1770 • 1770
Arras • 1783
Valenciennes
Watteau
1758 • Amiens
1783 • St Quentin
• Antwerp
• Brussels
De Champaigne
Charleville

1741 • Rouen
Jouvenet
Les Andelys
Poussin
1750 Blérancourt
Compiègne
Beauvais
Laon
Le Nain
1748 • Reims
Chantilly
Paris
Versailles
Rambouillet

N O R M A N D Y

• Château de Balleroy

St Malo •

• Rennes

1757 • Le Mans

• Châteaudun
1786 Orléans
Ménars
Blois
1760 Tours

• Angers
Loire

1757 Nantes

• Richelieu

1771 • Poitiers

• Rochefort

Bay of Biscay

• Limoges

L I M O G E S

• Le Bouille
1712 Bordeaux
Dordogne

G U Y E N N E
Garonne

1779 • Bayonne

1720 • Toulouse

• Metz
Vic-sur-Seille
De La Tour
Nancy 1702
Toul
Lunéville
Haroue
Chamagne
Claude
Strasbourg

Fontainebleau
Seine
1773 • Troyes
Mignard
Sens
Vallery
• Tanlay
Châlons-sur-Marne
Marne
Meuse

1782 • Langres
• Scey-sur-Saône
• Neuf-Brisach
Rhône

1767 • Dijon
F R A N C H E C O M T E
1773 • Besançon
B U R G U N D Y
• Arc-et-Senans

• Moulins
Saône
• Tournus
Greuze

1783 • Mâcon

1757 • Lyon
• Vienne

1762 • Grenoble

• Nîmes
Natoire
1738 • Montpellier
Vien
Arles
Avignon
Vernet
1765 • Aix-en-Provence
1752 • Marseille
Puget
1786 • Toulon
• Grasse
Fragonard

L A N G U E D O C
P R O V E N C E

• Perpignan
Rigaud

Mediterranean Sea

[Inset map — Paris region]

Seine
• Eaubonne
Maisons
• Désert de Retz
Marly
Rueil
Louveciennes
Sèvres
Wideville
Meudon ⊙ PARIS
⊙ VERSAILLES
• Champs
Marne

• Vaux-le-Vicomte

• Brunoy

0 10 20 kms
0 5 10 miles

© Antony White Publishing Ltd.

219

European Art Academies 1563–1815

Art academies grew out of the desire of artists to be accepted as practitioners of a learned profession rather than mere craftsmen, to be on a par with poets or musical composers. Three of the giants of the period – Leonardo da Vinci (1452–1519), Michelangelo (1475–1564) and Raphael (1483–1520) – revolutionized attitudes, gaining respect for artists as creative thinkers, not merely highly skilled artisans.

From about 1500 the term "academy" was applied to informal gatherings of artists, but it was not until 1563 that the first formal art academy was founded in Florence, which had Michelangelo and Duke Cosimo de' Medici as its joint presidents. Its aim was to emulate literary academies in exalting the dignity of the profession. Florence's academy was followed by the Accademia di San Luca in Rome (1593) and the Accademia delle Belle Arti (1620) in Milan, and the word also began to be applied to private institutions where artists met to draw from the nude model; the Carracci family of painters founded a famous example of this type in Bologna in the 1580s.

It was in France, however, that the most important step was taken in giving academies their central role in artistic education. In 1648 Louis XIV founded the Académie Royale de Peinture et de Sculpture, and although it initially met with strong opposition from the guilds, it soon established a virtual monopoly of teaching and became the model on which later academies based their aims and methods. There was nothing novel about the ideas promoted there, which were based firmly on Italian precedent, but the French Academy was much more systematic and thoroughly organized than anything earlier, with carefully planned courses and set timetables. Geometry, perspective, anatomy and history were among the subjects taught and great stress was laid on the importance of drawing. The aspiring artist was expected to absorb the work of approved masters and gain a thorough knowledge of antique statuary (which was regarded as setting a matchless ideal of beauty) before drawing from life. This became standard practice in academies, and casts of the most famous antique statues – such as the Apollo Belvedere, the Belvedere Torso and the Laocoön (all in the Vatican) – were found in drawing classes all over Europe.

A few other art academies were set up in the 17th century, for example in The Hague (1656), Nuremberg (1678), Turin (also 1678) and Berlin (1690), but the 18th century – particularly the late 18th century – was the great age of the foundation of academies (the majority of those shown on the map date from the period 1750–1800). Such institutions made a particular appeal in the Age of Enlightenment, with its stress on rational thought, and in the prevailing artistic climate of Neoclassicism, with its respect for clarity and order.

In France the provincial academies, for example Toulouse (1726), Amiens (1758) and Dijon (1767), were branch schools of the Académie Royale in Paris, and the situation was similar in Spain. The Academia de San Fernando was founded in Madrid in 1752, and the academies of Valencia (1753), Barcelona (1775), Zaragoza (1778), Valladolid (1779) and Cadiz (1789) were all dependent on it. In Germany, many princes opened drawing schools in their capitals, as at Mannheim (1752), Düsseldorf (1767) and Karlsruhe (1786). In the

Left: *Annibale Carracci (1560–1609):* Landscape with Bathers *(Prado, Madrid).*

Annibale was one of three members of the Carracci family who founded the Academy of Bologna in 1585–6. His greatest work was for the Palazzo Farnese in Rome. His idealized classical landscape is a link between High Renaissance and Baroque painting.

Right: *Sir Joshua Reynolds (1723–92): detail from* David Garrick Between the Muses of Tragedy and Comedy, *1762 (Somerset Maugham Collection, London).*

Reynolds, founder of the Royal Academy, was far and away the most important British artist of the 18th century. His fifteen Discourses *expound the academic virtues of history painting, but most of his own works were portraits; but here Garrick, the famous actor, is in an allegorical pose between two muses.*

EUROPEAN ART ACADEMIES 1563–1815

□ Drawing school
◉ Major academy
○ Other academy

Funding of institution:
○ Municipal/state
○ Princely
○ Private
○ Royal/imperial
○ Other

0 100 200 300 400 500 kms
0 100 200 300 miles

North Sea
Baltic Sea
Atlantic Ocean
Mediterranean Sea

Glasgow · Edinburgh · Dublin · London · St Petersburg · Stockholm · Copenhagen · Berlin · Amsterdam · Rotterdam · Antwerp · Brussels · Ghent · Middelburg · The Hague · Ypres · Lille · St Omer · Douai · Arras · Rouen · Tournai · Malines · Liège · Valenciennes · Düsseldorf · Gotha · Erfurt · Leipzig · Dresden · Weimar · Frankfurt · Mainz · Hanau · Beauvais · St Quentin · Amiens · Paris · Reims · Mannheim · Zweibrucken · Ohringen · Bayreuth · Prague · Nuremberg · Troyes · Karlsruhe · Stuttgart · Nantes · Le Mans · Orléans · Langres · Strasbourg · Augsburg · Munich · Vienna · Châtellerault · Tours · Dijon · Poitiers · Besançon · Zurich · Mâcon · Geneva · Bordeaux · Lyon · Grenoble · Milan · Verona · Venice · Bayonne · Turin · Genoa · Parma · Mantua · Modena · Ferrara · Toulouse · Montpellier · Aix-en-Provence · Carrara · Bologna · Marseille · Lucca · Florence · Toulon · Valladolid · Zaragoza · Madrid · Barcelona · Rome · Naples · Valencia · Cadiz

London
Royal Academy
John Flaxman (1755–1826): sculptor
Sir Joshua Reynolds (1723–92)
Benjamin West (1738–1820)
Madrid
Louis Michel van Loo (1707–71)
Anton Rafael Mengs (1728–79)
Mantua
Giovanni Cadioli (1710–67)
Naples
Anton Rafael Mengs (1728–79)
Johann Tischbein (1751–1829)
Nuremberg
Joachim von Sandrart (1606–88)
Paris
Académie des Beaux-Arts
Jean-Auguste-Dominique Ingres (1780–1867)
Académie Royale
Charles Le Brun (1619–90)
Joseph Vien (1716–1809)
Institut de France
Jacques-Louis David (1748–1825)
François Gérard (1770–1837)
Pierre Guérin (1774–1833)
Pierre Prud'hon (1758–1823)
Parma
Laurent Guiard (1723–88): sculptor
Rome
Academie de France
Noël Coypel (1628–1707)
Jean-Auguste-Dominique Ingres (1780–1867)
St Petersburg
Louis Le Lorrain (1715–59)
Stockholm
Pierre Larchevêque (1721–78): sculptor
Stuttgart
Johan Heinrich von Dannecker (1758–1841): sculptor
Nicholas Guibal (1725–84)
Turin
Laurent Pécheux (1729–1821)
Vienna
Friedrich Fuger (1751–1818)
Ignaz Günther (1725–75): sculptor
Jacob von Schuppen (1670–1751)
Johann-Baptist Straub (1704–84): sculptor
Franz Zauner (1746–1822): sculptor

Leading Academicians
Antwerp
David Teniers II (1610–90)
Berlin
Daniel Chodowiecki (1726–1801)
Christian Rauch (1777–1857): sculptor
Andreas Schlüter (c.1660–1714): sculptor
Copenhagen
Bertel Thorwaldsen (1768–1844): sculptor
Johann Wiedeweldt (1731–1802): sculptor
Dresden
Christian Hagendorn (1712–80)
Dusseldorf
Johann Peter von Langer (1756–1824)
Karlsruhe
Philipp-Jacob Becker (1759–1829)
Leipzig
Adam Oeser (1717–99)

© Antony White Publishing Ltd.

Low Countries most of the academies were municipal foundations, as at Amsterdam (1758), Malines (1761), Liège (1773) and Rotterdam (also 1773). Italy's academies were founded in a variety of ways and were often cultural as well as teaching centers.

In Britain, the famous Royal Academy was established in 1768, but there were forerunners in London in the St. Martin's Lane Academy, which dated from 1711, and the Society of Artists, founded in the 1750s and incorporated by royal charter in 1765. There were also private academies in Dublin (1746), Glasgow (1753) and Edinburgh (1760). These were all far surpassed in importance by the Royal Academy, however, which achieved a new professional status for artists in Britain – a tranformation embodied by the first president of the Academy, Sir Joshua Reynolds (1723–92). His pupil and biographer James Northcote (1746–1831) wrote that Reynolds "contrived to move in a higher sphere of society than any English artist had done before".

Paris in the 17th Century

At the end of the 16th century France was worn out by civil war and French art was at one of its lowest ebbs. At the end of the 17th century France was the leading power in Europe with Paris the acknowledged center of artistic taste. This remarkable transformation was due to a series of illustrious rulers and statesmen, beginning with Henri IV (1589–1610) who established peace in 1598.

Henri's works included the Place Royale (now the Place des Vosges), the Pont Neuf with the adjacent Place Dauphine, and the Hôpital St. Louis. The names of the architects are generally unknown, and it is assumed that the king himself was the creative master-mind, even if the details were worked out by professional builders. Certainly his schemes have a boldness of vision that suggests a single powerful personality behind them. Replacing a maze of small streets with broad, straight thoroughfares lined with regular façades, Henri set a pattern for Paris's development that reached its apotheosis in the 19th century in the work of Baron Haussmann. Whereas later schemes were often ruthless in their efficiency, however, Henri's masterpiece – the Place Royale – is a model of enlightened uniformity, humane and lovable in spite of its grand scale; Parisians like to claim it as the most beautiful square in the world.

Henri was succeeded by his eight-year-old son Louis XIII (1610–43), with his mother (Henri's widow), Marie de Médicis, acting as regent. For her, Salomon de Brosse (c.1571–1626), the greatest French architect of the early 17th century, built the Palais du Luxembourg (begun 1615), for which Peter Paul Rubens (1577-1640) painted a famous cycle of pictures on Marie's life (now in the Louvre). She saw little of the palace, however, for she spent much of her later life in exile, and the conduct of state affairs was left mainly to Cardinal de Richelieu, Louis' chief minister from 1624 until his death in 1642.

Richelieu was a major artistic patron as well as one of the most brilliant statesmen of the age. His chief memorial in Paris is the church of the Sorbonne (begun 1635), the first large-scale domed Italianate church in Paris, by Jacques Lemercier (c.1585–1654). This was followed by two greater buildings in the same vein: the Val-de-Grâce (begun 1645), principally by François Mansart (1598–1666), the outstanding French architect of the century, and the Dôme des Invalides (c.1679–91) by his great-nephew Jules Hardouin-Mansart (1646–1708).

Louis XIV (1643–1715) ruled, after he reached his majority, without a chief minister, but he was aided by the extremely efficient administrator Jean-Baptiste Colbert. Louis understood the propaganda value of art, and had Colbert organize state control of the arts, directing them towards his personal glorification (the king's vanity knew no bounds). In 1661 Colbert became Vice-Protector of the *Académie Royale de Peinture et de Sculpture* (founded 1648) and used it as an instrument for imposing official standards of taste, its guiding principle being the idea that art can be taught by rational rules. The academy became the model for similar bodies throughout Europe, and the insistence on unified standards and precepts eventually gave the term "academic art" a pejorative meaning, suggesting tameness and lack of originality.

Another instrument in Louis' control of the arts was the Gobelins factory, now synonymous with tapestries (which it still produces). But for some 30 years after Louis took it over in 1662 it made virtually everything necessary for the furnishing of royal palaces – its official title was *Manufacture royale des meubles de la couronne*. Its director, Charles Lebrun (1619–90) became the dominant artist of Louis' reign, and Colbert's instrument in imposing his artistic policies.

Above: St. Étienne du Mont, façade, 1610–25, Paris.

Originally a Gothic church, St. Étienne du Mont was remodeled on the inside in the 16th century, and given a new façade in the early 17th; this contained different classical motifs such as the triumphal arch and Corinthian half-columns juxtaposed, but not wholly digested.

Left: Les Invalides. *Hospital and plan by Libéral Bruant (c.1635–97), dome and chapel by Jules Hardouin-Mansart (1646–1708), 1670–1708, Paris.*

Planned on open ground to the southwest of Paris as a hospital for disabled army veterans. Bruant's plans were completed by 1677, but in 1670 Louis XIV commissioned Mansart to produce a second domed chapel based loosely on St. Peter's in Rome, which became the definitive example of mature French Baroque architecture.

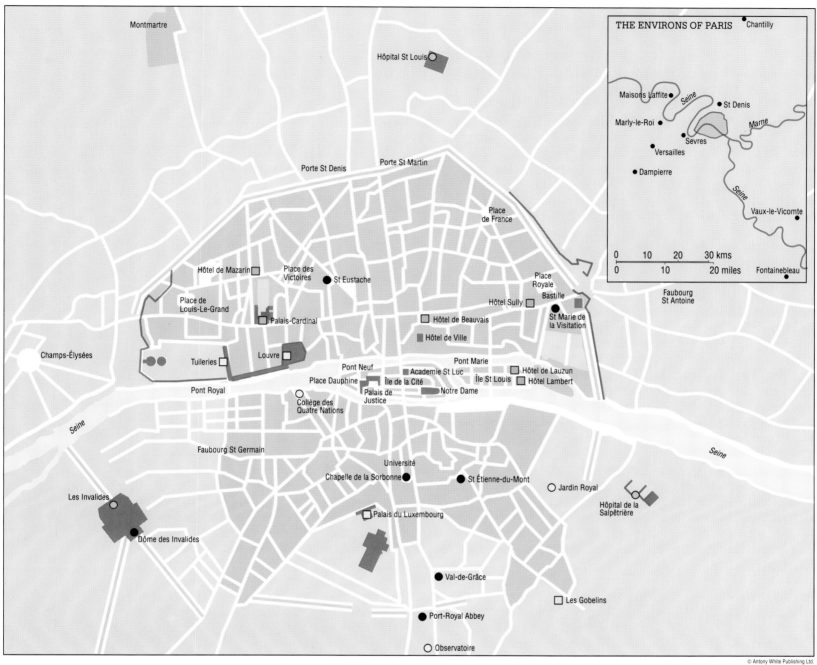

The Environs of Paris
Chantilly
Maisons Laffite
Seine
St Denis
Marly-le-Roi
Marne
Sevres
Versailles
Dampierre
Seine
Vaux-le-Vicomte
0 10 20 30 kms
0 10 20 miles
Fontainebleau
Faubourg
St Antoine

© Antony White Publishing Ltd.

PARIS IN THE 17TH CENTURY

● Church
□ Royal residence
▪ Aristocratic house
○ Hospital
○ Educational institute
□ Factory
▪ Earlier buildings
— City walls
 Boulevards

0 250 500 750 meters
0 200 400 600 800 yards

After 1682, when Louis transferred his court to Versailles, artistic activity was concentrated on the palace there, but before this date the Louvre remained the principal royal residence. The present building (replacing a medieval fortress) had been begun by Francis I in 1546, but by Louis' reign it still lacked an east front – what was to be the great show façade looking towards the heart of the city. Plans by various artists were considered before Louis summoned Gianlorenzo Bernini (1598–1680) from Rome. Bernini was unchallenged as the greatest artist of the age, but his designs were abandoned in favor of one by Lebrun, Louis Le Vau (1612–70) and Claude Perrault (1613–88); this was built in 1667–70 and is one of the supreme masterpieces of French classicism – lucid, severely elegant and beautifully detailed. The episode is one of great symbolic significance. The invitation to Bernini was in effect a command, one of a series of humiliations Louis inflicted on Pope Alexander VII, and the victory of the French artists over Bernini completed the

insult to Italian pride. Paris had now replaced Rome as the artistic capital of Europe.

Louis' other great projects in Paris included two huge hospitals: Les Invalides (1670–77), a home for invalid soldiers, and the Salpêtrière, of about the same date, a refuge for the poor that later became an asylum. Libéral Bruant (c.1635–97) was the architect of Les Invalides (to which Jules Hardouin-Mansart later added the domed church) and also of the chapel at the Salpêtrière, the most interesting part of the building.

Although royal commissions dominated the age, the 17th century also saw some superb domestic architecture in Paris. The French term for a town mansion is hôtel; two of the finest are the Hôtel Sully (1624–9), attributed to Jean Androuet du Cerceau, which is remarkable for its carved external decoration, and the Hôtel Lambert (begun 1640) by Louis Le Vau, which has a gallery decorated by Charles Lebrun (c.1650) that is the finest French room to survive from this period.

Paris in the 18th Century

The 18th century was a time of political tension and financial crisis for France, beginning with the War of the Spanish Succession and ending with the Revolution and the opening salvos of the Napoleonic Wars. While France declined politically under Louis XV (1715–74) and Louis XVI (1774–93), however, the country's art continued to flourish abundantly. There was a host of first-class architects, painters and sculptors, and some applied arts – such as furniture – reached standards that have rarely been equaled. Most of the best French artists of the period worked for at least part of their careers in Paris, which completely dominated the nation's cultural affairs. Although all major provincial towns could boast fine buildings and some of them (particularly Toulouse in the far south) had strong local traditions of painting, virtually any ambitious artist wanted to make his or her name in Paris. This was where great opportunities lay, and in particular the Salon – the famous exhibition of the *Académie Royale de Peinture et de Sculpture* – was the only public forum in which an artist could make a reputation overnight. Named after the Salon d'Apollon in the Louvre in which it was held, the Salon began in 1667; it was held annually up to 1737, every two years from then until the Revolution, and then once again it became an annual event.

Although many leading French artists studied antique and Italian art, and the Prix de Rome, which entitled the winner to a four-year stay in Rome at the state's expense, was the traditional stepping stone to artistic stardom, French art decisively freed itself from dependence on foreign models. The Rococo style which spread over Europe was a French creation, and painters such as Jean-Antoine Watteau (1684–1721), François Boucher (1703–1770) and Jean-Honoré Fragonard (1732–1806) had a sophistication and charm essentially Parisian. If the 17th century was a royal age, the 18th century was rather an aristocratic one, and there was a growing sense of relaxation and intimacy in art, a refreshing change from the monotonous magnificence of Louis XIV's Versailles. It was an age of the boudoir rather than the stateroom.

The intimate and playful Rococo style is expressed mainly in the figurative arts and in interior decoration rather than in architecture, although in the work of many French architects of the period there is an elegance, deftness and polish that partakes of the Rococo spirit. Ange-Jacques Gabriel (1698–1782) was the outstanding French architect of the age. He was appointed First Architect to the king in 1742 and his major works include the École Militaire (1751–1788) and the Place Louis XV (now the Place de la Concorde, begun 1755), the biggest and most magnificent square in Paris. The Place Vendôme (begun 1698) by Jules Hardouin-Mansart (1646–1708) is almost comparable in scale and grandeur. These majestic pieces of town planning continued the tradition of Henri IV of arranging imposing public spaces or monuments at focal points where major roads meet, but whereas Henri's buildings were of homely brick with stone dressings, Hardouin-Mansart and Gabriel's buildings are of the finest quality masonry, conveying an air of truly metropolitan splendor.

Although those great squares play an important part in creating the image of Paris, more typical of the age are the achievements in domestic architecture. The town houses of the wealthy were often fairly small by the standards of the preceding century, but the greatest Paris house of the 18th century, the Hôtel de Soubise (now the Archives Nationales), is distinctly palatial. Alexis Delamair (1676–1745) designed the building in 1705–9; it was substantially extended by Germain Boffrand (1667–1754) in the 1730s, and decorated in the most sumptuous manner by a team of artists and craftsmen, notably Carle van Loo (1705–65). The grand and often rather heavy style of the 17th century gave way to something much lighter, with pastel colors, mirrors and pretty painted panels; and delicate furniture and furnishings were much in evidence.

Below left: *Jacques-Germain Soufflot (1713–80):* Ste. Geneviève (The Panthéon), *1757–90, Paris.*

The Corinthian columned façade and the dome of Ste. Geneviève are as pure an example of French Neoclassicism as the dome of the Invalides was of French Baroque.

Below: *Jean-Honoré Fragonard (1732–1806):* La Chemise Enlevée *(Louvre, Paris).*

Rococo erotic exuberance, from a painter whose career was later ruined by the Neoclassical severity of revolutionary taste after 1789.

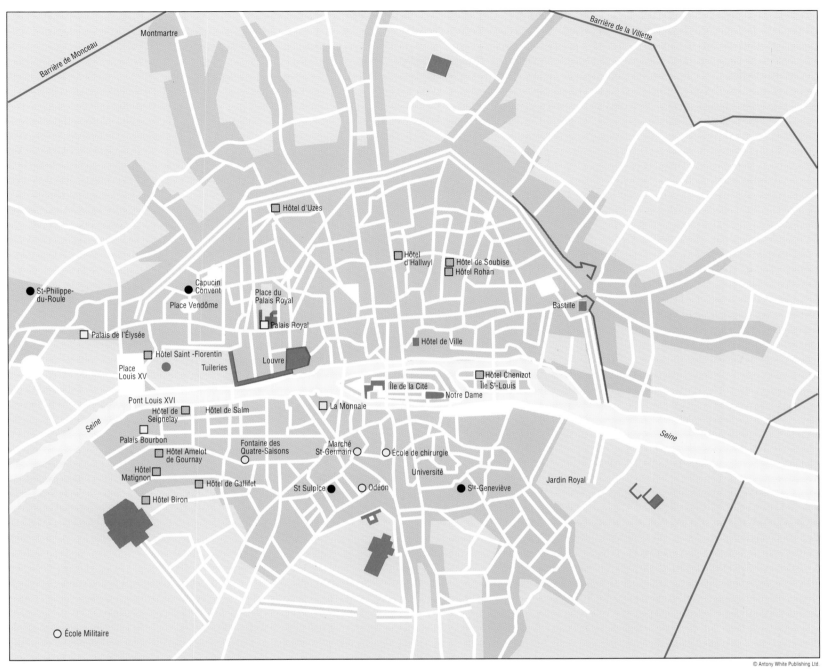

Montmartre

Barrière de la Villette

Barrière de Monceau

Barrière de Monceau

St-Philippe-
du-Roule

Hôtel d'Uzès

Capucin
Convent

Hôtel
d'Hallwyl

Hôtel de Soubise
Hôtel Rohan

Place du
Palais Royal

Place Vendôme

Palais de l'Élysée

Bastille

Hôtel Saint -Florentin

Place
Louis XV

Palais Royal

Tuileries

Louvre

Hôtel de Ville

Hôtel Chenizot
Île St-Louis

Pont Louis XVI

Hôtel de
Seignelay

Hôtel de Salm

Île de la Cité

Notre Dame

La Monnaie

Seine

Seine

Palais Bourbon

Hôtel Amelot
de Gournay

Fontaine des
Quatre-Saisons

Marché
St-Germain

École de chirurgie

Jardin Royal

Hôtel
Matignon

Université

Hôtel de Gallifet

St Sulpice

Odéon

Ste-Geneviève

Hôtel Biron

École Militaire

© Antony White Publishing Ltd.

PARIS IN THE 18TH CENTURY

- ● Church
- ☐ Royal residence
- ▢ Aristocratic house
- ◯ Hospital
- ◯ Educational institute
- ◯ Factory
- ☐ Other important sites
- ▪ Earlier buildings

— City walls

░ Boulevards

— Customs barrier

| 0 | 250 | 500 | 750 meters |
| 0 | 200 400 600 | 800 yards |

In the second half of the century, however, there came a strong reaction against such frivolity and the Neoclassical style swept away Rococo lightheartedness. Neoclassicism attempted to revive the spirit as well as the forms of Greek and Roman art; in Paris, the first stirrings towards it are appropriately in the work of an Italian – the façade of St. Sulpice (1737) by the Florentine Giovanni Servandoni (1695–1766). The central masterpiece of the style is another church, Ste. Geneviève (begun 1757) by Jacques-Germain Soufflot (1713–80), a huge, austerely beautiful building crowned by one of the world's finest domes. It triumphantly captures the solemnity of ancient art, but the graceful proportions are typically French. At the Revolution Ste. Geneviève (dedicated to the patron saint of Paris) was secularized as a burial place for national heroes and renamed the Panthéon. The Neoclassical style accorded perfectly with the ideals of the Revolution in its desire to restore heroic Roman virtues to public life, just as its clarity and order

appealed to the philosophical spirit of the Age of Enlightenment. The paintings of Jacques-Louis David (1748–1825) similarly encapsulate the sentiments of the time.

Other buildings in which the new gravity is seen include the Capuchin Convent (1780–2) by Alexandre Théodore Brogniart (1739–1813), the Mint (*Monnaie*, 1768–75) by Jacques-Denis Antoine (1733–1801), and in domestic architecture the Hôtel de Gallifet (1775–96) by Jacques-Guillaume Legrand (1743–1808). The most imaginative and radical buildings in style, however, are the series of toll gates (*barrières*) circling Paris, designed by Claude-Nicolas Ledoux (1736– 1806) and built from 1785; the forms are daringly stark and minimalist, sometimes pared down to almost unadorned basic geometrical shapes. Of the 40 that were built, four survive, the most impressive being the Barrière de la Villette. These massively bold buildings had a symbolic as well as a practical purpose, enabling those approaching Paris to sense its greatness from afar.

European Palace Architecture 1600–1789

Palaces are built to impress, and the most obvious way for a building to impress is through sheer size; and some of the palaces of the 17th and 18th centuries are among the most colossal edifices ever erected. Most famous of all in this respect is Versailles, begun in 1624 as a fairly modest hunting lodge for Louis XIII (1610–43) and expanded by his son Louis XIV (1643–1715) into the supreme physical expression of royal grandeur. Some 30,000 workmen labored in its construction and about 1000 noblemen and 4000 attendants lived there. Versailles represents, too, another important theme in the culture of the period – the integration of all the arts to produce an overwhelming whole (the German term for this is *Gesamtkunstwerk* – "total work of art"). Painters, sculptors and craftsmen embellished the interior, and outside André Le Nôtre (1613–1700), the greatest of all designers of formal gardens, created a setting worthy of the building.

The furnishings at Versailles originally included a set of silver furniture in the state bedroom, but this was melted down during a financial crisis in 1689, and money shortages and other practical problems often curtailed the building ambitions of even the kings of great countries. In England, for example, the celebrated Banqueting House (1619–22) built by Inigo Jones (1573–1652) for James I (1603–25) is only a tiny part of the huge Whitehall Palace that was envisaged by his son and successor Charles I (1625–49).

Another scheme that did not get off the drawing board was Gianlorenzo Bernini's (1598–1680) series of designs for the Louvre in Paris. These were commissioned by Louis XIV in 1664–5, and abandoned in favor of a French plan, but Bernini's designs for an uncompromisingly severe, block-like building exercised great influence on European palace design. The young Christopher Wren (1632–1723) met Bernini in Paris and wrote: "Bernini's design of the Louvre I would have given my skin for, but the old reserved Italian gave me but a few minutes view... I had only time to copy it in my fancy and memory." There is little of Bernini's influence in Wren's major executed palace design – his extensions to Hampton Court (1689–94) for William III (1689–1702) – but engravings made from Bernini's designs were the chief inspiration for the Royal Palaces in Madrid and Stockholm and one of the sources for the Royal Palace at Caserta.

Some of the greatest palaces were built not for kings and queens but for rulers of fairly small territories. The supreme example is the Residenz (begun 1719) at Würzburg in Germany, built by Balthasar Neumann (1687–1753), the most brilliant architect of the age in Central Europe, for a succession of prince-bishops of Würzburg (they were both secular and ecclesiastical heads of the state). The Residenz was begun in the reign of Johann Philipp Franz Graf Schönborn, the Schönborns being a family whose reputation as patrons of the arts compares with that of the Medici in Italy. When he died in 1724, a rival family – the Huttens – assumed power, and work in the Residenz virtually stopped, but in 1729 the Schönborns were restored to the prince-bishopric and work on the building resumed. It was not finally completed until 1776, after the architect's death, but Neumann lived long enough to see the superb fresco decoration (1750–3) carried out by Giambattista Tiepolo (1696–1770).

Not all palaces were designed primarily as dwelling places. The "palazzina" (villa) at Stupinigi near Turin (1729–33), for example, in spite of its size and grandeur, was built as a hunting lodge for King Vittorio Amedeo II of Savoy. Its designer, Filippo Juvarra (1678–1736), was the greatest Italian architect of the 18th century. The Zwinger at Dresden (1709–22) was built for Friedrich Augustus II (Augustus the Strong) as a pleasure pavilion for royal festivities. Appropriately it is light-hearted in style, with much frothy Rococo decoration. The architect was Matthaeus Daniel Pöppelmann (1662–1736). In England, the greatest palace of the age – Blenheim Palace (1705–24) – was built as a national monument to the Duke of Marlborough in gratitude for his great victory over the French at Blenheim in 1704, which checked Louis XIV's attempts to dominate Europe. The architect was Sir John Vanbrugh (1664–1726) assisted by Nicholas Hawksmoor (1661–1736). The palace is magnificently flamboyant, but inconvenient as a home, drawing forth the wrath of the Duchess of Marlborough, who had a long-running feud with Vanbrugh and longed for "a clean sweet house and garden be it ever so small".

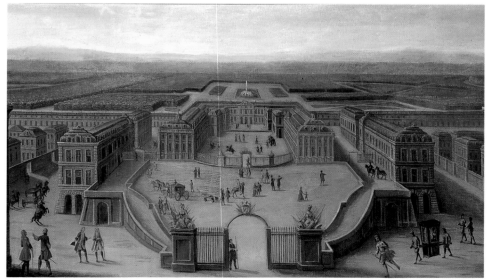

Left: Palazzo Barberini, *1628–33, Rome.*

The most important Baroque palace in Rome, it was built for the Barberini, the family of Pope Urban VIII by, amongst others, Carlo Maderno (1556–1629), Gianlorenzo Bernini (1598–1680) and Pietro da Cortona (1596–1669).

Below: *Anonymous, 18th century,* The Palace of Versailles, *1661–1756 (Château de Versailles, Paris).*

Louis XIV decided to move the French Court from the Louvre to Versailles in 1668, and the latter became throughout the 18th century the home of the French Court.

EUROPEAN PALACE ARCHITECTURE

☐ 17th century palace site
☐ 18th century palace site

| 0 | 100 | 200 | 300 kms |
| 0 | 100 | | 200 miles |

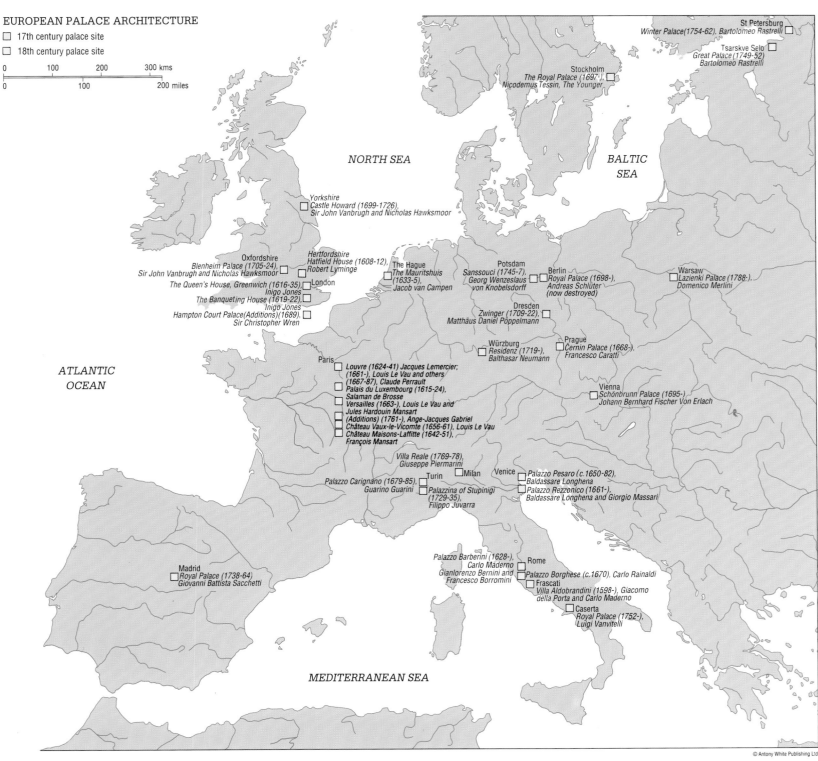

NORTH SEA

BALTIC SEA

ATLANTIC OCEAN

MEDITERRANEAN SEA

St Petersburg
Winter Palace(1754-62), Bartolomeo Rastrelli

Tsarskve Selo
Great Palace (1749-52)
Bartolomeo Rastrelli

Stockholm
The Royal Palace (1697-),
Nicodemus Tessin, The Younger

Yorkshire
Castle Howard (1699-1726),
Sir John Vanbrugh and Nicholas Hawksmoor

Oxfordshire
Blenheim Palace (1705-24),
Sir John Vanbrugh and Nicholas Hawksmoor

Hertfordshire
Hatfield House (1608-12),
Robert Lyminge

The Hague
The Mauritshuis (1633-5),
Jacob van Campen

The Queen's House, Greenwich (1616-35),
Inigo Jones
The Banqueting House (1619-22),
Inigo Jones
Hampton Court Palace(Additions)(1689),
Sir Christopher Wren

London

Potsdam
Sanssouci (1745-7),
Georg Wenzeslaus
von Knobelsdorff

Berlin
Royal Palace (1698-),
Andreas Schlüter
(now destroyed)

Warsaw
Lazienki Palace (1788-),
Domenico Merlini

Dresden
Zwinger (1709-22),
Matthäus Daniel Pöppelmann

Würzburg
Residenz (1719-),
Balthasar Neumann

Prague
Cernin Palace (1668-),
Francesco Caratti

Paris
Louvre (1624-41) Jacques Lemercier;
(1661-), Louis Le Vau and others
(1667-87), Claude Perrault
Palais du Luxembourg (1615-24),
Salaman de Brosse
Versailles (1663-), Louis Le Vau and
Jules Hardouin Mansart
(Additions) (1761-), Ange-Jacques Gabriel
Château Vaux-le-Vicomte (1656-61), Louis Le Vau
Château Maisons-Laffitte (1642-51),
François Mansart

Vienna
Schönbrunn Palace (1695-)
Johann Bernhard Fischer Von Erlach

Villa Reale (1769-78),
Giuseppe Piermarini

Milan

Turin
Palazzo Carignano (1679-85),
Guarino Guarini
Palazzina of Stupinigi
(1729-35),
Filippo Juvarra

Venice
Palazzo Pesaro (c.1650-82),
Baldassare Longhena
Palazzo Rezzonico (1661-),
Baldassare Longhena and Giorgio Massari

Madrid
Royal Palace (1738-64)
Giovanni Battista Sacchetti

Palazzo Barberini (1628-),
Carlo Maderno
Gianlorenzo Bernini and
Francesco Borromini

Rome
Palazzo Borghese (c.1670), Carlo Rainaldi

Frascati
Villa Aldobrandini (1598-), Giacomo
della Porta and Carlo Maderno

Caserta
Royal Palace (1752-),
Luigi Vanvitelli

© Antony White Publishing Ltd.

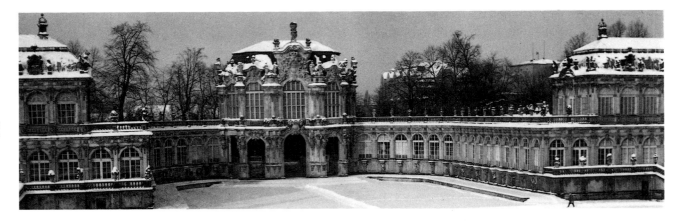

Right: *Matthaeus Daniel Pöppelmann (1662–1736),* The Zwinger, *begun 1709 but never completed, with sculptural decoration by Balthasar Permoser, Dresden.*

Built for Augustus the Strong, Elector of Saxony and King of Poland, the Zwinger was the most exciting, original and theatrical of Rococo palaces. Pöppelmann visited both Rome and Vienna in 1710 after receiving the commission.

Art and Architecture in the Netherlands in the 17th Century

Although some variations in character already existed between the art of the northern and southern Netherlands in the 15th and 16th centuries, it was only with the secession of the United Provinces at the beginning of the 17th century that a fundamental difference in practice, taste and style grew up between the two countries, and this divergence increased with time.

In the south, with Spain still in control, the Catholic church maintained its time-honored role as patron, influencing much of the subject-matter painted by Flemish artists. History painting, both religious and secular, maintained its prime position, with painters of landscape, genre and still life playing a subsidiary role. In addition, local taste encouraged specialists in animal and hunting pictures, architectural fantasies and the painting of collectors' galleries. The dominance of Rubens (1577–1640) ensured that Antwerp remained the artistic capital, and the various other centers, including Brussels with its archducal court, essentially followed its example.

In the northern Netherlands artists received a little patronage from the stadholder's court and from the government in The Hague. From the Protestant church the only commission available was for the painting of organ shutters. Town or city councils, guilds, militia companies and various governing bodies provided some commissions, mainly portraiture but also for the relatively few history paintings produced during the century. In general, artists had to look to an unprecedented degree to the private sector at all levels of society for the sale of their works.

Apart from Amsterdam, which became increasingly cosmopolitan and successful in attracting artists from other towns, this new situation succeeded in giving each center its own artistic character, with its own style and

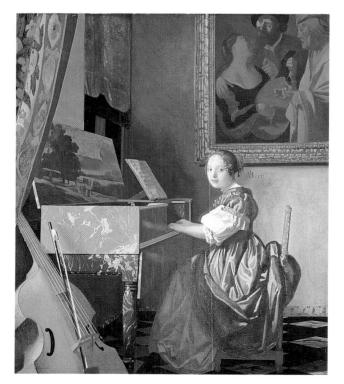

Left: *Jan Vermeer (1632–75):* A Young Woman Seated at a Virginal, c.1670, *(National Gallery, London).*

Little is know of Vermeer, a native of Delft. He was probably not a full-time painter and relatively few of his works survive; but the quality of light, the calm poetry, and the distillation of the genre subject-matter represent one of the greatest achievements of Dutch painting. This portrait combined a restrained tender intimacy of detail, maximum subtlety of light, a musical theme, a landscape in the open lid of the virginals, and a "picture within a picture".

taste in subject-matter. As a result of this privatization of patronage, a great expansion occurred in the demand for bourgeois portraiture, landscape and genre, and these became the predominant subjects in the northern Netherlands. Still lifes, architectural views (both interior and exterior), marine and animal subjects were also popular. Specialization in one or more categories became increasingly the practice among Dutch artists. Only Rembrandt (1606–69) succeeded in covering the entire range of subject-matter.

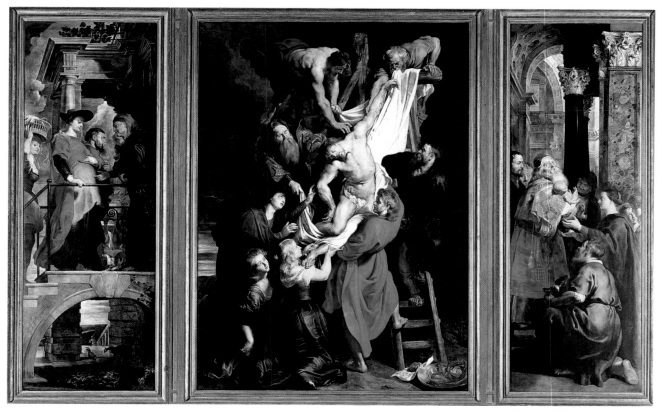

Left: *Peter Paul Rubens (1577–1640):* The Descent from the Cross, *triptych, 1611–14, Antwerp Cathedral.*

Rubens, baptized a Calvinist, but a devout converted Catholic, was the ultimate courtier artist of the 16th century. Based in Antwerp, he became in 1609 court painter to the Spanish viceroy in the Netherlands. This is the second to his great altarpieces for Antwerp Cathedral – showing The Visitation, *and* The Presentation in the Temple *on either side of* The Descent from the Cross. *His rich painterly Baroque technique incorporated both elements of Venetian design and also the composition and lighting of the Roman period of Caravaggio. But the result is purely Flemish.*

THE NETHERLANDS IN THE SEVENTEENTH CENTURY

- ◉ Major city
- • Town
- ☐ *Private house*
- ——— Border of the Dutch Republic in 1648

```
0    20    40    60 kms
0    20         40 miles
```

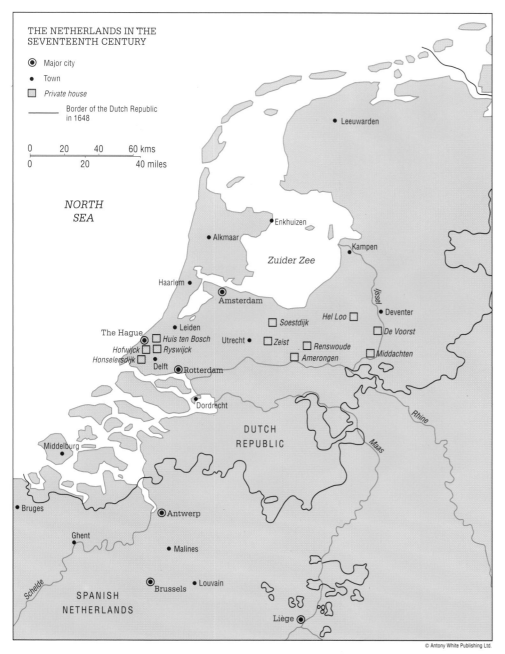

NORTH SEA

Leeuwarden

Enkhuizen

Alkmaar

Kampen

Zuider Zee

Haarlem

Amsterdam

Hel Loo · Deventer

Leiden · ☐ *Soestdijk*

IJssel

The Hague · ◉ ☐ *Huis ten Bosch*

Hofwijck ☐ ☐ *Ryswijck* Utrecht · ☐ *Zeist* ☐ *Renswoude*

Honselersdijk ☐ ☐ *De Voorst*

Delft · ☐ *Amerongen* ☐ *Middachten*

◉ Rotterdam

· Dordrecht

Rhine

Middelburg

DUTCH REPUBLIC

Maas

· Bruges

◉ Antwerp

Ghent · · Malines

Schelde

◉ Brussels · Louvain

SPANISH NETHERLANDS

· Liège

© Antony White Publishing Ltd.

Periods of temporary residence are indicated in italics. Short periods of residence are not given.

Alkmaar
Painting: Caesar van Everdingen (c.1617/8–78).

Amsterdam
History: Pieter Lastman (1583–1633), Jan Lievens (1607–74: *from 1644 intermittently*), Gerard de Lairesse (1641–1711).
Portraiture: Nicholaes Eliasz. Pickenoy (1590/1–1654/6), Thomas de Keyser (1596/7–1667), Bartholomeus van der Helst (1613–70).
Rembrandt school: Rembrandt (1606–69; *from 1631*), Jacob Backer (1608–51), Govaert Flinck (1615–60), Ferdinand Bol (1616–80), Philips Koninck (1619–88).
Landscape: Gillis van Coninxloo (1544–1607), Hercules Seghers (1589/90–1633/8: *1614–31*), Bartholomeus Breenbergh (1598–1657), Aert van der Neer (1603/4–77), Jan Asselyn (before 1610–52), Karel du Jardin (1622–78), Adam Pynacker (1625–73), Jacob van Ruisdael (1628/9–82; *from 1657*), Meindert Hobbema (1638–1709), Jan van der Heyden (1637–1712).
Architectural: Emanuel de Witte (1617–92; *from 1652*).
Seascape: Simon de Vlieger (1600–53), Willem van de Velde I (1611–93) and II (1633–1707) (*both until 1672*), Jan van de Capelle (1626–79).
Genre: Wille Duyster(1588/9–1635), Pieter Codde (1599–1678), Gabriel Metsu (1629–67; *from 1657*), Pieter de Hooch (1629–84: *from c.1663*).
Still Life: Willem Kalf (1619–93)
Sculpture: Artus Quellin (1609–68), Hans van Mildert (d.1638), Hendrik Verbruggen (c.1655–1724).
Architecture: See page231.

Antwerp
Painting: Peter Paul Rubens (1577–1640), Jacob Jordaens (1593–1678), Anthony van Dyck (1599–1641).
History: Otto van Veen(1556–1629), Abraham Janssens (1573/4–1632), Gerard Seghers (1591–1651), Erasmus Quellinus (1607–78), Jan Lievens (*1635–44*; also Portraits).
Portraits: Frans Pourbus (1569–1622), Cornelis de Vos (1584–1651).
Landscape: Joos de Momper (1564–1635), Jan Brueghel (1568–1625), Lucas van Uden(1596–1625), Jan Wildens (1586–1653).
Genre: Adriaen Brouwer (c.1605–38), David Teniers (1610–90).

Still Life: Frans Snyders (1579–1657), Daniel Seghers (1590–1661), Jan Fyt (1611–61).
Architecture: See page 233.

Bruges
Painting: Jacob van Ost (1601–71).
Architecture: Jezuietenkerk by Pieter Huyssens (1619)

Brussels
Painting: Caspar de Crayer (1584–1669), Jacques d'Arthois (1613–86), Michael Sweerts (1624–64).
Architecture: Jezuietenkerk by Father Hoeimaker (1606), completed by Jacob Francart (from 1616). Karmelietenkerk by Wenceslaus Cobergher (begun 1607). Augustinerkerk by Jacob Francart (1621). Grote Markt rebuilt 1697.

Delft
Portraiture: Michiel van Miereveld (1567–1641).
Architectural: Carel Fabritius (1622–54), Emanuel de Witte (*1641–52*).
Landscape/animals: Paulus Potter (1625–54; *1646–9*).
Genre: Jan Vermeer (1632–75); Pieter de Hooch (*1653–c.1663*).

Deventer
Painting: Gerard ter Borch (1617–81)

Dordrecht
Painting: Albert Cuyp (1620–91), Samuel van Hoogstraeten (1627–78), Nicholaes Mees (1634–93), Godfried Schalcken (1643–1706)

Enkhuizen
Architecture: Stadhuis by Steven Vennekool (d.1719)

Ghent
Architecture: St. Pieter (begun 1619)

Haarlem
History: Karel van Mander (1548–1606), Hendrik Goltzius (1558–1616/7), Cornelis Cornelisz. van Haarlem (1562–1638), Salomon de Bray (1597–1664).
Portraiture: Frans Hals (1581/5–1666).
Seascape: Hendrick Vroom (c.1566–1640).
Landscape: Esaias van de Velde (c.1590/1–1630), Willem Buytewech (1591/2–1624), Cornelis Vroom (c.1591/2–1661), Pieter Molyn (1595–1661), Salomon van Ruysdael, (c.1600-70)

Right: *Albert Cuyp (1620–91):*
A River Landscape, *detail, early work (Private Collection).*

Cuyp was a landscape painter from Dordrecht, a town on the delta of the River Rhine. His atmospheric rendering of light, particularly light and water, influenced the whole development of landscape painting in England. His later work, after the example of Claude and Italianate classical landscape painting, employed a gentler more golden hue, especially in sunrise and sunset scenes.

Amsterdam in the 17th Century

Around 1600, Amsterdam was a city with a rapidly growing population matched by a vast expansion of its role, taken over from Antwerp, as the commercial and financial center of the Netherlands. By the turn of the century it had doubled its population to 60,000; by 1620 this had grown to 100,000, a figure which was again doubled by 1660. A substantial proportion of the early immigrants, who played an important part in enabling Amsterdam to become the center of world trade, came from Flanders and Brabant. They were later followed by other immigrants from all over the continent, and Amsterdam became the "melting-pot" of Europe.

The medieval settlement established on the banks of the River Amstel at the point where it joined the River Ij had grown by the mid-16th century to a city concentrated around four central canals, enclosed by the Singel and protected on its perimeter by city fortifications. At the end of the century the pressure of its rapidly growing population led to the first stage of a major expansion. In 1613 a plan established new fortifications along a perimeter that would allow an area for building development four times the original size of the city, and included the three great concentric canals, the Heren, Keizers and Prinsen Grachten, intersected by a pattern of radial streets.

By 1663 the shape of the city had been transformed from a rectangle to a semi-circle, stretching from the poor area of the Jordaan on the west, built without any overall plan, to the pleasure gardens, the Plantage, on the east, an area designated for building but never developed because of the slowing of the economy in the late 17th century.

Although the strict planning of the new city eventually became the responsibility of the city architect, Daniel Stalpaert (1615–76), the early stages of the development were dominated by the work of a previous holder of that office, the sculptor and architect Hendrik de Keyser (1565–1621). Keyser accomplished the embellishment of the new canals with two churches with imposing towers, and numerous houses with their richly varied gables of alternating brick and stone, a continuing feature of the city's architecture; he also added decorative pinnacles to the old city fortifications. Open to foreign influence, his architecture developed from the prevailing late Mannerist style, apparent in his building of the Beurs, a repetition of the London Exchange (built in 1566), towards the Classicism seen in Westerkerk. Dutch Classicism, principally inspired by Scamozzi (1552–1616), was expressed at its purest and grandest in the new Stadhuis designed by Jacob van Campen (1595–1657), the austere lines of which, especially in the interior, are greatly enhanced by abundant sculpture. Scamozzi's giant pilaster, employed already by van Campen on the façades of the Koymanshuis and Accijnhuis, and which became a feature of Dutch architecture, was copied by later architects, most resplendently by Justus Vingboons (c.1620–98) in the Trippenhuis. As well as changing the design of gables to match the latest taste, they also built houses taller because of the lack of space and the increasingly high cost of land.

Above: *Gerrit Berckheyde (1638–98):* View of the Kloveniersburgwal in Amsterdam, *late 17th century (Private Collection, London).*

Looking north along this major canal, the Trippenhuis (1662, by Justus Vingboons for the brothers Trip) is on the right and the Waag (the old Weigh House) in the Nieuwe Markt to the north.

Below: *Jacob van Campen (1595–1657):* The Stadhuis (now the Royal Palace), 1648–55, Amsterdam.

Built entirely of stone, rather than the brick more common in the Netherlands, austere and heavy with its giant pilasters, the Stadhuis or Town Hall reflected precisely the civic aspirations of 17th-century Amsterdam.

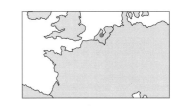

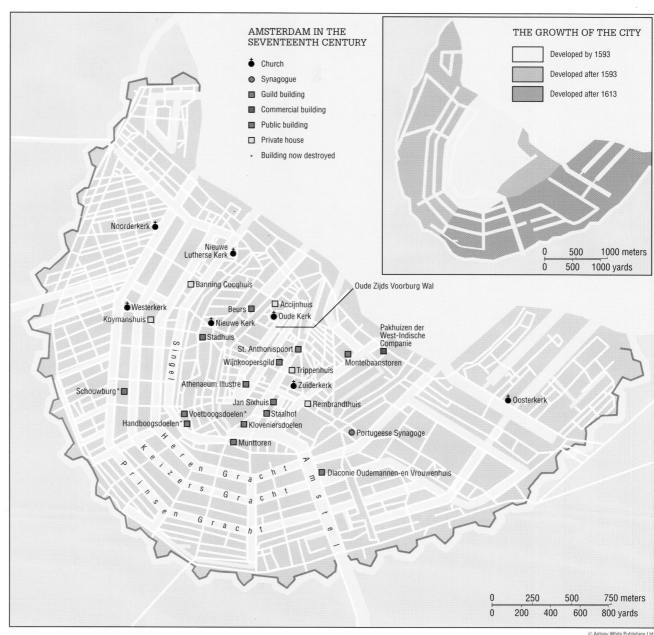

AMSTERDAM IN THE
SEVENTEENTH CENTURY

- ☗ Church
- ○ Synagogue
- ■ Guild building
- ■ Commercial building
- ■ Public building
- □ Private house
- · Building now destroyed

THE GROWTH OF THE CITY

- ☐ Developed by 1593
- ☐ Developed after 1593
- ☐ Developed after 1613

© Antony White Publishing Ltd.

Right: *Rembrandt van Rijn
(1606–69), detail from* The
Staalmeesters *(The Sampling
Officers of the Cloth Guild),
1661–2 (Rijksmuseum,
Amsterdam).*

*In 1661–2 Rembrandt received
two great commissions, one for the
new Stadhuis and one, a group
portrait, for the officers of the cloth
guild to hang in their own
building. His work for the Town
Hall was taken down almost
immediately, for reasons not
known, but* The Staalmeesters
*remains one of the enduring
portraits of the type of merchant
who created the wealth of 17th-
century Amsterdam.*

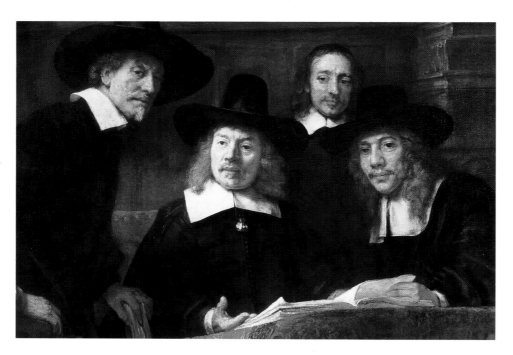

Antwerp

Antwerp was founded in the 12th century around its fortress, the Steen, situated on the quay beside the River Schelde. Steady expansion in the 15th century led to rapid growth in the early 16th, when the city achieved commercial supremacy in northern Europe. Architecturally, its most important monument was the new Stadhuis, built by Cornelis Floris (1514–75), which established the Flemish Renaissance style. But Antwerp's power and wealth were decimated by the Spanish invasion in 1567, which led to extensive destruction of the city, and between 1577 and 1589 the halving of its population of 100,000, many of whom fled north for both religious and economic reasons. It permanently lost its position as the major port in the north. Only with the signing of the Twelve Years' Truce in 1609 and the reopening of the River Schelde on the payment of dues to the Dutch, who controlled access to the sea, did the city, without ever recovering its former prosperity, slowly start to revive. In 1616 an English visitor commented on the almost total absence of people on the streets and the lack of any sign of commercial activity.

In a city reconverted to Catholicism, the Church became the principal patron. Besides repairing damage inflicted by the Protestant revolt, the Jesuits – supported by the Dominicans, Augustinians and secular clergy – set about promoting extensive building and decoration of churches during the first decades of the century. The Plantin and other presses established Antwerp as a major European center of religious publishing, propagating the beliefs of the Counter-Reformation movement.

The principal artistic figure was Peter Paul Rubens (1577–1640), who after his return from Italy in 1608 played a major role, supported by an active studio, in the refurbishment of the churches, both old and new. Jacob Jordaens (1593–1678) and to a lesser extent, owing to his absences abroad, Anthony van Dyck (1599–1641) also played their part in embellishing the city. Apart from greatly extending his characteristic 16th-century house with an Italianate studio and triumphal arch, Rubens was responsible for designing much architectural detail within the churches as well as the sculpture for the façade of the new Jesuit Church, St. Carolus Borromeus, the most sumptuous Baroque church in the southern Netherlands. He may also have played a part in the architecture, although the plan and much of the elevation was the work of the Jesuit architect Pieter Huyssens (1577–1637). Despite not yet having visited Italy, he developed the design from various Roman models. The almost contemporary Sint Augustinuskerk by Wenzel Cobergher (c.1560–1634), the first Fleming to introduce Italian architectural ideas, was significant for the first use in the Netherlands of Tuscan columns in the nave.

Although temporary (but recorded for posterity in sets of engravings), the extensive street decorations – consisting of triumphal arches, stages with pictures and floats – created for the Joyous Entry of a new ruler (designed by Otto van Veen for Albert and Isabella in 1599, and by Rubens for the Cardinal Infante Ferdinand in 1635) introduced historical, allegorical and emblematic ideas and up-to-date architectural forms to the city.

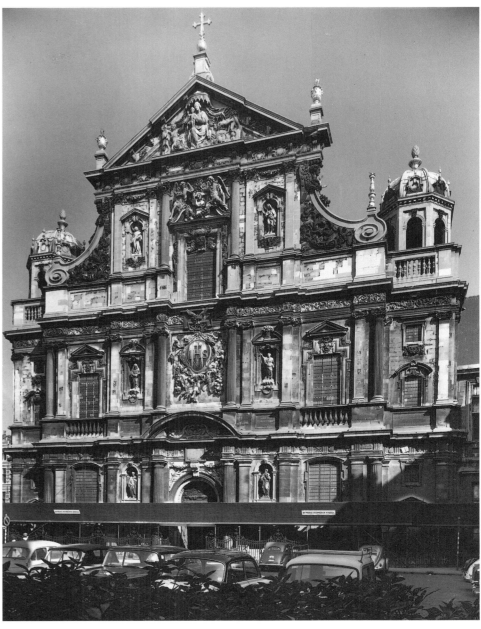

Left: *Jan Bruegel the Elder (1568–1625):* The Outskirts of Antwerp in Winter *(Private collection).*

Son of Pieter the Elder, and known as Velvet, Jewel or Flower Bruegel, his landscapes are profusely animated with human and animal figures, executed with the delicacy of a miniature.

ANTWERP IN THE
SEVENTEENTH CENTURY

- 🪧 Church building
- ◼ Guild
- ☐ Private house
- ◼ Public building
- • Building now destroyed

| 0 | 250 | 500 | 750 meters |
| 0 | 250 | 500 | 750 yards |

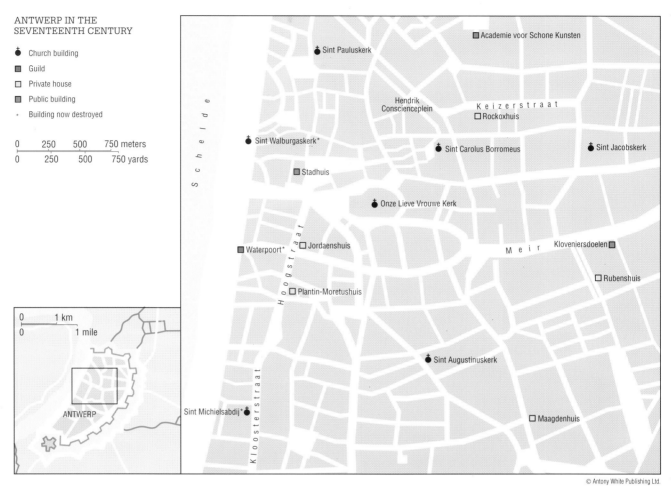

© Antony White Publishing Ltd.

Right: *Peter Paul Rubens (1577–1640):* Doubting Thomas *1613–15, (Royal Museum, Antwerp).*

Center panel of a triptych painted for the funeral monument of Nicolas Rockox, and erected in his lifetime in the Church of the Recollects (St. Paul), Antwerp. The shutters of the triptych are of Rockox and his wife.

Left: *Pieter Huyssens (1577–1637):* The Church of St. Carolus Borromeus *1615–25, Antwerp.*

Following a fire in 1718, the church was largely rebuilt. The façade is strongly Italianate, apparently based on a 16th century design for Florence Cathedral.

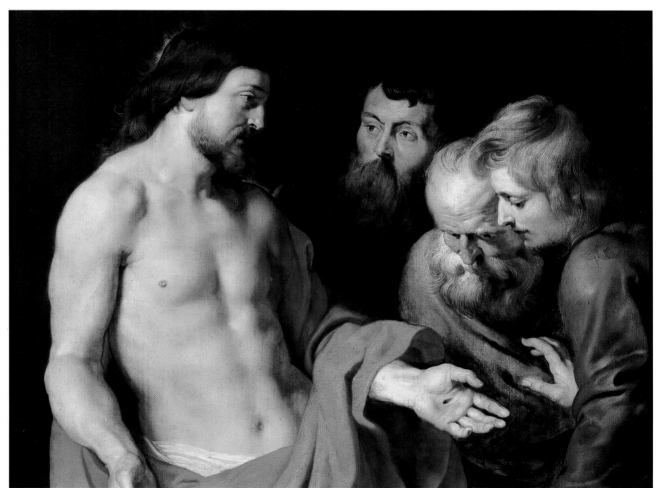

The Dutch Artist in his Landscape

Landscape in all its variety became one of the most popular themes in Dutch 17th-century art. The impetus for treating it as a subject in its own right came from Flemish art: both from what had been done at an earlier date, transmitted mainly through the medium of prints, and from the example of those artists, such as Gillis van Coninxloo (1544–1607), who had fled to the northern Netherlands to escape the troubles at home.

The particular beauty of the Dutch landscape, with its unique light and weather, its low-lying land bordered in the east by dunes criss-crossed by water and punctuated by churches and farms surrounded by trees, was admired in contemporary literature as well as in art, both for itself and as an expression of national pride.

A number of Dutch artists, following Karel van Mander's (1548–1606) precept that young painters should "go out of town to look at nature and spend time making sketches" (*Het Schilderboek*, 1604), started to make realistic studies of identifiable scenery. At this early stage the tendency was for the artist to concentrate on the vicinity of his home town; Goltzius (1558–1617) and Esaias van de Velde (*c.*1591–1630), for example, made studies of motifs around Haarlem, which quickly established itself as the most advanced center for developing a national landscape. Some artists, such as Hendrick Avercamp (1585–1634) at Kampen, Aelbert Cuyp (1620–91) at Dordrecht, and Salomon van Ruysdael (*c.*1600–70) in the dunes with their villages around Beverwijk, continued to make a feature of exploring their home territory as widely as possible.

By the middle of the century sketching tours farther afield became popular. Jan van Goyen (1596–1656) wandered frequently and widely throughout the northern Netherlands. The rivers, particularly the Rhine and the Maas, became much studied by artists who, apart from taking advantage of the wide, open views with occasional towns providing a center of interest, were able to travel more rapidly by boat than by road. In the east, the towns of Rhenen, Arnhem, Emmerich and Cleves were all studied by a number of artists. Probably in 1650 Nicolaes Berchem (1620–83) and Jacob van Ruisdael (*c.*1628–82) made a journey east as far as Bentheim in northern Germany.

About the same time Rembrandt (1606–69) travelled as far east as Arnhem; earlier Hercules Seghers (1589–*c.*1638) visited the town of Rhenen. Much closer to the main artistic centers, Scheveningen with its active beach-life became a favorite site, particularly when it was the setting for such an historic occasion as the departure of Charles II for England in 1660. The ruins of Brederode, Muiderberg and the Huis te Kleef near Haarlem with their antiquarian associations were popular subjects.

But although realistic landscape, whether studied at home or abroad, became the starting-point for much of Dutch art throughout the century, the artist back in his studio, except when faced with the special demands of topographical art, imaginatively reshaped the raw material collected in his sketches to produce in the final composition an example of what Samuel van Hoogstraeten called "selective naturalness".

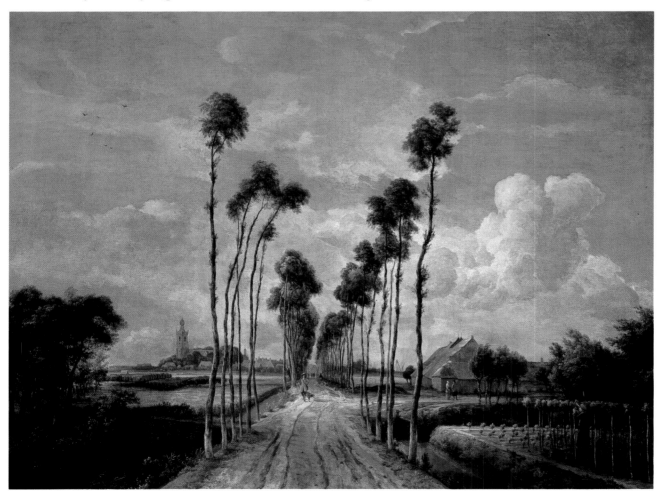

Left: *Meindert Hobbema (1636–1709):* Avenue at Middelharnis, *1699 (National Gallery, London).*

Hobbema's classic image of trees at Middelharnis in the Rhine delta epitomizes the Dutch artist's delight in the local landscape, and his sensitive and romantic approach to the ever-changing light created by broad skies and constant proximity to sea and fresh water.

DUTCH ARTISTS IN THEIR LANDSCAPE

- ◉ Major city
- ○ Town and regional center
- ◯ Artist working in locality

Key to artists

1. Hendrick Avercamp (1585–1634)
2. Jan Beerstraeten (1622–66)
3. Nicolas Berchem (1620–83)
4. Gerrit Berckheyde (1638–98)
5. Anthonie van Borssum (1629/30–77)
6. Andries Both (1612/13–41)
7. Willem Buytewech (1591/2–1624)
8. Aelbert Cuyp (1620–91)
9. Lambert Doomer (1622–1700)
10. Gerbrand van den Eeckhout (1621–74)
11. Hendrick Goltzius (1558–1616/7)
12. Jan van Goyen (1596–1656)
13. Jan Hackaert (c. 1629–85)
14. Joris van der Hagen (c. 1615–69)
15. Jan van der Heyden (1637–1712)
16. Meindert Hobbema (1638–1709)
17. Pieter de Hooch (1629–84)
18. Philips de Koninck (1638–1709)
19. Jan Lievens (1607–1683)
20. Aert van der Neer (1603/4–77)
21. Hendrick ten Oever (1639–1716)
22. Paulus Potter (1625–1654)
23. Rembrandt (1606–69)
24. Jacob van Ruisdael (1628/9–82)
25. Salomon van Ruysdael (c. 1600/2–70)
26. Pieter Saenredam (1597–1665)
27. Herman Saftleven (1609–85)
28. Hercules Seghers (1589/90–1633)
29. Adriaen van de Velde (1630–72)
30. Esaias van de Velde (c. 1590/1–1630)
31. Willem van de Velde II (1633–1707)
32. Adriaen van de Venne (1589–1662)
33. Jan Vermeer (1632–75)
34. Vincent van der Vinne (1628–1702)
35. Claes Jansz. Visscher (1587–1652)
36. Simon de Vlieger (c. 1600–52)
37. Hendrick Vroom (c. 1566–1640)
38. Jan Wijnants (1620/5–84)
39. Adam Willaerts (1577–1644)

Right: *Jan van Goyen (1596–1656):* **The Beach at Scheveningen,** *1625 (Christie's, London).*

Scheveningen, a port and coastal resort near The Hague, was a favorite site for Dutch landscape and seascape artists.

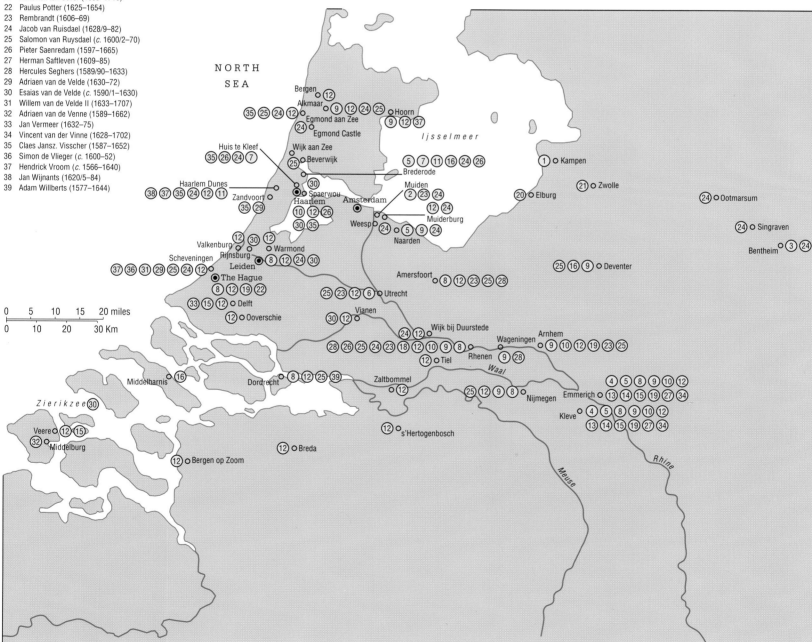

Rembrandt's Landscape Art and the Environs of Amsterdam

Rembrandt (1606–69) was not the first artist to explore the countryside around Amsterdam. His predecessor Claes Jansz. Visscher (1586–1652) had already studied some of Rembrandt's favorite motifs, such as Kostverloren, Sloterdijk and Diemen, in the first decade of the 17th century. Rembrandt's principal subjects were the characteristic Dutch farmhouses surrounded by trees, and wide views of the rivers and canals with their attendant life. This analysis started shortly after he moved into his new house in the Breestraat in 1639 and lasted for about 15 years, during which time he produced a substantial body of drawings and etchings either directly studied or subsequently developed from the landscape around the Dutch capital. Before this his few landscapes had lacked a sense of place, but now he concentrated upon the beauty and variety of the locality, often returning to study the same motif from different viewpoints, in different conditions or under different lights. From a preoccupation with surface pattern in the early prints and drawings, he concentrated on the effects of scale, distance and air.

Within an hour Rembrandt could reach on foot almost any site he drew. From the existing prints and drawings it is possible to determine his various walks. On some occasions he would leave Amsterdam by the Haarlemmerpoort and go west through Sloterdijk as far as Halfweg, with the option of visiting the outermost western bulwark of Amsterdam, de Blauwhoofd, which offered views across the River Ij and back towards the harbor. On others he would walk southwest through the Heilewegspoort to the Overtoom and then on to either Sloten or Amstelveen. But by far his favorite route was through the St. Anthoniespoort and along the Amstel, passing the Blauwbrug and then such frequently studied motifs as the Omval and Kostverloren until he reached Ouderkerk. Sometimes he continued out onto the Bullewijk, a tributary of the Amstel. Having reached the Omval, the artist sometimes branched east towards the village of Diemen, studied more than any other motif, and then returned to Amsterdam along the Diemerdijk, a walk that offered panoramic views across the Ij to the north.

The Jewish Cemetery at Ouderkerk was studied by several other artists. In particular, Jacob van Ruisdael (c.1628/9–82) made two drawings of tombs there, most probably in the 1650s, which served as the reference for his two famous paintings on the theme of the Jewish Cemetery.

Below: *Rembrandt van Rijn (1606–69):* The Omval on the River Amstel, *etching and drypoint, 1645 (British Museum, London).*

The windmill and group of houses on the River Amstel was a favorite subject of Rembrandt's. Here he has used a mixture of etching (engraving by biting into a copper plate with acid) and drypoint – working directly onto the plate with a graving tool – to achieve a mixture of atmosphere and tonal range with spontaneity.

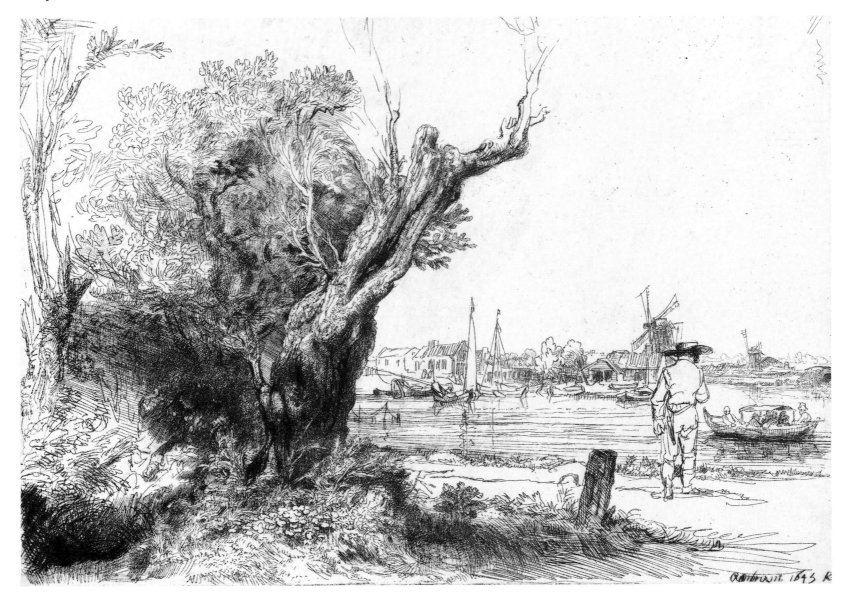

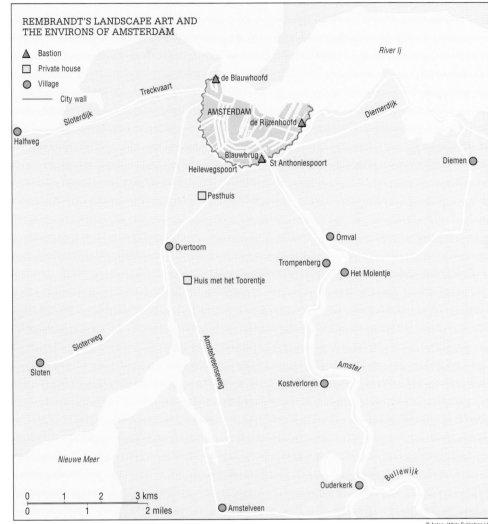

REMBRANDT'S LANDSCAPE ART AND
THE ENVIRONS OF AMSTERDAM

▲ Bastion
☐ Private house
⦿ Village
—— City wall

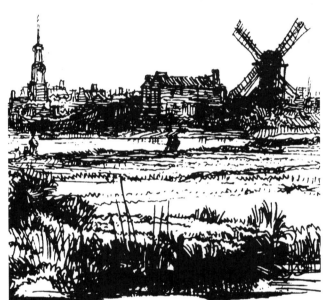

Above: *Rembrandt van Rijn (1606–69):* View of Amsterdam *(detail), etching c.1640.*

Right: *Rembrandt van Rijn (1606–69):* A River with a Sailing Boat on Nieuwe Meer, *pen and brown ink (Private Collection).*

Rembrandt's pen and ink drawings captured, with a bare minimum of line and tone, the structure and atmosphere of the landscape.

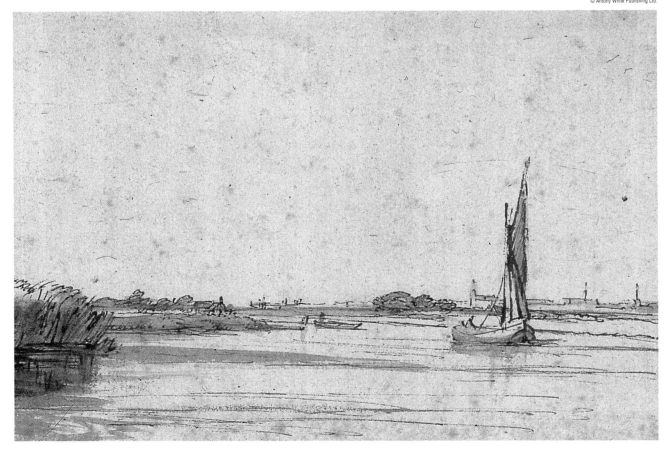

Central European Art and Architecture 1600–1789

Central Europe in the 17th and 18th centuries was made up of a great many small states and independent cities. After the Reformation in the 16th century, the north of the region became mainly Protestant, while the south remained largely Catholic. This division was strengthened by the Thirty Years' War (1618–48), which had a crippling effect on the arts. In the period of recovery afterwards, and especially following the peace treaty of 1699, the arts began to flourish in the south, not least in the service of the Catholic Church; but in the Protestant north there was comparatively little encouragement for the arts. In the south, major building activities were at first concentrated in the great cities of Prague and Vienna, but from the early 18th century there was a marvelous architectural efflorescence throughout the region. Moreover, whereas in the 17th century many of the most important commissions went to foreigners, in the 18th century the dominant architects were native Germans, Austrians and Czechs.

Catholic Central Europe whole-heartedly took up the Baroque style, which was born in Rome and was strongly associated with the Counter-Reformation. But in Central Europe – as it merged with the Rococo – it took on a form that was quite distinct from its Italian models. Instead of gravity and grandeur there is gaiety and exuberance; spaces take on highly elaborate shapes that flow into one another and surfaces ripple with decoration, so that the stable vertical and horizontal lines that usually determine architectural forms are at times magically dissolved. Painting and decoration played a great part in the total effect. Unlike many of the finest Italian Baroque churches, those in Central Europe were generally designed with painted ceilings as an integral part, and this kind of decorative painting flourished much more notably than easel painting, in which German, Austrian and Czech achievements were modest during this period. The Czech architect Killian Ignaz Dientzenhofer (1689–1751) typified the move from Italianate influences to a more independent regional Baroque style.

The orchestration of painting, sculpture, architecture and decoration into an artistic unit reaches one of its peaks in the work of the Asam brothers from Bavaria, Cosmas Damian Asam (1686–1739) and Egid Quirin Asam (1692–1750), who often worked together. Cosmas Damian was a fresco painter, Egid Quirin was a sculptor and stuccoist, and both were architects. Their collaborative masterpiece is the church of St. John Nepomuk in Munich (1733–46), which is often referred to as the "Asamkirche" (they paid for it themselves and it is attached to Egid Quirin's house).

The greatest Central European architect of the period was the German Balthasar Neumann (1687–1753). He was fortunate to work for enlightened patrons (particularly the Schönborn family) at the time of a building boom. Using his opportunities he produced a succession of superb buildings in which his inventive genius is matched by the beauty of the craftsmanship. His finest secular work is the Residenz (prince-bishops' palace) at Würzburg (1719–53) and his greatest ecclesiastical work is the pilgrimage church of Vierzehnheiligen ("Fourteen Saints") near Bamberg (1743–53).

Among the other masterpieces of the period are several buildings in Vienna by the two greatest Austrian architects of the period, Johann Bernhard Fischer von Erlach (1656–1723) and Johann Lukas von Hildebrandt (1668–1745), notably Fischer's mighty Karlskirche (begun 1716) and Hildebrandt's Lower and Upper Belvedere, (1713–16) and (1721–5) respectively. Dominikus Zimmermann (1685–1766) worked to equal effect but in the more rural areas of south Bavaria, such as with his two churches at Steinhausen. Less famous is their countryman Jakob Prandtauer (1660–1726), but he was the architect of perhaps the greatest of all Baroque monasteries, Melk (begun 1702), gloriously situated above the Danube.

In the Protestant north the most important patron was Frederick the Great (1740–86), who was a highly cultured man as well as a brilliant soldier who laid the foundations of the Prussian military state. His court architect (and close friend) was Georg Wenzeslaus von Knobelsdorff (1699–1753) who built for him (among much else) the opera house in Berlin (1741–3) and the palace of Sanssouci at Potsdam (1745–7), for which Frederick himself provided an initial sketch (it still survives). The palace shows his taste for the lighthearted French Rococo style, as the name Sanssouci (French for "carefree") suggests.

In church architecture, one building stands above all others in the north – the Frauenkirche in Dresden (1722–38) by Georg Bähr (1666–1738). Commissioned by the city fathers as a Protestant showpiece, it has splendid Baroque vigor but is completely different in form from the Baroque churches of the south, having a compact, centralized design, with galleried tiers of seating rising as if in a theater.

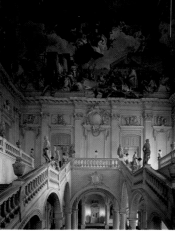

Above: *Johann Balthasar Neumann (1687–1753):* Grand Staircase, the Residenz, *1735, Würzburg.*

Neumann's great staircase at the Prince-Bishop's palace at Würzburg epitomizes the palatial aristocratic aspect of German Rococo architecture and decoration. The spectacular frescoes are the culmination of the decorative art of the 18th-century Venetian master Giovanni Battista Tiepolo (1696–1770).

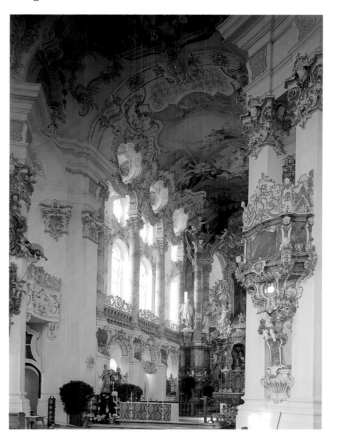

Left: *Dominikus Zimmermann (1685–1766):* Pilgrimage Church of Die Wies, *1746–1754, near Steingaden, Bavaria.*

This rural pilgrimage church, "in the meadows", was built for the rural community of Steingaden, not for an aristocratic patron or a wealthy institution. Decorated with frescoes by the architect's brother Johann (1680–1758), the white-painted walls, rhythmic movement and integrated mural decoration are pure Bavarian ecclesiastical Rococo.

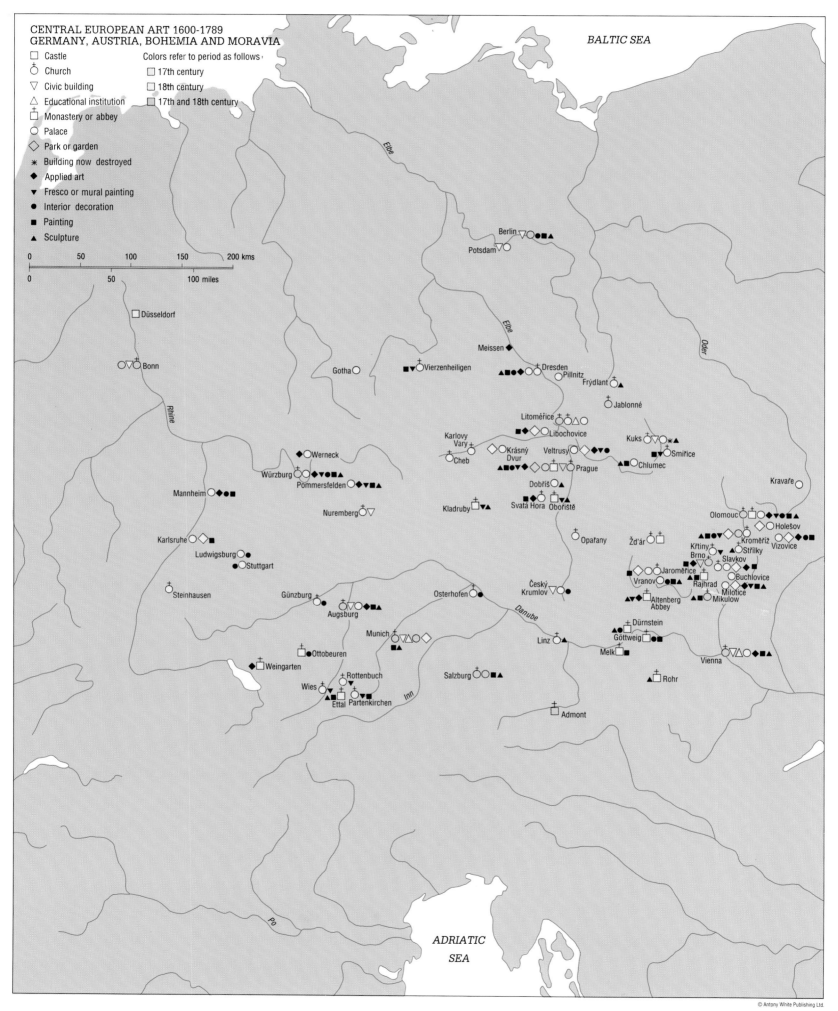

CENTRAL EUROPEAN ART 1600-1789
GERMANY, AUSTRIA, BOHEMIA AND MORAVIA

□ Castle Colors refer to period as follows:
◐ Church
▽ Civic building □ 17th century
△ Educational institution □ 18th century
⊟ Monastery or abbey □ 17th and 18th century
○ Palace
◇ Park or garden
✳ Building now destroyed
◆ Applied art
▼ Fresco or mural painting
● Interior decoration
■ Painting
▲ Sculpture

0 50 100 150 200 kms
0 50 100 miles

BALTIC SEA

Elbe

Oder

Rhine

Düsseldorf

Bonn

Gotha

Berlin
Potsdam

Meissen

Vierzenheiligen
Dresden
Pillnitz
Frýdlant
Jablonné

Litoměřice
Libochovice
Kuks
Smiřice

Karlovy Vary
Cheb
Krásný Dvur
Veltrusy
Prague
Chlumec

Werneck
Würzburg
Pömmersfelden

Dobříš

Mannheim

Kladruby
Svatá Hora
Oboříště

Nuremberg

Kravaře

Olomouc
Holešov
Vizovice

Karlsruhe

Opařany

Žďár

Křtiny
Brno
Slavkov
Střílky
Kroměříž

Ludwigsburg
Stuttgart

Steinhausen

Günzburg

Osterhofen

Český Krumlov

Vranov
Jaroměřice
Rajhrad
Buchlovice
Milotice
Mikulow

Augsburg

Munich

Altenberg Abbey

Danube

Dürnstein
Göttweig

Linz
Melk

Vienna

Ottobeuren

Weingarten

Wies
Rottenbuch
Ettal
Partenkirchen

Inn

Salzburg

Rohr

Admont

Po

ADRIATIC
SEA

Prague

The combination of a superb natural site with a host of outstanding buildings makes Prague – by common consent – one of the most beautiful cities in the world. Although the history of Bohemia and Czechoslovakia has often been turbulent, Prague itself has escaped serious destruction.

The date of the legendary foundation of Prague is A.D. 723. The city grew rapidly in size and prosperity in the 14th century, and under Charles IV it became the capital of the Holy Roman Empire and one of Europe's major cities. Charles (king of Bohemia 1346–78, and Holy Roman Emperor 1355–78) was an enlightened ruler and an outstanding patron of the arts, and gave the major impetus to the construction of the cathedral, encouraged the growth of the planned New Town (Nové Město) adjacent to the Old Town, and built the celebrated Charles Bridge across the Vltava, linking the New Town and the Lesser Quarter (Malà Strana). These three communities – Old Town, New Town, and Lesser Quarter – together with the hill of Hradčany (on which the castle and cathedral stand) form the historic center of Prague, with the hill of Vyšehrad (site of a great fortress) a slightly outlying area of major importance.

From 1526 Prague was under the rule of the Hapsburgs, and after the Thirty Years' War (1618–48) Bohemia was completely subordinate to Austrian rule. From an artistic point of view, the most interesting of the Hapsburg rulers was Rudolph II (king of Bohemia 1575–1611, Holy Roman Emperor 1576–1612); he was mentally unstable and politically inept but tolerant of Protestantism and passionately devoted to art and learning. Distinguished painters, sculptors and craftsmen came to Prague from all over Europe to work at his court, which became the center of a highly sophisticated late Mannerist style. Almost immediately after his death, the first Lutheran church in Prague opened, home to the famed "Prazske Jezulatko" (baby Jesus).

Prague was a natural crossroads for artistic currents, and many of its greatest 17th- and 18th- century architects were foreigners. The forcible imposition of Catholicism by the Hapsburgs meant that there was a great demand for new churches (especially from the Jesuits), and the suppression of the old Protestant Czech nobility left the new Hapsburg ruling class eager to impress their status in palace building. At first the major stylistic impulse came from Italy, for example the ruggedly handsome Leopold Gate (c.1670) by Carlo Lurago (c.1618–84) and the Černin Palace (begun 1668) by Francesco Caralti (d.1677) – an extremely vigorous design that reworks Palladian ideas in a Baroque spirit. A more refined, classical strain is seen in the work of Jean-Baptiste Mathey (c.1630-95), a Frenchman who settled in Prague in 1675, and the Austrian Johann Bernard Fischer von Erlach (1656-1723), one of the acknowledged geniuses of Baroque architecture. His cultured, aristocratic style is seen in the Clam-Gallas Palace (1707–12) and the magnificent Monstrance for Loreta church.

Among Czech architects the most important was Kilian Ignaz Dientzenhofer (1689–1751), the leading member of a family of architects that originated in Bavaria. Among his many fine works are the exquisite Villa Amerika (1717–20), built as a summerhouse and now the Dvořák Museum, and the dome and tower (1737–51) of St. Nicholas in the Lesser Quarter, among the most prominent landmarks in panoramas of Prague. The church had been begun by Kilian Ignaz's father, Christoph Dientzenhofer (1655–1722), in 1703. Next to the Dientzenhofers, Franz Maximilian Kanka (1674–1766) was probably the most prolific Czech architect working in Prague in the period. There are also innumerable fine townhouses of the period, often painted pretty pastel colors, as is common in Central Europe.

This was a great age for sculpture in Prague as well as for architecture. The leading lights were the Austrian-born Matyáš Bernard Braun (1684–1738) and Ferdinand Maximilian Brokoff (1688–1731), who was of Hungarian extraction; both are represented in the splendid array of figures and groups that adorn the Charles Bridge. This is one of the most remarkable open-air ensembles of sculpture in Europe, and Prague has a host of other outdoor sculpture of high quality, Braun's mighty Atlas figures on the portal of the Clam-Gallas Palace being particularly outstanding.

Czech painting of the same period is not quite of the same standard, but Václav Vavřinec Reiner (c.1686–1743) was an accomplished fresco decorator who adorned the ceilings of many churches and palaces in Prague. His work is overshadowed, however, by the glorious ceiling painting (1794) in the Philosophical Hall of the Strahov Library by the Austrian Franz Anton Maulpertsch (1724–96), the last of the great decorators in the Baroque and Rococo tradition. By this time the aged Maulpertsch was a magnificent relic of a former age, for the Neoclassical style was now virtually all-conquering. In architecture, the change in taste is seen in the relatively severe forms of the Tyl Theatre (1781–83).

Above: *Adriaen van de Vries (c.1550–1626), statuary, Valdstejnsky Palace, Prague.*

Born in the Hague, de Vries was a pupil of Giovanni da Bologna in Florence and worked in Prague for Emperor Rudolph II. His work, using a loose modeled technique emphasizing light and shade on the surface of flesh, was known throughout Europe.

Ferdinand Maximilian Brokoff (1688–1731), Decorative Sculpture, Morzinsky Palace, Prague.

The son and pupil of Johann Brokoff, he produced massive sculptures, and their expressive qualities with slightly theatrical gestures, enable them to dominate their podia.

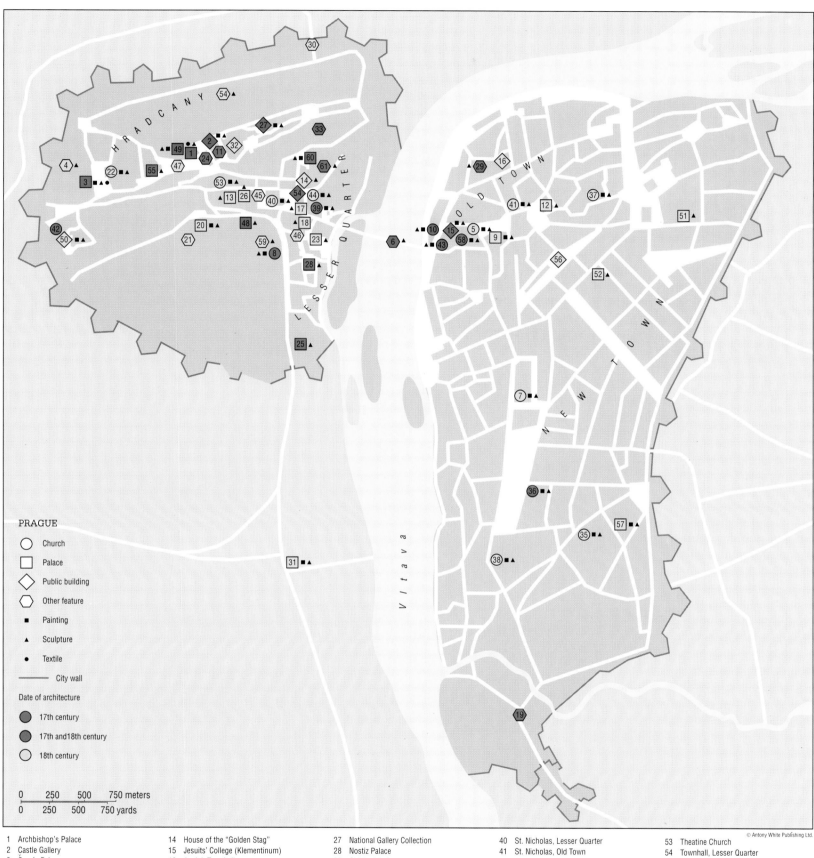

PRAGUE

○ Church

□ Palace

◇ Public building

⬡ Other feature

■ Painting

▲ Sculpture

● Textile

—— City wall

Date of architecture

● 17th century

◐ 17th and 18th century

○ 18th century

| 0 | 250 | 500 | 750 meters |
| 0 | 250 | 500 | 750 yards |

© Antony White Publishing Ltd.

1	Archbishop's Palace	14	House of the "Golden Stag"	27	National Gallery Collection	40	St. Nicholas, Lesser Quarter	53	Theatine Church
2	Castle Gallery	15	Jesuits' College (Klementinum)	28	Nostiz Palace	41	St. Nicholas, Old Town	54	Townhall, Lesser Quarter
3	Černín Palace	16	Jewish Townhall	29	Old Jewish Cemetery	42	St. Roch	55	Tuscany Palace
4	Černín Palace Garden	17	Kaiserstein Palace	30	Písecká Gate	43	St. Salvator	56	Tyl Theater
5	Chapel of mirrors	18	Kounic Palace	31	Portheim Villa	44	St. Thomas	57	Villa Amerika
6	Charles' Bridge	19	Leopold Gate, with Vyšehrad Fortress	32	Prague Castle	45	Sculpture group of the Holy Trinity	58	Vlašska Chapel
7	Church of the Holy Trinity	20	Lobkowicz Palace	33	Prague Castle Gardens	46	Sculpture group of St. John the Baptist	59	Vrtba Garden
8	Church of the Virgin Mary Victorious	21	Lobkowicz Palace Garden	34	Royal Gardens	47	Sculpture group of the Virgin Mary	60	Wallenstein Palace
9	Clam-Gallas Palace	22	Loreto Monastery	35	St. Catherine	48	Schönborn Palace	61	Wallenstein Palace Garden
10	Crusaders' Church (St. Francis)	23	Maltese Grand-Prior's Palace	36	St. Ignaties	49	Šternberg Palace with gallery		
11	Fountains	24	Mathias Gate	37	St. James	50	Strahov Library		
12	Golz-Kinsky Palace	25	Michna Palace	38	St. John on the Rock	51	Sweerts-Špork Palace		
13	Hohenstein Palace	26	Morzini Palace	39	St. Joseph	52	Sylva-Taroucca Palace		

Vienna

The Turks besieged Vienna in 1529 and again in 1683. Their repulse (by German and Polish relief forces) on the second occasion was a turning point in history – the Ottoman Empire began to decline and Austria, which recovered Hungary from the Turks in 1699, rose as a great European power. Victory over the Turks stimulated national pride and ushered in a building boom. After the fallow period of the Thirty Years War (1618–48) the last years of the 17th century and the first half of the 18th were Austria's greatest age in architecture. Previously, Italians had won major commissions in Vienna – such as Carlo Antonio Carlone (Church of the Nine Angelic Choirs, 1662) and Filiberto Lucchese (Leopold Range of the Hofburg – the Imperial Palace – 1661–8). Now Austrian artists came into their own, with Johann Fischer von Erlach (1656–1723) and Johann Lukas von Hildebrandt (1668–1745) ranking among the greatest European architects of the age. Between them they were responsible for most of Vienna's outstanding Baroque buildings.

At the time Vienna had an unusual layout, described by the visiting Englishman, John Moore, in 1779: "No houses without the walls are allowed to be built nearer than 600 yards; so that there is a circular field of 600 paces broad all around the town...Beyond the plain, the suburbs are built. They form a very extensive and magnificent town of an irregular circular form, containing within its bosom a spacious field, which has for its center the original town of Vienna." Visitors often remarked on the narrowness of the streets in the city center. Buildings tended to be tall, to make the best of the available space.

Fischer von Erlach settled in Vienna in 1687, after training in Italy, and became chief architect to the imperial court in 1704. Hildebrandt, who was born in Italy, settled in Vienna in 1697, became a court architect in 1700 and chief court architect in 1723 on Fischer's death.

Both of them were mainly secular architects, working for the great aristocratic families as well as the imperial family, but Fischer von Erlach's masterpiece is an ecclesiastical building – the Karlskirche (Charles Church), begun in 1716 and finished after his death by his son Joseph Emanuel Fischer von Erlach (1693–1742). The church glorifies the emperor as much as the saint, the pair of huge triumphal columns that flank the entrance extolling him as a second Augustus and a second Solomon. Fischer von Erlach's other supreme masterpiece is the Hofbibliothek (Imperial Library) in the Hofburg (Imperial Palace) begun in 1722 and finished by his son. It is one of the grandest library buildings in the world. Fischer's style draws on his knowledge of Italian Baroque architecture, but has an intellectual, aristocratic quality that is his own. Hildebrandt's style was more elegant and graceful, with a typically Viennese charm and vivacity. It is seen at its most festive in the Daun-Kinsky Palace (1713–16). His most famous works are the Lower Belvedere (1714–15) and the Upper Belvedere (1720–4), palaces built for Prince Eugene of Savoy, a great general in the service of the Holy Roman Empire.

The Baroque buildings of Vienna usually had rich sculptural and painted decoration. Ceiling painting became an Austrian speciality in this period, the leading artists including Johann Rottmayr (1654–1730), who decorated the Karlskirche (1725), and Daniel Gran (1694–1757), who painted the vaults of the Hofbibliothek (1730). Among outdoor sculpture, the most interesting monument is the Pestsaüle (Plague Column) of 1682–94, a huge, multi-figure, pyramidical composition commemorating the terrible plague of 1679. The appearance of Vienna during this age was superbly documented by the Italian view-painter Bernardo Bellotto (1720–80), nephew of the famous Canaletto; who worked in Vienna 1757–61.

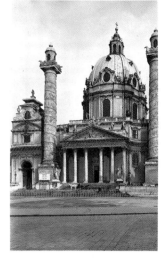

Above: *Johann Fischer von Erlach (1656–1723):* Karlskirche, *begun 1716, Vienna.*

The highly original façade of the Karlskirche endowed by the Emperor Charles VI in thanksgiving for the deliverance of Vienna from the plague in 1713, combines an extremely wide front with replicas of two Roman columns, those of Trajan and Marcus Aurelius.

Below: *Johann Lukas von Hildebrant (1668–1745):* The Upper Belvedere, *1720–24, Vienna.*

The two Belvederes built for Prince Eugene, the lower in 1714/5 were Hildebrandt's secular masterpieces in terms of grandeur of concept and design.

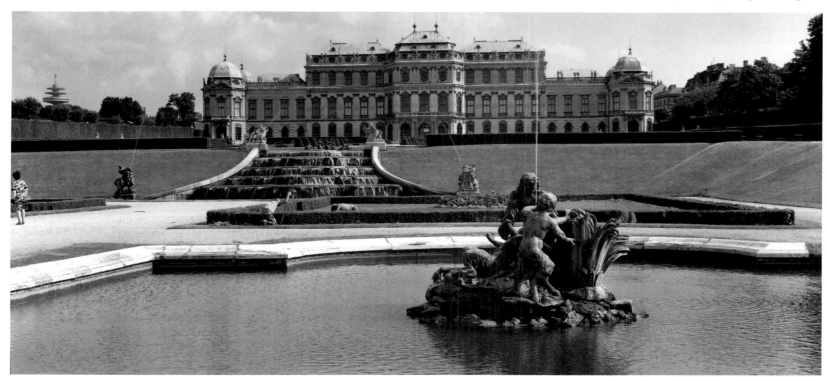

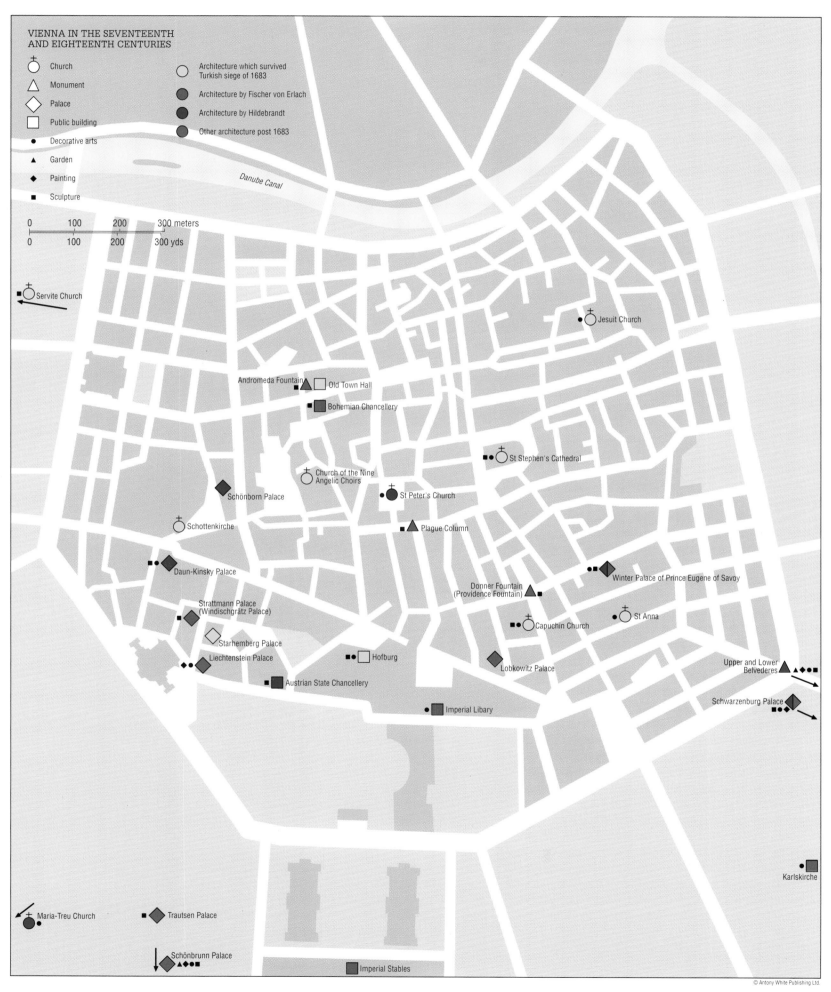

VIENNA IN THE SEVENTEENTH AND EIGHTEENTH CENTURIES

- ✛ ◯ Church
- △ Monument
- ◇ Palace
- ☐ Public building

- ● Decorative arts
- ▲ Garden
- ◆ Painting
- ■ Sculpture

- ◯ Architecture which survived Turkish siege of 1683
- ◯ Architecture by Fischer von Erlach
- ◯ Architecture by Hildebrandt
- ◯ Other architecture post 1683

0 100 200 300 meters
0 100 200 300 yds

Danube Canal

Servite Church

Jesuit Church

Andromeda Fountain — Old Town Hall

Bohemian Chancellery

St Stephen's Cathedral

Church of the Nine Angelic Choirs

Schönborn Palace

St Peter's Church

Schottenkirche

Plague Column

Daun-Kinsky Palace

Winter Palace of Prince Eugene of Savoy

Donner Fountain (Providence Fountain)

Strattmann Palace (Windischgrätz Palace)

St Anna

Capuchin Church

Starhemberg Palace

Liechtenstein Palace

Hofburg

Lobkowitz Palace

Upper and Lower Belvederes

Austrian State Chancellery

Schwarzenburg Palace

Imperial Libary

Karlskirche

Maria-Treu Church

Trautsen Palace

Schönbrunn Palace

Imperial Stables

© Antony White Publishing Ltd.

Eastern European Art
1600–1789

The Thirty Years' War (1618–48) had a devastating effect on many parts of Europe. Germany was worst hit, but Eastern Europe also suffered destruction and depopulation, and political and economic conditions in Hungary and Poland remained generally unpropitious for art throughout most of the 17th century. The Poles virtually lost their natural identity when the Elector of Saxony became King of Poland in 1697, while Hungary became part of the Hapsburg dominions and after 1711 was in effect ruled from Vienna.

In Hungary there were fine churches and civic buildings (notably in Budapest, which needed extensive rebuilding after a great fire in 1723), but the most characteristic form was the palace. A particularly lovely example is that at Ráckeve (1701–2) by the great Austrian architect Johann Lukas von Hildebrandt (1668–1745), beautifully situated on an island in the Danube near Budapest. Frescoes by Franz Anton Maulpertsch (1724–96) here, and in Sümeg and Tápa, represent a strong regional Baroque. Despite this, a striking feature of 18th-century Hungarian architecture is that the Neoclassical style was established very early. The key building in this respect is the cathedral at Vác (1763–77) by the Italian architect Isidore Canevale (1730–86). Slovakia, a part of Hungary, was home to an interesting church at Trnava, a Jesuit's church at Trencín and a part of the Bratislava Castle transformed by G. B. Carlone.

In Poland in the 17th century, the leading architect was a Dutchman, Tylman van Gameren (d.1706). He settled in Poland in 1665 and designed churches and palaces in Warsaw and Kraków in a restrained Baroque style. In the 18th century a more full-blooded Baroque style developed; and the German Matthaeus Daniel Pöppelmann (1662–1736), famous as the designer of the Zwinger at Dresden, was one of the architects who worked in the huge Saxon Palace in Warsaw, which was begun c.1726. A prime example of the Polish Baroque are the elegant Lazienki gardens in Warsaw, beautifully restored after World War II. The Baroque style continued to flourish in parts of Poland until the end of the century. King Stanislav Augustus (1764–85), an amateur painter himself, did much to foster interest in art and many foreign artists came to work at his court.

In painting and sculpture, as in architecture, Hungary and Poland imported much of their talent in the 17th and 18th centuries. The most famous painter to be associated with either of these countries in this period was probably the Italian Bernardo Bellotto (1720–80), the nephew and pupil of the famous Canaletto. He spent the last 12 years of his life as court painter in Warsaw, and his highly detailed views of the city were later used as guides to the reconstruction of buildings that had been destroyed in the Second World War. In sculpture, perhaps the most interesting figure is the Austrian Georg Raphael Donner (1693–1741). He did much work for the cathedral there, including a group of *St. Martin and the Beggar* that is one of the most original sculptural masterpieces of the age; the saint, on horseback, is not shown in armour, as was customary, but in contemporary hussar's uniform.

After the battle of Toltava (1709) Russia became an important power. The key event in Russian art of the period was Peter the Great's (1682–1725) foundation of a new capital at St. Petersburg in 1703, a symbol of his determination to open his country to the West. Peter brought numerous Western architects and craftsmen to St. Petersburg, among them the Italian-Swiss Domenico Trezzini (1670–1734), who designed the Cathedral of St. Peter and St. Paul (1712–33) and many other buildings in the new capital. Peter the Great intended that it should stand comparison with any of the great European cities he had seen on his extensive travels. Of course, Russia was firmly rooted in its tradition of kremlins – complex monasteries and churches with onion-shaped roofs, and in some areas a unique Baroque style, incorporating the kremlin, developed.

Peter's policies were continued by a series of powerful empresses – Anna Iounnovna (1730–40), Elizabeth (1741–62) and Catherine the Great (1762–96) – and under them St. Petersburg became one of the greatest cities in Europe. The leading architect of the period was Bartolomeo Rastrelli (1700–71); he was the son of an Italian sculptor and trained partly in Paris, but spent almost all his adult life in Russia. He is best known for his huge palaces, vigorously Baroque in style and enlivened by brightly painted façades, notably the Fourth Winter Palace in St. Petersburg (1754–62) and the Great Palace at Tsarskoe Selo, now Pushkin (1749–52). His other buildings include the Cathedral of St. Andrew at Kiev (1747–67), in which the onion domes recall the forms of traditional Russian architecture. Rastrelli marks the swansong of the Baroque style in Russia, for Neoclassism was well established by 1770s.

Russia produced some talented painters and sculptors in the 18th century, but the one great masterpiece in either art to be produced was the work of a Frenchman. It is the huge equestrian statue of Peter the Great in St. Petersburg by Étienne-Maurice Falconet (1716–91), who spent twelve years in Russia working on it (1766–78). The statue was unveiled in 1782.

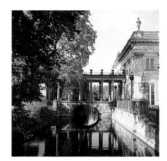

Above: *Domenico Merlini (1731 –97):* "Na Wodzie" Palace, *1784–95, Warsaw, Poland.*

Merlini and Giacomo Fontana (1710–93) created the first phase of neo-classical architecture in Eastern Europe at the Court of King Stanislav Augustus Poniatowski (1764–85).

Below: The Hermitage in the garden of the Great (Catherine or old) Palace, *1749–52, Pushkin, Russia.*

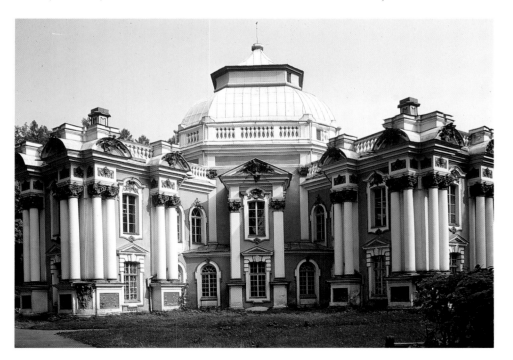

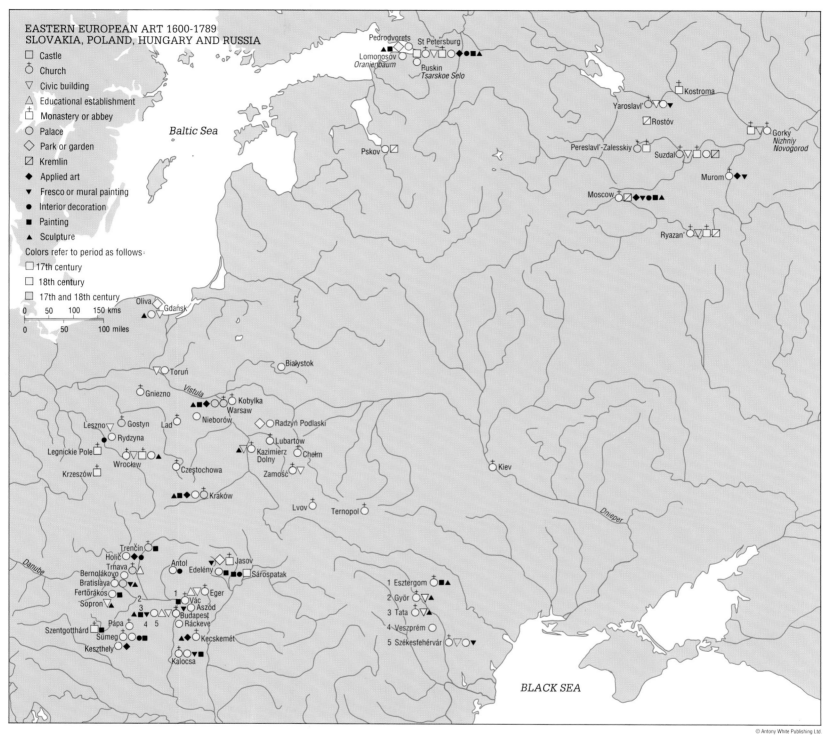

EASTERN EUROPEAN ART 1600-1789
SLOVAKIA, POLAND, HUNGARY AND RUSSIA

☐ Castle
⌖ Church
▽ Civic building
△ Educational establishment
☖ Monastery or abbey
○ Palace
◇ Park or garden
⊠ Kremlin
◆ Applied art
▼ Fresco or mural painting
● Interior decoration
■ Painting
▲ Sculpture

Colors refer to period as follows:
☐ 17th century
☐ 18th century
☐ 17th and 18th century

0 50 100 150 kms
0 50 100 miles

Baltic Sea

Pedrodvorets
St Petersburg
Lomonosov
Oranienbaum
Ruskin
Tsarskoe Selo

Kostroma
Yaroslavl'
Rostóv
Gorky
Nizhniy Novogorod
Pskov
Pereslavl'-Zalesskiy
Suzdal
Murom
Moscow
Ryazan'

Kiev

Vistula

Oliva
Gdańsk

Toruń
Białystok
Gniezno
Kobylka
Warsaw
Nieborów
Radzyń Podlaski
Leszno
Gostyn
Lad
Lubartów
Rydzyna
Legnickie Pole
Kazimierz Dolny
Chełm
Wrocław
Częstochowa
Zamość
Krzeszów
Kraków
Lvov
Ternopol

Dnieper

Danube
Trenčín
Holíč
Trnava
Antol
Jasov
Bernolákovo
Edelény
Bratislava
Sárospatak
Fertőrákos
Eger
Sopron
Vác
Aszód
Pápa
Budapest
Szentgotthárd
Ráckeve
Sümeg
Kecskemét
Keszthely
Kalocsa

1 Esztergom
2 Győr
3 Tata
4 Veszprém
5 Székesfehérvár

BLACK SEA

© Antony White Publishing Ltd.

245

Right: The City of Bratislava
in the 17th century.

*Bratislava (Presburg in German,
Pozsony in Hungarian), the
capital of Hungary from 1541 to
1784, was much rebuilt in the
17th and 18th centuries.*

London

The Strand, the route from the City of London to the royal palaces of Westminster and, later, Whitehall, was lined with the houses of the great from the 13th century. In the early 17th century the greatest art patrons after the king, Arundel and Buckingham, transformed their houses in the Strand, Arundel House and York House, into Renaissance palaces. Even more impressive was Inigo Jones' work for Queen Henrietta Maria at Somerset House. Elsewhere there was an attempt to emulate the urban planning developments of continental cities such as Paris and Leghorn; Covent Garden Piazza and Lincoln's Inn Fields were impressive projects to provide stately housing for gentlemen rather than for great lords.

The Civil War put a stop to all building but when it was over the movement westwards from the ancient centre of London started in earnest. The major development was the Earl of St. Albans' estate in St. James's, centered on St. James's Square, but Pall Mall became residential and Piccadilly replaced the Strand as the most fashionable street for great houses. Houses sprang up around the fringes of the newly developed areas. Soho was created with its grid system of Greek, Thrift (Frith), Dean and Wardour Streets and the centerpiece of Soho Square contained Monmouth House and Carlisle House. The spoke interchange of Seven Dials was created to the north of Covent Garden and the Red Lion Square area to the north of Lincoln's Inn Fields was laid out.

Of course, the greatest development in late 17th century London should have been the rebuilding of the City after the Great Fire of 1666. However, this was not to be and Wren had to content himself with rebuilding 81 city churches including 51 brand new buildings. To the west he contributed St. James's, Piccadilly to the Earl of St. Albans' estate and possibly St. Anne's, Soho to the Soho development. The limited church building in the new western developments was sparked by the 1710 act calling for new churches to be provided from the tax on coal. The most imposing results were Hawksmoor's East End churches, and St. George's, Bloomsbury in the West End. Other new churches in the West End included St. Martin-in-the-Fields, St. George's, Hanover Square, St. Mary-le-Strand and St. Giles-in-the-Fields.

In the early 17th century Piccadilly remained the street of palaces. Clarendon House was demolished and replaced by Albemarle, Dover and Bond Streets but others appeared and remnants of the greatest Palladian mansion, Burlington House, still survive. The Strand, meanwhile, had become London's main shopping street and Soho, filled with Huguenot refugees after the Revocation of the Edict of Nantes in 1685 rapidly lost its popularity as a fashionable place to live. After the lapse in building caused by the War of Spanish Succession the movement westwards was taken up again with increased enthusiasm. The Earl of Scarborough's estate was developed in Hanover Square and its surrounding streets from 1717–19 and Sir Richard Grosvenor's much larger estate was developed from 1725 with the enormous Grosvenor Square at its centerpiece. The whole area of the Grosvenor Mayfair Estate had been built on by the mid 1750s.

North of Oxford Street the Earl of Oxford developed the area around Cavendish Square and from the 1770s the Harley Estate developed north from Cavendish Square to the new Marylebone Road. To the west the Portman Estate included Gloucester Place and the newly fashionable Portman Square and to the east the Bedford Estate was developed around Bedford, Russell and Woburn Squares. Various Acts of Parliament controlled the extent and quality of building, the most important being the 1774 act in which four types of house were defined, from the expensive £850 variety to the more utilitarian £150 house. The uniformity of much of Georgian London is due to these considered contributions to town planning. There were some more individual conceptions, most importantly the Adam brothers' Adelphi scheme on the Thames on the site of Durham House.

Below: James Gibbs (1682–1754): St. Mary-le-Strand, 1714–19, London.

Gibbs had studied with Carlo Fontana in Rome, and this, one of his early churches, betrays Italian influences with the upper floor Venetian windows.

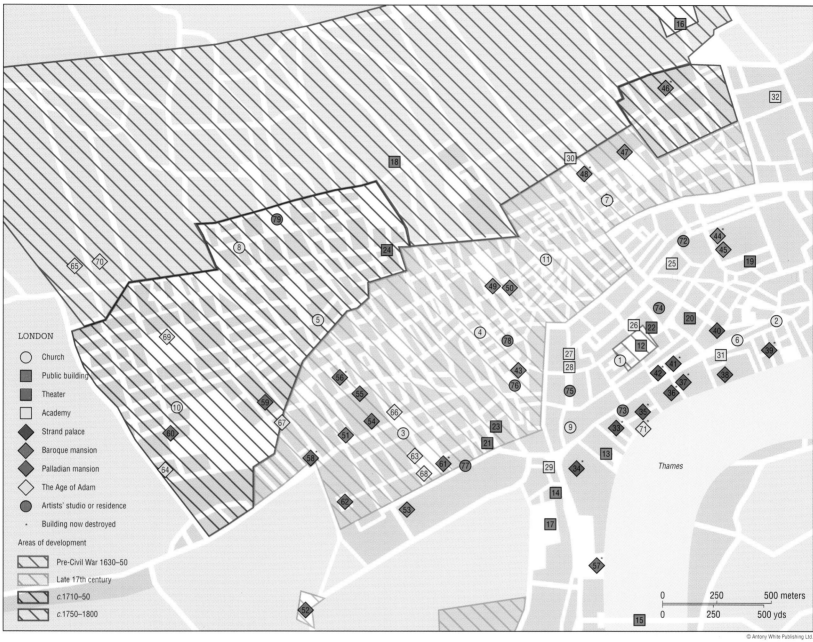

LONDON

○ Church

■ Public building

■ Theater

□ Academy

◆ Strand palace

◆ Baroque mansion

◆ Palladian mansion

◇ The Age of Adam

● Artists' studio or residence

* Building now destroyed

Areas of development

▨ Pre-Civil War 1630–50

▨ Late 17th century

▨ c.1710–50

▨ c.1750–1800

Thames

0 250 500 meters

0 250 500 yds

© Antony White Publishing Ltd.

Ecclesiastical buildings

1 St Paul, Covent Garden, 1631–38, Inigo Jones
2 St Clement Dane, 1680–82, Sir Christopher Wren (steeples, 1719, James Gibbs)
3 St James, Piccadilly, 1676–84, Sir Christopher Wren
4 St Anne, Soho, 1686–1717, Sir Christopher Wren
5 St George, Hanover Square, 1721–24, John James
6 St Mary le Strand, 1714–17, James Gibbs
7 St George, Bloomsbury, 1720–30, Nicholas Hawksmoor
8 St Peter, Vere Street, 1721–24, James Gibbs
9 St Martin-in-the-Fields, 1722–26, James Gibbs (rebuild)
10 Grosvenor Chapel, c.1730, Benjamin Timbrell
11 St Giles-in-the-Fields, 1731–33, Henry Flitcroft

Public Institutes and Facilities

12 Covent Garden Market, 1630
13 Hungerford Market, 1682
14 The Admiralty,1722–26, Thomas Ripley, (screen, 1759–61, Robert Adam)
15 Westminster Bridge, 1862, Thomas Page, 1739–50, Charles Labelyre

16 Foundling Hospital, 1745–51, Theodore Jacobson
17 Horse Guards, 1750–60, William Kent and John Vardy
18 Middlesex Hospital, 1755 John Paine

Theaters

19 Lincoln's Inn Fields, 1658–1794
20 Theatre Royal, Drury Lane, 1764, Sir Christopher Wren; 1775, Robert Adam; 1794, Henry Holland; 1810–12, Benjamin Wyatt
21 Opera House, 1704, Sir John Vanbrugh
22 Theatre Royal, Covent Garden, 1732, Edward Shephard; 1792, Henry Holland
23 Little Theatre, Haymarket, 1720, John Potter, (Theatre Royal from 1767) 1821, John Nash
24 The Pantheon, Oxford Street, 1722, James Wyatt; 1938, Robert Lutyens

Academies and Exhibition rooms

25 Kneller's Academy, 1711–23
26 Thornhill's Academy, 1724–34
27 Cheron & Vanderbak's Academy, 1720–c.1725
28 St Martin's Lane Academy, 1735–67
29 Great Exhibition Room, from 1757
30 British Museum, Montagu House, from 1759
31 Royal Academy, Old Somerset House 1771, transferred to new building 1780

32 Society of Arts 1754, John Street Adelphi from 1774

The Strand Palaces

33 Site of York House
34 Northumberland House, started 1608; Strand façade reconstructed 1748–50 by Daniel Garrett then James Paine; interior decoration 1770 by Robert Adam, destroyed 1874
35 Site of Durham House
36 Site of Salisbury House
37 Site of Worcester House
38 Somerset House, chapel, 1630–35 Inigo Jones; Gallery, 1661–62, by John Webb
39 Site of Arundel House
40 Craven House, 1620, Balthasar Gerbier; 1690, Cpt. William Winde converted into tenements by 1800
41 Site of Bedford House
42 Site of Bedford House

Baroque Mansions

43 Leicester House, 1630s
44 Carlisle House (later Newcastle House), 1641–42
45 Lindsay House, c.1640
46 Powis House, 1713
47 Bedford House (ex-Southhampton House), 1657, remodelled, 1758, by Henry Flitcroft
48 Montagu House, Robert Hooke, 1675–79, burned; 1687, Fouget

49 Monmouth House, 1683–84; mannerist façade, c.1718, added by Thomas Archer
50 Carlisle House, Soho Square, 1685
51 Site of Clarendon House, 1664–67 Sir Roger Pratt, demolished 1683
52 Buckingham House, William Winde 1703–05
53 Marlborough House, 1709–12, Sir Christopher Wren

Palladian Mansions

54 Burlington House, 1665; external additions, 1715 & 1719, by James Gibbs; refaced, 1720, by Colen Campbell
55 Queensbury House, 1721–23, Giacomo Leoni
56 General Wade's House, 1723, Lord Burlington
57 Pembroke House, c.1723, Colen Campbell; demolished 1757 and replaced by a building by Sir William Chambers
58 Devonshire House, 1730s, William Kent, on site of 1672 house
59 44 Berkeley Square, 1742–47, William Kent
60 Chesterfield House, 1747–52, Isaac Ware
61 Future site of Norfolk House, 1748, Matthew Brettingham the Elder
62 Future site of Spencer House, 1756, John Vardy; 1766, Vardy/James Stuart interiors

The Age of Adam

63 Future site of Lichfield House, 1764–66, James Stuart
64 Future site of Londonderry House, Park Lane, 1765, James Stuart
65 Future site of Montagu House, Portman Square, 1774–82, James Stuart
66 Future site of Melbourne House,1771–76, Sir William Chambers (Albany from 1802 by Henry Holland)
67 Future site of Lansdowne House, 1761–68, Robert Adam
68 Future site of 20 St James' Square, 1775–89, Robert Adam
69 Future site of Derby House, 1773–75, R. Edwin, refurbished by Robert Adam
70 Future site of Home House, 1777, Robert Adam
71 Future site of the Adelphi, 1768–74, main part, Adam Brothers

Artists' Studios and Residences

72 Great Queen Street area
73 The Strand
74 Covent Garden
75 St Martins Lane
76 Leicester Square
77 St James'
78 Soho
79 North of Oxford Street

247

Bath and Edinburgh

During the 18th century Bath developed as the most fashionable resort in Europe. Polite society flocked to the city to take the waters, dance, gossip and gamble away from the realities of London and the boredom of country estates. The first pump room was built in 1704 but the architectural development of Bath did not begin until the late 1720s when John Wood the Elder began to lay-out Queen Square. In 1725 Wood had presented the landlord, Robert Gay, with a grand plan for Bath including a Royal Forum, a Grand Circus and an Imperial Gymnasium. These classical dreams were translated into the schemes that sparked the growth of Bath over the next hundred years: Queen Square, North and South Parades and King's Circus.

Wood saw his great quadrangle of buildings near the Abbey as a Royal Forum but only a portion was built: North and South Parades and the connecting streets. His concept for the upper town, starting with Queen Square, was more fully realised with the King's Circus, completed by John Wood the Younger after his father's death. The younger Wood continued the sequence with Royal Crescent, the most striking piece of town planning of the 18th century. The old Assembly Rooms near the Abbey were not impressive enough for the ever grander, more numerous patrons. Wood obliged by building a set of new Assembly Rooms to the east of King's Circus with a magnificent sequence of rooms including an octagonal antechamber and card room. Wood the Younger also built the Hot Bath for the corporation but the other major center of social activity in Bath, the Pump Room, was

rebuilt by Thomas Baldwin, the most distinguished architect of the next generation. He was also responsible for the approaches to the Pump Room, the Guildhall and the development of Bathwick, along Great Pulteney Street, reaching across Robert Adam's Pulteney Bridge.

Later architects were inspired by the sweep, scale and dignity of the buildings by the Woods and Baldwin and wrapped one elegant terrace after another around the steep slopes surrounding the city. The map shows how the principal Bath architects developed different areas of the city in the 18th century.

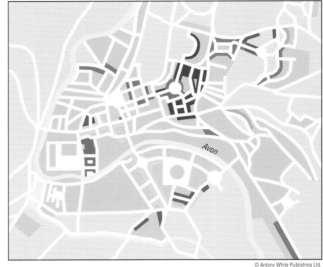

BATH

Built up area

Gardens or fields

Principal architects:

Thomas Baldwin

John Eveleigh

John Palmer

John Pinch

John Wood the Elder

John Wood the Younger

| 0 | 300 | 600 meters |
| 0 | 300 | 600 yards |

© Antony White Publishing Ltd.

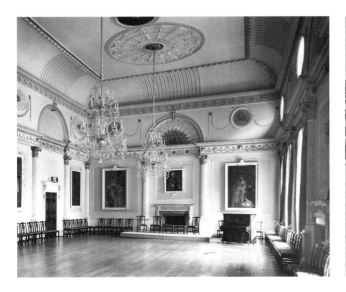

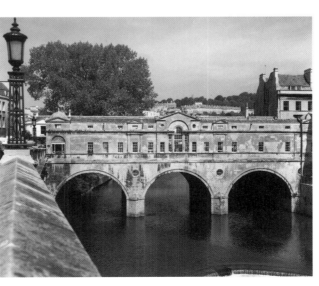

Left: *John Wood the Younger (1728–81):* The Royal Crescent, Bath *1767–75.*

The ground floor of the truly magnificent Royal Crescent is completely plain with 100 giant ionic columns above. This was the first time that the shape of a crescent was used, and it was widely copied later.

Far Left: *Thomas Baldwin (1750–1820):* The Banqueting Hall, The Guildhall, *1776, Bath.*

As City Surveyor, Baldwin was one of the principal creators of Georgian Bath. This sumptuous hall features Corinthian columns, each pair carrying a blank arch. The color scheme is light coffee-color and gold.

Left: *Robert Adam (1728–92):* Pulteney Bridge, *1769–74, Bath.*

This unusual shop-lined bridge, was initially planned twenty years before it was built. The three arches span the River Avon, above the medieval Abbey weir.

For the first fifty years after the Union with England in 1707 Edinburgh stagnated. The situation was saved by George Drummond (*b*.1687) who encouraged the civic pride that led to the building of the New Town and the creation of one of the most beautiful and dignified cities in Europe. This led first to John Adam's Exchange in the old town. The draining of the North Loch began in 1759 and the great North Bridge, over the valley to what was to become the New Town, was built from 1763 and finally finished in 1772. It was designed by William Mylne with alterations by John Adam. His more distinguished sons, Robert and James, designed the Register House, 1774–8, at the north end of the bridge.

In 1766 a competition for the design of the New Town produced six plans. James Craig's simple design of two squares joined by a central street, with two flanking and three cross streets, was adopted in 1767 and building soon began at the east end with St. Andrew's Square. A number of general rules were laid down but the earlier houses have a more individual aspect than those built after the stricter provisions of 1782 (The Earl of Moray insisted on very strict "Articles and Conditions" for his estate in 1822). The building moved steadily westwards on the rectangular plot owned by the city and feoffed out to individuals who paid for their own houses.

Building slowed down during the Napoleonic Wars but with the early 19th century there was an extraordinary building boom. There had been some building to the south of Edinburgh, helped by the construction of the South Bridge in 1786–8, but the important schemes were all to the north. At the eastern approach to Princes Street, Archibald Elliot's elegant Waterloo Place and Waterloo Bridge were built. Buildings were kept deliberately low to retain the view across the city and beyond; William Playfair's Calton Hill Scheme appeared, inspired by the Piazza del Popolo in Rome. To the north of the New Town there were three estates; the larger one directly to the north belonging to Heriot's Hospital, that to the north west owned by the Earl of Moray and beyond this a smaller estate owned by the painter Henry Raeburn. These were developed over the first quarter of the 19th century and gave Edinburgh an unequalled array of classical urban architecture. The map shows the development of classical Edinburgh along with the principal buildings 1753–1827.

EDINBURGH

| | Built up area |
| | Gardens or fields |

Architects and designers:

	Robert Brown and Gillespie Graham?
	James Craig
	Gillespie Graham
	William Playfair
	David Stewart, Robert Reid and William Sibbald
	Unknown acrhitect

Right: University of Edinburgh Old Quadrangle, *1789–1827, Edinburgh.*

The outside of the quad (1789, not shown) was by Robert Adam 1728–92) and is considered his greatest public work. The inside was completed by William H. Playfair (1819–27) in the Greek Revival Style, surmounted by the dome (Sir Rowland Anderson, 1879) and based on Adam's intended design, but greatly enlarged.

© Antony White Publishing Ltd.

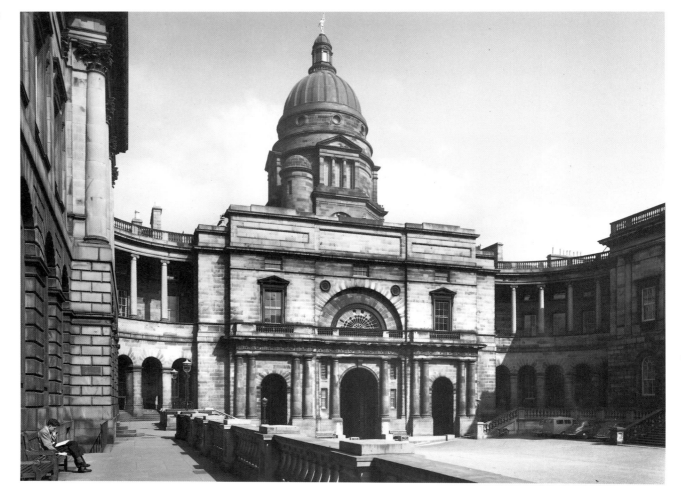

Sources of Building Stone in 18th-century Britain and Ireland

The complex geology of the British Isles explains the great variety in type and quality of building stone available. The changes in the character of the rock are far greater than in other European countries of comparable size and the result is that the landscape of the British Isles, although less spectacular than other parts of Europe, offers a remarkable variety within a small area.

The geological pattern of the British Isles runs predominantly from the southwest to the northeast, and following that direction allows us to observe the use of building stones of approximately the same age and character. Generally speaking, it is true to say that the younger rocks lie to the east and southeast, the older to the west and northwest. The most dominant feature on the map, with reference to England in particular, is the limestone belt, the long and relatively narrow band of rock which curves from Portland Bill in Dorset to the Humber and terminates in the Cleveland Hills of Yorkshire. It is on this belt that the majority of the most famous English stone quarries lie – Portland, Bath, Painswick, Weldon, Ketton, Colleyweston, Barnack, Clipsham and Ancaster to name but a few. These are the quarries that give English architecture its character.

According to their composition, building stones are broadly classed as granites, sandstones, limestones and slates. Commercially, the various kinds of building stones are usually designated by the name of the locality or region in which the quarry is situated.

Over ninety per cent of the stones used for building are limestone and sandstone. Limestone consists primarily of carbonate of lime, sandstones of particles of quartz mixed with other minerals such as mica and felspar. The remaining building stones are largely granite and marble, both used because they can be polished. Most forms of granite are igneous rock; that is, they were formed when molten material cooled. Granite is extremely hard and durable with the added advantage of being both impervious to water and resistant to atmospheric pollution in towns. Marble is a crystalline form of limestone and is rarely found in Britain, although Purbeck 'marble' was very popular with the cathedral builders of the Middle Ages. Regional building styles are, of course, based on the materials locally available and the techniques to which those materials lend themselves. Stone houses are a feature of the limestone belt, from the splendors of Georgian Bath to the northeast via the picturesque villages of the Cotswolds and the Midlands which exemplify the tradition in which window mullions and roofing slates as well as walls are made from local stone.

However, the limestone belt produces only one group of vernacular building materials. Despite the scarcity of true marble in England, to the north and west of the oolitic limestone older geological formations provide a variety of stone from the red, gray, brown and yellow sandstones of the West Midlands to the tough carboniferous limestones of the north as well as the hard granites and slates of Scotland, the Lake District, parts of Devon and Cornwall and the northwest of Ireland .

The hardness of various stones determines their use in buildings. Decorative carving and fine moldings are common where the stone is smooth textured like the red sandstone of Cheshire; but where the stone is hard, like the granite of Aberdeen or of southwest England, the difficulty of working is reflected in the relative austerity and comparative lack of decoration in local building.

Another important factor in the choice of stone for building is its suitability for the climate to which it has to be exposed. Stone that proves durable in country air may decay rapidly in a polluted city atmosphere or where exposed to strong salt winds from the sea. Extremes of temperature can also be prejudicial to the life of stone. Sharp fluctuations of heat and cold cause movements in the substance of stone, which can hasten its disintegration.

The difficulty for many centuries in the British Isles was the cost of transporting stone to the considerable areas of the country where it was not readily available. It is one of the main reasons why London, for instance, is predominantly built from brick, with only the most prestigious buildings dressed with stone. With the depletion of the forests, builders increasingly turned to using clay to make bricks and tiles. Although used by the Romans, these materials had been neglected. Contact with the Low Countries, mainly through the wool trade, led to the importation of more sophisticated techniques of using brick, especially in the southeast of England.

The use of tiles was more widespread because there was limited choice of materials sufficiently weatherproof and lightweight to be a suitable material for roofing. Thatch was extensively used for roofing in rural areas, but its combustibility prohibited its use in towns. As a result, stone slates were used in districts where the local stone could be split thin enough. The thin, gray slate quarried in Wales, the Lake District and Cornwall proved ideal as roofing because of its durability and lightness, and with the dawn of easy transportation in the 19th century penetrated all parts of the British Isles.

Above, top: *Sir Christopher Wren:* St Paul's Cathedral, *1675–1711, London.*

St Paul's is clad in Portland stone, a limestone of fine and even texture which became very popular in the 17th century when water power and frame saws enabled the cutting of large blocks at the Dorset quarry.

Above: 12, Great George Street, *town house c.1756, London.*

The great age of English brick building really began after 1660, particularly in the southeast of England due to the absence of stone.

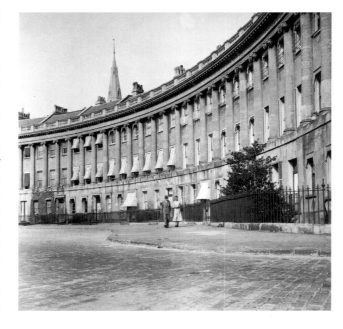

Left: *John Wood the Younger:* Royal Crescent, *Bath.*

Bath stone is an oolitic limestone which became fashionable in the 1720s when promoted by Ralph Allen, Master of Ceremonies at Bath.

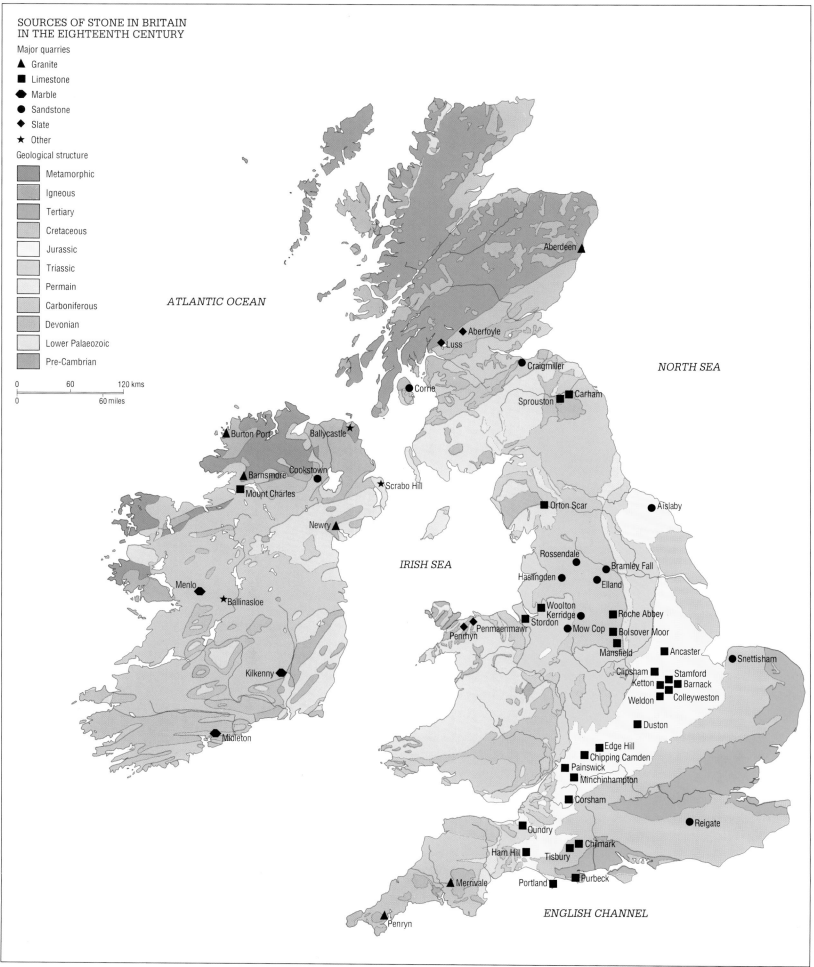

SOURCES OF STONE IN BRITAIN IN THE EIGHTEENTH CENTURY

Major quarries

▲ Granite
■ Limestone
◆ Marble
● Sandstone
◆ Slate
★ Other

Geological structure

Metamorphic
Igneous
Tertiary
Cretaceous
Jurassic
Triassic
Permain
Carboniferous
Devonian
Lower Palaeozoic
Pre-Cambrian

0 60 120 kms
0 60 miles

ATLANTIC OCEAN

Aberdeen ▲

◆ Aberfoyle
◆ Luss
● Craigmiller

NORTH SEA

● Corrie

Sprouston ■ Carham

▲ Burton Port ★ Ballycastle

▲ Barnsmore ● Cookstown
■ Mount Charles ★ Scrabo Hill

■ Orton Scar ● Aislaby

Newry ▲

IRISH SEA

Rossendale ● ● Bramley Fall
Haslingden ● ● Elland

● Menlo
★ Ballinasloe

■ Woolton ■ Roche Abbey
◆ Penrhyn Kerridge ●
Penmaenmawr ◆ ■ Stordon ● Mow Cop ■ Bolsover Moor

◆ Kilkenny Mansfield ● ■ Ancaster

■ Clipsham ● Snettisham
Ketton ■ ■ Stamford
■ Barnack
Weldon ■ ■ Colleyweston

■ Duston

◆ Midleton

■ Edge Hill
■ Chipping Camden
■ Painswick
■ Minchinhampton

■ Corsham

● Reigate

■ Oundry

Ham Hill ■ ■ Chilmark
Tisbury

▲ Merrivale Portland ■ ■ Purbeck

▲ Penryn

ENGLISH CHANNEL

© Antony White Publishing Ltd.

251

The Spread of the Country House in Great Britain

During the reign of the first Queen Elizabeth (1558–1603) the country house begins to emerge as a distinct architectural genre. As a result of the relative political stability and increased wealth that followed the Wars of the Roses (1455–1485) the traditional medieval manor house was gradually shorn of its fortifications and adapted to the new requirements of spaciousness, luxury and domestic privacy which the next generation of landowners demanded.

The new houses of the second half of the 16th century contained more varied domestic spaces than their predecessors and, in particular, the use of the great hall as the primary living and sleeping area was abandoned. A far greater awareness of trends from the Continent is witnessed by the gradual introduction from c.1560 of architectural treatises and pattern books which provided British gentlemen, architects and builders with a knowledge of Italian and French Renaissance designs. Another relevant factor is the decline in church building and indeed civic building of any kind after the Reformation of the 1530s. As a result, much of the creative energy of the aristocracy was channeled into building great country houses, often on lands confiscated from the Church and its monastic foundations. Many of the great houses of the late 16th century, like Burghley, Wollaton and Hardwick, competed with one another in providing opulent settings for entertaining the Queen and her large contingent of courtiers during her summer 'progresses'.

In architectural terms the Elizabethan and Jacobean country house broke from the enclosed courtyard, with its collegiate and monastic origins, in favour of more open designs based on 'E' or 'H' shapes. The impact of Continental classicism was made manifest by a more determined symmetry as well as the liberal use of applied decoration, albeit in an often illiterate way. Perhaps the most innovative architectural features of the Elizabethan and Jacobean house are the long gallery, used by the household for recreation in inclement weather, and the introduction of elaborate oak staircases.

Remarkably few grand houses survive from the middle years of the 17th century, which can partly be explained by the Civil War and its aftermath, but those that do survive, like Hugh May's Eltham Lodge of the early 1660s, are strongly influenced by the rectangular solidity of Dutch prototypes. However, by the end of the century a number of houses with projecting wings and hipped roofs begin to emerge, like Belton House in Lincolnshire of the 1680s. It should be noted that during these years the formal garden with its geometric parterres and avenues became an increasingly important part of the ensemble.

The baroque style in Great Britain is somewhat tamer than its Continental counterpart but architects such as Sir John Vanbrugh created houses in the first years of the 18th century – e.g. Castle Howard and Blenheim – of such monumentality and magnificence that applying the term *palace* is not to exaggerate, although palace architecture as a phenomenon was always more European than British. By that date the French and Italian manner of setting the grander principal apartments on the *piano nobile*, on the first landing of the principal staircase, in a series of interconnecting rooms was already well-established and the decoration of these suites became of prime importance to the architect and patron.

The 18th century undoubtedly witnessed the greatest proliferation of country house building. Profits from the increasing number of economically productive estates were frequently used for building houses and 'improving' the landscapes adjoining them. In addition, the ubiquity of the Grand Tour for the sons of the aristocracy enhanced the steady flow to Great Britain of precious works of art, especially from Italy, and these needed places for display. Houses like Lord Burlington's villa at Chiswick of the late 1720s and the Earl of Leicester's Holkham Hall begun a few years later were built essentially for the display of newly acquired treasures and for grand entertaining rather than for daily living. Both of those examples aspired to the rational principles of the great 16th-century Italian architect Palladio, whose ideas had first been introduced to the British public a century earlier by Inigo Jones in buildings like the Queen's House at Greenwich. Most Palladian houses emphasized a temple-like classical portico and pediment on the main façade, and the grand rooms, including newer features like a formal dining room and a library, often radiated from a large central hall or saloon.

Although in the mid-18th century architects occasionally experimented with the more exotic elements of rococo and chinoiserie decoration, and with the beginnings of neo-gothic late in the century, the determined rise of a more scholarly neoclassicism fueled by the archeological discoveries of Pompeii and Herculaneum as well as those in the Levant created the climate for the emergence of architects like Robert Adam, who brought interior decoration to a spectacular and graceful climax in houses like Syon and Osterley near London and Mellerstain in Berwickshire between 1760 and 1780.

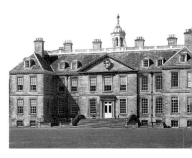

Above: *William Winde (d.1722):* Belton House, The West Front, *c.1689, Grantham, Lincolnshire.*

Built by a London mason for John Brownlow and modeled on Clarendon House, Piccadilly. It shows the relationship between town and country house architecture at the end of the 17th century. The attribution to Sir Christopher Wren is almost certainly wrong.

Below: *Robert Adam (1728–92):* The Library, Mellerstain House, *1760–80, near Kelso, Berwickshire.*

Robert Adam was the greatest British neoclassical architect of the late 18th century, responding to scholarly analysis and archeological discoveries of classical painting and decoration as found at Pompeii and Herculaneum. Robert and James Adam decorated the interior of this house built by John Carr.

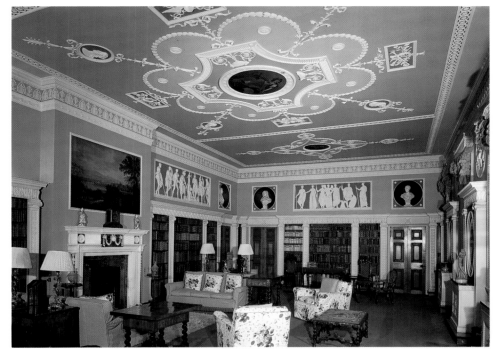

THE SPREAD OF THE ENGLISH COUNTRY HOUSE

- ● Town / city
- ☐ Elizabethan or Jacobean house
- ☐ Carolean house
- ☐ Baroque house
- ☐ Palladian house
- ☐ Neo-classical house
- ☐ 16th century house
- ☐ 17th century house
- ☐ 18th century house

| | 0 | 50 | 100 | 150 kms |
| 0 | 50 | | 100 miles |

ATLANTIC OCEAN

NORTH SEA

IRISH SEA

1 Thomas Thorp (d.1569)
2 Robert Smythson (1535–1614)
3 Bernard Janssen (active c.1603–16)
4 Robert Lyming (d.1628)
5 John Thorp (c.1563–1655)
6 Inigo Jones (c.1573–1652)
7 John Webb (1611–72)
8 Isaac de Caus (d.c.1656)
9 Hugh May (1622–84)
10 Sir Roger Pratt (1620–85)
11 William Winde (d.1722)
12 William Talman (1650–1719)
13 Thomas Archer (c.1668–1743)
14 Sir John Vanbrugh (1664–1726)
15 Giacomo Leoni (c.1686–1746)
16 Sir James Thornhill (1675–1734)
17 Colen Campbell (1676–1729)
18 William Kent ? (c.1685–1748)
19 Earl of Burlington (1694–1743)
20 Henry Flitcroft (1697–1769)
21 Roger Morris (1695–1749)
22 Sanderson Miller (1716–80)
23 Sir William Chambers (1723–96)
24 Robert Adam (1728–92)
25 James Paine (1717–89)
26 John Carr of York (1723–1807)
27 George Stewart (c.1730–1806)
28 James Wyatt (1746–1813)
29 John Allen (d.1641)
30 Sir Edward Lovett Pearce (1699–1733)
31 Richard Castle (d.1751)
32 William Vitruvius Morrison (1794–1838)
33 Robert Mylne (1633–1710)
34 Sir WIlliam Bruce (c.1630–1710)
35 James Smith (c.1645–1731)

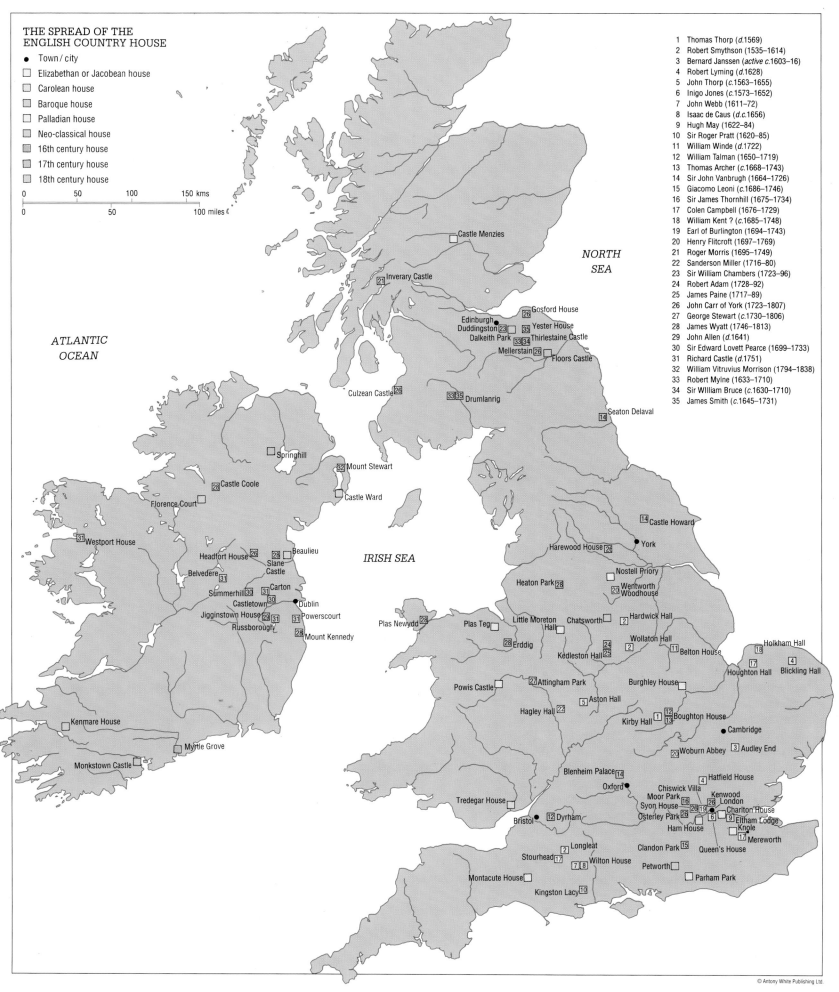

Castle Menzies

Inverary Castle 21

Gosford House 26
Edinburgh Duddingston 23 35 Yester House
Dalkeith Park 33 34 Thirlestaine Castle
Mellerstain 26
Floors Castle

Culzean Castle 26

33 35 Drumlanrig

Seaton Delaval 14

Springhill

32 Mount Stewart
Castle Coole 28 Castle Ward
Florence Court

Castle Howard 14

Westport House 31

Headfort House 26 28 Beaulieu
Belvedere 31 Slane Castle
Summerhill 30 25 31 Carton
Castletown 30
Jigginstown House 25 31 31 Powerscourt
Russborough 28 Mount Kennedy

Harewood House 26 ● York

Nostell Priory
Heaton Park 28 20 Wentworth Woodhouse

Plas Newydd 28 Plas Teg Little Moreton Hall Chatsworth Hardwick Hall
28 Erddig Wollaton Hall 2
Kedleston Hall 24 25 2 11 Belton House

Holkham Hall 18
17 Houghton Hall 4 Blickling Hall

Kenmare House

Myrtle Grove

Monkstown Castle

Powis Castle 27 Attingham Park Burghley House
Hagley Hall 22 5 Aston Hall
Kirby Hall 1 12 13 Boughton House ● Cambridge

20 Woburn Abbey 3 Audley End

Tredegar House

Blenheim Palace 14
Oxford ● 4 Hatfield House
Chiswick Villa
Moor Park Kenwood
Syon House 26 19 London
Osterley Park 26 Charlton House
Ham House 9 Eltham Lodge
Knole
17 Mereworth

12 Dyrham
Bristol ●

2 Longleat
Stourhead 17 Wilton House Clandon Park 15 Queen's House
7 8
Montacute House Petworth
Kingston Lacy 10 Parham Park

253

© Antony White Publishing Ltd.

British Art in the 18th Century

Before the mid 18th-century, landscape painting in Britain was largely confined to topographical views of towns and the great landed estates, but in the second half of the century there was a growing interest in visiting and depicting the actual scenery of the British Isles. This was partly a result of the considerable improvement in the modes of transport, with better roads in particular facilitating the 'discovery' of the remoter beauties of the British Isles, but was also a facet of a much wider antiquarianism, that led enthusiasts for local history to integrate the printed word with an image of a specific county, town or parish. There was a parallel development with the growth of tourism from around the 1760s onwards.

The British traveler had discovered Italy in earnest at the beginning of the 18th century, but as a result of the French Revolution and the Napoleonic Wars all but the most foolhardy were denied access to the Continent for several decades. From around 1770 Wales, the Lake District, the Western Highlands of Scotland and parts of Ireland were opened up to tourists, and especially landscape artists, traveling there in search of the picturesque.

Guidebooks were increasingly designed not only to help plan an itinerary, but also to help the reader respond to the scenery witnessed. A literary interest in the Lake District, for instance, began as early as the 1750s, but the developing taste for mountain scenery in painting was encouraged by such publications as Thomas Pennant's (1726–98) *Tours in Scotland* (1771) and *Tours in Wales* (1778), which helped ensure that the conscientious tourist experienced the 'correct' sensations when confronted with Nature.

It was no longer sufficient for artists merely to produce the sort of pastiches of 17th-century Italian landscape painting popularized by John Wootton (*c*.1682–1764) and George Lambert (1700–65) in the first half of the 18th century. Indeed, the qualities of the British landscape were increasingly put on a par with Italy, and the desire to see landscape in picturesque terms is an important development in late 18th-century British

landscape painting. Perhaps the first sign of the influence of the picturesque can be seen in the work of architects and landscape gardeners at the beginning of the century gaining strength with the writings of the intrepid Rev. William Gilpin (1724–1804), a pioneer of picturesque travel whose tours to the Wye Valley and South Wales, undertaken in 1770, were finally published in 1783. Gilpin described the picturesque as being 'expressive of that peculiar kind of beauty, which is agreeable in a picture'. The picturesque tour undoubtedly encouraged landscape painting, especially in watercolors, and the flowering of the latter in England in the last years of the century was an important contribution to European Romanticism.

Above: *John 'Warwick' Smith (1749–1831):* The Hon. Robert Fulke Greville's Phaeton crossing the mountain range between Pont Aberglaslyn and Tan y Bwlch *(Private Collection).*

The alternative "Grand Tour" of England, Wales and Scotland in search of both romantic scenery and medieval antiquities provided adventures and landscape as wild as anything in the Alps or Italy. John Smith had earlier gained the name "Warwick" after traveling in Italy with the Earl of Warwick.

Left: *Joseph Mallord William Turner (1775–1851):* Tintern Abbey, *watercolor (British Museum, London).*

The ruins of Tintern Abbey in Monmouthshire were amongst the earliest medieval sites to attract the attention of Romantic artists in Britain in search of the picturesque.

THE WESTERN HIGHLANDS

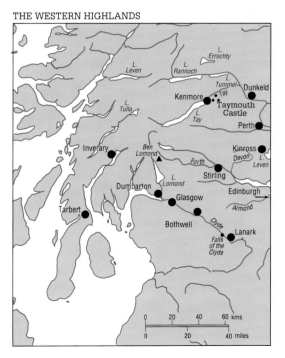

THE LAKE DISTRICT

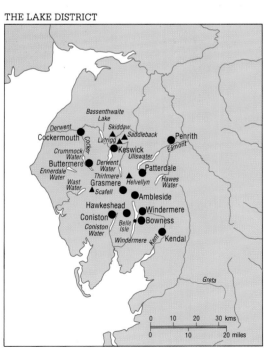

NORTH WALES

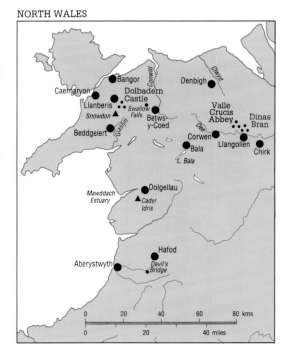

THE DISCOVERY OF BRITAIN AND THE RISE OF LANDSCAPE PAINTING IN THE EIGHTEENTH CENTURY

- ● Town or village
- ▢ Country house
- ∴ Castle, hill fort or abbey
- ▲ Mountain
- • Other topographical feature

Artists' dates refer to known
visits to the area

0	100	200	300 kms
0	100		200 miles

THE WESTERN HIGHLANDS
James Norie (1730s)
Paul Sandby (1747 and after)
Thomas Sandby (1746)
Alexander and John Runciman (1770s)
Jacob More (1770s)
William Gilpin (1770s)
Thomas Hearne (1778)
Alexander Naysmyth (late 1780s/early 1790s)
David Allan (1780s/early 1790s)
Joseph Farington (1788)
Julius Caeser Ibbetson (1800)

THE LAKE DISTRICT
William Gilpin (1772)
Sir George Beaumont (c.1777)
Thomas Hearne (1777 and 1778)
Joseph Farington (1778, 1781)
Thomas Gainsborough (1783)
Philip de Loutherbourg (1783)
Francis Wheatley (1784)
Francis Towne (1786)
Edward Dayes (1791)
John White Abbott (1792)
Paul Sandby (1793)
John Warwick Smith (early 1790s)
Joseph Wright of Derby (1794)
J.M.W.Turner (1797)

NORTH WALES
Samuel Buck (late 1730s)
John Boydell (mid-late 1740s)
Richard Wilson (1760s/1770s)
Thomas Jones
Paul Sandby (1760s)
William Gilpin (1773)
Julius Caesar Ibbetson (1792)
John Warwick Smith (1792)
Thomas Rowlandson (1797)
J.M.W.Turner (1797)

THE WYE VALLEY
William Gilpin (1770)
Thomas Hearne (late 1780s)
J.M.W.Turner 1793
Thomas Girtin 1793

IRELAND
Richard Carver (1750s)
George Barrett (1760s)
Solomon Delane (1760s-1780s)
George Mullins (1760s/70s)
Thomas Roberts (1760s/70s)
William Ashford (1760s onwards)
Jonathan Fisher (1760s/70s)
Francis Wheatley (1779-1783)

THE WYE VALLEY

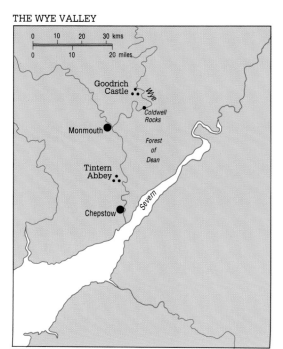

DUBLIN AND THE WICKLOW MOUNTAINS

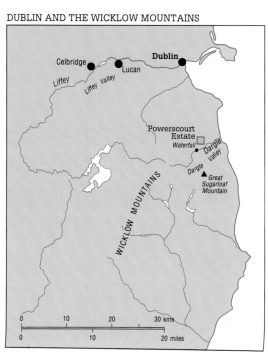

SOUTH-WEST IRELAND

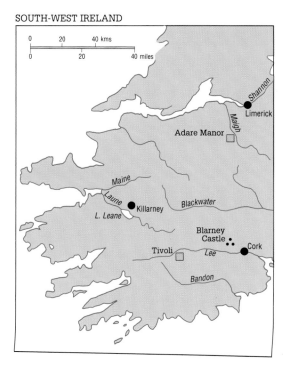

American Art and Architecture to 1825

English influences were predominant in all the arts during the 17th and 18th centuries, and, particularly along the eastern seaboard, America continued to look to Britain long after they freed themselves from her rule. Before *c*.1790 there was little painting other than portraiture, and the modest demand for this was supplied by limners, anonymous itinerant artists with no professional training. An early known limner is Thomas Smith, to whom a few pictures have been assigned, the most well-known being his supposed self-portrait in the Worcester Art Museum.

America's emerging élite, absorbing Baroque and Rococo portraiture from imported European prints, found some native-born artists such as Robert Feke, who achieved a credible if uneven degree of proficiency. At the same time, the arrival of immigrant painters, among them the Scottish John Smibert and the Swiss, Jeremiah Theüs swelled the ranks. Two British portraitists also arrived, Joseph Blackburn and John Wollaston. The first American artists to achieve international reputations were John Singleton Copley and Benjamin West. However, after sojourns in Rome, they both settled in London for the rest of their lives.

Many young Americans followed in their footsteps: John Trumbull launched his career as a history painter with beautiful oil sketches of scenes from the Revolutionary War; Washington Allston, after two stays in London, attracted strong support for his historical and landscape paintings. Seeking professional training, young painters went to England where many flocked to Benjamin West's studio, among them the talented Charles Willson Peale and Gilbert Stuart whose free painterly style was gleaned from English portrait painters like Sir Joshua Reynolds and Gainsborough. Landscapes were also becoming popular, and Thomas Birch from Philadelphia essayed them as well as seascapes and genre painting. The new popularity of the other painting genres gave rise to the Hudson River School in New York about 1825.

In architecture as well, English traditions held sway. Most 17th century colonial buildings were timber-framed, combined with panels of wattle and daub, and differed little from vernacular dwellings in 16th and 17th century England. In New England, shortage of good stone and brick continued the use of wood for even quite ambitious buildings throughout the 18th century. Even the leading Virginian of his day, George Washington, built his Mount Vernon home of wood.

Perhaps the most polished architect was William Buckland who went on to become the leading architect of pre-Revolutionary Annapolis. Peter Harrison stands out for the Palladian correctness of his buildings, which relied heavily on engraved models. The influence of pattern books is particularly important after 1750, the most plagiarized authors being James Gibbs (St. Martin-in-the-Fields, London), Robert Morris and Abraham Swan.

Although Thomas Jefferson and other progressive Americans expressed a desire to break away symbolically from Britsh models, in practice they still continued to draw heavily on them. The influence of Robert Adam and James Wyatt began to be felt in the last years of the century in the elegant work of such architects as Charles Bulfinch of Boston and Samuel McIntire of Salem. Ironically it was the arrival of the Englishman Benjamin Latrobe, introducing a direct infusion of both professionalism and the latest European neoclassicism, that propelled American architecture into its next phase.

Left: *Gilbert Stuart (1755–1828):* The Skater, *1782, oil on canvas (National Gallery of Washington).*

Born in Rhode Island, portraitist Stuart worked in Edinburgh 1772–3, London 1775–87, where he enjoyed considerable success and where The Skater *was painted, and in Dublin 1787–92 after which he returned permanently to America. Between 1794–1803 he painted the definitive three life portraits of Washington, and spent his last twenty years in Boston.*

Below: *Charles Bulfinch (1763–1844):* Boston State House, *1795–8, Boston.*

Bulfinch's imposing State House replaced the 1713 building, and reflects both the aspirations of post-colonial Massachusetts and a lingering admiration for English architectural models, in this case William Thornton's Washington Capitol and Sir William Chambers' Somerset House.

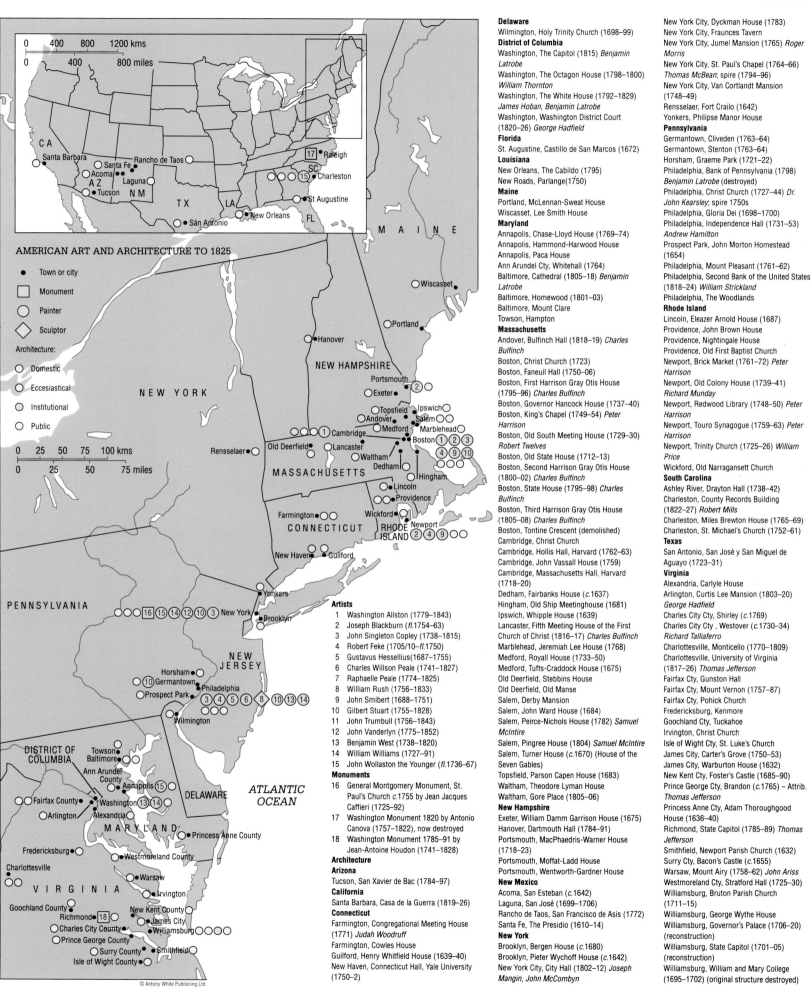

Delaware
Wilmington, Holy Trinity Church (1698–99)
District of Columbia
Washington, The Capitol (1815) *Benjamin Latrobe*
Washington, The Octagon House (1798–1800) *William Thornton*
Washington, The White House (1792–1829) *James Hoban, Benjamin Latrobe*
Washington, Washington District Court (1820–26) *George Hadfield*
Florida
St. Augustine, Castillo de San Marcos (1672)
Louisiana
New Orleans, The Cabildo (1795)
New Roads, Parlange(1750)
Maine
Portland, McLennan-Sweat House
Wiscasset, Lee Smith House
Maryland
Annapolis, Chase-Lloyd House (1769–74)
Annapolis, Hammond-Harwood House
Annapolis, Paca House
Ann Arundel Cty, Whitehall (1764)
Baltimore, Cathedral (1805–18) *Benjamin Latrobe*
Baltimore, Homewood (1801–03)
Baltimore, Mount Clare
Towson, Hampton
Massachusetts
Andover, Bulfinch Hall (1818–19) *Charles Bulfinch*
Boston, Christ Church (1723)
Boston, Faneuil Hall (1750–06)
Boston, First Harrison Gray Otis House (1795–96) *Charles Bulfinch*
Boston, Governor Hancock House (1737–40)
Boston, King's Chapel (1749–54) *Peter Harrison*
Boston, Old South Meeting House (1729–30) *Robert Twelves*
Boston, Old State House (1712–13)
Boston, Second Harrison Gray Otis House (1800–02) *Charles Bulfinch*
Boston, State House (1795–98) *Charles Bulfinch*
Boston, Third Harrison Gray Otis House (1805–08) *Charles Bulfinch*
Boston, Tontine Crescent (demolished)
Cambridge, Christ Church
Cambridge, Hollis Hall, Harvard (1762–63)
Cambridge, John Vassall House (1759)
Cambridge, Massachusetts Hall, Harvard (1718–20)
Dedham, Fairbanks House (c.1637)
Hingham, Old Ship Meetinghouse (1681)
Ipswich, Whipple House (1639)
Lancaster, Fifth Meeting House of the First Church of Christ (1816–17) *Charles Bulfinch*
Marblehead, Jeremiah Lee House (1768)
Medford, Royall House (1733–50)
Medford, Tufts-Craddock House (1675)
Old Deerfield, Stebbins House
Old Deerfield, Old Manse
Salem, Derby Mansion
Salem, John Ward House (1684)
Salem, Peirce-Nichols House (1782) *Samuel McIntire*
Salem, Pingree House (1804) *Samuel McIntire*
Salem, Turner House (c.1670) (House of the Seven Gables)
Topsfield, Parson Capen House (1683)
Waltham, Theodore Lyman House
Waltham, Gore Place (1805–06)
New Hampshire
Exeter, William Damm Garrison House (1675)
Hanover, Dartmouth Hall (1784–91)
Portsmouth, MacPhaedris-Warner House (1718–23)
Portsmouth, Moffat-Ladd House
Portsmouth, Wentworth-Gardner House
New Mexico
Acoma, San Esteban (c.1642)
Laguna, San José (1699–1706)
Rancho de Taos, San Francisco de Asis (1772)
Santa Fe, The Presidio (1610–14)
New York
Brooklyn, Bergen House (c.1680)
Brooklyn, Pieter Wychoff House (c.1642)
New York City, City Hall (1802–12) *Joseph Mangin, John McComby*

New York City, Dyckman House (1783)
New York City, Fraunces Tavern
New York City, Jumel Mansion (1765) *Roger Morris*
New York City, St. Paul's Chapel (1764–66) *Thomas McBean*; spire (1794–96)
New York City, Van Cortlandt Mansion (1748–49)
Rensselaer, Fort Crailo (1642)
Yonkers, Philipse Manor House
Pennsylvania
Germantown, Cliveden (1763–64)
Germantown, Stenton (1763–64)
Horsham, Graeme Park (1721–22)
Philadelphia, Bank of Pennsylvania (1798) *Benjamin Latrobe* (destroyed)
Philadelphia, Christ Church (1727–44) *Dr. John Kearsley*; spire 1750s
Philadelphia, Gloria Dei (1698–1700)
Philadelphia, Independence Hall (1731–53) *Andrew Hamilton*
Prospect Park, John Morton Homestead (1654)
Philadelphia, Mount Pleasant (1761–62)
Philadelphia, Second Bank of the United States (1818–24) *William Strickland*
Philadelphia, The Woodlands
Rhode Island
Lincoln, Eleazer Arnold House (1687)
Providence, John Brown House
Providence, Nightingale House
Providence, Old First Baptist Church
Newport, Brick Market (1761–72) *Peter Harrison*
Newport, Old Colony House (1739–41) *Richard Munday*
Newport, Redwood Library (1748–50) *Peter Harrison*
Newport, Touro Synagogue (1759–63) *Peter Harrison*
Newport, Trinity Church (1725–26) *William Price*
Wickford, Old Narragansett Church
South Carolina
Ashley River, Drayton Hall (1738–42)
Charleston, County Records Building (1822–27) *Robert Mills*
Charleston, Miles Brewton House (1765–69)
Charleston, St. Michael's Church (1752–61)
Texas
San Antonio, San José y San Miguel de Aguayo (1723–31)
Virginia
Alexandria, Carlyle House
Arlington, Curtis Lee Mansion (1803–20) *George Hadfield*
Charles City Cty, Shirley (c.1769)
Charles City Cty , Westover (c.1730–34) *Richard Talliaferro*
Charlottesville, Monticello (1770–1809)
Charlottesville, University of Virginia (1817–26) *Thomas Jefferson*
Fairfax Cty, Gunston Hall
Fairfax Cty, Mount Vernon (1757–87)
Fairfax Cty, Pohick Church
Fredericksburg, Kenmore
Goochland Cty, Tuckahoe
Irvington, Christ Church
Isle of Wight Cty, St. Luke's Church
James City, Carter's Grove (1750–53)
James City, Warburton House (1632)
New Kent Cty, Foster's Castle (1685–90)
Prince George Cty, Brandon (c.1765) – Attrib. *Thomas Jefferson*
Princess Anne Cty, Adam Thoroughgood House (1636–40)
Richmond, State Capitol (1785–89) *Thomas Jefferson*
Smithfield, Newport Parish Church (1632)
Surry Cty, Bacon's Castle (c.1655)
Warsaw, Mount Airy (1758–62) *John Ariss*
Westmoreland Cty, Stratford Hall (1725–30)
Williamsburg, Bruton Parish Church (1711–15)
Williamsburg, George Wythe House
Williamsburg, Governor's Palace (1706–20) (reconstruction)
Williamsburg, State Capitol (1701–05) (reconstruction)
Williamsburg, William and Mary College (1695–1702) (original structure destroyed)

Text on the map:

AMERICAN ART AND ARCHITECTURE TO 1825

• Town or city
▢ Monument
◯ Painter
◇ Sculptor
Architecture:
◯ Domestic
◯ Eccesiastical
◯ Institutional
◯ Public

Artists
1 Washington Allston (1779–1843)
2 Joseph Blackburn (fl.1754–63)
3 John Singleton Copley (1738–1815)
4 Robert Feke (1705/10–fl.1750)
5 Gustavus Hessellius(1687–1755)
6 Charles Willson Peale (1741–1827)
7 Raphaelle Peale (1774–1825)
8 William Rush (1756–1833)
9 John Smibert (1688–1751)
10 Gilbert Stuart (1755–1828)
11 John Trumbull (1756–1843)
12 John Vanderlyn (1775–1852)
13 Benjamin West (1738–1820)
14 William Williams (1727–91)
15 John Wollaston the Younger (fl.1736–67)
Monuments
16 General Montgomery Monument, St. Paul's Church c.1755 by Jean Jacques Caffieri (1725–92)
17 Washington Monument 1820 by Antonio Canova (1757–1822), now destroyed
18 Washington Monument 1785–91 by Jean-Antoine Houdon (1741–1828)
Architecture
Arizona
Tucson, San Xavier de Bac (1784–97)
California
Santa Barbara, Casa de la Guerra (1819–26)
Connecticut
Farmington, Congregational Meeting House (1771) *Judah Woodruff*
Farmington, Cowles House
Guilford, Henry Whitfield House (1639–40)
New Haven, Connecticut Hall, Yale University (1750–2)

© Antony White Publishing Ltd.

Colonial Latin America 1500–1820: Iberian Influences

The inspiration and stylistic roots of the art and architectural monuments of colonial Latin America originated in the Iberian peninsula. For the indigenous peoples, the new art forms, part and parcel of the religious, cultural and institutional baggage the Iberian immigrants brought with them to the New World, were strange and exotic imports totally outside their previous experience. In the course of some 300 years, this imported European art, especially the architecture, was transformed and regenerated into a proper and distinctive expression, *sui generis*, of the historical realities experienced by both the native and the immigrant peoples of the New World.

At the end of the 15th century, Spain and Portugal were, except for overseas explorations, still generally outside the "modernizing" currents of the Renaissance. Only then was the struggle between Christendom and Islam, the *Reconquista*, being brought to a victorious conclusion with the fall of Muslim Granada to the Catholic monarchs, Ferdinand and Isabella, in 1492, some ten months before Christopher Columbus inadvertently found America, thinking he was in Asia. After 800 years of Islamic domination, it was not surprising that one of the most pervading determinants of Iberian history (both Spanish and Portuguese), and therefore of Latin American history as well, was the after-life of its Islamic past. The opposing forces of Islam and Christianity grappled not only on the field of battle, but frequently became entwined in a single building where Christian and Islamic elements existed side by side, blending into a syncretic, but harmonious, style. Iberian Islamic architecture is coeval with the Carolingian, the Romanesque and the Gothic in Christian Europe. As the *Reconquista* progressed, and with it the gradual eclipse of Muslim rule, these Christian styles arriving from Europe across the Pyrenees were each blended with and even superimposed on the deep-rooted, centuries-old Islamic architectural building conventions, giving rise to new styles, as for example the *mudéjar*, which is a mixture of the Gothic and Islamic.

The same quality of fusion characterized the architectural styles – Gothic, Renaissance, Baroque – which were transplanted wholesale to Hispano-America during its 300 years or so of colonial history, to be subtly altered by both distance and local cultural forces. But an important condition of Latin American art and architecture was the time-lag between the original appearance of a style in Europe and its arrival in the New World, frequently resulting in the introduction of a style out of chronological context with the parent style from which it was derived.

The first cathedral to be founded in Hispano-America was at Santo Domingo in the Dominican Republic [see pages 262–3]. Its design was believed to have been inspired by the construction of the cathedral of Seville in Spain, the largest Gothic building in Europe, which was begun in the 15th century but not completed until the second quarter of the 16th. But the style of the Santo Domingo building is very reminiscent of Late Gothic, with many Islamic traits, as well as a special facet of the Italian Renaissance style, the Plateresque. Plateresque,

however, was first employed in Spain only towards the end of the 15th century and was restricted to architectural decoration as an overlay over Gothic forms. About half a century later it was used to decorate the façade of the cathedral of Santo Domingo (*c.*1521–41).

The same mixture of styles taken out of chronological context characterized many of the 16th-century churches and monastic complexes built in Mexico by the mendicant orders (Franciscan, Dominican, Augustinian) – for example, at Actopan, Ixmiquilpan, Huejotzingo, Tlalmanalco and Yecapixtla.

The delayed appearance of Iberian styles continued during the whole of the colonial period, and also occurred in the so-called Hispano-American Baroque. Because of its seeming lack of spatial innovations, art historians have argued about the use of the term "Baroque" to characterize the new, florid and outrageously animated 18th-century Hispano-American architecture, especially that of Mexico. To some, Spanish American Baroque was, by definition, not baroque in the full sense of its pristine meaning because of the absence of "baroque space", and the assumption that it merely employed repetitive decorative devices. But others insist it was, because the Baroque idiom was certainly employed in the execution of the decorative sculptural and painted details, principally façades, which became ornate, complex, involved and convoluted forms in the 18th century when church façades (except in Brazil, see below pages 264–5) became gigantic outdoor retables or altarpieces, replete with sculptured figures as well as overall surface decoration in relief.

Above: *Lorenzo Rodríguez (c.1704–74)* Sagrario Metropolitano, *1749–68, Mexico City.*

Located in the southeast corner of the cathedral, the "ultrabaroque" façade marks the triumph of the estipite, a pilaster shaft that gives the façade the appearance of an elaborate wooden retable, or altarpiece.

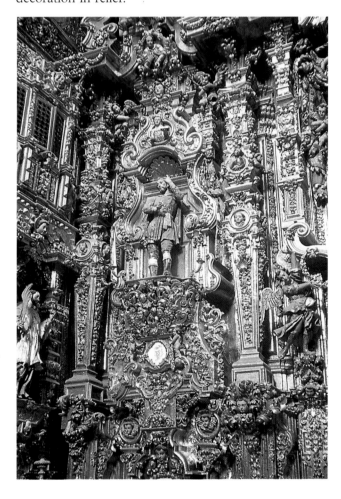

Left: The church of San Martín (c.1755), Tepotzotlán, Mexico.

The altarpiece, or retable, of Ntra. Sra. de Guadalupe. Detail, San Isidro Labrador. Estipites and the entire surface are overlaid with intricate floral and geometric ornamentation.

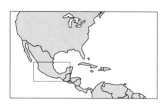

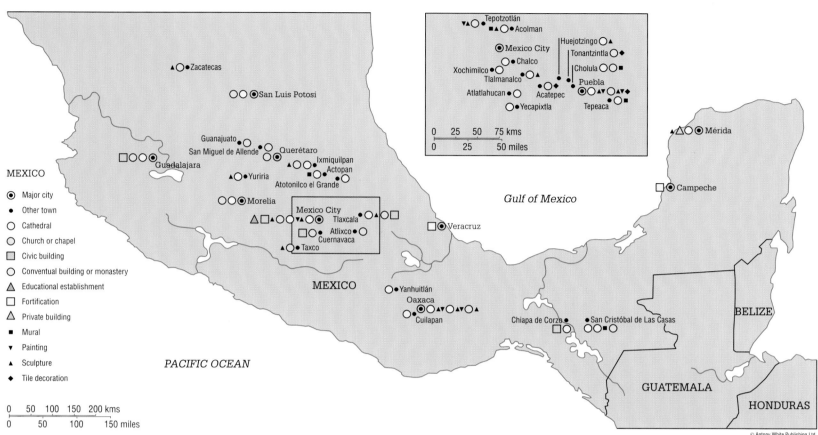

MEXICO

- ◉ Major city
- • Other town
- ○ Cathedral
- ○ Church or chapel
- ▢ Civic building
- ○ Conventual building or monastery
- △ Educational establishment
- ▢ Fortification
- △ Private building
- ■ Mural
- ▼ Painting
- ▲ Sculpture
- ◆ Tile decoration

Zacatecas

San Luis Potosí

Guanajuato
San Miguel de Allende
Querétaro
Ixmiquilpan
Actopan
Guadalajara
Yuriria
Atotonilco el Grande

Morelia

Mexico City
Tlaxcala
Atlixco
Cuernavaca

Taxco

MEXICO

Veracruz

Gulf of Mexico

PACIFIC OCEAN

Yanhuitlán
Oaxaca
Cuilapan

Chiapa de Corzo
San Cristóbal de Las Casas

BELIZE

GUATEMALA

HONDURAS

Campeche

Mérida

Tepotzotlán
Acolman
Mexico City
Huejotzingo
Tonantzintla
Chalco
Cholula
Xochimilco
Tlalmanalco
Puebla
Atlatlahucan
Acatepec
Tepeaca
Yecapixtla

0 25 50 75 kms
0 25 50 miles

© Antony White Publishing Ltd.

Right: Church of the *Convento*, monastery of San Agustín, *(c.1550)*, Alcoman, Mexico.

A view of the west front with Plateresque ornamentation. The church building itself is Gothic.

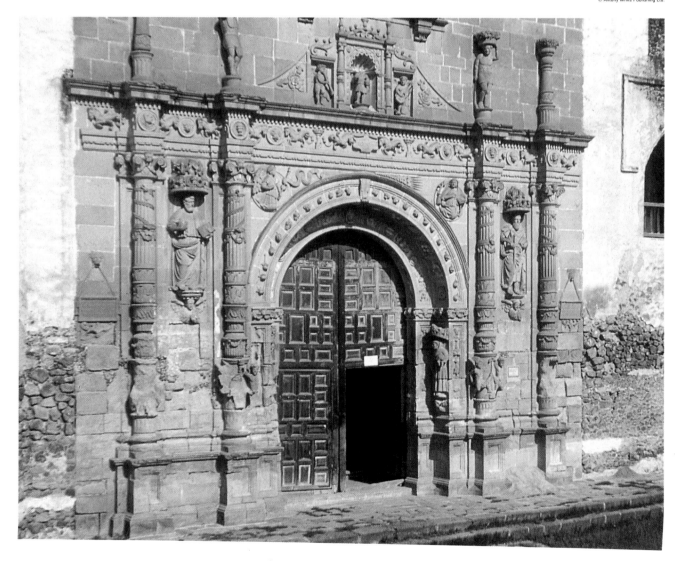

Colonial Latin America 1500–1820: Architecture

The extravagant "Baroque" style of Latin America was particularly highly developed in Mexico [see pages 258–9] from the mid-18th century, and has been variously dubbed "ultrabaroque", "archibaroque", and even Churrigueresque, though it had little or nothing to do with the innovations of the Spanish architects, the Churrigueras. The outstanding example of this overembellished decorative style is on the façade of the Sagrario, the cathedral parish church in Mexico City. A special type of pilaster shaft, the *estipite*, was employed here, so that the façade appears to be like a carved wooden retable. The *estipite* might best be described as an applied pilaster with the shape of an inverted, elongated, truncated pyramid.

These Hispano-American examples differed markedly from the "classical" European Baroque. In the New World the Baroque elements were confined to the decorative parts of the building, which continued to preserve the traditional rectilinear plans, yet were fronted with these outrageously involved decorated façades. Among the prime examples are the church in Zacatecas, Mexico; the Sagrario in Mexico City; some churches in Antigua Guatemala (El Carmen, La Merced and La Candelaria); and the church of La Compañía in Quito, Ecuador [see pages 264–5].

During most of the colonial period, and especially in the 17th century, the Caribbean Sea and the Antilles were the favored hunting-grounds of pirates and buccaneers who preyed on Spanish ships carrying the

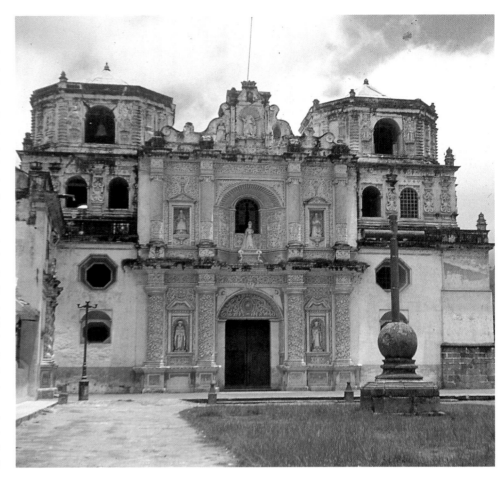

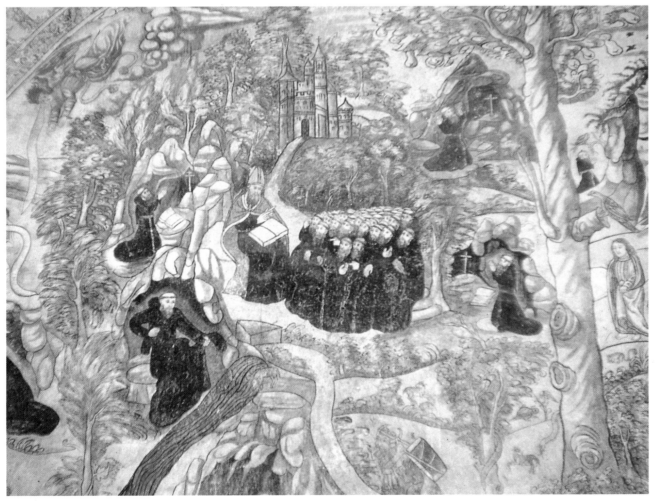

Above: The Church of La Merced *(mid-18th century), Antigua, Guatemala.*

Profuse, carved stucco ornamentation, ataurique, *with interlacing floral and geometric motifs as well as free-standing sculptures decorate the façade, which is like an altarpiece, or retable, in design.*

Left: Augustinian Church and Cloister *(late 16th century), Actopan, Mexico.*

Detail of the mural painting in the refectory of the convento depicting the life of San Agustín.

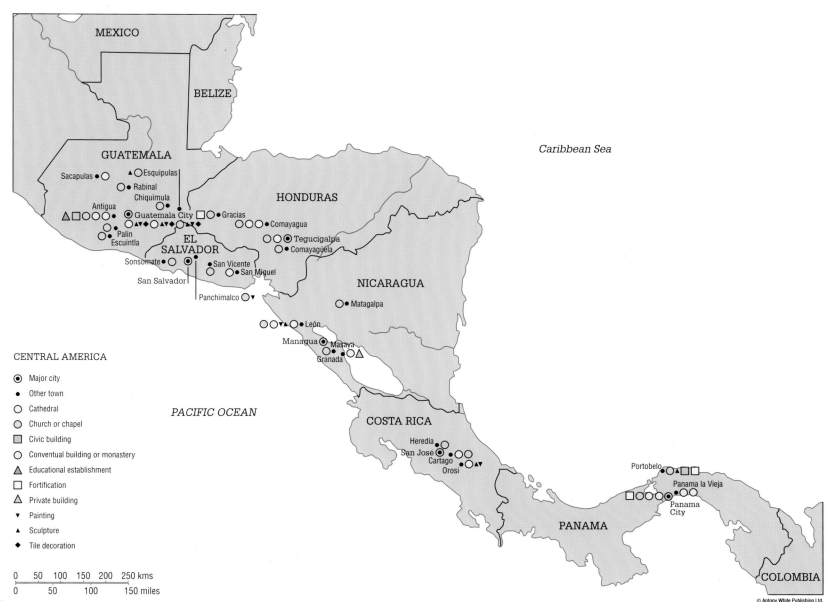

CENTRAL AMERICA

⊙ Major city
● Other town
○ Cathedral
○ Church or chapel
▢ Civic building
○ Conventual building or monastery
△ Educational establishment
▢ Fortification
△ Private building
▼ Painting
▲ Sculpture
◆ Tile decoration

| 0 | 50 | 100 | 150 | 200 | 250 kms |
| 0 | | 50 | 100 | | 150 miles |

Caribbean Sea

PACIFIC OCEAN

© Antony White Publishing Ltd.

treasure of the colonies to Spain [see pages 262–3]. In the early 16th century it had not been necessary to protect the port cities, but in 1586 Sir Francis Drake sacked the city of Santo Domingo. The Spanish authorities soon realized that the security of the coasts, and particularly of the port cities, which were attacked and sacked time and time again, was of paramount importance if they were to maintain their supremacy. Because Santo Domingo could not be effectively defended, Havana became the principal port from which convoys would sail to Spain. Fortifications were constructed not only there but also at San Juan in Puerto Rico, St. Augustine in Florida, Vera Cruz and Campeche in Mexico, Porto Bello in Panama, Cartagena in Colombia, and elsewhere. (Similar fortifications were constructed in the principal ports on the Pacific side, as, for instance, at the first Spanish urban center on the isthmus, Panama la Vieja, which was sacked by the English pirate Morgan in 1671).

The architecture in the Spanish colonies of South America is somewhat different [see pages 264–5]. Two distinct regional styles developed, one in the highlands of the Andes, the other along the coastal plain, especially in Peru. The differences are due, in part, to the

materials and methods of construction: stone and brick in the highlands; on the coast adobe, or sun-dried brick, as well as an innovative device for roofs, the *quincha*. Made of plastered matted reeds supported on timber frames or brick ribs, the *quincha* was light in weight and less costly to erect than masonry vaults, which would only be soon destroyed in the ever-recurring earthquakes which plagued the region.

Another difference from the architecture of Mexico and Central America was the closer adherence to European models. For example, the Franciscan church and *convento* in Quito (1535–c.1575) was designed and built by a Flemish friar-architect, Fray Jodoco Ricke. The church has a very Italianate façade, unlike the contemporary churches of Mexico, and follows European models very closely. Yet the interior is anything but Italianate, being resplendent with gold leaf covering the wood carvings and the slightly pointed Gothic transverse arches which support a magnificent *mudéjar* wood-beamed and paneled ceiling – an *artesonado*. It is another striking example of the asynchronous quality and mélange of styles, derived from European sources and melded to form a harmonious stylistic ensemble.

Colonial Latin America 1500–1820: Sculpture

The earliest examples of colonial Latin American sculpture are in Santo Domingo – as, for example, on the frieze of the main façade of the cathedral. Inside there are several Renaissance-style tombs embedded in the walls. In Mexico [see pages 258–259], in the 16th century, sculpture was usually confined to the main portals of the churches attached to the monasteries built by the mendicant orders. The majority of these early examples were executed in a backward-looking, Gothic-like style or in the Plateresque. This type of sculpted decoration continued, but from the mid-16th century on its style was more closely derived from Late Gothic German and Flemish woodcuts. The sculpture betrayed the origins of its influence from two-dimensional sources in that it was generally flat, almost calligraphic at times. In some instances, the style was reminiscent of the Renaissance, as for example the relief sculptures on the jambs of the arched openings of the open-air chapel at Tlalmanalco where, though the subject-matter was Christian, the "primitive quality" of the work suggested that it had been executed by native craftsmen.

Another influence on Mexican colonial sculpture was that stemming from the Spanish wood-carving tradition, principally from Seville and Granada. In addition to sculptures and retables produced in Mexico, many religious images placed in the retables or altarpieces were actually imported from Spain; some are still to be found in the cathedrals of Mexico City and Puebla [see pages 258–259]. The resplendently gilded retable in the Capilla del Rosario in the Church of Santo Domingo in Puebla (c.1650) is especially noteworthy. It was designed with Baroque architectural members – striated and twisted spiraling columns, densely covered with floral motifs.

In Central America, particularly in the capital of the colony, Antigua Guatemala (Santiago de Guatemala during the colonial period), sculpture was more developed than painting. The city's sculptors produced images which were exported to the rest of Central America; many still exist in the cathedrals and churches of Honduras, El Salvador, Nicaragua, Costa Rica and the Mexican state of Chiapas [see pages 260–1]. After the catastrophic destruction of Antigua by an earthquake in 1773, many of the images in its churches were moved to their counterparts in the new capital, Guatemala City. One such image of outstanding quality is the Cristo de los Reyes, now housed in the cathedral. Fine examples of Antiguan sculpture still exist in many churches in small towns and villages – for example, the "Black Christ" by Quirio Catano (c.1595) which is still venerated in the pilgrimage church in Esquipulas.

A noteworthy school of sculpture developed in Ecuador, principally in Quito [see pages 264–5]. As elsewhere, during the 16th century many religious images were imported from Spain (mostly from Seville). Another, but somewhat less important, school grew up in Colombia; in the 17th century strong stylistic influences from Seville reached Bogotá, whose sculptors were not as creative as those of Quito. By then, in Quito, local Indians and mestizos had become the principal craftsmen. However, they still worked in the European Spanish manner, creating a school of wood-carving,

especially of pulpits and retables, some of which still exist in the churches of La Concepcion, Santa Cruz, La Compañía, San Francisco and La Merced in Quito. Like most colonial retables still extant these date from the 18th century; all are replete with striated and twisted solomonic columns, the hallmark of the Baroque style – as, for example, on the especially ornate façade and interior of La Compañía.

The sculpture of Peru and Bolivia was strongly influenced by the *quiteño* school and by the 18th century equaled or even surpassed it in quality. In Chile and Argentina very little sculpture from the colonial period survives [see pages 264–5].

Painting in Spanish America was not as sophisticated, original or important as architecture. Though there were many excellent artists, the restraints imposed by the Church on subject-matter and even on style of execution made it impossible for artists to be creative or innovative.

Above: Old Spanish Fort, *(1586–1640), San Juan, Puerto Rico.*

Massive fortifications were built throughout the region in response to the sack of Santo Domingo by Sir Francis Drake in 1586.

Right: Santo Domingo Cathedral, *(early to mid-16th century), Santo Domingo, Dominican Republic.*

A view of the west front of the building, which is Gothic in design and construction. The design and decoration of the main façade, however, is Plateresque.

Below: The Palace of Diego Columbus (Colón), *(early 16th century), Santo Domingo, Dominican Republic.*

The two-story portal of late Gothic style is repeated on the rear.

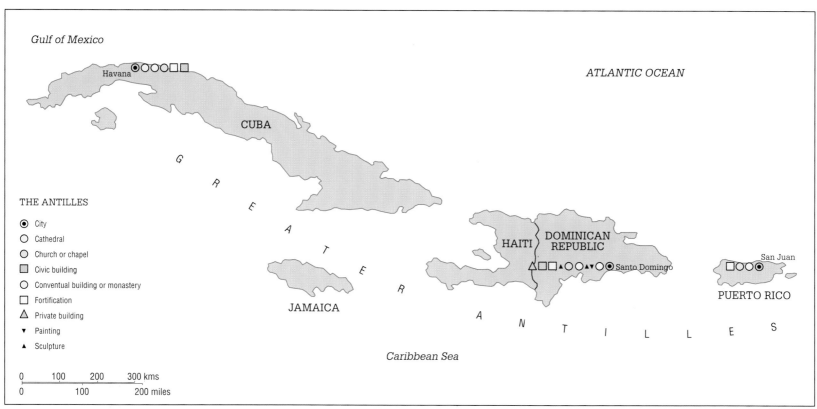

Gulf of Mexico

ATLANTIC OCEAN

Havana

CUBA

G R E A T E R

THE ANTILLES

⊙ City
○ Cathedral
○ Church or chapel
▢ Civic building
○ Conventual building or monastery
▢ Fortification
△ Private building
▼ Painting
▲ Sculpture

0 100 200 300 kms
0 100 200 miles

HAITI

DOMINICAN
REPUBLIC

Santo Domingo

San Juan

PUERTO RICO

JAMAICA

A N T I L L E S

Caribbean Sea

© Antony White Publishing Ltd.

Colonial Latin America 1500–1820: Painting

Much of colonial Latin American painting may be categorized as "folk" or "native" art; it is "archaic-bound", lacking originality and frequently slavishly following the style of the prints and woodcuts which the clergy handed out to painters to copy, to prevent them from straying from canonical requirements. Many of the woodcuts and prints were of Flemish origin, imported from Antwerp, and some came from Rome. From the 16th century until the very end of the colonial period artists followed the style and subject matter of these prints, so that Latin American painting was ever "archaic-bound", conventional and unoriginal, the subject matter strictly religious in content and usually taken from the New Testament. Perhaps even more so than in sculpture, there was also a vigorous and continuing trade in pictures imported from Seville and elsewhere in Andalucía.

There are a few examples of mural painting in 16th-century Mexico, the majority in the churches and *conventos* of the Franciscan and Augustinian orders [see pages 258–9]. Cuzco was also largely dependent on European models, though *cuzqueño* paintings, it would seem, were almost mass-produced and were exported throughout the rest of South America.

Artistic development in Brazil reflected the traditions of its mother country, Portugal, more closely than it did in the Spanish colonies. The principal Brazilian monuments – in architecture, sculpture and painting – date from the 18th century; there was nothing comparable to the lavishly decorated church façades so common in Mexico and parts of Central America. The main centers of artistic activity were along the coast: not only the port cities, but those in the vast Brazilian hinterland also, were in closer contact with Portuguese design and construction than was the case elsewhere in Latin America.

Some of the most important centers were in the province of Minas Gerais, a great mining area north of Rio de Janeiro; in the city of Rio itself; and in Bahía (now Salvador), which was the capital until 1763 when it was moved to Rio. A truly Baroque style developed, with octagonal naves predominating until about 1740 – for example, in the churches of N.S. da Glôria do Outeiro in Rio de Janeiro and of Pilar in Ouro Prêto. One of the most interesting churches in Conceiçào da Praia in Salvador, which also has an octagonal plan.

From the second half of the 18th century there was great building activity in Minas Gerais, where curved façades and undulating nave walls became common, especially after 1765 – for example, the churches of Bom Jesus in Congonhas do Campo and San Francisco in Ouro Prêto, which was designed and built by the famous sculptor Antônio Francisco Lisboa (1738–1814), known as Aleijadinho. Compared with the rest of colonial Latin America, in Brazil sculpture was not often employed for decorating church façades, which tended to be rather plain, nor was it of the same high quality – except for the work of Lisboa. His principal sculptural works were the stone pulpits in the church of San José and the main altar in the church of San Francisco in Ouro Prêto. But his best work is the magnificent processional figures in the Bom Jesus church in Congonhas do Campo.

Brazilian painting was far inferior in quality to that of Hispano-America. Like their counterparts elsewhere, Brazilian artists depended for their subject matter and its execution and style on European engravings, especially those imported from Antwerp and Rome.

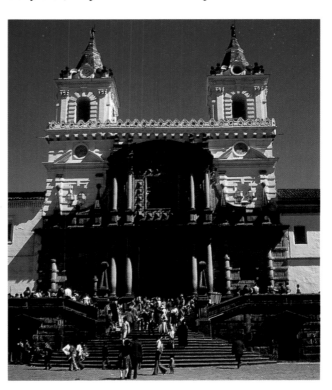

Far left: The Church of Nossa Senhora de Gloría do Outeiro, *(1714–30), Rio de Janeiro, Brazil.*

Earliest of the Brazilian octagonal naves, it was in the vanguard of progressive work anywhere.

Left: The Church of San Francisco *(c.1535), Quito, Ecuador.*

The construction of the Italianate façade was directed by a Fleming, Fray Jodoco Ricke, and the church and clerestory were completed by about 1575.

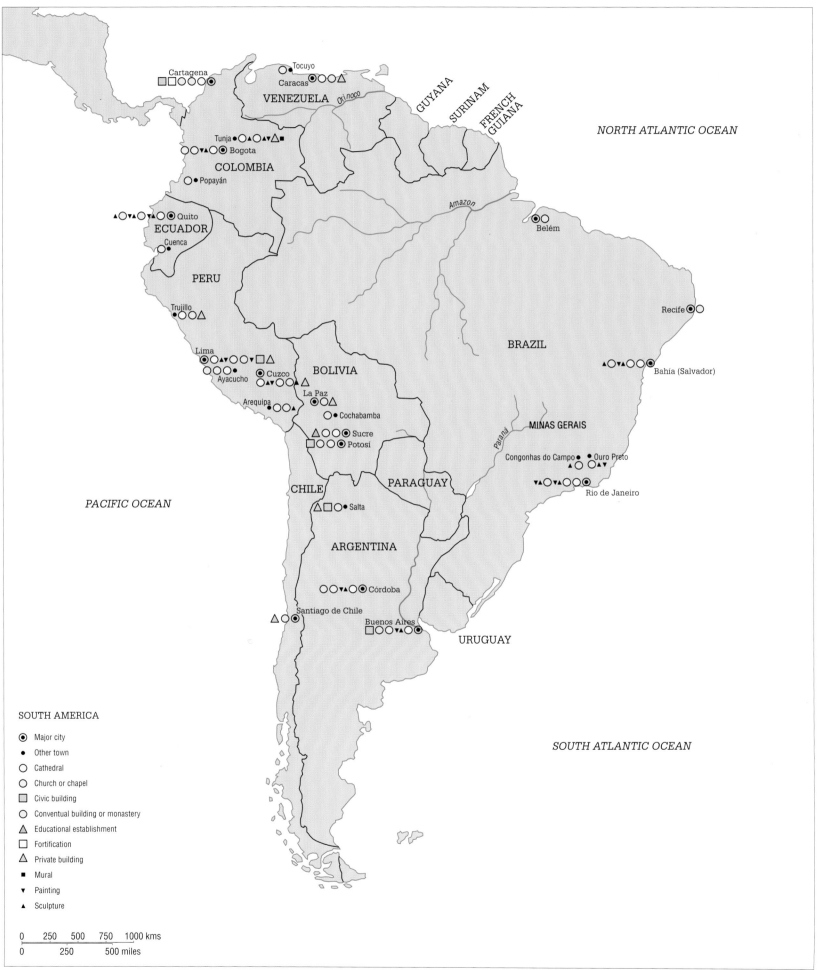

Cartagena
Tocuyo
Caracas
VENEZUELA
Orinoco
GUYANA
SURINAM
FRENCH GUIANA
NORTH ATLANTIC OCEAN

Tunja
Bogota
COLOMBIA
Popayán

Amazon

Belém

Quito
ECUADOR
Cuenca

PERU

Recife

Trujillo

BRAZIL

Lima
Cuzco
BOLIVIA
Ayacucho
Arequipa
La Paz
Cochabamba
Sucre
Potosí

Bahía (Salvador)

MINAS GERAIS

Congonhas do Campo
Ouro Preto

CHILE
PARAGUAY
Rio de Janeiro

Salta

PACIFIC OCEAN

ARGENTINA

Córdoba

Santiago de Chile
Buenos Aires
URUGUAY

SOUTH ATLANTIC OCEAN

SOUTH AMERICA

⊙ Major city
• Other town
○ Cathedral
○ Church or chapel
▢ Civic building
○ Conventual building or monastery
△ Educational establishment
▫ Fortification
△ Private building
■ Mural
▼ Painting
▲ Sculpture

0 250 500 750 1000 kms
0 250 500 miles

© Antony White Publishing Ltd.

Above: *Joseph Mallord William Turner (1775–1851): detail from* Rain, Steam and Speed, the Great Western Railway *(National Gallery, London).*

THE MODERN WORLD

1789–1950

The Modern Age began with the Enlightenment, the Industrial Revolution and the French Revolution of 1789; out of which grew both the Neo-classical and Romantic movements. Throughout the 19th century the city of Paris was the mecca for all European and American artists who wished to study either academic or modern art, and in particular the achievements of the Impressionists, Post-Impressionists, the Fauves and the Cubists. This primacy of Paris did not change until the catastrophic political events of the 20th century led to the emigration of many artists to America where in the late 1940s the growth of a specifically American style of painting began to shift the center of the art world from Paris to Manhattan.

Above: *Jules Le Franc (b.1887):* The Eiffel Tower *(Private Collection).*

Revolutionary and Napoleonic Europe

The 18th century, the age of Enlightenment, ended with the French Revolution of 1789, the failure of which led to the rise of Napoleon. The shock waves from France affected every country in Europe, and a new series of defensive alliances were forged between the European powers as a result. Paris was the setting for the drama of the Revolution. In January 1793 Louis XVI was guillotined, and France declared a republic which far from bringing stability unleashed the Terror, led by the Jacobins and the *sans-culottes*.

The European powers were horrified by the social, political and military implications of the years 1789–92. The new regime declared war against Austria in April 1792 – both an ideological crusade and an attempt to push French territory back to its nearest natural frontiers: the Alps and the Rhine. The Austrians and the Prussians marched on Paris – incredibly the French forces were well mobilized. Savoy and part of the Austrian Netherlands were invaded by French troops; in 1793 Britain, the Dutch, some of the Italian states and Spain entered the battle against France. By 1794 the tide turned decisively in favour of the French, and Spain and Prussia left the war, Napoleon Bonaparte took command of the "Army of Italy", and by 1797 extracted a surrender from the Austrians. In Italy, Napoleon secured the Cisalpine (Milanese) and Ligurian (Genoese) republics; the next year the papal states were invaded and Rome itself captured. Napoleon was named First Consul in 1799, and crowned Emperor of the French people in 1804; a new dynasty had virtually replaced the old.

Four wars of the Coalition saw constant shifts of alliance with and collaboration against France whose most significant ally, Russia, soon began to mistrust its relationship with the Emperor. Napoleon retaliated by marching on Russia and seizing Moscow – a shallow victory which culminated in the virtual destruction of the *Grand Armée* – wiped out by cold and starvation as much as by battle. Prussia rose against Napoleonic rule, and together with the Allies, defeated Napoleon at Leipzig in 1813. The allied army entered Paris in 1814, and, in a coup arranged by the veteran diplomat Talleyrand, the Bourbon dynasty in the person of Louis XVIII was reinstated.

Napoleon was imprisoned on the island of Elba but managed to escape and raise yet another army which was quickly, although narrowly, defeated at Waterloo in 1815.

The Allies tried to put the clock back at the peace congress of Vienna, but despite a generation of social and political repression, Napoleon had managed to spread the ideas of the Revolution across Europe. He also destroyed the old political order. The long-term results were two-fold; the revolutions of 1848, 1870 and 1917 on the one hand, the unification of both Germany and Italy on the other.

Left: *Jacques-Louis David (1748–1825):* Napoleon Crossing the Alps, *1800 (Schloss Charlottenburg, Berlin).*

EUROPE UNDER NAPOLEON: 1812

French Empire

Areas under Napoleonic rule

Other dependent states

Boundary of Confederation of the Rhine

0 100 200 300 400 kms
0 100 200 miles

ATLANTIC OCEAN

Oporto
R. Douro
Val
PORTUGAL
Lisbon
R. Tagus
S
Seville
Gran
Gibraltar
Tangier Ceuta
MOROCCO

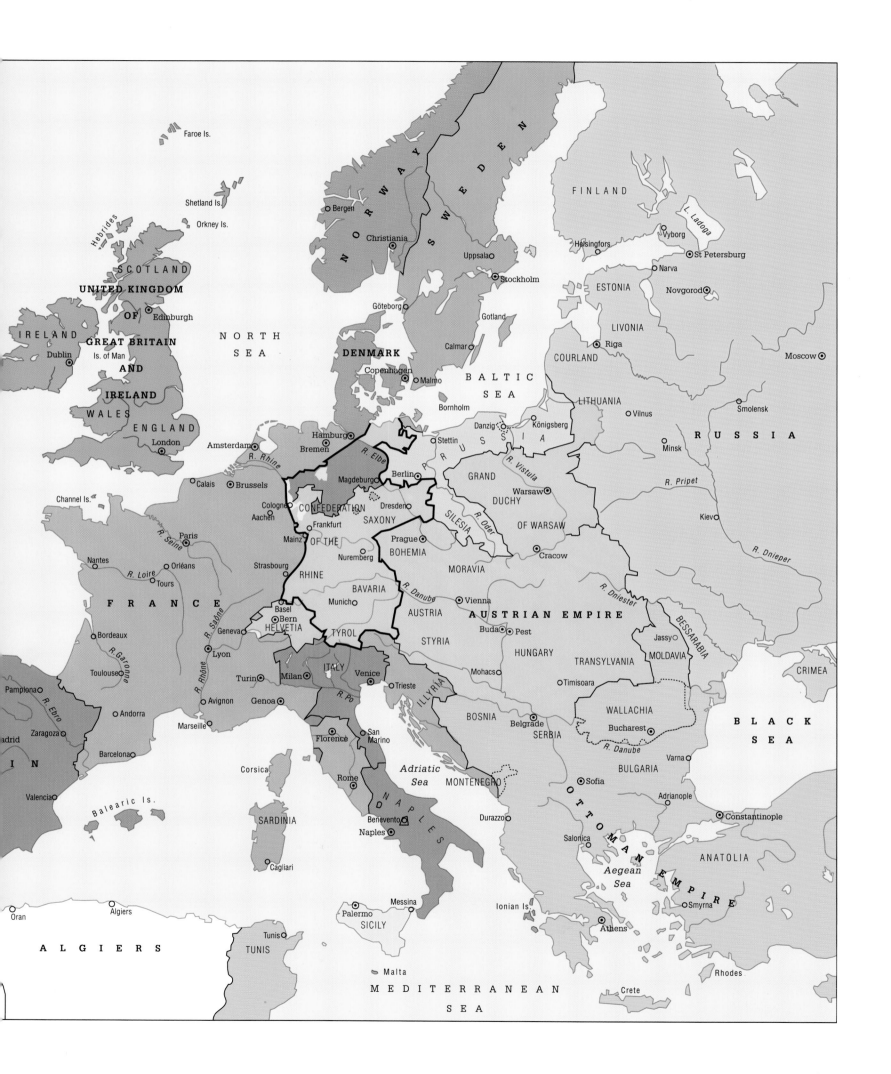

Faroe Is.

Shetland Is.
Orkney Is.

Hebrides

S C O T L A N D

UNITED KINGDOM

IRELAND

OF Edinburgh

Dublin **GREAT BRITAIN**

Is. of Man **AND**

IRELAND

W A L E S

E N G L A N D

London

Channel Is.

N O R T H

S E A

N O R W A Y

Bergen

Christiania

S W E D E N

Uppsala

Stockholm

Göteborg

Calmar

DENMARK

Copenhagen

Malmo

Bornholm

B A L T I C

S E A

Gotland

F I N L A N D

L. Ladoga

Helsingfors

Vyborg

St Petersburg

Narva

Novgorod

E S T O N I A

L I V O N I A

Riga

C O U R L A N D

L I T H U A N I A

Vilnus

Danzig

Königsberg

Moscow

Smolensk

Minsk

R U S S I A

Amsterdam

Brussels

Calais

R. Rhine

Hamburg

Bremen

Magdeburg

R. Elbe

Berlin

Stettin

P R U S S I A

G R A N D

D U C H Y

R. Vistula

Warsaw

O F W A R S A W

Cracow

R. Pripet

Kiev

R. Dnieper

Cologne

Aachen

CONFEDERATION

Frankfurt

Mainz

OF

Dresden

SAXONY

SILESIA

R. Oder

Paris

R. Seine

Nantes

Orléans

Tours

R. Loire

F R A N C E

Bordeaux

R. Garonne

Toulouse

Strasbourg

RHINE

Nuremberg

Basel

Bern

Geneva

HELVETIA

Lyon

R. Rhône

R. Saône

BAVARIA

Munich

R. Danube

TYROL

ITALY

Prague

BOHEMIA

MORAVIA

AUSTRIA

Vienna

STYRIA

Buda Pest

HUNGARY

Mohacs

AUSTRIAN EMPIRE

TRANSYLVANIA

Timisoara

R. Dniester

MOLDAVIA

Jassy

BESSARABIA

C R I M E A

Pamplona

R. Ebro

Zaragoza

adrid

Barcelona

Valencia

I N

Andorra

Avignon

Marseille

Turin

Milan

Genoa

Florence

San
Marino

R. Po

Venice

Trieste

ILLYRIA

BOSNIA

Belgrade

SERBIA

Bucharest

WALLACHIA

R. Danube

Varna

B L A C K

S E A

Balearic Is.

SARDINIA

Corsica

Rome

Benevento

Naples

N
A
P
L
E
S

*Adriatic
Sea*

MONTENEGRO

Durazzo

Sofia

BULGARIA

Salonica

Adrianople

Constantinople

A N A T O L I A

Cagliari

Oran

Algiers

Palermo

SICILY

Messina

Tunis

Ionian Is.

O
T
T
O
M
A
N

*Aegean
Sea*

E
M
P
I
R
E

Smyrna

Athens

A L G I E R S

TUNIS

Malta

Crete

Rhodes

M E D I T E R R A N E A N

S E A

269

Europe Between the Wars

At the start of 1918 Europe was divided between the Central Powers, including Germany, Austria-Hungary, Bulgaria and Turkey, and the Allies who included Britain, France, Italy and, from 1917, America. The hostilities of the First World War ended with a series of armistices in late 1918. The peace treaty signed at the Palace of Versailles on June 28th 1919 changed the face of Europe and made Germany responsible for financial reparations for all losses sustained by the Allies. At one stroke, Germany was pauperized and any hope of postwar political stability was crushed.

A proposal for a League of Nations was first made in 1918: its aim was to secure and maintain world peace and to safeguard the political independence of smaller states. The League ultimately failed; its credibility was seriously weakened by America's refusal to join and its inability to prevent the invasion of Manchuria by Japan in 1931. Within two turbulent decades of the Treaty of Versailles Europe was again on the brink of war.

Extremist movements gained popularity as the political spectrum polarized between democratic and totalitarian regimes. Modern forms of dictatorship emerged. In Italy Mussolini and the Fascist government were enshrined in power fully from 1926 onwards; Spain had the dictator Primo de Rivera; and Germany, Adolf Hitler. In 1922 the 10th All-Russian Congress of Soviets formed the Union of Soviet Socialist Republics (U.S.S.R.). Communism was pushed forward first by Lenin, followed, more brutally, by Stalin. Spain was divided by civil war in 1936 after the July uprising led by General Francisco Franco who became Commander-in-Chief of the armed forces and head of the Spanish State. This internal conflict became a practice ground for the new dictators.

Anxiety concerning German aggression increased in the 1930s, but a series of alliances between other European powers had little effect. In 1935 general conscription was re-introduced in Germany and by the end of 1937 a policy of German expansionism was publicly advocated by the Führer. Austria was formally incorporated into the German Empire in 1938, and Czechoslovakia was invaded in the same year. During the Munich conference of September 1938 a non-aggressive alliance was signed between Germany and Britain and an understanding achieved between France and Germany – only to be severed in September 1939 with the German invasion of Poland, and the alliance of Germany, Italy and Japan.

Above: *George Grosz (1893–1959):* Berlin night-club, *(Private Collection).*

EUROPE IN 1926

ATLANTIC OCEAN

Oporto

R. Douro

Val

PORTUGAL

Lisbon

R. Tagus

S

Seville

Grana

Gibraltar

Tangier

Ceuta

MOROCCO

0 100 200 300 400 kms
0 100 200 miles

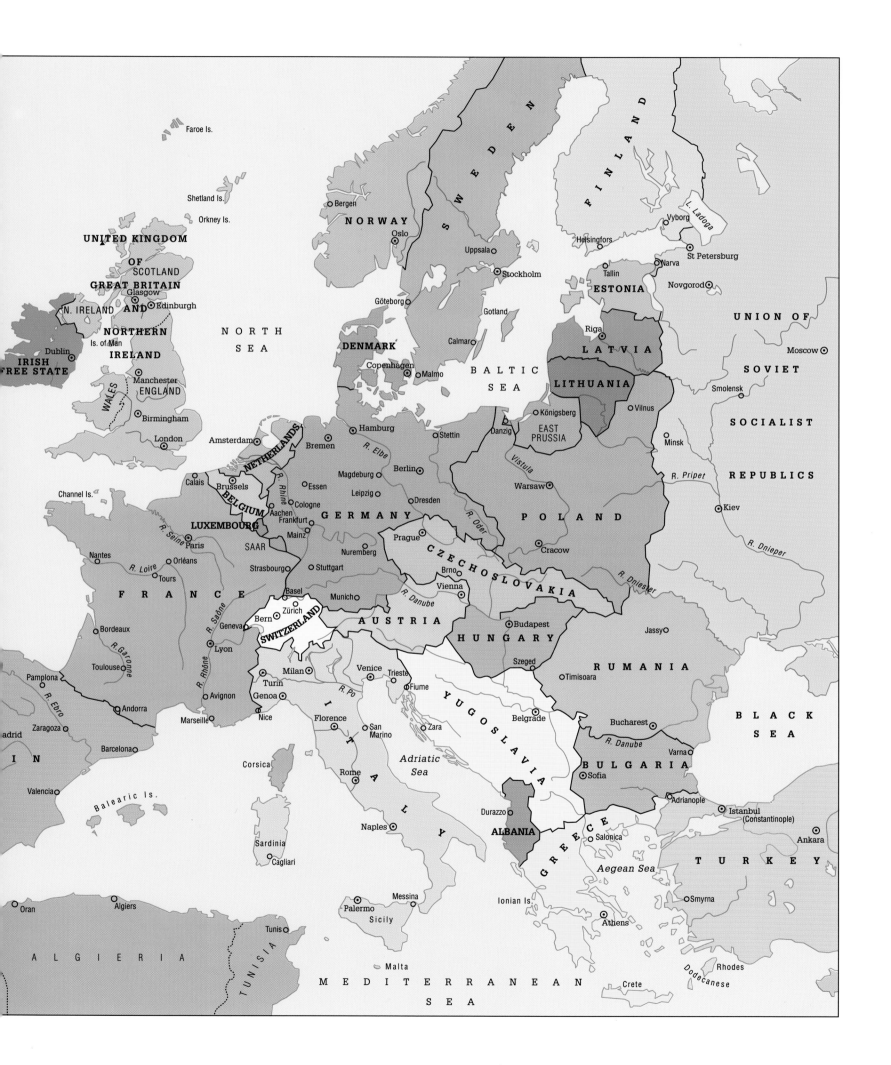

Faroe Is.

Shetland Is.

Orkney Is.

UNITED KINGDOM

OF SCOTLAND

GREAT BRITAIN
Glasgow ⊙
N. IRELAND **AND** ⊙ Edinburgh

IRISH Dublin ⊙ **NORTHERN**
FREE STATE Is. of Man **IRELAND**

Manchester ⊙
WALES **ENGLAND**

Birmingham ⊙

London ⊙

N O R T H

S E A

Bergen ⊙

N O R W A Y

Oslo ⊙

Uppsala ⊙

Göteborg ⊙

Stockholm ⊙

DENMARK

Copenhagen ⊙
Malmo ⊙

Calmar ⊙

Gotland

B A L T I C

S E A

S W E D E N

F I N L A N D

Helsingfors ⊙

L. Ladoga

Vyborg ⊙

Narva ⊙ St Petersburg ⊙

Tallin ⊙ **ESTONIA** Novgorod ⊙

Riga ⊙ **L A T V I A**

LITHUANIA Königsberg ⊙ Vilnus ⊙

Danzig ⊙ **EAST**
PRUSSIA Minsk ⊙

U N I O N O F

S O V I E T

Moscow ⊙

Smolensk ⊙

S O C I A L I S T

Channel Is.

Amsterdam ⊙ **NETHERLANDS**

Calais ⊙ Brussels ⊙
BELGIUM
LUXEMBOURG

Hamburg ⊙

Bremen ⊙

R. Elbe

Essen ⊙ Magdeburg ⊙ Berlin ⊙

Cologne ⊙
Aachen ⊙
Frankfurt ⊙
Mainz ⊙

G E R M A N Y

Leipzig ⊙ Dresden ⊙

Prague ⊙

Stettin ⊙

R. Oder

Vistula

Warsaw ⊙

P O L A N D

Cracow ⊙

Minsk ⊙

R. Pripet

R E P U B L I C S

Kiev ⊙

R. Dnieper

Nantes ⊙

R. Seine Paris ⊙

SAAR

Orléans ⊙

R. Loire
Tours ⊙

Strasbourg ⊙

Nuremberg ⊙

Stuttgart ⊙

C Z E C H O S L O V A K I A

Brno ⊙

Vienna ⊙

R. Dniester

F R A N C E

R. Saône

R. Rhône

Bordeaux ⊙

R. Garonne

Lyon ⊙

Toulouse ⊙

Basel
Bern ⊙ Zürich ⊙
Geneva ⊙ **SWITZERLAND**

Munich ⊙

R. Danube

A U S T R I A

Budapest ⊙

H U N G A R Y

Szeged ⊙

Jassy ⊙

R U M A N I A

Timisoara ⊙

Pamplona ⊙

R. Ebro

Zaragoza ⊙

adrid ⊙

Barcelona ⊙

Andorra ⊙

Avignon ⊙

Marseille ⊙

Milan ⊙

Turin ⊙

Genoa ⊙

Nice ⊙

I

Venice ⊙ Trieste ⊙

R. Po

Fiume ⊙

Zara ⊙

Florence ⊙

San
Marino ⊙

Belgrade ⊙

Y U G O S L A V I A

Bucharest ⊙

R. Danube

Varna ⊙

B U L G A R I A

Sofia ⊙

B L A C K

S E A

Valencia ⊙

Balearic Is.

I N

Corsica

T

Rome ⊙

A

L

Y

Adriatic
Sea

Durazzo ⊙

ALBANIA

Adrianople ⊙

Istanbul ⊙
(Constantinople)

Salonica ⊙

G
R
E
E
C
E

Ankara ⊙

T U R K E Y

Smyrna ⊙

Oran ⊙ Algiers ⊙

Sardinia

Cagliari ⊙

Naples ⊙

Sicily

Palermo ⊙

Messina ⊙

Aegean Sea

Athens ⊙

Ionian Is.

Rhodes ⊙

Dodecanese

A L G I E R I A

TUNISIA

Tunis ⊙

Malta

Crete

M E D I T E R R A N E A N

S E A

271

Neoclassical Art and Architecture in Europe

Neoclassicism is the name given to the movement that dominated European art from the mid-18th century to the early 19th century. It was inspired by the art of Greece and Rome, and Neoclassical artists attempted to revive the spirit as well as the forms of their ancient models. Many earlier artists, of course, had been deeply influenced by antique art, but the Neoclassicists differed from them in the scientific spirit with which they investigated and studied ancient remains; the discovery of the ruins of the cities of Herculaneum and Pompeii (where serious excavation began in 1709 and 1748 respectively) was a great stimulus. These two cities near Naples had been buried by an eruption of Mount Vesuvius in A.D. 79; a wealth of art and other remains was uncovered in an excellent state of preservation and had a profound effect on European taste, particularly on interior design. In France, Neoclassicism was associated with the reforming ideals of the Revolution, which are perfectly embodied in the paintings of Jacques-Louis David. Two of his most famous works – *The Oath of the Horatii* (Louvre,1784) and *Brutus and his Dead Sons* (Louvre,1789) – are concerned with the theme of patriotic duty triumphing over personal feeling. David often used his art for political propaganda. His noble, severe and intellectually rigorous pictures show Neoclassicism at its purest and most ardent, but they represent only one aspect of a many-sided movement; it also embraced the exquisite linear grace of Ingres, the scientific bent of Joseph Wright of Derby and the sheer prettiness of Angelica Kauffmann, whose paintings still have much of the spirit of Rococo – the frothy, frivolous style to which Neoclassicism was to some extent a backlash.

All these artists spent part of their career in Rome, which was the birthplace and chief center of Neoclassicism. Most of the leading artists of the period at least visited the city, and several of them spent the major part of their career there. Of the three most famous sculptors of the age, for example, the Italian Canova and the Dane Thorvaldsen lived in Rome for most of their lives and the Englishman Flaxman spent seven years there (1787–94). Two Germans living in Rome – the painter Mengs and the scholar Winckelmann – were prominent in giving Neoclassicism its intellectual justification and international reputation. Winckelmann wrote two highly influential books on ancient painting and sculpture, published in 1755 and 1764, but Mengs was the channel through which Winckelmann's ideas were expressed on canvas. To modern taste he does not rank high as an artist, his work seeming flimsy and derivative, but he had an immense contemporary reputation, being widely regarded as the greatest living painter.

Books played an important role in the dissemination of Neoclassicism. Because it placed respect for the authority of the antique above personal expression, Neoclassicism particularly lent itself to codification and literary explanation; among the most important literary works of the time are the *Discourses* of Sir Joshua Reynolds, delivered as lectures to students at the Royal Academy in London (1769–90), and the articles and reviews of Denis Diderot, the chief editor of the great *Encyclopédie* (1751–72), a work that played a leading role in shaping the rationalist and humanitarian views of the Age of Enlightenment.

Adam is one of the architects who illustrate how varied Neoclassical architecture is. Some Neoclassicists were constrained by their admiration for antiquity, producing buildings that were lifeless and rule-bound, but others used it as a springboard for their imagination. Adam is renowned for the exquisite refinement of his work, especially his interiors; he supervised his buildings down to the last detail. Soane's style was very different and highly original, featuring unusual spatial arrangements and a quirky paring away of detail to an almost diagrammatic simplicity. The flawless good taste of Gabriel, the massive strength of Ledoux and the inventiveness and sense of fantasy of Zakharov (whose St. Petersburg Admiralty is said to be the largest Neoclassical building in the world) show other aspects of the variety of the movement.

Early Neoclassical architecture was based on Roman exemplars, but architects subsequently turned to Greece for inspiration. A pioneer was James "Athenian" Stuart, who visited Greece in 1751–5, designed the first building in Europe to imitate the Greek style – the Temple at Hagley (1758) – and published the first accurate survey of ancient Greek buildings, *The Antiquities of Athens* (1762, second volume 1789). The Greek Revival, as the movement of which he was in the forefront was known, did not take off seriously until the 1790s, however, by which time there was a widespread interest in the gravity and simplicity of Greek buildings. Schinkel was perhaps the most powerful exponent of the style, which culminated in the 1820s and 1830s. It had its last great flowering in the work of Alexander "Greek" Thomson in Glasgow; his buildings are not purely Grecian, for they introduce elements from Egyptian and even Indian architecture, but they have a boldness and grandeur worthy of the finest ancient models.

Above: *Jean Auguste Dominique Ingres (1780–1867):* Woman Bathing ('La Baigneuse de Valpinçon'), *1808 (Louvre, Paris).*

This mature painting shows Ingres, a pupil of David, striving for perfection in his use of color. His consummate draftsmanship dominates but the powerful and tranquil colors show deliberateness and clarity.

Below: *Jacques-Louis David (1748–1825):* The Oath of the Horatii, *1784 (Louvre, Paris).*

Returning from Rome where he spent the years 1775–80 studying ancient monuments and sculptures as well as works of the Renaissance and Baroque, David adopted a rigorous classical approach to his painting. The Oath of the Horatii was called by one contemporary critic "the most beautiful painting of the century".

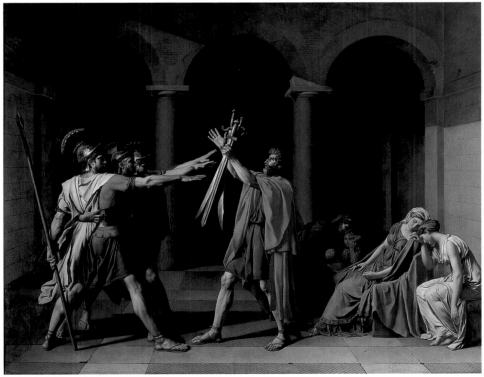

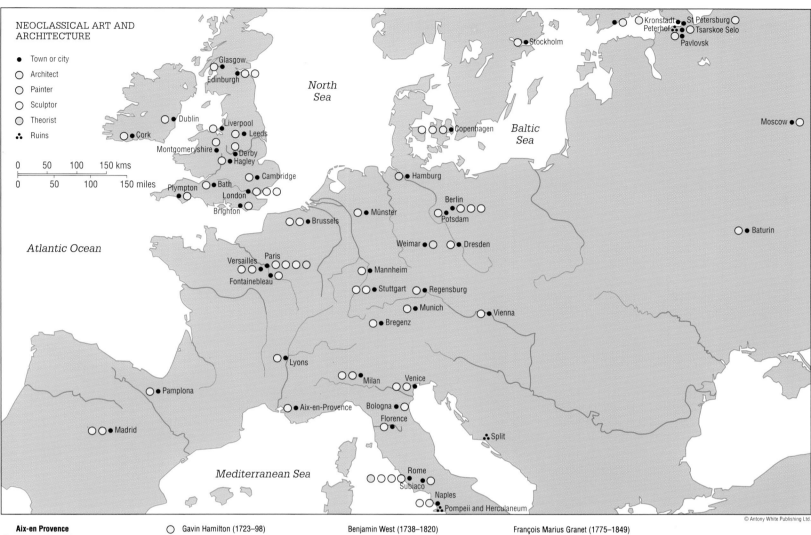

NEOCLASSICAL ART AND ARCHITECTURE

- ● Town or city
- ○ Architect
- ○ Painter
- ○ Sculptor
- ○ Theorist
- ⊶ Ruins

0 50 100 150 kms
0 50 100 150 miles

North Sea

Baltic Sea

Atlantic Ocean

Mediterranean Sea

Glasgow
Edinburgh
Dublin
Cork
Liverpool
Leeds
Montgomeryshire
Derby
Hagley
Plympton
Bath
Cambridge
London
Brighton
Brussels
Münster
Weimar
Versailles
Paris
Fontainebleau
Mannheim
Stuttgart
Regensburg
Munich
Bregenz
Vienna
Lyons
Milan
Venice
Bologna
Florence
Aix-en-Provence
Pamplona
Madrid
Rome
Subiaco
Naples
Pompeii and Herculaneum
Split
Hamburg
Berlin
Potsdam
Dresden
Copenhagen
Stockholm
Kronstadt
Peterhof
St Petersburg
Tsarskoe Selo
Pavlovsk
Moscow
Baturin

© Antony White Publishing Ltd.

Aix-en Provence
○ François Marius Granet (1775–49)
Bath
○ Joseph Wright of Derby (1734–97)
Baturin
○ Charles Cameron (c.1743–1812)
Berlin
○ Friedrich Gilly (1772–1800)
Leo von Klenze (1784–1864)
Carl Gotthard Langhans (1732–1808)
Karl Friedrich von Schinkel (1781–1841)
○ Asmus Jakob Carstens (1754–98)
○ Johann Gottfried Schadow (1764–1850)
Bologna
○ Benjamin West (1738–1820)
Bregenz
○ Angelica Kauffmann (1741–1807)
Brighton
○ Henry Holland (1745–1806)
Brussels
○ Jacques-Louis David (1748–1825)
○ Pierre-Jean David d'Angers (1788–1856)
Cambridge
○ William Wilkins (1778–1839)
Copenhagen
○ Theophilus von Hansen (1813–91)
○ Nicolai Abraham Abildgaard (1743–1809)
○ Bertel Thorvaldsen (1770–1844)
Cork
○ James Barry (1741–1806)
Derby
○ Joseph Wright of Derby (1734–97)
Dresden
○ Anton Raffael Mengs (1728–79)
Dublin
○ Sir William Chambers (1723–96)
James Gandon (1743–1823)
Edinburgh
○ Robert Adam (1728–92)
Thomas Hamilton (1784–1858)
William Henry Playfair (1790–1857)

○ Gavin Hamilton (1723–98)
Florence
○ Jean Auguste Dominique Ingres (1780–1867)
Benjamin West (1738–1820)
Fontainebleau
○ Ange-Jacques Gabriel (1698–1782)
Glasgow
○ Alexander Thomson (1817–75)
Hagley
James Stuart (1713–88)
Hamburg
○ Gotthold Ephraim Lessing (1729–81)
Helsinki
○ Carl Ludwig Engel (1778–1840)
Christian Henrik Grosch (1801–65)
Kronstadt
○ Charles Cameron (c.1743–1812)
Andrei Dimitrievich Zakharov (1761–1811)
Leeds
○ Robert Adam (1728–92)
Liverpool
○ Harvey Lonsdale Elmes (1814–47)
London
○ Robert Adam (1728–92)
Sir William Chambers (1723–96)
George Dance (1741–1825)
Henry Holland (1745–1806)
Henry William and William Inwood (1794–1843 & c.1771–1843)
John Nash (1752–1835)
Sir Robert Smirke (1780–1867)
Sir John Soane (1753–1837)
James Stuart (1713–88)
William Wilkins (1778–1839)
○ James Barry (1741–1806)
John Singleton Copley (1738–1815)
Gavin Hamilton (1723–98)
Angelica Kauffmann (1741–1807)
Sir Joshua Reynolds (1723–92)
George Stubbs (1724–1806)

Benjamin West (1738–1820)
Richard Wilson (1713–82)
Johann Zoffany (1733–1810)
○ Thomas Banks (1735–1805)
John Flaxman (1755–1826)
Joseph Nollekens (1737–1823)
Lyons
○ Jacques Germain Soufflot (1713–80)
Madrid
○ Juan de Villanueva (1739–1811)
○ Anton Raffael Mengs (1728–79)
Mannheim
○ Eberhard Wächter (1762–1852)
Milan
○ Charles Cameron (c.1743–1812)
Giuseppe Piermarini (1734–1808)
○ Baron Antoine-Jean Gros (1771–1835)
Montgomeryshire
○ Richard Wilson (1713–82)
Moscow
○ Ivan Yegorovich Starov (1744–1808)
Munich
○ Leo von Klenze (1784–1864)
Münster
○ Karl Friedrich von Schinkel (1781–1841)
Naples
○ Luigi Vanvitelli (1700–73)
○ Nicolai Abraham Abildgaard (1743-1809)
Pamplona
○ Ventura Rodriguez (1717–85)
Paris
○ Jacques-Denis Antoine (1733–1801)
Etienne-Louis Boullée (1728–99)
Jean François Thérèse Chalgrin (1739–1811)
Ange-Jacques Gabriel (1698–1782)
Leo von Klenze (1784–1864)
Claude-Nicholas Ledoux (1736–1806)
Jacques Germain Soufflot (1713–80)
Pierre Vignon (1762–1828)
○ Jacques-Louis David (1748–1825)
Baron François Gérard (1770–1837)

François Marius Granet (1775–1849)
Baron Antoine-Jean Gros (1771–1835)
Jean Auguste Dominique Ingres (1780–1867)
Christian Gottlieb Schick (1776–1812)
Eberhard Wächter (1762–1852)
○ Antonio Canova (1757–1822)
Johann Heinrich von Dannecker (1758–1841)
Jean-Baptiste Pigalle (1714–85)
○ Denis Diderot (1713–84)
Pavlovsk
○ Charles Cameron (c.1743–1812)
Thomas de Thomon (1754–1813)
Plympton
○ Sir Joshua Reynolds (1723–92)
Potsdam
○ Karl Friedrich von Schinkel (1781–1841)
Pushkin
○ Charles Cameron (c.1743–1812)
Regensburg
○ Leo von Klenze (1784–1864)
Rome
○ Giovanni Battista Piranesi (1720–78)
Michelangelo Simonetti (1724–81)
Luigi Vanvitelli (1700–73)
○ Nicolai Abraham Abildgaard (1743–1809)
Pompeo Batoni (1708–87)
Asmus Jakob Carstens (1754–98)
Jacques-Louis David (1748–1825)
Anne Louis Girodet (1767–1824)
Gavin Hamilton (1723–98)
Jean Auguste Dominique Ingres (1780–1867)
Angelica Kauffmann (1741–1807)
Joseph Anton Koch (1768–1839)
Anton Raffael Mengs (1728–79)
Christian Gottlieb Schick (1776–1812)
Eberhard Wächter (1762–1852)
Benjamin West (1738–1820)
Thomas Banks (1735–1805)
○ Antonio Canova (1757–1822)

Johann Heinrich von Dannecker (1758–1841)
Pierre-Jean David d'Angers (1788–1856)
John Flaxman (1755–1826)
Joseph Nollekens (1737–1823)
Jean-Baptiste Pigalle (1714–85)
Johann Gottfried Schadow (1764–1850)
Johan Tobias Sergel (1740–1814)
Bertel Thorvaldsen (1770–1844)
○ Johann Joachim Winckelmann (1717–68)
St. Petersburg
○ Charles Cameron (c.1743–1812)
Leo von Klenze (1784–1864)
Giacomo Quarenghi (1744–1817)
Karl Ivanovich Rossi (1775–1849)
Ivan Yegorovich Starov (1744–1808)
Thomas de Thomon (1754–1813)
Jean-Baptiste Michel Vallin de la Mothe (1729–1800)
Andrei Nikiforovich Voronikhin (1760–1814)
Andrei Dimitrievich Zakharov (1761–1811)
Stockholm
○ Johan Tobias Sergel (1740–1814)
Stuttgart
○ Johann Heinrich von Dannecker (1758–1841)
Subiaco
○ Giacomo Quarenghi (1744–1817)
Venice
○ Anton Raffael Mengs (1728–79)
○ Antonio Canova (1757–1822)
Versailles
○ Ange-Jacques Gabriel (1698–1782)
○ François-Marius Granet (1775–1849)
Vienna
○ Joseph Anton Koch (1768–1839)
Eberhard Wächter (1762–1852)
○ Antonio Canova (1757–1822)
Weimar
○ Johann Wolfgang von Goethe (1749–1832)

Romanticism in Germany, Italy and the North

The Romantic movement swept Europe in the late 18th and early 19th centuries. In artistic matters it is extremely difficult to define, as it represents a state of mind or a set of attitudes rather than a particular style. In reaction to the ideals of order and rationalism beloved of the Age of Enlightenment and the Neoclassical movement, Romantic artists reveled in the passionate and the emotional and explored the exotic and the mysterious. This was expressed in various ways – in exaltation of the forces of nature, for example, in the use of mystical symbolism, and in the admiration and imitation of cultures that were distant in time and place, particularly the Gothic Middle Ages.

Landscape painting is one of the archetypal forms of Romantic art, and Germany's greatest Romantic painter – Caspar David Friedrich – is one of the most remarkable and original figures in the history of art. He was intensely introspective and lived quietly in Dresden for most of his life, devotedly pursuing his personal vision of the spiritual significance of landscape. He discovered aspects of nature that had hitherto been ignored in art, particularly fog-bound or snow-covered mountains. Although his pictures generally do not use obvious religious symbolism, they convey a sense of divine awe in front of the beauty and mystery of nature.

A different vein of feeling is seen in the landscapes of the Austrian Joseph Anton Koch, who worked mainly in Rome (in suitably Romantic style he crossed the Alps on foot) but also in Vienna in 1812–15. In their grandness and firmness of structure, his landscapes are descended from the masters of the 17th-century classical tradition, above all Nicholas Poussin, but his choice of subjects – particularly mountain torrents – is very much of his age. His treatment of mountains, however, is strikingly different to Friedrich's; whereas Friedrich evokes a mysterious mood, Koch uses a cold, clear light that captures the limpid atmosphere of the Alps.

Philipp Otto Runge worked mainly in Hamburg, where he settled in 1803. Like Friedrich, he was of mystical turn of mind, but unlike Friedrich he concentrated mainly on figure subjects, although often with a landscape setting. In his work he tried to express pantheistic notions of the harmony of mankind and nature, using a personal language of symbols – drawn from both Christian and pagan sources – that makes him something of a German parallel to the great English poet-painter William Blake. Runge also painted superb portraits. These are in a more conventional style, yet even so they have a strange, unearthly quality that sets them apart from the work of any other painter.

Runge's painting are often stiff or archaic-looking, but they are not specifically medieval. Medievalism, however, was an important feature in much German Romantic painting. It took its most remarkable form in the work of the Nazarenes, a group of young, idealistic artists whose nucleus was formed by a number of students at the Vienna Academy; in 1809 they formed an association called the Brotherhood of St. Luke (Lukasbrüder), named after the patron saint of painting, but they were nicknamed Nazarenes because of their archaic, pseudo-biblical dress and hairstyles. They not only

painted medieval subjects, including scenes from German history, but tried to live like medieval artist-monks, taking vows of chastity and poverty. Their style was bright, clear, lovingly detailed and often rather fairy-tale-like. One of their aims was the revival of fresco painting, and this bore particular fruit in the work of Peter von Cornelius, who joined the group in Italy in 1811. In 1819 he moved to Munich and he was largely responsible for making the city this center of a fresco renaissance. Other leading members of the Nazarenes were Friedrich Overbeck and Franz Pforr.

Albrecht Dürer, one of the heroes of the Nazarenes, was inspiration for the woodcuts of Alfred Rethel, who made a famous series called *Another Dance of Death* (1849), an allegorical depiction of the revolutionary events of 1848, with the figure of Death embodying anarchy. As a painter, Rethel was responsible for one of the biggest fresco cycles of the day – in Aachen Town Hall on the life of Charlemagne. It was begun in 1847 and left unfinished when Rethel became mad in 1853.

There was a good deal of artistic give and take between Germany and Scandinavia in the Romantic period. Both Friedrich and Runge studied at the Copenhagen Academy, and Friedrich was a friend of the Norwegian landscapist Johan Christian Dahl, who was a professor at the Dresden Academy from 1824 until his death in 1857. Landscape was the art in which the Scandinavians generally excelled, their paintings tending to be more naturalistic and less subjective than those of their German counterparts.

In the Low Countries, artistic achievements in this period could not compare with past glories, but Belgium produced one of the great curiosities of the history of art. Antoine Wiertz painted huge allegorical, historical and religious canvases in a wild-eyed style that verges on the demented and represents the most melodramatic extreme of Romanticism. His studio in Brussels is now a museum devoted to his work.

Above: *Caspar David Friedrich (1774–1840): detail from* Two Men Contemplating the Moon, *oil, 1819. (Kunstsammlungen, Gemäldegalerie Neue Meister, Dresden).*

Friedrich was the leading painter in Germany during the Romantic era. He was an isolated, lonely figure, suffering from melancholia, but his art had a universal dimension and later influenced the Symbolists.

Below: *Karl Spitzweg (1808–85):* The Poor Poet, *oil, 1839 (National Galerie, Berlin).*

One of the most significant of the indigenous low-life painters of Munich, Spitzweg uses here an old theme already explored by Hogarth among others. The poet is lying in bed to keep warm, even having to burn his manuscripts in the fire, while interrupting his writing to catch a flea.

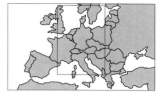

Romantic Artists

1　Jacques Laurent Agasse (1767–1849)
2　Karl Blechen (1798–1840)
3　Nils Johan Blommér (1816–53)
4　Vincenzo Bonomini (1757–1834)
5　Carlo Bossoli (1815–84)
6　Carl Friedrich von Breda (1759–1818)
7　Ippolito Caffi (1809–66)
8　Giovanni Carnovali, called Il Piccio (c.1806–73)
9　Peter von Cornelius (1783–1867)
10　Johann Christian Clausen Dahl (1788–1857)
11　Pierre-Jean David d' Angers (1788–1856)
12　Thomas Fearnley (1802–42)
13　Bengt Erland Fogelberg (1786–1854)
14　Antonio Fontanesi (1818–82)
15　Caspar David Friedrich (1774–1840)
16　Felice Giani (1758–1823)
17　Baron Antoine-Jean Gros (1771–1835)
18　Francesco Hayez (1791–1882)
19　August Heinrich (1794–1822)
20　Jens Juel (1745–1802)
21　Joseph Anton Koch (1768–1839)
22　Piotr Michalowski (1801–55)
23　Ernst Ferdinand Oehme (1797–1855)
24　Ferdinand Olivier (1785–1841)
25　Johann Friedrich Overbeck (1789–1869)
26　Erik Pauelsen (1749–90)
27　Franz Pforr (1788–1812)
28　Ferdinand von Rayski (1807–90)
29　Alfred Rethel (1816–59)
30　Adrian Ludwig Richter (1803–84)
31　Karl Rottmann (1797–1850)
32　François Rude (1784–1855)
33　Philipp Otto Runge (1777–1810)
34　Karl Friedrich Schinkel (1781–1841)
35　Moritz von Schwind (1804–71)
36　Peter Christian Skovgaard (1817–75)
37　Jörgen Sonne (1801–90)
38　Karl Spitzweg (1808–85)
39　Ferdinand Georg Waldmüller (1793–1865)
40　Anton Wiertz (1806–65)

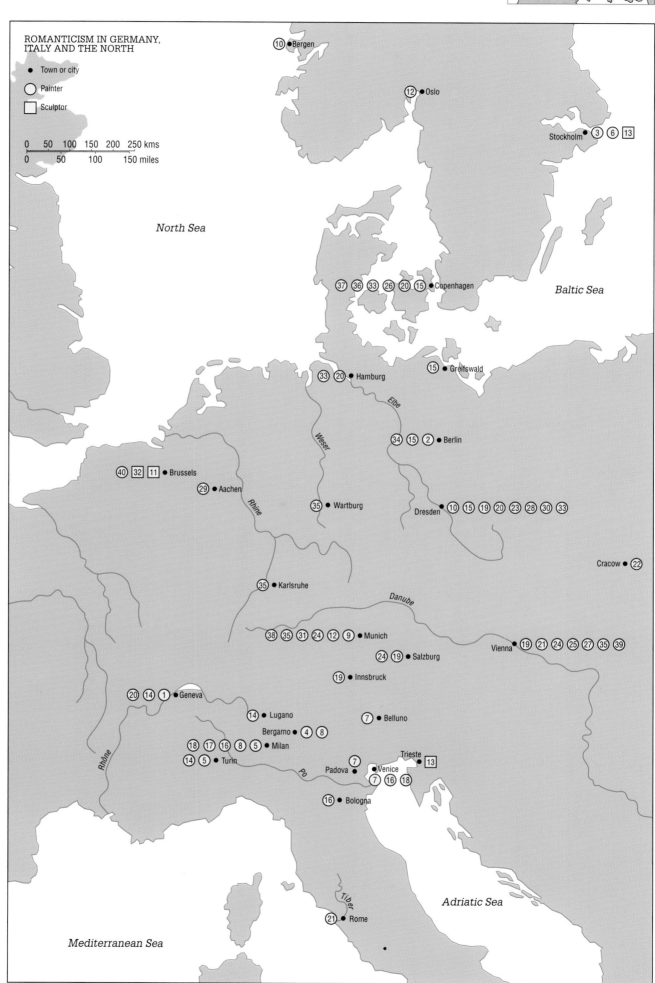

Above: *Philipp Otto Runge (1777–1810):* Morning (small version), *oil , 1806 (Kunsthalle, Hamburg).*

Runge was a German Romantic draughtsman, painter and theorist who questioned the entire basis of classical art and sought inspiration in the literature of the Romantics. This oil sketch shows an ideal woman as the dual bearer both of the day and of a new era of love.

Romanticism in France, Spain and the Mediterranean

French Romantic art was predominant during the Restoration (1815–1830) and the July Monarchy (1830–1848) – an art of colour and emotion and of flowing and expressive line, as opposed to the restrained but infinitely subtle and descriptive line of the classicists. In painting the differences between the two approaches to drawing and painting were epitomised by the rivalry, and indeed considerable personal dislike, between Delacroix and Ingres. Notwithstanding there is more similarity than generally accepted between the subject matter of the two painters; and the fascination of Ingres with the supposedly voluptuous aspect of orientalism demonstrates a clear overlap of taste.

Romanticism was essentially individual, anti-rational and obsessed with death, destruction, the bizarre and the exotic. It was also, and particularly in England, both pastoral and picturesque, concerned with the sensitive record of the natural surroundings. Indeed the Paris salon of 1824 was known as the "English Salon" and was dominated by the landscape paintings of Bonington and Constable. French Romantic painting was also literary. Studio paintings in Paris looked to literature for subjects that would tackle the fundamental themes of man and his destiny; death; love; war and solitude. They were inspired by writers like Dante, Shakespeare, Scott and Byron; they showed a preference for subjects drawn from national and near contemporary history, and in particular the glorification of Napoleon and the creation of the Napoleonic myth.

French involvement in the arab countries of North Africa provided the opportunity to travel; popular support for the Greek War of Independence gave a focus to both hatred and admiration for the supposed ferocity of the Ottoman Empire in its decline.

The Raft of the Medusa by Théodore Géricault, exhibited at the salon of 1819, first brought to people's attention the fact that a work of art can create out of a temporary subject an atmosphere infinitely different from the tragic and timeless aura of neoclasical tragedy. *The Death of Sardanapulus* by Eugène Delacroix, painted in 1827 and exhibited in 1829, is the great masterpiece of Romantic painting, incorporating almost all the elements which go to make up Romantic taste in France.

There was no romantic movement in Spain to match the breadth and achievement of that in France, England or Germany. However in the works of Francisco de Goya (1746–1829) there is found a world of imagination and fantasy, horror and violence, all recalled in a vivid and highly original graphic style. Goya, for many years a court painter, responded to the experiences of the Peninsula War with a series of etchings, *The Disasters of War*, 1810–1814, which in their savagery and creative fantasy are the equal of the scenes of rape, pillage and murder painted by Géricault and Delacroix. In old age, ill and largely abandoned by the court, Goya produced a series of 14 "Black Paintings" which encapsulated another side of the romanticism of fear and deprivation which anticipated the expressionism of the 20th century.

Left: *Théodore Géricault (1791–1824):* An Arab Holding the Head of his Dead Horse, *pencil drawing (Private Collection).*

Géricault was a devoted horseman, and an early and enormously influential Romantic with a passion for the macabre, dramatic and exotic.

Below: *Francisco Goya (1746–1828):* The Pilgrimage to San Isidro, c.*1821/3 (Prado, Madrid).*

Goya became ill again in 1819, moved outside Madrid and produced 14 large violent and expressive murals, his "Black Paintings".

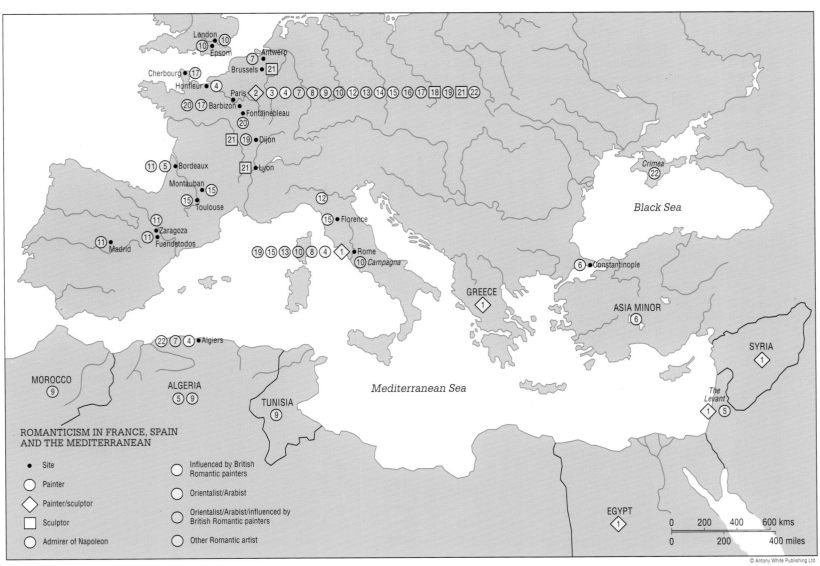

ROMANTICISM IN FRANCE, SPAIN
AND THE MEDITERRANEAN

- • Site
- ◯ Painter
- ◇ Painter/sculptor
- ☐ Sculptor
- ◯ Admirer of Napoleon
- ◯ Influenced by British Romantic painters
- ◯ Orientalist/Arabist
- ◯ Orientalist/Arabist/influenced by British Romantic painters
- ◯ Other Romantic artist

1 Jules-Robert Auguste (1789–1850)
2 Antoine-Louis Barye (1796–1875)
3 Nicolas-Toussaint Charlet (1792–1845)
4 Théodore Chassériau (1819–56)
5 Adrien Dauzats (1804–68)
6 Alexandre-Gabriel Decamps (1803–60)
7 Eugène Delacroix (1798–1863)
8 Paul Delaroche (1797–1856)
9 Eugène Fromentin (1820–76)
10 Théodore Géricault (1791–1824)
11 Francisco de Goya (1746–1828)
12 Antoine-Jean, Baron Gros (1771–1835)
13 Pierre-Narcisse, Baron Guérin (1774–1833)
14 Paul Huet (1803–69)
15 Jean-Auguste-Dominique Ingres (1780–1867)
16 Georges Michel (1763–1843)
17 Jean-François Millet (1814–75)
18 Antoine-Augustin Préault (1809–79)
19 Pierre-Paul Prud'hon (1758–1823)
20 Théodore Rousseau (1812–67)
21 François Rude (1784–1855)
22 Émile-Jean-Horace Vernet (1789–1863)

Right: *Eugène Delacroix (1798–1863):* Les Femmes d'Algers, *1834 (Louvre, Paris).*

Delacroix visited North Africa in 1832, an experience which enabled him to study Arab life at first hand. In this picture he also developed a revolutionary use of color – using vibrating, complementary tones.

Romanticism in Britain

In the visual arts, Britain's greatest contribution to the Romantic movement was in landscape painting. Constable and Turner were among the most original geniuses of the age, and a host of other fine painters contributed to a landscape tradition that was unsurpassed in any other country. In particular, Britain had a unique school of landscape watercolorists; watercolor was very much a British speciality and in quantity and quality it reached a peak of development in the late 18th and early 19th centuries (Cotman and Girtin are among the most illustrious names).

Constable and Turner were almost exact contemporaries, but their careers took very different courses. Turner was a child prodigy, first exhibiting at the Royal Academy when he was only 15, and he soon became highly successful; when the deeply personal work of his later years was attacked because of its daring freedom, he was rich and famous and could ignore criticism. Constable was slow to mature; he did not become financially secure until he was 40, when his father – a prosperous corn merchant – died, and he was not elected a full member of the Royal Academy until he was 53 (Turner achieved this distinction at the early age of 26). Turner lived in London all his life, but he was an inveterate traveler. Constable never left England and was happiest painting the places he knew best, particularly the Suffolk countryside where he grew up. Both men were inspired by the art of the past, but whereas Turner consciously matched himself against the celebrated Frenchman Claude Lorraine, Constable owed more to the example of the 17th-century Dutch School. (Dutch influence was particularly strong in East Anglia, notably in the work of the Suffolk-born Thomas Gainsborough and of the members of the Norwich School, a group of painters associated with the Norwich Society of Artists, founded in 1803 with John Crome as president.) In spite of their reverence of the Old Masters, however, both Constable and Turner are remarkable for the way in which they defied convention and looked at the world afresh.

Turner was not the only British artist of his period to travel the country in search of suitable subjects; indeed it became fashionable for artists to make "Picturesque Tours", "picturesque" being a term that indicated a delight in roughness and irregularity in the landscape. The "wilder" parts of Britain were particularly favored for such tours and sketching expeditions, notably the Lake District, the rugged landscape of Northumberland, the Highlands of Scotland and the mountains of Wales (the Welsh-born Richard Wilson, the first major British oil painter to specialize in landscape, helped to popularize this area).

British landscape painters did not confine themselves to pictures of the real world, however. Turner painted historical subjects with landscape settings, and John Martin treated similar themes in a spectacularly melodramatic fashion, specializing in cataclysmic events from the Bible in which hordes of tiny figures are set in vast architectural or natural settings. Francis Danby, an Irish-born painter who lived mainly in London and Bristol, worked in a similar apocalyptic vein. More inward-looking imaginative worlds were explored by Samuel Palmer. In the late 1820s and early 1830s he lived in Shoreham, a village in Kent, and was the central figure of a group of artists called the Ancients who painted strange, mystical landscapes tinged with religious feeling; other members of the group were Calvert and Linnell, who was Palmer's father-in-law. Palmer's paintings of this time are bold but lovingly detailed, with a deliberately archaic look, conveying a sense of mystical rapture; after he left Shoreham much of the magic went out of his work.

Palmer was a friend and supporter of William Blake, the greatest of British visionary artists, who in his lifetime was generally regarded merely as an eccentric rather than a genius. He was a figure artist rather than a landscapist, expressing (as he did in his poetry) a personal mythology of great power and complexity. Blake was trained as an engraver, and he eschewed conventional methods of painting in favor of various experimental tehniques of color printing. He often illustrated his own poems as well as those of other writers, notably Dante and Milton. Among more mainstream figure painters, the outstanding British Romantic artist was perhaps Sir Thomas Lawrence, whose portraits are painted with superb dash and a masterly fluid touch. Lawrence's professional and social success contrasts with the tragi-comical life of Benjamin Robert Haydon, who – in true romantic fashion – committed suicide, worn out by failure. His talent as a history painter fell far short of his ambitions and he was constantly in debt, but he was a brilliant lecturer who was far ahead of his time in promoting the social purpose of art.

Among sculptors, there is none who can be considered wholeheartedly Romantic, although even the work of such a dedicated Neoclassicist as John Flaxman is often tinged with Romantic feeling. Thomas Banks is also considered a Neoclassicist, but his most famous work can be described as Romantic because of its emotional charge – the tomb of Penelope Boothby (1793) in Ashbourne Church, Derbyshire.

Above: *William Blake (1757–1827):* The Sick Rose *from* Songs of Experience, *(c.1791–94), engraving.*

The years 1793–4 mark a crisis in the life of Blake and his radical friends. The September Massacre (1792) and the execution of the King and Queen of France (1793) led to a repression of all radicalism in England by Pitt's government. The plant forms are now angular and the rose branch has aggressively large thorns, like saw-teeth.

Below: *John Constable (1776–1837):* The Hay Wain, *1821 (National Gallery, London).*

Completed from a full-scale sketch, and painted at speed. Constable was highly disciplined and his accuracy on such a large scale must have presented real technical problems

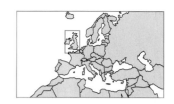

Below: *Joseph Mallord William Turner (1775–1851):* Snow Storm: Hannibal and his army crossing the Alps, *1812, oil on canvas (Tate Gallery, London).*

Turner's use of the novel effect of his vortex-like composition draws the spectator into its swirling depths.

Bottom of page: *Samuel Palmer (1805–81):* In a Shoreham Garden, *c.1829, watercolor and body color, on prepared board (Victoria and Albert Museum, London).*

One of Palmer's most richly conceived works from the Shoreham period. There is a dream-like quality to the painting, accentuated by the figure of a woman in a red and white dress.

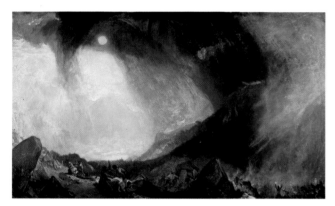

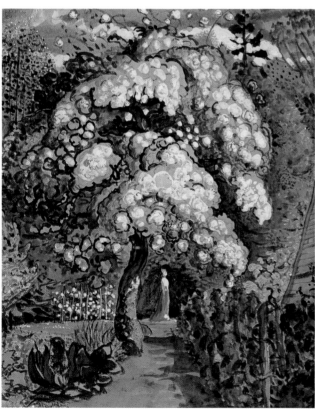

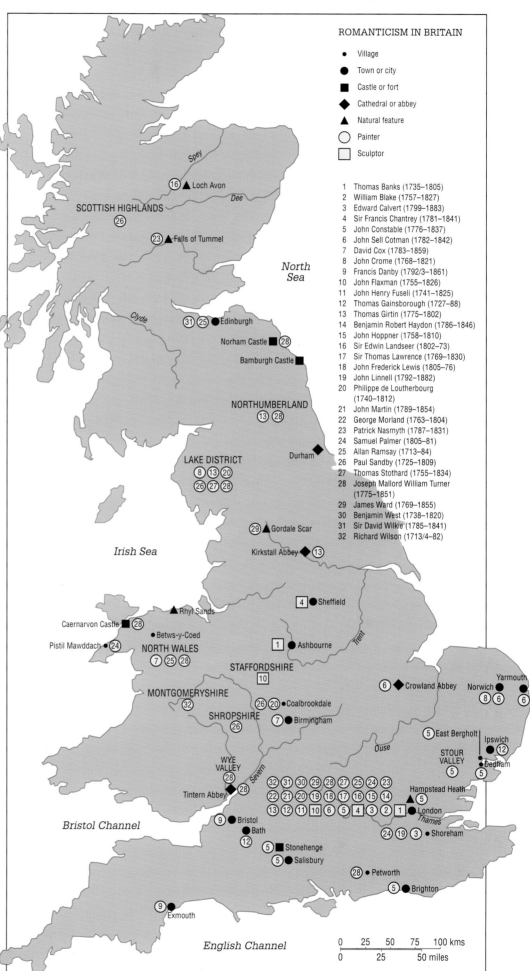

ROMANTICISM IN BRITAIN

- • Village
- ● Town or city
- ■ Castle or fort
- ◆ Cathedral or abbey
- ▲ Natural feature
- ○ Painter
- □ Sculptor

1 Thomas Banks (1735–1805)
2 William Blake (1757–1827)
3 Edward Calvert (1799–1883)
4 Sir Francis Chantrey (1781–1841)
5 John Constable (1776–1837)
6 John Sell Cotman (1782–1842)
7 David Cox (1783–1859)
8 John Crome (1768–1821)
9 Francis Danby (1792/3–1861)
10 John Flaxman (1755–1826)
11 John Henry Fuseli (1741–1825)
12 Thomas Gainsborough (1727–88)
13 Thomas Girtin (1775–1802)
14 Benjamin Robert Haydon (1786–1846)
15 John Hoppner (1758–1810)
16 Sir Edwin Landseer (1802–73)
17 Sir Thomas Lawrence (1769–1830)
18 John Frederick Lewis (1805–76)
19 John Linnell (1792–1882)
20 Philippe de Loutherbourg (1740–1812)
21 John Martin (1789–1854)
22 George Morland (1763–1804)
23 Patrick Nasmyth (1787–1831)
24 Samuel Palmer (1805–81)
25 Allan Ramsay (1713–84)
26 Paul Sandby (1725–1809)
27 Thomas Stothard (1755–1834)
28 Joseph Mallord William Turner (1775–1851)
29 James Ward (1769–1855)
30 Benjamin West (1738–1820)
31 Sir David Wilkie (1785–1841)
32 Richard Wilson (1713/4–82)

© Antony White Publishing Ltd.

19th-Century Realism

"Realism" is a word that is used with various meanings in the history of art. Like the word "naturalism", it conveys – in its broadest sense – a desire on behalf of the artist to represent things accurately and objectively, although the exact shade of meaning will vary greatly according to context. "Realism" is a more loaded word than "naturalism", however, for it often carries with it the idea of the rejection of conventionally attractive subjects in favor of more down-to-earth themes, even commonplace or ugly ones.

"Realism" first refers to a movement centered on Gustave Courbet – not only because he was a painter of power and originality, but also because he was a man of limitless self-confidence (and unbounded conceit) who enjoyed controversy and cultivated a high public profile.

Courbet was born at Ornans in the Jura Mountains near the Swiss border and the work that more than any other established his reputation was *Burial at Ornans* (Musée d'Orsay, Paris), which made a sensational impact when exhibited at the Paris Salon in 1850. Never before had a humdrum everyday scene been accorded such epic treatment. Some critics thought it was crude and deliberately ugly, but others were impressed by its gravity, grandeur and honesty. Courbet was seen not only as an artistic rebel, but also as a revolutionary socialist. He willingly accepted this role, as it suited his image, but there is no obvious political statement in the picture. In 1855 Courbet exhibited his most famous work, *The Painter's Studio*, a huge self-allegory showing "the moral and physical history of my studio", with Courbet himself in the midst of "all the people who serve my cause, sustain me in my ideal and support my activity". Unlike the *Burial*, this picture does have political intent (although it is subtly expressed), attacking the Emperor Napoleon III (1852–70). After the fall of Napoleon in 1870, Courbet was head of the arts' commission in the revolutionary government known as the Commune; when this too fell in 1871 he was imprisoned, and in 1873 he fled to Switzerland, where he spent the rest of his life.

Among figure painters, Courbet stood head and shoulders above his French Realist contemporaries, only Jean-François Millet – celebrated for his peasant scenes – rivaling him in fame; apart from these two, the best French Realists are found among illustrators and sculptors. Honoré Daumier was a fine painter and a brilliant sculptor, but he is best known as a caricaturist – the greatest of the 19th century. Another illustrator, Constantin Guys, was less profound, but he was regarded by the poet and critic Charles Baudelaire as the representative *par excellence* of contemporary society; in 1863 Baudelaire wrote a famous essay on him entitled "The Painter of Modern Life".

French Realism had many offshoots, parallels and variants elsewhere in Europe, notably in Germany, where Wilhelm Leibl was greatly influenced by Courbet. The Hungarian Mihály von Munkácsy was similarly influenced by Courbet (he lived in Paris 1872–96); his subjects were often literary.

Less specifically related to French Realism are the various traditions of naturalistic landscape painting that flourished in the 19th century. The most influential landscapist of the century was a Frenchman, Jean Baptiste Camille Corot; his directness of vision and unaffected naturalism was an inspiration to a host of painters, notably the Barbizon School, of which Théodore Rousseau was the leader. Outside France, the most notable group of landscapists was the Hague School in the Netherlands, the best known of whom is probably Josef Israels.

Realism – in the sense of trying to look at the world in a completely fresh way, casting aside artistic preconceptions – was also expressed in a totally different way in the work of two groups of young, idealistic painters – the Nazarenes in Germany and the Pre-Raphaelites in England. Both groups wanted to get away from what they considered the insincerity of academic art, and in their different ways they tried to revive the spiritual attitudes of the Middle Ages.

Below, top: *Gustave Courbet (1819–77):* The Painter's Studio, *1855 (Musée d'Orsay, Paris).*

This enormous painting (20 x 12) (6m x 3.5m) is set in Courbet's Paris studio. It was a turning point in his artistic career, painted at a time when he was assailed by hypochondria.

Below, bottom: *Adolf Friedrich Erdumann von Menzel (1815–1905):* The funeral of the Martyrs of the Berlin Revolution, *1848 (National Gallery, Berlin).*

A self-taught painter, Menzel was advanced in his use of color, and in his documentation of contemporary reality.

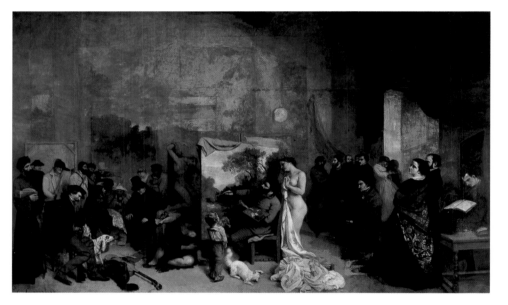

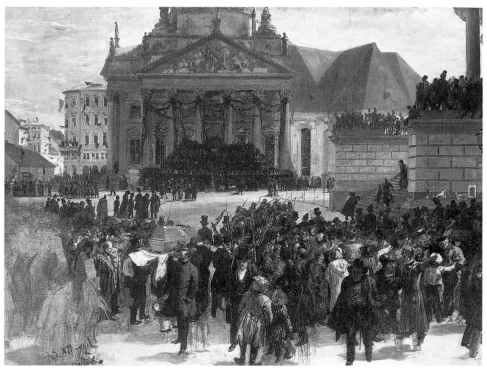

NINETEENTH CENTURY REALISM

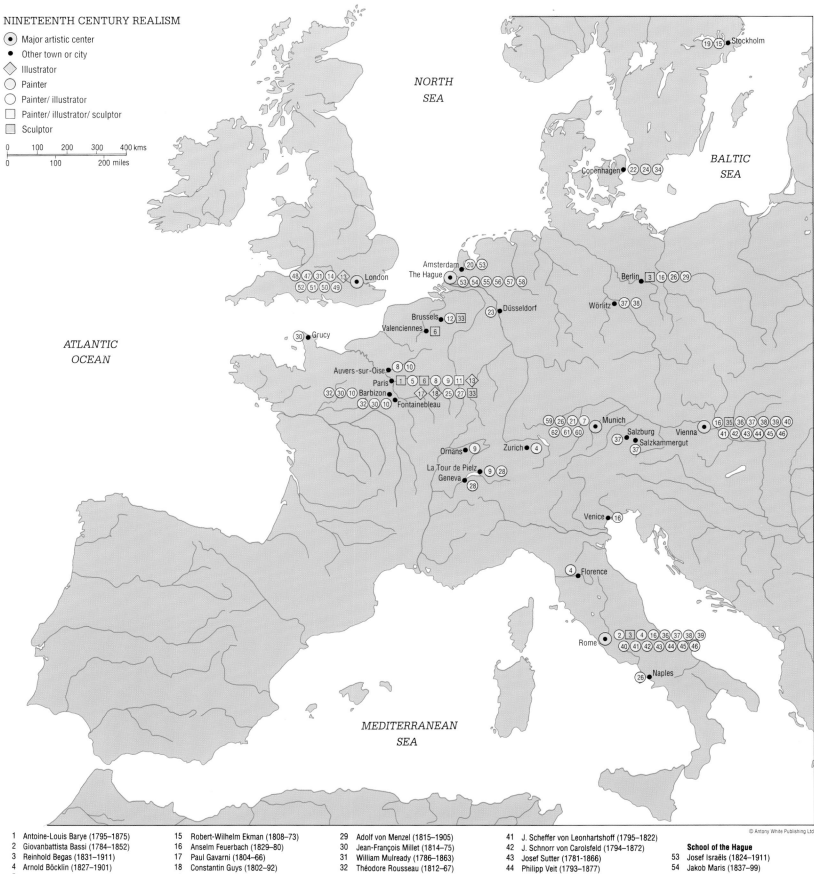

- ⊙ Major artistic center
- • Other town or city
- ◇ Illustrator
- ○ Painter
- ○ Painter/ illustrator
- □ Painter/ illustrator/ sculptor
- ▢ Sculptor

0	100	200	300	400 kms
0	100		200 miles	

NORTH SEA

BALTIC SEA

ATLANTIC OCEAN

MEDITERRANEAN SEA

Stockholm 19 15

Copenhagen 22 24 34

Amsterdam 20 53
The Hague 53 54 55 56 57 58

Berlin 3 16 26 29

Wörlitz 37 38

Brussels 12 33
Valenciennes 6
Düsseldorf 23

London 48 47 31 14 13 / 52 51 50 49

Grucy 30

Auvers-sur-Oise 8 10
Paris 1 5 6 8 9 11 13
Barbizon 32 30 10 / 17 18 25 27 33
Fontainebleau 32 30 10

Munich 59 26 21 7 / 62 61 60
Salzburg 37
Salzkammergut 37
Vienna 16 35 36 37 38 39 40 / 41 42 43 44 45 46

Ornans 9
Zurich 4

La Tour de Pielz 9 28
Geneva 28

Venice 16

Florence 4

Rome 2 3 4 16 36 37 38 39 / 40 41 42 43 44 45 46

Naples 26

© Antony White Publishing Ltd.

1 Antoine-Louis Barye (1795–1875)
2 Giovanbattista Bassi (1784–1852)
3 Reinhold Begas (1831–1911)
4 Arnold Böcklin (1827–1901)
5 Rosa Bonheur (1822–99)
6 Jean-Baptiste Carpeaux (1827–75)
7 Peter von Cornelius (1783–1867)
8 Jean-Baptiste-Camille Corot (1796–1875)
9 Gustave Courbet (1819–77)
10 Charles-François Daubigny (1817–78)
11 Honoré Daumier (1808–79)
12 Charles De Groux (1825–70)
13 Gustave Doré (1832–83)
14 William Dyce (1806–64)

15 Robert-Wilhelm Ekman (1808–73)
16 Anselm Feuerbach (1829–80)
17 Paul Gavarni (1804–66)
18 Constantin Guys (1802–92)
19 Werner Homberg (1830–60)
20 Johan Barthold Jongkind (1819–91)
21 Wilhelm von Kobell (1766–1855)
22 Christen Købke (1810–48)
23 Ludwig Knaus (1829–1910)
24 Vilhelm Kyhn (1819–1903)
25 Edouard Manet (1832–83)
26 Hans von Marées (1837–87)
27 Jean-Louis-Ernest Meissonier (1815–91)
28 Barthélémy Menn (1815–93)

29 Adolf von Menzel (1815–1905)
30 Jean-François Millet (1814–75)
31 William Mulready (1786–1863)
32 Théodore Rousseau (1812–67)
33 François Rude (1784–1855)
34 Peter Skovgaard (1817–75)
35 Victor Tilgner (1844–96)

The Nazarenes
36 Johann Hottinger (1788–1828)
37 Ferdinand Olivier (1785–1841)
38 Friedrich Olivier (1791–1859)
39 Johann Overbeck (1789–1869)
40 Franz Pforr (1788–1812)

41 J. Scheffer von Leonhartshoff (1795–1822)
42 J. Schnorr von Carolsfeld (1794–1872)
43 Josef Sutter (1781–1866)
44 Philipp Veit (1793–1877)
45 Georg Vogel (1788–1879)
46 Josef Wintergest (1783–1867)

The Pre-Raphaelites
47 Edward Burne-Jones (1833–98)
48 Ford Madox Brown (1821–93)
49 Arthur Hughes (1832–1915)
50 William Holman Hunt (1827–1910)
51 John Everett Millais (1829–96)
52 Dante Gabriel Rossetti (1828–82)

School of the Hague
53 Josef Israëls (1824–1911)
54 Jakob Maris (1837–99)
55 Matthijs Maris (1839–1917)
56 Willem Maris (1844–1910)
57 Anton Mauve (1838–88)
58 Hendrik Mesdag (1831–1915)

The Liebl Group
59 Wilhelm Leibl (1844–1900)
60 Milhály von Munkácsy (1844–1909)
61 Johann Sperl (1840–1914)
62 Wilhelm Trubner (1851–1917)

Impressionists and Post-Impressionists in Paris and Northern France

The Impressionists were the most influential group of painters of the late 19th century.

They first came together in the 1860s. Bazille, Monet, Renoir and Sisley, who formed the early nucleus of the group, met as students of Charles Gleyre (1808–74), one of the most respected professors at the École des Beaux-Arts, but they broke away from academic tradition to paint together in the open air in the Forest of Fontainebleau. In this they followed the example of the Barbizon School, who had worked in the area in the 1840s. The Impressionists were among the generation of Frenchmen that first benefited from a good railway service, and one of the features of their art is that they often portrayed the outskirts of Paris as well as the city center, especially beauty spots and other scenes of suburban leisure. The Gare St. Lazare was opened in 1837 and served an area along the Seine to the north-west of Paris that became particularly associated with the Impressionists; Asnières, the first stop across the Seine, was less than ten minutes away, and Argenteuil, where Monet lived in 1871–8, was less than fifteeen. As the line was extended from Paris to Rouen (1843) and Le Havre (1847), the Gare St. Lazare became the gateway to the whole of north-west France.

The first Impressionist group exhibition was held in Paris in 1874 and seven others followed (1876, 1877, 1879, 1880, 1881, 1882, 1886). Pissarro was the only artist who exhibited at all eight; Manet did not show at any of them (and Bazille – killed in action in the Franco-Prussian War – had died too young). Among the other big names, the number of exhibitions in which works were shown varied from two (Cézanne) to seven (Degas and Morisot); Renoir and Sisley exhibited at four, Monet at five. As this suggests, the degree of involvement among the painters varied greatly. They were never a formal group, but there were friendly ties linking each of them to most of the others (although Degas and – more especially – Manet were set somewhat apart because they came from a higher social class than the others).

Apart from those who had met as students, the Impressionists came together mainly through café society. The Café Guerbois, at 11 Grande rue des Batignolles (now the Avenue de Clichy), was the favorite meeting place. Manet, who was a much-respected senior figure, began frequenting it in 1866 and was soon holding court there every Thursday. The Batignolles quarter has other associations with the Impressionists. Several of them either lived or had studios there, and before the name "Impressionism" was coined (by a sarcastic reviewer of the 1874 exhibition) the painters were sometimes referred to collectively as the Batignolles group.

The 1870s marked the high point and most cohesive period of Impressionism, Monet's home at Argenteuil acting as one of the chief focuses. Pissarro, who was the oldest of the Impressionists and something of a father figure to several of the others, was another focal point; from 1872 to 1882 he lived at Pontoise, where Cézanne and Gauguin (both of whom spoke glowingly of him) were among his visitors.

After about 1880, the artists who had formed the Impressionist group increasingly went their own ways

geographically as well as artistically. Cézanne settled in his native Aix-en-Provence in 1886, for example, and Renoir became disenchanted with Impressionism, seeking a greater sense of solidity in his work, partly inspired by a visit to Italy in 1881–2. At the last Impressionist exhibition in 1886 only Degas, Morisot and Pissarro remained of the original inner circle, and only Monet continued to pursue throughout his life the Impressionist ideal of open-air painting (and even he came to rely more and more on studio work to complete his pictures). In 1878 Monet moved to Vétheuil, then from 1881 lived and worked at various places on the Normandy coast including Dieppe, Etretat and Le Havre (his boyhood home), before finally settling in 1883 at Giverny on the Seine, where he created his famous and beautiful water garden.

Many of the Post-Impressionists thought that the Impressionists – in their overriding concern with the effects of light and color – had sacrificed the emotional and intellectual content of art. They therefore tended to look at landscape in a different way and to be less interested in beauty spots as such. Seurat, for example, favored several of the same sites as the Impressionists, but he looked at the leisure activities of the middle classes with a gently satirical eye.

Above: *Claude Monet (1840–1926):* The Gare St. Lazare, *1877 (Musée d'Orsay, Paris).*

Monet painted a series of studies of the Gare St. Lazare in Paris, examining with a fully Impressionist palette the interplay of light and steam with the cast iron structure of the vaults. The station was also the gateway to the landscape north-west of Paris most loved by the Impressionists.

Left: *Georges Seurat (1859–91):* La Baignade (Bathers at Asnières), *1883–4 (National Gallery, London).*

Seurat painted the scene on the banks of the Seine on the outskirts of Paris, transforming it into a monumental almost classical image.

Below: *Pierre Auguste Renoir (1841–1919):* La Grenouillière, *1869 (Pushkin Museum, Moscow).*

Renoir and Monet both worked for several months in 1869 at La Grenouillière, a bathing place in the Seine near Bougival.

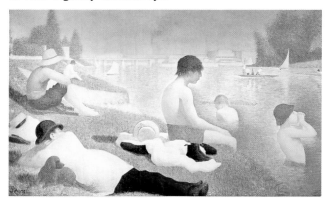

IMPRESSIONISTS AND POST-IMPRESSIONISTS IN NORTHERN FRANCE AND PARIS

- ▣ Paris: all artists worked or visited here
- ◉ Major artistic center
- ● Town or village
- ◯ Impressionist artist
- ◯ Other artist

1 Giuseppe Abbati (1836–68): Macchiaiolo
2 Rudolf von Alt (1812–1905): German Naturalist; Impressionist Influenced
3 Vito d'Ancona (1825–84): Macchiaiolo
4 Louis Anquetin (1861–1932): Cloisonist
5 Frédéric Bazille (1841–70): Founder Impressionist
6 Émile Bernard (1868–1941): Synthetist; Nabis; Rose-Croix
7 Pierre Bonnard (1867–1947): Founder Nabis (1888)
8 Eugène Boudin (1824–98): Precursor of Impressionism
9 George Breitner (1857–1923): Dutch Impressionist
10 Mary Cassatt (1844–1926): American-born Impressionist; worked only in Paris
11 Paul Cézanne (1839–1906): Founder Impressionist; Post-Impressionist
12 Lovis Corinth (1858–1925): German Impressionist; Expressionist (see pp. 290–291)
13 Giovanni Costa (1827–1903): Macchiaiolo
14 Tranquillo Cremona (1837–78): Milanese Divisionist
15 Henri Edmond Cross (1856–1910): Neo-Impressionist
16 Edgar Degas (1834–1917): Founder-Impressionist
17 Maurice Denis (1870–1943): Founder Nabis (1888); Christian Symbolist
18 Giovanni Fattori (1825–1908): Macchiaiolo
19 Roger Fry (1866–1934): Independent Post-Impressionist
20 Paul Gauguin (1848–1903): Impressionist; Symbolist/Synthetist; also worked Martinique and Tahiti
21 Vincent van Gogh (1853–90): Dutch Realist; Impressionist; Post-Impressionist
22 Vittore Grubicy de Dragon (1851–1920): Milanese Divisionist

23 Ferdinand Hodler (1853–1918): Swiss Symbolist; Rose-Croix
24 Johan Barthold Jongkind (1819–91): Realist; precursor of Impressionism
25 Silvestro Lega (1826–95): Macchiaiolo
26 Max Liebermann (1847–1935): German Impressionist
27 Wilhelm Leibl (1844–1900): German Naturalist; Impressionist influenced
28 Édouard Manet (1832–83): Realist; Impressionist
29 Jacob Meyer de Haan (1852–95): Synthetist
30 Otto Modersohn (1865–1943): Worpswede Naturalist
31 Paula Modersohn-Becker (1876–1907): Worpswede Naturalist
32 Claude Monet (1840–1926): Founder Impressionist
33 Adolphe Monticelli (1824–86): Late Romantic with proto-Impressionist technique
34 Berthe Morisot (1841–95): Impressionist
35 Edvard Munch (1863–1944): Norwegian Post-Impressionist; precursor of Expressionism (see pp. 290–291)
36 Giuseppe de Nittis (1846–84): Macchiaiolo
37 Filippo Palizzi (1818–99): Independent; preceded Macchiaiolo
38 Giuseppe Pellizza da Volpedo (1868–1907): Milanese Divisionist
39 Camille Pissarro (1830–1903): Founder Impressionist; Neo-Impressionist
40 Lucien Pissarro (1863–1944): Neo-Impressionist
41 Gaetano Previati (1852–1920): Divisionist
42 Pierre Puvis de Chavannes (1824–98): Monumental decorative painter; precursor of Symbolism

43 Odilon Redon (1840–1916): Independent Symbolist
44 Pierre-Auguste Renoir (1841–1919): Founder Impressionist
45 Christian Rohlfs (1849–1938): German Impressionist; Expressionist (see pp. 290–291)
46 Medardo Rosso (1858–1928): Impressionist sculptor
47 Théo van Rysselberghe (1862–1926): Neo-Impressionist
48 Karl Schuch (1846–1903): German Naturalist; Leibl Group
49 Giovanni Segantini (1858–99): Milanese Divisionist
50 Raffaello Sernesi (1838–66): Macchiaiolo
51 Paul Sérusier (1863–1927): Synthetist; Founder Nabis (1888)
52 Georges Seurat (1859–91): Neo-Impressionist; inventor of Pointillism
53 Walter Richard Sickert (1860–1942): English Post-Impressionist
54 Paul Signac (1863–1935): Neo-Impressionist; Pointillist
55 Telemaco Signorini (1835–1901): Macchiaiolo
56 Alfred Sisley (1839–99): Founder Impressionist
57 Max Slevogt (1868–1932): German Impressionist
58 Philip Wilson Steer (1860–1942): English Impressionist
59 Hans Thoma (1839–1924): German Naturalist; Leibl Group
60 James Tissot (1836–1902): Franco-British painter of social scene
61 Henri de Toulouse-Lautrec (1864–1901): Independent Post-Impressionist

62 Wilhelm Trebner (1851–1917): German Naturalist; Leibl Group
63 Henri van de Velde (1863–1957): Post-Impressionist
64 Jan Verkade (1868–1946): Post-Impressionist
65 Edouard Vuillard (1868–1940): Founder Nabis (1888); worked only in Paris

66 Friedrich Wasmann (1805–86): German Impressionist

"IMPRESSIONIST" PARIS

- ▢ Favorite Impressionist sites
- △ Art studio
- ◯ Exhibition
- ▢ Public landmark
- — City limit

MONTMARTRE
- Lapin Agile
- Moulin de la Galette
- Sacré Cœur
- Moulin Rouge (61)
- Place Pigalle
- (44)

LES BATIGNOLLES
- Café Guerbois
- Place de Clichy

- Place de l'Europe (39)
- Gare St Lazare
- Arc de Triomphe
- Palais de l'Industrie
- Grand Palais
- Palais de l'Élyseé
- Jardin des Tuileries
- Louvre
- LEFT BANK
- École des Beaux-Arts
- Institut
- Champ-de-Mars
- Musée du Luxembourg
- Panthéon
- MONTPARNASSE

0 1 2 3 kms
0 1 2 miles

Towns and places (main map)

Gravelines (52)
Boulogne (28)
Dieppe (53)(44)(32)
Les Petites Dalles (39)(32)
Fécamp (54)(32)
Étretat (32)
Le Crotoy (52)
Ste Adresse (8)(32)
Le Havre
Honfleur (52)
Trouville (52)(24)(32)
Deauville (32)(24)
Rouen (32)
Éragny-sur-Epte (39)
Chantilly (44)(11)
Pontoise (39)(20)(11)
Giverny (11)(44)
La Roche-Guyon (32)
Vétheuil (32)
Osny
Auvers-sur-Oise (39)(34)(54)
St Germain-en-Laye (17)
Chatou
Poissy (32)
Rueil (28)
Médan
Argenteuil (28)(32)(44)(56)
Asnières (43)(48)(54)
Marly-le-Roi (56)(44)
Louveciennes
Paris (39)
Vincennes
Suresnes (56)
Bougival (34)(56)(44)(39)
St Cloud (56)
Ville d'Avray (32)(34)
Montgeron (28)
Sèvres (56)
Chailly-en-Bière
Barbizon village
Fontainebleau
Marlotte
Moret-sur-Loing (56)
St-Mammès (56)

0 10 20 30 kms
0 10 20 miles

© Antony White Publishing Ltd.

Impressionist and Post-Impressionist France

Geographically it is characteristic of the Post-Impressionist generation apart from Seurat that its artists found their chief inspiration away from Paris, the Île de France and the Departement de la Seine. Thus the discovery of Brittany by Gauguin and his younger followers, notably Émile Bernard, was an important factor in the development of the new style known as Synthetism or Symbolism, in many ways the obverse of Impressionism, which laid stress on the decorative and the symbolic and eschewed naturalism.

It was in 1888/9 in Brittany in the villages of Pont Aven and Le Pouldu that Gauguin and his followers were able to discover in the landscape and life of the Breton peasants, a simplicity and force which rejuvenated their own art and lead to one of the most important tendencies of modern art: the cult of the primitive.

Through contact with the primitive, Gauguin was able to deal in new ways with the traditional themes of life, death and the mysteries of existence and it was this that led him in the second half of his career to the South Seas, to Tahiti in 1891 and to Dominica in the Marquesas Islands in 1901.

Stylistically the flatness and decorative values of his Breton works which often use bold areas of bright color as a means of conveying the inner, spiritual content of a scene – his *Vision After the Sermon* is an example of this – had great influence on younger artists in Paris and one of them, Sérusier, took back from Pont Aven a small, brightly-hued landscape which he had painted under Gauguin's direction and which became known as the *Talisman*. Sérusier was a member of the group christened the Nabis, which also included Bonnard, Vuillard, Toulouse-Lautrec, Maurice Denis and Bernard and while they had divergent aims the last two aiming at a highly stylized, often mystical art, the others at a more decorative Impressionism, influenced by Degas, and treating contemporary subjects or landscape – all show the move away from naturalism characteristic of Post-Impressionism.

The career of Vincent van Gogh has obvious parallels with that of Gauguin. He too sought, in his move to Arles in 1888, to escape from civilization and dreamed of establishing in Provence an artists' colony, for which the ill-fated visit of Gauguin was meant to be a cockshy. After his Dutch beginnings, Van Gogh, in Paris, passed through an Impressionist phase and continued thereafter to paint directly from nature. Unlike Gauguin he never abandoned the division of colors or worked entirely from the imagination, but his approach to his subjects was deeply emotional and his response to the color and brilliance of the South was conditioned by feelings about the simplicity and beauty of the landscape, which led him to describe it as 'Japanese', the embodiment that is of a purer way of living. The oscillations of Van Gogh's temperament and later his madness lead, of course, to some of the most passionate landscapes ever painted but, even at St. Rémy and Auvers when he was under treatment, his grasp of his artistic means never faltered. He never lost his capacity to convey, through paint, structures of great decorative coherence – his sense of color matches that of Veronese – reconciling both the appearance of his subjects and his feelings about them.

The career of Paul Cézanne spans the whole period covered by this entry since he was born a year earlier than Monet and died in 1906. He spans too in his art the whole gamut from realism and late romanticism to the 20th century, anticipating in his later works some of the achievements of Cubism, so that, as often with the greatest artists, the usual categories, in this case Impressionist and Post-Impressionist, hardly apply to him. Although he exhibited in the first Impressionist exhibition and disciplined his initially over-emotional art under the influence of Pissarro, Cézanne was never, because of his concern with structure, truly an Impressionist. It was the nature of the landscape as displayed by light rather than the light itself that concerned him and for this reason the choice of motifs is very important in his art. Born in Provence, Cézanne found his greatest inspiration in his native landscape, and especially in the mountain, La Montagne Ste Victoire, which dominates his birthplace, the town of Aix-en-Provence, but throughout his life he painted regularly in the Seine basin and occasionally, on a one-off basis, at places like Talloires on the Lac d'Annecy when he was on holiday.

But despite their individuality and sense of place, his landscapes are almost never peopled and his relation to them has the character of a one to one dialogue. This is particularly true of his latest works which seem indeed to be meditations on the nature of vision and of reality itself. In his conception of art as 'a harmony parallel to nature' and in his desire 'to make out of Impressionism something permanent and enduring like the art of the Museums', Cézanne has affinities with the other Post-Impressionists but his vision is his own and by clearing away all preconceptions about how and what we see he laid the foundations for 20th century art.

Below: *Paul Gauguin (1848–1903):* The Vision after the Sermon, *or* Jacob's struggle with the Angel, *oil on canvas, 1888 (National Gallery of Scotland, Edinburgh)*

Gauguin used Breton peasants as the observers of this visionary scene, and designed it like a Japanese print. He achieved, in his own words, "a superstitious simplicicty".

1 Giuseppe Abbati (1836–68): Macchiaiolo
2 Rudolf von Alt (1812–1905): German Naturalist; Impressionist Influenced
3 Vito d'Ancona (1825–84): Macchiaiolo
4 Louis Anquetin (1861–1932): Cloisonist
5 Frédéric Bazille (1841–70): Founder Impressionist
6 Émile Bernard (1868–1941): Synthetist; Nabis; Rose-Croix
7 Pierre Bonnard (1867–1947): Founder Nabis (1888)
8 Eugene Boudin (1824–98): Precursor of Impressionism
9 George Breitner (1857–1923): Dutch Impressionist
10 Mary Cassatt (1844–1926): American-born Impressionist
11 Paul Cézanne (1839–1906): Founder Impressionist; Post-Impressionist
12 Lovis Corinth (1858–1925): German Impressionist; Expressionist (see pages 290–1)
13 Giovanni Costa (1826–1903): Macchiaiolo
14 Tranquillo Cremona (1837–78): Milanese Divisionist
15 Henri Edmond Cross (1856–1910): Neo-Impressionist
16 Edgar Degas (1834–1917): Founder-Impressionist
17 Maurice Denis (1870–1943): Founder Nabis (1888); Christian Symbolist
18 Giovanni Fattori (1825–1908): Macchiaiolo
19 Roger Fry (1866–1934): Post Impressionist
20 Paul Gauguin (1848–1903): Impressionist; Symbolist/Synthetist; also worked Martinique and Tahiti
21 Vincent van Gogh (1853–90): Dutch Realist; Impressionist; Post-Impressionist
22 Vittore Grubicy de Dragon (1851–1920): Milanese Divisionist
23 Ferdinand Hodler (1853–1918): Swiss Symbolist; Rose-Croix
24 Johan Barthold Jongkind (1819–91): Realist; precursor of Impressionism
25 Silvestro Lega (1826–95): Macchiaiolo
26 Max Liebermann (1847–1935): German Impressionist
27 Wilhelm Leibl (1844–1900): German Naturalist; Impressionist influenced
28 Édouard Manet (1832–83): Realist; Impressionist
29 Jacob Meyer de Haan (1852–95): Synthetist
30 Otto Modersohn (1865–1943): Worpswede Naturalist
31 Paula Modersohn-Becker (1876–1907):
32 Claude Monet (1840–1926): Founder Impressionist
33 Adolphe Monticelli (1824–86): Late Romantic with proto-Impressionist technique
34 Berthe Morisot (1841–95): Impressionist
35 Edvard Munch (1863–1944): Norwegian Post-Impressionist; precursor of Expressionism (pages 290–1)
36 Giuseppe de Nittis (1846–84): Macchiaiolo
37 Fillippo Palizzi (1818–99): Independent; preceded Macchiaioli
38 Giuseppe Pellizza da Volpedo (1868–1907): Milanese Divisionist
39 Camille Pissarro (1830–1903): Founder Impressionist; Neo-Impressionist
40 Lucien Pissarro (1863–1944): Neo-Impressionist
41 Gaetano Previati (1852–1920): Divisionist
42 Pierre Puvis de Chavannes (1824–98): Monumental decorative painter precursor of Symbolist
43 Odilon Redon (1840–1916): Independent Symbolist
44 Pierre Auguste Renoir (1841–1919): Founder Impressionist
45 Christian Rohlfs (1849–1938): German Impressionist; Expressionist (see pages 290–1)
46 Medardo Rosso (1858–1928): Impressionist sculptor
47 Theo van Rysselberghe (1862–1926): Neo-Impressionist

48 Karl Schuch (1846–1903): German Naturalist; Leibl Group
49 Giovanni Segantini (1858–99): Milanese Divisionist
50 Raffaello Sernesi (1838–66): Macchiaiolo
51 Paul Sérusier (1863–1927): Synthetist; Founder Nabis (1888)
52 Georges Seurat (1859–91): Neo-Impressionist; inventor of Pointillism
53 Walter Richard Sickert (1860–1942): English Post-Impressionist
54 Paul Signac (1863–1935): Neo-Impressionist; Pointillist
55 Telemaco Signorini (1835–1901): Macchiaiolo
56 Alfred Sisley (1839–99): Founder Impressionist
57 Max Slevogt (1868–1932): German Impressionist
58 Philip Wilson Steer (1860–1942): English Impressionist
59 Hans Thoma (1839–1924): German Naturalist; Leibl Group
60 James Tissot (1836–1902): Franco-British painter of social scene
61 Henri de Toulouse-Lautrec (1864–1901): Independent Post-Impressionist
62 Wilhelm Trebner (1851–1917): German Naturalist; Leibl Group
63 Henry van de Velde (1863–1957): Post-Impressionist
64 Jan Verkade (1868–1946): Post-Impressionist
65 Edouard Vuillard (1868–1940): Founder Nabis (1888)
66 Friedrich Wasmann (1805–86): German Impressionist

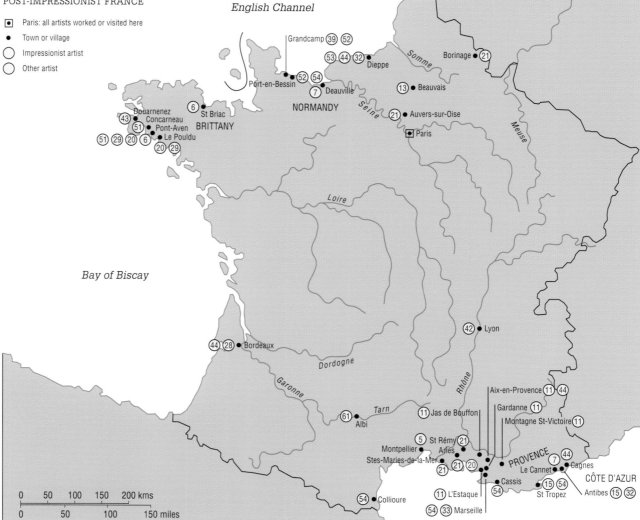

IMPRESSIONIST AND POST-IMPRESSIONIST FRANCE

◉ Paris: all artists worked or visited here
● Town or village
○ Impressionist artist
○ Other artist

© Antony White Publishing Ltd.

Below: *Paul Cézanne (1839–1906)* Lac d'Annecy c.1890 (Courtauld Gallery, London).

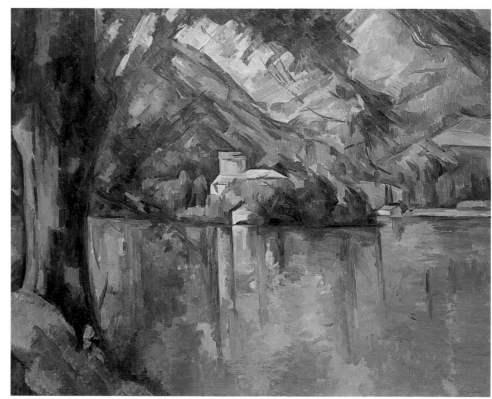

The Spread of Impressionism and Post-Impressionism

Impressionism was essentially a French phenomenon, but it had a very wide influence outside France, the light colors, sketchy brushwork and informal composition that were its hallmarks being adapted to traditions of painting already current in various countries. It was perhaps in Germany that the style was taken up with greatest gusto.

The three outstanding German Impressionists were Lovis Corinth, Max Liebermann and Max Slevogt; all three visited Paris and all of them worked mainly in Munich and Berlin. Corinth and Slevogt were just as interested in allegorical, historical and religious subjects as in modern scenes, and although Liebermann's favorite themes (landscapes, portraits, everyday life) were close to those of his French exemplars, in his treatment of the human figure he also owed much to his German contemporary Wilhelm Leibl, who in turn was influenced by the Realism of Courbet. Liebermann lived in Paris for most of the period 1873–8, but it was only after about 1890 that his work became markedly Impressionist in style.

Post-Impressionism was a term first invented in 1910 by the English critic and painter, Roger Fry, whose painting was of less importance than his criticism. Fry organized two large exhibitions of Post-Impressionism in London in 1910 and 1912 – thereby defining the style internationally for the first time. In England the most important disciple of Impressionism had been Wilson Steer (1860–1942) who had studied in Paris 1882–3 and was particularly influenced by Degas and Monet. Walter Richard Sickert epitomized the English approach to both Impressionism and Post-Impressionism, creating effects of light by juxtaposing pale colors against a dark tonal background. He painted a lot in Venice, and, as with many English of this period, in Dieppe on the Channel coast.

Post-Impressionism in the German-speaking countries was more varied and original than Impressionism. The most powerful representative of the movement was not in fact German but Norwegian – Edvard Munch, who lived mainly in Germany, mostly Berlin, from 1892 to 1908. The anguished intensity of his work is deeply personal and was one of the major inspirations for German Expressionism. Another artist with a highly subjective vision was Paula Modersohn-Becker, who with her husband Otto Modersohn was part of the famous artists' colony at Worpswede. Her style may owe something to each of them but is entirely distinct, characterized by extremely bold, flat forms, muted colors and an air of melancholy compassion. Grandeur of form of a different type is seen in the work of the Swiss artist Ferdinand Hodler, who worked mainly in Geneva, concentrating on mystical allegorical subjects with monumental figures. They rank among the most impressive Symbolist works of the time.

The response to Impressionism and Post-Impressionism in Italy forms a strong contrast to that in Germany. Degas came from an Italian family and lived in Italy 1856–9; Manet visited the country twice in the 1850s; an Italian painter, Giuseppe de Nittis, showed work at the first Impressionist exhibition in Paris in 1874.

There was, however, a parallel development to Impressionism in Italy, in the work of a group of painters called the Macchiaioli, who worked mainly in Florence in the 1860s. Like the Impressionists, they revolted against academic conventions and painted in a clear fresh way using blots or patches (*macchie*) of color. The leading members of the group included Fattori, Lega and Signorini.

Post-Impressionism in Italy was also focused on a specific movement – Divisionism, an Italian equivalent of the Neo-Impressionism of Seurat and his followers. The Divisionists' use of a myriad of small dots of pure color was based on a reading of the same optical texts that inspired the French Neo-Impressionists, but they had little direct knowledge of Seurat's paintings. Divisionism flourished paticularly in north-west Italy from about 1890 to 1907 (the death of Pelizza da Volpedo, its most dedicated exponent) and also spread to Rome. Among the other leading Divisionists were Grubicy de Dragon, who was also a picture dealer and art critic, and Previati, who wrote two treatises on optical principles and painting technique and translated another from French.

Above: *Walter Richard Sickert (1860–1942):* St. Jacques Church, Dieppe *(Private Collection).*

Sickert made numerous sketches of the port and town of Dieppe, on the Normandy coast, which was a point of contact of British and French artists during the post-impressionist period.

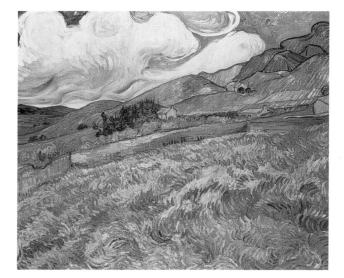

Left: *Vincent van Gogh (1853–90):* Landscape at St. Rémy, *1889 (Ny Carlsberg Glypotek, Copenhagen).*

One of van Gogh's last landscapes, showing his use of the Impressionist palette but for emotional intensity rather than optical realism.

Below: *Edvard Munch (1863–1944)* The Dance of Life, *1890's, (Nasjonalgallereit, Oslo).*

Munch was Norwegian, trained in Berlin, and influenced by the line and symbolism of Gaugin. The Dance of Life is an emotional rendering of the image of the three ages of man.

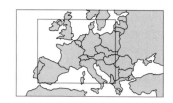

1. Giuseppe Abbati (1836–68): Macchiaiolo
2. Rudolf von Alt (1812–1905): German Naturalist; Impressionist Influenced
3. Vito d'Ancona (1825–84): Macchiaiolo
4. Louis Anquetin (1861–1932): Cloisonist
5. Frédéric Bazille (1841–70): Founder Impressionist
6. Émile Bernard (1868–1941): Synthetist; Nabis; Rose-Croix
7. Pierre Bonnard (1867–1947): Founder Nabis (1888)
8. Eugene Boudin (1824–98): Precursor of Impressionism
9. George Breitner (1857–1923): Dutch Impressionist
10. Mary Cassatt (1844–1926): American-born Impressionist
11. Paul Cézanne (1839–1906): Founder Impressionist; Post-Impressionist
12. Lovis Corinth (1858–1925): German Impressionist; Expressionist (see pages 290–1)
13. Giovanni Costa (1826–1903): Macchiaiolo
14. Tranquillo Cremona (1837–78): Milanese Divisionist
15. Henri Edmond Cross (1856–1910): Neo-Impressionist
16. Edgar Degas (1834–1917): Founder-Impressionist
17. Maurice Denis (1870–1943): Founder Nabis (1888); Christian Symbolist
18. Giovanni Fattori (1825–1908): Macchiaiolo
19. Roger Fry (1866–1934): Post Impressionist
20. Paul Gauguin (1848–1903): Impressionist; Symbolist/Synthetist; also worked Martinique and Tahiti
21. Vincent van Gogh (1853–90): Dutch Realist; Impressionist; Post-Impressionist
22. Vittore Grubicy de Dragon (1851–1920): Milanese Divisionist
23. Ferdinand Hodler (1853–1918): Swiss Symbolist; Rose-Croix
24. Johan Barthold Jongkind (1819–91): Realist; precursor of Impressionism
25. Silvestro Lega (1826–95): Macchiaiolo
26. Max Liebermann (1847–1935): German Impressionist
27. Wilhelm Leibl (1844–1900): German Naturalist; Impressionist influenced
28. Édouard Manet (1832–83): Realist; Impressionist
29. Jacob Meyer de Haan (1852–95): Synthetist
30. Otto Modersohn (1865–1943): Worpswede Naturalist
31. Paula Modersohn-Becker (1876–1907):
32. Claude Monet (1840–1926): Founder Impressionist
33. Adolphe Monticelli (1824–86): Late Romantic with proto-Impressionist technique
34. Berthe Morisot (1841–95): Impressionist
35. Edvard Munch (1863–1944): Norwegian Post-Impressionist; precursor of Expressionism (pages 290–1)
36. Giuseppe de Nittis (1846–84): Macchiaolo
37. Fillippo Palizzi (1818–99): Independent; preceded Macchiaioli
38. Giuseppe Pellizza da Volpedo (1868–1907): Milanese Divisionist
39. Camille Pissarro (1830–1903): Founder Impressionist; Neo-Impressionist
40. Lucien Pissarro (1863–1944): Neo-Impressionist
41. Gaetano Previati (1852–1920): Divisionist
42. Pierre Puvis de Chavannes (1824–98): Monumental decorative painter precursor of Symbolist
43. Odilon Redon (1840–1916): Independent Symbolist
44. Pierre Auguste Renoir (1841–1919): Founder Impressionist
45. Christian Rohlfs (1849–1938): German Impressionist; Expressionist (see pages 290–1)
46. Medardo Rosso (1858–1928): Impressionist sculptor
47. Theo van Rysselberghe (1862–1926): Neo-Impressionist
48. Karl Schuch (1846–1903): German Naturalist; Leibl Group
49. Giovanni Segantini (1858–99): Milanese Divisionist
50. Raffaello Sernesi (1838–66): Macchiaiolo
51. Paul Sérusier (1863–1927): Synthetist; Founder Nabis (1888)
52. Georges Seurat (1859–91): Neo-Impressionist; inventor of Pointillism
53. Walter Richard Sickert (1860–1942): English Post-Impressionist
54. Paul Signac (1863–1935): Neo-Impressionist; Pointillist
55. Telemaco Signorini (1835–1901): Macchiaiolo
56. Alfred Sisley (1839–99): Founder Impressionist
57. Max Slevogt (1868–1932): German Impressionist
58. Philip Wilson Steer (1860–1942): English Impressionist
59. Hans Thoma (1839–1924): German Naturalist; Leibl Group
60. James Tissot (1836–1902): Franco-British painter of social scene
61. Henri de Toulouse-Lautrec (1864–1901): Independent Post-Impressionist
62. Wilhelm Trebner (1851–1917): German Naturalist; Leibl Group
63. Henry van de Velde (1863–1957): Post-Impressionist
64. Jan Verkade (1868–1946): Post-Impressionist
65. Edouard Vuillard (1868–1940): Founder Nabis (1888)
66. Friedrich Wasmann (1805–86): German Impressionist

THE SPREAD OF IMPRESSIONISM AND POST-IMPRESSIONISM

- ⊡ Paris: all artists worked or visited here
- ⊙ Major artistic center
- • Town or city
- ◯ Divisionist
- ◯ Impressionist
- ◯ Macchiaiolo
- ◯ Other artist

North Sea

Baltic Sea

Copenhagen 20

Amsterdam 9 29

Hamburg 12 27 66

Walberswick 58

Zaandam 32

Worpswede 31 30

Elbe

London 60 58 55 53 40 39 32 19 13

The Hague 26 21

Neunen 21

Berlin 57 35 26 12

Antwerp 63 54 21

Hagen

Ghent 47

Dusseldorf 59 30 45 63

Weimar 45

Rhine

Brussels 63 61 47 5 4

Frankfurt 57

Seine

Paris

Loire

Karlsruhe 59 30

Munich 2 12 26 27 30 48 57 59 62

Beuron 64 51

Urfeld 12

Danube

Geneva 23

Savognin 49

Engadine 49

49

Bay of Biscay

Milan 14 22 38 41 46 49

Turin 46

Po

Venice 6 28 32 44 53 54 60

Ebro

Florence 1 3 13 16 18

Livorno 18

25 26 50 55

Adriatic Sea

Madrid 47 6

Mediterranean Sea

Rome 61 51 44 24 17 16 13

Naples 44 37 16 1

Barletta 36

0 100 200 300 kms
0 100 200 miles

© Antony White Publishing Ltd.

Above: *Giuseppe de Nittis (1846–1884):* An Arab by a Doorway *(Private Collection).*

De Nittis' work was close to the naturalistic approach of Monet and Degas.

Right: *Medardo Rosso (1858–1928)* Head of a Man, *plaster, (Private Collection).*

Rosso was the only sculptor to succeed in consciously using the the Impressionists' fragmented images three-dimensionally.

Fauvism and Cubism

Fauvism was the first of the series of major avant-garde art movements that revolutionized European art in the years between 1900 and the First World War; Cubism was the most radical and influential of these movements.

The keynote of Fauvism is the use of extremely vivid color, sometimes employed entirely non-naturalistically so that, for example, flesh might be depicted as green or grass blue. The name was coined in 1905 when the painters who made up the Fauves exhibited together in Paris at the Salon d'Automne, an alternative to the official salon that had been established two years earlier. The art critic Louis Vauxcelles, seeing a Renaissance-style statue incongrously placed among such aggressively novel paintings, exclaimed: *"Donatello au milieu des fauves"* (Donatello among the wild beasts). Henri Matisse was the dominant figure of the group; aged 36, he was a few years older than any of the others, who were mainly in their twenties. Among them were André Derain, Maurice de Vlaminck, Othon Friesz and the Dutch-born Kees van Dongen. In the next two years they were joined by others including Georges Braque and Raoul Dufy.

Landscape was the most common subject of the Fauves and much of their work is associated with certain favorite places. The Normandy coast, for example, was a notable source of inspiration, but the blazing sunshine of the Mediterranean was the most powerful stimulus to their vibrant sense of color. Matisse in particular explored the possibilities of pure color and is regarded as the pre-eminent colorist in 20th-century art; but by 1908 or 1909 Fauvism as a movement had ceased to exist, and most of the members of the group had embarked on other paths. Although it was short-lived, however, Fauvism had a major impact on other movements, particularly on Expressionism in Germany.

Georges Braque made the most remarkable transformation of any of the Fauves, abandoning its impulsive, subjective qualities for a style of geometrical analysis. In this he was joined by Pablo Picasso and together they created Cubism, one of the most momentous turning-points in Western art. Instead of depicting subjects from a single, fixed viewpoint, they broke them into a multi-

plicity of facets, so that several different aspects of an object could be seen simultaneously. The archetypal Cubist subject was still-life, but landscape also played a considerable part in the development of the movement.

In 1910 came the first reference to a school of Cubist artists when Robert Delaunay, Henri Le Fauconnier, Albert Gleizes, Fernand Léger and Jean Metzinger exhibited together. Rather than any of these, however, it is Juan Gris who is regarded as the third great figure of Cubism.

Cubism was taken up and developed by a host of artists, proving infinitely adaptable and giving birth to numerous other movements and "isms". In France, Robert Delaunay was the chief exponent of Orphism (or Orphic Cubism), which introduced a new element of lyrical color to the austere style of Braque and Picasso. Duchamp, Léger and Picabia were among the other exponents. There is a kinship in the work of the *Blaue Reiter* group in Munich. In Italy, Futurism took a sense of fragmentation from Cubism but added to it a feeling of movement and the excitement of the machine. Similar concerns are seen in Vorticism, a British movement, and in Russia Futurism was adapted into Rayonism. None of these movements or groups survived beyond the First World War, but Cubism continued to have resonances long after that.

Cubism influenced not only painters but also sculptors. The three most important sculptors to work in a Cubist idiom for a major part of their careers were the Russian-born Archipenko, the Lithuanian-born Lipchitz, and Laurens, who was born, lived and died in Paris. Outside Paris, some of the best Cubist sculpture was produced in Prague, where Filla and Gutfreund were part of a flourishing Cubist school.

Above: *Georges Braque (1882–1963):* Musical Instruments, c.1908, oil (collection Mr and Mrs Claude Laurens, Paris).

Braque considered this to be his first Cubist painting, in which he endeavored to create space and volume, while negating perspective and showing different angles.

Left: *Pablo Picasso (1881– 1973):* Female nude, c.1908 (Narodni Gallery, Prague).

Picasso worked closely with Braque from 1907 and together they arrived at a cubist vision that, as here, broke up the planes of the subject. Picasso's treatment of the nude was also tinged with his studies of primitive art.

Far left: *Alexei von Jawlensky (1864–1941):* Landscape, Murnau, c.1907 (Kunstmuseum, Düsseldorf).

The south German town of Murnau, as depicted here with its red-roofed buildings, towering church steeple, and lush pastoral surroundings, was a favorite subject for Jawlensky and his Fauve peers, Gabriele Munter and Wassily Kandinsky, between 1905 and 1907. A seminal yet short-lived period that was embraced by French and German painters alike, Fauvism in Germany evolved into Expressionism, the signature movement of twentieth-century German art.

FAUVISM AND CUBISM

- ⊙ Paris (center of both movements)
- ● Other sites
- ☐ Painter
- ◇ Painter/sculptor
- ○ Sculptor
- ○ Fauvist
- ○ Cubist
- ○ Cubist influenced

Fauvism
1 Georges Braque (1882–1963)
2 André Derain (1880–1954)
3 Kees van Dongen (1877–1968)
4 Raoul Dufy (1877–1953)
5 Othon Friesz (1879–1949)
6 Henri Manguin (1874–1949)
7 Albert Marquet (1875–1947)
8 Henri Matisse (1869–1954)
9 Georges Rouault (1871–1958)
10 Maurice de Vlaminck (1876–1958)

Cubism
11 Alexander Archipenko (1887–1964)
12 Georges Braque (1882–1963)
13 Robert Delaunay (1885–1941)
14 Marcel Duchamp (1887–1968)
15 Raymond Duchamp-Villon (1876–1918)
16 Henri Le Fauconnier (1881–1946)
17 Lyonel Feininger (1871–1956)
18 Albert Gleizes (1881–1953)
19 Juan Gris (1887–1927)
20 Henri Laurens (1885–1954)
21 Fernand Léger (1881–1955)
22 Jacques Lipchitz (1891–1973)
23 Jean Metzinger (1883–1953)
24 Francis Picabia (1879–1973)
25 Pablo Picasso (1881–1973)
26 Jacques Villon (1875–1963)
27 Ossip Zadkine (1890–1967)

Artists influenced by Cubism
28 Vincenc Beneš (1883–
29 Heinrich Campendonk (1889–1957)
30 Josef Čapek (1887–1945)
31 Emil Filla (1882–1953)
32 Nathalie Gontcharova (1881–1962)
33 Otto Gutfreund (1889–1927)
34 Bohumil Kubišta (1884–1918)41
35 August Macke (1887–1914)
36 Kasimir Malevich (1878–1935)
37 Franz Marc (1880–1916)
38 Piet Mondrian (1872–1944)
39 Lyubov Popova (1889–1924)
40 Antonín Procházka (1882–1945)
41 Luigi Russolo (1885–1947)
42 Mario Sironi (1885–1961)
43 Ardengo Soffici (1879–1964)
44 Nadezhda Udaltsova (1886–1961)

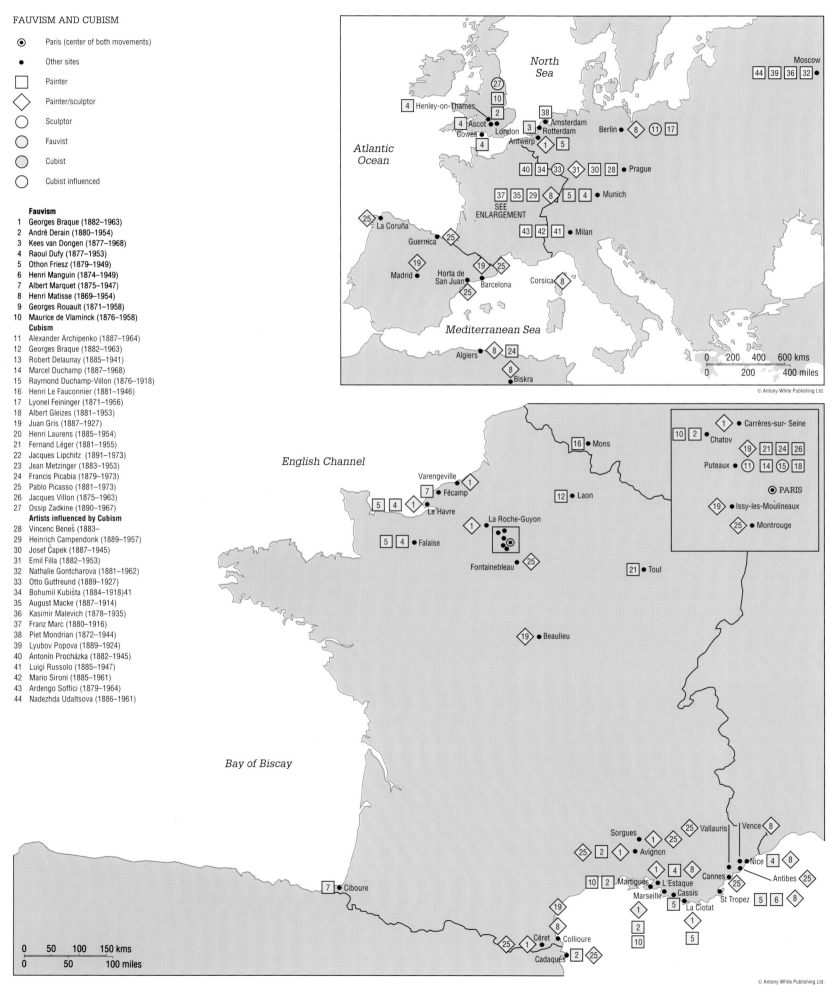

Expressionism

"Expressionism" is an imprecise but indispensable word in the study of art. It denotes the use of exaggeration and distinction for emotional effect, and in its broadest sense can be applied to art of any time or place that emphasizes turbulent subjective feeling (the intensely emotional religious paintings of the 16th-century masters El Greco and Grünewald are early examples: the "gestural" abstract paintings of Jackson Pollock and Willem de Kooning are modern manifestations). The term however is applied specifically to a movement in German art which flourished more vigorously in Germany than anywhere else from about 1905 to about 1930.

Two great artists are regarded as the joint fountainheads of Expressionism – the Dutchman Vincent van Gogh and the Norwegian Edvard Munch. Van Gogh, who used color and line not naturalistically but emotionally, was little known at the time of his death in 1890, but his fame soon grew rapidly, and he was enormously influential. Munch had a traumatic childhood and showed an unprecedented ability to communicate extreme mental states and to give pictorial form to the inmost thoughts that haunted him.

Munch lived mainly in Germany from 1892 to 1908 and made an extremely powerful impact there; in 1892 an exhibition in Berlin was closed because the works he showed in it caused such an uproar. His angst-ridden vision of life was one of the most important influences on the first major group of German Expressionists – Die Brücke (The Bridge). The name was chosen because the members – who met as students in Dresden – wished their work to serve as a bridge to the art of the future, but the aims of the group are vague. They used bold, unnaturalistic color, but their work was strident, with forms violently clashing and paint handled with a crude vigor. Die Brücke transferred its activities to Berlin in 1910, but the group dissolved in 1913 because of personal rifts among the members.

A more short-lived group, but one that is regarded as marking the highpoint of German Expressionism, was Der Blaue Reiter (The Blue Rider), named after a painting by Kandinsky, its most famous member. The group was founded in Munich in 1911 and disintegrated in the First World War, during which two of its members – August Macke and Franz Marc – were killed in action. The aims of the individual members of Der Blaue Reiter varied greatly, but they shared a desire to express spiritual values in their art.

In the period between the First and Second World Wars the most powerful force in German Expressionism was the Neue Sachlichkeit (New Objectivity) movement, which stressed an interest in social criticism, reflecting disgust at the horrors of war and the depravity of a decadent society. The name was coined for an exhibition in Mannheim in 1925 and the two leading figures of the movement were Otto Dix and George Grosz, who rank among the most brilliant and powerful satirists in the history of art. Their work was opposed by the Nazis (Dix was dismissed from his teaching post at the Dresden Academy in 1933 and Grosz was prosecuted several times for blasphemy and obscenity before moving to America in 1933) and the movement dissipated in the 1930s, the Nazis favoring a wooden, traditional style that glorified Hitler's Germany.

As well as these groups and movements, there were numerous outstanding independent Expressionists in Germany and Austria. Among them were: Max Beckmann, whose art was transformed by his horrifying experiences as a medical orderly during the First World War, which led him to overpowering allegorical depictions of cruelty and lust; Oskar Kokoschka, a brilliant portraitist and landscape painter, who remained true to his Expressionist ideals throughout his long life; Egon Schiele, one of the artists who made Vienna such an innovative and exciting artistic center in the early 20th century and who painted and drew some of the most achingly intense nudes in modern art.

Belgium had earlier produced one of the great independent spirits of Expressionism – James Ensor, who spent most of his life living in seclusion in his home town of Ostende, exploring a world of bizarre private imagery – skeletons and carnival masks are much in evidence – with a gruesome sense of humor.

Above: *Ernst Kirchner (1880–1938):* The Red Tower, *(Museum Folkwang, Essen, Germany).*

Kirchner was the most famous of the Brücke group, the most overtly expressionist of German movements in Modern art.

Above: *Paul Klee (1879–1940):* Stadt der Kirchen, *1918, watercolor (Private collection).*

Klee, a Swiss painter and graphic artist, exhibited with the Blaue Reiter group and taught painting at the Bauhaus. As in this watercolor of churches in a city, his work was highly poetic and personal and only expressionist in its freedom and lyricism.

Left: *Otto Dix (1891–1969):* Grosstadt (Urban Debauchery), *(Staatsgalerie, Stuttgart).*

Dix, with George Grosz, belonged to the Neue Sachlichkeit movement (The New Objectivity) – using a violent expressionist technique to pillory and satirize the horrors of war and, as in this study of urban excess, the decadence of German society in the 1920s.

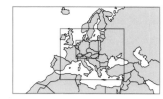

EXPRESSIONISM

- ⊙ Major artistic center
- • Town or city
- ○ Painter
- □ Sculptor

Expressionist movements
- ○ CoBrA
- ○ Der Blaue Reiter
- ○ Die Brücke
- ○ Les Vingt
- ○ Neue Sachlichkeit
- ○ Osma
- ○ Other expressionist
- ⦿ Precursor of expressionism

0 ___ 100 ___ 200 kms
0 ___ 100 miles

1 Pierre Alechinsky (b.1927)
2 Karel Appel (b.1921)
3 Ernst Barlach (1870–1938)
4 Max Beckmann (1884–1950)
5 Arnold Böcklin (1827–1901)
6 Lovis Corinth (1858–1925)
7 Corneille (Cornelis van Beverloo) (b.1922)
8 Otto Dix (1891–1969)
9 James Ensor (1860–1949)

10 Lyonel Feininger (1871–1956)
11 Emil Filla (1882–1953)
12 Vincent van Gogh (1853–90)
13 George Grosz (1893–1959)
14 Erich Heckel (1883–1970)
15 Ferdinand Hodler (1853–1918)
16 Karl Hofer (1878–1955)
17 Adolf Hölzel (1853–1934)
18 Alexei von Jawlensky (1864–1941)
19 Asger Jorn (1914–73)
20 Wassily Kandinsky (1866–1944)
21 Fernand Khnopff (1858–1921)
22 Ernst Kirchner (1880–1938)
23 Paul Klee (1879–1940)
24 Gustav Klimt (1862–1918)
25 Oskar Kokoschka (1886–1980)
26 Käthe Kollwitz (1867–1945)
27 Wilhelm Lehmbruck (1881–1919)
28 August Macke (1887–1914)
29 Franz Marc (1880–1916)
30 Paula Modersohn-Becker (1876–1907)
31 Otto Müller (1874–1930)
32 Edvard Munch (1863–1944)
33 Gabriele Münter (1877–1962)
34 Emile Nolde (1867–1956)
35 Max Pechstein (1881–1955)
36 Christian Rohlfs (1849–1938)
37 Georges Rouault (1871–1958)
38 Egon Schiele (1890–1918)
39 Karl Schmidt-Rottluff (1884–1976)
40 Chaïm Soutine (1894–1943)
41 Václav Spála (1885–1946)
42 Franz von Stuck (1863–1928)
43 Jan Toorop (1858–1928)
44 Henry van der Velde (1863–1957)

Modern Movements in Design and the Applied Arts 1851–1939

1851 signified a new thrust in the development of design and the applied arts, with the opening of the Great Exhibition, principally organised by Henry Cole (1801–82), at the Crystal Palace in London. People from all nations flooded to London to see Sir Joseph Paxton's (1801–65) cathedral-like glass and steel pavilion filled with the proudest products the world could manufacture.

Such exhibitions, sometimes controversial, generated a new attitude to the nature of design through form and function across Europe. As the twentieth century approached, adherence to fastidious decoration diminished and was replaced by a more intimate, individual and humanistic aesthetic. In England the initiative was taken by William Morris, who championed the social responsibilities of the artist and found expression of his ideals in the Arts and Crafts movement. The impact was enormous.

The English arts and crafts architects had taken on the role not only of designers of buildings but also of fitments and fittings. Richard Norman Shaw, Philip Webb, Charles Voysey and Edwin Lutyens all designed tables, chairs, dressers and interiors for their clients.

Mackay Hugh Baillie Scott's reputation reached the Grand Duke of Hesse, Ernst Ludwig, at Darmstadt, who commissioned him to decorate the Palace dining and drawing rooms. His European commissions also included tapestries and interiors for Karl Schmidt's Dresden Werkstätten, as well as designs for Queen Marie of Romania.

The free flow of ideas, commissions and the need to show designs at international exhibitions, meant that craftsmen, designers and architects were influenced by more than one creative movement. Charles Rennie Mackintosh spanned both the Arts and Crafts Movement and Art Nouveau. In 1900 he showed his work at the Vienna Secession (Austria's Art Nouveau) Exhibition along side Josef Hoffman and Joseph Olbrich, which instantly gave him international recognition. In Brussels Victor Horta was among the first to develop the organic forms of the Art Nouveau style in his use of ironwork and similar decorative architectural features. Horta later

designed the front of Samuel Bing's Parisian shop *L'Art Nouveau*, which gave its name to the movement. Glass by Émile Gallé, jewelry by René Lalique, metalwork by William Benson as well as wallpapers and fabrics by Morris, Walter Crane and Voysey were on show. With its roots in London, Art Nouveau spread throughout Europe. Prague was the most important center after Paris and Vienna, with pockets located in the Netherlands and Italy, while Spain produced the idiosyncratic Gaudí (1852–1926).

With the complex Constructivist movement following the 1917 Russian Revolution, politics, art and design were united in the ideology, propaganda and restructuring of a new order. Alexander Rodchenko and El Lissitzsky worked as typographers, illustrators and book designers. Like Vladimir Tatlin they travelled to central Europe making contact with fellow artists and designers such as Gerrit Rietveld. Lissitzsky, who had studied in Darmstadt before the Revolution, had also been influenced by the abstract Suprematist painter Kasimir Malevich and by 1921 was teaching architecture in Moscow at the Vhkutemas, the Russian equivalent of the Bauhaus.

In Germany the magnetic pull for modernity in design, industry and architecture was to be seen in the highly influential Bauhaus founded in 1919 at Weimar under the direction of Walter Gropius. Here, Marcel Breuer taught furniture design and László Moholy-Nagy (1887–1946) metalwork. The ideological stance of the Bauhaus resulted in conflict, and political pressure forced its move to Dessau in 1925. A further move followed to Berlin in 1932, with Mies van der Rohe as Director, as a result of the hostility of National Socialism. A year later the school was closed by the Nazis, with staff and students dispersed into Europe.

By 1939 International Modernism had established a hold on a range of products from glassware, ceramics, furniture, theater design, fashion as well as architecture and industrial design. Le Corbusier, for instance, was influenced by a number of varied movements and artists which provided him with a rich source of material.

Left: *William Morris (1834–96):* Fireplace, *The Red House, Bexleyheath, England.*

Morris designed and manufactured the wallpaper and furniture for his newly commissioned home, The Red House.

Right: *William de Morgan (1839–1917):* Earthenware dish, c.1890 (Victoria and Albert Museum, London).

Peacock motifs were a frequent feature of de Morgan's "Persian" style.

Left: *Marcel Breuer (1902–81):* Armchair, 1924 (Private Collection).

This oak, lath and linen armchair was designed for the Bauhaus building in Weimar.

46 Gio Ponti (1892–1979):
Architect/Designer
47 Eugenio Quarti (1867–1931): Art
Nouveau, Art Deco Designer
48 Richard Riemerschmid (1868–1957):
Painter/Architect Designer
49 Gerrit Rietveld (1888–1964): De Stijl
Architect/Furniture Designer
50 Alexander Rodchenko (1891–1956):
Constructivist Painter/Designer
51 Antonio Sant'Elia (1888–1916):
Architect/Designer
52 Gustave Serrurier-Bovy (1858–1910): Art
Nouveau Architect/Designer
53 Richard Norman Shaw (1831–1912):
Architect Designer
54 Guido Stella (1882–1941): Art Nouveau,
Art Deco Designer, Glass, Posters, Books
55 Vladimir Tatlin (1885–1953):
Constructivist Painter/Designer
56 Jan Thorn Prikker (1868–1932): Art
Nouveau Painter/Designer
57 Henri van de Velde (1863–1957): Art
Nouveau Painter/Designer
58 Charles Voysey (1857–1941): Arts and
Crafts Architect/Designer
59 Otto Wagner (1841–1918): Secessionist
Architect/Designer
60 Philip Webb (1831–1915): Arts and Crafts
Architect/Designer

MODERN MOVEMENTS IN DESIGN
AND THE APPLIED ARTS 1851–1939

- Town or city
- Art deco
- Art nouveau
- Arts and crafts
- Bauhaus
- Constructivist
- De Stijl
- Futurist
- Independent
- Secessionist

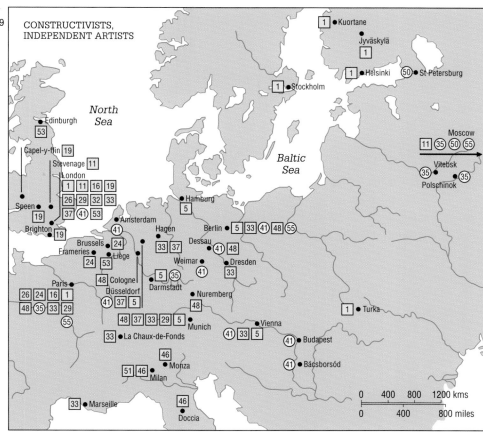

CONSTRUCTIVISTS,
INDEPENDENT ARTISTS

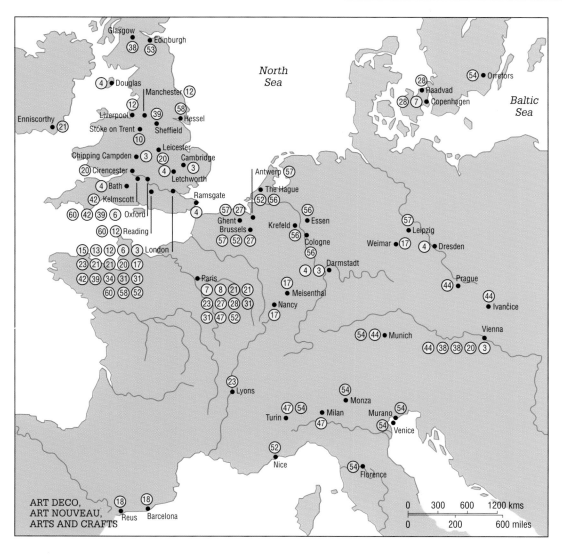

ART DECO,
ART NOUVEAU,
ARTS AND CRAFTS

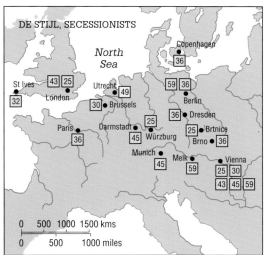

DE STIJL, SECESSIONISTS

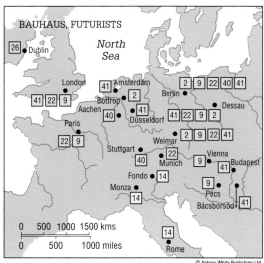

BAUHAUS, FUTURISTS

© Antony White Publishing Ltd.

293

Dada and Surrealism

Dada and Surrealism were two of the dominant movements in Western art in the period from 1915 to about 1940. They were closely related; several artists figured in both movements, each of which was conceived as a state of mind and way of life rather than a set of stylistic attitudes. Both were strongly anti-rationalist and much concerned with creating effects that were incongruous or shocking, but whereas Dada was essentially nihilistic, Surrealism was positive in spirit.

Dada was created in Zurich in 1915–16, a product of the disgust and disillusionment engendered by the First World War. There are several accounts of how the name Dada came about, the most popular being that it was chosen at random from the pages of a French-German dictionary (it is French for "hobby-horse"). This reflects the emphasis on chance and foolery typical of the movement. In Zurich Dada was predominantly literary, the Romanian poet Tristan Tzara (1886–1963) being a key figure; the main representative figure from the visual arts was Jean Arp. Tzara made "chance" poetry from words cut from a newspaper and pasted together at random, just as Arp made compositions from pieces of drawings that he had torn up and thrown away.

Dada arose in New York at about the same time as it did in Zurich, Marcel Duchamp and Francis Picabia being the chief artists involved. Duchamp was one of the most provocative figures in modern art, amazingly fertile in the ideas with which he questioned assumptions about the nature of art. In 1917, for example, when he submitted to an exhibition in New York a urinal signed R. Mutt and entitled *Fountain* he was showing the potential absurdity of the "democratic" exhibition policy – anyone could show their work on payment of a modest fee. Picabia was not himself a particularly outstanding artist, but he was a potent force in spreading Dada (and later Surrealist) ideals because he was energetic, much traveled and involved himself with the Dadaist periodical *391* which he founded in Barcelona in 1916, and which appeared irregularly until 1924.

From Zurich Dada spread to Berlin and other cities in a war-wrecked Germany. In Berlin the movement was predominantly political, expressed particularly through the brilliant photomontages of Raoul Hausmann and John Heartfield (who anglicized his name from the original Helmut Herzfelde as a protest against German nationalistic fervour) and through the biting social satire of Otto Dix and George Grosz. In Cologne a brief Dada movement (1919–20) was centered on Max Ernst, who made witty and suggestive use of collage, and Jean Arp, who moved there from Zurich when the war ended. In Hanover one man – Kurt Schwitters – dominated the scene. Schwitters made works of art from refuse such as bus tickets and discarded string, eventually making sculptural or even architectural installations from such materials.

Dada was introduced to Paris in 1919 by Picabia and there was a Dada festival in Prague in 1921 in which Hausmann and Schwitters participated, but at a meeting in Weimar in 1922, attended by Arp, Schwitters and others, Tzara delivered a funeral oration on the movement. Although short-lived, it was highly influential, its

tendency towards absurdity and whimsicality being taken over by Surrealism.

Like Dada, Surrealism was a literary as well as an artistic movement. The founder and chief spokesman of the movement was the French poet, essayist and critic André Breton (1896–1966). He wrote that its purpose was "to resolve the previously contradictary conditions of dreams and reality into an absolute reality, a super-reality", and Surrealist artists were much concerned to explore imagery from dreams and the subconscious. The ways in which they did this varied from the scrupulously detailed "hand-painted dream photographs" of Salvador Dalí to the experiments of artists such as André Masson with "automatic" techniques in which the artist tries to relinquish conscious control of what his hand is doing, letting the subconscious take over.

Paris was the center of Surrealism from its birth (marked by Breton's first *Surrealist Manifesto* in 1924) until the Second World War, when the emigration of many artists to the United States made New York the new hub of activity. It did not take root in Germany, but flourished vigorously in Belgium – in the work of René Magritte, the most inspired of all Surrealist painters, and Paul Delvaux, the most long-lived upholder of the tradition. Many artists who were not in sympathy with the political aims of Surrealism (for a time it was associated with the French Communist Party) and were never formal members of the movement were nevertheless influenced by its imagery. In Britain, for example, Paul Nash (who helped to organize the 1936 London exhibition) and Henry Moore went through a Surrealist phase. As an organized movement Surrealism broke up during the Second World War, but its ideas and techniques continued to be influential, forming, for example, a fundamental source for Abstract Expressionsim.

Below: Salvador Dalí *(1904–89):* Le Visage de la Guerre, *oil on canvas, 1940 (Museum Boymans, Rotterdam).*

Although painted in California at the start of the Second World War, Le Visage de la Guerre *was probably a reminiscence of the horrors of the Spanish Civil War, still fresh in Dalí's memory. Dalí himself stressed that this is his only work that includes a genuine imprint of his hand (bottom right).*

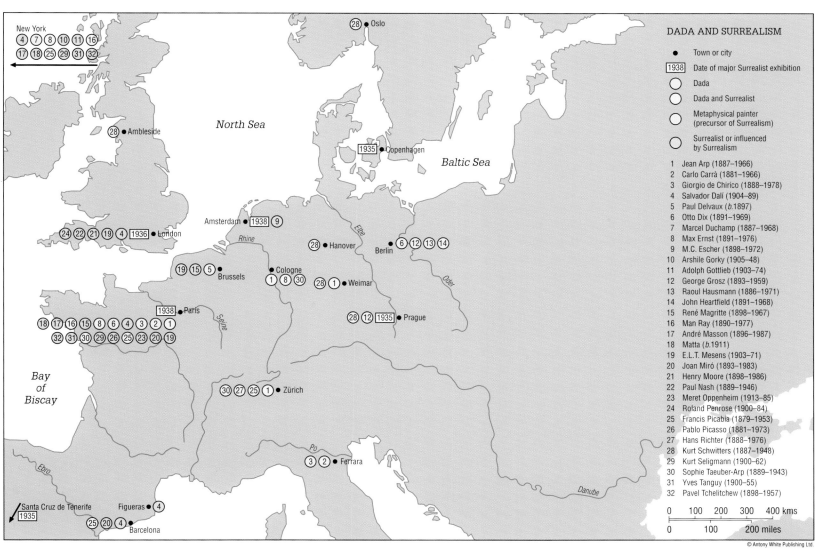

DADA AND SURREALISM

- ● Town or city
- 1938 Date of major Surrealist exhibition
- ◯ Dada
- ◯ Dada and Surrealist
- ◯ Metaphysical painter (precursor of Surrealism)
- ◯ Surrealist or influenced by Surrealism

1 Jean Arp (1887–1966)
2 Carlo Carrà (1881–1966)
3 Giorgio de Chirico (1888–1978)
4 Salvador Dalí (1904–89)
5 Paul Delvaux (b.1897)
6 Otto Dix (1891–1969)
7 Marcel Duchamp (1887–1968)
8 Max Ernst (1891–1976)
9 M.C. Escher (1898–1972)
10 Arshile Gorky (1905–48)
11 Adolph Gottlieb (1903–74)
12 George Grosz (1893–1959)
13 Raoul Hausmann (1886–1971)
14 John Heartfield (1891–1968)
15 René Magritte (1898–1967)
16 Man Ray (1890–1977)
17 André Masson (1896–1987)
18 Matta (b.1911)
19 E.L.T. Mesens (1903–71)
20 Joan Miró (1893–1983)
21 Henry Moore (1898–1986)
22 Paul Nash (1889–1946)
23 Meret Oppenheim (1913–85)
24 Roland Penrose (1900–84)
25 Francis Picabia (1879–1953)
26 Pablo Picasso (1881–1973)
27 Hans Richter (1888–1976)
28 Kurt Schwitters (1887–1948)
29 Kurt Seligmann (1900–62)
30 Sophie Taeuber-Arp (1889–1943)
31 Yves Tanguy (1900–55)
32 Pavel Tchelitchew (1898–1957)

| 0 | 100 | 200 | 300 | 400 kms |

| 0 | 100 | | 200 miles |

© Antony White Publishing Ltd.

Right: *Giorgio de Chirico (1888–1978):* The Melancholy of Departure, *oil on canvas, 1916 (Tate Gallery, London).*

De Chirico included maps in three still-life compositions of this period. His compositional formula juxtaposing the relief of the maps and the eerie theatrical space surrounding them, had become more daringly asymetrical, and the paintings' surfaces densely manipulated with the intricate hatching of the maps' topographic contours.

Far right: *Francis Picabia (1879–1953):* Parade Amoureuse, *oil on canvas, 1917 (Private Collection).*

A Paris-born artist, Picabia met Duchamp in 1910, in 1913 exhibited at the Armory Show in New York, and with Duchamp help to found American Dada. Many of his collages and constructions of this period make use of mechanistic fantasies and functionless machines.

Non-objective Art

The word "abstract" is indispensable in the study of 20th-century art, but its usage can cause difficulty and ambiguity, and even some artists who are thought of as quintessentially abstract have hated the term. Taking the word literally, to "abstract" is to summarize or concentrate or to separate something from something else. Many of the sculptures of Henry Moore, for example are derived from the forms of the human body but are so radically simplified that they can be called non-representational or abstract. Other modern artists have created images that have no connection with external reality but rather are made up of forms and colors that exist entirely for their own sake. The term "non-objective art" is applied to this second kind of abstract art. Alexander Rodchenko, a Russian painter, sculptor, industrial designer and photographer, is said to have coined the term and it was given wide currency by the Russian-born, German-based painter Wassily Kandinsky in his book *Concerning the Spiritual in Art*, published in 1912.

There is often no clearcut division between these two broad kinds of abstraction, but certain artists did pursue the ideal of "pure" abstraction with an almost religious fervour, the chief centers of the "cult" being in Russia and Holland. In the decade 1910-20, in which abstract art was born and achieved a distinctive identity, nowhere was a more exciting place of artistic experimentation than Moscow. It cannot be said that abstract art was created there; it evolved more or less simultaneously in several countries, but Russia produced a particularly rich crop of innovative movements, of which the most important were Rayonism, Suprematism and Constructivism.

Rayonism was associated mainly with Goncharova and Larionov, who launched the movement officially in Moscow in 1913, declaring it to be "a synthesis of Cubism, Futurism and Orphism". Their paintings used bundles of slanting lines to express an obscure theory concerning invisible rays and convey a sense of dynamic energy. Kasimir Malevich, one of the key figures in the development of abstract art, was associated with Goncharova and Larionov during the brief period when Rayonism flourished (1912-14), but he struck out on his own with the movement called Suprematism, which he made public in Moscow in 1915. He created the most radically pure abstract works up to that date, limiting himself to basic geometric shapes and a narrow range of color and reaching a point beyond which he found it impossible to progress with a series of paintings (c.1918) of a white square on a white background. Constructivism also used pure abstract forms, but whereas Suprematism was associated with Malevich's mystical ideas, Constructivism reflected modern technology, using industrial materials such as glass and plastic. Vladimir Tatlin, painter, sculptor, designer and maker of "contructions", founded the movement in about 1913, and the other leading figures were Rodchenko and the sculptors Naum Gabo and Antoine Pevsner.

There was a good deal of cross-fertilization between Russian and Western modern art. Malevich, for example, accompanied an exhibition of his works to Berlin and Warsaw in 1927, and Gabo and Pevsner left

Russia in 1922 (following the condemnation of Constructivism by the Soviet regime, which demanded "socially useful" art) and spread Constructivist ideas throughout Europe. They were particularly influential on the Bauhaus, the famous German design school that was one of the key centers of advanced thinking in the arts in the 1920s, and on the Dutch group De Stijl, which promoted a style of austere abstract clarity. The Bauhaus opened in Weimar in 1919, moved to Dessau in 1925 and to Berlin in 1932, before being closed by the Nazis in 1933. The De Stijl group (the name is Dutch for "the style") likewise embraced architects and designers, but the key figures were the painters Piet Mondrian and Theo van Doesburg. De Stijl was founded in 1917, and it published a journal with the same title from 1917 to 1928 (with a final number appearing in 1932 as a memorial to van Doesburg). Mondrian was the outstanding painter of the group and van Doesburg its chief theoretician and spokesman.

Both Mondrian and van Doesburg travelled widely and their ideas spread in Europe and in the USA, where Mondrian settled in 1940. The idea of Concrete Art, coined to describe abstract art that uses only simple geometric forms, was enthusiastically taken up in Switzerland by Max Bill and Richard Lohse, who based their work on mathematical premises. In 1919–38 Mondrian lived in Paris and contributed to the journal of *Cercle et Carré* (Circle and Square) a discussion and exhibition society for Constructivist artists founded there in 1929. He had a keen following in England, where he lived in 1938–40. Ben Nicholson, who met Mondrian in Paris in 1934, produced a series of uncompromisingly pure white reliefs in the 1930s using only right angles and circles. He was one of the editors of Circle, a manifesto of Constructivism published in London in 1937.

Below: *Piet Mondrian (1870–1944):* Composition with Colour Planes, *1917 (Private Collection).*

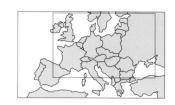

NON-OBJECTIVE ART

- ● Town or city
- ◯ Painter
- ▢ Sculptor
- ◇ Sculptor/painter
- ◯ Abstraction-Création, Cercle et Carré or Concrete Art
- ◯ Bauhaus

- ◯ Constructivist, De Stijl or Suprematist
- ◯ Independent
- ◯ Orphist, Rayonist or Synchromist
- ◯ Vorticist

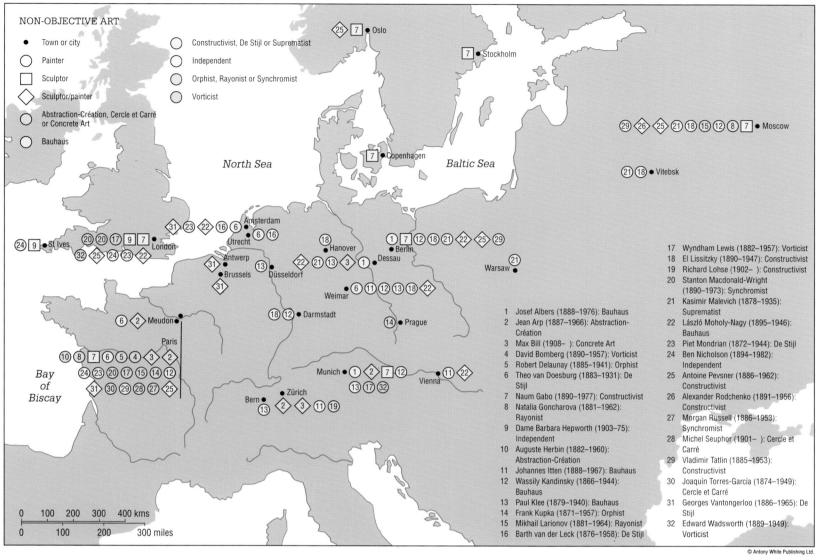

1 Josef Albers (1888–1976): Bauhaus
2 Jean Arp (1887–1966): Abstraction-Création
3 Max Bill (1908–): Concrete Art
4 David Bomberg (1890–1957): Vorticist
5 Robert Delaunay (1885–1941): Orphist
6 Theo van Doesburg (1883–1931): De Stijl
7 Naum Gabo (1890–1977): Constructivist
8 Natalia Goncharova (1881–1962): Rayonist
9 Dame Barbara Hepworth (1903–75): Independent
10 Auguste Herbin (1882–1960): Abstraction-Création
11 Johannes Itten (1888–1967): Bauhaus
12 Wassily Kandinsky (1866–1944): Bauhaus
13 Paul Klee (1879–1940): Bauhaus
14 Frank Kupka (1871–1957): Orphist
15 Mikhail Larionov (1881–1964): Rayonist
16 Barth van der Leck (1876–1958): De Stijl

17 Wyndham Lewis (1882–1957): Vorticist
18 El Lissitzky (1890–1947): Constructivist
19 Richard Lohse (1902–): Constructivist
20 Stanton Macdonald-Wright (1890–1973): Synchromist
21 Kasimir Malevich (1878–1935): Suprematist
22 László Moholy-Nagy (1895–1946): Bauhaus
23 Piet Mondrian (1872–1944): De Stijl
24 Ben Nicholson (1894–1982): Independent
25 Antoine Pevsner (1886–1962): Constructivist
26 Alexander Rodchenko (1891–1956): Constructivist
27 Morgan Russell (1886–1953): Synchromist
28 Michel Seuphor (1901–): Cercle et Carré
29 Vladimir Tatlin (1885–1953): Constructivist
30 Joaquín Torres-García (1874–1949): Cercle et Carré
31 Georges Vantongerloo (1886–1965): De Stijl
32 Edward Wadsworth (1889–1949): Vorticist

© Antony White Publishing Ltd.

Right: *Kasimir Malevich (1878–1935):* Suprematist Composition, *oil on canvas, c.1915 (Museum of Modern Art, New York).*

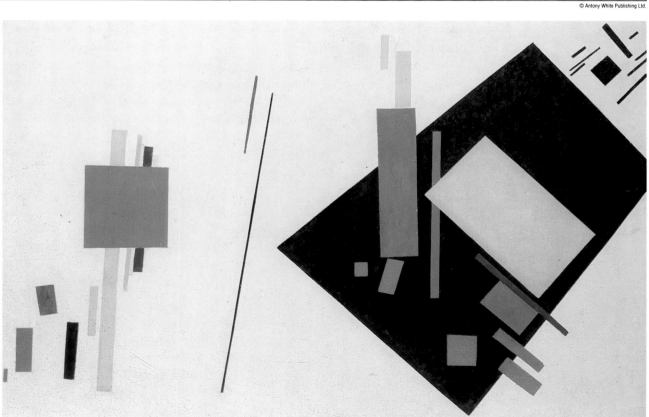

The Rise of Nazism and the Emigration of Artists to the United States

Adolf Hitler became Chancellor of Germany in January 1933 and his Nazi Party immediately began systematic persecution of Jews. This prompted emigration on a massive scale, and between 1933 and the outbreak of the Second World War in 1939 an estimated 225,000 Jews left Germany, 100,000 Austria and 35,000 Czechoslovakia (a decree in November 1941 altogether prohibited further Jewish departure). Among those who left were many distinguished men and women, including scientists such as Albert Einstein and numerous artists.

It was not only Jewish artists who were persecuted, however, for the Nazis thought that art should be in tune with their political doctrines and they repressed and ridiculed (and even destroyed) works that conflicted with their ideology. The art of which they approved was thoroughly traditional in style and technique, glorifying Hitler, militarism and the ideal of Aryan supremacy. *Avant-garde* art was condemned as "political and cultural anarchy", and the term "Degenerate Art" was coined to refer to all modern art that met with Nazi disapproval. In 1937 an exhibition using the term as its title opened in Munich and then travelled to Berlin, Hamburg and other German cities. It featured more than 700 paintings, drawings and sculptures confiscated from the major German museums and the exhibits were provided with inflammatory labels and commentaries (sometimes obscene jokes). The exhibition was a huge propaganda success, more than two million people seeing it in Munich alone. In addition to the works shown, more than 15,000 others were confiscated; some of them were sold, others burnt. The artist with the "distinction" of having the most works confiscated was the racially "pure" Emil Nolde (1867–1956), who had even been a member of the Nazi party.

By this time a stream of artists had already left Germany. A key event was the closing of the Bauhaus, the country's most important school of art and design, by the Nazis in April 1933; they declared it "a breeding ground of cultural Bolshevism". The director of the Bauhaus, Ludwig Mies van der Rohe, one of the greatest architects of the 20th century, remained in Germany until 1937, when he moved to the United States. The first to move in America (1933) was Josef Albers, who became a much respected teacher, mainly at Black Mountain College (a newly-founded experimental school) in North Carolina, but also at Harvard and Yale. He was followed by Walter Gropius, the founder of the Bauhaus, who moved to England in 1934 and then to America in 1937; Marcel Breuer, notable mainly as a furniture designer, who settled in the United States in 1937, worked in partnership with Gropius and like him taught at Harvard; and László Moholy-Nagy, who lived in Amsterdam and London before moving to the United States in 1937; in Chicago he was director of the short-lived New Bauhaus and in 1938 founded his own School of Design, which he directed until his death.

The other major movement to be imported in the Nazi era was Surrealism, arriving mainly via Paris. Five of the lay members of the movement – Breton, Dalí, Ernst, Masson and Man Ray (American-born but based in Paris since 1921) – all settled in the United States in

either 1940 or 1941. Ernst travelled by air from Lisbon with the American art patron, collector and dealer Peggy Guggenheim, who for many years had lived mainly in Europe. Her gallery in New York, Art of this Century, which opened in 1942, was a catalyst in the creation of the New York School. She briefly married Ernst and had an affair with Yves Tanguy.

Not all artists wanted or were able to take refuge in America. Joan Miró planned to go to the United States with his family after the fall of France, but he was unable to obtain a passage, so he moved to Majorca (where his wife had relatives) in 1940, then in 1942 returned to his home town of Barcelona. Max Beckmann, dismissed from his professorship in Frankfurt by the Nazis in 1933, remained in Germany until 1937, when ten of his Expressionist paintings were shown in the Degenerate Art exhibition. He settled in Amsterdam until 1947, then spent the last three years of his life in the United States. Kurt Schwitters, one of the leading figures of the Dada movement, moved to Oslo in 1937, and after the German invasion of Norway in 1940 he fled to England.

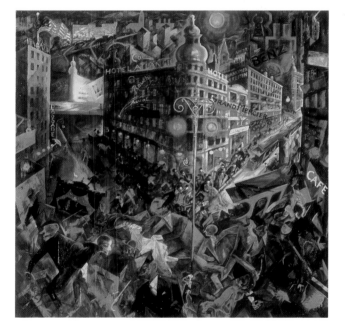

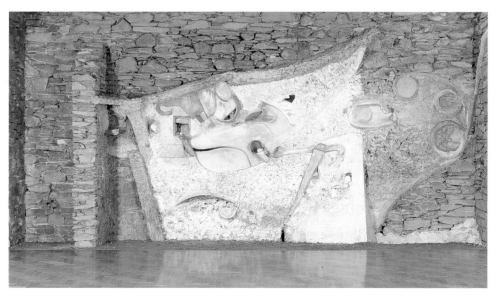

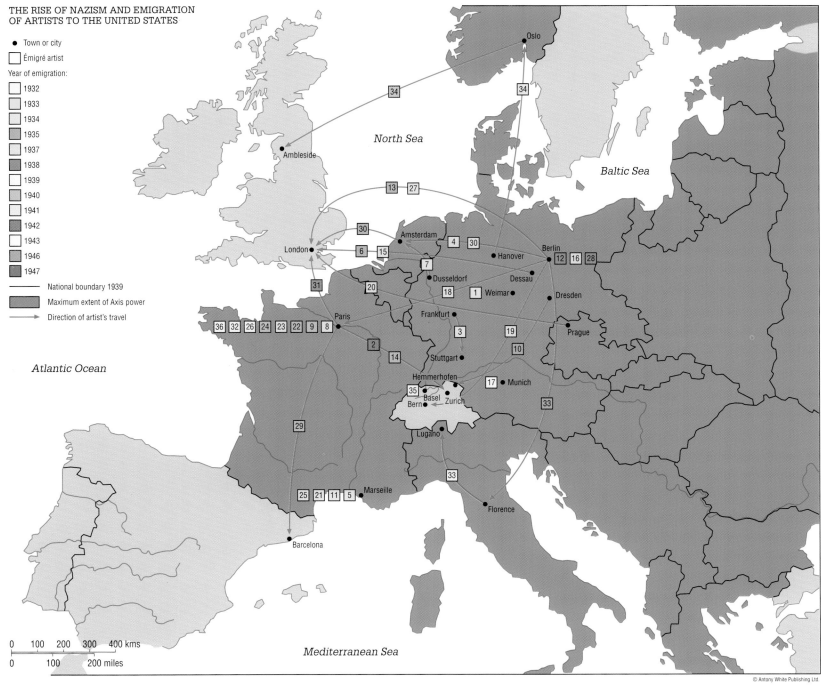

- Town or city
- ☐ Émigré artist

Year of emigration:
- ☐ 1932
- ☐ 1933
- ☐ 1934
- ☐ 1935
- ☐ 1937
- ☐ 1938
- ☐ 1939
- ☐ 1940
- ☐ 1941
- ☐ 1942
- ☐ 1943
- ☐ 1946
- ☐ 1947

— National boundary 1939

▨ Maximum extent of Axis power

→ Direction of artist's travel

© Antony White Publishing Ltd.

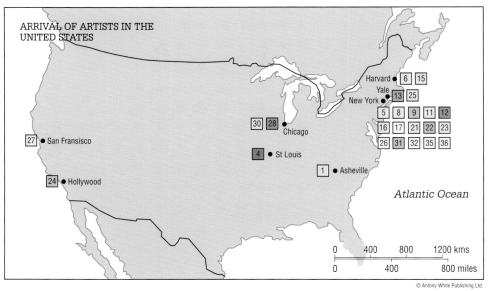

ARRIVAL OF ARTISTS IN THE
UNITED STATES

© Antony White Publishing Ltd.

1 Josef Albers (1888–1976)
2 Jean Arp (1887–1966)
3 Willi Baumeister (1889–1955)
4 Max Beckmann (1884–1950)
5 André Breton (1896–1966)
6 Marcel Breuer (1902–81)
7 Heinrich Campendonk (1889–1957)
8 Marc Chagall (1887–1985)
9 Salvador Dali (1904–89)
10 Otto Dix (1891–1969)
11 Max Ernst (1891–1976)
12 Lyonel Feininger (1871–1956)
13 Naum Gabo (1890–1977)
14 Alberto Giacometti (1901–66)
15 Walter Gropius (1883–1969)
16 George Grosz (1893–1959)
17 Hans Hofmann (1880–1966)
18 Wasily Kandinsky (1866–1944)
19 Paul Klee (1879–1940)
20 Oskar Kokoschka (1886–1980)
21 Wifredo Lam (1902–82)
22 Fernand Léger (1881–1955)
23 Jacques Lipchitz (1891–1973)
24 Man Ray (1890–1977)
25 André Masson (1896–1987)
26 Roberto Matta (b.1911)
27 Erich Mendelsohn (1887–1953)
28 Ludwig Mies van der Rohe (1886–1969)
29 Joan Miró (1893–1983)
30 László Moholy-Nagy (1895–1946)
31 Piet Mondrian (1872–1944)
32 Amédée Ozenfant (1886–1966)
33 Hans Purrmann (1880–1966)
34 Kurt Schwitters (1887–1948)
35 Kurt Seligmann (1900–62)
36 Yves Tanguy (1900–55)

European Architecture in the 19th Century

The 19th century opened to the ravages of the Napoleonic Wars. Just as individual countries struggled to establish their identities in the face of change so, too, architecture sought a new expression for this new age. The strong neo-classical tradition inherited from the 18th century continued in the early 19th century, and the strongest proponents of the style were, in England, John Soane, and in Germany, Karl Friedrich Schinkel and Leo von Klenze.

More generally characterisic of the 19th century is the emergence of a diversity of architectural styles. Publications played an increasingly important role in offering alternatives to neo-classicism. An important teacher and author in France J. N. L. Durand, in his influential work, *Précis des leçons données à l'école Polytechnique* (1802–1809), proposed a normative and economic building typology based on structure with aesthetics being a secondary consideration. The impact of Durand's writing augmented with the rise of antiquarian societies in England and France was that architects were no longer compelled to clad their buildings in neo-classical garb. The Romanesque and Gothic, especially took on new value becoming a rich source for architectural inspiration. In Germany, Heinrich Hubsch's *In welcham Style sollen wir bauen?* (1826), and in England A. W. N. Pugin's *Contrasts* (1836) and John Ruskin's *Seven Lamps of Architecture* and *Stones of Venice* urged examination of medieval sources. Architects were urged to consider the present needs and technology using history as point of departure for their work.

The first buildings in alternative styles began to appear early in the century. John Nash worked in a variety of expressions ranging from the Islamic to the Italianate. A.W.N. Pugin, J.W. Wild and William Butterfield in England, Lassus, Gau and Ballu in France, and Persius in Germany worked within the medieval idiom. This period was one of abstraction of the principles gleaned from historical examples.

The Gothic revival dominated the latter half of the century under the influence of Eugène Emmanuel Viollet-le-Duc in France and George Gilbert Scott and George Edmund Street in England. Viollet-le-Duc, Director of Buildings and Restoration in France, supported 13th century High French Gothic as a national style, but, more importantly, as a rational method of construction which could be adapted to modern materials. Viollet-le-Duc's book *Entretiens*, a collection of his lectures at the École des Beaux Arts in Paris, includes several illustrations of Gothic vaulting rendered in iron. Street went a step further and proposed extending the use of Gothic beyond ecclesiastical to secular buildings. Deane & Woodward's Oxford Museum and Street's Law Courts are examples of adapting the Gothic to non-religious buildings. The High Victorian period in England is characterised by Gothic Revival architecture.

Medieval revivals were not the only option during the 19th century. The Renaissance provided inspiration for Charles Barry in England and for Gottfried Semper in Germany. A new brand of classicism, known as Beaux-Arts classicism, also emerged at mid-century with the work of Charles Garnier on the Paris Opéra. The Free

Style based on a ranging adaptation of abstracted historical elements developed in England late in the century. Richard Norman Shaw's large public buildings exemplify this movement, though Shaw is perhaps better known for his work on large country estates which mark the culmination of the English Domestic Revival.

The 19th century's greatest contribution to the history of architecture is arguably the development of iron and glass construction. Early in the century iron construction was limited to engineering projects such as bridges. With the invention of the Bessemer Process in the mid-1800s, iron became a stronger and more economically viable construction material. Glass used with iron offered means of lightweight construction suitable for creating airy and spacious buildings such as exhibtion halls and department stores. Engineers and designers such as Paxton and Eiffel exploited the possibilities of these improved construction materials and paved the way for much of the 20th century.

Left: *Philip Webb (1831–1915):* The Red House, *1859–60 (Bexleyheath, England).*

Commissioned by William Morris, the house took its name from Webb's use of brick and tiles. The design is eclectic, although, with the high-pitched roofs and pointed arches, it is Gothic in character. The plan is informal and unconventional, but essentially practical. The remarkable interiors and decoration were by Morris & Co.

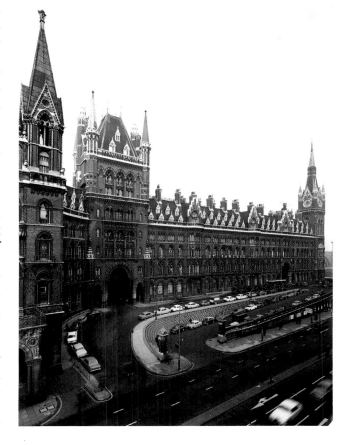

Left: *Sir George Gilbert Scott (1811–78):* St Pancras Hotel and Station Block, *1865–71 (London).*

One of Gilbert Scott's major works, it was the showpiece for the Midland Railway Company, providing extensive hotel accommodation as well as the normal railway offices. An excellent example of Scott's secular work, it is in the High Victorian style, blending Italian, French and Flemish elements.

NINETEENTH CENTURY EUROPEAN ARCHITECTURE

- ⊙ Capital city
- ● Town or city

Architectural style

- ▢ Beaux-Arts classicism
- ◯ English domestic revival
- ▢ Free style
- ▢ Industrial revolution
- ◯ Medieval revival : gothic
- ◯ Medieval revival : romanesque
- ◯ Neo-classicism (Greek revival)
- ▢ Picturesque
- ▢ Rationalism
- ◯ Renaissance revival

0 100 200 300 kms
0 100 200 miles

1 Paul Abadie (1812-84)
2 Alessandro Antonelli (1798-1888)
3 Théodore Ballu (1817-85)
4 Victor Baltard (1805-74)
5 Charles Barry (1795-1860)
6 J.E. Barthélémy (1799-1868)
7 François-Joseph Bélanger (1744-1818)
8 Henri Beyaert (1823-1894)
9 Pietro Bianchi (1787-1849)
10 M. Gottlieb Bindesböll (1800-56)
11 Louis-Auguste Boileau (1812-96)
12 Pierre Bossan (1814-88)
13 Cuthbert Brodrick (1822-1905)
14 Isambard Kingdom Brunel (1806-59)
15 Decimus Burton (1800-81)
16 William Butterfield (1814-1900)
17 Jean-François Chalgrin (1739-1811)
18 Charles Robert Cockerell (1788-1863)
19 Victor Contamin (1840-93)
20 P.J.H. Cuypers (1827-1921)
21 Félix Jacques Duban (1797-1870)
22 François-Alexandre Duquesney (1790-1849)
23 Gustave Eiffel (1832-1923)
24 Harvey Lonsdale Elmes (1814-47)
25 Henri Espérandieu (1829-74)
26 P-F-L. Fontaine (1762-1853) and C. Percier (1764-1838)
27 Charles Garnier (1825-98)
28 Friedrich von Gärtner (1792-1847)
29 Franz Gau (1790-1854)
30 Edward William Godwin (1833-86)
31 Jacques Hittorff (1792-1867)
32 Giuseppe Japelli (1783-1852)
33 Leo von Klenze (1784-1864)
34 Henri Labrouste (1801-75)
35 Victor Laloux (1850-1937)
36 Jean-Baptiste-Antoine Lassus (1807-57)
37 Hector Lefuel (1810-80)
38 Jean-Baptiste Lepère (1761-1844)
39 Arthur Heygate Mackmurdo (1851-1942)
40 Giuseppe Mengoni (1829-77)
41 John Nash (1752-1835)
42 Narciso Pascual y Coloner (1808-70)
43 Joseph Paxton (1801-65)
44 Ludwig Persius (1803-45)
45 William Henry Playfair (v. 1789-1857)
46 Joseph Poelaert (1817-79)
47 Augustus W.N. Pugin (1812-52)
48 Giuseppe Sacconi (1854-1905)
49 Jules Saulnier (1828-1900)
50 Karl Friedrich Schinkel (1781-1841)
51 George Gilbert Scott (1811-78)
52 Paul Sédille (1836-1900)
53 Gottfried Semper (1803-79)
54 Richard Norman Shaw (1831—1912)
55 Robert Smirke (1780-1867)
56 John Soane (1753-1837)
57 George Edmund Street (1824-81)
58 Alexander Thompson (1817-75)
59 Eugène Train (1832-1903)
60 Léon Vaudoyer (1803-72)
61 Pierre-Alexandre Vignon (1763-1828)
62 Eugène Viollet-le-Duc (1814-79)
63 Ludovico Visconti (1791-1853)
64 Charles F.A. Voysey (1857-1941)
65 Alfred Waterhouse (1830-1905)
66 Philip Speakman Webb (1831-1915)
67 James Wyatt (1747-1813)

City Planning in the 19th and 20th Centuries

Few human institutions have evoked such depth of feeling and contradictory attitiudes as the city. Rousseau thought "cities are the final pit of the human spirit", while Johnson's view was that "when a man is tired of London, he is tired of life".

Most towns and cities in Europe grew as the centuries passed: Edinburgh had a medieval center with 18th century additions; Bath flourished late enough to have a strong 18th century taste; industrial towns had a solid and uncompromising 19th century appearance. However there were attempts during the 19th and 20th centuries at planning from first principles.

Washington DC, designed by Charles L'Enfant, 1791–92, was created *ex novo* on a swampy site on the Potomac River and its plan was a curious hybrid, drawing upon two centuries of Baroque city planning to apply urbanistic language to the needs of a democratic nation. The result was a striking plan with a basic grid pattern, and over it a series of avenues – originally thirteen in number, one for each state of the Union – tied together by a major east-west axis culminating in the Capitol, and a minor north-south axis leading to the White House.

In London between 1812–27 John Nash created a grandiose scheme linking Regent's Park to the north with St. James' Park, via Regent Street and Carlton House Terrace. With the design vocabulary of Neoclassicism, Nash gave the area a dynamic scenographic character consistent with Romanticism.

In Europe during the mid-nineteenth century, two influential but differing major projects were underway. Baron Haussmann's plan of Paris (1853–70) rationalized circulation, modernized the civic infrastructure and re-established symbolic political control over the city. In Vienna, Ludwig Forster developed the Ringstrasse, replacing the old civic fortifications with broader, straighter streets.

Later in the century attempts were made at company or factory towns, designed to counter the physical and psychological toll of urban industrial life. Port Sun-light, England, built for the Lever Company from 1888–onwards; the Krupp worker colonies, 1872–onwards, in Essen, Germany; and the notorious Pullman project in Illinois, America bore traces of a revived interest in Beaux Arts and emulated Olmsted's attempt at an anti-city with low-density, single-family housing and ample greenery.

Daniel H. Burnham (1846–1912) and Edward H. Bennett, co-authors of the Plan of Chicago (1909), far surpassed Haussmann in their understanding of the city as a whole. Culturally their plan was a resplendent reflection of America's optimism at the time.

Unexecuted, but indispensable for its contribution to the vision of the modern city, Le Corbusier's book *La Ville Radieuse* (1931–3) integrated aspects of the modern condition which international Modernism regarded as hallmarks of contemporary culture. His "city" was founded upon the automobile and the functional separation of the components of urban life.

Examples of 20th century *non*-residential urbanism include The Rockefeller Center, 1932–39, New York City and Mies van der Rohe's atypical Illinois Institute of Technology (1939–40), Chicago, the latter with its harmonious interplay of mass and space and subtly crafted design relationships of the buildings.

Below left: *Daniel Burnham (1846–1912): design for a proposed Civic Center, from* Plan of Chicago, *1909.*

Burnham's plan tried to impose an order of breathtaking scope on Chicago, with the major institutions coordinated on an axis leading from a great harbor to this monumental Civic Center. However, his simplistic and unrealistic plan made no allowances for skyscrapers, billboards, one-storey buildings or elevated railways.

Below: *Le Corbusier (1887–1966): a page from his book* La Ville Radieuse (The Radiant City), *first published in 1935.*

Corbusier sub-titled La Ville Radieuse "Elements of a doctrine of urbanism" and dedicated it to "AUTHORITY". "It describes ...the rapid and violent growth of the modern phenomenon of urbanism; the explosion of accumulated anxieties and the outbreak of hysteria."

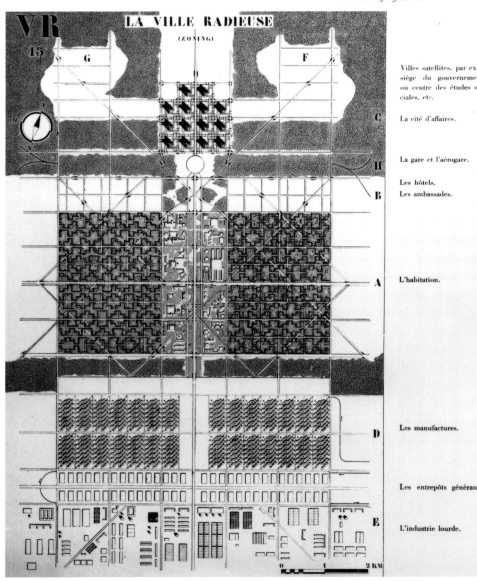

CITY PLANNING IN THE NINETEENTH AND TWENTIETH CENTURIES

- ● City
- ◯ Model town
- ◯ Garden city
- ◯ Factory town
- ◯ Monumental Beaux-Arts metropolis
- ◯ Modern industrial metropolis
- ◯ Other town plan

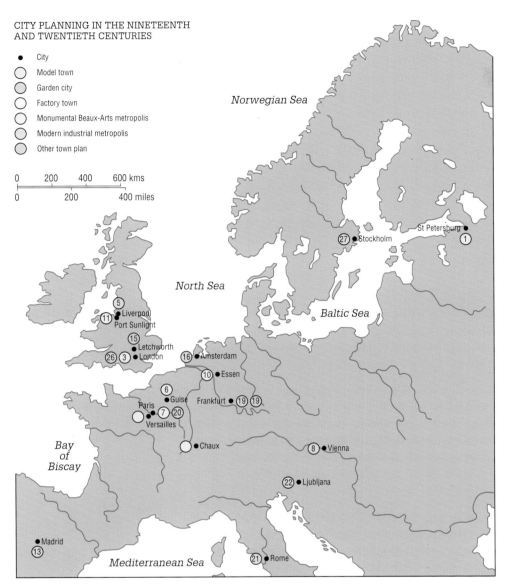

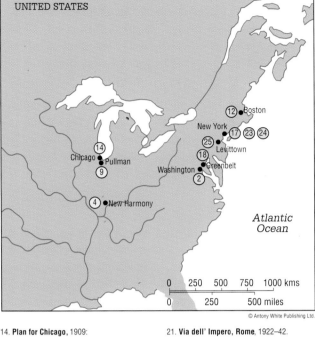

© Antony White Publishing Ltd.

14. Plan for Chicago, 1909:
Daniel Hudson Burnham (1846–1912)
Directly descended from Haussmann's plan for Paris and Beaux-Arts planning principles, the plan reflected American optimism at the time and expressed in the bombastic monumentality of the design an emphasis on the cultural and ceremonial centers of urban life.

15. Letchworth Garden City, 1903:
Barry Parker (1867–1941) and Sir Raymond Unwin (1863–1940)
The Garden City idea, probably the most influential theoretical statement on cities in the 20th century at Letchworth and its successors, combined progressive social organisation and a deeply romanticised medievalism in its architecture and social thought, mostly derived from the teachings of William Morris.

16. Amsterdam, 1901,1915 ff:
Henrik Berlage (1856–1934) and others
One of the most important features of the plan for South Amsterdam is its pioneering use of the 'superblock', great monolithic blocks of housing one after another, giving the impression from the air of a warehouse or factory district. The street plan was extremely regular in a large grid plan.

17. Sunnyside Gardens, New York City,
1924–28: Clarence Stein and Henry Wright.

18. Greenbelt, Maryland, 1935–38:
Clarence Stein and Tracy Augur.

19. Housing Estates, Frankfurt, from c.1925:
Ernst May
May's housing estates on the outskirts of Frankfurt were built under the National Socialist regime and the architecture is Modern and severe. Inspired initially by the Garden City ideal, but accommodating the Modern Movement, May created a streetscape monumental in its unremitting symmetry and intimate in its use of interior pedestrian streets.

20. La Ville Radieuse, 1931–33:
Charles-Édouard (Jeanneret) Le Corbusier (1887–1966)
Corbusier's vision of the modern city that architects and planners have striven to create. The skyscraper made it possible to have high population density without high building density, so towns could rise within a park setting, interrupted only by highways. Corbusier's city was founded upon the automobile and the functional separation of the components of urban life.

21. Via dell' Impero, Rome, 1922–42.
This was the primary street that Mussolini had cut through the ongoing excavations of the Fori Imperiali and was designed as a platform from which one could see 'the grandeur that was Rome'. Cutting a brutal, absolutely straight swarth through the Fori, it connected the symbol of Rome's past, The Colosseum, with that of its future, Mussolini's residence in the Palazzo Venezia.

22. Ljubljana, 1928–40:
José Plecnik
This is an almost unparalleled exercise in urban design from an Austrian Art Nouveau perspective. Plecnik's famous riverside promenade is at once monumental and precious, classical and quirky, and his street plan had a clear accessible symbolic quality that was rare.

23. Rockefeller Center, New York City,
1932–39:
Reinhard and Hofmeister, with Harvey Wiley Corbett (1873–1954) and Raymond Hood (1881–1934)
The Rockefeller Centre is a canonical example of an urban design composed of tall, essentially Modernist buildings, and manages to be congenial to pedestrians through an alchemy of interior streets, public open space and articulation near ground level.

24. Stuyvesant Town, New York City, 1942.
Although a private development, Stuyvesant Town was a prototype of American public housing for those on low incomes. The high-rise buildings were based on Le Corbusier's 'machines for living' and surrounded by a certain amount of open space.

25. Levittown, New Jersey.
Public housing, simular to that of Stuyvesant Town, New York City, was begun in 1947.

26. Greater London Plan, 1944:
L. P. Abercrombie
Signalling the increasingly independent nature of the modern metropolis, the plan was completely dependent on the automobile and on mass transport. Probably one of the most famous examples of immediate post-war planning, it relies on the idea of satellite towns with functional autonomy and use of greenbelts.

27. Stockholm, General Plan, 1944–54,
Sven Markelius (1889–1972)

1. **St. Petersburg.** The first modern capital city to be built according to an overall plan – founded by Peter the Great (1682–1725) and continued by Elizabeth (1741–61) and Catherine the Great (1762–96), it became the great neo-classical city of the north.

2. **Washington DC:** Plan prepared 1790 by Pierre-Charles L'Enfant (1754–1825). Laid out by L'Enfant, a French engineer, the prototype of the plan was not the Baroque city but a French hunting park. There were to be no walled-in streets and squares, but rather isolated block-like structures. However, only The White House and The Capitol, neither by L'Enfant, still occupy focal points in the plan. He was dismissed from public service in 1792.

3. **Regent Street and Regent's Park, London,** 1812–27: John Nash (1752–1835).
Nash seized the opportunity to realize the Prince Regent's ambition to embellish London in a way to rival Paris. He created a vastly original example of civic design, and carried out in an urban situation the principles of Picturesque landscaping.

4. **New Harmony, Indiana,** 1825–28: Robert Owen, c.1825.
Buying a fading utopian settlement in order to found his model village, the plan Owen devised for New Harmony to promote his social and economic ideas, emphasized the rational separation of the various functions of the "cooperative" village. It attempted to embrace the burgeoning factory system and harness it to the creation of an egalitarian society.

5. **Birkenhead Park, Liverpool,** 1844: Sir Joseph Paxton (1801–65)
The translation of Romanticism and the Picturesque into planning terms, Paxton confined his curvilinear "organic" design to the park, but tried to reconcile it to the surrounding urban form.

6. **Familistère, Guise,** c.1859:
Jean Baptiste Godin
Still in existence today, the genesis of Familistère places it directly in line with the planning experiments of the Enlightenment, such as Ledoux's plan for the Royal Saltworks at Chaux. The core of the town is actually a single large building, reminiscent of a French palace, which addresses the surrounding landscape in much the same way as Versailles.

7. **Paris,** 1853–70:
Baron Georges Eugène Haussmann (1809–81)
The natural paradigm of the Beaux-Arts Monumental City, it is the supreme example of the way that while still working aesthetically from Baroque principles, the plan had primarily functional ends.

8. **Ringstrasse, Vienna,** 1859–72:
Christian Friedrich Ludwig von Forster (1797–1863)
This kind of development, rather than Haussmann's interventions in Paris, is much more representative of the way a medieval town can accomodate modern orthogonal planning. The broader, straighter streets became more processional in character, after the relics of a bygone political order were demolished.

9. **Pullmann, Illinois,** 1867:
S.S. Beman

10. **Krupp Workers Colonies, Essen,** 1872

11. **Port Sunlight:** built for the Lever Company, from 1888
An example of late 19th century factory towns, this plan was blatantly paternalistic, seeking personal and social improvement but not societal improvement. With low density, single family housing, curvilinear streets and ample greenery, the attempt was to create an anti-city with close proximity to nature.

12. **Parkway system, Boston, Massachusetts,** 1891:
Frederick Law Olmsted (1822–1903)
Olmsted's greatest contribution to city planning was the idea of the greenway: taking long strips of under-developed and often undesirable land within metropolitan areas and making not just parks, but urban promenades, recreation areas and streets to give a therapeutic antidote to the ills of urban life.

13. **Ciudad Lineal, Madrid,** 1894:
Arturo Soria y Mata
Mata described his city as "a single street, 500 metres wide and of the length that may be necessary. Such will be the city of the future, whose extremities will be Cadiz and St. Petersburg", a design envisioning infinite replication and expansion. A small-scale version was actually executed on the outskirts of Madrid.

World Fairs 1851–1951

Fairs are as old as civilization, but by agreement the first event of World Fair caliber was the Crystal Palace exhibition in London in 1851. The effect of this fair, and its progeny, was more far-reaching culturally than politically. It exposed Europeans to each other and the rest of the world, especially to their exotic colonial subjects, stimulating and changing the disciplines of anthropology, ethnology, comparative religion, and especially art and architecture. The Crystal Palace was archetypal, with its innovative and daring architecture enclosing a vast interior space and in its use of the arts to enhance the status of the event. Amid idealized settings one could see the best contemporary artists, arts, crafts and all manner of consumer goods, the apotheosis of Commerce.

The desire to inspire and amaze, the union of engineering and art, would be an important facet of fair art and architecture. Technology was of great importance: the Eiffel tower, the tallest building in the world for forty years, was originally a flamboyant piece built solely for the 1889 Fair in Paris.

World Fairs also created interest in the popular history and origins of European art. As early as the Crystal Palace, five "reconstructions" of prestigious ancient styles: Egyptian, Assyrian, Greek, Roman and European Moorish, found room within its cavernous walls. While such direct historical references did not become standardized, in 1867, at Paris, Auguste Édouard Mariette, the founder of modern Egyptology, directed the construction of an impressive "temple égyptien" furnished with masterworks from the Musée de Boula in Cairo.

Originally, the first painting exhibitions were only of works created within a year of the show, but gradually shows of Old Masters were added. The British clearly led this trend, and their show of 1908 brought the largest collection ever of French art to England. In America this proved so popular that the collection of Old Masters from the 1939 New York Fair toured until 1942.

The national ambitions of Fair organizers often affected art in unanticipated ways. In an effort to win support for colonial policies, beginning in 1867 native villages were constructed and natives were imported for *tableaux-vivants*. In 1878, 1889 and 1900 primitive art from Oceania and Africa was presented to the public in Paris. Probably the most famous individual touched by these displays was Paul Gauguin, who left for Tahiti in 1891 having seen the 1889 show in Paris.

After this influential exhibition the ethnographic collection was open to the public at the Palais du Trocadéro, but it was African art in the 1900 show, with its use of forms and space, which was to find great favor among the Fauves and Cubists, Vlaminck and Derain in particular collecting West African pieces.

Curiously, modernism was slow to arrive. However, in the San Diego and San Francisco fairs, mural and sculptural decoration was distinctive. One of the most important British contributions to modernism was a retrospective of the Glasgow School in the 1938 fair in that city. Modernism was finally embraced definitively in both the 1937 and 1939 fairs, more as a reaction to the use of classical forms by fascists than for any specifically aesthetic reasons.

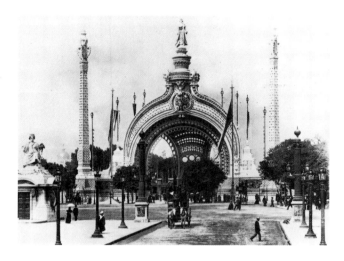

Left: *René Binet (1866–1911):* La Porte Monumentale, *1900 Exposition Universelle, Paris.*

The Art Nouveau style reached its peak in France at the 1900 Exposition. The most ostentatious Art Nouveau structure was Binet's three-legged arched dome, the main entrance to the Expostion on the Place de la Concorde.

Below left: *Henri-Louis Contamin (1840–93):* Les Ponts Roulant, *Palais des Machines, 1889 Exposition Universelle, Paris.*

The Palais des Machines was an engineering masterpiece – the roof pivoted on a huge pin at the apex of each arch allowing the structure to take up the necessary movement within itself. This giant travelling platform allowed visitors to look down on the marvels of science and invention.

Below: *Louis Sullivan (1856–1924)* Door of the Transportation Building, *1893 World Fair, Chicago.*

The great arched Golden Door of Transportation was decorated with allegorical figures in bas-relief covered with a thin layer of gold leaf. The ribbons contain quotations from Bacon and Macaulay.

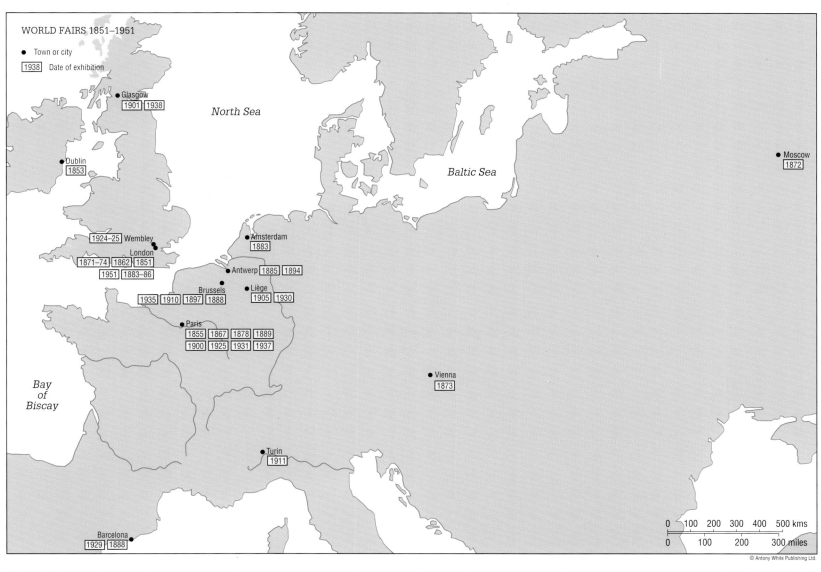

WORLD FAIRS 1851–1951

● Town or city

1938 Date of exhibition

North Sea

● Glasgow
1901 1938

Baltic Sea

● Dublin
1853

● Moscow
1872

1924–25 Wembley
London
1871–74 1862 1851
1951 1883–86

● Amsterdam
1883

Antwerp 1885 1894

Brussels ● Liège
1935 1910 1897 1888 1905 1930

● Paris
1855 1867 1878 1889
1900 1925 1931 1937

● Vienna
1873

*Bay
of
Biscay*

● Turin
1911

Barcelona
1929 1888

| 0 | 100 | 200 | 300 | 400 | 500 kms |
| 0 | | 100 | 200 | | 300 miles |

© Antony White Publishing Ltd.

THE UNITED STATES

Atlantic Ocean

● Boston
1883

● Buffalo 1901

● New York 1853–54 1939–40

Philadephia ●
1876 1926

● Chicago
1893 1933–34

● San Francisco
1915

● St Louis
1904

● San Diego
1915–16

● New Orleans
1884–85

Gulf of Mexico

| 0 | 200 | 400 | 600 | 800 kms |
| 0 | | 200 | 400 | | 600 miles |

AUSTRALIA

*Indian
Ocean*

● Sydney
1879–80

Melbourne ●
1880–81

*Tasman
Sea*

| 0 | 400 | 800 | 1200 kms |
| 0 | | 400 | | 800 miles |

© Antony White Publishing Ltd.

Modern Movements in Architecture: Europe

European modern movements at the beginning of the 20th century continued the reaction against academic classicism and began a search for a vocabulary that would express the machine age and its new building materials. Architects in many European cities thought that classicism was at times inappropriate to their national identity. William Morris (1834–96) founded the Arts and Crafts movement during the 1860s and emphasized simplicity of design and honest expression of material and function through a revival of medieval designs and use of decorative motifs from nature and proved widely influential into the 20th century.

Many countries adopted arts and crafts ideals and adapted them to local concerns and tastes. In the 1880s Belgian designer Victor Horta, architect of the Tassel House in Brussels (1892–93), developed Art Nouveau, a style typified by flowing whiplash curve motifs from nature that were applied to everything from jewelry to buildings. In Austria Otto Wagner inspired the Vienna Secession which produced designers like Joseph Maria Olbrich, designer of Vienna's Secession House (1898–99), and Josef Hoffmann, designer of the Palais Stoclet in Brussels (1905–11).

Expressionism, a brief movement in Germany between 1919 and 1921, producing an architecture based on mystical symbols including crystals, caves and bones. Prime examples of Expressionist architecture include Erich Mendelsohn's Einstein Tower (1920–21) near Potsdam, Germany, and Hanz Poelzig's Grosses Schauspielhaus in Berlin, Germany (1919). Ludwig Mies van der Rohe used Expressionist forms in his 1921 project for a Berlin office building that was to be built with an all steel frame sheathed completely in glass, mimicking crystalline forms.

In 1908 Peter Behrens designed the Turbine Factory in Berlin in which he coupled Arts and Crafts ideals with modern building materials and a new building type. His factory became a bridge to the next phase of European modernism. Modern designers' exploration of how the new vocabulary would shape housing frequently used large blank surfaces of white or lightly colored stucco punctured by windows. Charles-Édouard Jeanneret, better known as Le Corbusier, designed many houses during the 1920s. At the Villa Savoye in Poissy, France (1928–29) Le Corbusier created a sculptural building with steel and concrete structure, stucco walls, and steel-framed windows. These ideals were encouraged by new schools like the Bauhaus which grew out of Arts and Crafts schools. The Bauhaus building in Dessau, Germany (1925–26) by Walter Gropius embodied the same modernist principles of Behren's factory.

The interest in factory and machine aesthetics remained prominent in Europe for progressive architects until well after World War II. In 1932 Henry-Russell Hitchcock and Philip Johnson assembled an exhibition in New York which featured The International Style, a stylistic label that has become the catch-all for this period of modernism.

Above: *Alvar Aalto (1898–1976):* Tuberculosis Sanitorium, *1929–33 (Paimio, Finland).*

This building rivalled the Bauhaus in size, if not in complexity, and was the first major application of the new architecture, and its special applicability, to the design of hospitals.

Far left: *Le Corbusier (1887–1965):* Unité d'Habitation, *1947–52 (Marseilles, France).*

In one single block (540 x 172 ft high/165 x 56 m), Corbusier accommodated 337 apartments, shopping streets, community services, an hotel and a recreational landscape on the roof. A building of great sculptural power and experiential richness, the analogy to an ocean liner is apt.

Left: *Victor Horta (1861–1947):* 25 rue Americaine, c.1898 *(Brussels, Belgium).*

Art Nouveau emerged fully – fledged in Brussels in Horta's buildings: the special interest in this case is that he occupied the house himself.

Below: *Walter Gropius (1883–1969):* The Bauhaus building, *1925–6 (Dessau, Germany).*

The first major example of the new architecture to be executed.

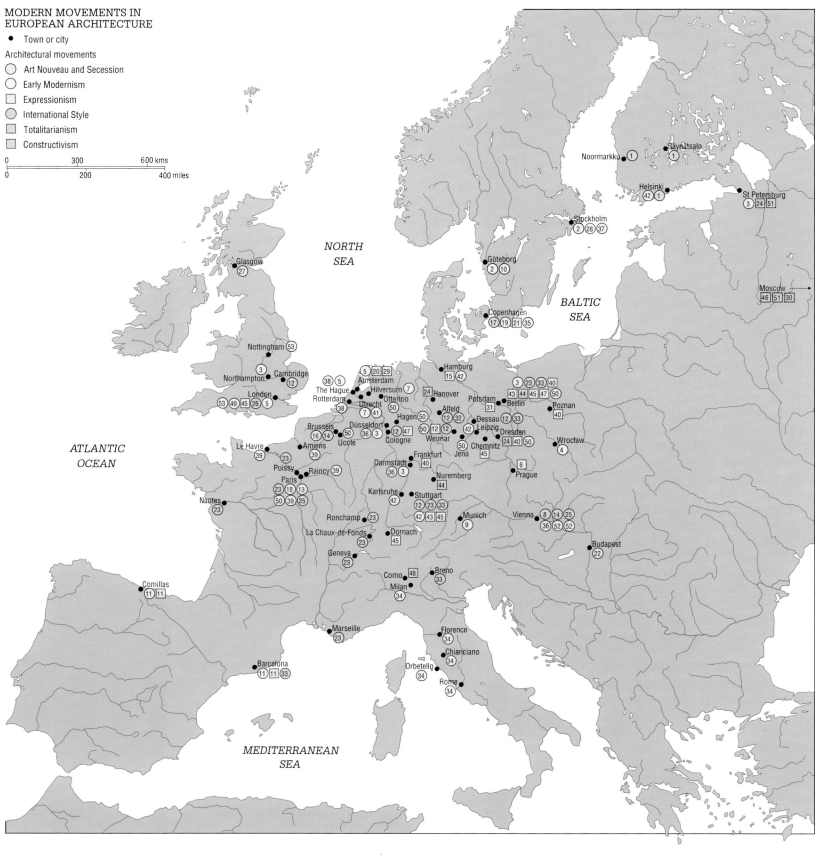

● Town or city

Architectural movements

◯ Art Nouveau and Secession

◯ Early Modernism

☐ Expressionism

◯ International Style

☐ Totalitarianism

☐ Constructivism

0 300 600 kms

0 200 400 miles

NORTH
SEA

BALTIC
SEA

ATLANTIC
OCEAN

MEDITERRANEAN
SEA

Noormarkku ① ● Säynätsalo ①

Helsinki
㊷ ①

St Petersburg
③ ㉔ ㊿

Stockholm
② ㉘ ㊲

Göteborg
② ⑩

Moscow →
㊻ ㊿ ㉚

Glasgow
㉗

Copenhagen
⑰ ⑲ ㉑ ㉟

Nottingham �53

Cambridge
③ ⑫
Northampton

Hamburg
⑮ ㊷

Amsterdam
⑤ ⑳ ㉙

London
�53 ㊾ ㊺ ㉖ ⑤

Hilversum ⑦
The Hague
Rotterdam
㊳
Utrecht
⑦ ㊶
Otterloo
㊿

Hanover
㉔

Potsdam
㉛

Berlin
③ ㉓ �33 ㊵
㊸ ㊹ ㊺ ㊼
㊿

Poznan
㊵

Hagen
㊿

Alfeld
⑫ ㉜

Dessau ⑫ �33
Leipzig
Dresden
㉔ ㉔ ㊿

Wrocław
④

Düsseldorf
⑫ ㊼

Weimar
㊷

Brussels
⑯ ⑭

Uccle
Cologne
⑫ ⑫

Jena
㊿
Chemnitz
㊺

Prague
⑥

Le Havre
㊴

Amiens
㊴

Frankfurt
㊵

Nuremberg
㊹

Poissy
Paris
㉓ ⑱ ⑬
㊿ ㊴ ㉕

Raincy ㊴

Darmstadt
㊱ ③

Karlsruhe
㊷

Stuttgart
⑫ ㉓ �33
㊷ ㊸ ㊺

Munich
⑨

Vienna
⑧ ⑭ ㉕
㊱ ㊿ ㊿

Nantes
㊴

Ronchamp ㉓

La Chaux-de-Fonds
㉓

Dornach
㊺

Budapest
㉒

Geneva
㉓

Como ㊽
Milan
㉞

Breno
�33

Comillas
⑪ ⑪

Marseille
㉓

Florence
㉞

Chianciano
㉞

Barcelona
⑪ ⑪ �33

Orbetello
㉞

Rome
㉞

307

1	Alvar Aalto (1898–1976)	12	Walter Gropius (1883–1969)	23	Charles-Édouard Jeanneret Le Corbusier (1887–1965)	33	Ludwig Mies van der Rohe (1886–1969)	44	Albert Speer (1905–81)
2	Gunnar Asplund (1885–1940)	13	Hector Guimard (1867–1942)	24	El Lissitsky (1890–1941)	34	Pier Luigi Nervi (1891–1979)	45	Rudolf Steiner (1861–1925)
3	Peter Behrens (1868–1940)	14	Josef Hoffmann (1870–1956)	25	Adolf Loos (1870–1933)	35	Martin Nyrop (1849–1923)	46	Vladimir Tatlin (1885–1953)
4	Max Berg (1870–1947)	15	Fritz Höger (1877–1949)	26	Berthold Lubetkin (1901–90)	36	Josef Olbrich (1867–1908)	47	Bruno Taut (1880–1938)
5	Hendrik Petrus Berlage (1856–1934)	16	Victor Horta (1861–1947)	27	Charles Rennie Mackintosh (1868–1928)	37	Ragnar Ostberg (1866–1945)	48	Guiseppe Terragni (1904–41)
6	Josef Chochol (1880–1956)	17	Arne Jacobsen (1902–71)	28	Sven Markelius (1889–1972)	38	Jacobus J.P. Oud (1890–1963)	49	Charles Harrison Townsend (1851–1928)
7	Willem Marinus Dudoc (1884–1974)	18	Franz Jourdain (1847–1935)	29	J. M. van der Meij (1868–1949)	39	Auguste Perret (1874–1954)	50	Henry van de Velde (1863–1957)
8	Karl Ehn (1884–1957)	19	Hack Kampmann (1856–1920)	30	Konstantin Melnikov (1890–1974)	40	Hans Poelzig (1869–1936)	51	Aleksandr Vesnin (1883–1959)
9	August Endell (1871–1925)	20	Michel de Klerk (1884–1923)	31	Erich Mendelsohn (1887–1953)	41	Gerrit Rietveld (1888–1964)	52	Otto Wagner (1841–1918)
10	Sigfrid Ericsson (1879–1958)	21	Peter Vilhelm Jensen Klink (1853–1930)	32	Adolf Meyer (1881–1925)	42	Eero Saarinen (1910–61)	53	Owen Williams (1890–1969)
11	Antoni Gaudi y Cornet (1852–1926)	22	Ödön Lechner (1845–1914)			43	Hans Scharoun (1893–1972)		

The Emergence of Modern American Architecture

American architecture of the 19th and 20th centuries struggled with issues of identity. Thomas Jefferson (1743–1826) first attempted to improve American building by consciously importing European thought. His University of Virginia in Charlottesville (1817–26) created a lawn framed by ten major pavilions, each designed after an important example of classical architecture. During the second quarter of the century architects like William Strickland (1787–1854) and Ithiel Town (1784–1844) sought to introduce a more correct classicism with Greek Revival architecture. The appropriateness of classicism was challenged by the introduction of Gothic Revival architecture as promoted by architects like Andrew Jackson Davis (1803–92) and Richard Upjohn (1802–78) who produced primarily church and house designs. Gothic Revival was imported from Britain and tempered for American taste. Coupled with a revival of interest in early American buildings it led to the development of the Stick and Shingle style, also known as Victorian, during the later half of the 19th century. Virtually all of these styles were limited to the east coast and the eastern portion of the mid-west.

European influence in the United States strengthened with the return of Richard Morris Hunt (1827–95) from the École des Beaux Arts in Paris. Hunt's office produced several important designers, some of whom, like Charles F. McKim eventually became leading architects themselves. McKim's firm, formed with William R. Mead and Stanford White, became the leading builders of the American Renaissance, an adaptation of Classical Style to modern American use.

Henry Hobson Richardson trained in Paris and developed a masssive and individual Romanesque style. He influenced Louis Sullivan who devoted his career to developing uniquely American architecture, including the architectural expression of America's modern high-rise buildings like his Wainwright Building (St. Louis, Missouri, 1890–91). Other Chicago architects like William le Baron Jenney and Daniel Burnham pioneered the development of steel-frame engineering and explored the architectural ramifications. Jenney, Burnham, Sullivan, and others came to be known as the Chicago School and are considered the fathers of American modernism. Frank Lloyd Wright, originally a draftsman for Sullivan, devoted most of his long career to the definition and creation of the American house. His Prairie School house designs, like the Robie House in Chicago (1909), were meant to belong to the American landscape and embody the American versions of Arts and Crafts movement ideals.

Dramatic increases in land value in New York, as in Chicago, at the turn of the century challenged architects to develop a talent for tall buildings, dubbed "skyscrapers". Early New York skyscrapers, like Cass Gilbert's Woolworth Building (1913) employed classical or Gothic detailing to express the tallness of the building, but a building ordinance of 1916 required tall buildings to set back in prescribed increments as they increased in height creating a stepped profile that came to be associated with New York's skyline. William van Alen's Chrysler Building and The Empire State Building by William Lamb (1929–31) epitomize New York's skyscrapers.

Several important European architects came to the United States during the 1930s, most notably Walter Gropius (1883–1969) and Ludwig Mies van der Rohe, and brought with them the International Style. Mies van der Rohe produced a new campus for the Illinois Institute of Technology (1939–40). All of the buildings were simple and box-like and used a steel structure frame with glass and opaque panel infill on the exterior. This steel and glass vocabulary, sometimes called the glass box, became the standard way to build for corporate and governmental buildings in the United States after World War II, replacing the classicism of the American Renaissance. The numerous examples range from the Glass House (1945–9) in New Canaan, Connecticut by Philip Johnson, to the Lever House (1950–4) in New York by Skidmore, Owings and Merrill.

Below: *Frank Lloyd Wright (1867–1959):* The Kaufmann House, ("Falling Water"), *1937–9 (Connellsville, Pennsylvania).*

This luxurious building straddles at its waterfall a stream called Bear Run. Built on solid rock, the chimney and the hearth, as in the Prairie Houses, are the focal point of the design. "Falling Water" is Wright's summary statement about domestic architecture. The contrast between the structured and inverted back of the house with the open front is the organizing principle for entering and going through the house.

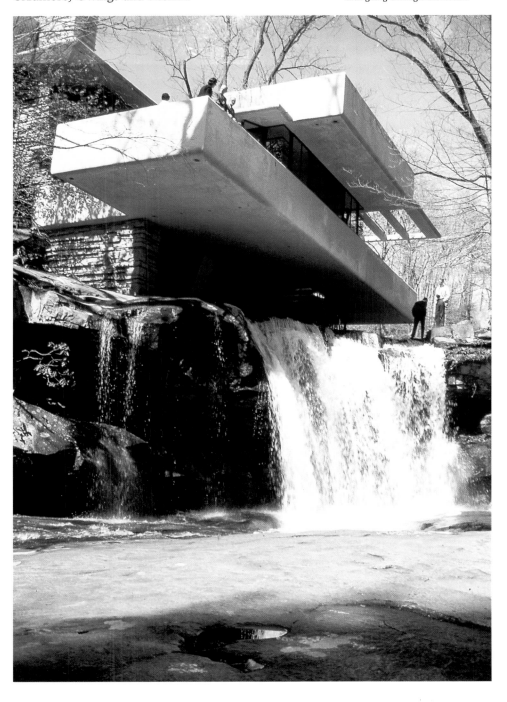

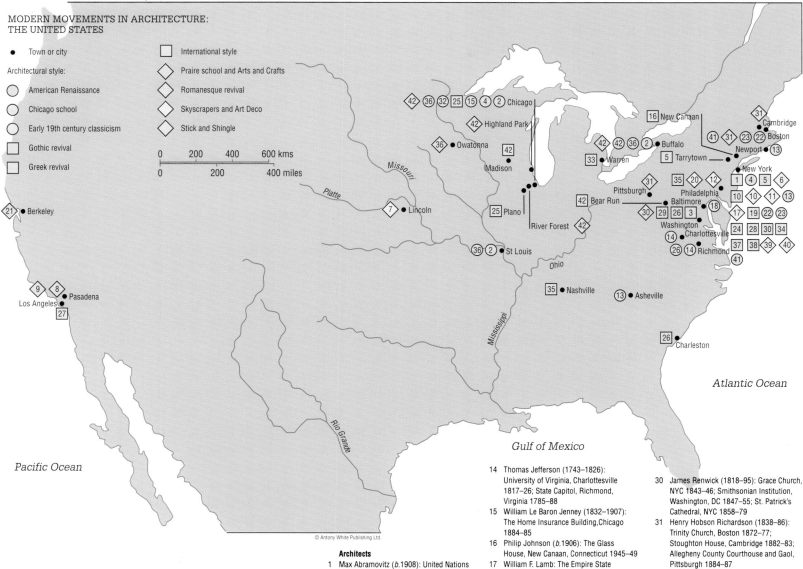

Legend:

- ● Town or city

Architectural style:

- ◯ American Renaissance
- ◯ Chicago school
- ◯ Early 19th century classicism
- ▢ Gothic revival
- ▢ Greek revival
- ▢ International style
- ◇ Prairie school and Arts and Crafts
- ◇ Romanesque revival
- ◇ Skyscrapers and Art Deco
- ◇ Stick and Shingle

Scale:
0 200 400 600 kms
0 200 400 miles

Map labels: Chicago, Highland Park, Owatonna, Madison, New Canaan, Buffalo, Warren, Tarrytown, Cambridge, Boston, Newport, New York, Pittsburgh, Philadelphia, Baltimore, Bear Run, River Forest, Washington, Charlottesville, Richmond, Plano, Lincoln, St Louis, Nashville, Asheville, Berkeley, Los Angeles, Pasadena, Charleston

Missouri, Platte, Ohio, Mississippi, Rio Grande

Pacific Ocean

Gulf of Mexico

Atlantic Ocean

© Antony White Publishing Ltd.

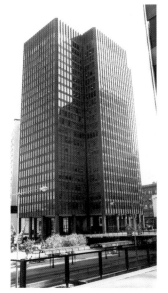

Above: *Mies van der Rohe
(1886–1969):* One Charles
Center, *1963, Baltimore.*

*This 22-storey block was designed
as a copy of The Seagram
Building (1958) with aluminum
instead of bronze cladding.*

Above: *William van Alen
(1883–1954):* The Chrysler
Building, *1928–30, New York.*

*Celebrating the "Jazz age", Van
Alen's Art Deco aspirations
created an American icon.*

Architects

1 Max Abramovitz (*b.*1908): United Nations Building, NYC 1947–50

2 Dankmar Adler (1844–1900): Auditorium Building, Chicago 1887–89; The Wainwright Building, St. Louis, Missouri 1890–91; The Guaranty Building, Buffalo, NY 1894–95

3 Henry Bacon (1866–1924): Lincoln Memorial, Washington, DC 1911–22

4 Daniel Burnham (1846–1912): The Monadnock Building, Chicago 1889–91 The Reliance Building, Chicago 1894–95; Fuller Building, NYC 1901–3

5 Andrew Jackson Davis (1803–92): Customs house, NYC 1833–42; Lyndhurst, Tarrytown, NY 1893

6 Cass Gilbert (1850–1934): Woolworth Building, NYC 1913

7 Bertram Goodhue (1869–1924): State Capitol Building, Lincoln, Nebraska 1920–32

8 Charles S. Greene (1868–1957): Gamble House, Pasadena, California 1907–8

9 Henry M. Greene (1870–1954): Gamble house, Pasadena, California 1907–8

10 Wallace K. Harrison (1895–1981): Rockefeller Center, NYC 1931–39; United Nations Building, NYC 1947–50

11 Raymond M. Hood (1881–1934): Rockefeller Center, NYC 1931–39

12 George Howe (1886–1955): Philadelphia Saving Fund Society, Philadelphia, Pennsylvania 1928–32

13 Richard Morris Hunt (1827–95): Vanderbilt Mansion, NYC 1879–81; Biltmore, Asheville, North Carolina 1890–95; The Breakers, Newport, Rhode Island 1892–95

14 Thomas Jefferson (1743–1826): University of Virginia, Charlottesville 1817–26; State Capitol, Richmond, Virginia 1785–88

15 William Le Baron Jenney (1832–1907): The Home Insurance Building, Chicago 1884–85

16 Philip Johnson (*b.*1906): The Glass House, New Canaan, Connecticut 1945–49

17 William F. Lamb: The Empire State Building, NYC 1929–31

18 William Henry Latrobe (1764–1820): St. Mary's Cathedral, Baltimore 1814–18

19 Charles-Edouard Le Corbusier (1877–1966): United Nations Building, NYC 1947–50

20 William Lescaze (1896–1969): Philadelphia Saving Fund Society, Philadelphia 1928–32

21 Bernard Ralph Maybeck (1862–1957): First Church of Christ Scientist, Berkeley, California 1910–12

22 Charles F. McKim (1849–1909): Boston City Public Library, Boston 1888–95; Pennsylvania Station, NYC 1902–11

23 William Rutherford Mead (1848–1928): Boston City Public Library, Boston 1888–95; Pennsylvania Station, NYC 1902–11

24 John Ogden Merril (1896–1975): Lever House, NYC 1950–52

25 Ludwig Mies van der Rohe (1886–1969): Illinois Institute of Technology, Chicago (1939–40); Farnsworth House, Plano, Illinois 1945–51; 860 and 880 Lake Shore Drive,Chicago 1948–51

26 Robert Mills (1781–1855): Monumental Church, Richmond, Virginia 1812; County Record Office, Charleston, South Carolina 1822–23; Treasury Building, Washington, DC 1836–42

27 Richard Neutra (1892–1970): Lovell House, Los Angeles 1927–29

28 Nathaniel Owings (*b.*1903): Lever House, NYC 1950–52

29 John Russell Pope (1874–1937): Temple of Scottish Rite, Washington, DC 1916

30 James Renwick (1818–95): Grace Church, NYC 1843–46; Smithsonian Institution, Washington, DC 1847–55; St. Patrick's Cathedral, NYC 1858–79

31 Henry Hobson Richardson (1838–86): Trinity Church, Boston 1872–77; Stoughton House, Cambridge 1882–83; Allegheny County Courthouse and Gaol, Pittsburgh 1884–87

32 John Wellborn Root (1850–91): The Monadnock Building, Chicago 1889–91

33 Eero Saarinen (1910–61): General Motors Technical Center, Warren, Michigan 1945–50

34 Louis Skidmore (1897–1962): Lever House, NYC 1950–52

35 William Strickland (1787–1854): Second Bank of the United States, Philadelphia 1812–18; State Capitol, Nashville, Tennessee 1845–59

36 Louis Sullivan (1856–1924): Auditorium Building, Chicago 1887–89; The Wainwright Building, St. Louis, Missouri 1890–91; The Guaranty Building, Buffalo, NY 1894–95; National Farmers Bank, Owatonna, Minnesota 1907–8

37 Ithiel Town (1784–1844): Customs House, NYC 1833–42

38 Richard Upjohn (1802–78): Trinity Church, NYC 1839–46

39 William van Alen (1883–1954): Chrysler Building, NYC 1926–30

40 Ralph Walker (*b.*1889): Barclay-Vesey Building, NYC 1922–26

41 Stanford White (1856–1906): Boston City Public Library, Boston 1888–95; Pennsylvania Station, NYC 1902–11

42 Frank Lloyd Wright (1867–1959): Winslow House, River House, Illinois 1893; The Wards Willets House, Highland Park, Illinois 1902; The Larkin Building, Buffalo, NY 1904; The Martin House, Buffalo, NY 1904; The Robie House, Chicago 1909; Falling Water, Bear Run, Pennsylvania 1937; Herbert Jacobs House, Madison, Wisconsin 1937

American Art 1825–1900

The years 1825 and 1900 bracket a period of amazing growth, development and change in the history of painting, sculpture and architecture in the United States. Before the Civil War (1861–65), American art was dominated by landscape paintings of the Hudson River School. This movement was born in 1826 when the young Thomas Cole arrived in New York from his home in Ohio. His depictions of the Hudson River and its environs in compositions that blended the beautiful and the sublime, the real and the ideal, took the New York art world by storm. Cole's example was quickly followed by artists such as Asher B. Durand, Martin J. Heade, Frederic E. Church, Jasper Cropsey, Worthington Whittredge, and Albert Bierstadt. A style which has been dubbed Luminism and which was a branch of the Hudson River School was practiced by artists such as Fitz Hugh Lane, John F. Kensett, and Sanford Gifford. They painted ultra-serene, open-ended landscapes and marines with glossy, highly-polished surfaces seemingly devoid of movement and sound.

While the Hudson River School survived into the 1870s, most American landscape painters after the Civil War were not interested in the specificity of the older style but joined in the growing international movement of "art for art's sake." Nature was used to express emotion with an emphasis on mood instead of location. The American Tonalists, who in style and technique had affiliations with the French Barbizon artists, were among the first to paint in the new manner. George Inness, Bruce Crane, Birge Harrison, Dwight Tryon, Edward Redfield, and Thomas Dewing were all members of this group. A number of these artists also painted in an impressionist style. The century ended with the founding of The Ten American Painters, a group of American Impressionists who gave a distinctly American translation to the famous style which had originated in France.

Childe Hassam, John Twacthman, William Merrit Chase, Frank Benson, Joseph DeCamp, J. Alden Weir, and others were members of the Ten. They shared stylistic concerns with Mary Cassat and James McNeil Whistler who spent most of their lives abroad; John Singer Sargent, who spent his entire life in Europe but retained his American citizenship; and Thomas Eakins, who left his native Philadelphia for only a few years to study in France. They were among the most adept and innovative figure painters and portraitists of their day. Eakins was also the most famous American Realist, an interest he shared with a group of artists from Cincinnati, Ohio, and its environs, who studied in Munich.

Romanticism was introduced to America in the figural works of Washington Allston and had further translations in paint in the extremely popular genre works of William Sidney Mount and George Caleb Bingham and in the still lifes of John F. Francis. In sculpture the romantic, revivalist spirit flourished. Neoclassicism gave its language of idealization and purity to the work of the first generation of professional American sculptors which included Horatio Greenough, Hiram Powers and Thomas Crawford. Like most American sculptors of the time, these men spent most of their adult life in Italy where they had the best marble and marble crafts-

men. They were joined there by William Henry Rinehart, Joel Hart, William Wetmore Story and Harriet Hosmer among others.

After the Civil War, American sculptors began going to Paris instead of Italy, attracted by the cosmopolitan atmosphere and superior education facilities. Augustus Saint-Gaudens led the way and was joined in these new pursuits by John Q. A. Ward, Daniel Chester French and Frederick MacMonnies. Unlike their predecessors, these sculptors did not settle into long periods of expatriation but returned to America to create, among other things, bronze monuments in a realistic yet expressive manner which glorified the salvaged Union.

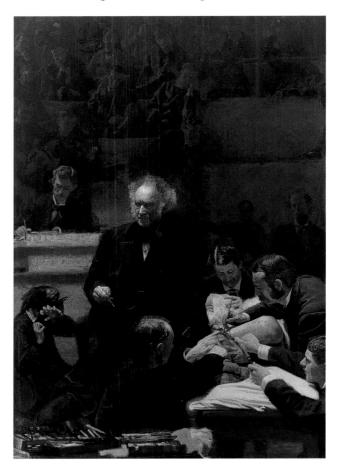

Left: *Thomas Eakins (1844–1916):* The Gross Clinic, *oil on canvas, 1875 (Jefferson Medical College of Philadelphia).*

Eakins had studied anatomy at Jefferson Medical College (as well as fine arts in Pennsylvania), and after a trip to Spain (1869) where he admired Ribera and Velázquez, again took up anatomical studies in 1870. One important result of his studies was this genre painting of Dr Samuel D. Gross, the celebrated surgeon, in his operating amphitheater. Rejected by the art jury of the Philadelphia Centennial Exhibition, 1876, it was finally hung in the medical section.

Below: *Winslow Homer (1836–1910)* Hound and Hunter, *c.1892 (National Gallery, Washington).*

In 1882, after trips to Paris and London, Homer moved for good to Prout's Neck, Maine, and lived in quiet isolation. His delineation of both men and women became increasingly heroic, and he continued to examine what he felt were the profound themes of life, death and survival. The identity of the subject of this painting is thought to be Mike Flynn, a young farm boy from the Adirondacks.

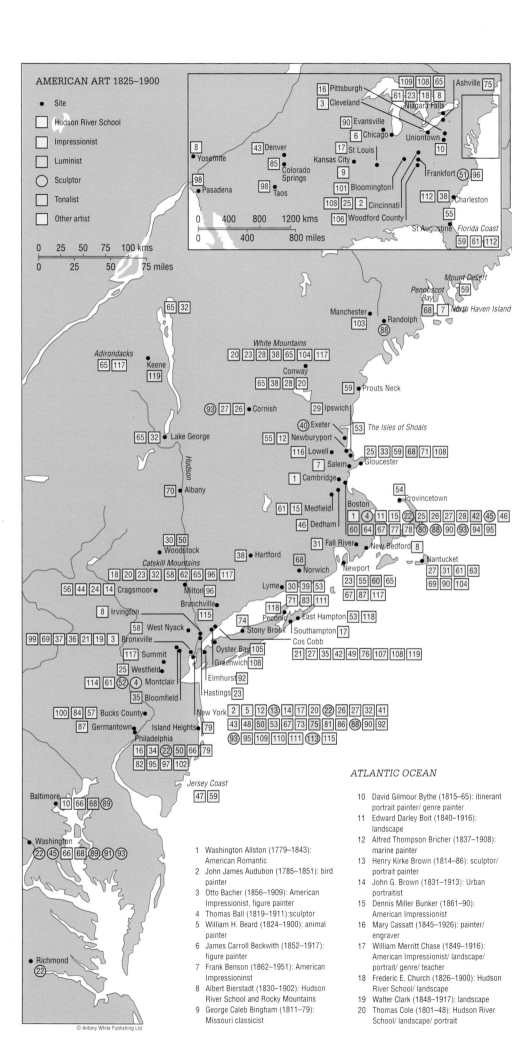

AMERICAN ART 1825–1900

- • Site
- □ Hudson River School
- □ Impressionist
- □ Luminist
- ○ Sculptor
- □ Tonalist
- □ Other artist

1 Washington Allston (1779–1843): American Romantic
2 John James Audubon (1785–1851): bird painter
3 Otto Bacher (1856–1909): American Impressionist, figure painter
4 Thomas Ball (1819–1911): sculptor
5 William H. Beard (1824–1900): animal painter
6 James Carroll Beckwith (1852–1917): figure painter
7 Frank Benson (1862–1951): American Impressioninst
8 Albert Bierstadt (1830–1902): Hudson River School and Rocky Mountains
9 George Caleb Bingham (1811–79): Missouri classicist
10 David Gilmour Bythe (1815–65): itinerant portrait painter/ genre painter
11 Edward Darley Boit (1840–1916): landscape
12 Alfred Thompson Bricher (1837–1908): marine painter
13 Henry Kirke Brown (1814–86): sculptor/ portrait painter
14 John G. Brown (1831–1913): Urban portraitist
15 Dennis Miller Bunker (1861–90): American Impressionist
16 Mary Cassatt (1845–1926): painter/ engraver
17 William Merritt Chase (1849–1916): American Impressionist/ landscape/ portrait/ genre/ teacher
18 Frederic E. Church (1826–1900): Hudson River School/ landscape
19 Walter Clark (1848–1917): landscape
20 Thomas Cole (1801–48): Hudson River School/ landscape/ portrait

21 Bruce Crane (1857–1937): landscape/ tonalist
22 Thomas Crawford (1813–1857): sculptor
23 Jasper F. Cropsey (1823–1900): Hudson River School/ landscape
24 Charles C. Curran (1861–1942): painter/ teacher
25 Joseph DeCamp (1858–1923): Impressionist
26 Maria Oakey Dewing (1845–1928): painter
27 Thomas Wilmer Dewing (1851–1939): Impressionist
28 Thomas Doughty (1793–1856): landscape
29 Arthur Wesley Dow (1857–1922): landscape/ engraver/ teacher
30 Frank V. DuMond (1865–1951): painter/ illustrator
31 Robert Spear Dunning (1829–1905): portrait/ genre
32 Asher B. Durand (1796–1886): Hudson River School/ engraver/ painter
33 Frank Duveneck (1848–1919): painter/ teacher
34 Thomas Eakins (1844–1916): painter/ sculptor/ photographer
35 Charles Warren Eaton (1857–1937): Tonalist/ landscape
36 Francis W. Edmonds (1806–1863): genre/ portrait
37 Mary Fairchild (1858–1946): painter (married W.H. Low)
38 Alvan Fisher (1792–1863): landscape/ portrait
39 Will Howe Foote (1874–1965): portrait
40 Daniel Chester French (1850–1931): sculptor
41 Frederick Carl Frieseke (1874–1939): American Impressionist
42 George Fuller (1822–1884): Tonalist/ portrait/ landscape
43 Sanford R. Gifford (1823–80): Hudson River School/ landscape/ portrait
44 Eliza Greatorex (1820–1897): landscape/ cityscape
45 Horatio Greenough (1805–52): Neo-Classical sculptor
46 Philip Leslie Hale (1869–1917): American Impressionist
47 James Hamilton (1819–1878): marine/ landscape
48 William M. Harnett (1848–92): still life painter
49 Alexander Harrison (1853–90): Tonalist
50 Lovell Birge Harrison (1854–1929): Tonalist/ painter/ illustrator/ teacher
51 Joel Tanner Hart (1810–77): sculptor
52 J. Scott Hartley (1845–1912): sculptor
53 Frederick Childe Hassam (1859–1935): American Impressionist/ painter/ engraver
54 Charles W. Hawthorne (1872–1930): Impressionist
55 Martin Johnson Heade (1819–1904): Hudson River School
56 Edward Lamson Henry (1841–1919): landscape/ portrait
57 Edward Hicks (1780–1849): landscape/ historical (primitive)
58 John Henry Hill (1839–1922): landscape/ etcher
59 Winslow Homer (1836–1910): marine/ landscape
60 William Morris Hunt (1824–79): Tonalist/ portrait/ mural
61 George Inness (1825–94): Hudson River School/ tonalist/ landscape
62 David Johnson (1827–1908): landscape
63 Eastman Johnson (1824–1906): genre/ portrait
64 Hugh Bolton Jones (1848–1927): landscape
65 John F. Kensett (1816–72): Hudson River School/ luminist
66 Charles Bird King (1785–1862): portrait
67 John La Farge (1835–1910): mural/ still life/ landscape/ stained glass
68 Fitz Hugh Lane (1804–65): Luminist/ landscape/ marine
69 Will Hickock Low (1853–1992): painter/ illustrator
70 Homer Dodge Martin (1836–97): Tonalist/ landscape/ illustrator
71 Willard L. Metcalf (1858–1925): American Impressionist/ landscape
72 Richard E. Miller (1875–1943): American Impressionist/ painter/ illustrator
73 Samuel F.B. Morse (1791–1872): portrait/ minaturist/ teacher
74 William Sidney Mount (1807–68): portrait/ still life/ animals/ genre
75 J. Francis Murphy (1853–1921): Tonalist/ landscape
76 Leonard Ochtman (1854–1934): landscape
77 William Page (1811–85): portrait/ figure
78 Lilla Cabot Perry (1848–1933): American Impressionist/ genre/ landscape
79 John F. Peto (1854–1907): still life
80 Hiram Powers (1805–1873): sculptor
81 John Quidor (1801–81): figure painter
82 Milne Ramsey (1846–1915): still life/ genre/ history
83 Henry Ward Ranger (1858–1916): landscape
84 Edward W. Redfield (1869–1965): American Impressionist
85 Robert Reid (1862–1929): American Impressionist
86 Frederic Remington (1861–1909): Wild West painter/ sculptor
87 William Trost Richards (1833–1905): marine/ landscape/ still life/ portrait
88 William Rimmer (1816–79): sculptor/ portrait/ figure
89 William H. Rinehart (1825–1874): sculptor
90 Theodore Robinson (1852–96): American Impressionist
91 Randolph Rogers (1825–92): sculptor
92 Albert Pinkham Ryder (1847–1917): painter
93 Augustus Saint-Gaudens (1848–1907): sculptor
94 Robert Salmon (c.1775–c.1842): marine painter
95 John Singer Sargent (1856–1925): portrait
96 Paul Sawyier (1865–1917): landscape
97 Walter Elmer Schofield (1869–1944): landscape
98 Joseph Henry Sharp (1859–1953): Indian painter
99 George Henry Smillie (1840–1921): landscape
100 Robert Spencer (1879–1931): landscape
101 Theodore C. Steele (1847–1926): landscape
102 Thomas Sully (1783–1872): portrait/ miniature/ figure painting
103 Edmund Tarbell (1862–1938): Boston Impressionist/ painter/ teacher
104 Abbott H. Thayer (1849–1921): painter
105 Louis C. Tiffany (1848–1933): painter/ crafts
106 Edward Troye (1808–74): animal/ portrait/ figure painting
107 Dwight W. Tryon (1849–1925): Tonalist/ landscape
108 John H. Twachtman (1853–1902): American Impressionist/ landscape
109 John Vanderlyn (1775–1852): portrait/ historical/ landscape
110 Elihu Vedder (1836–1923): figure/ mural
111 Robert W. Vonnoh (1858–1933): American Impressionist
112 William Aiken Walker (c.1838–1921): genre/ portrait
113 John Q. A. Ward (1830–1910): sculptor
114 Frederick J. Waugh (1861–1940): marine painter
115 J. Alden Weir (1852–1919): American Impressionist/ painter/ engraver
116 James Abbott McNeill Whistler (1834–1903): Impressionist
117 Thomas Worthington Whittredge (1820–1910): Hudson River School/ landscape
118 Irving R. Wiles (1861–1948): portrait
119 Alexander H. Wyant (1836–1892): Tonalist/ landscape

© Antony White Publishing Ltd.

American Art 1900–1950

American art in the 20th century, whether academic or modernist, was initially subservient to the whims of European taste. There was a common assumption that the achievements of European art, whether in the field of society portraiture or of experimentation with abstraction or the *avant-garde*, were superior. Gradually however the search for a specifically American content and vision (such as had in effect already existed in the best of 19th century American painting) became of paramount importance to the American artist.

Academic tradition reflected taste in Paris, London and Munich. However, the observation of the American scene grew out of the tradition of the schools of Philadelphia, later influenced by study in Munich rather than Paris. The most important of these were a group of artists inspired by the teaching of Robert Henri, all of whom worked as newspaper illustrators in Philadelpia and New York in the last great decade of the manually illustrated daily newspaper and magazine. These painters, such as John Sloan and George Bellows, became the nucleus of the Ash can movement – or the Eight of 1908 – who for the first time recorded realistically, and with wit, the appearance of the streets and sidewalks and the rooftops of New York.

After the First World War this tradition of realism, and the portrayal of the American scene, was continued by those who had observed the disciplines of modernism, such as the Precisionists, by a few wholly original observers such as Edward Hopper and Grant Wood, and by a self-consciously and aggressively realist regionalist movement with artists such as Thomas Hart Benton. Realism at its best reflected an American vision which was acute and original; at worst a reflection of cultural isolationism. An element of social realism, and even polemic, was added during the Depression especially in relation to the murals painted by unemployed artists under the aegis of the Works Progress Administration.

Modernism in American art, as opposed to the influx of Impressionism, was in part promoted through the influence of literary patrons such as Gertrude Stein and her brother Michael, resident in Paris, who introduced American students to Picasso and Matisse. In New York the public was first exposed to European modernism at the Armory Show in 1913; and also through the enlightened exhibitions of modern European and American art and photography created by Alfred Stieglitz at his 291 Gallery in New York from 1905 to 1917.

The 20s and 30s were for modernism in America a time of confusion and self-doubt. A few artists, for instance John Marin, with his seascapes of Maine, and Stuart Davis, with his jazz-inspired abstracts, reached a personal statement – but many were confused by the conflicting need to be both modern, and therefore European, and American. Paradoxically this problem was in part solved by the arrival in New York of various generations of European émigrés: at first the Dadaists Marcel Duchamp and Francis Picabia; later refugees from Nazism such as Josef Albers; and then during the Second War a host of Surrealists and German expressionists. This strange *mélange*, with the teaching of Albers and of Hans Hofmann, and with Peggy Guggenheim

showing paintings in her apartment in New York, proved the catalyst for the creation of Abstract Expressionism, a style of painting that married the automatism of the Surrealists to the freedom of expressionist technique. For the first time America produced a school of painters of undoubted international standing: Jackson Pollock, Willem de Kooning and Robert Motherwell; and, to proclaim their achievement, the critic Clement Greenberg.

Earlier maps in this atlas show that the cultural center of the western world has moved through the course of time: from Athens to Rome, Constantinople, Northumbria, Aachen, Florence, back to Rome and penultimately to Paris. Although it was not obvious at the time, in retrospect it is clear that by 1950, the leadership of *avant-garde* art had made a further switch: from Paris across the Atlantic to New York.

Below: *Thomas Hart Benton (1889–1975):* City Activities with Subway, *oil on canvas, 1930, mural, (New School for Social Research).*

Benton's murals portrayed America in an aggressively realist manner proclaiming his independence from modern art.

Below bottom: *Willem de Kooning (b.1904):* Untitled *1950, oil on canvas (Private collection).*

De Kooning's nervous calligraphic line dances wildly across the surface of the canvas in a rhythm of swiftly executed dramatic movement.

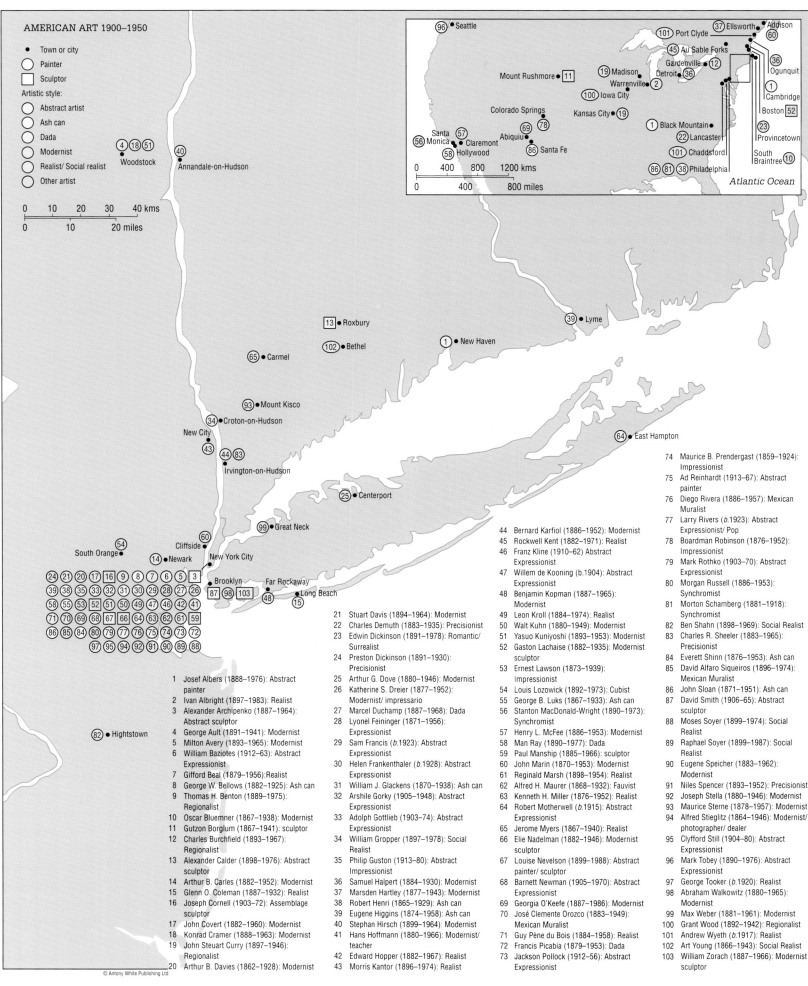

AMERICAN ART 1900–1950

- • Town or city
- ◯ Painter
- ▢ Sculptor

Artistic style:
- ◯ Abstract artist
- ◯ Ash can
- ◯ Dada
- ◯ Modernist
- ◯ Realist/ Social realist
- ◯ Other artist

Scale: 0 10 20 30 40 kms / 0 10 20 miles

Inset labels:
- 96 • Seattle
- 101 • Port Clyde 37 • Ellsworth Addison 60
- 45 • Au Sable Forks
- Gardenville 12 36 Ogunquit
- 11 Mount Rushmore 19 • Madison Detroit 36 1 Cambridge
- Warrenville 2 Boston 52
- 100 • Iowa City
- Colorado Springs Kansas City 19 1 • Black Mountain 23 Provincetown
- 56 Santa 57 69 78 22 • Lancaster
- Monica • Claremont Abiquiu 86 • Santa Fe 101 • Chaddsford South
- 58 • Hollywood Braintree 10
- 86 81 38 • Philadelphia
- 0 400 800 1200 kms
- 0 400 800 miles
- Atlantic Ocean

Main map labels:
- 4 18 51 • Woodstock
- 40 • Annandale-on-Hudson
- 13 • Roxbury
- 102 • Bethel 1 • New Haven
- 65 • Carmel 39 • Lyme
- 93 • Mount Kisco
- 34 • Croton-on-Hudson
- New City 64 • East Hampton
- 43
- 44 83
- Irvington-on-Hudson
- 25 • Centerport
- 99 • Great Neck
- 54 60 Cliffside
- South Orange • 14 • Newark
- New York City
- 24 21 20 17 16 9 8 7 5 3
- 39 38 35 33 32 31 30 29 28 27 26 • Brooklyn Far Rockaway
- 58 55 53 52 51 50 49 47 46 42 41 87 98 103
- 71 70 69 68 67 66 64 63 62 61 59 48 15 • Long Beach
- 86 85 84 80 79 77 76 75 74 73 72
- 97 95 94 92 91 90 89 88
- 82 • Hightstown

1 Josef Albers (1888–1976): Abstract painter
2 Ivan Albright (1897–1983): Realist
3 Alexander Archipenko (1887–1964): Abstract sculptor
4 George Ault (1891–1941): Modernist
5 Milton Avery (1893–1965): Modernist
6 William Baziotes (1912–63): Abstract Expressionist
7 Gifford Beal (1879–1956):Realist
8 George W. Bellows (1882–1925): Ash can
9 Thomas H. Benton (1889–1975): Regionalist
10 Oscar Bluemner (1867–1938): Modernist
11 Gutzon Borglum (1867–1941): sculptor
12 Charles Burchfield (1893–1967): Regionalist
13 Alexander Calder (1898–1976): Abstract sculptor
14 Arthur B. Carles (1882–1952): Modernist
15 Glenn O. Coleman (1887–1932): Realist
16 Joseph Cornell (1903–72): Assemblage sculptor
17 John Covert (1882–1960): Modernist
18 Konrad Cramer (1888–1963): Modernist
19 John Steuart Curry (1897–1946): Regionalist
20 Arthur B. Davies (1862–1928): Modernist

21 Stuart Davis (1894–1964): Modernist
22 Charles Demuth (1883–1935): Precisionist
23 Edwin Dickinson (1891–1978): Romantic/ Surrealist
24 Preston Dickinson (1891–1930): Precisionist
25 Arthur G. Dove (1880–1946): Modernist
26 Katherine S. Dreier (1877–1952): Modernist/ impressario
27 Marcel Duchamp (1887–1968): Dada
28 Lyonel Feininger (1871–1956): Expressionist
29 Sam Francis (b.1923): Abstract Expressionist
30 Helen Frankenthaler (b.1928): Abstract Expressionist
31 William J. Glackens (1870–1938): Ash can
32 Arshile Gorky (1905–1948): Abstract Expressionist
33 Adolph Gottlieb (1903–74): Abstract Expressionist
34 William Gropper (1897–1978): Social Realist
35 Philip Guston (1913–80): Abstract Impressionist
36 Samuel Halpert (1884–1930): Modernist
37 Marsden Hartley (1877–1943): Modernist
38 Robert Henri (1865–1929): Ash can
39 Eugene Higgins (1874–1958): Ash can
40 Stephan Hirsch (1899–1964): Modernist
41 Hans Hoffman (1880–1966): Modernist/ teacher
42 Edward Hopper (1882–1967): Realist
43 Morris Kantor (1896–1974): Realist

44 Bernard Karfiol (1886–1952): Modernist
45 Rockwell Kent (1882–1971): Realist
46 Franz Kline (1910–62) Abstract Expressionist
47 Willem de Kooning (b.1904): Abstract Expressionist
48 Benjamin Kopman (1887–1965): Modernist
49 Leon Kroll (1884–1974): Realist
50 Walt Kuhn (1880–1949): Modernist
51 Yasuo Kuniyoshi (1893–1953): Modernist
52 Gaston Lachaise (1882–1935): Modernist sculptor
53 Ernest Lawson (1873–1939): Impressionist
54 Louis Lozowick (1892–1973): Cubist
55 George B. Luks (1867–1933): Ash can
56 Stanton MacDonald-Wright (1890–1973): Synchromist
57 Henry L. McFee (1886–1953): Modernist
58 Man Ray (1890–1977): Dada
59 Paul Manship (1885–1966): sculptor
60 John Marin (1870–1953): Modernist
61 Reginald Marsh (1898–1954): Realist
62 Alfred H. Maurer (1868–1932): Fauvist
63 Kenneth H. Miller (1876–1952): Realist
64 Robert Motherwell (b.1915): Abstract Expressionist
65 Jerome Myers (1867–1940): Realist
66 Elie Nadelman (1882–1946): Modernist sculptor
67 Louise Nevelson (1899–1988): Abstract painter/ sculptor
68 Barnett Newman (1905–1970): Abstract Expressionist
69 Georgia O'Keefe (1887–1986): Modernist
70 José Clemente Orozco (1883–1949): Mexican Muralist
71 Guy Pène du Bois (1884–1958): Realist
72 Francis Picabia (1879–1953): Dada
73 Jackson Pollock (1912–56): Abstract Expressionist

74 Maurice B. Prendergast (1859–1924): Impressionist
75 Ad Reinhardt (1913–67): Abstract painter
76 Diego Rivera (1886–1957): Mexican Muralist
77 Larry Rivers (b.1923): Abstract Expressionist/ Pop
78 Boardman Robinson (1876–1952): Impressionist
79 Mark Rothko (1903–70): Abstract Expressionist
80 Morgan Russell (1886–1953): Synchromist
81 Morton Schamberg (1881–1918): Synchromist
82 Ben Shahn (1898–1969): Social Realist
83 Charles R. Sheeler (1883–1965): Precisionist
84 Everett Shinn (1876–1953): Ash can
85 David Alfaro Siqueiros (1896–1974): Mexican Muralist
86 John Sloan (1871–1951): Ash can
87 David Smith (1906–65): Abstract sculptor
88 Moses Soyer (1899–1974): Social Realist
89 Raphael Soyer (1899–1987): Social Realist
90 Eugene Speicher (1883–1962): Modernist
91 Niles Spencer (1893–1952): Precisionist
92 Joseph Stella (1880–1946): Modernist
93 Maurice Sterne (1878–1957): Modernist
94 Alfred Stieglitz (1864–1946): Modernist/ photographer/ dealer
95 Clyfford Still (1904–80): Abstract Expressionist
96 Mark Tobey (1890–1976): Abstract Expressionist
97 George Tooker (b.1920): Realist
98 Abraham Walkowitz (1880–1965): Modernist
99 Max Weber (1881–1961): Modernist
100 Grant Wood (1892–1942): Regionalist
101 Andrew Wyeth (b.1917): Realist
102 Art Young (1866–1943): Social Realist
103 William Zorach (1887–1966): Modernist sculptor

© Antony White Publishing Ltd.

Index

Text references in regular type e.g. 62: Map references in bold type e.g. **63**: Illustration references in bold italic type e.g. *80*

Index

Text references in regular type e.g. 62: Map references in bold type e.g. **63**: Illustration references in bold italic type e.g. *80*

315

Index

Text references in regular type e.g. 62: Map references in bold type e.g. **63**: Illustration references in bold italic type e.g. *80*

316

Index

Text references in regular type e.g. 62: Map references in bold type e.g. **63**: Illustration references in bold italic type e.g. *80*

317

Index

Text references in regular type e.g. 62: Map references in bold type e.g. **63**: Illustration references in bold italic type e.g. *80*

Index

Text references in regular type e.g. 62: Map references in bold type e.g. **63**: Illustration references in bold italic type e.g. *80*

Index

Text references in regular type e.g. 62: Map references in bold type e.g. **63**: Illustration references in bold italic type e.g. *80*

Index

Text references in regular type e.g. 62: Map references in bold type e.g. **63**: Illustration references in bold italic type e.g. *80*

Index

Text references in regular type e.g. 62: Map references in bold type e.g. **63**: Illustration references in bold italic type e.g. *80*

322

Index

Text references in regular type e.g. 62: Map references in bold type e.g. 63: Illustration references in bold italic type e.g. *80*

Index

Text references in regular type e.g. 62: Map references in bold type e.g. 63: Illustration references in bold italic type e.g. *80*

Index

Text references in regular type e.g. 62: Map references in bold type e.g. 63: Illustration references in bold italic type e.g. 80

Index

Text references in regular type e.g. 62: Map references in bold type e.g. 63: Illustration references in bold italic type e.g. *80*

Index

Text references in regular type e.g. 62: Map references in bold type e.g. 63: Illustration references in bold italic type e.g. 80

Index

Text references in regular type e.g. 62: Map references in bold type e.g. 63: Illustration references in bold italic type e.g. 80

Index

Text references in regular type e.g. 62: Map references in bold type e.g. **63**: Illustration references in bold italic type e.g. *80*

329

Index

Text references in regular type e.g. 62: Map references in bold type e.g. **63**: Illustration references in bold italic type e.g. *80*

Index

Text references in regular type e.g. 62: Map references in bold type e.g. **63**: Illustration references in bold italic type e.g. *80*

Illustrations and credits

Composition, Museum of Modern
Art, New York. (Photograph:
Bridgeman Art Library)

298 George Grosz: Metropolis.
© DACS 1992, Thyssen-
Bornemisza Collection, Lugano-
Casta. (Photograph: Bridgeman
Art Library)

Kurt Schwitters: Wall Relief.
© DACS 1992, Hatton Gallery,
University of Newcastle upon Tyne.
(Photograph: Bridgeman Art
Library)

300 Philip Webb: The Red House,
Bexleyheath.
(Photograph: Conway Library,
Courtauld Institute of Art)

Sir George Gilbert Scott: St.
Pancras Hotel and Station Block,
London.
(Photograph: RHCM)

302 Daniel Burnham: from Plan of
Chicago
(Photograph: British Architectural
Library/RIBA)

Le Corbusier: from La Ville
Radieuse
(Photograph: British Architectural
Library/RIBA)

304 René Binet: La Porte
Monumentale, Paris.
(Photograph: Héliotypies de E. Le
Deley)

Henri-Louis Contamin: Les Ponts,
Roulant, Paris.
(Photograph: The Illustrated
London News)

Louis Sullivan: Door of the
Transportation Building, Chicago.

306 Alvar Aalto: Tuberculosis
Sanitorium, Paimio.
(Photograph: RIBA)

Le Corbusier: Unité d Habitation,
Marseilles.
(Photograph: RIBA)

Victor Horta: 25 rue Americaine,
Brussels.
(Photograph: Conway Library,
Courtauld Institute of Art)

308 Frank Lloyd Wright: The
Kaufmann House, Connellsville,
Pennsylvania.
(Photograph: RIBA)

309 Mies van der Rohe: One Charles
Center, Baltimore.
(Photograph: Conway Library,
Courtauld Institute of Art)

William van Alen: The Chrysler
Building, New York.
(Photograph: Conway Library,
Courtauld Institute of Art)

310 Thomas Eakins: The Gross Clinic,
Jefferson Medical College of
Philadelphia.
(Photograph: Bridgeman Art
Library)

Winslow Homer: Hound and
Hunter, National Gallery,
Washington.
(Photograph: Bridgeman Art
Library)

312 Thomas Hart Benton: City
Activities with Subway.
© DACS, London/VAGA, New
York 1992, New School for Social
Research.
(Photograph: Bridgeman Art
Library)

Willem de Kooning: Untitled,
1950. © 1992 Willem de
Kooning/ARS, New York. H.
Gates, Pennsylvania.
(Photograph: Bridgeman Art
Library)